W9-BKY-528

SAMS
Teach Yourself

Digital Photography and
Photoshop Elements 3

Carla Rose

All in One

SAMS *800 East 96th Street, Indianapolis, Indiana, 46240 USA*

Sams Teach Yourself Digital Photography and Photoshop Elements 3 All in One

Copyright © 2005 by Sams Publishing

All rights reserved. No part of this book shall be reproduced, stored in a retrieval system, or transmitted by any means, electronic, mechanical, photocopying, recording, or otherwise, without written permission from the publisher. No patent liability is assumed with respect to the use of the information contained herein. Although every precaution has been taken in the preparation of this book, the publisher and author assume no responsibility for errors or omissions. Nor is any liability assumed for damages resulting from the use of the information contained herein.

International Standard Book Number: 0-672-32688-4

Library of Congress Catalog Card Number: 2004091349

Printed in the United States of America

First Printing: December 2004

07 06 05 04 4 3 2 1

Trademarks

All terms mentioned in this book that are known to be trademarks or service marks have been appropriately capitalized. Sams Publishing cannot attest to the accuracy of this information. Use of a term in this book should not be regarded as affecting the validity of any trademark or service mark.

Adobe and Photoshop are registered trademarks of Adobe Systems, Inc.

Warning and Disclaimer

Every effort has been made to make this book as complete and as accurate as possible, but no warranty or fitness is implied. The information provided is on an "as is" basis. The author and the publisher shall have neither liability nor responsibility to any person or entity with respect to any loss or damages arising from the information contained in this book.

Bulk Sales

Sams Publishing offers excellent discounts on this book when ordered in quantity for bulk purchases or special sales. For more information, please contact

U.S. Corporate and Government Sales
1-800-382-3419
corpsales@pearsontechgroup.com

For sales outside of the U.S., please contact

International Sales
1-317-428-3341
international@pearsontechgroup.com

Acquisitions Editors
Betsy Brown
Linda Bump Harrison

Development Editors
Alice Martina Smith
Jonathan Steever

Managing Editor
Charlotte Clapp

Project Editor
George E. Nedeff

Production Editor
Benjamin Berg

Proofreader
Tricia Liebig

Indexer
Chris Barrick
Sharon Shock

Technical Editors
Michelle Jones
Jay Rose

Publishing Coordinator
Vanessa Evans

Interior Designer
Gary Adair

Page Layout
Heather Wilkins

Contents at a Glance

Introduction .. 1

Part I: The Basics

CHAPTER 1 Understanding the Digital Revolution 13

2 The Digital Camera 27

3 Technical Details 53

Part II: Taking Better Pictures

CHAPTER 4 Seeing Photographically 79

5 Telling a Story 107

6 Controlling the Environment 125

7 Painting with Light 147

8 Shooting Portraits 165

Part III: Putting Your Photos to Work

CHAPTER 9 Saving and Uploading Your Pictures 179

10 Better Pictures Through Digital Wizardry 199

11 Welcome to Photoshop Elements 211

12 A Tour of the Desktop 219

13 Handling Photoshop Elements Files 247

14 Printing Your Pictures 265

15 Posting Your Work on the Web 285

16 Keeping Track of Your Pictures 305

Part IV: Working with the Tools

CHAPTER 17 Making Selections and Using Layers 331

18 Working with the Brush Tools 353

19 Adding Type ... 367

Part V: Simple Improvements

CHAPTER 20 Cropping and Resizing a Photo 383

21 Too Light/Too Dark: Adjusting Brightness, Contrast, and Color 407

22 Removing Red Eye, Dust, and Scratches 429

Part VI: Photo Rescue

CHAPTER 23 Using How Tos and Tutorials 447

24 Repairing Black-and-White Pictures 459

25 Making Color Repairs 479

26 Removing and Replacing Objects 495

27 Using the Improvement Filters 511

Part VII: Getting Creative

CHAPTER 28 Color Modes and Color Models 541

29 Creating Art from Scratch 553

30 Using the Artistic Filters 573

31 Making Composite Images 599

32 Going Wild with Your Images 631

Part VIII: Appendixes

APPENDIX A Glossary 675

B Photoshop Elements Menus 695

C All the Shortcuts... 701

Index 707

Table of Contents

Introduction 1

 What Is Photography? 1
 A Brief History of Photography 2
 Get a Lens, Friends... 3
 Mr. Eastman's Invention 4
 It IS Rocket Science! 5
 Space Frozen in Time 5
 Magic Moments 7
 The Photograph As a Communications Tool 7
 The Photograph As an Abstraction of Reality 8
 Color Is Critical 9

Part I: The Basics

CHAPTER 1: Understanding the Digital Revolution 13

 Considering Digital Graphics 13
 Advantages of Digital Photography Over Film 14
 Disadvantages of Digital Photography 16
 Computers As a Photo Tool 17
 Making Versus Taking a Picture 18
 How Photos Are Used Today 19
 Magazine and Newspaper Photographs 21
 Advertising/TV Photography 23
 Law Enforcement 23
 Weddings 23
 Photos in Web Publishing 24
 Summary 25

CHAPTER 2: The Digital Camera 27

How to Make a Simple Camera ..28
How the Camera Works ..29
 Lenses and Focusing ...29
 Camera Pros and Cons ...30
How Digital Cameras Work ...33
 Inside the Camera ...34
 Color and the CCD ..35
Bit Depth and Resolution ...37
 Resolution ..39
Overview of Current Digital Cameras43
 Snapshot Cameras ...43
 Intermediate Cameras ...45
 Professional/Prosumer Cameras45
 Disposable Cameras ...48
Memory Cards ..49
Using Video Cameras for Still Photos50
Summary ...51

CHAPTER 3: Technical Details 53

Understanding How Lenses Work ..53
 Focusing ..54
 Focal Length ...55
 Visual Angle ...56
 Zoom Versus Prime Lenses ..57
 Distortion ...59
 Depth of Field ...59
Manipulating Exposure Controls ..62
 Aperture ..62
 Shutter Issues ...64
 White Balance ...65

Learning Workarounds for Camera Settings 66
 Focus Workarounds 66
 Flash Workarounds 69
 Exposure Workarounds 71
Caring for Digital Cameras 73
 Lens and Screen Cleaning 74
 Batteries and AC Adapters 75
Summary 76

Part II: Taking Better Pictures

CHAPTER 4: Seeing Photographically 79
Comparing What You See and What the Lens Sees 80
Organizing Perception = Composition 81
Framing a Picture 83
 The Shape of the Image 83
 The Shape of the Subject 85
 The Shape of the Space 86
 Dealing with Print and Screen Formats 88
 Learning the Rule of Thirds 89
Discovering Perspective—The Illusion of Reality 91
 Linear Perspective 92
 Aerial Perspective 93
 Contrast in Sharpness 93
 Vertical Location 94
 Overlapping 95
The Importance of Scale 96
 A Matter of Comparison 97
 Using the Horizon 98
 Choosing Your Viewpoint 99
Finding Balance and Symmetry 100
Building Relationships 102

Working with Texture and Pattern .. 104

 Texture .. 104

 Pattern .. 105

Summary .. 106

CHAPTER 5: Telling a Story **107**

How Does a Picture Communicate? .. 107

 Symbols ... 108

 Shared Experiences ... 109

 Creating a Mood .. 110

Using Color ... 114

 Color Defined .. 115

 Using Limited Palettes .. 116

 Working with Tonality ... 117

 Monochrome ... 118

Planning Photo Essays ... 119

 Shooting a Photo Essay ... 120

Release Forms ... 122

Summary .. 124

CHAPTER 6: Controlling the Environment **125**

Natural Backgrounds .. 125

Indoor Settings .. 129

 Using Backdrops and Props ... 131

 Finding Interesting Backgrounds .. 132

 Props for All Occasions ... 132

Improving on Nature .. 134

 Dulling Spray .. 134

 Tapes ... 136

Clothing and Makeup .. 136

 The Glamour Drape ... 137

Food Photography .. 139

 Tricks of the Trade .. 140

Designing Photos for Type and Image Enhancement 142

 Planning for Type .. 142

 Catalogs ... 144

Summary ... 146

CHAPTER 7: Painting with Light **147**

Using Available Light ... 147

 Larger Source = Softer Light 148

 Smaller Source = Harder Light 150

 Balancing Daylight and Artificial Light 151

Using Built-in Flash .. 152

Using Studio Lighting ... 153

 Choosing Lights .. 154

 Keys, Accents, and Fills 155

 Cookies, Flags, and Gobos 158

Tabletop Lighting ... 159

 Shooting Tables .. 160

 The Jewelry Tent 161

 Pitching a Tent .. 161

Summary ... 163

CHAPTER 8: Shooting Portraits **165**

Portrait Posing .. 165

 Couples and Group Portraits 167

 The Flattering Portrait Trick 168

Children and Other Animals 170

 Babies ... 170

 Toddlers ... 171

 Older Kids ... 171

 Pets ... 172

 Farm and Zoo Animals 173

 Wildlife ... 174

 Motion in a Still Picture 175

Summary ... 176

Part III: Putting Your Photos to Work

CHAPTER 9: Saving and Uploading Your Pictures .. 179

 Getting from the Camera to the Computer ..179

 Transferring an Image ..183

 Using a Card Reader for Image Transfer186

 File Formats and File Sizes ..187

 Saving File Space ..189

 Using File Compression with Saved Images192

 Other Formats ..193

 Storage Media ..193

 Scanned Images ..194

 Using a Scanner ..194

 Scanning Film ..196

 Scanning Small Objects ..196

 Summary ..198

CHAPTER 10: Better Pictures Through Digital Wizardry199

 Can You Improve on Perfection? ..199

 Moral and Ethical Issues ..200

 Software for Image Enhancement ..201

 Microsoft Picture It! Photo Edition202

 Jasc Paint Shop Pro ..204

 Adobe Photoshop CS ..206

 Adobe Photoshop Elements ..206

 Other Photo Software ..208

 Summary ..209

CHAPTER 11: Welcome to Photoshop Elements ..211

 Opening Elements ..213

 Getting Help ..214

 Tool Tips ..215

 Recipes ..216

 The Help Button ..218

 Summary ..218

CHAPTER 12: A Tour of the Desktop **219**

Finding Your Way Around ..220

Understanding the Shortcuts Bar221

Starting a New Image ...224

Using the Tools in the Toolbox ...225

 Utility Tools ..225

 Selection Tools ...226

 Miscellaneous Tools ...228

 Painting Tools ...228

 Toning Tools ...229

 Colors ...230

 Tool Shortcuts ..230

Understanding the Options Bar ..231

Using the Menus ..232

Taking a Look at the File and Edit Menus233

 Using the File Browser ...233

What's on the Edit Menu? ...234

Taking a Look at the Image Menu235

 Rotate ...235

 Transformations ..236

 Divide Scanned Photos ..237

 Crop/Resize ..238

 Modes ...238

Taking a Look at the Enhance Menu238

 Adjust Smart Fix ...239

 Adjust Lighting ..239

 Adjust Color ..239

Taking a Look at the Layer Menu240

Taking a Look at the Select Menu240

Taking a Look at the Filter Menu241

Taking a Look at the View Menu242

Taking a Look at the Window Menu243

Using the Photo Bin ...245

Setting Preferences .. 245

Summary .. 246

CHAPTER 13: Handling Photoshop Elements Files **247**

Starting a New Image File .. 247

Browsing for a File .. 249

Saving Your Work .. 251

 Choosing a File Format 252

 Choosing Other Save Options 254

Adjusting Resolution .. 255

Saving for the Web .. 258

Attaching Files to Email .. 259

Exporting a PDF .. 260

Undoing and Redoing .. 261

Using the Undo History Palette 262

Summary .. 263

CHAPTER 14: Printing Your Pictures **265**

Choosing a Printer .. 265

 Inkjet Printers .. 266

 All in One Printer/Scanner/Copier Combinations ... 268

 Laser Printers .. 269

 Dye-Sublimation Printers 270

 Imagesetters .. 271

Preparing the Image .. 271

 Choosing a Paper Type 273

 Selecting Page Setup Options 274

 Previewing an Image .. 278

Printing the Page .. 280

Making Contact Sheets and Picture Packages 281

 Contact Sheets .. 282

 Picture Packages .. 283

Summary .. 284

CHAPTER 15: Posting Your Work on the Web 285

 Internet Limitations and What They Mean to You 286

 Optimizing Images for the Web 287

 JPEG (Joint Photographic Experts Group) 289

 GIF (Graphics Interchange Format) 290

 PNG (Portable Network Graphics) 292

 Optimizing a Graphic Step by Step 293

 Preparing Text for the Web 295

 Preparing Backgrounds 296

 Making Transparent Images 299

 Making Pages Load Faster 300

 Creating a Web Gallery 301

 Emailing a Picture 303

 Summary 304

CHAPTER 16: Keeping Track of Your Pictures 305

 Photoshop Elements Organizer 305

 Understanding Organizer 306

 Starting an Album 309

 Maintaining Links in Organizer 311

 Finding Your Photos 312

 Making Photo Collections 316

 Searching for a Photo 317

 Working with the Photo 317

 iPhoto for Macintosh 320

 Importing Photos 321

 Arranging and Sorting Your Pictures 323

 Editing a Photo 325

 Creating Albums 326

 Sharing Your Photos 327

 Summary 328

Part IV: Working with the Tools

CHAPTER 17: Making Selections and Using Layers 331

Using the Selection Tools 331

Making Selections with Marquees 332

Selecting with the Lasso Tools 333

Making Selections with the Magic Wand 335

Using the Selection Brush Tool 336

Selecting and Deselecting All 337

Modifying Selections 338

Inverting a Selection 338

Feathering a Selection 339

Changing Your Selection with Modify, Grow, Similar 340

Saving and Loading Selections 340

Stroking and Filling Selections 341

Using the Paint Bucket Tool to Fill a Selection 343

Working with Layers 344

Managing Layers 346

Adding a New Layer 348

Moving or Removing a Layer 348

Grouping Layers Together 349

Changing Layer Opacity 350

Summary 352

CHAPTER 18: Working with the Brush Tools 353

The Brushes Palette 354

Brush Options Dialog Box 355

Tablet Options 357

Brushes 359

The Airbrush 359

The Brush 360

The Impressionist Brush 361

The Color Replacement Brush 361

The Eraser ... 363

The Pencil ... 365

Summary ... 366

CHAPTER 19: Adding Type **367**

Using the Type Tools ... 368

 Adding Horizontal and Vertical Type 370

 Choosing Fonts ... 371

Using the Type Mask Tools ... 372

Working with Layer Styles and Text 375

 Editing Layer Styles .. 376

Warping Text .. 378

Summary ... 380

Part V: Simple Improvements

CHAPTER 20: Cropping and Resizing a Photo **383**

Cropping ... 384

Thinking About Good Composition 385

Resizing ... 387

 Resizing an Image .. 388

 Resizing a Canvas .. 389

 Resizing a Portion of an Image 391

Rotating an Image .. 392

 Flipping Images .. 393

 Rotating by Degrees ... 394

Straightening Images .. 394

 Straightening and Leveling "By Hand" 395

 Straightening Selections .. 397

Skewing Selections ... 400

Distorting Selections ... 400

Changing the Perspective of a Selection 403

Summary ... 405

CHAPTER 21: Too Light/Too Dark: Adjusting Brightness, Contrast, and Color 407

Quick Fix ..407

Using the Automatic Correction Tools ..409

 Auto Smart Fix ..409

 Auto Levels ..410

 Auto Contrast ..412

 Auto Color Correction ..413

Adjusting by Eye with Color Variations ..416

Adjusting Color with Color Cast ..417

Adjusting Color with Hue/Saturation ..418

Removing and Replacing Color ..421

Compensating for Lighting Mistakes ..423

Correcting an Image, Step by Step ..424

Summary ..427

CHAPTER 22: Removing Red Eye, Dust, and Scratches 429

Making Basic Cleanups ..429

 Removing Small Objects with the Clone Stamp Tool430

 Removing Small Objects with Copy and Paste432

Fixing Red Eye ..433

 A Pound of Prevention… ..434

 A Couple of Cures ..435

 Fixing Red Eye from Scratch ..437

Removing Dust and Scratches ..439

 Using the Dust & Scratches Filter ..439

 Using the Despeckle and Unsharp Mask Filters440

 Removing Dust and Scratches with the Clone Stamp442

Summary ..443

Part VI: Photo Rescue

CHAPTER 23: Using How Tos and Tutorials 447

Using How Tos ..447

Doing a "To Do" ..449

Following a Tutorial .. 451

Going Online for Help and Inspiration .. 453

 Websites for Ideas and Help .. 454

 Photoshop Elements User Newsletter 455

 The National Association of Photoshop Professionals 456

Summary ... 456

CHAPTER 24: Repairing Black-and-White Pictures **459**

Easy Fixes ... 460

 Correcting Lack of Contrast .. 462

 Dodging and Burning ... 464

 Painting Over Small Blotches ... 466

Preparing an Old Photo for Repair by Removing Sepia 467

Repairing Serious Damage .. 467

 First Steps .. 468

 Repairing Tears .. 468

Applying Vignetting ... 470

Cleaning Up a Picture, Step by Step ... 473

Applying Tints ... 475

Summary ... 477

CHAPTER 25: Making Color Repairs **479**

Correcting Color Cast .. 480

Lightening Shadows and Improving Contrast 481

Making Selective Color Adjustments ... 482

Image Correction Tools ... 484

 Blur and Sharpen .. 485

 The Sponge Tool .. 488

Adjusting Saturation ... 488

 The Smudge Tool ... 489

Making Repairs When Nothing's Really Wrong 491

Hand Coloring a Black-and-White Photo 493

Summary ... 494

CHAPTER 26: Removing and Replacing Objects **495**

Drag-and-Drop Copying .. 495

Removing a Person .. 500

Replacing a Face .. 503

Putting Back What Was Never There 505

Summary ... 510

CHAPTER 27: Using the Improvement Filters **511**

Working with Filters .. 511

Using the Sharpen Filters ... 513

Using the Blur Filters .. 516

 Smart Blur .. 517

 Gaussian Blur .. 519

 Radial Blur ... 520

 Motion Blur .. 522

Adding or Removing Noise .. 524

 Despeckle .. 524

 Dust & Scratches .. 525

 Median ... 526

 Add Noise .. 526

Using the Render Filters ... 527

 Clouds ... 528

 Difference Clouds .. 529

 Lens Flare .. 529

 Lighting Effects .. 529

 Texture Fill ... 532

 3D Transform .. 533

Adding Texture ... 535

Adjusting the Effect of Filters .. 536

Summary ... 537

Part VII: Getting Creative

CHAPTER 28: Color Modes and Color Models 541

Color Models 542

 RGB Model 544

 CMYK Model 544

 HSB Model 544

The Modes and Models of Color 545

 Bitmap and Grayscale 545

 RGB 547

 Indexed Color 547

Color Bit Depth and Why It Matters 551

Calibrating Your Monitor 552

Summary 552

CHAPTER 29: Creating Art from Scratch 553

Choosing Colors 553

 Using Color Pickers 554

 Using the Swatches Palette 555

 Other Tips for Selecting Colors 556

Using the Shape Tools 557

 Changing the Style 558

 Setting the Geometry Options 559

 Drawing Additional Shapes 560

 Finding More Custom Shapes 561

 Selecting a Shape 562

Using the Brush Tool 565

 Setting Brush Options 565

 Painting with the Impressionist Brush 566

Adding New Elements to an Existing Picture 567

Using the Pencil Tool 568

 Setting Pencil Options 568

 Replacing One Color with Another 569

Using the Eraser Tools .. 570

 Erasing with the Eraser Tool .. 570

 Erasing with the Background Eraser Tool 571

Summary ... 572

CHAPTER 30: Using the Artistic Filters **573**

Using the Watercolor Filters .. 574

 Dry Brush ... 577

 Spatter ... 578

Simulating Oil Painting .. 580

 Underpainting .. 580

 Palette Knife .. 582

 Paint Daubs ... 583

Working with Pastels, Chalk, Charcoal, and Pen 584

 Rough Pastels .. 584

 Smudge Stick ... 585

 Chalk & Charcoal .. 586

 Conté Crayon .. 587

 Graphic Pen and Halftone Pattern 588

 Sumi-e ... 590

Creating a Neon Effect with Glowing Edges 591

 Adding a Neon Glow ... 593

Texturizing with Grain .. 594

Sponging an Image ... 595

Summary ... 596

CHAPTER 31: Making Composite Images **599**

Working with Lighting and Scale ... 599

Using Layer Styles to Create Composites 601

Using Adjustment Layers to Fix Image Problems 604

 Adding an Adjustment Layer .. 604

 Editing the Adjustment Layer Mask 606

Understanding Blend Modes..608

Applying Effects..613

 Making an Effect from Scratch..616

 Creating Drop Shadows from Scratch..619

 Making Reflections..621

Using Distortions to Blend Composite Images..622

Putting Together Stitched Panoramas..625

 Working with Photomerge..626

 Considerations When You Shoot a Panorama..629

Summary..630

CHAPTER 32: Going Wild with Your Images **631**

Posterizing Colors..632

Adjusting the Threshold..633

Liquifying an Image..634

Replacing Colors with Gradient Map and Invert..637

 Using Gradient Map..637

 Creating Your Own Gradient..638

 Using Invert..640

Animating a GIF..640

Setting Type in a Circle..643

Using the Magic Eraser..647

Adding Metallic Effects..653

Using Weird Effects..655

 Plastic Wrap..655

 Diffuse Glow..656

 Ocean Ripple..657

 Wave..658

 Solarize..659

Pixelate Filters..660

 Crystallize..661

 Pointillism and Mosaic..662

Stylize .. 663

 Find Edges, Glowing Edges, and Trace Contour 663

 Wind .. 666

 Emboss .. 667

Combining Filters .. 667

 Texturizer .. 668

 Rough Pastels and Film Grain .. 668

Third-Party Filters .. 670

Orbs .. 670

Summary .. 672

Part VIII: Appendixes

APPENDIX A: Glossary **675**

APPENDIX B: Photoshop Elements Menus **695**

 Mac Menus .. 695

 Windows Menus .. 698

APPENDIX C: All the Shortcuts... **701**

Index **707**

About the Author

Carla Rose started her photography career at the age of 8 with a Brownie Hawkeye. A graduate of the School of the Museum of Fine Arts in Boston, she worked as a TV news photographer and film editor, as well as an advertising copywriter and graphic artist, before discovering the Macintosh. She has written all or part of about 30 computer books, including *Sams Teach Yourself Adobe Photoshop CS in 24 Hours*; *Maclopedia*; *Adobe InDesign for the Mac*; *Sams Teach Yourself Digital Photography in 14 Days*; *Sams Teach Yourself Photoshop 4 in 14 Days*; *The Whole Mac*; *Managing the Windows NT Server*; *PageMaker 6.5 Complete*; *Mac Online*; *The First Book of Macintosh*; *The First Book of PageMaker 4 for Macintosh*; *It's a Mad, Mad, Mad, Mad Mac*; *Turbocharge Your Mac*; and *Everything You Ever Wanted to Know About the Mac*. She is a contributing editor for *Photoshop User Magazine* and has also written for publications ranging from the *Atlantic Fisherman* to *Adobe Magazine* to the *New Yorker*. She lives near Boston, Massachusetts, with her husband, audio guru Jay Rose, and several large, friendly cats. She welcomes email addressed to author@graphicalcat.com but regrets that she cannot reply to every message.

Dedication

For the Gang at Termite Terrace

Acknowledgments

No project this big could ever get started, much less completed, without help from a lot of wonderful people. I'd like to thank the folks at Sams, especially Mark Taber, Betsy Brown, Linda Harrison, and Vanessa Evans. Thanks to Michelle Jones and Jay Rose for a thorough technical edit, Jon Steever and Alice Martina Smith for strong development, Ben Berg for expert copy editing, and George Nedeff (Georgius Porgius) for keeping it all on track.

Thanks also to the Adobe folks for providing beta software and for coming up with a wonderful product. Big thanks to the people who supplied photos and/or their own faces for use in the illustrations, including Tanit Sakakini, Wendie Hansen, Judy Blair, Carole Harrison, Linda Standart, Linda Pendelton, Susie MacLeod, Don Maynard, Ali Williams, Naomi Rose, Kara Marzahn, and Samantha Nocera. As always, thanks to my friends in the ABCs for their moral support as I worked 20-hour days to meet deadlines.

Apologies and a hug to everyone I had to ignore or chase away while I worked, especially the cats and the kids. And the biggest hug and deepest gratitude of all to my wonderful husband, Jay, who always does what needs to be done.

Note to Readers

This book was produced using beta versions of Adobe Photoshop Elements 3 for Windows and Mac. Every effort has been made to ensure that the text and screen shots are as accurate as possible, but there may be minor cosmetic differences in the release version of the software. This should not affect the usefulness of the book.

We Want to Hear from You!

As the reader of this book, *you* are our most important critic and commentator. We value your opinion and want to know what we're doing right, what we could do better, what areas you'd like to see us publish in, and any other words of wisdom you're willing to pass our way.

You can email or write me directly to let me know what you did or didn't like about this book—as well as what we can do to make our books stronger.

Please note that I cannot help you with technical problems related to the topic of this book, and that due to the high volume of mail I receive, I might not be able to reply to every message.

When you write, please be sure to include this book's title and author as well as your name and phone or email address. I will carefully review your comments and share them with the author and editors who worked on the book.

Email: graphics@samspublishing.com

Mail: Mark Taber
 Associate Publisher
 Sams Publishing
 800 East 96th Street
 Indianapolis, IN 46240 USA

Reader Services

For more information about this book or others from Sams Publishing, visit our website at www.samspublishing.com. Type the ISBN (excluding hyphens) or the title of the book in the Search box to find the book you're looking for.

INTRODUCTION

Before we get into the technical aspects of choosing a digital camera and using it, let's think for a few minutes about photos, and the science, art, and philosophy of making them.

What Is Photography?

Is it an art, or a science? Is it a tool? Or is it magic? It can be any or all of these, depending on your approach. Photography can be a lucrative career, an engaging hobby, a means of self-expression, and an all-consuming passion. It can also be "none of the above" if you simply point the camera, press the button, and drop the results off at the drugstore for processing. At the very least, photography is the act of creating a photograph.

This brings us to the next obvious question: What is a photograph? We used to be able to define it as an image formed on light-sensitive material, chemically stabilized and projected on a screen for viewing or printed, negative to positive, on light-sensitive paper. That's not, if you'll excuse the pun, the whole picture. It's much more. Poetically, it's a moment frozen in time. It's your son's first wobbly steps, your daughter's confident stride as she crosses the stage to accept her diploma. It's the Grand Canyon at sunset or waves pounding the rocky Maine coast. It's whatever excites you, intrigues you, dazzles you with beauty. It's also what sells your product, identifies you for your passport, or illustrates a news story.

Even the technical definition above is only part of the story. Computers have changed the process, just as they have changed much of the rest of our lives. Digital cameras are replacing film cameras, even at the highest professional levels. And photo-retouching, once a skilled art, is now an easy, and in some cases, automatic procedure.

However, some of the basics are still true. You still need light and a lens to collect it. You need a sensitive surface on which to form the image. You need a shutter to control the amount of time the light enters the camera. You need a way to preserve the captured image and to display it. Why do you need these tools? Let's start at the beginning.

A Brief History of Photography

Photograph comes from two Greek words meaning "light" and "writing." A photograph, then, is the result of a process that converts light to an image. Over the past 180 years, the process has undergone a tremendous number of changes. The earliest known experiments in capturing an image with light-sensitive materials were performed by a French lithographer and inventor, Joseph-Nicéphore Niépce in 1826: He coated a tin sheet with asphalt containing a silver solution and placed the resulting plate inside an artist's *camera obscura*, a device then commonly used for tracing landscapes and architecture in correct perspective. Figure I.1 shows a diagram of the camera obscura.

FIGURE I.1
The light passed through a crude lens, often just a pinhole, and hit an angled mirror, which reflected the image on a sheet of ground glass.

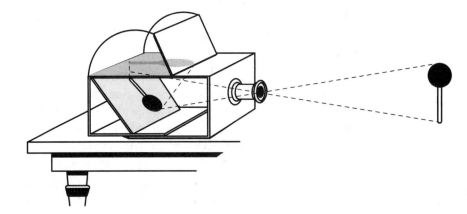

Niépce left the camera obscura on a windowsill at his home in central France, and eight hours later had captured a fuzzy but recognizable picture of his yard and outbuildings. You can see it at http://www.niepce.com/pagus/pagus-inv.html. Eventually, Niépce pooled his knowledge with that of Jacques Daguerre, a Parisian scenery designer who had also been experimenting with light-sensitive chemicals.

By 1839, Daguerre had devised a much improved photographic plate. He coated copper sheets with silver, and then exposed them to iodine fumes to make silver iodide. After exposure, the plate was developed to bring out the image by placing it over a pot of heated mercury. The mercury bonded with the silver, producing a positive image. These early "daguerreotypes" could be used only for architecture and scenery or post-mortem portraiture. No person could sit still for the half hour exposure required. By the time of the American Civil War, glass plate photos were more common and the technique had improved so live portraits were possible. Figure I.2 shows a Civil War soldier in an original glass plate photo.

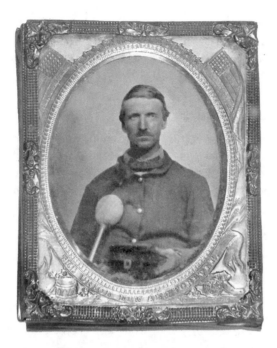

FIGURE I.2
The inscription beneath reads "The Union Now and Forever."

Get a Lens, Friends...

Continued experimentation brought better images faster. The Austrian mathematics professor, Joseph Petzval, realized that Daguerre's crude camera simply needed a good lens. He designed a combination of convex and concave lenses that could be focused to produce a sharp image. Petzval had a sample lens ground and mounted in a telescope-like brass housing by the Voightlander optical company. The result was a camera that reduced exposure time to less than 60 seconds. This made the camera a reasonable tool for capturing images of people as well as landscapes and buildings.

The Voightlander company produced thousands of cameras using Petzval's lens design. Other optical companies began producing lenses, and the camera design evolved into a wooden box with a leather bellows on the front. The bellows made it possible to move the lens back and forth to focus the image on a piece of ground glass. The photographer threw a black cloth over himself and the camera body to block out unwanted light while he focused and replaced the ground glass with a glass photographic plate when he was ready to make the picture. This was the view camera, used by both professional and amateur photographers for most of the 19th century, and well into the 20th. It was large, heavy, and clumsy. The

plates were extremely fragile, and until about 1880, they had to be made on the spot. The photographer carried his darkroom with him, coating the glass plates with silver salts in collodion (a glue-like substance). They had to be used wet, and developed before they dried.

Mr. Eastman's Invention

Meanwhile, the early motion picture camera made use of the same sort of photographic emulsion on long reels of cellulose acetate film. The film emulsion was more sensitive, and exposure times were only a fraction of a second. In 1888, George Eastman put the two ideas together and produced the first handheld camera, the Kodak #1, which used rolls of film instead of glass plates (see Figure I.3).

FIGURE 1.3
The Kodak #1 had a 1/25-second shutter, a fixed focus lens, and two rollers that moved the film. It took round pictures.

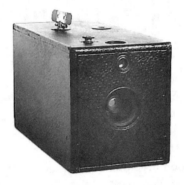

It was small enough to carry around, about seven inches long by four wide, and four inches high. It held enough film for a hundred pictures, and when the roll was finished, the owner sent the camera back to Eastman so the film could be processed and printed, and the camera reloaded. Eastman's snapshot camera turned many thousands of people into amateur photographers, recording everything from family picnics and trips abroad to train wrecks and fires.

Because cameras could easily be carried to news events, photographs replaced etchings and lithographs in magazines and newspapers. Despite all this, the only really drastic change in photographic methods occurred in the 1950s when Edwin Land introduced the "Picture in a Minute" Polaroid. Impatience, coupled with technological advances, brought us a step closer to the digital camera. The Polaroid incorporated developing chemicals into the film. After you took the picture, you pulled the film past a roller that squeezed developer over the exposed film. A minute later, you peeled off the picture and coated it with a combination hardener and fixative. It took only a minute to develop.

It IS Rocket Science!

It was NASA who gave us our first look at digital photography. Back in the early days of the space probe, engineers needed to find a way to send the pictures from TV cameras on rocket ships back to Earth. TV signals could travel only relatively short distances with normal transmitters, but a radio signal at specific frequencies could travel much further. The TV signals could be *digitized*, converted to ones and zeros that could then be sent by radio, received back at NASA headquarters, interpreted by a computer, and translated back to grayscale photos. Visit http://marsrovers.jpl.nasa.gov/spotlight/opportunity/images/MIPL_Moon_first_ 040707152943.jpg to see the first close-up of the moon, taken on July 31, 1964.

Space Frozen in Time

Sensitive film and the mechanical shutter brought about the first big revolution in photography. Instead of the long exposures that Daguerre's plates required, the photographer could freeze a runner in motion, a crashing wave at the seashore, or a fleeting expression on a young girl's face. He or she could literally make time stand still. It was, and still is, magic. Typical digital cameras today use shutter speeds of up to 1/4000th of a second. That's fast enough to freeze almost any action. You can catch a hummingbird's wings in mid-flap, or a cat in mid-pounce.

The concept of freezing time is an important one. A fast shutter speed can capture motion that the eye can't see. For this reason, high-speed photography is often used to document industrial processes that happen too quickly for the naked eye, such as the potato chip cooker shown in Figure I.4.

Freezing time also makes it possible to keep records of features that change over time. To a parent, few things are as valuable as those pictures of baby's first step, first birthday, and all the other "firsts" on the way to growing up. As adults, we all love to go back in time with the family album, looking at the scenes and familiar faces of many years ago. The camera can reproduce the past more faithfully and more permanently than our memories. Even when the pictures are fuzzy, poorly composed, or badly exposed, they are still precious to us because of the times and people they represent. They have frozen an instant in time that had a particular meaning to us. However, unless the picture is clear enough to speak to someone who doesn't know the people in it, or who wasn't at the event, it may be perceived as a failure. If your pictures will be viewed by a wider audience than your family and friends, you must make the "message" as clear as possible. In Figure I.5, the photographer took this picture to the Health Department to document the mess in his neighbor's yard.

FIGURE I.4
Pictures help pin-
point the cause of
mechanical failure.

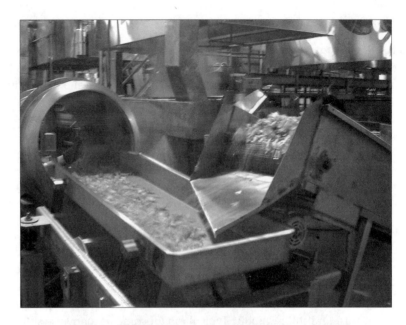

FIGURE I.5
Documentary pho-
tography: He's
attracting rats and
mosquitoes, and
the neighbors don't
appreciate his lawn
ornaments.

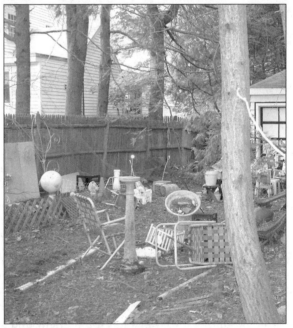

Magic Moments

Finding the right moment to click the shutter is often what makes the photograph a success or a flop. In taking pictures that are time-dependent, the trick is to catch what *Life* magazine photographer Henri Cartier-Bresson referred to as "the decisive moment." It's that split second when the action is at its peak, when history is made, or when the revealing expression crosses the subject's face.

To the photojournalist, it's the second when the assassin's bullet strikes, when the plane explodes in mid-air, or perhaps when two world leaders reach agreement and shake hands at the summit meeting. Some of these moments can be planned for. Others depend on luck—on being in the right place at the right time—with the camera aimed toward the action. Amateur photographers, as well as the professionals, can sometimes catch these "lucky" shots. The photographs of President Kennedy's assassination are a case in point. All were taken by amateurs who happened to be there and have their cameras ready.

The Photograph As a Communications Tool

As the saying goes, "A picture is worth a thousand words." Pictures speak to us. They have meaning. They represent reality. They convey emotions. They may speak of joy or loneliness, of pain, of friendship, or of good times shared. They may simply tell us what the recipe should look like prepared, how the sweater looks on the model, or what's inside a can of peas.

The difference between photojournalism and social documentation is often blurred. The photojournalist attempts to record what's there, what's happening, without imposing his or her feelings about it. Social documentary, however, has an attitude. The documentary photographer shoots a particular subject or scene because it may help to convince others of the need to either preserve or change the situation.

An example of this social documentation is the work of photographers Margaret Bourke-White and Dorothea Lange in the 1930s. They photographed scenes of poverty in rural America—they showed the agony of a mother watching her children starve, defeat on the faces of the men in the Depression-era bread line, and the sorrow of a dustbowl farmer forced to pack up his family and leave his land in search of work. Their pictures, many of which were published in *Life* magazine, were a major factor in bringing about unemployment insurance and other

programs to aid the poor and homeless. It was photojournalism, in that it documented conditions at the time, but it became a social commentary as well because the subjects were selected specifically to make a point about the unacceptable conditions with which they lived.

When you take a picture, you need to be clear about the purpose of creating it. Are you recording a scene for posterity, or are you sharing your feelings about the subject? Are you simply documenting what's there, or are you pointing out something that's particularly interesting or beautiful?

The Photograph As an Abstraction of Reality

Most pictures are of something—a person, a place, a thing—recognizable as what it is. Others fit more into the category of abstract art. Depending simply on how it's cropped, the object in Figures I.6 and I.7 is either an abstract shape (possibly a nude model) or a vegetable. The object itself hasn't changed. What has changed is the perspective from which we view the object.

FIGURE I.6
Object #1, up close. (Photos by Tanit Sakakini)

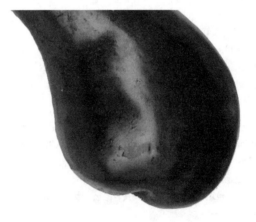

To a certain extent, all photographs are art, and all photographs are abstract. The nature of reducing a three-dimensional object to a two-dimensional image is by definition an abstraction. Reducing a color image to shades of gray is another abstraction. To an artist, however, abstraction implies something a bit more complex. The tightly cropped veggie in Figure 1.6 is an abstraction of the quality of "eggplant-ness." It has colors and curves, but it's not a specific, identifiable object, as is the other one in Figure 1.7. By removing some of the identifying detail, we have reduced it from an object to an abstraction of that object.

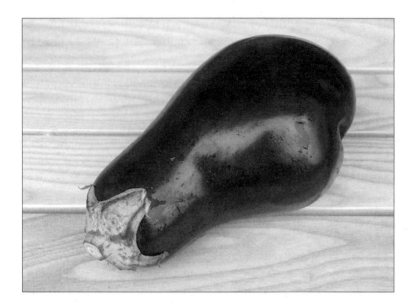

FIGURE I.7
Object #2, from a
distance. It's simply
an eggplant.

The key to successful abstraction is to consider the composition of the picture. The lines and patterns and shapes of the objects photographed must be made to relate to the shape of the picture. It must appeal to the viewer. Abstract art, according to photographer Edward Steichen, appeals first to the emotions, and then to the intellect.

The sensuous curves and shiny skin of the eggplant are aesthetically pleasing. They catch the viewer's eye simply because they are pleasant to view. The pleasure, in turn, leads the viewer to wonder what the abstract object represents. We might find ourselves comparing the shape and texture to other familiar objects and asking ourselves, "Is it a flower? No. Is it some piece of human anatomy? No. Is it…" and so on, playing a game of "Animal, Vegetable, or Mineral" until we finally realize that it is indeed, a vegetable.

Looking again at the curves of the eggplant, if it were some other color, perhaps a deep brown or silver, we would see it very differently—we would try to impose some other reality on it. We might see it as a polished stone, or as a musical instrument.

Color Is Critical

Most of us see the world in color. Even those people who are said to be "color blind" usually see some kind of color. They might be deficient in the ability to see

red or blue, so their perception of purple or green or yellow is also different. Seeing the world only in shades of gray, as photographers did for many years, is an abstraction of reality.

Of course, all photos—with the exception of three dimensional holograms—are an abstraction anyway. Very few photo subjects are completely flat. When you take a picture, you are flattening what you see onto a page or a screen.

Color helps us interpret what we see, and allows us to look at an abstract shape like the eggplant and decode it into something we can recognize. If your intention is to be as abstract as possible, you can often pitch your viewers a visual curve ball by changing the color of the object to something unusual, like making the eggplant turquoise blue or adding stripes. That is one of the more creative aspects of digital photography, and one that's very simple to do.

When you add a computer and the right software to your digital camera, you open new doors for creative expression. In the chapters ahead you'll learn how to choose and use the right digital camera for your picture-taking needs, and you'll learn how to improve your photos with Adobe Photoshop Elements 3, the stream-lined version of Adobe Photoshop, which has been the choice of professional graphic artists ever since its introduction in 1987.

PART I

The Basics

CHAPTER 1 Understanding the Digital Revolution **13**

CHAPTER 2 The Digital Camera **27**

CHAPTER 3 Technical Details **53**

CHAPTER 1

Understanding the Digital Revolution

What You'll Learn in This Chapter:

▶ Considering Digital Graphics

▶ Computers As a Photo Tool

▶ Making Versus Taking a Picture

▶ How Photos Are Used Today

There's no question that the computer age has changed our lives, though some folks would argue that the changes aren't necessarily better. With everything from toasters to telephones to vacuum cleaners gone digital, it's a brave new world. Personal computers and cameras are just a small part of it. In this chapter, we'll try to understand digital technology as it applies to photography.

Considering Digital Graphics

Long before there were digital cameras, there was digital darkroom technology. Adobe Photoshop and Letraset ColorStudio first appeared in 1989, but even before that, there was a black-and-white image-editing program called Digital Darkroom from Silicon Beach Software. You could adjust the brightness and contrast of a scanned photo, as well as crop, rotate, and posterize the image. You could even use the paintbrush to retouch spots that needed it. At that point, it wasn't really any more than you could do to a real photo in a real darkroom. But, as people began to explore the possibilities, the market grew for this kind of software. Because Digital Darkroom was limited to 8-bit grayscale, which translated into 8-bit color, it simply wasn't good enough for professional photographs.

Almost as soon as Apple introduced a Mac with 24-bit color, Photoshop and ColorStudio were released. Because of the cost (ColorStudio originally sold for $1,995), these weren't programs for the hobbyist, but rather for the commercial art studio, television production facility, or ad agency. Consumers begged for more affordable image software, and it gradually became available. Programs such as SuperPaint and BeagleWorks Paint let amateurs have as much fun as the professionals, even if the results were more limited.

Digital cameras have also been around longer than you might think. Apple's QuickTake 100, introduced to an eager market in 1994, was the first affordable digital camera for the average person, but there were high-end (a fancy way to say high-priced) models a couple of years earlier. Hollywood had already discovered the effectiveness of shooting both film and video at the same time, using a lens with a prism that sent one image to the film camera gate and the other to the video camera. By this time, there were also many video-capture systems that took single frames from a videotape, or from a "live" image on a camcorder or video camera.

Advantages of Digital Photography Over Film

The advantages of digital photography are many. Digital cameras are lightweight and easy to carry. You don't need to buy film or pay for processing. You don't need to set up a darkroom to do your own photo finishing, so you don't need to deal with the mess and smell of chemicals, the stains on your fingers and clothing, and the expense of building and furnishing a darkroom. You won't contribute to the chemical pollution of the environment by pouring used developer, fix, or other potentially hazardous waste into the sewer or sending them into the regional water supply.

There's no waiting for film to process or prints to be made and scanned. You can look at your digital photos as soon as you've taken them. If there's a TV set handy, you can display your pictures on the TV screen just by plugging in a cable that's included with the camera. Transferring the photo from the camera to the computer takes only a few seconds. Unlike the 15-step process shown in Figure 1.1, all you do is plug a cable from the camera into the computer, open the program that came with the camera, and choose the picture to import.

Digital cameras also let you throw away the bad shots, so they don't waste memory. The good ones will last as long as the hard disk, floppy, CD-ROM, or other storage medium you save them on...virtually forever, without scratching, fading, or color shifting.

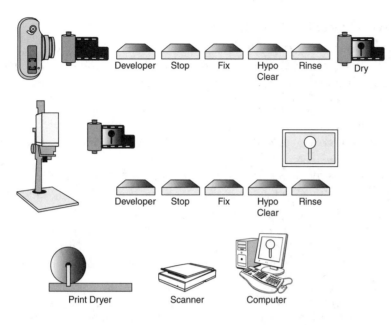

FIGURE 1.1
Fifteen steps for
film and paper; one
step digitally.

Some digital cameras save pictures to a memory card, a piece of plastic about half the size of a business card, only a little thicker. You can pack 20 of these flashcards in the space occupied by just two rolls of 35mm film, and carry as many as 2,100 high-quality pictures, instead of the 72 that the film holds. Flashcards aren't cheap, so you might think twice about buying that many, but they are reusable. If you carry only a couple and have access to a computer, you can upload your pictures and recycle the flashcard to hold more, an ideal situation for the world traveler or roving photojournalist.

Nikon now has a wireless transmitter that can instantly send your photo from the camera to a computer using the same FTP system that uploads and downloads files to the Internet.

By the Way

After you're past the initial investment—the camera, the computer, image-manipulation software, and a color printer—your pictures don't cost you anything. You'll never run out of film, and you'll never need to buy any. In the long run, you'll save money—even if you buy the most expensive camera you can afford—because you won't ever again have to pay for film or processing or multiple prints.

Disadvantages of Digital Photography

Only a few disadvantages to using a digital camera exist. The major one is cost, although you now get a lot more for your money than you did even a couple of years ago. New models have much higher resolution, meaning their pictures can be blown up large without showing individual pixels.

High-end digital cameras such as the Nikon D2h are quite expensive. The highest of the high-end models currently is the Canon EOS 1Ds, which will set you back about $8,000. Backing down from the stratosphere to something in the affordable range, for under $200, you can get a camera that's technically comparable to a similarly priced 35mm snapshot camera. Of course, you can spend as little as $15 for a disposable digital camera that takes 27 shots. After you fill the camera's memory, you return it to the store or send it to a processor and you get your pictures back as prints, and on a CD-ROM. There are also many older digitals for sale for a small amount of money at camera stores and disadvantages online.

Did you
Know?

> You won't be paying for film, but you might want to find a place to buy AA batteries by the case. Lithium batteries will give you longer service, but because they cost more, it's a toss-up to whether you'll save anything by using them. A couple of sets of rechargeable batteries and a charger are definitely a wise investment.

Some digital cameras are frustrating to use because there's a delay between the time you press the shutter and the time the camera takes the picture. Although it's usually less than a full second, the cat has jumped off the table, the baby's smile has turned to tears, or the train has passed.

Digital cameras usually weigh a couple of ounces more than comparable film cameras because of the batteries they require. This is rarely a problem for most of us, but if you're going to be carrying your camera and spare batteries all day as you travel, even those few ounces start to make a difference. Look for a small, lightweight model for travel photos. There are some amazingly small ones, like the Casio model that's only a half inch thick and about the size of a standard business card, and still has excellent resolution.

Finally, some people say there are still quality differences between digital and film cameras, that film has a certain "look" which digital photos don't have. I, personally, am not convinced I can see a difference. If you are converting your digital photos to grayscale, it is possible to see a difference if you look very carefully. Film is slightly more sensitive. An especially good black and white photographer, such as the late Ansel Adams shot very carefully exposed photos in which you

could really see at least 10 different steps, or shades of gray, from white to black. He called them zones, and based his zone system of exposure on them. Digital pictures which must be converted from color to grayscale seldom achieve that many grays. To see examples of Adams's work and what a well-exposed black and white photo should look like, visit http://www.historyplace.com/ unitedstates/adams/index.html.

Computers As a Photo Tool

Computers and digital photography go hand in hand. The pictures you take are seldom as perfect as you want them. The professionals spend as much time and care editing their work as they do shooting it, sometimes more. Computer programs let us make everything from minor repairs, such as cropping out an unintentional shadow or tree branch, to changing gray days to sunny ones and removing blotches, wrinkles, and moles from portraits. The second half of this book is devoted to a single, simple editing program from Adobe. Photoshop Elements 3 contains most of the tools from its parent, Adobe Photoshop. It's a little easier to use, a lot less expensive, and nearly as powerful. You'll be amazed at what you can do to your pictures, but first you need to shoot them.

The computer, with the help of programs such as Photoshop Elements, can incorporate your photographs into any kind of document, from a printed catalog or report to a multimedia presentation, as well as a lavishly illustrated web page. One overwhelming advantage that a digital camera has over a conventional camera is that, within a matter of a minute or two after you've shot a picture, you can open it in a program such as Photoshop and crop, color correct, and place it where you want it. You can handle the entire process yourself (see Figure 1.2). You don't need to send the pictures to be processed, and then off to a service bureau for color scanning. Just plug the camera into the computer, save the pictures, and carry on.

Because programs such as Photoshop are bitmapped paint programs, they are capable of extremely subtle, pixel-by-pixel corrections as well as quick, all-over changes. You can achieve effects with these programs that you couldn't possibly manage any other way, certainly not with traditional photo techniques. Retouching is much easier. Standard color correction can be done automatically, or if you're looking for something out of the ordinary, you can try as many variations as you like. "Undo" is just a keystroke away, and you're not wasting expensive photo paper and chemicals experimenting.

FIGURE 1.2
Importing and edit-
ing a picture in
Photoshop
Elements 3.

That's the second major difference. Because you're not constrained by the techni-
cal limits of the photographic process or the need to economize on materials,
you're free to try as many different versions of the picture as you can invent. Save
them, print them, or dump them in the trash and start over. All you've spent is
time.

Making Versus Taking a Picture

When you use a conventional camera, you "take" a picture. You shoot what's
there. When you get involved with the image-manipulation possibilities of the
digital photo/digital darkroom combination, you're not taking a picture, you're
making a picture. Sometimes you'll know ahead of time exactly what elements
you need to make a picture. Other times, you'll start with no particular concept
and experiment until you create a satisfactory picture. It works either way.

When you look at images in ads, on magazine covers, on software packages, and
practically everywhere else, most of the photos you'll see are made, rather than
shot. It's not always convenient, or even possible, to set up some of the shots art
directors ask for.

Assume, for example, that you're asked to provide a picture of a hand pointing
upward, balancing the world on one finger, against a background of blue sky and

clouds. You can put out a casting call for a juggler who can balance objects on a fingertip, search for a globe the right size, and wait for a day with perfect sky and clouds. You set everything up, shoot from a low angle, and hope the juggler doesn't drop the prop until you get a good shot. Or, you can find any acceptable hand, shoot it digitally against a seamless background, and open it up in Photoshop. Instead of using a globe, you can go to NASA's photo library and download one of the classic "Earth from Space" photos. Then you render the clouds as a background with a Photoshop filter called Render, Clouds. Finally, you put all three pieces together as shown in Figure 1.3.

FIGURE 1.3
It's easier to assemble the pieces than to shoot the picture.

How Photos Are Used Today

If you sit down and try to make a list, as I did, of the uses of digital photography, you better have a sharp pencil and a long sheet of paper. The traditional uses—magazines, newspapers, advertising, multimedia, web publishing—are just the tip of the iceberg. Insurance companies, real estate offices, hospitals and doctor's offices, industries of all kinds, schools and colleges, farms, and small businesses are among the markets in which digital cameras are used.

In order to purchase auto insurance, many states require the company take pictures of your vehicle at the time the insurance goes into effect. It's an anti-fraud measure—to prevent new claims on any old damage. The digital "before" pictures go into a computer file. If you have an accident and file a claim, a digital "after" picture showing the damage can be compared to the picture on file, and both put into the computerized claim form.

Real estate agencies can give potential buyers a website address and let them do their looking from a digital catalog of available homes. They need not drive all over town looking at properties that don't interest them. Using a digital camera, these documents can be prepared quickly and easily by anyone in the office (see Figure 1.4). It doesn't take an expert to do the job.

FIGURE 1.4
The sellers don't have dozens of "lookers" clomping through the house every weekend, only serious buyers.

Medical uses of digital photography include imaging for patient charts, recording procedures for use in journal articles, and a great deal more. Dermatologists use digital cameras to photograph suspected skin cancers, to check for changes over time. They take "before" and "after" pictures of certain conditions such as acne or eczema to see how treatment is progressing. Plastic surgeons take "before" pictures, and alter them in a program like Photoshop to show patients how the proposed new nose or chin will look. For accident victims requiring extensive reconstruction, surgeons can use any existing photographs of the patient. These will be scanned, and often shown on a monitor in the operating room, enabling the surgical team to see exactly what they're trying to reproduce.

Digital photos are ideal for any kind of an identification system. The camera connects to the computer and inserts the photo into a preset form with the subject's name and data entered, as in Figure 1.5. Moments later, a special printer spits out the full color card, already plastic laminated. The photo can also be saved in

the computer as part of a student's or employee's record, and updated whenever a change in hairstyle or color, or some other identifying characteristic, makes it necessary.

Boston Fitness Club

Judy Jetson
Personal Trainer

FIGURE 1.5
Using digital photos to create an ID badge.

The digital camera makes it easy to document all kinds of activities and situations. Because most consumer models are lightweight and extremely simple to use, they can be made accessible to plant foremen, safety inspectors, supervisory personnel, and others who might need to file reports in case of injury or machine failure. Special purpose digital cameras are used in agriculture to determine vegetation index using infrared and near infrared spectroscopy. The Dycam Agricultural Digital Camera uses filters that pass only red and infrared light. The resulting images are evaluated with software supplied with the camera, to enable "precision farming."

Magazine and Newspaper Photographs

Pick up any newspaper, from the *Boston Herald* to the *National Enquirer*. You'll find that many photographs, particularly those in the more sensational tabloids, have been digitally altered. (How do you *think* they got that photo of the President shaking hands with the Space Alien?) The same holds true of magazines. Perhaps the model for the cover shot was having a "bad hair" day, or his face broke out, or she added five pounds—all of it under the chin. The art director can do a little

digital magic and everything is perfect again. A certain amount of retouching is allowed and expected, especially in portraiture. There's no reason a picture can't be flattering.

This technique can backfire, though, if the model is someone well-known. *Time* and *Newsweek* caught heavy flak a couple of years ago when they both featured the same cover shot of a certain retired athlete who had become a central figure in a double murder investigation. One magazine had used the photo "as is," the other had "juiced it up," so to speak. By altering the skin tones a little and emphasizing the contrast and skin texture, one of the publications made the gentleman look quite sinister. Trial by Photoshop?

Pyramid Shift

Digitally revising a photo is a relatively new technique, but it has always been possible to paint out parts you didn't want or to move bits of the scenery around. In 1983, *National Geographic* did a cover story on Egypt. When it sent a photographer to get shots of a camel train and pyramids, he stood in the wrong spot. The art director liked the shot but thought the pyramids were too far apart for the magazine's vertical cover format. So, he took a pair of scissors, and moved them. Of course, he did it neatly, airbrushing and retouching as needed. But, as soon as the story and photo appeared in print, the magazine started getting letters from people who had been there and knew the shot was impossible. Eventually, they had to admit taking artistic license. In another photo the same year, they electronically added the top of a Polish soldier's cap, which had been hidden in the original photo. Once again, they were "caught" by eagle-eyed readers.

Many magazines use these tricks. Some, such as *National Geographic*, may not admit it until someone catches them. Others make a special point of "creatively" editing and combining photos, type, texture screens, and what have you. Look at *Wired* magazine as an example of digital wizardry pushed to the max.

Is this kind of image manipulation ethical? There's an ongoing debate about this issue. In the field of photojournalism, the question is especially important. Most publications have a policy of not allowing photo manipulation of news, sports, or "hard feature" photos. These pictures have to be used "as is." Non-news pictures or photo-illustrations, however, may be retouched, combined, and electronically enhanced as necessary. The Associated Press, one of the major news wire services providing photographs to newspapers all over the world, issued the following statement on electronics and photo ethics: "The content of a photograph will NEVER be changed or manipulated in any way." (Quoted in *The Oregonian*, 4/28/91.) Not all publications think this way, of course. Supermarket tabloid

newspapers, such as the *National Enquirer*, use edited photos frequently and don't identify them as such. You can't always believe what you see in print.

Advertising/TV Photography

The point of advertising photography, particularly product photography, is to make the advertiser and product look good. Like the people and scenery in the editorial pages of the magazine, the ads are full of models who've typically been made to look thinner, younger, and more glamorous.

And what about the product itself? Chocolates can be sprayed with varnish so they look shiny under the lights. Soup may be shown served in a bowl full of marbles to raise the chunky veggies up where they can be seen. The can of spinach will probably have the green brightened. (Nobody would buy it if they saw what it really looks like.) Food stylists have a full arsenal of tricks to make the groceries glow.

No matter whether the product is a disposable diaper, a diamond ring, a hub adapter, microtome, or a flange bearing, tricks exist to make it more appealing. A dab of glycerin helps make the highlight glisten. Shooting it at a particular angle might make it look bigger, fluffier, whiter, or whatever. Is it misleading? Perhaps. Is it putting your best foot forward? Absolutely. If you're doing product photography, don't hesitate to use as many tricks as you can. The competition does.

Law Enforcement

One of my sons is a paramedic and teaches emergency medicine. He carries a small digital camera in his medic kit. Josh uses some of his photos when he's teaching, to show the kinds of crashes that cause specific injuries. Most police cars are now equipped with digital still cameras as well as small digital video cameras. They use these to record accident scenes and to document other kinds of disasters. (See Figure 1.6.) If a suspect is caught, the cops can snap his or her photo and immediately send it back to the scene for an ID. Digital photos are also distributed electronically for manhunts and for Amber Alerts to find missing children.

Weddings

Many wedding photographers have switched from film to digital. One major advantage they cite is that they can burn through a 36 exposure roll of film in just a few minutes, while they can shoot as many as 100 photos or more on a

single CompactFlash card. They don't miss important moments because they're out of film, and they don't need a second camera and an assistant to reload one while they use the other. It takes only a few seconds to pop out one card and pop in another from the supply they keep in a jacket pocket.

FIGURE 1.6
Here, a state cop records a really bad accident. (Photo by Tanit Sakakini.)

Photos in Web Publishing

Digital cameras and web publishing go together like peaches and cream...no, more like aspirin and a headache. Using digital photos is the solution that enables anyone to have attractive, attention-grabbing, informative web pages. Digital photos don't need to be scanned. When you upload them from the camera, they're ready to edit, or even to paste in as they are. Of course, you may need to convert them to GIF or JPEG, but that's easy enough with shareware utilities if you don't even want to open them in an editing program such as Photoshop Elements.

You can make electronic photo albums, and either post them on your web pages or upload them to a host such as Snapfish (www.snapfish.com) or Ofoto (www.ofoto.com) where they are password protected so you can share them with your friends and not with nosy web surfers.

If you're interested in scrapbooking, check out my book, *Digital Memories, Scrapbooking with Your Computer.* You can get it at your favorite bookstore or at www.quepublishing.com. It has a ton of suggestions and sources for all kinds of scrapbooking materials, page composition, and everything else you need to preserve your memories.

Summary

The art of photography has come a very long way since the first picture was made. Advances in lenses, film, and finally digital circuitry have given us cameras capable of taking a single photo in a thousandth of a second, and uploading it to a computer for further improvements. Nevertheless, no matter what kind of camera you use, getting good pictures from it is as much a matter of vision and skill as it is equipment choice. You need to understand the digital process. Only then can you impose your own creativity to get the perfect shot.

CHAPTER 2

The Digital Camera

What You'll Learn in This Chapter:

▶ How to Make a Simple Camera
▶ How the Camera Works
▶ How Digital Cameras Work
▶ Bit Depth and Resolution
▶ Overview of Current Digital Cameras
▶ Memory Cards
▶ Using Video Cameras for Still Photos

While it may be true that you don't have to know how to build a pencil in order to write with one, it helps to know that the black stuff makes the mark, and that you hold it with the sharp end pointing down. Similarly, you'll make better pictures if you understand how the camera works, in order to see things as it sees them. In this chapter we'll look at cameras—both film and digital—and see what's inside the box.

Imagine yourself in a tent, in the desert. The year is not known—at least not to you, but it is some four centuries before the birth of Christ. The sun is beating down without mercy, as it always does here in the Middle East. Before you crawled into the tent, you noticed that some animal has chewed a small hole in the goat skin. Or, perhaps it is a just a nick in the skin from when the hair was plucked out and the hide tanned. No matter. It is but a tiny hole. Your eyes become accustomed to the darkness inside the tent. There is a splash of light on the far side, from that small hole. Your eyes are drawn to it. As you watch, a pair of shadowy forms move from one side to the other. Suddenly you gasp with horror. What manner of witchcraft is this? You realize that what you have just seen is a man leading a camel. The figures are upside down, to be sure, but you know what you have seen. You fling up the

edge of the tent and crawl outside. There, just a few cubits away, is a man with a camel. You peek under the tent flap. He's upside down. Outside the tent, he's right side up. Witchcraft, to be sure. Convinced your tent is haunted, you seize a burning twig from the cooking pit and set it on fire. You could have no way of knowing you've just been inside the world's first camera.

How to Make a Simple Camera

A camera is nothing more (or less) than a lightproof box with a hole in one side and a flat side opposite the hole. If you have access to a darkroom for photographic processing and printing, you can try making a very simple camera from an empty box. A round oatmeal box is traditional, but any kind of covered light-tight box will do. You'll also need a piece of (black and white) negative film and the chemicals to process it. Figure 2.1 shows how an oatmeal box becomes a camera.

FIGURE 2.1
A pinhole camera can be made from any lightproof container.

First, make a small hole in the bottom of the oatmeal box with a hat pin, small nail, or something similarly sharp and thin. Hold your finger over this hole or block it with a piece of black tape or cardboard. Working in total darkness, attach a piece of unexposed photographic film to the cover (inside of course). When you're sure that the box is tightly closed and will allow no light to enter, you can turn on the lights. Aim your camera at whatever you want to take a picture of, and uncover the hole for less than one second. Cover it again, and return to the dark room. Remove the film and process it. You should have a somewhat fuzzy, but recognizable negative of whatever you photographed. If you were careful to note which edge of the film was up, you'll probably be surprised to discover that it's the bottom of the picture. The light rays entering through the pinhole or lens are inverted, as in Figure 2.2, and transposed (flipped left to right).

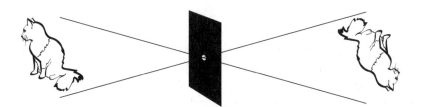

FIGURE 2.2
The image is both inverted and flipped.

How the Camera Works

The oatmeal box is a basic camera: a box, with a hole to allow light; a shutter, to control the light; and a light-sensitive surface to receive the light. No matter how sophisticated the camera becomes, it still has those four parts. The light admitting hole, which as you've seen need be nothing more than a pinhole, usually contains a lens. The shutter can be mechanical, electronic, or even "digital" (yes, fingers are digits). The light-sensitive surface may be film, or in the case of a digital camera, an array of electronic image receptors.

Lenses and Focusing

The lens and the shutter were the major refinements that made photography a tool rather than an interesting gimmick. Lenses serve two functions. They gather more light than a simple pinhole can admit, so the exposure can be shorter. More importantly, lenses focus the rays of light so that the image produced on the focal plane (the surface where the film is) is sharper.

The lens itself may be made of finely ground and polished glass or it might be cast from transparent plastic. Inexpensive "fixed focus" cameras often have a plastic lens, designed to provide an approximately correct focused image at anywhere from about four feet to infinity. Better cameras can be focused by changing the distance between the lens and the focal plane. The most modern "autofocus" camera systems use either sonar or an infrared light beam to measure the distance from camera to subject and adjust the focus automatically. The shorter the distance between the subject and the lens, the longer the relative distance between the lens and the film. Determining the distance can be accomplished in any of several ways. Many cameras have calibrated marks on the lens mount, perhaps at increments such as 2 feet, 5 feet, 10 feet, and infinity. Turning the barrel of the lens to match the indicator with the approximate distance to the subject provides a reasonably accurate focus.

Some cameras have a rangefinder, which also serves as a frame to help you compose the picture. It's like a small window that shows you a view similar to what the lens will capture. These are called, appropriately, rangefinder or viewfinder cameras. The Leica is perhaps the best known of these. Most small digital cameras use a similar system, though many also have a small screen which can display the view through the lens. The lens and the viewfinder are related to each other only by proximity. The viewfinder is usually an inch or so above the lens, and may be to the side of it as well, as it is in Figure 2.3. When you look through the viewfinder you see approximately what the lens sees, but because you're not looking through the lens, it's not exactly the same view.

FIGURE 2.3
The viewfinder camera is commonly used for snapshots.

Viewfinder

Film

Lens

Camera Pros and Cons

The advantages of the viewfinder camera are that it's lightweight and easy to carry around. It can be made inexpensively (disposable cameras are viewfinder cameras), but the more sophisticated and expensive models have coupled rangefinders, which enable the user to focus quite accurately by lining up the top and bottom of the picture. The main disadvantage is that the camera has a built-in defect called parallax error. Because the rangefinder is located above and to the left or right of the lens, it doesn't see quite the same view as the lens, so critical compositions can suffer (see Figure 2.4). For a quick test of parallax error, look straight ahead and close your left eye. Notice where the bridge of your nose cuts off your view of objects to the right. Now, close your left eye and open your right. The view is quite different, even though your eyes are separated by only a couple of inches.

Other cameras use a prism and mirror arrangement to let you look through the lens and manually adjust the focus until the image projected on the focusing screen looks sharp. These are called single lens reflex cameras, or SLRs for short, because they use only one lens. (The lens is actually a combination of lens elements, as shown in Figure 2.5.) Light falls on the image and is reflected toward the camera. It passes through the lens, and bounces off an angled mirror up into the prism. It then reflects from one side of the prism to the opposite side, taking a path parallel to the mirror. From here, it is reflected back, through the eyepiece, where the image can be seen, right side up and correctly oriented.

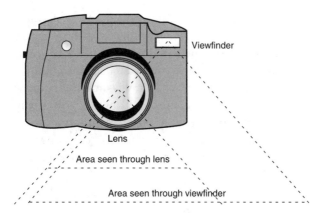

FIGURE 2.4
The problem of parallax.

The chief advantage of an SLR, such as the one shown in Figure 2.5, is that you're looking through the same lens that takes the picture. No parallax problem exists. Focusing is quick and easy, so these cameras are good for candid photography. Many of the current crop of digital cameras use the same principle, but instead of looking through a peephole to see what the lens sees, you simply look at the LCD display. With regard to conventional film cameras, the SLR has several disadvantages. It's heavier than the rangefinder camera because of the weight of the mirror and prism, and with more moving parts, it's more vulnerable to injury. It's also noisy. The mirror and the shutter make clanking sounds as they activate.

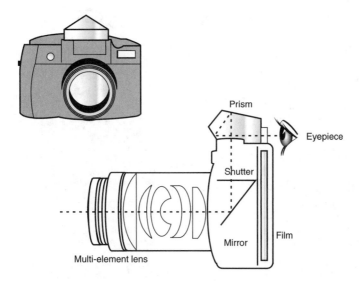

FIGURE 2.5
The single lens reflex camera.

The twin lens reflex uses two lenses, like the rangefinder or viewfinder cameras, but it provides a focusing screen for the viewing lens, with marks etched onto it to help with composing the picture. The lenses are, again like the rangefinder camera, related by proximity. They are also coupled together, so that focusing the viewing lens also focuses the "taking" lens. These cameras are rugged but awkward to use. As Figure 2.6 shows, you must look down at the viewing screen. They are subject to parallax error, like the viewfinder cameras, and the image on the viewing screen is flipped left to right. Lenses on these cameras are rarely interchangeable, so you are limited as to how wide an angle or how far away you can see.

View cameras are the most like the pinhole camera. The lens admits light to a viewing screen. You move the lens back and forth using the bellows until the image on the screen is sharp. (You're seeing it upside down and backward, but at least you can see it.) Then you slide in a plate or a film holder, and take the picture. The major disadvantage of this kind of camera is the size and weight. These are not snapshot cameras by any stretch of the imagination. In fact, the equipment, shown in the diagram in Figure 2.7, has changed very little since the days of Daguerre and Matthew Brady. Today, these cameras are used chiefly for architectural photography, because the bellows-mounted lens can be used to compensate for perspective distortion in the photograph.

FIGURE 2.6
The twin lens reflex camera.

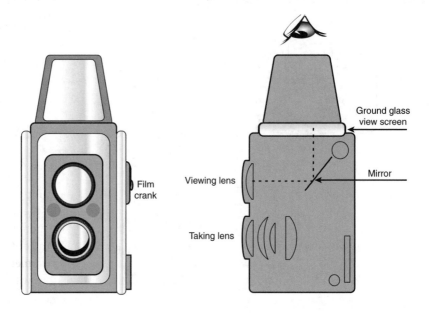

Leather bellows

Ground glass view screen

Plate holder

Focusing rail

FIGURE 2.7
The view camera.

Today, there are also digital backs for some of these larger cameras, as well as a good selection of digital SLRs, toward the higher end of the price scale. These cameras use the same interchangeable lenses as their film-using cousins, making it easier for the pro or semi-professional to make the switch to digital.

How Digital Cameras Work

The only serious difference between a digital camera and any of the film cameras we've just reviewed is the presence or absence of film. The digital camera replaces the film with a specialized semiconductor—a bit of silicon that conducts some, but not all, of the electricity that reaches it. This particular kind of semiconductor is called a *charge coupled device*, or *CCD* for short. It's made up of thousands of separate photosensitive elements arranged in a grid that usually correspond to the shape of the viewfinder. The image passes through the lens and strikes the CCD, which converts the light into electrical charges. The intensity of the charge varies depending on the intensity of the light that strikes each element. In that respect, it's very much like film. Replace the elements with dots of light-sensitive emulsion on a piece of film and you're back where you started, with a film camera.

When you press the button on the digital camera, the CCD passes the information from each element to an analog-to-digital converter, which encodes the data and sends it to be stored in RAM for later downloading, or stores it to a more permanent flashcard memory. That's a second difference, of course. The film camera is limited to, at most, 36 pictures per roll of film. The amount of flashcard memory is what limits the number of pictures your digital camera can hold, but with the latest memory cards holding up to a gigabyte of information, that can be a lot of photos. We'll talk more about memory cards later in this chapter.

Inside the Camera

If you pried open a digital camera, you'd see the battery pack that powers the camera, along with a bunch of tiny computer chips and a larger rectangular device that looks like a miniature flat screen TV. That's the CCD, and it's the part that replaces film in the camera. It translates light into digital information, essentially ones and zeros that can be stored in its memory and later transferred to the computer and decoded into a photo. The CCD contains a grid of photosensitive elements arranged in vertical and horizontal rows, as shown in Figure 2.8. Think of them as being arranged like cells in a spreadsheet. The elements are called pixels, short for *picture elements*. Each element in the grid represents one pixel of the image. When you press the shutter button, the entire image is exposed and captured at once. Some newer cameras use a different kind of device called a CMOS chip, but there's no difference as far as the final result. It simply handles the digitizing process differently.

FIGURE 2.8
In reality, the dots are *much* smaller than this.

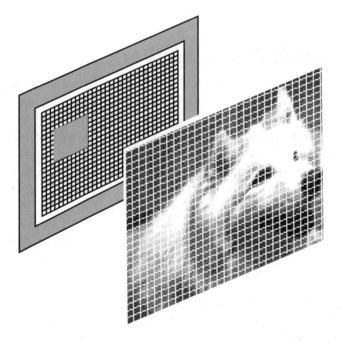

Obviously, the more pixels in the grid, the better resolution you get in the captured image. Typical low priced digital cameras have a 1,600×1,200 maximum resolution. If you do the arithmetic, that's 2 Megapixels. Advances in technology since the first digitals came out have now given us affordable cameras with as much as 8 Megapixel resolution. A Megapixel is a million pixels, so squeezing

that many onto a small silicon chip is pretty amazing. But within the next few years we could see cameras with even higher resolution. The science just keeps on getting better. Of course, right now we're at a stage where the cameras are much better than either the printers or the TV/computer screens we use to look at our photos.

Did you Know?

> If you look for a used camera on eBay or in a local photo store, you can find perfectly good "snapshot" digital models that were the top of the line a few years ago. Generally, the prices will be a lot lower, and you still get a decent photo for your scrapbook or wallet, or to put on a website. You just can't make huge enlargements from a lower resolution photo without seeing the individual pixels.

Color and the CCD

To save the incoming image in color, the light must pass through a set of color filters before it reaches the CCD or CMOS. Each color filter blocks one of the three primary light colors (red, blue, and green) that make up the color image. Color film, for comparison purposes, uses three different layers of emulsion, sensitive to the three colors of light. Blue is on top, then green, then red. But at any given point on the negative you have the information from all three layers. This isn't possible to do in digital photography. Each picture element, or pixel, can be sensitive to only one color at a time. Color can be achieved by taking three separate exposures of the scene, one for each of the three color filters, and then combining the three exposures electronically to produce the final image.

The Color of Light

Back a million years ago when I went to grade school, every child was given two pencils, a ruler, an eraser, and a box of crayons at the start of the school year. The size of the crayon box was determined by the grade you were in. Kindergarten and first grade got flat boxes with eight big thick crayons per box: the primaries, the secondaries, and brown and black. That was how we learned them, even back then. The primaries were yellow, red, and blue. The secondaries were what you got when you mixed any two primaries: orange, from yellow and red; green, from yellow and blue; and purple, from red and blue. Brown was the mix of all three primaries, and black was, well, black was black.

That's how we knew them, until high school. By then, we'd outgrown crayons, of course. We filed into our physics class and threw the previous nine years of learning out the window. The primary colors, according to the physics teacher were red, green, and blue. And if you mixed them you got, not brown or even the mysterious black, but white!

Those of us still taking art classes listened to the physics lecture skeptically, and we went down to the art room to try mixing red, green, and blue paint. We got, inevitably, brown or at least a brownish, greenish, reddish, ugly mess. We asked the art teacher about this, and were sent upstairs to the drama department for a demonstration. The stage lights had filters in red, green, and blue. When all of the lights were on, the result was, sure enough, white light. Why? When you're dealing with light, the drama teacher explained, colors are subtractive. They cancel each other out. When you're dealing with paint, the colors add to each other, giving that muddy brown mess. Aha! We were enlightened.

When you bought your computer system, you had to deal with this issue, whether or not you knew it at the time. Your monitor uses light to produce color. That's why it's called an RGB (red, green, blue) monitor. Your printer uses ink to produce color. Not red ink, green ink, and blue ink, but a set of colors called cyan, magenta, and yellow, along with our old standby black. This color system is known by its initials, CMYK. Why K for black? A diligent reader informed me that it's a print shop term for key line, a thin black line that keeps colored inks from bleeding into each other.

Digital cameras manage color in one of two ways. One way embeds the color filters in the CCD array, with adjacent pixels having different filters. Figure 2.9 shows one possible arrangement. In the process of recording the picture, the microprocessor inside the camera takes the signal from each pixel and averages it with the closest ones of the same color, making an educated guess as to what's supposed to be in between them.

This method enables instant exposure. Microprocessors can "think" very quickly. The only drawback is that the image produced by one of the lower resolution cameras has a very slight fuzziness, because of the math involved. If you try, for example, to photograph a card with a black square in the middle, you won't see an absolutely clean edge to the square. The pixels that happen to be where the image of the edge lands try to average the difference between the 100 percent black and the 100 percent white, and therefore represent a 50 percent gray. Those immediately adjacent to the 50 percent gray will try to average between it and the ones on the other side, and so on. So even though each pixel is averaging what's adjacent to it, by the time you are five pixels away from the edge, you're up to 98.4 percent black. The difference between that and 100 percent black is imperceptible to the human eye. But the difference over the spread of five pixels is slightly noticeable, and you see it as a very slight fuzziness. Of course, by the time you've worked your way up to a camera with 5 Megapixel or greater resolution, the individual pixels are so small they're impossible to see without a microscope. Bottom line—don't worry about it.

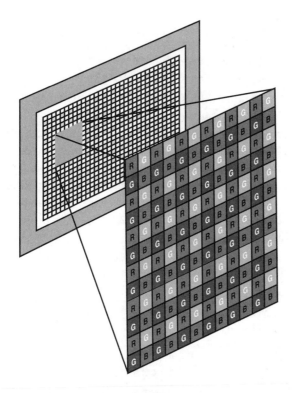

FIGURE 2.9
Embedded color filters in the CCD array.

Bit Depth and Resolution

When you take a picture with a conventional camera and good-quality color film, you can reproduce nearly as many colors as the human eye can see. Depending on the quality of the printing job and the speed of the film, you may or may not be aware of the little tiny dots of emulsion that make up the grain of the film. Today's fine grain, high-speed films and papers make it almost impossible to see grain with the naked eye, unless the picture is enlarged a great deal.

When you scan the conventional photo print in order to display it on the computer, it may not look quite as good as it did on paper. Depending on the scanner you use, you may find that the color transitions don't seem to be as smooth as they were in the original picture. You may notice a sort of striped or spotted effect in large blocks of solid color. The same thing may happen when you look at a picture taken with a digital snapshot camera.

Digital images, including those generated by a scanner and by a digital camera, are described in terms of resolution and color bit depth, which may also be called pixel depth. Let's look first at bit depth.

By the Way

This next section gets fairly technical. If you don't want to try to understand bit depth, just make sure your camera/scanner/and monitor are all set to 16-bit color (or 32-bit, if possible) and don't worry about it.

You know that the computer thinks in *bits*, or binary digits. All data is processed in terms of either ones (1) or zeros (0), regardless of whether it's a photograph, the novel you're writing in your spare time, or your checkbook data. The basic choice for a single pixel on the monitor screen is, therefore, one or zero, on or off, black or white. The black or white pixel has a color resolution, or bit depth, of one bit (2^1). As soon as you move up to a 2-bit bit depth, the colors increase exponentially (2^2). Instead of black or white, you have four colors. In a 3-bit system (2^3), each pixel can have eight colors, and so on. Table 2.1 shows the possible number of colors for common bit depths.

TABLE 2.1 Color As a Function of Bit Depth

Binary	Bit Depth	Number of Colors
2^1	1 bit	2 colors
2^2	2 bit	4 colors
2^3	3 bit	9 colors
2^4	4 bit	16 colors
2^5	5 bit	32 colors
2^6	6 bit	64 colors
2^7	7 bit	128 colors
2^8	8 bit	256 colors
2^{16}	16 bit	32,768 colors
2^{24}	24 bit	16,777,216 colors
2^{32}	32 bit	more than 4 billion colors

If a camera or scanner captures an image at 8 bits, it will have only 256 colors. This may or may not be a problem, depending on what the image is being used for. When you use 8-bit color, each pixel selects one of 256 colors. To further complicate matters, digital cameras and monitors mix the three channels of colored light that they receive (RGB, remember?). So on top of the 256 pixels in 8-bit color, each one of the pixels has three channels: red, green, and blue. The color of each pixel is determined by the intensities of red, green, and blue it's displaying, 0–255. A value of 0 means that there's none of that channel's color in the pixel. For example, a pixel with channel values of 150 red, 0 green, and 100 blue will be reddish purple.

The colors are defined using either 16 or 24 bits per pixel, so the 256 colors can actually be chosen from a palette of either 262,144 or 16.7 million possible colors. This kind of color palette is also called a color lookup table, and the system that applies it is called indexed color. It works very well under some circumstances. If you're displaying a single picture (GIF) on the web, for example, the color palette will be oriented toward the colors needed in that particular picture. If it's a landscape with many greens and browns, the palette will be mostly green and brown. Under other conditions, it's not so great. For instance, if you add a second picture to the same web page, it will use the same palette even though it's a portrait of a girl in a red and blue dress. The result is that, instead of having one acceptable picture, you can end up with two that are unsatisfactory.

If your video monitor is capable of displaying only 8-bit color, it doesn't matter whether the original image is 8 bits deep or 24 bits deep. The final output is limited by the monitor's capabilities. Actually, in most cases, it's not the monitor that holds you back; it's the video card. The VGA cards found in old PCs can't display more than 256 colors regardless of the monitor. SVGA cards do better, as does Macintosh. In 32-bit color, in addition to the 24 bits of color information, there's an additional 8 bits of grayscale added to the colors. Some PCs use an intermediate mode, 16-bit color. Each pixel takes up two bytes, or 16 bits. Five each are used for the red and blue color value. Six bits are used for green, because the human eye is more sensitive to colors in the yellow-green part of the spectrum, and can therefore make better use of the information.

Resolution

Resolution refers at different times to the number of pixels per inch of the monitor display, the number of dots per inch that the printer can output, or the number of pixels in the original image. Confusing? Yes. Think of them as image resolution and device resolution, and they may be easier to understand. Image resolution is measured in *pixels per inch (ppi)*.

Typically, digital snapshot cameras give you a choice of several settings for resolution. They call these Basic, Normal, Fine, and High Quality, or some similar variation. Basic, or low resolution images are okay for the web, but really can't be printed larger than 2×3 inches without seeing individual pixels. High resolution or fine quality simply means that the image appears to be made up of continuous tones rather than individual dots, because there are more pixels, and therefore less space are between the dots. It's more like a "regular" photograph. Of course, a lot depends on whether the image is enlarged. Even the best quality film has grain, which is close in appearance to magnified pixels.

What difference does it make? The more pixels, the better the image quality. It's that simple. If you're going to display your pictures on the Web, in postage stamp size, Basic or Normal is adequate. If you're planning to do anything more with them, Normal probably isn't good enough. Higher resolution means bigger and better pictures.

Figure 2.10 shows a picture shot at Normal resolution with the Nikon CoolPix 5700. Even at a small size, you're aware of the slightly patchy quality of the image, and the stair step effect at the edges of the flower. When you enlarge it, as in Figure 2.11, you see how quickly the image deteriorates. Recommendation: Forget Basic and Normal. Always use the best resolution available. After all, if you had a choice between a sharp pencil and a dull one, you wouldn't choose to write with the dull one.

FIGURE 2.10
Normal resolution,
not enlarged.

For commercial purposes, you need something better than a two or three Megapixel resolution, which means something better than a snapshot camera. Current high-end cameras are capable of resolutions as high as eight million pixels. The pictures these cameras take are incredibly detailed. Even the Nikon at 5Mp does quite well on detail at its Fine setting (see Figure 2.12).

FIGURE 2.11
Normal, enlarged to
200 percent.

FIGURE 2.12
Detail of fine quali-
ty resolution
enlarged.

Device resolution is measured in *dpi,* or *dots per inch.* When you transfer an image from the screen to the printer, the pixels on the screen must be converted to dots that the printer can print. A given number of pixels make up a given number of dots on the page. Here again, the greater number of dots on the page means a

better quality rendition. Today's inkjet and laser printers generally use a 1,200dpi resolution, which is more than adequate for most uses. You can get a 1,200dpi inkjet printer for $100, or less. Printer manufacturers make most of their profit on the ink cartridges, which are expensive.

Resolution is important if you want to enlarge your pictures. Table 2.2 shows the most common camera resolutions and the acceptable image sizes that they produce.

TABLE 2.2 Digital Camera Resolution Chart

Camera Resolution	Video Display	4×5 or 4×6 Print	5×7 Print	8×10 Print	11×14 Print	16×20 Print
320×240 (cell phone)	OK	OK	Poor	Poor	Poor	Poor
640×480 (0.3Mp)	Good	Good	Poor	Poor	Poor	Poor
1,024×768	Excellent	Excellent	Good	OK	Poor	Poor
1,280×960 (1Mp)	Excellent	Photo Quality	Very Good	Good	Poor	Poor
1,600×1,200 (2Mp)	Excellent	Photo Quality	Photo Quality	Very Good	OK	Poor
2,048×1,536 (3Mp)	Excellent	Photo Quality	Photo Quality	Excellent	Good	OK
2,240×1,680 (4Mp)	Excellent	Photo Quality	Photo Quality	Photo Quality	Very Good	Good
2,560×1,920 (5Mp)	Excellent	Photo Quality	Photo Quality	Photo Quality	Excellent	Very Good
3,032×2,008 (6Mp)	Excellent	Photo Quality	Photo Quality	Photo Quality	Photo Quality	Excellent

Poor = Grainy, jagged edges

OK = Fair, but not much detail

Good = Shows some detail

Very Good = Not photo quality but nearly so

Excellent = Difficult to tell it's not film

Photo Quality = Can't tell it's digital

Overview of Current Digital Cameras

It's not necessarily price that determines what you get, but price is as good a place as any to begin. You can spend as little as $100 for a digital camera or as much as $8,000 or more. Before you shop, consider how you plan to use the camera. Is it a new toy for the family, or are you investing in photo equipment for business reasons? If you're a doctor or dentist, you need accurate color and the ability to take close up pictures. If your business is real estate, you may need a wide-angle lens, but high resolution and perfect color are less important. If you're going to use the camera for travel, will you want to spend part of your camera budget on spare flash cards or a portable hard drive to download your photos?

Although I mention specific models in the pages that follow, digital cameras are just like any other piece of computer equipment. The day after you buy one, manufacturers will announce a new model that does more and costs less. These are the cameras on the shelves as of August, 2004. Expect to see newer and better ones announced at every major computer and/or photography trade show. Camera manufacturers usually introduce new products at the Consumer Electronics Show (CES), and the Photographic Marketing Industry show (PMAI). Of course, as the new models appear, prices go down on the older ones, so you may be able to find a bargain.

Snapshot Cameras

Cameras at the low end of the price scale are adequate for taking pictures of your family, friends, pets, and vacation trips. You'll be able to view your pictures on the TV screen, save them on CD-ROM/DVD, import them into your computer, and try all the fancy digital tricks you'll learn later on in the book. You'll certainly be able to use the pictures on your website or print them on your color inkjet printer. They're great for scrapbooking, and for making prints up to 5×7 or even 8×10. Bigger enlargements will start to lose quality, since most cameras in the $100–$400 range are generally 3 Megapixel models. There are at least 20 to 30 different makes and models as of this writing, and more coming along.

Typical of these cameras is the Olympus D-540 shown in Figure 2.13. It has 3 Megapixel resolution, for prints up to 8×10. It has a 3x optical zoom lens with autofocus, and a $200 price tag. Cameras like this are perfect for "point and shoot" photography. Simply frame the picture in the viewfinder or on the LCD screen, zoom in or out as needed, and press the shutter button. The camera does the rest. Your picture is correctly exposed and in focus, unless you're shooting in the dark or jumping up and down when you click the shutter.

FIGURE 2.13
The Olympus D-540
is a typical pocket-
sized snapshot
camera.

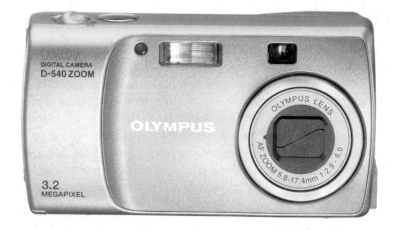

There are, as I said earlier, a lot of cameras that fall into this category. What should you look for in a snapshot camera? The first thing I'd check out is the way the camera fits my hands. Some are awkward to hold because of their body shape or size. Some of the newest ones are small enough to fit in a shirt pocket, but too small for the average user to handle comfortably. Casio's Exilim series is a case in point. I love these little cameras for their size and "cuteness" factor. They are the same size as a credit card and less than an inch thick. The EX Z4U, shown in Figure 2.14, has 4 Megapixel resolution, and takes some very nice pictures, if you can use a fingernail to switch it on and off and to press the shutter. It comes with a docking station that recharges its battery and lets you download photos to your computer or watch a desktop slide show on the LCD screen. At $400, it's clearly not a kids' toy, but neither is it practical for most adults.

By the
Way

In the race to make everything smaller, faster, and smarter, technology has had to deal with the human interface factor. Have you ever wondered why the newest cell phones have all those extras: cameras, GPS, Internet, Bluetooth, and so on? It's because there's extra room inside and they might as well fill it. The touch pad has to be big enough to enter a number or a short text message. And there has to be a certain distance between the speaker (the ear part) and the microphone (the talk part). So, for an extra buck or two, the makers can throw in a chip that handles your email and tells you where the closest French restaurant is. And they can charge you much more for the phone because it has those extras.

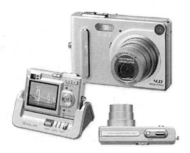

FIGURE 2.14
The Casio EX Z4U has a lens that telescopes out for use.

Intermediate Cameras

There's such a fine line between the fancier snapshot cameras and what I call the intermediates that it's tempting to lump them all together. Still, they have differences, and the most obvious one is price. Anything that costs over $400 is automatically out of the snapshot camera class, no matter how badly it performs or how limited it is. Most of the cameras in the $400—$600 price range are very good for most general purpose photography. You should expect to find 4 or 5 Megapixel resolution and at least a 3x optical zoom lens. The Nikon Coolpix 5200, seen in Figure 2.15, is a good example. It features 5.1 Megapixel resolution and a 3x optical zoom. It also has a movie mode that records movies with sound at TV quality (30 frames per second). How long a movie you can make depends on the size of the memory card you have installed. It comes with only a 12MB card, which only holds four high-quality images. Toss that one, and replace it with a much bigger memory card, 256 or 512MB, and you'll have a good all around camera. Olympus, HP, and Canon make very similar models with similar features and price.

Here again, even if you end up buying your camera from Amazon.com, or one of the computer catalog and Internet companies, go to a camera store or computer store and try out the ones that interest you. See how the controls fit your fingers. See if you can hold the camera comfortably, and if you wear glasses, be sure you can see through the rangefinder.

Professional/Prosumer Cameras

Serious photographers, both amateur and professional, don't mind spending money on their equipment because they want the best there is, and they expect it to cost more. It's like the difference between a Kia and a Mercedes. They'll both

get you there, but the more expensive car has softer, heated leather seats, automatic everything, and a much better sound system. If you're using your camera for baby pictures or casual snapshots, you don't need all the bells and whistles. Those of us who've worked our way up to top of the line 35mm SLR cameras are sometimes reluctant to abandon the investment we've made in lenses and accessories to make the switch to digital. The good news is that we don't have to. Whether you have Nikon, Canon, Kodak, or some other brand of 35mm SLR, you can use your lenses on a Canon, Kodak, or Nikon digital SLR. (You may need an adapter, depending on the type of camera.)

FIGURE 2.15
The Nikon Coolpix 5200, a typical intermediate camera.

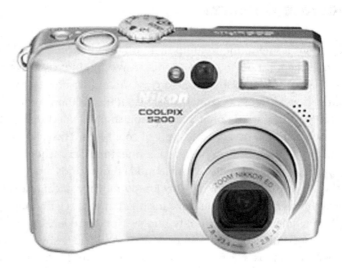

The Canon EOS-1D Mark II is a new, improved version of the EOS-1D, hence the Mark II addition. If you're considering this camera, make sure you look for Mark II on it. It makes a big difference, actually a difference of about four Megapixels. The new Canon has an amazing 8 Megapixel resolution, plus a buffer memory so you can shoot continuously without having to wait while the camera saves the previous photo. That, by the way, is a problem with some of the higher resolution digital cameras. You may miss a lot of good shots while the camera's saving the previous one, especially if you save in .tif or RAW format. Those files are much larger than .jpg files because they're uncompressed.

The street price for the Canon is around $4,500—not including the lens. If you don't have a Canon lens lying around unused, expect to add on another $200–$400 for a lens.

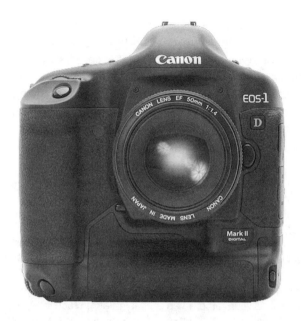

FIGURE 2.16
Canon's EOS 1,
Mark II.

You'll notice when you pick up one of these digital SLRs that they're a lot bigger and heavier than the intermediates, and hardly even the same species as the little Casio. The camera, with an average-size zoom lens attached, weighs about five pounds. After a few hours, you'll begin to notice that weight around your neck or over your shoulder.

Nikon makes a similar camera body, the D-70 Digital SLR. It uses Nikkor lenses, like its 35mm cousins, and gives you a 6 Megapixel image, for considerably less money. It sells, with an 18–70mm zoom lens, for $1,300, as of 8/04. Of course, as newer models come along, the prices for all of the current cameras will drop dramatically, even if the camera maker doesn't discontinue them.

One of the many advantages to the professional user, and to specialized users in the medical, legal, and similar professions, is that these camera makers have been dealing with their special needs for years, so there's a huge assortment of special purpose macro focus lenses, ring lights, strobes, and other accessories that will also fit the digital cameras.

There are also some equally serious cameras that don't use separate lenses, instead having a built-in zoom. The advantages to these cameras are size, weight, and resolution. They're all up in the 8 Megapixel range, and all priced right around $1,000. They are lighter and more compact, and won't wear you out if

you're traveling. They combine the ease of a point and shoot camera with manual override of the automatic settings. Rather than letting the camera choose the appropriate combination of aperture and shutter speed, you can do it yourself. If you want to stop action with a very fast shutter, do so. If you want maximum depth of field, and have a tripod or a very steady hand for a long exposure, go for it. These cameras allow you to get creative in ways that a simple point and shoot model can't. Of course, you do have to know what you're trying to accomplish.

Did you Know?

No matter what kind of camera you end up buying, do yourself a favor. When you get it home, don't throw away the packing materials. First, sit down with it and read the manual, cover to cover. Learn what each button does, what kind of lens it has, and what the storage capacity is. Find out how to erase pictures you don't want, and how to view them in the camera, if yours can do that. Find out how to toggle between normal and high resolution. Be sure you know how to install the batteries and memory card.

Then take the camera out and practice with it, before you start trying to use it for anything important. If your camera has a built-in flash, practice turning it on and off. Take pictures with and without the flash. If your camera has a self-timer, mount it on a tripod and take a picture of yourself. If you want to experiment with portraits and haven't got a model handy, borrow a teddy bear and shoot him. Pick up a bunch of flowers at the grocery store and photograph them under different kinds of light. Learn what your particular camera can and can't do. You may be surprised at how well it does in low light conditions or how sharp your pictures are. If the surprises aren't so pleasant, and if you've kept the box and the receipt, you can exchange it for a different one and try again.

Disposable Cameras

Well, okay, they're not exactly disposable. More correctly, they are called "single use" cameras. You can buy these little digital cameras at the grocery store, pharmacy, or at gift shops in such places as theme parks and other tourist attractions. Each camera holds a total of 27 pictures. You can erase only the last picture you took, but at least you have some protection from wasted shots. When the camera memory is full, you take it back where you got it or to a local camera store or film processor, or mail it to one. In a few days, you get back a set of prints along with a CD of your pictures. Meanwhile, the camera memory is erased, and it's repackaged and resold. The picture quality is similar to the film-type "disposables" that probably hang on the same rack, but you have the advantages of using digital media.

Memory Cards

Having read this far, you've encountered many references to flashcards or memory cards. There are several different kinds, and you really need to know which is which. They're all simply little plastic hard shelled cases that protect a flash memory chip (a hunk of silicon that stores digital data), but they come in different sizes and shapes because manufacturers weren't able to agree on standards. Digital cameras, PDAs, even some music players and cell phones use memory cards. If you have several of these devices, it's helpful if they all use the same kind of card. The most popular types of flash memory cards for use in digital cameras are CompactFlash (CF), SmartMedia (SM), Memory Stick (MS), MultiMediaCard (MMC), Secure Digital (SD), and xD-Picture Card (xD). They are *not* interchangeable. Each one looks slightly different. Figure 2.17 shows two of the most common, a Compact Flash card and an xD card. Some cameras may be able to use more than one kind, but only if they have separate slots for each.

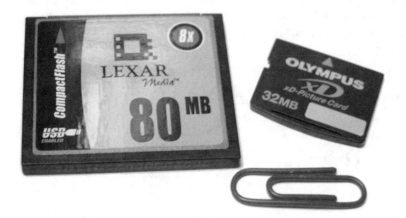

FIGURE 2.17
Memory cards should be stored in their plastic cases when not in the camera.

Cameras usually come equipped with a memory card, though not one big enough to be much use. The 16MB cards that ship with typical point and shoot or even intermediate level cameras will hold only a handful of high quality pictures. You can, and should, immediately purchase a decent sized card, and keep the 16MB card for a spare. Today, you can buy Compact Flash cards in sizes all the way up to 2 Gigabytes. That's a whole lot of photos. I had a hard time filling a 512MB card on a weeklong vacation to Nova Scotia last year, and didn't need the three extra smaller cards I brought as backup.

When you attempt to use any of these cards, be sure they're fully seated. It takes a firm push, at least the first few times, to seat the pins into their sockets. Don't insert or remove the card while the camera is turned on.

Using Video Cameras for Still Photos

Before there were digital still cameras, there were video cameras. Several different "frame-grabber" systems were developed to enable you to import a frame from your videotape or a "live" image from your camcorder. Today, the process is a lot easier. Most digital camcorders also have a still image mode that either saves the pictures in camera memory for later downloading or records them to a memory card, which you can then pop into a card reader or directly into some kind of printer, as well as simply plug a cable from the camera to a USB or FireWire port. If you have an older VHS or HI8 analog video system, you can get a converter box such as the Belkin USB VideoBus II shown in Figure 2.18 that will turn your signals into digital video for use with a computer. Of course, the digital still photos from a camera designed for motion pictures aren't going to be as sharp or as high resolution as pictures from a camera designed for still photography.

FIGURE 2.18
The USB connector plugs into the computer, and the audio and video plugs go into the appropriate camera sockets.

The Belkin system comes with MGI's VideoWave IV SE and MGI's PhotoSuite III SE to work with both movies and still images. And you can also use software such as Adobe Premiere or Apple's iMovie to save single frames from a video or to insert your digital photos into a movie—wonderful for adding professional-looking titles and credits to your home movies, as well as for serious video editing.

Summary

A camera is really nothing more than a lens, shutter, and some sort of light-sensitive material. The lens can be a complicated multi-focus zoom lens or just a bubble of glass or plastic. The light-sensitive recording source may be film, or a specialized kind of silicon chip. Either way, you take a picture by allowing some light to pass through the lens and land on the film or chip. Film is processed with chemicals, while digital images are processed with more computer chips and saved to a memory card. When you download a digital picture, you're downloading the ones and zeros that describe the color and brightness of each individual pixel that makes up the picture. The more pixels you have, the better the resolution and amount of detail in the final photo. The computer software decodes the picture and displays it on the screen, where you can make any changes you think are necessary, and then save it and print it.

Digital cameras today are available in all sizes from tiny to about as large as a comparable film camera, with resolution all the way up to 8 Megapixels. Remember that as with any other computer product, the camera you buy will be replaced by a faster, smarter, and probably less expensive one before very long. Find a camera that suits your needs and feels good in your hands. You don't need the top of the line professional models to send pictures of the new baby to doting relatives. You can even use a camcorder to take still pictures.

CHAPTER 3

Technical Details

What You'll Learn in This Chapter:

- ▶ Understanding How Lenses Work
- ▶ Manipulating Exposure Controls
- ▶ Learning Workarounds for Camera Settings
- ▶ Caring for Digital Cameras

It's important to understand the differences between telephoto, wide-angle, and normal lenses, and how shutter speeds affect the photograph, even if your camera doesn't enable you to control these functions. At the very least, you'll know why your pictures come out the way they do, and at best you will learn how to use the factors you *can* control to make up for those factors you can't do much about.

Understanding How Lenses Work

The lens is the camera's eye. Like the human eye, some focus better than others. Some see farther away; others can read the fine print. Camera lenses can be made of many individual polished glass elements, or cast as a bubble of transparent plastic. Its function is to focus light rays onto the light-sensitive surface. The better it does the job, the clearer your picture is. The simplest type of lens is a single element convex lens, the same kind used in a magnifying glass. In profile, it is thick in the middle and tapered at the ends, as shown in Figure 3.1.

As you learned in the description of the pinhole camera, light travels in a straight line through a transparent medium. However, when light passes from one transparent medium to another, for example, through a lens, the light rays can be bent or *refracted*. This means that more light rays from each point on the subject are gathered and refracted toward each other so that they meet at the same point.

FIGURE 3.1
The convex lens is
thick in the middle
and tapered at the
ends.

FIGURE 3.1
The convex lens is
thick in the middle
and tapered at the
ends.

In Figure 3.2, you can see some of the light rays from a specific point on the tree passing through the lens and converging to form that point on the image of the tree.

FIGURE 3.2
Refraction happens
when the light is
slowed down by the
density of the
glass.

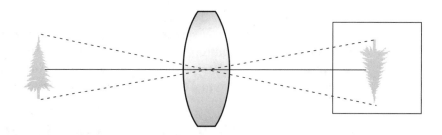

This point of convergence is called the *focal plane*. Conventional cameras are designed so that the film is held in position precisely on the focal plane, to get the best possible picture. Digital cameras direct the light to the CCD (Charge Coupled Device—the "digital film"), which replaces the film at the focal plane.

Focusing

In a fixed focus camera, the ideal distances between the lens, the average subject, and the focal plane have been mathematically calculated. The lens and film holder are positioned according to this measurement and can't be changed, regardless of whether you're photographing a distant mountain or a nearby flower. In a variable focus camera, there's a mechanism to move the lens forward and backward, while still keeping it centered on the focal plane. This enables you to compensate for a subject that's closer to, or farther away from, the lens.

Typical autofocus snapshot cameras send out a beam of sound (sonar) or infrared light. Most digital cameras use the infrared light method, and nearly all of the current models have built-in autofocus.

> When a scene is brightly lit, it's easier to determine whether the depth of field (area in focus) is shallow. Use "flat lighting" (general over-all illumination) to lower the contrast if you are concerned about keeping foreground and background relatively in focus.

High-end professional digital SLR cameras use a system called *passive autofocus*, which "reads" the image, comparing the contrast of adjacent areas of the frame as it appears in the viewfinder. Focusing with this system is quite precise, and there's no problem switching lenses because the focus measurement is done through whatever lens is mounted.

Using autofocusing provides no guarantee that what you want in focus will be so. Autofocusing is difficult when the subject is very close. If the camera can't focus, you may need to move back. Focusing is also difficult if the subject has very low contrast, such as a white wall, sky, or the side of a building with very little detail.

Subjects that move fast or flicker, such as a fluorescent light or candle flame, can cause focusing problems. Subjects under low lighting conditions or strongly back-lit, such as the statue in Color Plate 3.1, can cause problems for both focus and exposure metering. In this case, I exposed for the sky, allowing the statue and the branches to be in silhouette, and focused on the bridge of the statue's nose. Because it was a bright day, the small aperture provided acceptable focus on the branches to the right of the picture, which were about 50 feet away. The branches on the left were more than 100 feet distant, and are definitely less sharp.

Some autofocus cameras include a focus lock. If you can lock the focus, you can resolve many of the problems discussed here. Simply find something else that you can focus on that is the same distance away as the difficult subject. When it's in focus, enable the focus lock, recompose your picture, and shoot it.

Focal Length

You've heard lenses discussed in terms such as normal, telephoto, and wide-angle. What do these terms really mean? Lenses vary in focal length. A "long" lens is a telephoto lens, and a "short" lens is a wide angle lens. Physically, the telephoto is anywhere up to a foot long or more, while a wide angle lens is anywhere from one to three inches long. Focal length is an important concept, because the focal length determines the size of the image projected on the film or CCD at a given

distance from the camera, and it also determines the width of the area in front of the camera included in the picture.

In conventional camera terms, a normal lens is one that has a focal length approximately equal to the diagonal of the picture's negative area. Normal on a 35mm camera, which uses a 24×36mm negative, is when the focal length is approximately 43mm, which could be determined from the Pythagorean Theorem, if you were so inclined. (Trust me. It works.) On a typical digital camera, the area of the CCD is much smaller than the area of a 35mm negative, so normal is much smaller, too. The standard lens on the Ricoh RDC-2 is a 5.6mm lens (equivalent to a 55mm lens on a 35mm camera). The lens on the Casio QV100 has a 4.9mm focal length.

To determine the focal length of a lens, the lens designer or optical engineer sets the lens focus to (theoretical) infinity and measures the distance from the optical center of the lens to the focal plane (see Figure 3.3). (For practical purposes, the horizon at sea level is assumed to be infinity although it's really only a few miles away. Optical infinity is not a measurable distance, but rather the furthest point at which the lens can focus.) Fortunately, you don't need to worry about this. If you have a camera that uses interchangeable lenses, they're labeled. Some low-end (inexpensive) cameras don't have a normal lens, but instead let you flip back and forth between a wide-angle and telephoto. Because the wide lens isn't extremely wide, and the telephoto lens isn't extremely long, one or the other suffice for most normal shots. If your camera has only one lens built-in, assume it's a "normal" lens. A few special purpose cameras, such as the disposable panoramic ones, have a wide-angle or moderate telephoto lens instead.

FIGURE 3.3
This is the way it's done in physics class.

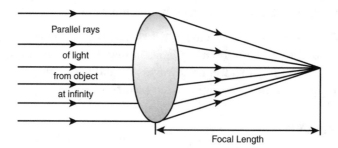

Parallel rays

of light

from object

at infinity

Focal Length

Visual Angle

A normal lens is curved to a degree that admits light from about the same angle of view, or visual angle, that our eyes do. A wide-angle lens has a greater curve and sees more of the scene than we do. The peep-holes sometimes found in doors, especially in hotel rooms, are a good example of a wide-angle lens. Objects within the

scene are smaller than they would be if seen through a normal lens. A telephoto lens has less of a curve and sees a narrower angle of view. Because it's seeing less of the scene, however, objects appear much larger. They are magnified as if seen through a telescope, hence the name. Doubling the focal length of the lens actually doubles the size of the image. Figure 3.4 shows examples of all these lenses.

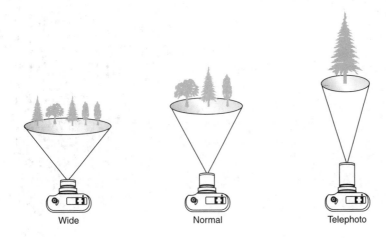

Wide Normal Telephoto

FIGURE 3.4
Wide, normal, and telephoto lenses and how their visual angles vary.

The most important rule to remember about focal lengths is that a "short" lens (that is, any lens with a focal length less than normal for the camera format) is a wide-angle lens. A "long" lens (that is, any lens with a focal length greater than normal for the camera format) is a telephoto lens.

Did you Know?

Zoom Versus Prime Lenses

A lens that has a single focal length is called a prime lens. A zoom lens is a lens that can shift its focal length. Because most modern lenses are made up of several individual lens elements, it's a fairly easy matter to build the lens in such a way that rotating the barrel moves one of the elements back and forth, thus changing the focal length. The barrel itself may even telescope in and out becoming longer or shorter as needed. Zoom lenses cover a range of focal lengths. Common zoom lenses for 35mm applications are 30–70mm (wide-angle to slight telephoto); 70–300mm (slight to definite telephoto); and so on. Of course, you're not limited to the ends of the spectrum here. The 30–70mm lens can be used as a 30, 35, 50, 70, or anywhere in between. Instead of carrying a set of prime lenses and changing them, you can carry just one and zoom in and out as you shift your attention from the distant forest to the nearby tree. Figures 3.5 and 3.6 show the same scene as photographed with a wide-angle and telephoto lens.

FIGURE 3.5
Photograph taken
with a wide-angle
view.

FIGURE 3.6
The same scene,
through a telephoto
lens.

Most of the current digital cameras have zoom lenses. However, many of these have a fairly limited zoom ratio, often 3:1. If you intend to use your camera for more than one kind of photography—for instance, travel pictures, which really need a wide angle lens to capture as much as possible, and portraits, which are best done with a medium telephoto—look for a camera with a higher zoom ratio. It's also important to make sure that you're using optical zoom, rather than digital zoom, for reasons which I'll explain in a moment.

If you're fortunate enough to be using one of the camera systems that use interchangeable lenses, such as the Nikon D-1, you have literally dozens of lenses to choose from—all the way from an 8mm fisheye (ultra wide angle), to a 1,000mm extreme telephoto.

It used to be true that zoom lenses were not as sharp as prime lenses, but testing shows the differences in the current crop of lenses to be so minor that it's not worth worrying about.

Distortion

There's one difficulty that all photographers must face. When you send light, which wants to travel in a straight line, through a piece of curved glass, you inevitably get distortion. This is particularly obvious when you use a wide-angle lens on a very close subject (see Figure 3.7). Objects at the edge of the scene may look as if they'd been stretched. Objects closest to the camera are enlarged.

You can work around this by either cropping the picture to remove the distorted parts or by switching to a normal lens. Wide-angle lenses shouldn't be used for portraits, because they tend to make noses and chins appear grotesquely large, but they're good for catching the action at a sporting event. When you shoot you can be fairly certain that the ball or hockey puck is somewhere within the picture, and you can crop until you have a reasonable composition.

Telephoto lenses have their own set of problems. They must be held steady when you shoot, as they accentuate any camera movement. They appear to compress perspective, producing a flat, two-dimensional effect. This works to your advantage in portraiture and wildlife photography because you can stand a bit farther away from your subject and not crowd him or her.

Depth of Field

Depth of field is sometimes called depth of focus, which is perhaps a more accurate term. It refers to the extent of the scene, from close to far, that is in focus in

the picture (see Figure 3.8). You can see every bump and paint flake in the stern of the dory, but the texture of the rope in the bow is barely visible.

FIGURE 3.7
Notice how large the hand is, compared to the face.

FIGURE 3.8
Depth of field is the extent of the scene in focus in the photograph.

Several factors influence depth of field, but the most important is the viewer's tolerance for fuzziness. When the lens is focused to provide a sharp image of a particular object within the scene, objects closer and farther away are less sharp. Because the decline in sharpness is gradual, when you look at the photo you may not be conscious of the blur. Some lenses, notably wide-angle lenses, provide sharp focus over a greater depth of field than others. Any well-made normal lens should also have acceptable depth of field.

Of course, sharp focus is, itself, a relative term. The lens reproduces an image of a point as a small circle. Pictures are made up of millions or even billions of these circles. They're called *circles of confusion*. When the lens is focused on an object, it means that the circles that make up the object are as small as they can possibly be. The unassisted eye can't discern fine detail.

Even a person with excellent close vision can't see circles smaller than 1/100th of an inch in diameter. They look like dots, and they merge to form the image. At the sharpest point of focus the circles are the smallest. As you get farther away from that point, the circles get bigger, so that eventually you see them as circles rather than as points. At this point, you're aware that the image is blurred. Depth of field, therefore, is the area in which the circles of confusion aren't large enough to be noticed. Figure 3.9 shows a greatly magnified (theoretical) view.

FIGURE 3.9
Circles of confusion. In a real camera, there'd be an infinite number of overlapping ones.

In general, the depth of field is divided in thirds so that one third of the area in focus is in front of the focal point (object in focus), and two-thirds of the focused area is behind it. As the camera moves nearer to the object, the depth of field narrows and becomes more evenly divided, up to halfway on either side of the focal point, when the object is close enough to give an image equal to the size of the original object, or at a distance equal to twice the focal length of the lens. At this point, the depth of field is extremely shallow, on the order of an inch or less on each side of the point of focus. This is important to remember if you are using a macro lens to photograph small objects such as stamps or coins.

Macro is shorthand for macrofocus, and indicates a lens that is able to focus on very close objects. Many digital cameras have a macro setting, for close-ups.

Manipulating Exposure Controls

The lens admits light. The diaphragm and shutter control how much. In a conventional camera, or in a digital camera that's based on a conventional camera body, these are mechanical devices. The diaphragm controls the brightness, or *intensity*, of the light. The shutter controls the *duration* of the light.

Aperture

Aperture means opening. It refers to the opening or hole left by the diaphragm that allows light to pass through the lens. Essentially, the diaphragm is a set of metal plates or leaves that open and close to make a larger or smaller hole. The diaphragm is mounted in between the glass elements of a lens. When it's open all the way, the lens admits as much light as possible. When it's a tiny hole, obviously, it doesn't admit much light at all. The diaphragm openings, or apertures, are called f/ numbers or *f/stops*. They're assigned numbers according to the diameter of the diaphragm opening, expressed as a ratio of the focal length of the lens.

Confusing? Maybe an example will help make this clearer. Let's say you have a 50mm lens. That means the focal length, or the distance from the optical center of the lens to the film plane, is 50mm (see Figure 3.10). The widest aperture possible on that particular lens is 25mm. That gives you a ratio of 1:2, usually expressed as f/2. A different 50mm lens can have a bigger piece of glass and a wider aperture. It might be, for example an f/1.8 lens.

FIGURE 3.10
Because the focal length is twice the maximum aperture, this is an f/2 lens.

Diaphragms would be useless if they were always wide open, so the lens has settings for smaller apertures. When you change the f/stop, the blades of the diaphragm move apart or together to produce a larger or smaller hole. To make matters more confusing, the smallest numbers are the largest openings, and the largest numbers are the smallest openings. It works this way because the f/stops represent fractions of the focal length of the lens. Just as 1/4 is twice as large as 1/8, f/4 is twice as wide an aperture as f/8.

Digital cameras use an automatic exposure system to measure the light and adjust the shutter and aperture, turning on an internal flash if necessary. On many digital models, you can set the auto exposure system to choose the best overall exposure or to give priority to either the aperture or shutter speed by pressing the Mode button, as shown in Figure 3.11. On many cameras, you can also override the automatic exposure system and choose your own settings. You can compensate for back-lit subjects or use a faster shutter to stop motion.

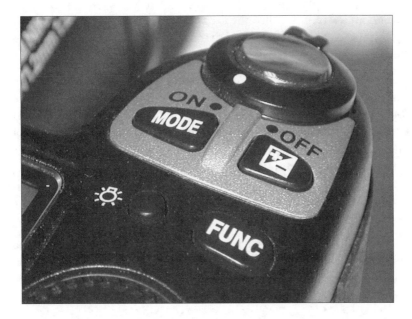

FIGURE 3.11
Press the Mode button to cycle through settings. (This is also an example of a macro lens photo.)

Nevertheless, aperture is a consideration for the digital photographer because it affects several other camera functions, including depth of field. When the lens is set at a smaller aperture (higher number f/stop), the light rays that enter it are doing so through the flattest, optically best part of the lens. Therefore, there is less fuzziness (smaller circles of confusion) and better depth of field than when the entire lens is admitting light. To increase the depth of field, use the smallest

possible lens aperture. This may require a very long exposure, or adding more (artificial) light to the scene.

Shutter Issues

In a conventional camera, you must deal with two different mechanisms for controlling the amount of light that reaches the film. The aperture is the first variable. The shutter is the second variable. The shutter opens for a fraction of a second to allow light to reach the film.

Exposure is, therefore, a function of the intensity of the light and the time the light is allowed to strike the sensitive surface. When there's more light, less time is needed. When there's less light, more time is needed. The relationship between these two variables can be expressed as an equation:

Exposure (E) is the product of (=) Intensity (I) multiplied by (×) Time (T).

This equation, $E = I \times T$, is called the *Reciprocity Law*. I and T are reciprocals, which means if you increase one and decrease the other by the same factor, the result is the same.

Of course, you must use some sort of measuring system to determine how much light is falling on the subject. Many conventional cameras and all digital cameras are equipped with light meters that measure the amount of light reflected from the subject to the camera. A microchip inside the camera takes the light measurement and computes a suitable combination of aperture and shutter speed to expose the film correctly. If your picture requires a certain shutter speed, it calculates the correct aperture. If you want to use a very small aperture to gain as much depth of field as possible, the camera sets itself to the appropriate shutter speed.

In a camera with a fixed aperture lens, the shutter speed varies according to how much light is available. Digital cameras use an electronic shutter instead of the mechanical ones found in conventional cameras. Effective electronic shutter speed can be anywhere from 1/2 to 1/4,000th of a second.

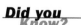

When you must use a fast shutter speed to capture something in motion and your camera doesn't enable you to set the shutter speed, you can trick it by setting the aperture to its widest opening, and by making sure the subject is brightly lit. This forces the electronic shutter to open and close very quickly, so as not to overexpose the picture.

White Balance

Digital cameras have a capability not possessed by the conventional camera. In addition to measuring how much light falls on the subject, most digital cameras also measure the color temperature of the light and adjust accordingly so that any white objects in the picture will be white, rather than yellow, green, or some other color. Color temperature is measured on the Kelvin scale, and can best be explained if you think of a piece of metal being heated. When it's cold, it is black. As it is heated, it eventually glows a dull red, and then a bright cherry red, and then orange, yellow, on up to a brilliant blue-white. Table 3.1 shows the color temperature of some typical light sources.

TABLE 3.1 Color Temperature of Typical Light Sources

Light Source	Approximate Color Temperature (in Degrees Kelvin)
Candle flame	1,930
Dawn sunlight	2,000
Household light bulb	2,760–2,960
"Warm-white" fluorescent lamp	3,000
Photoflood bulb	3,400
"Daylight" fluorescent lamp	4,500
Sunlight at noon	5,400
Average daylight (sun and sky combined)	6,500
Blue sky	12,00–18,000

As you can see, daylight is a lot bluer (higher on the Kelvin scale) than indoor light. That's why pictures taken outdoors may have a bluish cast, or pictures taken inside may seen to have a warm, orange tone. Most, but not all, digital cameras, attempt to find something white in the scene and compare it to their internal reference on what white should look like. They then adjust their levels to match. If the camera can't compensate for the quality of light, you can adjust it when you upload your pictures to the computer. Sometimes, though, the effect of unadjusted whites can be very helpful.

In the picture in Figure 3.12, the cat was lit only by daylight coming in the window. It was, as you can see, a snowy, overcast day. Even though the sky was gray rather than blue, the color temperature was close to that of blue sky. The cold tones made the black and white cat even more black and white. The softly diffused light illuminates him evenly, avoiding highlights and shadows, and adding a slightly hazy, romantic quality to the portrait.

FIGURE 3.12
The light in this
photo creates a
pensive pussycat.

Learning Workarounds for Camera Settings

Digital photographers at all levels have an advantage shared only by those professionals who do their own color darkroom work. If you have to make compromises when you shoot your pictures, you can almost always improve your work after you upload it to the computer. Having said that, I should also point out that you'll be able to do much more with a picture if it's good to begin with.

Focus Workarounds

Rule number one for keeping your pictures in focus, no matter what kind of camera you use, is to hold it steady. If your exposure is likely to be longer than 1/60th of a second, find something to brace yourself against, use a tripod, or at the very least, learn the *photographer's crunch*.

This is a position that becomes second nature after a while. Begin by standing with your feet a little wider apart than normal, so you've got a good firm footing under you. Hold the camera with both hands, and press your upper arms and elbows into your ribs, as shown in Figure 3.13. If you need a low angle, sit, kneel,

or lie down, with your elbows firmly braced. As you look through the viewfinder, rest the camera against your nose. If your camera uses an LCD view screen instead of a viewfinder, hold it at a comfortable viewing distance away, but again with your elbows and upper arms pressed tight to your body. Just before you press the shutter, stop breathing for a second or two.

If your camera has a fixed focus lens, you're going to need to do some experimenting. Start by memorizing the information that came with the camera about focus distances. You'll probably find something like "Focus Distance: two feet (0.5m) to infinity." Common sense tells you that nothing is going to be in perfect focus at both two feet and infinity. You can safely assume that they're referring to reasonably acceptable depth of field, rather than focal point. Knowing that, you can therefore determine that the actual focal point is probably somewhere around 6–8 feet.

Take a few test pictures with a subject at that distance, and see if they're acceptably sharp. Then try a couple at 4 feet and 10 feet, and see what differences, if any, you can notice. You can "sharpen" pictures in the computer, too, by using the tools in a program such as Adobe Photoshop Elements or Jasc Paint Shop Pro.

FIGURE 3.13
Holding the camera steady.

Autofocus cameras have their own set of problems, as previously noted. The main thing to remember when you use an autofocus camera is that the focusing mechanism is aimed at the center of the frame. If you're shooting a couple, it's entirely possible that the camera may try to focus through the gap between the people. Focus on one or the other, lock the focus if possible, recompose, and shoot before you let go of the focus lock, so the subjects stay in focus.

If you know that your autofocus camera uses sonar focusing, don't try to take pictures through a closed window. The sound waves bounce off the glass, and give you a perfectly focused window, with a blur beyond it (see Figure 3.14). This sometimes happens with infrared autofocus cameras, too, although a few seem to be able to look past the glass. The best workaround for this is to open the window!

FIGURE 3.14
D'oh! If I'd rolled the window down, this would have been a nice shot.

Did you Know?

If you must shoot through a closed window, as on a train or bus, hold the camera so it's at an angle to the glass. Then, infrared or sonic waves from the focusing device will bounce away from the camera instead of back at it, and the camera will autofocus at infinity, which is exactly what you want it to do.

If you're shooting a group of people or a scattering of objects such as a field of flowers and need as much depth of field as possible, focus about a third of the way back. Doing so will take advantage of as much sharpness as your lens can

provide. Similarly, if you have two subjects—one at 6 feet away and the other at 12 feet—your focus should be at 8 feet, in order to take full advantage of the rule that depth of focus extends one-third in front of the focal point and two-thirds behind it.

Flash Workarounds

Cameras with built-in flash are very useful in certain situations. Obviously, when you're shooting indoors and haven't enough light, the flash fills in. You can also use it outdoors when you need a little extra light on a subject that's backlit or in shade. Some photographers are reluctant to use built-in flash, for several reasons. Having the flash mounted on the camera produces a flat, head-on light with no modeling effect. The roundness of the subject is lost. This isn't so bad if the subject is a piece of furniture, but if you're shooting a portrait, the effect may make it look more like a mug shot (see Figure 3.15).

FIGURE 3.15
Notice the shadow directly behind his head.

With built-in flash, there are no shadows to add contour to the face. In fact, the only shadow you'll see is cast on the background right behind the subject's head. It may even merge with the head to the point where you can't tell what's hair and what's wall. The cure for this is quite simple. Place the subject between three

and six feet in front of the background. This gives room for the shadow to fall harmlessly out of the way, and still sheds enough light on the background so that your subject won't appear to be looming out of a hole (see Figure 3.16). To avoid the flat look, have the subject turn his or her head slightly to one side.

FIGURE 3.16
Moving the subject away from the background keeps the shadow out of the picture.

Did you Know?

Use the same trick described in Figure 3.16 if you're shooting outdoors in the sun. Move the subjects far enough away from vertical surfaces so that their shadows aren't part of the picture.

Another problem with the built-in flash is that it casts bright highlights on reflective subjects. Occasionally, this effect is good, but sometimes the highlight is just too much glare. To soften it, tape a single layer of tissue over the flash, taking care that the tape and/or tissue doesn't interfere with the lens, meter, or anything else. The tissue should diffuse the light just enough to block the glare, without darkening the picture noticeably. Figure 3.17 shows before and after examples.

A related problem is called "red eye" when it affects people and "green eye" when it affects animals. If the subject's pupils are wide open, as they tend to be in dim light, and you take a flash picture, the light reflects off the backs of the retinas and into the camera lens (see Figure 3.18). It's easy enough to fix in an image

editing program like Photoshop Elements, but it's easier still to avoid it. Simply have the subject look somewhere other than at the camera. If that's not possible, for example if the shot has to be face forward, turn up the room lights as bright as possible, so the pupils of the subject's eyes are already as small as possible.

FIGURE 3.17
The picture on the left was shot without tissue. The one on the right used the tissue to diffuse the light. Notice the harsher shadows in the picture on the left.

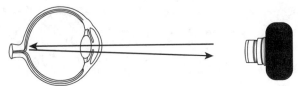

FIGURE 3.18
Red eye is caused by light bouncing off the subject's retinas and back into the camera.

Exposure Workarounds

In general in digital photography, it's better to underexpose than to overexpose. If your pictures are a little too dark, you can usually lighten them enough to bring out the detail. If you have overexposed your picture, there's frequently no way to save it. The detail just isn't there. Use "bad" pictures to experiment with special effects. The photo in Figure 3.19 was shot just about at dawn. In the uncorrected version on the top, the details are lost in the darkness. Photoshop Elements's auto correct brought back most of the detail, and saved this one.

FIGURE 3.19
Lighthouse at
dawn.

Remember that you can correct for color temperature. If all you have available is fluorescent light, use it. If your subject's skin tones pick up a greenish cast from the lights, you can fix it later. If you have a couple of clip-on lights, but only standard household bulbs, go ahead and use them. A warm portrait is better than a dark one.

If you're planning to shoot pictures outdoors, be sure to consider the time of day and angle of the sun. You won't get a flattering portrait at high noon with the sun directly overhead, but you get better architectural shots then. Shoot the scenery midday, and save the people pictures for later, as the sunlight warms up and the sun's angle casts shadows.

If your camera enables you to see what you have shot, always stop and check after one or two pictures in a particular setting. You may decide to turn on another light or open a curtain. If you're outdoors, you may decide to move from sunlight to open shade, or to move so that the sun is over your shoulder.

Caring for Digital Cameras

You've made an investment in equipment. It is smart to take care of it. Not many things can go wrong, as long as you keep your camera dry and away from extreme temperatures. Use a wrist strap or neck strap at all times. Digital cameras contain delicate electronic parts and aren't meant to be dropped or thrown around. Keep your camera in a protective case when you aren't using it. Some cameras come with cases. Other companies sell the case separately, or send it to you as a premium when you return the registration card (see Figure 3.20).

FIGURE 3.20
The well-equipped photographer.

Even if you use the case that came with your camera, investing in a photographer's shoulder bag, fanny pack, or backpack is a smart idea. After all, even with the simplest snapshot camera, you'll want to carry around a notebook and pencil to make notes on what you shot, spare batteries, an extra flashcard, and lens

cleaning tissues. You may eventually add lenses and filters and perhaps a folding tripod. You need a convenient way to keep it all together; the shoulder bag is probably the best choice.

If your camera came with a lens cap, use it! I keep mine on a loop of heavy nylon twine attached to the camera strap. It's a bit of a nuisance to have it dangling, but at least I always know where it is. Just make sure you pop it off before you start shooting. Otherwise, you could end up with lots of photos of the inside of the lens cap.

Lens and Screen Cleaning

Sooner or later, you'll get fingerprints or dust on the lens or viewscreen and have to clean the camera. If the maker has provided a lint free cloth, use it. (Be sure you keep the cloth in its plastic bag when you aren't using it. It can pick up grit otherwise, and do more harm than good.) If you don't have a special cloth, go to a camera store and buy a package of untreated lens-cleaning tissues. Never use the chemically treated tissues made for eyeglass cleaning. They may damage your camera lens.

To remove visible dust from the lens, tear out one sheet of tissue. Roll it, and then tear the roll in half, so the jagged edges of the tissue make a sort of paper brush (see Figure 3.21). Use this to brush dust very gently from the center out to the edges. If the dust seems stuck, breathe on the surface of the lens. The moisture from your breath loosens the dust. Follow manufacturer's directions regarding the use of lens-cleaning fluids.

FIGURE 3.21
Making a brush
from tissue.

LCD viewing screens can be cleaned in the same way. These are more prone to fingerprints. You may have to use gentle pressure on the screen to remove oily fingerprints.

Batteries and AC Adapters

Digital cameras don't just run on batteries. They *eat* them! I never go out for a day of picture-taking with fewer than three sets in my bag. Batteries can get expensive, to say nothing of being wasteful and bad for the environment. Disposal of dead batteries is a problem municipalities are beginning to recognize. If you incinerate them, they explode, sending chemicals into the air. If you bury them, they corrode and leak chemicals into the ground, where they eventually end up in the water supply.

Most snapshot digital cameras use AA batteries, which are available anywhere. Alkaline batteries are the least expensive, but lithium batteries last longer. Rechargeable nickel-cadmium (NiCad) batteries are the best alternative, although they cost the most initially. It pays to have several sets of batteries, so you can switch when necessary. Of course, you also need a charger. It pays for itself in about 10 photo sessions.

A couple of tricks are necessary when working with NiCad batteries. To get the most use out of them, discharge them completely before you recharge them. If you put half-charged batteries into the charger thinking to "top them off," you'll discover a strange effect. The battery tends to remember the amount of charge it took, and next time you try to charge it, it accepts only half a charge.

NiCads eventually wear out. If you number the batteries and keep a notebook to remind you how many times you've recharged each set, and approximately how many pictures you were able to take after each charge, you'll have some advance warning when they're wearing out, and can plan accordingly.

Some of the more expensive cameras also use more expensive, rechargeable Lithium Ion batteries (Li-Ion, for short). These last a good deal longer, but you still need to carry a spare if you're planning to take a lot of photos.

AC adapters are little cubes that plug into a standard outlet, and contain a transformer than converts the regular 110 volt electricity to the same strength as the camera batteries. It's helpful if you do a lot of work on a copy stand or in a studio situation where you can leave the camera plugged in. If your camera can use an AC adapter, it will have a socket for a small plug labeled "DC in." Some, but not all, AC adapters can also recharge the camera's rechargeable batteries in place.

Read your manual to find out whether you need to put your batteries into a separate charger.

Summary

Cameras, and digital cameras in particular, rely on a lot of basic science and technology to make them work. It's not absolutely necessary that you know everything there is to know about how lenses and exposure meters work, but a basic understanding of them will help you take better pictures. Most of today's cameras have autofocus lenses, either a prime lens with a fixed focal length or a zoom lens, which has a variable focal length, permitting both wide-angle panoramas and telephoto close-ups. They also have automatic exposure meters that measure the available light and adjust the lens aperture/shutter speed combination for the best picture. For some special effects, you may need to override the automatic settings. Keep your camera clean and dry, and avoid scratching the lens. Always keep spare batteries with you when you go out to shoot pictures.

PART II

Taking Better Pictures

CHAPTER 4 Seeing Photographically 79

CHAPTER 5 Telling a Story 107

CHAPTER 6 Controlling the Environment 125

CHAPTER 7 Painting with Light 147

CHAPTER 8 Shooting Portraits 165

CHAPTER 4

Seeing Photographically

What You'll Learn in This Chapter:

- ▶ Comparing What You See and What the Lens Sees
- ▶ Organizing Perception = Composition
- ▶ Framing a Picture
- ▶ Discovering Perspective—The Illusion of Reality
- ▶ The Importance of Scale
- ▶ Finding Balance and Symmetry
- ▶ Building Relationships
- ▶ Working with Texture and Pattern

Whoever said the camera doesn't lie was lying. The camera can exaggerate certain features and ignore others. It can compress perspective. It can stop time and freeze motion. Learning to see the way the camera sees will make you more aware of what's around you. It doesn't matter, in this case, whether there's film or a CCD and flashcard in your camera. Conventional cameras and digital cameras are alike in every way except recording media.

"Thinking photographically" is a process that happens within you, not inside the camera. In this chapter, you're going to learn to compose and design good pictures. The same rules apply, whether your medium is digital photography, film photography, or even painting or drawing. Mastering the basics will make you a much better artist in any medium in which you choose to create.

Comparing What You See and What the Lens Sees

How do you see the world around you? It's there when you open your eyes, but what's really happening? The process of seeing begins with light. Light strikes the objects that make up our world: walls, floors, furniture, trees, grass, people, animals, sky. It's reflected back from them in different amounts. Our eyes respond to the light rays that bounce off the objects around us. First, we see shapes, distinguishing them from the background. Next, we see color, and finally detail. Only then can we process the information to know whether we've seen a black cat or a red flower. It all happens in a fraction of a second. As soon as we can gather enough information to identify one object, we move onto the next, and so on. When there's less light, it takes longer to decode the signals. That's why, in the middle of the night, clothes thrown over a chair can look like an intruder. We see the shape and try to reconcile it with other similar shapes. Then, if there's enough light to add color and detail to the equation, we quickly realize that it's the T-shirt and jeans we tossed aside earlier. If not, we may experience a rush of adrenaline that will finally wake us up enough to realize it's just the chair.

Like our eyes, the camera needs light. Unlike us, it doesn't need to understand what it sees. It just needs to record the points of reflected light. Making sense of the picture is up to us. The black shape in Figure 4.1 matches our previous experiences of cats and black. We haven't seen these black cats in this position before, but other cats sleep in similar positions. So, this must be a picture of a pair of black cats.

FIGURE 4.1
Shape = cat, position = lying sprawled, color = black; must be a black cat.

In two dimensions, the cat has a shape. In three dimensions, it has volume. Although you see the picture on the page or on the screen as a cat-shaped lump against a light background, your mind redefines it as a cat on a wooden floor.

You've added back a dimension that's present in reality, but not in the photo. You've added depth.

There's a reason why we have two eyes, and it isn't just in case one is injured. The reason is to allow us depth perception. Depth perception keeps us from bumping into the furniture. It helps the outfielder figure out where to stand to catch the ball that's moving toward him at 60 miles per hour. It's telling me how far I have to reach to pick up my coffee mug and where to move my arm so that I can put it down again without spilling. It lets the cat jump from chair to desk without landing on the floor (usually).

Depth perception in humans is a function of having two eyes that see slightly different, but overlapping images. Why different? The pupils of your eyes are about two and a half inches apart and therefore each eye is looking at the world from a slightly different angle. Things that are close to you appear less similar in the view from each eye than things that are further away. Your brain processes the information, judging the degree of difference between the two images and interpreting the information as perspective and depth. If you close one eye, you lose your depth perception. With only one image to process instead of two, your brain can't interpret the amount of space between objects. Try it.

The camera has, in effect, only one eye. It "sees" in two dimensions, not in three. This is entirely appropriate, since you're seeing the pictures you take either on a flat screen or printed on a piece of flat paper. By using light and shade, perspective, contrasting colors, and as many other techniques as necessary, we can create the illusion of a third dimension in our pictures. And maybe that's the real magic of photography.

Organizing Perception = Composition

When you open your eyes, you see what's there. If you really want to look at something, you tend to block out the stuff around it. You focus in on the particular thing that interests you. You might not notice anything else, or you might be vaguely aware of your surroundings. But most of the time, you're not particularly intent on any one thing. You're simply taking it all in, and that works fine for walking around without tripping on the furniture. But if you want to describe the scene to someone else, you probably start by describing the space, and then one or two of the things in it. You select just a few from all of the possible details that help describe the scene. You're imposing a structure on it. You're organizing it in your narration, by choosing what to put in and what to leave out. When you take a photograph of the scene, you need to do the same thing. You need to

organize the space, to find the important elements to include and the unimportant ones to ignore.

Creating a picture, in this sense, is much like telling a story. You've heard, or read, well-told stories, and probably bad ones as well. Good ones always describe the events and surroundings clearly, in coherent order, with just enough detail to give a sense of the scene. Bad ones wander, bringing in irrelevant bits, backtracking through the plot, and generally telling you more than you want to know but leaving out something significant. When you look at a good picture, you know right away what it's about. A bad picture tends to bury the subject in too much background, or hide it with a setting that's the same color, or find some other way to make it obscure.

Just as you learn to be selective in describing a scene, you need to learn to be selective in looking at it. One of the best ways to learn to see selectively is to look at smaller parts rather than at the whole picture. It's easiest if you have a way to block out the things you're *not* looking at. A cardboard frame can be a big help.

You need a couple of L-shaped pieces of plain mat board or illustration board, like the ones in Figure 4.2. These were a mat from a 5×7 photo, simply cut into two L's. If you don't have spare mats lying around, you can buy precut ones at an art supply, photo, or stationery store, or cut them out of whatever's available. Hold them so that they form a frame, and slide them to change the frame shape as you wish, from horizontal to vertical, to square.

FIGURE 4.2
The frame needn't be very big.

If you hold the frame up about a foot or so in front of you and look through it with one eye, you're turning yourself into a camera. You have given yourself a viewfinder and a single lens. Now you can see what the camera sees.

As you look through the frame, you might find yourself moving it around to block out parts of objects, to create compositions of lines and textures, and to select small areas that are visually interesting. The more of this you do, the more you're training yourself to see selectively.

As you grow accustomed to this way of looking at the world, you'll start to notice that much of what catches your eye is not the objects themselves, but a line or texture, or a patch of color, or perhaps a pattern of repeated lines. These patterns and textures can make fascinating abstract photos.

Framing a Picture

The frame defines the edges of the picture. The relationship of the edges to each other defines the shape or *format* of the picture. Is it tall and thin? Square? A perfect 3:4 rectangle? Is it a portrait or a landscape? Two factors influence the format of the picture. The first is how it is displayed. The second is the shape of the subject. Will this photo be shown full-frame on your monitor? Is it a product shot of a small round object for a catalog or web page? Is it art? Is it advertising? Is it just for fun?

Sometimes the display medium determines the format. If you're shooting a picture for a magazine cover, you know that it's going to be a certain shape and size, eight inches wide more or less, and about 11 inches high. That's the format you have to work within. If you're shooting pictures for the inside pages, your format may be the same, or it may be different. The art director may specify a certain part of the page to fill or ask for a two-page spread. If you're illustrating a catalog of machine parts, your photos will be quite different from the ones you'd take for a catalog of fashions. If you're photographing a tall, narrow floor lamp, the picture needn't be the same shape as if it were a long, low couch.

The Shape of the Image

Most digital cameras don't use the same format as the standard 35mm camera, which is a ratio of 2:3. Instead they use the 3:4 format, which is the same ratio as a TV screen or video monitor. Figure 4.3 shows a comparison of the two. It can be either horizontal or vertical. The image format you'll be working with is most likely to be the 3:4 format.

There are also what's called medium format cameras, for professional use, which have a square format similar to that of a 120mm film negative. These are much less common within the digital photography scene, due to their astronomical prices.

FIGURE 4.3
The black frame inside the digital frame shows the relative dimensions of a 35mm photo.

Remember that (unless you have a square format camera) you can turn the camera to shoot vertical pictures. Some photographers get stuck in a rut of always holding the camera horizontally. It seems to fit naturally in our hands this way, and the view is one we're used to, after years of watching TV or staring at computer screens, which are usually oriented horizontally.

The horizontal format produces a feeling of tranquility. It's stable and calm, like a landscape on a warm summer day. It's not going anywhere. The vertical format is more dynamic. It suggests dignity and pride, people on the move, or growth in an upward direction. Use these emotions when you compose a picture. What are you trying to say with the picture? Will the subject work in either direction? If so, shoot both. You may be able to use them at different times, or for different purposes.

No matter what size and shape your pictures end up, they'll start out the same, except that you may hold the camera sideways to shoot a lamp, the Eiffel Tower, or any other tall object. That doesn't mean they have to stay in that format. Very

often you'll improve a picture by cropping it to a different shape. A long, thin strip of landscape may be just what your web page needs. The interesting tree may tell its story more effectively when you're not seeing the playground equipment alongside it. When you look at a subject, before you pick up the camera, think about how you're going to use the picture. If there are parts of it that you know you will crop out, don't worry about making them look good.

There's also a somewhat avant-garde photography trick of holding the camera at an angle while you shoot. This is called a *dutch angle* and you'll see it most often in MTV videos or TV commercials. The purpose is to provide a new perspective on a common object. Usually, however, it merely disorients and annoys the viewer. If you decide to try this, make sure you use an extreme angle, as much as 45 degrees off axis. Otherwise, it may look only like a crooked photo instead of "art."

The Shape of the Subject

The format is a shape—a rectangle. Within that, you must fit the shape of the subject. But these shapes are abstractions. There are really only three shapes: the rectangle, the circle, and the triangle. Everything we see can be reduced to these. The sleeping cat is a mass of circles. The apple is a circle. The pine tree is a triangle. Buildings, clouds, rocks, bananas—everything you might possibly point the camera at can be reduced to one, or a combination, of these shapes. Shapes contain lines, and the diagonals and arcs created for us by circular and triangular subjects add movement and flow to the picture. Sedate horizontals and verticals lend solidity.

One person in a picture may form a circle or a triangle or a rectangle, depending on the pose. Three people often make a triangle, in art as in amour. Use the triangle shape to position your subjects, and you've created a dynamic and interesting group portrait. Similarly, one piece of fruit in a still life, one flower, or one object of any kind is a single shape. Combining several objects combines their mass, visually, into what may be a quite different shape. This is the shape that needs to relate to the shape of the frame.

The shape of the actual subject may suggest a shape for cropping the photo. The apple shown in Figure 4.4 doesn't look right in a normal horizontal frame, but if we crop it to a square, it becomes a more interesting picture.

On the other hand, this landscape, shot in Nevada, works well in a horizontal frame. As you can see in Figure 4.5, if I just crop the middle out, making the picture vertical changes the subject of the photo from the huge open spaces, and emphasizes the line of mountains.

FIGURE 4.4
One round shape
fits nicely in a
square.

FIGURE 4.5
This could work
either way, depend-
ing on what I want
the picture to say.

The Shape of the Space

Tall subjects suggest tall pictures. Wide ones fill wide frames, but sometimes the "point" of the picture isn't the subject *per se*; it's the space around the subject. Consider the lone cyclist in Figure 4.6. If I crop the picture down to show just the guy on the bike, I have a decent picture of a him. If I leave the photo with as

much horizontal space around it as I can manage, I've made a very different statement about the bike race. The pack is gaining on him.

FIGURE 4.6
Lonely cyclist.

You must learn to consider space as an element of your photographic compositions, whether you're using a digital camera or a conventional one. With a single subject, you have a lot of options for where you place it in space. It can be right in the middle, off to the side, up high, or down low. It can fill the frame, or it can occupy a small corner of the picture. The setting may actually be the subject, with a point of interest somewhere in it, like any typical mountains at sunset photo.

When you add a second subject, the space in between the two becomes more important to the picture. It helps to establish the relationship (or possibly lack of relationship) between them.

Artists often speak of the concept of positive space and negative space. Positive space is the area occupied by the object. Negative space is the area around the object, or not occupied by it. Learning to see in terms of negative space takes practice, but can be mastered. Betty Edwards's book, *Drawing on the Right Side of the Brain* introduced this concept and remains the best work on the subject. Figure 4.7 shows a drawing of a cat, in terms of negative space. When I did this, I was visualizing and drawing the spaces around the cat, not the cat himself. First I drew lines to reveal the table and cat. Then I placed the mirror frame behind him, including the reflection as part of the shape of the frame.

FIGURE 4.7
Cat considering his
reflection.

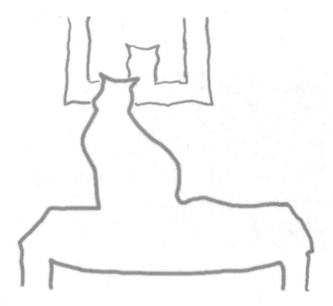

FIGURE 4.7
Cat considering his
reflection.

Dealing with Print and Screen Formats

It would be nice if all of our work ended up beautifully color-printed and hung on gallery walls. Then we could crop our pictures as we wished, use whatever format appealed to the eye, and not have to deal with the realities. Few photographers have that luxury. Mostly, we're taking pictures for a reason, and the reason dictates not only what we shoot but how we have to look at it.

Magazine covers have to be vertical. The best panoramic photo ever taken isn't going to make it onto the cover of *Travel*, unless you can convince the editors to go for a foldout. And that just doesn't happen. What can you do to make a horizontal scene vertical? Add more foreground. Add more sky. Preferably one or the other, not both, since the horizon shouldn't be placed right in the middle of the shot. Or apply your frame and find an interesting vertical composition within the panorama, and use that instead.

Computer screens are horizontal. (Okay, I know about the full-page and pivoting ones, but *most* computer screens are horizontal.) At worst, you'll lose some sky or some foreground from your vertical landscape. However, within the computer/video screen format you have more options. Maybe the picture doesn't have to fill the screen. Maybe you can float a square picture in the middle of the screen. Perhaps you can add type. It all depends on the purpose of the picture. If you're putting photos on a web page, smaller is better. Viewers hate to sit and

wait for a full page image to load. It can take a minute or more, depending on the connection speed. And, while a picture may indeed be worth a thousand words, it's seldom worth a hundred seconds.

If you're photographing items for a catalog, why worry about format at all? Shoot them on a white background, as I did in Figure 4.8, and crop away everything that's not part of the product.

FIGURE 4.8
Sometimes no format is the best format.

Before you shoot a picture, teach yourself to look at the edges of the frame, too. Are you chopping off the tops of heads? Have you cut off someone's feet? Is there something on the edge of the frame that either shouldn't be there at all or should be shown more? Would your picture be improved by stepping backward or forward a foot or two?

Learning the Rule of Thirds

Most pictures have what is called a *center of interest*. In a portrait of a single person, it's the face. In a group of people, one person dominates, while the rest are subordinate. The dominant one, because of position, size, or placement, is the center of interest. In a landscape or still life, the center of interest is the part of the picture to which the viewer's eye is attracted first. Your first step in composing a picture should be to find the center of interest. Most of the time, it's obvious. It's

the dominant feature of the landscape. It's the one yellow flower in the field of red ones. It's the widget that goes next to the catalog description, or the house that's for sale, or the cat asleep on the bed. It's why you're taking the picture.

Once you locate, or decide upon, the center of interest, you should look for anything in the scene that detracts from it. Is there something behind the portrait subject that interferes with him? Does he have a lamp, or a window, or some other object in the room that appears to be growing out of his head? If so, change your camera position, or else move him to a more neutral background.

The center of interest generally shouldn't be right in the middle of the picture. (The exception to this rule is, of course, the catalog picture, where nothing matters but the object you're photographing.) The center of interest also shouldn't be right at the edge of the picture, because this tends to draw the viewer's eye away from the rest of the scene, and usually right off the page. It knocks the viewer off balance. In a landscape or seascape, the horizon—if it shows—is usually a strong center of interest. It's sometimes very tempting to place the horizon right in the vertical middle of the page, so you have half a page of sky and half a page of ocean or grassy meadow or whatever. It's a kind of visual cliché and doesn't usually work very well. Try to avoid it.

If you analyze a number of successful pictures, you'll probably find that in more cases than not, the center of interest falls in one of only four spots within the frame. These spots can be defined, and even turned into a rule that artists and designers know as the *rule of thirds*. Quite simply, you divide the frame into thirds, vertically and horizontally, as in Figure 4.9. The four points where the lines intersect are the approximate "best" locations for the center of interest. In this photo of Nova Scotia fishing boats, notice that the boats, which are the subject, are aligned on the lower third line with the bow of one and the stern of the other touching the intersections of the vertical and horizontal thirds. This is *not* an accident.

Like all good rules, it's meant to be broken occasionally. (Think how much better the chocolate cake tastes after a week of dieting.) But if you follow it more often than not, your pictures have greater impact. Break the rule when the subject has so much impact it needs to be in the center, like the apple we showed earlier, either because it's the only thing in the picture or because it contrasts very dramatically with its background. Break it when the photo is "about" symmetry. For instance, the impact of a sunset reflected in a pool of water is less if it's *not* right in the center of the picture. Break the rule whenever you know it's right to break the rule.

FIGURE 4.9
Any of these four intersections is a good place to put the center of interest.

Discovering Perspective—The Illusion of Reality

Some pictures appear to jump out of their frames and come toward us. Others pull us in and seem to take us back behind the frame into another universe. Why? It's because the photographer has created for us a world that extends beyond the two dimensional plane of paper or screen and—however briefly—given us the illusion of a third dimension. The illusion works due to some fairly simple tricks, all of which come under the general heading of perspective.

Using any or all of these five perspective tricks conveys the illusion of space on a flat plane:

▶ Linear perspective

▶ Aerial perspective

▶ Contrast in sharpness

▶ Vertical location

▶ Overlapping figures

Art schools teach courses in perspective, either separately or as part of a drawing class. Reluctant students armed with T-squares and triangles feel as if they're

suddenly majoring in geometry rather than painting or sculpture, as they learn the differences between one-point and two-point perspective and the ins and outs of vanishing points, eye level, and horizon lines. What they're learning is *linear* perspective. You can reduce linear perspective to a series of rules and formulas like those taught in the math department.

Linear Perspective

Linear perspective is the kind you're most aware of in the real world. You see it every time you look at railroad tracks or look down a long road. Tracks, the edge of the highway, and fences all contain parallel lines. We know that parallel lines, although they are physically always the same distance apart, appear to meet at the horizon, as in the photo in Figure 4.10. We also know that lines at right angles to the parallel ones appear to diminish in size as they recede, as do the fence posts and railroad ties in the figure. We *know* this, so any time we see a picture of what appears to be parallel lines meeting, we mentally add distance to the picture. When we see objects that we believe to be similar, in diminishing sizes, we assume that they are the same size and far apart.

FIGURE 4.10
The point at which the parallel lines meet is the vanishing point.

Whenever your picture includes a horizon, be sure it's level unless you have some very good reason for tilting it. We're all accustomed to seeing the ocean or the prairie as a flat line. If it's even a few degrees off, the effect is unsettling and uncomfortable.

Aerial Perspective

Aerial perspective is a another real world effect. You see it when you look off into the distance, especially on a hazy day. Whatever is close to you is relatively dark, while the distant city skyline, mountains, or horizon is light and indistinct. The effect is caused by smoke, haze, dust, or fog in the air, or sometimes all of them mixed together. I took the picture in Figure 4.11 on a hazy day on the outskirts of Las Vegas, Nevada. The combination of a thermal inversion and air pollution made for a dense haze over the distant hills, but the air down on the desert floor was clear and dry.

FIGURE 4.11
Each step of distance is a different shade of gray.

You can often heighten the effect of aerial perspective in a landscape by including something very close to you in the shot. You might position yourself beneath a tree limb, so you have a few leaves and a bit of branch sticking down into the shot. You could use a doorway, a porch railing, or some other architectural detail. The foreground elements create a frame for the background, and contrast with it, both in the amount of detail and in the range of tones. The viewer's eye is drawn from the close objects back into the distance.

Contrast in Sharpness

Contrasts in sharpness are a natural effect for most people. The fact is, most of us see better up close than we see far away. Nearsightedness is more common than farsightedness in the general population. When we see something that's in focus, we assume it's closer than something that's not in focus. You can use this trick to create depth by focusing on a near object and letting the background go out of

focus. Figure 4.12 shows an example. If you have the option of using a telephoto lens, it may be easier to focus on the close elements of the scene, because telephoto lenses naturally have less depth of field.

FIGURE 4.12
The weeds in the foreground are in focus. The distant cabin isn't.

Sometimes you'll want to use the contrasting sharpness trick, but for one reason or another, you won't be able to do it in the camera. Perhaps the lighting conditions aren't right, or the background just isn't far enough away to be out of focus. You can still apply the technique, by deliberately blurring the background in a program such as Adobe Photoshop Elements. Remember that your picture isn't necessarily complete when you press the shutter. Unlike photographers using conventional cameras and film, you have lots of options after the picture is uploaded to the computer.

Vertical Location

Vertical location is a psychological trick. People are conditioned to looking up, rather than down, into the distance. Therefore, when something is placed higher within the frame, it appears further back. When something is low, it appears right down by your feet. Placing an object higher up in the picture frame and making it smaller in relation to the surrounding area makes it appear further away. Chinese artists have known this for centuries. Although you can see museums full

of beautifully drawn landscapes from dynasties almost two thousand years old, you'll almost never see one with anything like Western perspective. Instead they use a system of recessive diagonals (see Figure 4.13), which lead the viewer's eye up and back into the scene.

FIGURE 4.13
This is an ink and watercolor copy of a silk embroidered panel from circa 450 A.D.

Because this trick hasn't become a cliché like most of the others have, it's even more effective. When you have the option of arranging your subjects in this way, try it. You'll be pleasantly surprised at how well it works.

Overlapping

Overlapping one object with another always makes the one in back seem further back. Logically, it has to be since it's behind the closer one. This is the same in principle as the trick of including a piece of shrubbery or some other up-close object to make the background recede.

In Figure 4.14, there are several examples of overlapping. The brush in the fore-ground hides the edge of the cliff. The sweep of grassland overlaps the hills. The darker rocks overlap the lighter mountain behind them, pushing it still further back.

FIGURE 4.14
Overlapping can literally move mountains.

FIGURE 4.14
Overlapping can literally move mountains.

Watch Out!

Be especially careful about unintentional overlaps. Sometimes it seems that items sneak into the picture. You aren't aware of them until much later, and then you may have to spend hours in Elements removing them. Of course, they're not always accidental. I once saw a remarkable portrait of the CEO of a large corporation. He apparently enjoyed hunting and had a trophy deer head mounted and hung on a wall in his office. The photographer who was sent to shoot a portrait for a business magazine was an animal lover and managed to position the CEO so that he appeared to be wearing the deer's antlers. The CEO looked idiotic. What was *most* remarkable about the picture was that the magazine editor allowed it to run.

The Importance of Scale

In almost any picture, there are some parts of the scene in which nothing is happening. They might be empty sky, or lawn, or backdrop, or even the plate on which the apple is sitting. These empty spots are what we mean by "space," and they're as important to the composition as the subject. How much space should there be? That depends on what else is in the picture. Space and scale are dependent on each other.

A Matter of Comparison

If you see a picture of a silver ball on a plain background, you have no way of knowing whether it's a ball bearing, a silver-plated baseball, or a science fiction illustration of a strange planet. Nothing provides a visual reference about the size of the object. It could as easily be a quarter-inch or a thousand miles in diameter. If you place a screw or a paper clip next to the silver ball, you can then recognize it as being the size and shape of a ball bearing. Sometimes the visual ambiguity of not knowing what you're seeing or how big it is can make the picture more interesting, but if you want the picture to communicate, you need to give the viewers some cues about what they're looking at. Size is the easiest clue to provide.

When you're setting up a still life, include at least one recognizable object that the viewer can quickly identify. We all know, for instance, how large a typical banana is. Seeing it in the otherwise abstract assembly of shapes in Figure 4.15 tips us off that these are probably apples, oranges, and lemons that we're looking at.

When you photograph your company's widgets, consider that even though it's a catalog shot, the viewer might not know what he's looking for. If you can show the product in position or in use, that's one good way to identify it. Another is to show someone holding one, or a handful. If you want to be a little more creative, think about other ways to indicate size. You could spill them out of a paper cup or a crystal goblet, point to one with a sharp pencil, set down a couple of pennies next to them to show they're inexpensive, and so on.

FIGURE 4.15
Without the banana, would you know these shapes were fruit?

Scale isn't a problem with portraits. We *know* how big people are. If it's really criti-cal to know that someone is 5' 9", and someone else is 6' 2", there will probably be a wall behind them with the height marks painted on it. (In addition, the sub-jects probably have handy identification numbers on their chests and guilty expressions.) If you're photographing a landscape, however, and you don't want your majestic mountains to look like molehills, be sure to include something in the shot that tells us what we're supposed to be seeing. Include a tree, a person, a house, a fence, or something in the picture to indicate the scale. Placing any one of these objects in the foreground serves the additional purpose of pushing the background further back.

Using the Horizon

In landscape photography, and even more so in seascape photography, the posi-tion of the horizon line can be a major factor in creating a sense of space within the picture. Putting it down low makes the sky very big and important. A high horizon line makes the land the major element in the picture. The worst place-ment for the horizon is right in the middle of the frame, unless you're trying to point out symmetry between sky and land or water. If the horizon just happens to land in the middle, it makes the picture appear too carefully balanced and there-fore less interesting. Figures 4.16 through 4.18 show the effects of different horizon placement, within the same general scene.

FIGURE 4.16
The low horizon emphasizes the sky.

FIGURE 4.17
The high horizon emphasizes the beach.

FIGURE 4.18
There's no emphasis here. Boring horizon.

Choosing Your Viewpoint

Placing the horizon is a function of which way you point the camera: up or down. Where you place the camera, and yourself, is what really makes the picture. Choose your spot carefully. Do you want a low angle, shooting up at the

subject, or do you want to get up high and shoot down? How close should you be? The worst mistake that beginning photographers usually make is to stand too far away. They seem to think that the more they include in the frame, the better. This just isn't so. Including too much material takes the emphasis off the subject of the picture and places it on the background instead. By moving in closer, you crop out unwanted parts of the picture and give the viewer a better look at the subject.

Changing your angle can really open your eyes to the possibilities of a subject. Most of the time, we take our pictures standing up. Suppose you set aside your dignity and sprawled on the floor or stretched out on the grass. What if you climbed a ladder, or shot from a balcony or upper story window? You could even try just tipping the camera a little bit if your scene has strong diagonals and you want to make them stronger. Look for the angle that makes your picture most effective. Walk around the subject if possible. Sometimes the back is more interesting than the front.

Many times, you don't even realize what's going on within the frame in addition to the subject of the picture. It's easy to get involved, especially if the subject is something that may change at a moment's notice, such as children at play, or a deer grazing in a meadow that may get frightened and run away. If your camera has a telephoto lens, that helps a great deal. Otherwise, expect to do a great deal of cropping and enlarging in the computer, and realize that there are some scenes, such as the deer in the meadow, that you can't photograph. In such a case, set the camera aside and just enjoy the moment. In the long run, doing so is much more satisfactory than taking a bad picture of a great subject.

Finding Balance and Symmetry

The beginning of this chapter discussed shapes—the frame shape, the shape of the subject, and the shape of the space around the subject. Shapes have another attribute that you need to consider—visual weight. Dark shapes are heavier, visually, than light shapes. Large shapes are heavier than small ones. This is worth considering because you usually want to achieve a sense of balance in your compositions. Perfectly symmetrical compositions are always balanced, by definition. One side is the same as the other, but a picture needn't be symmetrical to be balanced. For example, a large empty space has a shape and an implied weight that can balance a small object in the corner of the frame. Imagine a plate with a single piece of fruit on it, or look at Figure 4.19 if you're getting tired of imagining things.

FIGURE 4.19
A square meal, and
a symmetrical
composition.

You could place the sushi right in the middle of the plate and the plate right in the middle of the rectangular frame. It would look fine there, and the composition would be balanced. No question about that. But suppose we moved the fish to the side of the plate (see Figure 4.20) and added some wasabi on the opposite side. We have a totally different composition, arguably more interesting and more dynamic. But it's still balanced, even though it's no longer symmetrical.

FIGURE 4.20
A balanced
meal needn't be
symmetrical.

If you think of the frame of the picture as sitting on a seesaw, it's obvious that any single subject in the middle of the frame is balanced. Two subjects, for instance a picture of two people side-by-side or face-to-face, are also balanced. They're of about equal size and complexity. More complicated pictures are harder to balance, unless you reduce them to collections of abstract shapes and lines. In general, asymmetric balance is more difficult to achieve, but more interesting.

Pictures needn't always be perfectly balanced. You may compose a picture that's deliberately a little bit off-balance because it's more dynamic that way, or because it leads the viewer's eye in a particular direction. Chances are that the viewer will attempt to find balance in it anyway. We all try to impose our own preferred structure on things we look at. If my interest is in color and texture, and yours is in light and shade, and strong directions, we could look at the same photograph and see two entirely different pictures.

Building Relationships

Whenever you have two or more objects in a picture, you've established a relationship between them. Probably the relationship was there all along. When you discovered it, you made it the reason for the picture. Or perhaps you created the relationship by moving one object close to another. In either case, you emphasize the relationship by placing the frame around the objects and by making a picture of them. The primary kind of relationship is *proximity*. When two things are close together, we perceive them as being related to each other, even if they're otherwise not. Consider Figures 4.21 and 4.22.

In the first scene, the two animals are on opposite sides of the picture. Essentially, no relationship exists between them. In the second version, the two objects form a triangle. We can see them as one shape rather than two. When you compose a picture, you need to be aware of the relationships that develop between nearby objects. Their tendency to form a single mass can sometimes overpower the rest of the composition. More often, though, that tendency is a useful tool that gives you large, simple, visual masses to work with, rather than small bits of visual clutter.

FIGURE 4.21
There's no relationship here.

FIGURE 4.22
There's a close relationship.

When you have objects that are spaced too far apart to be related by proximity, you tend to search for another way to relate them. Another effective way is to find a relationship in similarities. Objects may be similar in size, shape, color,

texture, or direction of movement. Similarity in any one of these attributes is enough to form a relationship. Similarity in two or more enforces it. The relationship usually takes the form of a pattern, with the shape, curve, line, or interval between the objects repeated again and again. This can become too predictable and therefore monotonous. Try interrupting the pattern by turning one of the related elements sideways, or change it in some other way. The surprise factor of having one piece of the pattern out of line or in a different color or shape makes the difference between a boring picture and an interesting one.

Working with Texture and Pattern

Textures are random. Patterns are repetitive. Patterns are generally flat, while textures are, by definition, three-dimensional. Aside from those relatively minor differences, you can consider them together as surface attributes. Texture and pattern can add interest to a composition or detract from it, depending on how you make use of them. Sometimes, the pattern or texture *is* the subject.

Texture

Texture is a particularly strong trigger for emotional responses. That makes sense, if you remember that, as babies, touch was one of the first senses that functioned reliably. Taste and smell take a while to develop, because infants aren't exposed to enough different tastes and smells to gather information about them. A baby's eyes don't really focus for several months. Hearing also phases in gradually, lest the baby be too startled by the daily cacophony of TV, radio, street noises, household appliances, and so on. But touch is with us from day one—the softness of a fleecy blanket, the smooth plastic of a toy, the fuzzy stuffed bear.

We're instinctively drawn to look at textures, even when we can't touch them. That's why abstract photos of textures work so well. We make an emotional connection to the picture first. Then we develop an intellectual connection as we begin to analyze what we're looking at. Textures, like the shingles in Figure 4.23, photograph most effectively when they're sidelit. The play of light and shadow enhances the viewer's perception of the texture as being three-dimensional.

FIGURE 4.23
The weathered
shingles are both
texture and pattern.

Pattern

Like textures, patterns are everywhere. In fact, much of what we see is both texture and pattern at once. Consider something as ordinary as a shelf full of books. The spines form a texture. They also make a strong pattern of vertical lines. Patterns hide in the bricks on a wall, the shingles on a roof, and the panes of a window. Any emotional response that a single object evokes in the viewer is magnified many times when the object is part of a pattern. This is true in music, in poetry, and even in dance and drama, as well as in the graphic arts. The glory of a Bach fugue or a Shakespearean sonnet is in the repeated patterns, the rhyme and rhythm of the notes or words.

If you have a strong light source, such as the sun, and a picket fence, you have a pattern of shadows that turns a boring lawn or plain sandy beach into a strong design element. If the shadows don't fall where you want them, wait a bit or come back another day at an earlier hour. Remember that the sun moves, and shadows move with it.

Did you Know?

The example in Figure 4.24 contrasts several different patterns made by stacks of fruit in the local grocery store. There's just enough irregularity to make the results interesting. If all of the apples and lemons were perfectly round and aligned in straight rows, the picture would be less engaging.

FIGURE 4.24
Found art, patterns
in fruit.

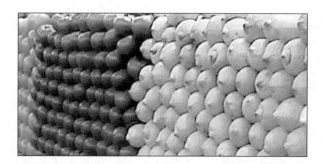

If the pattern is the picture, it must be obvious. Patterns work best when they fill the frame. Be careful about photographing a pattern with a wide-angle lens. The shift in perspective and size as the pattern recedes detracts from the visual impact. Patterns are most effective when photographed with a macro lens or a telephoto lens. Either one compresses the depth of field to lessen the effects of perspective, and this is one instance where you want as little perspective as possible.

Summary

It's not the camera that takes the picture. It's the eye, mind, and heart of the person behind the camera that turn a photo from okay to great. You need to learn to see what the camera sees, and to know how to compose a picture to make the most of the subject, whether it's a landscape, a bunch of flowers, or your favorite person.

CHAPTER 5

Telling a Story

What You'll Learn in This Chapter:

▶ How Does a Picture Communicate?
▶ Using Color
▶ Planning Photo Essays
▶ Release Forms

Photographers, like writers, are in the business of communication. To succeed in what is, after all, a risky business, you need a good vocabulary, a knowledge of idiom and metaphor, and the ability to turn clichés into fresh ideas. There's a grammar of images, just as there is of words. Fortunately, it's an easy language to learn.

How Does a Picture Communicate?

What is it that gives a picture meaning? How does it communicate? Let's start by looking at how people communicate with words. We agree on meanings, on definitions of particular words and phrases. If I say, "It's a nice day," you probably expect the sky to be blue and the temperature to be moderate. We have a shared basis of experience that defines "nice" weather in a certain way.

Images work the same way. If you saw a door with a silhouette of a man on it, you'd probably recognize it as the men's restroom even though no words told you so. The standing stick figure in trousers means men, and the similar stick figure in a skirt means women, even though women wear pants almost as often as men do. In Scotland, where men still wear kilts on occasion, the symbol on the door is still the same as it is in Chicago or Mexico City. Fortunately for the traveler in a hurry, these symbols compose a universal language.

Symbols

In photography, and in all of the graphic arts, we often use symbolism as a kind of shorthand to simplify communication. Lines are a particularly useful symbol. Horizontal lines imply stability or tranquility, in both positive and negative ways. The many strong horizontal lines in Figure 5.1 suggest a quiet backwater and a place where nothing much ever happens. A horizontal barrier, however, says "Stop! Stay where you are. You can't come in here."

FIGURE 5.1
This photo is full of horizontal lines.

Jagged lines connote danger, as in a barbed wire fence, a broken pane of glass, or a bolt of lightning. They also suggest nervous energy. Diagonal lines suggest movement and speed, such as objects blowing in the wind. Curved lines indicate graceful movement.

Some symbols are much more concrete. Babies and small animals are cute and helpless. They bring out a positive emotional response in most viewers. Can you look at the little girl in Figure 5.2 without smiling? I can't.

Snakes and spiders bring out an equally strong negative emotional response in many people. A sunset is almost always peaceful. A rainy day is generally sad, perhaps because people tend to think of rained out games and picnics. Mountains have dignity. Deep green forests and babbling brooks are relaxing.

FIGURE 5.2
Babies and children usually evoke strong responses in the viewer.

Shared Experiences

Some places are so frequently photographed and painted that, even if you have never seen them in person, you have a strong response to the image. The Statue of Liberty has the same meaning to most people who consider themselves hyphenated-Americans, whether the nationality in front of the hyphen is Irish, German, Swedish, Mexican, Chinese, or any other. You don't have to be French to recognize the Eiffel Tower or Dutch to appreciate a bouquet of tulips. Even if you're not hungry, a picture of a home-baked apple pie or some fresh-picked strawberries, as in Figure 5.3, might make you wish you had some.

You can use these "shared experience" symbols to reinforce your message. If, on the other hand, they're not part of the message, they may simply confuse the communication. Putting the cute little girl on the lawn of the house that is for sale might add to its appeal, but it also may turn off potential buyers who don't want to take away her home. Consider the potential negative effect of a shared experience, as well as the positive effect. The peaceful sunset indicates the end of the day, but it could be an unfortunate reminder of other endings to someone unwillingly facing retirement or illness.

FIGURE 5.3
You can practically
taste these berries,
and they symbolize
farm-fresh good-
ness.

Creating a Mood

In photography, mood is a function of light and contrast. When you want to
communicate a mood or elicit a particular emotional response, look at the
amount of light in the scene and the relative values of the brightest and darkest
areas. Light makes objects visible, but it does more than that. It defines them. It
displays their qualities—their surface textures, their translucency or reflectivity,
their lumps and bumps.

Mood also defines the atmosphere that surrounds the object. When you see a pic-
ture of a bridge emerging from the mist, you sense a very different mood than
that suggested by another picture of the same bridge in bright sun. Adding fog to
the scene changes its mood because it changes the contrast ratio between the
bridge and the surroundings. In this case, it dims the colors and lowers the con-
trast.

The contrast ratio, quite simply, is a way of expressing the degree of difference
between the lightest and darkest tones in the picture. Contrast ratios are the result
of several factors. The color and the amount of light that reflects back from the
surface of the subject influence the relative brightness at which you see it, but so
does the lighting ratio. The lighting ratio, again in simple terms, is the difference
between light and shade. On a sunny day at a high altitude, it can be as much as

20:1. That means that 20 times more light falls on the parts of the subject that are directly lit than falls on the parts that are in shadow. You see very white high-lights and very black shadows, because the ratio is so large. Under these lighting conditions, you are aware of very sharp edges and well-defined lines, but any details in the shaded areas are hard to decipher. In Figure 5.4, shot up in the mountains in Nevada, I focused on the interesting sandstone formation. Notice the contrast between the extreme detail in the sunny areas, and the complete lack of detail in the shadows.

FIGURE 5.4
There's almost no detail in the shadows.

Average outdoor scenes closer to sea level tend to have a medium-low lighting ratio. As you descend from the mountains, more of the sun's rays are absorbed by the air itself, and by the pollution that's unfortunately part of it in most of the world. The ratio here tends to be more like 8:1 to 5:1. The advantage to this ratio range is that you retain more shadow detail. Figure 5.5 shows an interesting range of contrasts. I shot this picture from the front door of a fisherman's shack in Nova Scotia. It was an extremely bright day, and even though the interior of the cabin was in deep shade, it was lit well enough to show quite a bit of detail. The barrel near the front is lit by bright sunlight and is almost overexposed.

FIGURE 5.5
Here there's less
variation in contrast
between the back
and front even
though the back of
the shanty is unlit.

Hazy skies, or bright overcast, will lower the ratio even more, also lowering contrast. Therefore, you see much less actual shadow and fewer darks and lights in the picture. Figure 5.6 shows a picture I took on a hazy day. Shadows are present, but soft-edged, and the lighting in general appears much more even. This low-contrast light is extremely flattering for portraiture. It's especially good for photographing teenagers with acne and anyone with wrinkles, because it tends to diffuse the lines and wrinkles that age provides and evens out blotchy skin tones.

As the clouds settle in and the fog rolls across the landscape, contrast practically disappears. There's a feeling of mystery, as the lighting seems to come from all over instead of from a single source. The lighting ratio is expressed as 1:1.

Thanks to the computer and digital camera, you can create these lighting conditions and contrast ratios even when nature doesn't cooperate. Two examples of the same scene appear in Figures 5.7 and 5.8. The first was shot on a sunny day (Figure 5.6). The second is obviously the same bridge in fog (Figure 5.7). Rather than wait for an appropriately foggy day, I simply edited the picture in Photoshop Elements to reduce the contrast and remove most of the saturated color. Then, to enhance the fog effect, I added a slight blur to the outlines and a more pronounced blur to the reflection of the bridge in the water.

FIGURE 5.6
This hazy day picture shows soft-edged shadows and even lighting.

FIGURE 5.7
A sunny day photo has medium-high contrast.

FIGURE 5.8
Reducing the con-
trast in Photoshop
Elements gives us
the bridge in fog.

Although it is difficult to do these tricks in a regular darkroom, the digital medi-
um lends itself to this kind of adjustment. Because you're working digitally, you
can manipulate contrast ratios and alter the mood of your pictures as you want.

Using Color

Color is exciting. It's fun. It's especially interesting when you're working on a
computer, simply because you can do so much with it. The current range of
graphics software for both Mac and Windows platforms provides you with the
tools to perform amazing feats of image manipulation magic. More important for
photographers intent on improving their work, the same digital tools can be used
to adjust exposures, edit out unwanted objects, and generally enhance pictures
that aren't as good as they could be.

Colorful scenes, whether they're staged in the studio or discovered in real life,
imply pleasure. The more colors you use, the more gaiety and excitement there
seems to be. Color Plate 5.9 shows a scene from the Las Vegas Strip, where you'll
probably find more color, and certainly more colors of neon light, than anywhere
else on the planet. Figure 5.9 shows the same scene in black and white. It's still
interesting, but just not as exciting.

FIGURE 5.9
Compared to the color version (Color Plate 5.9), this image is somewhat flat. (Photos by Naomi Rose.)

Pure colors speak to us differently than "muddy" colors. If you're shooting "what's there," you may not have much opportunity to do anything about the color. There's no way to make a street scene in Brooklyn, or Seattle, or Dubuque look as exciting and colorful as Las Vegas Boulevard, unless you paint in some neon lights in Photoshop or dress everyone in the scene in the brightest colors you can find. Consider, though, that the lack of color in a scene also makes a statement.

If, on the other hand, you're doing a portrait and want to make the subject more "important," have him or her wear a pure red or blue necktie. A woman executive might wear a brightly colored suit, or a gray, navy, or black suit with a bright blouse or scarf. To emphasize a person's "softer" side, stay with more muted colors.

Color Defined

When artists talk about color, they generally define it using a particular set of parameters called HSB. Photoshop uses the same color model. H stands for *hue*, which is the basic color from the color wheel, for example red, blue, or yellow. It's expressed in degrees (0–360 degrees), which correspond to the positions on the color wheel of the various colors. S is *saturation* or the strength of the color, and it's a percentage of the color minus the amount of gray in it. Pure color, with no

gray in it, is 100 percent saturated. Gray, with no color, is 0 percent saturated. Saturated colors are found at the edge of the color wheel and saturation decreases as you approach the center of the wheel. *Brightness*, the relative tone or lightness of the color, is also measured as a percentage, from 0 percent (Black) to 100 percent (White).

Color definition models exist, as well. The CMYK model, used for printing, defines colors according to their percentages of cyan, magenta, yellow, and black. The RGB model, which computer monitors and TV screens use for display, assigns values on a scale of 0–255 for each of the three (RGB) additive primaries. You won't really need to know the differences in the color models or when to apply which one, until you start working with Photoshop Elements or a similar image manipulation program.

Using Limited Palettes

If you're trying for dramatic effects, consider limiting your color palette. This is especially effective when you are photographing a still life or a fashion shot. Suppose you are setting up a still life with fruit. Rather than grabbing one each of everything in the market, how about trying an arrangement of only red, yellow, and orange, or even just yellows? Some golden apples, a grapefruit, a couple of lemons, and maybe something unusual like a slice of yellow melon could be an interesting composition (and a nice fruit salad afterward). See Figure 5.10 for an example of a limited palette.

Earth tones—tans, browns, cream white, yellows, and greens—are an example of a moderately limited palette. Sticking with only pastel shades of pink, blue, and green gives you a different, yet also limited, palette. Colors have strong emotional appeal and impact. Limiting your picture to a particular range of colors or tones is a definite "attention-grabber." It can make the communication much stronger.

In fashion photography, in which the major purpose is to make the clothes look good, look for backgrounds that accentuate the colors and fabrics. If the dress is red, a black and white or medium gray background will set it off better than a garden full of red flowers. If, on the other hand, your goal is a portrait or a landscape with someone in it, the red dress and red flowers could work very well together.

If you're shooting accessories, it's even easier to find backgrounds to set off the merchandise. They needn't be neutral. The black patent leather shoe stands out nicely from a red brick floor, or from a silver metallic panel, or even from a piece of white Styrofoam. Never throw anything away that might make a good photo background.

FIGURE 5.10
A study in limits
teaches you that
less can be more.

Working with Tonality

Tone, which may also be called value, brightness, or lightness, is another factor that helps to establish a mood. Technically, tone refers to the amount of light the particular color or gray reflects. Tones are generally divided into three groups: darks, middles, and lights, or shadows, midtones, and highlights. These groups correspond to the steps on a gray scale, on which 10 = black and 0 = white. Colors have the same tonal range as grays, from full strength down to the palest possible tint.

Limiting the tonal range is not the same as limiting the palette. Limiting the palette means restricting yourself to a few related colors. Limiting the tonal range means limiting your picture to only dark tones, only light tones, or only medium tones. Tones, of course, are relative. Within the range of darks, there's still a middle and a light. Middle gray is either dark or light depending on what's next to it. If the picture is dark, a middle gray might be the highlight. If the picture is very light, the middle gray tone may be the darkest shadow in it. You can make whites appear whiter by surrounding them with darker tones, and conversely, darks will seem darker if surrounded by white. White areas also appear larger than black ones of the same size, when offset by a contrasting tone. Figure 5.11 shows what may be a familiar optical illusion. Both inner squares are exactly the same size.

Factors that influence what you actually see include not only the tonal range of the subject, and its colors or lack of color, but also how well the digital camera can record the image, how well the computer monitor can display it, and how accurately your color printer can reproduce it. Understanding the limits of the technology will help you get the most from your equipment.

FIGURE 5.11
The white square definitely looks larger than the black one, even though both are the same size.

Monochrome

Monochrome is the most limited palette. Whether you reduce the picture to black and white or shades of gray, or perhaps to shades of ocher, olive, blue, or sepia, you have made a very powerful statement about the nature of the subject. By removing color from its characteristics, you force the viewer to see the subject in a different way, perhaps as pure shape or texture, or as an arrangement of shapes in space.

Consider J. M. Whistler's famous painting of his mother, *Arrangement in Gray and Black*. (See it at http://www.abcgallery.com/W/whistler/whistler37.html.) This is an example of monochrome at work. We remember it as the old woman sitting in a rocking chair, but we also remember the black triangles of her dress, the square wall behind her, the scarf over her hair, and the absolute lack of movement and life in the picture. Monochrome can do that. It can also reduce a dramatic scene to raw, gut-wrenching emotional content by taking out the "vividness" of the colors and leaving the viewer with only stark form and features.

You can see the effect of monochrome in many of the pictures in this book. Figure 5.12 shows a portrait turned into monochrome. By removing the color from this picture of a young woman, and tinting it sepia instead, we've added years to its age—the photo, that is, not the young lady. Sepia toning is an effect photographers have used in the darkroom for a long time, because it simulates the brownish quality of the early daguerreotypes.

FIGURE 5.12
This picture in monochrome could have been taken in 1904 instead of 2004. See it in the color section.

Planning Photo Essays

Photojournalists know the value of research. Before they shoot a story, they do their homework. If they're shooting an event, they find out (as much as they can beforehand) exactly what will be happening. If it's a parade, perhaps they'll call the organizers and get a list of participants, the order of march, and any historical tidbits about the parade. If it's a ceremony or performance of some kind, they'll get an advance copy of the program in order to anticipate which aspects of it will make a good story.

They scout locations ahead of time, whenever possible, and look for the best vantage points. If crowds are anticipated, they may bring a sturdy camera case to stand on, or a folding stepstool. They check regulations in advance. No flash photography in the cathedral? They'll use the slowest shutter speed and widest lens aperture possible.

If flash cameras are restricted where you're shooting, but your camera has a built-in flash, cover the flash with a piece of black tape. Even if you forget to turn the flash off, you won't disturb the atmosphere and embarrass yourself, or degrade pigments in priceless artwork.

Did you Know?

During all this advance preparation, they're also planning their shots. What is it about the event that makes it unique or newsworthy? Is it a sad occasion or a

happy one? Why is it being photographed at all? Is this a situation that merits documentation for historical reasons, such as a riot or a civil war? Does it qualify as "human interest"? Will they be looking for a series of pictures to tell the story, or for the single, revealing moment?

Shooting a Photo Essay

Shooting a series of pictures about a single subject produces what's called a photo essay. Like a written essay, the photo essay should flow in a logical sequence from point A to point B, with an introductory photo, one or more pictures that provide the exposition, and a conclusion. When you set out to create a photo essay, think about what you want to say before you decide how to say it. Are you explaining a process that has a logical sequence of events?

Let's analyze a mythical photo essay called "The Birthday Cake" as an example. In the first picture, a mother and child are in the supermarket studying the display of cake mixes. The child points to one particular mix. In the second picture, they're in the kitchen, studying the instructions on the box. The third picture shows a close-up of the batter being mixed. In the fourth, Mom is putting the cake pans in the oven while the child is licking the bowl. In picture five, the cake is frosted and they are writing "Happy Birthday, Daddy." In the sixth, and last, Mom and child stand on either side of Dad, who's grinning in the candlelight and preparing to blow out the candles.

You can plan all of these shots ahead of time, even sketching out the probable composition of the shots. Then you would know, for instance, that you want to be to the right of the child at the cake mix display, so he's not pointing off the page. You take a variety of shots, both close up and more distant, so you have a good sense of the environment they're in. You have followed the process well enough that someone else could duplicate it and get the same result. The happy faces in the final shot tell us how the participants feel about the subject.

If your photo essay deals with a less structured topic, try to find a way to give it a structure. Instead of, for instance, a general look at the problems of homelessness, you may consider "A Day in the Life" of a homeless person. This theme gives you

a chronological structure to work with, and by focusing on one person, you help viewers to empathize. Your message is therefore much stronger.

Not all essay topics lend themselves readily to structure. Occasionally, you'll encounter a situation that practically begs to be photographed, but seems too general for an essay, such as "Springtime in North Carolina." Ask yourself what it is about this topic that appeals to you. Perhaps it's the colors of the flowering trees, or the way the runoff from the mountain snow makes the waterfalls and streams flow faster. Maybe it's a particular local landmark that's especially lovely during this season. Find a way to tie your pictures together using one of these common themes, like the flowering trees, or the local landmark. If every picture has a tree in bloom, or was shot in and around the landmark site, there's a structure... perhaps not as tight as the previous examples, but structure nonetheless.

Figures 5.13 and 5.14 show two of the pictures from an essay I shot on one such topic. All the pictures in the series were taken at the Ethel M. cactus garden in Henderson, Nevada.

FIGURE 5. 13
Overview of the garden establishes the location and topic.

FIGURE 5.14
Now we can focus
in on small but
interesting details.

Release Forms

If you create a photo essay with recognizable people and intend to publish it, you may need to have your subjects sign a model release form. This is a legal document that allows you to use their pictures for commercial purposes. Some model releases specify that the model will be paid a given sum or a percentage of the proceeds from the sale of the picture. Others provide for a token payment, usually one dollar.

Camera stores generally stock a basic model release form in pads of 50. If you take the legal boilerplate from one of these, you can customize it with your name and address, and print your own release forms that will look much more professional. Many model releases also include text such as this:

> "I acknowledge that the photography session was conducted in a completely proper and highly professional manner, and this release was willingly signed at its termination."

This gives you some protection against potential lawsuits, but if you have any concerns at all about a "situation" developing, be sure there's another responsible adult present who can support your innocence.

There are a few conditions under which you don't need a model release:

- *News events*. Any situation that is considered a news event does not require model releases.

- *Ability to recognize person*. You also don't need a model release if the person you're showing isn't recognizable. The criterion is simple. Could his mother recognize him in the picture? If not, you're home free (see Figure 5.15).

FIGURE 5.15
This group of clam diggers didn't need to sign releases.

Regarding news events, you need to be a little bit sensitive about what's news and what's not. Freedom of the press gives you the right to publish pictures of people without their consent, but only for news reporting. You can't use the pictures for commercial or advertising purposes, and you can't use them to libel someone. People who are unwilling participants in a news story, for example the victim of a holdup, fire, or similar catastrophe, have also given up the right to privacy because the public's "right to know" supersedes it. Of course, these situations give rise to lawsuits, and the courts are more likely to side with the victim than with the photographer.

People who are "in the public eye," as in the entertainment business or in politics, have given up some of their "right of privacy." Their public appearances are news, simply because of who they are. Photos of Ben Affleck or Madonna walking down the street are news, because they rarely walk around in public. Sports figures, whether they're playing their sport or hanging out at the local pub, are

equally newsworthy. You could photograph them for the local paper and be within your rights as a news reporter. You couldn't, however, sell the pictures to a non-news publication, or put them on bubblegum cards or T-shirts. That would be a violation of their rights to their own likeness. The people who make the shirts, cards, and so on, pay the stars quite a lot of money for the right to use their faces. For your own protection, if you have any doubt at all about using a picture, get a release form from the subject.

What about obscenity? The boundary between art and pornography has been drawn and redrawn so many times and crossed so often that it's been reduced to a muddy pit. Still, you can look at a picture and know immediately what's what. Obscenity laws make it illegal to send certain materials through the mail. Attempts to enforce similar standards on the Internet are still being challenged and will undoubtedly add to the bank accounts of many attorneys on both sides of the question before it's resolved. What should you do as a photographer? It's up to you. Nudity, per se, isn't obscene. Nude photos, with appropriate releases, can be published. No one says they can't. But, in this author's personal opinion, most of the nude photos published on the Internet and elsewhere aren't intended as art. They are intended as pornography. The courts have given us a definition of pornography that asks if a specific picture violates "community standards." Let's put it this way... If there were a community whose standards it *didn't* violate, I wouldn't want to live there.

Summary

A good picture is one that has something to say. It communicates an idea, an emotion, or tells you something about its subject. Symbols help in communication, as do moods, and even the way color is used. Before you shoot a picture, think about what you want it to say to the people who see it. Plan your important pictures before you shoot them. Decide where to stand, and where the light should fall. If you're shooting a photo essay or series or related pictures, think about how the pictures will relate to each other and how each one you include will help to tell the story.

CHAPTER 6

Controlling the Environment

What You'll Learn in This Chapter:

- ▶ Natural Backgrounds
- ▶ Indoor Settings
- ▶ Improving on Nature
- ▶ Clothing and Makeup
- ▶ Food Photography
- ▶ Designing Photos for Type and Image Enhancement

Even though you can improve your digital pictures after you've taken them, you can save considerable time and effort by doing as much as you can to improve the scene *before* you shoot it. Let's look at specific techniques and tricks for improving portraits and product photography at the photo shoot, as well as how to shoot pictures that will be digitally enhanced and have type applied later on.

Natural Backgrounds

Few beginning photographers have the good fortune to work in fully equipped studios. Most of us simply do the best we can with what we have available. Because you are using a small, lightweight digital camera, you can go almost anywhere and grab pictures that would be impossible with a heavy-view camera and tripod, and difficult with a 35mm SLR and a heavy bag full of lenses. Your digital camera lets you roam freely and shoot unobtrusively.

One of the best and least expensive ways to get around the need for a studio is to photograph people outdoors or in their favorite setting. If you are assigned to get a portrait of the boss for your company's newsletter, for example, let him sit at his desk and do whatever he usually does, while you snap candid photos that show him

in action. Or take him for a walk around the premises. Is there a sign out front he can lean on (see Figure 6.1)? A workroom he can do something in? Can you put a hard hat on him and take him into the factory? These settings will result in much more natural portraits.

FIGURE 6.1
Insert the CEO next to the company logo.

One advantage of shooting portraits outdoors is that natural light is often more flattering than artificial light. Look for a bright, overcast day for the most even light. Strong sun/shade contrast will make wrinkles and "character lines" much more obvious. This is great if it's what you're trying to achieve, but if you want a picture that removes years from the subject rather than adding them, softer light is preferable.

Find a location in which your subject will be comfortable. An elegantly dressed woman wouldn't look right in the woods, but a formal garden or in front of a mansion like the one shown in Figure 6.2 would be a perfect setting. If you're photographing children, take them to a playground and catch them on the swings or in the sandbox, or maybe even upside down on the monkey bars. Because your camera is digital, you can shoot whatever catches your eye, and not worry about wasting film.

FIGURE 6.2
No matter where
you live, there are
excellent back-
grounds within
walking distance.

When you intend to use natural settings for commercial work, you may need to get permission from the owner. Of course, public streets are fine. City parks and playgrounds or state or national parks can generally be used without a special permit. Amusement parks and theme parks are a different matter. You can take as many pictures as you want at Disney World, as long as you don't use them commercially. Publish your photo of the castle or Mickey, and you'll get a visit from Disney's lawyers. Other parks, especially those featuring copyrighted characters, will have similar restrictions. If you're shooting on private property, get a release from the owner before you start. It will save you time later, if the pictures are good enough to sell.

Always scout locations before you take a model or a portrait subject to them. Try to go at the same time of day that you'll be shooting and under the same weather conditions. If you don't like what you see, figure out what's wrong. Do the shadows fall in the wrong direction? Then substitute early morning for late afternoon, and you're set.

Consider what changes you can make in Photoshop Elements or a similar program, before you rule out an otherwise ideal spot. Is the grass not quite green enough? You can touch it up later by putting more green into the picture. Is the mountain perfect except for a power line cutting across the valley? It's easy to drag a piece of something else over it. You can move a fence that's in the wrong

place or edit out the pieces of the picture that don't contribute to it. You may not be able to change your natural environment, but you will be able to fix most of the problems later by editing the picture.

As you gain familiarity with Adobe Photoshop Elements and similar programs, you'll discover many of the digital tricks you can do with them. For instance, if you want to use an outdoor background on a day when the weather isn't cooperating, it's not difficult, because you're working digitally. Whenever you see a nice location, take some pictures. File them by location, weather conditions, and time of day. When you have a portrait subject that you want to put into the background, shoot him or her against a plain-colored backdrop in the studio. Use even lighting so the subject is well-exposed. In Photoshop, remove the background from the portrait and then position your subject appropriately against the outdoor location. You'll learn how this is done, step by step, in a later chapter.

One of the most useful tools for shooting portraits outdoors can be a couple of sheets of foam core board. Take a can of spray glue (Scotch SprayMent Adhesive is perfect for this) and mount sheets of aluminum foil, shiny side up, to one side of the board (see Figure 6.3). Leave the other side white. Now you have a couple of lightweight reflectors. They'll add a little bit of light to soften a harsh shadow or backlight a model's hair.

FIGURE 6.3
A few wrinkles won't affect the reflecting power.

Position one reflector so that it adds a little light on the shaded side of the subject's face. Set the other one down in such a way that it bounces a bit of light off the subject's hair. Use the white side of the card for a softer reflection, or the foil side for a brighter one. You may need a couple of spring clamps from the hardware

store to hold your reflectors in position. You can prop the reflectors against your camera bag, a spare tripod, a tree, or whatever is convenient. Be resourceful.

> If your actions have attracted a couple of interested bystanders, or if you're shooting a child who comes with an over-involved parent, let them hold the reflectors.

Did you Know?

Indoor Settings

Although it's easy and fun to do your photography outdoors, the reality is that much of what you may be called upon to photograph demands a studio setting. Perhaps you need to take pictures of small parts for a catalog, or you're interested in flower or food photography. Or maybe, like me, you live in a part of the country that's only suitable for outdoor work for a couple of months of the year. In any case, you need to either build or improvise a studio. If all your work can be done on a tabletop, count yourself among the very fortunate. A tabletop studio is easy to set up, inexpensive, and takes very little space.

The main things you need are a sturdy table, a tripod for the camera, and a couple of lights. Should they be strobe (flash) lights or floodlights? Forget about strobe lights, unless you have a high-end digital camera that will work with electronic flashes. Less expensive digital cameras don't have a way to synchronize the external flash to the shutter. Besides, if you're just learning about lighting, floodlights are a much better choice. You can spend as long as you like setting up your lights, and you can see the effect of everything you do.

You can pick up a basic kit with a couple of light stands, a pair of clamp-on reflector flood sockets with bulbs, and even barn doors and a diffuser screen for under $200. If that's too much, visit the hardware store and buy a couple of clip-on sockets with reflectors, a couple of 75- or 100-watt bulbs, a roll of duct tape, a pair of thick gloves, and some wire (not plastic) screening. If you shop carefully, you should get this material for under $50. The household sockets and reflectors are about the same size as the ones meant for photography, but they may not tolerate bulbs over a specified wattage. If you can use 100-watt bulbs, you should have more than enough light, but 75-watt bulbs are probably adequate for most purposes.

> Those reflectors get *hot!* The gloves aren't just for show. They enable you to move the reflectors around without getting too badly burned. Turn the lights off when you don't need them and *never* lean a reflector lamp against anything flammable.

Watch Out!

You'll need something to clip the lights onto, but here, too, you can use your imagination. Perhaps there's a stepladder handy or a couple of chairs with backs the right height.

For a relatively small investment, assuming your studio has a solid ceiling (as opposed to suspended acoustical tile), you can buy several "polecat" poles. These are spring-loaded poles with a rubber tip on either end that you wedge in between the floor and the ceiling. They can hold lights, backdrop paper, or almost anything you need to hang from them.

If you cut several circles of screen wire a bit larger than your lamp reflector, you'll have a nice set of diffusers. Attach them with duct tape or clamps when you want a soft, even light without an obvious highlight. Figure 6.4 shows what this might look like. Rotate the circles to control the amount of light passing through the mesh.

FIGURE 6.4
A homemade diffuser for a clip-on flood light.

As for the tripod, it needn't be so big and heavy that your digital camera looks like a toy perched on top of it. There are dozens of lightweight but sturdy tripods with heads that pan, tilt, and raise up and down at the touch of a finger. The main reason for the tripod is so that you can set up your camera for a portrait or tabletop session and concentrate on what you're shooting, rather than concentrating on holding the camera still. Remember that it's okay to move the tripod around. Some photographers seem to think the tripod is nailed to the floor, and having set the camera up once, they won't move it again until they're ready to put it away.

Using Backdrops and Props

The bare tabletop and the wall behind it are almost never suitable backgrounds for the kinds of things you need to photograph. Using seamless paper is an easy way to get a neutral background. You can buy 12-yard long rolls of 26" wide paper for under $20 in any of about 40 different colors from your photo store. They'll be happy to sell you a rack to hang them from, but you can also make your own rack with a couple of uprights and a broom stick or two to hold the paper rolls (see Figure 6.5). If you clip the bottom edge of the paper to your table with a couple of clothespins, you can make it hold a nice, even curve where it changes from horizontal to vertical. With proper lighting, there will be no noticeable transition in the photo from table to background.

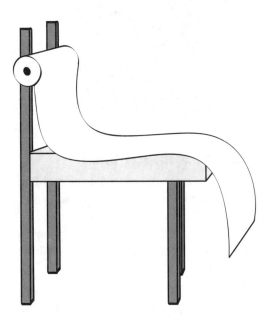

FIGURE 6.5
The paper is heavy enough to hold a curve if you don't crease it.

If you have more room, and need to photograph larger objects or people, the same type of seamless paper comes in widths up to 140". Wider rolls are a good deal more expensive, so you'll want to treat them carefully. Keeping the background clean is easy if you make sure no one walks on it in regular shoes. You can have your model or portrait subject wipe the soles of his shoes just before he steps onto the paper.

Another handy background that no one should be without is a piece of black velvet. Two yards of good quality velvet should cost about $25. That will be plenty of

material for tabletop photography. It drapes beautifully, and can be side lit to pick up its nap, or front lit for an absolutely flat effect. Figure 6.6 shows a piece of art glass photographed against a black velvet background. Placing it against the velvet drape eliminates a source of awkward reflections.

FIGURE 6.6
Glass is difficult to light.

Finding Interesting Backgrounds

One of your best sources for background material is a building supply store. Home Quarters and Home Depot are two of several coast-to-coast chain stores that carry a tremendous selection of tabletop and background materials. Check out displays of floor and ceiling tiles, embossed metal panels, plastic grids, wall-papers, plastic laminate sheets, wood parquet flooring, industrial carpeting, and whatever else strikes your fancy.

Don't forget about fabric stores, sign shops, art supply and stationery stores, and even the corner grocery store as sources for backgrounds. A sheet of heavily tex-tured watercolor paper might be just the thing for setting off porcelain plates. If you have to photograph a collection of spoons, it might be fun to set them up on a tray of cereal, or you could photograph the spoons filled with interesting colors and textures, such as curry powder and lentils. Your only real limit is your own creativity.

Props for All Occasions

How much you spend on props and backgrounds and how many you collect real-ly depends on what you need to photograph. If you're interested in doing food or

fashion photography, your prop closet will be huge. If you are interested in land-scapes, either because they're pretty or because you sell real estate, you won't need much in the way of props at all. Maybe a broken branch to hold in the corner of the frame as you shoot. And, again, because you're working in the digital realm, you have the option of adding a background after you take the picture. You can redesign the one that's there by changing its color, or posterizing it. You can photograph objects against plain white or black, and then add a textured background, a gradient, or whatever seems appropriate. You can even create a fantasy background in a fractal landscape program like Daz Productions Bryce 5, and put your objects into it. You might also use a 3D modeling program to create props that weren't there when you shot the photo. The possibilities are endless, because you needn't stick to reality.

Finding the props for a photo session can be a career in itself. There are people who specialize in props for still photography and film or video shoots. They arrive with a van or even a trailer truck full of goodies, and even though they've studied the script or the art director's sketches to know exactly what's needed, they are also prepared for any and all contingencies. For example, if you want the model to carry a book, the prop people will have an assortment of books in different sizes and colors, plus paper and markers or paints to whip up a custom cover if necessary. If you need clutter for an executive's desk, they'll supply the appropriate amount of paperwork, pens, telephone, knickknacks, and family portraits in muted silver frames.

Where do they get all this stuff? The same place you will—yard sales, garage sales, department store close-outs, Goodwill, begging from your friends and family, and so on. As soon as you know what you need, consider who might have it and ask to borrow it. Set up a relationship with local antique and craft dealers. Find a friendly furniture store who will let you send your own truck to borrow merchandise for a day. Be sure that you make a point of returning it on time and without any damages. When possible, give the store a credit line in the information about the pictures or at least a copy of the photo that used their stuff. It's not uncommon to see a microscopic line of type along the edge of a printed photo that reads something to the effect of "Furnishings courtesy of DecoRama Antiques, fruit from Harvard Gardens, make-up by Ms. Peggi, models from the Models Collective." It's the next best thing to getting paid, especially for people such as the fruit-stand owner who may never come any closer than this to stardom.

When you shop for props, look for items that will contrast with the backgrounds that you use. If you are planning to buy or borrow dishes for a food presentation,

find out first what kind of food is involved. You probably wouldn't serve spaghetti or fried eggs on your best china at home. Don't photograph these items on the fancy dishes, either. Look for plates and utensils that will be appropriate for what's being served. After all, you only need one or two of each, you don't need the full service for twelve.

Don't overlook accessories such as colorful napkins and place mats, or an interestingly shaped salt shaker that can improve a composition. Keep a few fresh flowers on hand, as well as a selection of fruits and vegetables for garnish—even to use as props in non-food related pictures. If you have to photograph a set of dishes, they'll be more interesting if one or two are being used for something. Put tea in a teacup and a crisp brown croissant on a plate, and you've added some interest and appeal to your picture.

Improving on Nature

You won't find many models or actors willing to face a camera without makeup. They know the importance of emphasizing their best features or covering up even a tiny flaw. Ordinary people have good points and flaws, too. If you're doing portraits, even just of family and friends, make sure they're putting their best face forward. The cute little kid with the dirty smudge on her nose won't thank you for that picture when she's a sophisticated teenager, and Uncle Harry, who's just a bit sensitive about his bald spot, will not appreciate the shot that has sun reflecting off of it.

Keep a comb and a small powder compact in your camera bag if you photograph people. Any neutral color of face powder will do. Dust it on shiny noses, foreheads, chins, scalps, or wherever is needed. Then wipe off the excess with a tissue. If you can see color, you have used too much makeup. People who are used to being photographed will generally provide their own makeup. You can certainly suggest more, or less, as you see fit.

Expect to do some retouching on most portraits. Even though you check everything before you shoot, you're likely to notice stray hairs, a shiny nose, or some other imperfection when you study the picture afterward. Here again, digital photographers have a big advantage. You can improve a sagging chin line, soften a wrinkle, or add a little extra color to a pale subject with just a few mouse clicks.

Dulling Spray

Dulling models or actors willing to face a camera without makeup. They spray serves the same purpose for glass and metal that talcum powder does on skin. It

stops the annoying reflections that create a hot spot in your picture. If you need to photograph anything made of chrome, stainless steel, or clear glass, you should always keep a can on hand. You can buy it at photo and art supply stores. Krylon and Marshalls are the most common brands. Use it sparingly, and be sure to wipe off the residue afterward. Figure 6.7 shows the "before" and "after," using dulling spray on a shiny metal object. Don't suppress every highlight, or you'll make the product look like it's made of suede instead of metal.

FIGURE 6.7
Gold is especially difficult to photograph.

If you don't have any dulling spray and need to knock out a single highlight, almost anything sticky or greasy will do. I've used hairspray, Vaseline, suntan oil, butter, and wax. The goal is just to apply a thin film of something that will break up the light.

Tapes

There are a half dozen different kinds of paper and cloth tape that are almost indispensable in the photo studio. The first is plain old cellophane tape, the second is masking tape, and the third is called either gaffer tape or duct tape, depending on whether you buy it from the photo store or the hardware store. Gaffers are the people on a film set who move lights and cables; they need very strong tape to hold things in place. Although the usual color is a sort of silvery gray, gaffer tape also comes in black and white and several colors—at a premium price. The hardware store variety will do just as well, for most purposes.

By the Way

> Gaffer tape is specially formulated not to leave the sticky residue that duct tape often does. Goo Gone removes most of the duct tape stickiness, but it can damage fabrics. If you're working with something critical, invest in a roll of real gaffer tape.

Another item that should be in your kit at all times is a roll of black crepe tape. Look for Scotch brand, type 235. It's exactly like familiar beige masking tape, only made with black paper. It is used to fasten things down unobtrusively and to mask light-reflecting surfaces that aren't in the picture but are casting unwanted glare.

You'll find more uses than you can imagine for double-stick tape in both thin and thick (foam tape) varieties. Use the foam tape to set something just a little bit away from the background. Build up several layers, if necessary. Thin double-stick tape is the answer for keeping pieces of a still life together, if they might otherwise get blown or knocked around. Use it, in little bits, to arrange the grapes in a bunch so that they drape more elegantly over the edge of the bowl.

Although not exactly a tape, those little sticky note papers are another "must have" item. Aside from their use for posting notes, the low-tack adhesive on the back is just right for picking up stray cat hairs or bits of lint without disrupting a critical arrangement. Yes, you can retouch them out in Photoshop Elements, but think of the time you save if they're not there at all.

Clothing and Makeup

Professional photographers who shoot portraits have learned the hard way that it's important to consult with the portrait subject ahead of time about clothing, makeup, and hair styling. Naturally, the choice of clothing is determined to some extent by the purpose of the portrait. The CEO had better not wear jeans and a

T-shirt for the photo in the annual report, even if she usually dresses that way. The author posing for a book jacket photo might want to dress according to the kind of book it is. Writers of romance novels tend to favor long, fluffy dressing gowns or formal wear. The author of those famous detective novels always wears a black leather jacket, baseball cap, and jeans, perhaps because he's trying to look like one of his characters. Remind men not to get their hair cut sooner than two or three days before the session, so they don't have that white line around the edges that a fresh haircut often gives.

The Glamour Drape

If you have female portrait clients who want to look elegant and aren't sure what to wear, you can provide the perfect "one size fits (and flatters) all" glamour outfit. All it takes is a yard of velvet. Make a diagonal cut from one corner, as shown in the diagram in Figure 6.8.

FIGURE 6.8
Making the glamour drape.

To use it, fold the cut edges under and position the V neckline appropriately. Bring the points back around the subject's shoulders and fasten them with a paper clip or clothespin. Adjust the drape to reveal as much or as little as the lady desires. Figure 6.9 shows how the drape looks in use.

FIGURE 6.9
Wearing the drape.

If you're hiring models for a project, you're expected to either provide their clothes or pay an allowance if they use their own outfits. Costumes of all kinds can be rented from theatrical costume shops, but if you need ordinary street clothes or sportswear for your models, have them bring a selection of clothing they're comfortable in. Be sure to specify appropriate footwear if their feet are in the picture. You can often borrow clothes and accessories from local shops, just by giving them a credit on the published photo. Something as simple as "Model's outfit from the Uneek Boutique" will do. Be sure that anything you borrow is returned promptly and in good condition.

Clothes that don't fit right can be "taken in" with a couple of spring-type (Bulldog) paper clips, as in Figure 6.10. Keep masking tape on hand to lift off lint, stray hairs, and loose threads. Never let the model drink, eat, or smoke wearing borrowed clothes. It's an invitation for disaster.

FIGURE 6.10
These are lighter than clothespins and won't pull the fabric down.

Food Photography

Taking pictures of food has provided a good income for many commercial photographers. If you have experience with desktop publishing, you may be able to carve a lucrative niche for yourself producing menus with digital photos of the entrees. Foods are fun to photograph, although you can't always count on eating the leftovers afterward. Frankly, some of the tricks to make things look good also make them inedible, but in a picture, it's appearance and not taste that matters.

Of course, there's another side to this issue. If you are photographing a specific product like a can of soup for an ad, you can't cheat and add more meat and veggies, and you can't fill the bowl with marbles to raise the existing ones up to the surface. If you're showing off the bowl and not the soup, anything you do to make the food look good is fine. There are "truth in advertising" laws and statutes at federal, state, and even local levels. The Federal Trade Commission is the regulating body that determines what's okay and what isn't. In general, anything you do to a "generic" food shot is okay. Anything you do that changes the appearance of a specific product, which is the subject of the ad, is probably not okay.

This is not to say that you can't put the item's best foot forward. For example, if you are going to photograph a steak dinner for a restaurant menu, you need to

use the same steaks and potatoes and whatever else is on the plate when the restaurant serves it. And you need to use the same plate. Using a smaller plate to make the meal look bigger isn't fair.

But now the fun starts. You take the steak and potato, or actually a dozen or so of each, back to your studio. If you have a home economist or food stylist working with you, she will prepare the food and arrange the plate. Otherwise, you'll be chief cook and bottlewasher, as well as photographer.

After you mash the potatoes, cool them. Mix butter and flour together in equal parts to make a stiff paste which you can chill and shape into "butter pats" for the potato. Glaze the carrots with Krylon spray and sprinkle some parsley flakes on them for texture. Lightly broil the steak on top so that it has an even brown tone. Use a propane torch to toast the edges, being careful not to char it. For a richer brown color, dilute Gravy Master coloring with water. Using a spray bottle, give the meat a misting of darker brown. Take a hot iron or a red hot metal skewer and burn in "grill" marks (see Figure 6.11). Finally, a few dots of glycerin will make the meat look juicier. If there's a piece of parsley on the plate, choose the lightest one you can find, because parsley always photographs darker.

FIGURE 6.11
Today's subject is tonight's dinner.

Tricks of the Trade

Your studio kitchen should include a good set of knives and paint brushes, and along with the usual cooking tools, a small butane or propane torch, a hair dryer, and as many different service pieces, plates, napkins, and utensils as you can

manage. You need paprika and dried parsley for garnish, as well as a good supply of fresh garnish materials. Soy sauce, Gravy Master, or even molasses can be used to turn meats or roast poultry brown. The torch browns meringues and chars the edges of a steak.

When you need to have food appear to be steaming hot, the best way to achieve the look is to use a tea kettle—out of camera range, of course. Tape a piece of plastic or rubber hose to the spout of the kettle and aim the steam so that it rises directly behind the cup of coffee or whatever else is supposed to be steaming. Shoot from a low enough angle that the source of the steam isn't obvious. Use a strong side light to emphasize the steam.

Some foods are especially hard to handle. Cut fruit won't turn brown if you soak it in a mixture of cold water and lemon juice before photographing it. If you don't have lemon juice, or if it makes the fruit look too yellow, you can also used crushed ascorbic acid (vitamin C) tablets dissolved in water. Egg yolks are easier to handle if you let them stand for several hours or overnight. They'll firm up enough so that you can move them where you want them. To restore the shininess of a freshly opened egg, paint the hardened yolk with glycerin.

Always prepare at least two of every food item you photograph. That way, if you don't notice a flaw in the item until it's ready to shoot, you still have a backup.

Glycerin

You can buy glycerin at the drug store or from a shop that sells candy making supplies. Either way, a bottle of glycerin is a vital tool for the food photographer, and a helpful one for many other purposes. Whenever something needs to look wet, glycerin photographs better than water alone. Use it with an eyedropper to make water spots on chrome, stainless steel, or plastic. Experiment with mixtures of glycerin and water to make bigger or smaller drops, and remember that glycerin in alcohol simulates bubbles.

A drop of glycerin on a model's or actor's cheek is the Hollywood solution for tears. If you don't dilute it, glycerin will stay put fairly well.

If glycerin drops are too big, and you want to achieve a dewy, moist look on the surface of a piece of fruit or other food item, use a plant mister with plain water. Just spray the surface lightly before you shoot.

Designing Photos for Type and Image Enhancement

Fine art photographers and news photographers don't have to deal with type. Editorial and advertising photographers do. Even amateur photographers, making pages for scrapbooks, will encounter the need for type. It might as well look right. Type makes very specific demands on its background, and you need to understand how to design and shoot pictures that lend themselves to the application of typography. Also, with so much being done to our digital images after they leave the camera, it's often necessary to plan the shot(s) so they'll work as a composite, be amenable to filters and other kinds of manipulation, and give you the results you hoped for when you first visualized the finished job.

Planning for Type

Ads sell something. Magazine articles entertain, instruct, or inform. Either way, they use words as well as pictures. When you add type to a page, you're adding another element to the layout, and it's not a quiet one. Type is visually "busy." It grabs your attention, even if it's in a language you don't understand or in characters you can't even decipher. Figure 6.12 has a "typical" ad, for a typical product. I've set the type in a font called Klingon. Notice that, even though you have no idea what the letters say or how to pronounce them, your eye is drawn to the type. The product is the *second* thing you notice, not the first.

Some typefaces are cleaner than others. That is to say they're plainer, less busy, or less distracting. Helvetica and Futura are often used in ads because they are clean, easy to read, and still graceful. Heavy faces, such as Cooper Black, can be used to balance a graphic, but may be too heavy for headlines of more than a couple of words. Placing type under or alongside a photo is almost always easier than running it across the picture.

When the type in an ad actually touches or sits on the picture, you run into many more headaches. In these cases the photo is often what's called a bleed, meaning that it runs right to the edge of the page and "bleeds" off, rather than having a margin between the edge of the ad and the edge of the page. Whether or not you can do this depends on the format of the publication in which the ad is running. Some magazines and newspapers still don't want to deal with bleeds. Others charge extra for them.

FIGURE 6.12
The Klingons
probably don't
understand our ads
either.

When type goes over the picture, be sure to discuss the colors for the lettering and the photo layout. Nothing is worse than shooting a beautiful picture with the background fading into a perfectly graduated gray and then finding out that there's black type over it. The type becomes illegible, and you don't look too good as a photographer.

A double-page spread has its own set of headaches for the photographer, as well as for the art director. You must design the photograph in such a way that nothing important gets lost in the *gutter*, which is the center of the spread where the two pages join. Depending on how the magazine is printed and bound, the gutter may make it hard to see part of the page. Figure 6.13 shows a double page, with type, used for a magazine article.

FIGURE 6.13
Advertising and editorial photography is a very well-paying profession.

Script is often used over a photograph, especially in ads with "feminine" appeal or when elegance is implied. However, in such a case, the background must be absolutely uncluttered; otherwise, the type will be impossible to read.

How much type the ad demands is another consideration, and one that the art director must figure out with the copywriter. Writers *can* be given a space to fill and a word count and told to write precisely *X* number of words. Most of them don't mind this technique, and actually welcome a specific assignment. However, it's just as common for the writer to start the process of creating an ad by writing a few paragraphs of copy and then handing it to the art director to "illustrate." The best approach, of course, is to work as a team, developing the concept, copy, and pictures jointly.

Catalogs

Shooting objects for catalogs can be a major headache, or it can be quite simple. The only difference is in how much advance preparation you have done. Digital photography is a natural choice for catalog work, since you can place the pictures directly into a page layout program, and crop and adjust them there. Adobe PageMaker and InDesign as well as QuarkXPress support Photoshop filters and plug-ins.

Catalog pages can, of course, be laid out in many different ways. If you have many related objects, it may make sense to put them all in one picture with the descriptions underneath (see Figure 6.14). If the objects in your catalog aren't closely related, or need more than a few words of description, it may be more effective to use a separate picture of each one with its description and selling copy next to it on the page. Figure 6.15 shows one way of doing this. Notice that the objects are positioned to lead the reader's eye to the related copy. This is important. Otherwise, the catalog turns into visual clutter, and the reader probably won't find what he's looking for. The catalog ends up on the floor, and you end up unemployed.

If you design the pages in advance, you'll know exactly which items to shoot in a group and which way to face the individual items. While it's true that you can flip the pictures in almost any graphics program, anything with type on it, or anything clearly "right-handed" or "left-handed," won't look correct when it is reversed.

FIGURE 6.14
Catalog illustration
with many items.

From our CATalog...

FIGURE 6.15
Catalog page of
single items.

Eye of the Tiger: He'll watch your stamps, pills, or whatever you keep in this cute enameled box. About 3 inches long. Imported from Sri Lanka.
#C104....................$ 7.50

All That Glitters: This golden kitten has faux diamonds on his collar and tail to perk up your favorite jacket or sweater. 14k gold. Made in USA.
C105...........$40.00

One more good point that my editor suggests (Thanks, Jon!) is to dress appropriately when you're shooting reflective items for a catalog or magazine page. That doesn't mean you need to wear a suit and tie, or bluejeans and a ragged t-shirt, either. The general rule is to wear black, so your reflection isn't so obvious. I know a lot of pros (both male and female) who have a working "uniform" of black t-shirt or turtleneck and black slacks. If you add a tweed blazer or a suede jacket, you're dressed for any occasion.

Summary

Every picture you shoot has some kind of a background. It may be scenery, or just a piece of white paper, but it's something you have to consider when you set up a shot. You can usually find interesting backgrounds right in your own neighborhood, even in your own backyard. Indoor settings can be equally useful. Think about places in your home or office that would make good backdrops for portraits or still life photos. If you need a plain backdrop, buy a roll of "seamless" paper. One roll lasts for years, if you handle it gently.

Props add interest to a photo, just as they do to a stage or movie set. Look for interesting dishes, placemats, and colorful cloth at yard sales and discount stores. Remember, you don't need a full set. If you photograph flowers, you should collect interesting containers. When you shoot portraits, advise the subject to wear appropriate clothing. Women usually apply their own makeup, but keep a neutral face powder for shiny spots, especially bald men's heads. Food and flower shots often need as much makeup as a model does. Master the tricks of *that* specialized trade and you'll be able to make a good living. If you are shooting a photo that's background for type, layout the shot first with a rough sketch, and make sure there's nothing in the background that will make the type hard to read. Always plan before you shoot. Catalog photography is most effective if you keep the pictures simple. Remember, the purpose of the photo is to sell the object, not for it to be great art.

CHAPTER 7

Painting with Light

What You'll Learn in This Chapter:

- ▶ Using Available Light
- ▶ Using Built-in Flash
- ▶ Using Studio Lighting
- ▶ Tabletop Lighting

Without light, there would be no image. Things would exist, but we couldn't see or take pictures of them. We have two different kinds of light to work with. We think of them as daylight and artificial light, but it would be more practical to think in terms of available light and added light.

Using Available Light

By definition, available light is whatever light falls on the subject without your turning on any additional lights. When you are outdoors, available light comes from the sun during daylight hours. It may also come from any other light sources that happen to be present, such as the neon lights on the strip in Las Vegas or the coals from a campfire. Available light can come from a single point source, which can be as dim as a candle flame or as bright as the blinding brilliance of a welder's torch. It can come from a source as broad and featureless as a cloudy sky. Each of these kinds of light is different, and each light affects the things on which it falls in a different way.

Available light has several advantages. It's there. It's free. More importantly, it's the real thing. When you use available light instead of artificial light, you're more apt to capture the real feeling or mood of the place and time where you're taking the picture. You haven't added anything to the scene except your point of view.

Available light pictures seem more authentic. Because available light comes in an infinite variety of colors, qualities, brightness, and moods, your pictures will also have more variety than if everything were evenly illuminated by two crossed floodlights. When you learn to make use of available light, you're not tied down to a suitcase full of light stands, cords, bulbs, and lamps—nor to a studio. You can go anywhere and shoot whatever you see. Portrait subjects will be more comfortable and more relaxed because they're not staring into bright lights. Digital cameras are particularly effective at taking pictures with available light because they are more sensitive than typical color films. Sensitivity of photographic materials is measured according to standards set by the American Standards Association and the International Standards Organization. The typical outdoor color print film has an ASA/ISO film speed rating of 200. The typical digital camera has an equivalent sensitivity to ASA/ISO film speed 1600, so it can capture images under almost all light conditions.

Of course, with all these advantages, there has to be a disadvantage. It's a major one, and the reason is obvious. With less light, the image quality isn't as good. Pictures can come out dark or underexposed. There's less detail in the image. Everything appears to be a bit fuzzy. You can't enlarge the picture as much, and you can't adjust the contrast and brightness to compensate without losing either the highlights or the shadow detail, or both. Still, within the computer, you can compensate for low light much more easily and more successfully than the conventional photographer, who is stuck with whatever film happens to be in the camera.

Larger Source = Softer Light

There's a reason that photographers love overcast days. It's because a cloudy sky produces an even, shadowless light that's great for taking pictures outside. Buildings, trees, and people are bathed in softly diffused light that falls off gradually. Colors seem brighter, as if lit from within. Look at the scene in Figure 7.1. Even though the sky is thoroughly overcast, the colors sparkle, and the dragon's fur is a vivid red. Note that there are no real shadows anywhere. On a day like this, the light waves are diffused as they pass through the layer of clouds. Individual rays of light are bent and diverted so that instead of all coming from the same source, they seem to come from many different sources, as if there were a dozen suns behind the clouds instead of just one.

Clouds are the major source of diffused light, but you can often find a similar quality of light on a foggy day or in smoke. Light in a snow storm is brighter and even less directional, because it is reflected back up from the snow on the ground, as well as down from the sky. Figure 7.2 shows a picture taken outdoors on a snowy day.

Notice that the branches of the tree appear to be lit from beneath, as well as from above. Beach sand and water have somewhat the same reflective properties.

FIGURE 7.1
Try to imagine this in full color: reds, greens, bright yellow feathers...

FIGURE 7.2
If you take your camera out in a snowstorm, seal it in a plastic bag. (Photo by Judy Storgaard.)

Soft light tends to wrap itself around objects. This propensity to wrap increases when the size of the light source increases. The wrap is directly proportional to the size, angle, and distance of the source. The more diffuse the source, the more of this wrapping effect you'll see. Wrap increases when you move the light closer to the subject.

Smaller Source = Harder Light

"Hard" light is the opposite of soft light. It's not necessarily brighter but has more glare. It brings out greater contrast. In terms of artificial light, a hard light is a spotlight with quite literally hard edges. You can see its outline on the floor, as opposed to the diffused light of a floodlight. In terms of available or ambient light, an example might be the candle flame, which lights a small area and throws the rest into shadow.

Outdoors, the sun shining unobstructed by clouds is the main source for "hard" light. Sure, it's 93 million miles away, and a lot more diffused than a spotlight. Still, bright sun can be thought of as a point source. It is light filled with contrast. It casts hard shadows. It is directional. These aren't drawbacks, just features that you have to recognize and work with, or work around, as the case may be.

You can't soften hard light. Your best bet if you must shoot outdoors when there's bright sun is to watch the time of day and plan your pictures for times when the shadows interfere least with whatever you are shooting. At noon, the light is pretty much directly overhead in spring and fall. Any shadows will be cast straight down, as in overhanging edges of buildings, and so on. These shadows shouldn't present too much of a problem, and they may actually help the rendering of the surface. In the winter, even at noon, the sun is at an angle, so there will be a little more shadow to contend with. It's worse in the winter because the sun (at least in the Northern Hemisphere) is at a lower angle.

Shadows point west in the morning and east in the afternoon, so if a building facade is in shadow in the morning, come back after lunch. It should be quite different. If the building is situated in a way that the side you need to shoot has long shadows in both morning and afternoon, it's probably better to wait for a cloudy day.

Balancing Daylight and Artificial Light

Daylight and artificial light have different color temperatures. They appear to be different colors, even though both are theoretically white light. When color rendition is critical, try to avoid mixing them, because daylight tends to be much hotter (more blue) than artificial light. Sometimes, you may encounter a scene that has both, such as an interior with some light coming in the window and a room light on, as well. Figure 7.3 shows an example of this situation.

The cat is backlit by the window and picks up some additional highlights from a desk lamp. There is no good way to balance the two kinds of light in this shot, unless you can cover the entire window with a sheet of filter material to convert the blue daylight to room light. Instead, you might choose to make your color corrections later in a program such as Photoshop Elements that enables you to select parts of the picture with a "magic wand" and apply filters and effects only to the selected area. The other alternative, and sometimes the better one, is to decide that the effect of the two kinds of light enhances the picture, and doesn't need to be "fixed."

FIGURE 7.3
The effect of two kinds of light can be more interesting than just one.

It's the film emulsion, not the camera, that makes the difference in conventional photography. There are indoor and outdoor films, but only one set of CCDs. So, digital camera pictures may need more color compensation.

Using Built-in Flash

Many of the current digital snapshot cameras include built-in flash units. These aren't especially powerful, but are helpful in low-light situations or as fill light when you're shooting outdoors in shade. Typically, they have an effective range of no more than 12–15 feet. If you're at a sporting event, a play, or a concert and are more than 15 feet from the action, don't even try to take flash pictures. All you will do is distract the performers and other audience members. Your flash won't reach the stage or the field. Instead, turn off the flash so the exposure meter will open the lens as wide as possible, and hope there's enough light for pictures. Stage performances are usually quite well lit, as are orchestral concerts. Single performers or small groups may not use bright enough lighting for pictures. Rock concerts are especially tricky, because the performers tend to go in for special lighting effects, which might seem brighter than they really are, and will proba- bly affect the colors you see. Other things at a rock concert can also affect what you see…don't inhale.

The biggest drawback to the built-in flash is its tendency to produce red eye. This is the phenomenon of light reflecting back from the inside of the subject's pupils, revealing the network of blood vessels inside. To borrow a word from my teenagers, it's "gross." It happens mostly when the room is dimly lit, and the sub- ject is staring into the flash. You can avoid it by turning up the general level of light in the room. This makes everyone's eyes close down a little bit, showing less pupil, and leaving less space for light to get in and out. It also helps if you have the subject look somewhere other than directly into the flash.

Did you Know?

> If you're shooting an object with a shiny surface, don't use the flash. It will reflect as glare. The closer you are to the object, the worse the glare will be. Also, watch for glare from closed windows when you use a flash indoors. Draw the curtains, or sim- ply change your angle, if it's a problem.

Having said all that, when *can* you use a flash? A flash is useful outdoors or inside when there is a single, strong light source in the room, to soften the shad- ows and help fill in some of the detail on the "dark" side of the subject. The pho- tos in Figure 7.4 were shot outside on a sunny day, with and without fill flash.

FIGURE 7.4
The left-hand picture, without the flash, has heavy shadows on the flowers. With the flash (on the right), there's more detail.

Using Studio Lighting

Few beginning photographers have the luxury of a full studio. More often they use a corner of the office, den, or living room, or maybe the kitchen table. How much lighting you need depends on what you're hoping to accomplish. You can do a nice job on portraits and on most tabletop photography with just a couple of lights and possibly one or two white and/or foil-covered boards as reflectors. The trick with lights is not how many, or how bright, but where you place them.

Raising and lowering the light source changes the angle at which the light strikes the subject, which changes the position and size of the shadows it casts. Moving the light source from front, to side, to back affects the direction of the light and the position of the highlights. Moving the light source closer to or further away from the subject affects the intensity of the light, making it more or less bright.

As in theatrical lighting, photographers may refer to floodlights and spots or spotlights. The floodlight gives a broad, soft, diffused beam, while the spotlight has a hard, relatively narrow beam. If it can shine a circle of light on the floor, it's a spotlight. If it lights up the room, it's a floodlight. Ordinary household flashlights are effectively spotlights, while the bulbs you use in lamps and ceiling fixtures are essentially floodlights.

Choosing Lights

What kind of lights should you buy and how many? You really need two, but three is better. Rather than buying more than three lights, look at lighting accessories, such as light stands, barn doors, diffusers, and filter holders. These will do you more good than extra candlepower. Although many conventional photographers prefer electronic flash (strobe) lights, stay away from them. First, it is much harder to teach yourself lighting when your lights are only turned on for a fraction of a second. You can't see the effect they have until you look at the picture you've taken. Second, but even more important, low- to mid-range digital cameras don't have a flash sync input. You won't be able to use the strobe with anything less than a high-end Nikon, Canon, or Kodak digital SLR.

Decide whether you want to look professional, or just get the job done. If appearances count, go to a camera store and buy lights and light stands that are intended for a photo studio. They'll cost more but are sturdy, reliable, and thoroughly "pro." If saving money is more important than how things look, buy your clip-on lights at the hardware store, discount store, or five-and-dime. They'll give the same amount of light—a 75-watt bulb is a 75-watt bulb, no matter what it's screwed into (although you'll pay less for the sockets). You should look for 75-watt reflector flood bulbs, instead of 75-watt household bulbs, though. It's not so much that they give you more light; they just aim it closer to where you want it.

FIGURE 7.5
Low-cost lighting solutions.

The main differences between photo store lights and hardware store lights is that the better ones (that's pronounced *more expensive*) have wooden handles so that

you can aim them without burning your fingers, and they often have ceramic sockets instead of stamped tin ones. They'll last longer, and they are a little safer. The cheap ones could possibly start a fire if you left them on all day.

Don't buy bulbs labeled reflector spot. They will give you a hot spot in the middle of the picture because they focus the light.

Watch Out!

In either case, get the kind of light fixtures that have a metal reflector bowl attached. Whether you're working with "real" or improvised light stands, get (or make) some sandbags. A 2–5 pound sandbag on the base of even a flimsy metal stand will keep it from tipping over as you aim your lights, and it will save you major headaches with broken bulbs. Another thing you need is a heavy duty extension cord (or several of them). It's Murphy's Law that where you need the light is just beyond the reach of the cord.

A couple of sets of barn doors are a helpful addition to the light kit. They clamp onto the reflector, and are simply a pair of metal doors that flap open and shut in front of the light, giving you the capability to block some of the light from the bulb. They let you put the light where you want it and keep it from going where it's not needed. You could, for instance, position a light with a barn door flap so that it hits the model's face without casting a shadow behind her onto the back-drop.

As you get more heavily involved in studio photography, you may want to invest in additional lights. Quartz broadlights, snoots, and a 5" quartz focusing light will be the most helpful additions to your kit. The broadlight is used to light a broad area, and can be controlled with its attached barn doors. It uses a 500-watt quartz bulb, is very bright, and gets very hot. The snoot is a hood that fits over a light to produce a tiny spot of light. It is used mostly for hair highlights, as a catch light to liven up a portrait subject's eyes, or to put a highlight on the edge of a glass or some other single object in a still life.

Keys, Accents, and Fills

A given light source can fill any of several functions. The principal source of illumination is called the *key light*. It's the light that does most of the work. It casts the shadows, if any, and is the main source of illumination for the shot. The *fill light* is used to fill in the shadows enough to bring out necessary detail. It doesn't (usually) eliminate the shadows, just lightens them a little. *Accent lights* are used, obviously, to put a small highlight to accent a particular spot, such as a model's hair or the rim of a glass. A *background light* is aimed at the background, either

from behind the subject or off to one side. It lightens the background so the subject doesn't blend into it. Bounce lights are any lights that are bounced off a reflective surface. Quite often an umbrella reflector is used with a bounce light shining into it, to give a soft non-directional light. You can also bounce light off a ceiling, a light-colored wall, a white card, or even the front of your own shirt, if you're working close to the subject. Your basic clip-on flood lights can serve any of these functions. It's the position of the light relative to the subject that gives it its name, not any special kind of bulb.

Placing a Key Light

When you're doing a "normal" portrait, the key light generally is placed at a 45-degree angle to the front and about 3–4 feet above the subject. The following figures show diagrams of possible lighting setups. In the first one, Figure 7.6, the key light is to the left of the camera, and covers the portrait subject. The fill light, to the camera's right, is placed slightly behind the subject, aimed so that it falls on his shoulder and hair. Figure 7.7 shows the portrait shot with this lighting setup.

FIGURE 7.6
Lighting a portrait.

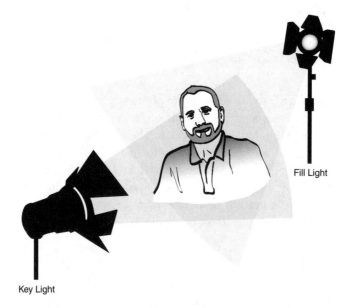

Fill Light

Key Light

Depending on the subject's clothing and hair color, and the color of the background, you may not need to add a background light to the setup. If you do, let it hit *just* the background and keep it either low or high so there will be some gradation across the surface.

FIGURE 7.7
Portrait shot with
key light and fill
light lighting setup.

Figure 7.8 is an even easier setup, with just one light. By putting the light slightly to the right of the camera, and the subject several feet out from the background, you can eliminate the shadow that would otherwise be cast on the background by the single light. Figure 7.9 shows the resulting portrait.

FIGURE 7.8
The key light does
all the work here.

When your key light comes from the front, it's called front lighting. That's pretty obvious. Equally so are *side lighting* and *back lighting*, at least in terms of where you place the key light. What is less obvious is how you can use side lighting and

back lighting for portraiture. These lighting techniques are not for everyday use but can be useful for special effects.

FIGURE 7.9
Portrait with a single (key) light.

Side lighting, for example, brings out the texture of skin and hair. Although middle-aged women would not find it flattering, it can give a sympathetic portrait of an older person, highlighting the character lines acquired by many years of living. Back lighting can be used to show off an unusual hairstyle; or with a small fill light on the face, it can create a moody, shadowed portrait. You can even let the subject hold up a piece of white paper or a book as if she's reading it, in order to get the necessary fill on her face.

Cookies, Flags, and Gobos

In lighting terms, cookies, flags, and gobos all refer to more or less the same thing. These are all items that you put in front of a light to cast a particular kind of shadow or to block a small area of light. You can make them out of spray-painted black aluminum or out of black matte board. Or you can do as most of the pros do and grab whatever is handy and hang it up with a piece of tape.

Why do you use them? There are several good reasons. You might use a flag, which is a small piece of black card, to block a single offending highlight. Cookies and gobos tend to be larger than flags, and usually cast a specific kind of

shadow. You might cut a cookie that resembles a venetian blind, or a spray of leaves, and use it to add interest to a background. These can be as simple as a torn piece of heavy paper, or a scrap of cardboard cut into a jagged shape with some holes poked in it. You're only using its shadow, so the cookie itself needn't be a work of art.

If you want to simulate a window, build a gobo in the shape of a window and let the light shine through it. Again, it needn't be anything fancy, and it certainly doesn't need glass. Just the suggestion of a couple of right angles and a crossed piece of molding will be enough to indicate window panes, especially if you also tack a bit of lace curtain on it. Figure 7.10 shows what this looks like.

FIGURE 7.10
A window gobo made from a used FedEx envelope and a paper towel.

Gobo is short for *go-between*. If you hang around with people who do sound instead of photography, you'll also hear the term used to describe the soundproof barriers used to isolate the drummer from the other musicians or actors in a radio drama.

By the Way

Tabletop Lighting

When you shoot small objects on a table, a kitchen counter, or on a piece of seamless paper, it's called tabletop photography—even if there's no actual table involved. Most people use either of two approaches to tabletop lighting. Either

they treat the objects as if each one was a portrait subject, putting the camera in front of them and using a key light and a fill light, or they handle them as essentially flat things, throwing lots of light at them and shooting down at them from above. Either way works. Mixing the two doesn't.

A third way of dealing with tabletop lighting is the most practical, and the most creative. Treat each set of objects as a unique problem and find a satisfactory solution. Sometimes, it will be to use two crossed lights. Sometimes, it will be to shoot straight down. Sometimes, it may be to put the object to be photographed on a sheet of Plexiglas and light it from underneath. This is a common trick of food photographers who need to make a glass of wine or beer look good. Lighting it through the bottom of the glass gives a glow that can't be managed any other way, and really makes any carbonation stand out.

Did you Know?

If you need to shoot something that is carbonated and you want to see lots of bubbles, have an assistant drop a few grains of sugar into it just before you take the picture. It activates the bubbles. Practice first, so that you see how little (or how much) to use.

Shooting Tables

Of course, you *can* use any sturdy table, desk, or other flat surface, but there are also special shooting tables designed for tabletop photography. They have a few advantages. One is height. You can typically adjust the height of the surface from 32" to 37", saving your back when you have many items to photograph. Also, the backdrop is built-in. These tabletops are designed to hold a sheet of thin, frosted Plexiglas or Formica in gentle curves to mimic the seamless paper backgrounds, and they fold up into a bundle of metal sticks and a roll of plastic when you want to use the floor space for something else.

Using translucent Plexiglas as a base and background enables you to place lights behind or beneath the shooting surface to eliminate shadows. Some of the custom tables also have light-stand adapters, and one has a dome on top in which you can place an overhead light.

The main reason for using any of these tables is that you can do catalog and product shots easily and quickly. When all you need is a basic "object on plain white background" photo, it takes only a few seconds per shot to position the object, shoot it, remove it, and replace it with the next one. With the camera set up on a tripod, all you need to do is move the product around and press the shutter button. Nothing could be easier or faster, especially if you have an assistant to keep track of which items have been shot.

The Jewelry Tent

Some products just don't lend themselves to this kind of "assembly line" photography. For one reason or another, they're more difficult to light. Jewelry is a good example. Shiny, round objects, such as roller bearings, are another. They pick up odd reflections, and these reflections often translate into distorted edges or black or white blobs in the middle of the object.

Using dulling spray may be okay on a machine part, but it's definitely taboo on a tennis bracelet worth several thousand dollars. Besides, jewelry is supposed to shine. The trouble is, each stone in the bracelet has 42 facets, the purpose of which are to reflect light back at you. Multiply the facets by the four dozen stones in the bracelet, and you have a lot of little bits of light bouncing around. Fortunately, there is a way to get good pictures of jewelry and other glittery objects. It is done with a translucent tent. You can either make one yourself out of any suitable white fabric, or buy a premade model in white rip-stop nylon that attaches to the commercial shooting tables previously described.

Pitching a Tent

1. To build your own jewelry tent, start with one of those metal frames used for hanging folders in a file cabinet. You can find them at any office supply store. See Figure 7.11.

2. Find a piece of white cloth big enough to drape over the top and three sides of the frame. An old sheet or pillowcase works well, or you can buy some thin white cotton at a fabric store. One yard is more than enough.

FIGURE 7.11
The jewelry tent can be made of any translucent fabric, but thin cotton, silk, or nylon are especially good.

To use the tent, set it up and position your lights so they shine through the sides of the tent, as in Figure 7.12. Place the jewelry or shiny objects inside the tent, and poke the camera lens through the front of the tent. There should be softly diffused, shadowless light on the item and its background. Remembering the discussion of soft light earlier in this chapter, you should be able to see how the soft, extremely diffused light within the tent wraps around the objects you're shooting. If you're seeing shadows, adjust the lights until they disappear. Be careful not to let the bulbs touch the cloth, lest you scorch or melt the cloth, or start a fire. If you pick up reflections from behind the camera, block off the opening of the tent, leaving only enough space to poke the camera lens through.

FIGURE 7.12
Place the lights equidistant from the box at about a 45 degree angle.

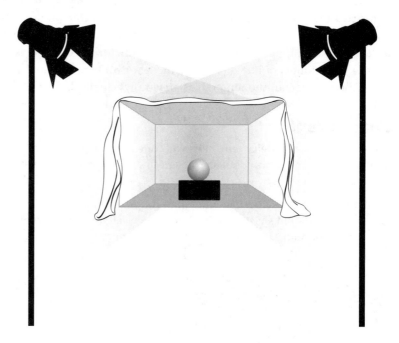

The tent is also good for silverware, mirrors, or any other reflective surface that would pick up the lights, the camera, you, and whatever else is in the room.

Don't reach for the tent automatically whenever you have a shiny object. You can occasionally put reflections to good use. For example, you can stick a colored card out of camera range, but place it where it will be "seen" by the silverware to add a glint of color to a place setting. More often, though, reflections are a nuisance for the photographer to deal with.

> If you *want* a lot of sparkle in the jewelry photo, use lots of lights, spread around the table, and shoot with a very fast shutter.

One of the advantages of using a digital camera for tabletop work is that you can stop partway through the job and upload your pictures to the computer to see what you've really got. Even on cameras that show you your pictures as you take them, it's hard to tell whether the detail is there or if the lighting is the way you visualized it. In the studio, you have the luxury of checking your work immediately. This is something conventional photographers can't do, unless they have a crew of darkroom assistants standing by to process and print their films as they shoot. Chalk up one more big point for working digitally!

Summary

Photos, by definition, need light. It doesn't matter whether the light is outdoor or indoors. You can put both daylight and indoor or studio lighting to work for you, especially if you know a few tricks about choosing the right kind of lights and putting them in the right places. There are key lights, accents, and fills. Sometimes you only need one light source; sometimes you need several. Using a cookie or gobo can prevent hot spots or add an interesting shadow to the picture. Tabletop lighting generally uses two lights crossed at a 45 degree angle to avoid shadows. When you have a shiny object to photograph, use a tent to soften the light and eliminate bad reflections.

CHAPTER 8

Shooting Portraits

What You'll Learn in This Chapter:

- ▶ Portrait Posing
- ▶ Children and Other Animals

Landscapes and still life arrangements such as fruit or flowers are easy photo subjects. They usually just sit there and don't give you any attitude. People are more difficult. I should know: I'm camera-shy myself. I've often said I'd rather pose for a root canal than a portrait. It's an attitude shared by many. Nevertheless, we sometimes need portraits, and even for something as simple as a passport photo, it's up to the photographer to make the subject look good, and feel relaxed.

Portrait Posing

The first rule for getting a good portrait is to make sure that your victim... er... subject is comfortable. The room should be neither too cool nor too warm. Remember that the lights add heat, so turn them off when you don't need them. Background music may help your subject to relax, as long as it's not too loud. Chatting with the person as you get ready to take the picture will almost always help, but only if you're at ease yourself. If you're relaxed and confident, your subject will be, too, but if you are nervous about your abilities or your equipment, the subject will pick up on that and stiffen up. I've heard more than one person say that posing for the passport picture was more painful than the pre-travel shots.

People tend to be more comfortable sitting than standing. Unless there's a reason for a full-length shot, let the portrait subject sit on something. There are all kinds of posing benches, adjustable height stools, and similar pieces of furniture that you can buy for the purpose. You can also use an ordinary chair (if you don't mind the

back of it showing in the picture), a piano bench or stool, or a bar stool. (Some portrait subjects find this one the most familiar.)

> If you want a comfortable seat that adjusts and doesn't cost too much, go to a music store and ask to see drummer's thrones. (Yep, that's what they're called.) They're sturdier than the ones sold for portrait studio work, because rock and roll drummers tend to kick them around. They adjust for height, and rotate easily so that your subject can shift from a left to right profile without moving the seat.

You may also want to invest in, or build, a posing table. You can drape it with velvet or spray it black to be unobtrusive. Commercially made ones are built with black felt over plywood, and will hold Velcro-tabbed fabric. The cutout side goes up against the subject, and gives him a place to put his arms. If you have a subject who wants to lean his head on his fist, perhaps to disguise a double chin, the table lets him rest his elbow so that it doesn't wobble or look awkward. The table is also useful when you want to have someone leaning toward the camera. He can rest his arms on it as if on a desk and not look, or feel, as if he is about to fall over.

Head-on portraits are probably the most common ones. They're certainly the most direct and revealing. Unless the subject has perfectly even features, however, they may not be the most flattering. The usual portrait lens is a short telephoto, and it tends to flatten out the face somewhat. Noses and chins take the worst of it. Noses, in particular, can be really strange when viewed directly. The pert, uptilted nose on the pretty girl tends to look more like a pig's snout—and even worse, you seem to be looking up into her nostrils. Just turning her head a few degrees to one side or the other can make a big difference (or you can have her look very slightly downward). Be careful about having people look down, however, because doing so emphasizes any flabbiness around the chin or neck.

Profiles are tricky. Again, if the subject has perfect features, or at least interesting ones, it can be a good pose. Faces with "character," specifically the lines, bumps, and wrinkles that we all get as we get older, can be wonderful subjects for portraits. To bring out the lines, use light from below. Have the subject actually looking down into the light, as in Figure 8.1. It's not a trick to use every day, but if the subject is willing and has the right kind of face, it can be very effective.

A good portrait reveals something about the person. Talk to your portrait subjects ahead of time. Find out how they plan to use the picture, and whether they want something posed and formal or relaxed and casual. How do they see themselves? Are they intense, always highly focused on something, whether it's work, or a

sport or hobby? Can you catch an avid sailor at the helm of his boat, or an artist painting a picture? When your photo subject is engrossed in an activity, he or she will take less notice of the camera and be less self-conscious. That virtually guarantees a better picture.

FIGURE 8.1
Dramatic lighting for a face with character.

Try to establish an appropriate mood in your studio or wherever you're shooting the picture. If you want the portrait to show a serious, thoughtful person, don't turn the radio on to a rock and roll station. Stick with the classics. If you want a happy picture, play something bouncy and fun, like a Jimmy Buffett reggae tune, or an up-tempo version of any song your subject likes.

Couples and Group Portraits

When you are shooting a picture of two people together, as in the stereotypical mother and child or newly engaged or married couple, try to find poses that let them look at each other, rather than at the camera. Position them so that one person's key light is the other's fill. (If you've already forgotten the difference between key and fill, go back to Chapter 7, "Painting with Light.") Groups of three should be posed to form a triangle. When you are photographing a small family group informally, have the parents sit on the ground with their legs bent and facing toward the outside of the frame. Pose one child behind and between the parents, while the other child sits in front of one parent's legs. If there are

more children, put the third one in front, and the fourth can share the standing space behind the parents. Never have a very tall person standing behind a kneeling one. It throws the balance of the group off.

If you need to do a more formal group shot, have two or three of the group seated, and the rest standing behind them. Disguise the tall group member by having him sit. If feet aren't showing, and no one else is tall enough to stand behind him, have someone stand on a phone book or low stool to add a couple of inches.

Because digital cameras tend to be small and possibly unimpressive to executives who are used to posing for studio portraits with a view camera or other large format camera, emphasize your flexibility. Move around, and shoot the group from several angles. Move in and out. Take *lots* of pictures. It will distract them, so they won't think you're just using a snapshot camera.

The Flattering Portrait Trick

I've forgotten which elegant dowager once quipped, "You can never be too rich or too thin." Although you can't do much to add to your clients' bank accounts, you can subtract several pounds from their faces with this trick.

Have the subject sit facing you, but turned just slightly, so he's looking over your shoulder rather than straight on. When you look at him, you want to see one ear, not both. You'll notice that the broad side of his face is toward you (see the sketch in Figure 8.2). Figure 8.3 shows an actual portrait shot with this lighting setup.

FIGURE 8.2
Set the light so it falls on the side of the subject's face that's away from you.

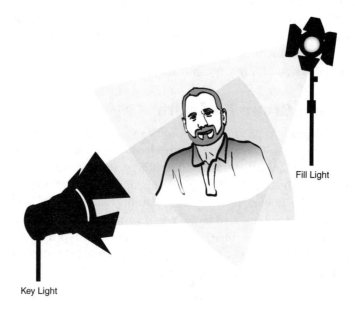

Fill Light

Key Light

When you light him, use one light, but don't aim it at the side of his face that is toward you. Instead, aim it at the side you see less of, the "short" side, rather than the "broad" side. This trick is called, appropriately, *short lighting*.

FIGURE 8.3
Short lit portraits
are more flattering.

When you light the broad side, it is called *broad lighting*. Broad lighting puts the emphasis on his ear and cheek, making him look chubby-faced, even if he's not. In the case of someone who *does* have a wide face, broad lighting is extremely unkind. News photographers use this technique frequently on politicians they disagree with. Former President Nixon was a prime example. His already impressive jowls were frequently magnified by the lights.

There's a myth that probably goes all the way back to Daguerre, that saying "cheese" as the picture is taken produces a happy smile. If you catch the subject at the exact fraction of a second when he says "chee…" you'll get to see some teeth, possibly, but not an expression that's worth recording. Forget cheese. Ask female subjects to say "peaches." It forms their lips into a pleasant expression, if not a smile. You want them to appear relaxed and comfortable, after all, not grinning. Ask male subjects to say "beer." They'll smile naturally after saying it, and that's when you shoot.

Did you Know?

Very few people have perfect faces and perfectly smooth hair. Chances are that you'll have to use a program like Photoshop Elements to do some retouching on the final portrait. It's easy to cover over minor imperfections, but you may want

to offer your portrait subject a comb and mirror and some neutral makeup if his or her hair or face will need a lot of post-session work. If there's an imperfection in the background, like a smudge on the wall, or a light switch that's distracting, remember that you can very easily take them out of the picture.

Children and Other Animals

Kids and critters are two of the most appealing photo subjects you'll ever encounter. They're also the most difficult to work with. The best way to get good pictures of children is to give them something to do and then get out of the way by using a telephoto lens. Use natural light whenever possible because flash is distracting, and kids are easily distracted without outside help. Swimming with the dolphins at the Dolphin Research Center in Marathon Key, Florida, was a perfect distraction. (See Figure 8.4.)

FIGURE 8.4
The dolphins didn't mind being photographed, and the kids didn't even notice the camera.

Babies

Babies are fairly easy to photograph, if you catch them when they're awake and not too hungry. A little advance preparation will make baby pictures a cinch. If you follow these basic steps, your baby pictures will be a success.

- ▶ Start by gathering your props. Roll a pillow tightly in a crib blanket to make a bolster cushion for the baby. If she's able to sit up, use the cushion behind her for support. If not, lie her on her stomach with her chest propped up on the roll.

- ▶ Put a favorite rattle or toy in her hand.

- ▶ Be ready to grab the picture when she realizes she's holding it, and smiles or looks surprised.

- ▶ For another cute picture, take a receiving blanket and drape it over her head so she appears to be looking out from under it.

- ▶ Hold a toy up high and wave it so she looks up. Get down on her level, instead of shooting down at her.

- ▶ To get her attention, use the rattle, a squeak toy, or other soft noises. Don't make loud noises that will frighten her.

Because of their skin tones, Caucasian and Asian babies generally look better against a blue background than a pink or yellow one. Darker skinned infants are equally cute on any light color. Very young babies are best photographed asleep. After all, it's what they do best.

Smiles are great, but babies and children, like the rest of us, have other moods. A serious portrait, or one where the child is about to burst into tears, can also be very effective.

Toddlers

Once they become mobile, toddlers want to move. Your task will be to guess where they're going to go and position yourself to capture them as they fly by. It's comparable to photographing a parade or bicycle race. Find your best view and wait for the action.

| Children of all ages become antsy if you take more than a few seconds to set up the shot, so prepare yourself and the camera first. Then ask them to do whatever you have in mind. |

Did you Know?

Older Kids

As children get older, they become self-conscious. They may reflect this as shyness and even refuse to be photographed, or they may develop a tendency to "mug"

for the camera. Neither attitude gives you much to work with. Observe children from a distance as they're engrossed in some activity and shoot them with your telephoto lens when they're unaware of you. (See Figure 8.5.) Soccer games, basketball, skating—whatever their chosen sport—it's bound to be a good opportunity for pictures. Attend the practice sessions as well as the games, and watch for kids on the sidelines as well as those in the middle of the action. You might discover that the real story at the Little League game isn't the star center-fielder, but rather the second-stringer, whose function is to cheer for everyone else.

FIGURE 8.5
Ballet in shin guards.

Pets

The advantage to shooting your own pets is that they know you, and aren't likely to be scared of you or your camera. The disadvantage is that they've come to associate things you do, such as calling their names, with getting a treat or going out for a walk. Bits of food will generally get their attention, but might not be a good reward for a dog prone to drooling. Try using a squeaky toy or a piece of rustling cellophane to keep the animal alert. Whenever possible, photograph the animal on a neutral background to avoid clutter in the picture, such as a sheet or rug. Outdoors, try for grass or perhaps a carpet of leaves.

Dogs who have had obedience training will sit or lie down on command and remain alert. Those who haven't may need to be held or photographed asleep.

Cats are even more difficult. Some will pose for you and seem to enjoy the attention. Others interpret your reaching for the camera as a signal to wash their hindquarters or hide under the bed. As with kids, you might be able to grab a shot while they're engrossed in play, as in Figure 8.6, or catching a quick nap.

FIGURE 8.6
Cat and mouse games....

Farm and Zoo Animals

In the case of farm and zoo animals, you have even less control over the background, and in most cases, you must shoot from a distance. At Big Cat Rescue in Tampa, Florida, I was able to get up close and personal with some of the cats, but it was difficult to photograph them without their cat-a-tat enclosures as background. In Figure 8.7, I sat in the cage with the Siberian lynx, but couldn't convince her to move away from the fence.

Be aware of the location of other animals in the picture. Interactions are great, but more often than not, you will get a wonderful portrait of one animal, but an awkward position on the other(s). You may be able to fix this with careful editing, but as always, starting with a better picture means that you will end up with a better picture.

FIGURE 8.7
Natasha, rescued
from a fur farm.

Wildlife

Sadly, many of the "affordable" digital snapshot cameras just don't have long enough lenses for serious wildlife photography. The bald eagle, bear, moose, or other critter that you might be fortunate enough to see out in the wild will be too far away to show up as more than a dot in the picture. If you have access to a high-end camera with interchangeable lenses, use a tripod and a long telephoto lens to capture your subjects as closely as you can.

If your interpretation of wildlife includes the kinds of animals you needn't go on safari to see, the digital camera is ideal. Digital cameras make less noise than conventional cameras, and won't frighten the ducks at the local pond or the chipmunk eating the nuts you've set out on the ground. If you're going to try to shoot pictures in a park or similar spot, pick a time when there are few people around to frighten the animals and birds. Early morning is usually good. Take a bag of dry cereal or some other food that will appeal to your subject, and be prepared to sit very still and wait for a long time. Before you settle down, look over the area where you'll be shooting, and remove anything like trash or cigarette butts that you wouldn't want in the picture. A camera such as the Nikon CoolPix 5700 is ideal for this kind of photography because you can hold it in your lap and rotate the view screen so that you can see and snap your pictures without excess movement. Don't use a flash.

Before you shoot, imagine your subject stacked four-high within the frame. If the stack fills the frame, it's big enough to shoot. Otherwise, you are too far away, or the critter is too small.

Motion in a Still Picture

When you are photographing subjects that are habitually in motion, such as animals and children, it's helpful to be able to show that movement as one of their characteristics. Photographs freeze time. When you take a picture of something in motion, generally your shutter speed will be fast enough to stop the motion and freeze the subject wherever it was in space at that particular fraction of a second. What you get is a still image of something you know to be in motion—the basketball players in mid-leap, or the child running across the soccer field.

To really show motion, you need to have something moving. The bike racers in Figure 8.8 were moving fast. I moved with them as I pressed the shutter, giving me sharp riders and a blurred background that suggests speed.

FIGURE 8.8
Moving the camera to keep the moving object in focus is called "panning."

If your "motion" picture doesn't have enough of a suggestion of movement, you might be able to add it later, using a photo editing program such as Photoshop Elements to blur either the moving object or the background.

Summary

Portrait photography is a challenge, but a rewarding one. When you shoot a portrait, you have two goals: First, to make the subject look as good as possible, and second, to tell the viewer something about the subject. You can use lighting tricks to either reveal or disguise many facial imperfections. And of course, you can retouch the picture afterward, to cover up blemishes or stray hairs. Babies and children are always good subjects, if you either catch them at a quiet moment or give them something to do. Older kids also need to be kept busy, so they don't "mug" for the camera. Pets and farm or zoo animals may be hard to photograph. Use a telephoto lens, and be patient. Wildlife photos can be terrific, if you can get close enough and then sit and wait for the animal to do something.

PART III

Putting Your Photos to Work

CHAPTER 9	Saving and Uploading Your Pictures	179
CHAPTER 10	Better Pictures Through Digital Wizardry	199
CHAPTER 11	Welcome to Photoshop Elements	211
CHAPTER 12	A Tour of the Desktop	219
CHAPTER 13	Handling Photoshop Elements Files	247
CHAPTER 14	Printing Your Pictures	265
CHAPTER 15	Posting Your Work on the Web	285
CHAPTER 16	Keeping Track of Your Pictures	305

CHAPTER 9

Saving and Uploading Your Pictures

What You'll Learn in This Chapter:

▶ Getting from the Camera to the Computer
▶ File Formats and File Sizes
▶ Storage Media
▶ Scanned Images

Your pictures have been beautifully composed, perfectly lit, and carefully shot. They're waiting in the camera's memory stick or compact flash card. Now what? How do you get them out of the camera into the computer, and what do you do with them once they're on your hard drive?

Getting from the Camera to the Computer

There are basically two ways to get your pictures from the camera into the computer. The simple way, which can be used with all of the current digital cameras, is simply plug and play. The more complicated way, really only necessary if you have an older camera that doesn't plug into the computer, is to use a card reader. We'll come back to those, but let's look at the easy way first.

When you bought your camera, you got a fistful of stuff along with it. There was probably a CD-ROM included in the bundle, along with the manuals. And there should have been a cable, or possibly a couple of different cables, depending on what kind of camera you bought. Let's take a closer look at these items.

If your camera is the kind that can play back pictures onto a TV screen, you'll have a video cable with one or possibly two RCA-type plugs on one end and a mini head-

phone plug on the other (see Figure 9.1). If you don't have one of these cables, it simply means that your camera wasn't designed to play back directly into a TV set. Plug the mini plug into the camera's AV out port and the RCA plug(s) into the TV. The yellow one goes to the video in jack, and the white one to the audio input, if there's any audio that you recorded with your photos. (Not all cameras offer this feature.)

FIGURE 9.1
This cable goes from the camera to video inputs on the TV set.

The cable you need to get the pictures into the computer is a different one. It will have whichever kind of plug your camera uses on one end, and a USB or FireWire plug on the other. Different brands of cameras use different connectors, so if you have two or more cameras, don't automatically assume that you only need one cable. Cables for the Nikon and Olympus cameras are shown in Figure 9.2. If you're not sure where to plug the cable in, check both your computer manual and camera manual before you start plugging.

If your USB ports are already in use, you have the choice of unplugging and replugging every time you need to download pictures, or buying a hub, which is a box that plugs into the appropriate USB or FireWire port. It works like an outlet strip, letting one USB port handle as many as seven or more USB devices. Because the plugs and cables tend to be somewhat delicate, the more often you unplug and replug them, the more you shorten their lives. The hub costs anywhere between $20–$50, depending on the number of inputs; consider it to be money well spent in terms of time and cables saved.

FIGURE 9.2
Note the difference between the two camera plugs.

If you haven't already done so, you'll also need to install the software that enables the computer to read the signals from the camera and download them as pictures. The program comes on a CD-ROM. If your computer can't read a CD-ROM, the camera manufacturer will have a current version of the necessary software available on their website.

Your camera may come with downloading software only or with additional program(s) for image manipulation. Depending on your brand of camera, you will probably get a copy of Olympus Camedia Master, Nikon View, Kodak EasyShare, or whatever your camera maker is using. You may also get a copy of Adobe Photoshop Elements.

Follow the installation instructions for your computer and operating system. On the Macintosh, you generally just double-click the installer for the appropriate OS version and follow the steps to install the program. In Windows, inserting the CD-ROM in the drive opens the installer, as seen in Figure 9.3. That starts the Install Shield Wizard, and you simply click through the various steps. You'll be prompted for your name and the program's serial number, so keep the CD sleeve handy.

After you install the software, you are almost ready to download some photos. Plug the camera to USB cable into any convenient USB port, and into the camera's digital I/O port. Figure 9.4 shows a typical one. (I/O stands for *in and out*, and not only lets you download your photos, but also upload them to the memory card after you've cropped and cleaned them up, so you can view the finished pictures on your TV set.)

FIGURE 9.3
A typical Windows installation.

The I/O port is also used to upgrade the camera's firmware—the program on the camera chip that does the processing. As programmers find newer and better ways to process images, the camera makers issue firmware updates, which are available on their websites. You simply download the update and follow the instructions to update your camera. It sure beats buying a new one.

FIGURE 9.4
The I/O connection on a Nikon CoolPix 5700.

All of the information for transferring pictures to the computer should be included in either the camera manual or the software manual. (These may even be two sections of the same booklet.)

Transferring an Image

With the software installed and the camera connected to the computer, you're ready to proceed. Because Olympus Camedia is fairly typical of the image handling software you're likely to use, let's use it as an example. After you start the application, you'll see a splash screen like the one in Figure 9.5. Click on Transfer Images From Camera. If you are using a different program, don't worry. All of the basic steps are the same. Verify that the camera is turned on and that both ends of the cable are plugged in to the appropriate places.

FIGURE 9.5
The Olympus Camedia splash screen menu.

> If you'd rather skip the splash screen menu and just get right to work, use the check box at the bottom of the screen that says "Don't show this screen." Instead, you'll go directly to the desktop interface. However, if you're planning to download images from the camera, don't turn off the splash screen, because it's the easiest way to reach that option.

By the Way

After you've asked for a transfer, you'll see thumbnails of the photos that are in the camera. Figure 9.6 shows an example. You can transfer all of them or just

select the ones you want by clicking on them. First, click the small button that toggles between All Images and Selected Images, press the Shift key, and click the pictures you want to select before you click the larger Transfer button above it. You also need a destination file for your pictures. Camedia creates albums, as do most image transfer programs. Albums are simply folders that keep your pictures organized. You can stick everything into one album and sort it later, or make separate albums for new sets of pictures. In Camedia, you'd click the New Album button at the bottom right of the screen and enter a title for the new album.

By the Way

Virtually all of the digital cameras currently on the market support both the Windows and Macintosh platforms, and supply appropriate software for both platforms.

FIGURE 9.6
Pictures are displayed as if they were slides on a light table.

After you click the Transfer button, you'll see a window like the one in Figure 9.7, telling you that your photos are being copied to your hard drive. In a few seconds, up to a minute or so depending on how many pictures are in the camera, your photos will be transferred to the new album, so you can, if you want, delete the images from the camera and free up space on the memory card to shoot new ones. To study them, go back to the menu and select Browse, and then click on the one you'd like to see enlarged.

FIGURE 9.7
This box, or one like it, shows down-loading progress.

Camedia doesn't give you a lot of options for working on your photos. You can crop, adjust brightness and contrast, and so on, and even add type, but there are better programs for creativity.

The Nikon series of cameras comes with a similar downloading program that actually has even fewer options for photo correction, but has the advantage of giving you the option to open a selected picture in your choice of photo editing software. Figure 9.8 shows the Nikon interface.

FIGURE 9.8
Here, again, you click on a photo to select it.

The Nikon software also includes an editor that can be accessed from the viewer. It has a selection of tools that enable you to make some basic corrections. It's shown in Figure 9.9. Simply move the sliders and watch the changes on the thumbnail at the top right of the screen. Click Apply when you're satisfied with what you see.

FIGURE 9.9
You can make basic color adjustments and resize your pictures, but nothing really complicated.

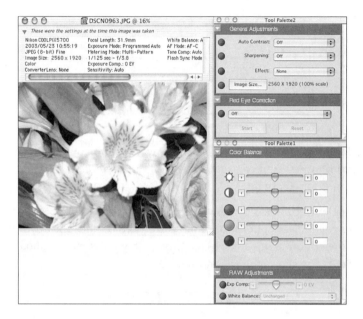

Using a Card Reader for Image Transfer

If, for some reason, you don't want to or are unable to plug your camera directly into the computer, you can remove the memory card from the camera and insert it into a card reader. This is a smallish USB device that acts as an auxiliary drive, and mounts the memory card on your desktop. From there, you can use the provided software to transfer your photos and put them into an album, or skip the software and simply copy them into a folder. The card reader is about the size of a deck of playing cards, and some models have slots for several different types of memory card. Shown in Figure 9.10 is a typical card reader, the Belkin Hi-Speed USB. It reads virtually all current memory cards, including XD Picture Card, CompactFlash I, CompactFlash II, SmartMedia, Secure Digital, Mini Secure Digital (Mini SD), MultiMediaCard, RSMMC, IBM Microdrive, Memory Stick, Memory Stick Duo, Memory Stick Pro, Memory Stick Pro Duo, Memory Stick MagicGate, and Memory Stick MagicGate Duo. It also transfers files to and from any PDA or portable music player with a USB connector.

If you have a laptop with a memory card slot, you can simply insert the memory card from the camera and copy your pictures onto the laptop. This is helpful when you're traveling and don't want to carry several cards. At then end of the day, or whenever your card is full, download all the photos and reformat the card for the next day's pictures.

FIGURE 9.10
It's versatile, and definitely "plug and play."

Now, there are even portable hard drives, with a slot in which you insert the memory card, and the data is automatically downloaded. These drives are pocket-sized and weigh anywhere from four to eight ounces. The Kanguru Media X-change 2, shown in Figure 9.11, is a typical example. They come in sizes from 20–80 gigabytes and are priced in the $200–$400 range depending on capacity. They're a great solution for the times when you don't want to carry a heavy laptop or worry about it disappearing from your car or hotel room when you travel. When you get home, plug the drive into a USB port and enjoy your photos.

FIGURE 9.11
You can fit an entire trip to Europe on an 80 gig drive.

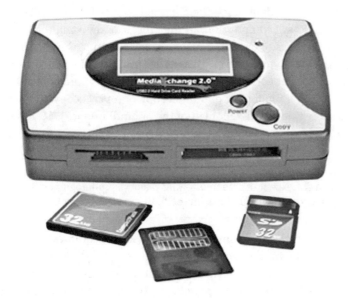

File Formats and File Sizes

Most digital cameras record files in JPEG format (they have a .JPG filename extension), but they use a special variation of .JPG called Exif. This is a standard

that allows extra information to be recorded by the camera into the image file. The Exif standard was developed in Japan, where most digital cameras are actually built, and is used in almost all models of digital cameras. The current version is 2.1. With each picture, it saves such details as the lens aperture and shutter speed, the date and time the picture was taken, and the make and model of the camera. It can also record data about the picture, keywords for filing it, and in some cameras, the GPS location where it was shot! Exif data stays with the picture, although you may edit it.

Less expensive digital cameras often don't give you a choice. All images are automatically saved as .JPGs. Some cameras can also save files as .TIFFs or as .RAWs. Both of these formats create very large image files, while the .JPG files are compressed so you can fit a lot more of them on a memory card. TIFF files may or may not be compressed, but if they are it's with a different kind of compression than the .JPEG format uses. If you are planning to make very large enlargements, (for example, 18×24 inches) of your pictures and work with Adobe Photoshop Elements or Photoshop CS, you'll want to save them as .RAW if possible.

The advantage of using .JPG is smaller files, and therefore more images per memory card. The disadvantage—there *has* to be one—is that JPEG compression is what's called "lossy" compression. In the process of reducing the file size, the camera takes averages of groups of pixels, rather than measuring and recording the value of each individual pixel. This really isn't a problem the first time a file is saved as a .JPG. But each successive save means that more data is lost. It's rather like making a photocopy of a photocopy of a photocopy. By the fourth generation, there's not a whole lot left of the original image. JPEG lets you to select how much compression (and therefore how much data loss) you'll allow.

By the Way

JPEG stands for *Joint Photographic Experts Group*, the folks who created the standard. As you might expect, it's geared toward displaying photographs, and therefore handles any sort of continuous tone (full-color or grayscale) image very well.

.RAW images are, as the name implies, unprocessed, uncompressed data. Not all cameras can save them, and not all graphics programs or image browsers can interpret them. In fact, each camera maker has their own version of .RAW, so you may need to use their software to download .RAW images and then save them into another format. .TIFF is a good compromise. TIFF is a standard format that's handled by all current graphics programs, and when you save a .TIFF file you have the option of saving it with or without compression. When I shoot multiple

pictures, I generally use the .JPEG format, and immediately convert them to .TIFFs when I upload them to the computer.

When you look at the list of possible file formats in the Save As dialog box, chances are you'll see a few unfamiliar ones. A digital photo is a scanned image. Therefore, by definition, it is an uncompressed bitmap, which means that the image is saved and described, pixel by pixel. .PICT, .BMP, .PCX, and .TIFF are all bitmap formats, as is .PSD, Photoshop's native image format. If you're using a graphics program such as Adobe Photoshop, Photoshop Elements, or Jasc Paint Shop Pro, this format will also be one of your options. Virtually all Macintosh graphics programs can open .PICT files. .BMP is one of the most widely used bitmap file formats for Microsoft Windows applications. .PCX is the standard bitmap format for PC Paintbrush, and it is used by many other PC applications as well. .TIFF, which stands for *Tagged Image File Format*, is common to both Windows and Mac platforms, and works well for images that must be transferred cross-platform. It is, however, at least partially exempt to the definition above, because .TIFFs can be compressed or not, depending on how you choose to save them. .TIFF files are standard in the printing industry for scans and for any graphics that must be printed out on high-resolution printers or imagesetters. Bitmaps can also be converted to .EPSF (*Encapsulated PostScript File*) format for use with PostScript printing devices. As a bottom line, whether you are working on a Mac or Windows computer, save your files as uncompressed .TIFFs.

If they're going to the web, wait until all the work is done and you're ready to upload. Then save a copy for the web as a .JPG or .PNG file. The Internet also supports .GIF files. .GIF stands for *Graphic Image Format*. It was the earliest graphics format, originally developed by CompuServe so their users could post pictures that other users could download. It uses limited colors, and really is only good for black and white or very limited color art. These files are compressed very small, but for photos and other continuous tone art, the effect is blotchy and unpleasant. If you're posting a pen and ink drawing, .GIFs are great. For photos, forget it!

If your photo is going to be used for desktop publishing or as part of a printed document, you can leave it as a .TIFF or .EPSF (PostScript) file for use with PostScript printers.

Saving File Space

Uncompressed bitmap files tend to be quite large, especially with today's high-resolution cameras. The greater the resolution, the more pixels there are. A

typical .JPG image saved directly from the camera to the hard drive from a 5 Megapixel camera occupies approximately 1.4MB of disk space. The same image, uncompressed and saved as an .EPSF file, fills up 14.1MB of disk space. Finally, that image as a 16-bit color .TIFF requires 28.1MB of space. Why so big? The .TIFF file includes a compressed version of the picture, plus information about the colors used in it. The .EPSF version translates the entire picture into the PostScript printing language. Given today's 100 gigabyte hard drives, this isn't quite as much of a problem as it used to be. However, just opening or copying a file that large is time-consuming. Sending it on the Internet would be ridiculous. That's where file compression steps in and becomes critical.

There are two ways to compress a file: lossless and lossy. .JPG, as we've already said, is a lossy compression format. Lossless compression is exactly what it sounds like. The file is compressed, but all of the information in it is retained. Nothing is lost. LZW compression is an example of lossless compression. (The initials stand for Lempel, Ziv, and Welch; the three guys who invented it.) .GIF files use the LZW compression system, with a limited color table. Colors are indexed and limited to a total of 256, no matter how many were in the original photo; so even though there's theoretically no loss of data, there may be a loss of color data if the original picture had more than 256 colors or shades of gray. The file described previously shrank to 500KB as a .GIF document, but the quality was not acceptable. You can see this in Figure 9.12. The upper left image is the original photo, the .GIF version is on the upper right, and the bottom are medium- and low-quality .JPGs.

A medium quality .JPG version of our typical file ended up as an 251KB document. The low-quality .JPG version was only 160KB, but looked just as good onscreen as the high-resolution .TIFF. Part of the reason for this, of course, is that the screen in question is a 24-bit color monitor, so you're seeing as many of the 16.7 million possible colors as were visible in the original scene. If you were using a less color-enabled screen, such as an old VGA monitor from an early PC, the low-quality .JPG image would probably look better than a .GIF version of the same picture, but not as good as the full-color .JPG version.

.JPGs are better for photographs, because the colors aren't limited, but they don't handle sharp contrasts as well as .GIFs. For example, a line of black pixels next to a line of white pixels reproduces perfectly as a .GIF, but comes out blurry as a .JPG. This is because of the way the JPEG standard looks at compression. It is designed to mimic the way the human eye sees images. We're more sensitive to variations in brightness than in hue. So, when compressing an image, the JPEG standard maintains more of the grayscale data than the color data, and can appear fuzzy. That's why .GIF is still the preferred format for line art.

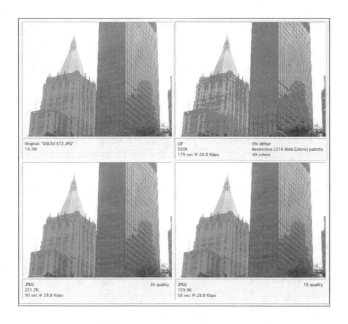

FIGURE 9.12
You can have a
small file or a com-
plete file, but not
both.

Interlacing is a method used with both .GIF and .JPG formats to make an image appear to display faster on a web page. Here's how it works: The file is divided into pieces called *scans*, which are saved in a scrambled order, so that as the picture loads, lines 1, 4, 7, 10, and so on are painted first. Then, lines 2, 5, 8, 11, and finally lines 3, 6, 9, 12. The effect is that the picture appears in bands from the top down and then fills in. Interlaced .GIFs use what's called GIF89a format. The similar format for .JPG is called Progressive JPEG.

.GIF images often have a colored border or frame around them, and there's no reason why they shouldn't. The border looks nice, and because it's all one color, it "costs" very little in terms of file space. However, .JPGs treat the color border differently, so the border actually adds greatly to the amount of file space needed. If you're converting a .GIF to a .JPG, crop the border off before you attempt to save it.

There's also an Internet graphics format called .PNG. That stands for *Portable Network Graphics*, and it's an excellent, lossless compression system that, for a number of reasons, never really caught on. It was introduced a few years ago, when there was what turned out to be a non-event regarding a possible patent violation by .GIF users, and the threat of a "tax" on .GIFs. That never happened, and the format wasn't supported by some browsers, so .PNG was mainly used only by the handful of people who developed it.

Using File Compression with Saved Images

When you're just learning to use tools such as Photoshop Elements, it makes a certain amount of sense to work on a duplicate copy of your original photo rather than on the original image. You can keep archived copies of your original camera files, including all the layers, in a compressed form and go back to them whenever you want to try something new. If you use the .JPG compression, however, you're going to lose image quality every time you decompress and recompress. And .JPG doesn't save layered files. Instead use a utility such as Aladdin's StuffIt or PKZip to store your files. These file compression programs use lossless compression to save disk space. The unstuffed file is identical to the original because everything taken out is put back.

How File Compression Works

File compression programs work by simple substitution. Let's consider a line of text that reads **These three trees are beeches.** To compress it, you can look for patterns. Every time you see the combination "th," you can substitute a *. Every time you find the "ee" combination, you can substitute !. And every time there's an "es," you can use @. So, you'll have: *@e *r! tr!s are b!ch@. Instead of 25 letters, you're down to 18, or a 28% saving.

Graphics files, of course, don't shrink as well as text files do. Photographic images are probably the hardest files to compress, simply because there's so much data and so little of it is repetitive. If your picture has large areas of flat color, it will compress better as a .GIF image than a photo that has lots of detail. There are more identical pixels. It also depends on what kind of file you're stuffing, and whether there's extraneous data or repeated patterns that can be compressed. Table 9.1 shows several different kinds of graphics files that have been zipped, as well as the unzipped versions. These are all the same image in different formats. Savings range from zero for the .PNG, which is already compressed, to 88% for the .TIFF, which has lots of duplicate information.

TABLE 9.1 All These Files Represent the Same Picture Saved in Different Formats

File Type	File Size
Flowers.bmp	1.5MB
Flowers.bmp.zip	1MB
Flowers.eps	2.8MB
Flowers.eps.zip	1.9MB
Flowers.jpg	180KB

TABLE 9.1 Continued

File Type	File Size
Flowers.jpg.zip	168KB
Flowers.pcx	1.5MB
Flowers.pcx.zip	1.1MB
Flowers.png	964KB
Flowers.png.zip	968KB
Flowers.psd	1.5MB
Flowers.psd.zip	1.1MB
Flowers.tif (compressed)	1.1MB
Flowers.tif.zip (compressed)	1.1MB
Flowers.tif (uncompressed)	1.5MB

Other Formats

Most image editing programs give you a choice of several other formats, as well as .GIF, .JPEG, .TIFF, .PICT, or .BMP. Pixar is a format designed specifically for exchanging files with PIXAR image computers. PIXAR uses Silicon Graphics and Sun workstations designed for high-end graphics applications, such as work involving three-dimensional images and animation. You've seen Pixar animation in such films as *Toy Story* and *Finding Nemo*. Targa is a format developed by TrueVision, makers of several PC video boards, and used by a number of PC/Windows painting and image editing programs. .PCX is a standard PC format used by PC Paintbrush. Scitex Continuous Tone (SCT) format is used for high-end image processing. The SCT/CT files are used primarily to store CMY and CMYK color space for the image, and are uncompressed. It's very doubtful that readers of this book will ever have to deal with Scitex or Pixar formats.

Storage Media

After a few photo sessions, your hard drive is going to get crowded, especially if you've saved your files as .PSDs, .TIFFs, or .BMPs. Because you can't just file the negatives away and stick the prints in an album, as you can with conventional film, how can you save your pictures for future use and display the best ones? Well, you could look for a bigger hard drive. When I first got into digital photography, the biggest hard drive available was a whopping 9 gigabytes, and cost about $2,000. Today, you can get a 200 gig drive for $140. How times have

changed! Of course, things can happen to hard drives, so it's always wise to have a backup system. When a 200 gigabyte hard drive dies, an awful lot of pictures can go away forever.

CDs and DVDs are a smart and cost-effective option, and definitely one to use, if only for backups. Whenever I have "important pictures," such as travel photos, pictures for clients, or anything else I know I'll want to preserve, I immediately make a CD-ROM with all of the pictures from that session, just as they've come from the camera. I can always go back and reload them if I want to work on them again. CDs aren't absolutely fail-proof either, although their main enemies are fingerprints and scratches. As long as you follow the handling instructions, your images should last for many years. Still, they aren't fireproof or flood proof. And they can delaminate or blister if bent, causing total data loss. If it's something I'm really concerned about saving, like my son's wedding photos, or trips to places I probably won't visit again, I make a second backup CD, and put it in storage somewhere outside the house, like a safe deposit box or in a box that another family member keeps for me.

Scanned Images

There's another kind of digital photography you need to know about. In one sense, it's not photography at all, but it uses the same principles. Your scanner is actually a kind of digital camera that turns your document into a computer image by photographing and processing one line at a time.

Using a Scanner

The most common type of scanner for home and office use is called a flatbed scanner. It looks something like a photocopier, and works in much the same way. Today, you can even get multi-purpose boxes that scan, make photocopies, and also print from your computer. Some even serve as fax machines. The machine has a flat glass bed and a moving lens inside that reads whatever you are scanning back and forth, one line at a time, and records the data as the digital camera does, but directly to the computer. Figure 9.13 is a picture of my current scanner, a Microtek ScanMaker 5700. I chose this one mainly because it is fast and reasonably accurate color-wise.

FIGURE 9.13
The Microtek
ScanMaker 5700.

Scanners aren't expensive, and using one is about as complicated as making a photocopy. Put the paper in, and click the Scan button. Graphics programs such as Paint Shop Pro, MS Picture It!, and Adobe Photoshop Elements will scan directly into an open page in the program. In fact, the majority of scanners on the market today come with one of these picture editing programs and usually with their own proprietary software as well. They're the answer to putting your old family photos into digital format to preserve them, and even retouching and rescuing the damaged ones.

These days you'll find scanners that connect to your computer by FireWire, as well as USB, parallel, and SCSI. And some even connect with no wires at all, via radio signals or infrared. The HP PSC 1350 and Epson CX 6400 are both combination scanner, printer, and copiers. For their size, they provide remarkably good quality for both scanning and printing, and you can plug a camera or CompactFlash card directly into either one. They are shown in Figure 9.14.

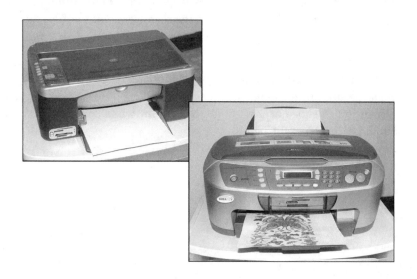

FIGURE 9.14
The HP PSC 1350
and the Epson CX
6400—both small,
but effective.

The way the memory card print feature works is really quite simple. First, you insert the card, or plug in the camera, and print a "proof" page that shows all the images on the card. Then you simply select the ones you want to print, and run them off in any size from 4×6 to 8 1/2×13.

At the high end of the spectrum, there are drum scanners, used to scan large film positives. To use one of these, you mount your art in the drum and it spins around past a beam of light that penetrates the image and sends data to a photo multiplier tube, far more sensitive than the CCDs that our digital cameras and flatbed scanners use. These cost upwards of $1,500 to as much as $20,000 or more, and really are only used in the publishing industry.

Scanning Film

Some scanners, though not all, can also scan film, so you can turn your Kodachrome slides into prints, or even work from an old negative. (After you've scanned it into a program such as Photoshop Elements, use the Invert command to turn it from negative to positive.) The film may need to be inserted into a drawer in the scanner or placed on a certain part of the glass where it will be lit from a bulb in the cover of the scanner. Be sure to set the scanning software to transparency rather than paper.

Scanning Small Objects

Use your scanner to photograph small objects, too. Old jewelry, coins, medals, and other small mementos will scan just as well as photos. Figure 9.15 shows a few examples. Notice how clear they are. When you are scanning things, make sure they don't scratch against the glass on the scanner top. If they do, they will leave a copy of the scratches on all subsequent scans.

When you scan objects, you may want to put a background behind them. That's fine, as long as you remember that the objects must go face down in the scanner, and the background sheet should go *on top* of them. In Figure 9.16, I'm getting ready to scan some beaded necklaces. You can see the white background sheet I am about to lay on top of the beads.

FIGURE 9.15
These were all scanned with the Microtek scanner.

FIGURE 9.16
Colorful beads want something neutral as a background.

Some scanners have an all black or all white cover, so you might not need a background, but this one also works with film, and has an illuminated panel which makes, at best, a confusing backdrop. The scanner lid has an extendable hinge so it can accommodate items up to an inch thick. That also comes in handy when you're scanning pages from a book.

Speaking of books, most scanner software includes an OCR program. *OCR* stands for *Optical Character Recognition*, and it's a little bit of magic if you have a printed

piece that you'd like to have as editable text. You put the page in the scanner, and choose OCR from the scanner's software. Then, the page is scanned and each character is scanned, recognized, and entered as text which you can read, reformat, and edit in any word processor. I'm a fairly fast typist, but the OCR software is much faster. As for accuracy, that depends on your original copy. If it's a beat up newspaper clipping, you may have to clean up the text. If it's a nice clean original, and not placed too crookedly on the scanner plate, you'll find the program is close to 100% accurate.

Summary

After you've filled up your memory cards with photos, you need to get them into the computer. The easiest way is to plug a USB cable from the camera to the computer and let the camera act as an external drive from which you copy the pictures. You can also use a card reader, which has a slot for the camera's memory card, and otherwise works the same way, as an external drive. File compression saves disk space but some kinds of compression, when overused, will degrade the image. Always keep a set of backups on a CD or DVD, so you can go back to the original photos whenever you want. Scanners are useful if you have old pictures that you want to convert to digital, to save them, and to rescue the damaged ones.

CHAPTER 10

Better Pictures Through Digital Wizardry

What You'll Learn in This Chapter:

▶ Can You Improve on Perfection?

▶ Moral and Ethical Issues

▶ Software for Image Enhancement

Now that you've transferred your pictures into the computer, you can finally get a really good look at them. Are they everything you dreamed of, or do they need some work? Be honest. Could tighter cropping improve the picture? Are the colors a little bit off? Are there gum wrappers or other trash where they shouldn't be? Would you like greener grass or a bluer sky? Is there something in the picture that detracts from it? All of these things are very easy to fix.

Can You Improve on Perfection?

Of course you can. If the picture is already "picture perfect" then why not do as Chef Emeril says, and kick it up a notch... Maybe several notches, even. You can turn it into a piece of fine art with a filter or two, you can posterize it, or make a color print into a black and white or duotone and then vignette it into an oval frame so it looks to be a hundred years old. When you're working in the digital darkroom, your possibilities are only limited by your own imagination. You can add other people or things to a photo, put them in places they've never been, and even take out people you don't want in the picture. Just had a messy divorce? Replace your ex-spouse with the dreamboat of your choice: maybe Brad Pitt or Jennifer Aniston.

The professional photographers who shoot covers for fashion magazines, and photos for advertising clients rely on retouching to make their pictures perfect. Even supermodels have bad hair days, or an occasional pimple. It's usually easier, and more natural-looking, to retouch the picture than to hide the zit with makeup. As you learned earlier, product photography is subject to all kinds of tricks. There are additional ones that can only happen after the picture's in the computer, things like making the steak a warmer shade of brown, putting a richer red in the tomato soup, and adding the perfect highlight to the chrome trim on the Porsche.

Moral and Ethical Issues

You can do a lot of digital tricks. They're done all the time. You can turn that can of beer in the politician's hand into a harmless can of soda, or vice versa, depending on your party affiliation. The question at hand is not "can you?" but "should you?"

There are certainly some ethical questions to be addressed if you're altering photographs for public display. It really depends on how the picture is to be used. Reputable newspapers and magazines tend to have strict guidelines about what they'll allow for photo manipulation. The general rule seems to be that, if a change affects the content of the photo rather than its appearance, you can't do it. You can lighten a too-dark picture of the politician, but you can't change the soda can in his hand into a beer can (or beer into soda). That would be making a change in content.

There was a situation that arose a few years back when a popular sports figure was on trial for murder. *Time* and *Newsweek* both featured the same mug shot photo of the suspect on their covers. However, one magazine had, whether intentionally or otherwise, darkened his skin tones and deepened the shadows, adding a sinister note to the image. Not anything else was changed. For a fascinating look at how photos can be altered to change history visit this website: http://www.tc.umn.edu/~hick0088/classes/csci_2101/false.html. You can see the *Time* and *Newsweek* covers there. This page also shows some of the altered photos from the Lenin era in Russia. Lenin was a close friend of Leon Trotsky, and the two were often photographed together. When Trotsky fell out of favor, he was not only exiled, but all of the photos that he'd appeared in were retouched, removing him from the scene. Is it right to rewrite history?

Editing a picture to improve the composition seems entirely reasonable if it's a picture for your own use, but when it's done by otherwise respectable news magazines and book publishers, there are ethical questions that ought to be considered. The producers of the *A Day in the Life* series are quite proud of the computer manipulations on the covers of the America, Canada, and Australia editions. A spokesman for the publisher was quoted as saying, "We are very proud of the fact that we were able to use this technology to make the covers more dramatic and more impressive."

Back in the days of the Reagan presidency, a photo appeared in *Picture Week* magazine of Nancy Reagan and Raisa Gorbachev apparently being quite friendly. The photo, however, was actually two separate shots combined to make one; a bit of history that never happened. The hoax was revealed when readers recognized the two photos as separate entities, but simply knowing that the manipulation was possible raised a red flag for many people both inside and outside the publishing industry. The question has been debated ever since. How much change is okay? How much is too much?

It's clear that you can't always believe what you see. The supermarket tabloids frequently feature pictures that stretch the bounds of believability. Remember the one of the president shaking hands with the space alien? Or Bigfoot carrying off the scantily clad woman? (Why was she dressed like that in the snow, anyway?) On the other hand, if a fashion model comes to work with frizzy hair, dark circles under her eyes, or if her face breaks out, retouching is required and expected. Where do you draw the line?

To me, it depends on what's being done and its effect on communication. If it changes the meaning of the photo, particularly in a way that could get you sued, don't do it. Could anyone's reputation be harmed by it? Don't do it. If it's just for fun and not for public display, go ahead, but be careful that the photos don't end up in the wrong hands or displayed on the web.

Software for Image Enhancement

As we discussed in the last chapter, the same software that downloads your photos can often make minor corrections. For more serious work—for example, if you need to repair a damaged picture, remove an awkward branch, or clean up teenaged skin—you need a more powerful graphics program. Let's take a quick look at several of these. There are others, but because of space restrictions, I've decided to limit this discussion to my personal top four.

Microsoft Picture It! Photo Edition

Picture It! is an inexpensive and easy to use program that also manages to be quite powerful. It's priced at less than $50, and has a neat and understandable interface. It's only available for Windows, so Mac folks will have to dream on or run it under Virtual PC for Macintosh.

By the Way

> Mac folks: Virtual PC runs very well on the Mac with Windows XP, and will handle just about any Windows software you need to run.

When you open Picture It!, you first see a splash screen that lets you select what you want to do. It's shown in Figure 10.1.

FIGURE 10.1
The thumbnails at the bottom of the screen show pictures you have recently opened.

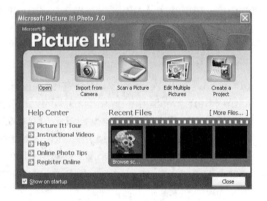

Figure 10.2 shows the basic layout of the Picture It! work area. At the left of the screen there's a list of common tasks you might do with your photo, and across the top of the screen, the menus and tool icons provide access to individual tools. You can even use the icons to download a photo from your camera or scanner.

There is a cropping tool, which allows you to crop by dragging a frame around the part of the image that you want to keep. You can correct brightness, contrast, and tint. You can even add type and special text effects to make your words stand out. There's instant "red eye" correction, and you can add edge effects and frames to the photos before you print them.

The Help screens, unlike those in some programs, are actually helpful, and walk you through such tasks as setting and styling type. To save expensive glossy photo paper, Picture It! lets you gang together different sized photos on the same page. There are some mini-programs within Picture It! that take you step by step through creating photo calendars, postcards, stationery, and more. In Figure 10.3,

I've placed a couple of wedding pictures into one of Picture It!'s scrapbook pages.
The next step would be to add some text.

FIGURE 10.2
The icons help you
find the tools you
need.

FIGURE 10.3
The pictures are
simply dragged into
the pre-formatted
page.

One thing I really like about Picture It! is the quality of the art supplied for its projects. It even has templates for CD-ROM labels and jewel box cases, so you can create a professional-looking presentation for the scrapbooks you send out on CD/DVD. The label and sticker templates are designed to work with standard Avery printable labels, available at any office supply store.

Picture It! doesn't have all the bells and whistles that the more advanced programs have. There are no filters, and very limited retouching tools. It's not good for photos that need major work, or for turning pictures into art, but if you are just starting out, it's a good first step. You'll soon want to move up to a more versatile program, though.

Jasc Paint Shop Pro

Jasc Paint Shop Pro comes highly recommended by my PC-using friends. It's strictly for Windows, though. There's no Mac version, and according to company sources, no plan for one. Paint Shop Pro does nearly everything that Adobe Photoshop does. There are effects to transform your pictures into art, and scripts to run that perform a number of useful tasks. The effects aren't very realistic, but if your idea of colored pencil drawing involves lots of texture, as if drawn on a paper towel, you'll like it. Figure 10.4 shows what this looks like.

FIGURE 10.4
The embossed look is overdone for what's supposed to be a flat drawing.

The figure also shows the Paint Shop Pro interface. As with other graphics editing software, there's a toolbox on the left and a menu bar and icon bar across the top of the work area. Windows on the right of the screen allow you to select colors, work with layers, and see a preview of effects.

One thing that's easy in Paint Shop Pro is picture straightening. Suppose you have a scanned picture like the one in Figure 10.5, but you put it in the scanner crooked, or you shot a landscape with a definite horizon while standing on uneven ground. To straighten it, use the straighten tool, which places a line on top of the photo. Drag one end of the line until it's parallel to the horizon, or imagined horizon. Double-click the image and it rotates the correct amount to level the picture. When you click somewhere else, the line goes away.

FIGURE 10.5
Photo editing in Paint Shop Pro. (Photo courtesy of Susie McLeod.)

The best news about Paint Shop Pro is that you can try it out, fully featured, for 60 days. Go to www.jasc.com/products/paintshoppro/? and look for downloads. If you decide you like it, you log on to Jasc's website and pay $99 for it. If not, the program will quietly expire when your time is up, and no, you can't keep re-installing it. It leaves behind a memo somewhere in your system that you've already installed it once, and you can't re-install without a key. Frankly, I wish more software companies used this approach.

Adobe Photoshop CS

Adobe Photoshop CS is the Rolls Royce of image editing software. Unfortunately, like the Rolls, it's priced accordingly. But your investment pays off if you're really serious about photography and graphics editing. It's really not as complicated as you might think, given the number of classes, video instructional materials, books, and whatnot dedicated to it. In fact, I can recommend an excellent book, *Sams Teach Yourself Photoshop CS in 24 Hours*. I know it's good. I wrote it. The interface, shown in Figure 10.6, is no more complicated than that of any of the other programs.

FIGURE 10.6
Adobe Photoshop CS on the Mac platform. There's also a Windows version.

Admittedly, some of Photoshop's more advanced tools and features, such as the ability to manipulate individual color channels, either RBG or CMYK, and to add your own Alpha channels, is not something the casual user ever needs. That's why Adobe took out the complicated stuff that most users never go near, reduced the price to under $100, and gave us Photoshop Elements.

Adobe Photoshop Elements

Adobe Photoshop Elements is more than just a stripped down baby brother to Photoshop. It's nearly as powerful, and has all of the features that make Photoshop so much fun and so rewarding to work with. There are both Mac and Windows versions, but unlike most cross-platform software, they are a bit

different. The difference is that the Windows version of Photoshop Elements includes an Organizer that sorts and files your photos. The Mac version lacks that. The screens are very similar. The tools are identical. As you can see in Figures 10.7 and 10.8, they are pretty much the same.

FIGURE 10.7
Adobe Photoshop Elements 3 for Mac.

FIGURE 10.8
Adobe Photoshop Elements 3 for Windows.

They look alike; they work alike. And they're the best possible tools for virtually anything you want to do with your pictures. Photoshop Elements is powerful, easily understandable, and affordable. That's why the rest of this book focuses on Photoshop Elements.

Other Photo Software

There are other programs that can do photo editing. VCW VicMan's Photo Editor is a new application for Windows that does basic editing and more. And the price is right: It's free. Check it out at www.vicman.net/vcwphoto/index.htm. Another freebie comes from Serif Software. PhotoPlus 5.5 is available for download at www.freeserifsoftware.com/serif/ph/ph5/index.asp. It's also just for Windows.

For the Mac, take a look at the shareware program GraphicConverter from Lemke Software. You can download it at http://www.lemkesoft.de/en/index.htm. This rather amazing little program was originally developed to convert graphics files from one format to another, and it still does that. At last count, it imports about 175 different graphics formats, and exports 75. That should cover just about any file you ever encounter. It'll even make .PDB files for your PalmPilot and .NGG files for your Nokia cell phone. But wait, there's more. This program, sort of a software Swiss Army knife, also can do image editing, including resizing, adjusting color balance, color depth, contrast, resolution, and sharpening. You can use it to browse folders of images, just by dragging the folder to the GC icon. It'll open up and display your pictures like slides on a light table, as in Figure 10.9. Would you rather watch them as a slide show? Select the pictures to include and click the slide show icon, or use Command+D to select an entire folder for your slide show.

There's a complete set of tools, including a clone tool, text tool, pencil and eraser, and all kinds of selection tools. It corrects red eye automatically, and has a bunch of interesting special effects, including two kinds of simulated color blindness. The shareware fee is only $30 and it's money well spent.

FIGURE 10.9
The GraphicConverter browser.

Summary

Even good pictures can use a little help. Cropping, color adjustments, and removing stray hair and blemishes are a matter of course for professional photographers. Some photos need even more work, and today's digital image software lets you do pretty much anything you can think of to a picture. There's sometimes a conflict between what you *can* do and what you *should* do. The general rule is that you can make needed corrections as long as they don't alter the content of the photo. You can digitally "wash" the toddler's face, but you can't turn her lollipop into a cigarette. There's plenty of software out there that can do these image manipulations. There are even free or low cost shareware programs that can often do as much as a commercial application costing a hundred dollars or more. Having tried most of them, I prefer Adobe Photoshop Elements for retouching and creative digital wizardry.

Welcome to Photoshop Elements

What You'll Learn in This Chapter:

▶ Opening Elements

▶ Getting Help

Adobe Photoshop Elements 3 is an amazing digital graphics program. It has tools that let you do virtually anything you can think of to a photo or any other kind of bitmapped art. Whoa! Only two sentences in and you're already encountering what may be unfamiliar words. Bitmapped? Digital graphics? Don't panic. It's really easy, and you'll be creating beautiful pictures before you know it.

The term *digital graphics* refers to any kind of graphic image—a photo, scanned art, even just a squiggle of color—that you've created or placed on an Elements page. Bitmapped graphics are shown on the screen as a mass of little colored bits or *pixels*. Each bit has a coded description of its color and position. If you make a change in one pixel—or a whole screenful—the computer will update the pixel descriptions and change the screen so you can see what you have done. Depending on how complicated the change is, and how much random access memory (RAM) your computer has available to do the math, your change may take anywhere from a fraction of a second to a minute or more.

Essentially, Photoshop Elements is a program that juggles numbers. Changing the numbers in the computer memory changes what you see on the screen. If you're good enough at math to know which numbers change, and by how much, you could make all those screen changes by hand. Most people aren't. (Besides, it would be terribly inefficient to make all the changes manually.) That's where Elements

steps in. Let's say you want to draw a red line about halfway down the page. You could figure out the positions of the pixels to change and change the color of each one from white to red. That's too much work. Let Elements do it. You just pick up a paintbrush, choose some red paint, and draw your line. There it is. The computer has taken all the math out of your hands and done the operation much faster than you could have on your own.

Now let's say you have a photo that's much too dark. If you were a photographer working in a darkroom, you would have to do some experimenting to find out how much lighter to print the photo. You'd probably find out that some parts need to be 15% lighter, some others 30% lighter, and some parts shouldn't change. You'd have to try to find a compromise and would probably waste several sheets of paper trying to get a good print. With Elements, you can look at the screen and lighten the image by moving a slider. More importantly, you can select and lighten specific parts of the picture without changing the rest. You've finally got control!

Photoshop Elements has two purposes: correction and creation. Use it to solve problems with pictures you've scanned or shot with a digital camera. Very few pictures are perfect right from the camera. You can recompose a picture by cropping away part of it. You can remove people or objects that shouldn't be there. You can make technical corrections for color, exposure, and even focus. Then you can get creative and have fun with it. Cure your kid's acne. Get rid of red eye. Change your lemons to limes, or your purple roses to sky blue ones. Liquify a clock face so it looks like one of Salvador Dali's dripping watches. Move your family group shot from the backyard to someplace more interesting. Add type to your pictures, remove backgrounds.... The only limit is your imagination.

Adobe Photoshop, despite being relatively easy to understand, is a heavy-duty professional hunk of software. Each revision (version CS is the most current) has added more tools and more bells and whistles for the pros. For its $650 price tag, you'll get a lot more features than most of us would ever use. Realizing that, the nice people at Adobe streamlined the software and created Photoshop Elements. They took out the more esoteric functions and added some nifty new ones, such as How To's: step-by-step recipes for all kinds of effects, tricks, and basic actions such as cleaning up a picture. They've given us almost the full power of Photoshop in a quick and easy-to-use program. Now there's no excuse for dusty scans, bad exposures, and other photographic sins. No more trees growing out of people's heads. No more faces too dark to see. Just picture after picture, better than you ever thought you could shoot.

You will understand the chapters that follow this a lot better if you read this book with your computer turned on and Elements open. When we go through some step-by-step processes, it's always best to work along instead of reading about it one day and then trying to figure it out the next.

By the Way

Opening Elements

Photoshop Elements opens with a Welcome screen, which gives you some choices to make regarding how you want to work. In the Windows version, shown in Figure 11.1, your choices are Product Overview, View and Organize Photos, Quickly Fix Photos, Edit and Enhance Photos, Make Photo Creation, and Start From Scratch. Users of Adobe Photoshop Album will recognize View and Organize Photos as being part of Album, integrated into the rest of the Elements package.

FIGURE 11.1
The Photoshop Elements Welcome screen (Windows version).

When you open the Mac version, shown in Figure 11.2, you may feel a little less welcome. There are only three options. You can Start From Scratch, Open File for Editing, or Connect to Camera or Scanner. Don't worry; these three will get you where you want to go. Adobe introduced Album last year, as a standalone photo cataloging tool. For reasons the marketing department never shared, they developed it only for Windows machines. So, when it came time to start work on Elements 3, there was no Mac Album equivalent ready to drop in. Mac people

simply have to find some other way to keep track of their photos. (Fortunately, your OS X Mac came with a great one.) We'll discuss some options in Chapter 16, "Keeping Track of Your Pictures with Photoshop Album."

FIGURE 11.2
The Photoshop
Elements Welcome
screen (Mac
version).

Meanwhile, in either version, you double-click the icon that represents what you want to do. On the Mac, if you choose Open a File, what you actually open is the File Browser, a slide-sorter that shows whatever pictures are in the folder you select. The File Browser is also present in the Windows version, but when you choose View and Organize you open the Organizer instead. Once you're in the Organizer, you can download pictures from your camera, scanner, PalmPilot, or cell phone. You can assign your photos to albums and mark them with keywords to help you find them.

Getting Help

The tools in Photoshop Elements are designed to make you feel as though you're dealing with the real thing, whenever possible. For instance, the paintbrush tools become pressure sensitive when you use a graphics tablet such as the Wacom Intuos2. *Dodging* and *burning*, which you might do in a real darkroom to lighten or darken parts of an image, are done in Photoshop Elements with tools that not only work the same way, but whose icons even look like their real-world counterparts. The Photoshop Elements desktop, which is where you end up if you choose Start From Scratch, is far less cluttered than my real one, and has a toolbox, the

usual menu bar, and a bar of shortcut buttons for actions, such as opening a new page, saving, and printing. (See Figure 11.3.) The Shortcuts bar also has what Adobe calls a palette well, where you can store palettes that you aren't immediately using. When you click on their file tabs, they'll pop open for you.

FIGURE 11.3
The Photoshop Elements desktop (Mac version).

When you open Elements, you will probably notice several windows arranged along the right side of the screen. These are called palettes. Each one has a particular function. Hints and How To's are information palettes. The Layers and History palettes hold lists. History has a palette entry for each step you take in correcting your picture. It lets you choose an earlier step and revert to it, effectively giving you the ability to undo multiple changes, or jump back again and redo them, if you haven't done something else instead. The Layers palette keeps track of whether each layer in a file contains type or an image, and in what order the layers should be displayed. The Color Swatches palette is a paint box. All of these are carefully designed to be user-friendly. You can generally guess what they do by looking at them, and if not, help is at hand.

Tool Tips

The most basic helper is one you should start to use immediately. (By the way, as I suggested in the introduction to this chapter, it's really a good idea to sit in front

of the computer, with Elements active, while you read this book. You need to be able to try things out as they come along.) Figure 11.4 shows some tool tips. They are like little yellow sticky notes that pop up on the screen if you hold the cursor over any tool, icon, or dialog box caption. They are extremely helpful if you're not sure what something does. A tip gives you either the name of the tool, or if that's obvious, its function.

FIGURE 11.4
Tool tips pop up within a couple of seconds.

If you don't see the tool tips popping up, open the General Preferences window and make sure that the Show Tool Tips option is checked. (In Windows, select Edit, then Preferences, then General. Mac users, Preferences are, as usual, on the first Photoshop Elements menu.)

Did you Know?

Recipes

If tool tips don't tell you enough, or if you want some step-by-step directions, open the How To palette. Here you can find lists of "recipes" for common Photoshop functions such as "Change an Object's Color," or "Rotate an Object." Figure 11.5 shows an example of such a recipe.

As you can see, the recipe steps even have Do This Step for Me buttons, so you can make the task absolutely foolproof. If you're in a hurry or feeling lazy, just use the recipes that Elements provides. If you don't see exactly what you're looking for, or if you just want to keep up to date, open the pull-down menu at the top of the palette and choose Download New Adobe Recipe Items. You'll be connected to Adobe's website, where you'll find a list of all the latest recipes and How To's.

FIGURE 11.5
Recipes are reduced into simple steps.

You'll notice an arrow labeled More on this and other palettes (see Figure 11.6). *Always* click it to see what's there. It will take you to other options, allow you to put the palette away, and possibly give you access to additional commands.

FIGURE 11.6
A menu pops up when you click the More button. This one's the Layer menu.

The Help Button

When all else fails, and you don't even know what it is that you don't under-stand, click the big question mark icon on the Shortcuts bar or type your question into the small window provided on the bar. (See Figure 11.7.) You needn't use proper grammar, just find a couple of words that come close to your question. Of course, the more specific you are, the fewer topics you'll have to wade through. "Setting Type" gave me well over 100 entries.

FIGURE 11.7
"Setting type" list all topics that include those words, or anything close.

The question mark button will take you to the beginning of the program's excel-lent Help manual. Enter a topic if you know what you're looking for, or just scroll through until something looks relevant.

For more information, choose Photoshop Elements Online from the Help menu. This takes you directly to the Elements website. This is where you'll find program updates, if any, as well as tips, tutorials, and more.

Check out Elements-friendly websites, such as www.planetphotoshop.com and www.photoshopuser.com. And, of course, you can try writing to me (author@graphicalcat.com). I don't promise to answer every question that comes in, but if your question's a good one, I'll give it my best shot.

Summary

Adobe Photoshop Elements can do nearly everything its big brother, Photoshop, can do. It's not complicated, and there's help whenever you need it. Holding the cursor over an unfamiliar tool opens a tool tip that tells you the name or func-tion of the item and offers a keyboard shortcut, if it has one. Recipes make tasks such as fixing a faded photo and removing dust and scratches a snap. In many cases, you just click Do This Step for Me, and it's done. Help screens open in your browser, and also give you direct access to Adobe's website, where you can down-load additional recipes, program updates, and more.

CHAPTER 12

A Tour of the Desktop

What You'll Learn in This Chapter:

- ▶ Finding Your Way Around
- ▶ Understanding the Shortcuts Bar
- ▶ Starting a New Image
- ▶ Using the Tools in the Toolbox
- ▶ Understanding the Options Bar
- ▶ Using the Menus
- ▶ Taking a Look at the File and Edit Menus
- ▶ What's on the Edit Menu?
- ▶ Taking a Look at the Image Menu
- ▶ Taking a Look at the Enhance Menu
- ▶ Taking a Look at the Layer Menu
- ▶ Taking a Look at the Select Menu
- ▶ Taking a Look at the Filter Menu
- ▶ Taking a Look at the View Menu
- ▶ Taking a Look at the Window Menu
- ▶ Using the Photo Bin
- ▶ Setting Preferences

Luckily for us, the Adobe Photoshop Elements 3 working environment is a desktop, rather than a smelly, messy darkroom. It used to be that going into the darkroom was the only way you could do much of anything with a photo. That's why there are so many shoeboxes full of bad photos in so many attics, basements, and forgotten closets. Begin now to think about where they are. Pretty soon, you'll want to find them and fix them.

Finding Your Way Around

Let's start by looking again at the Elements desktop shown in Figure 12.1. As with most other programs, there is a menu bar at the top. Next, there's a Shortcuts bar and beneath it, an Options bar. At the left is the toolbox and on the right end of the Shortcuts bar is the palette bin. Rulers may or may not be displayed in the image area as shown here; their display is controlled by a command on the View menu, which is discussed later in this chapter.

FIGURE 12.1

Your desktop should look something like this.

Shortcuts bar Options bar

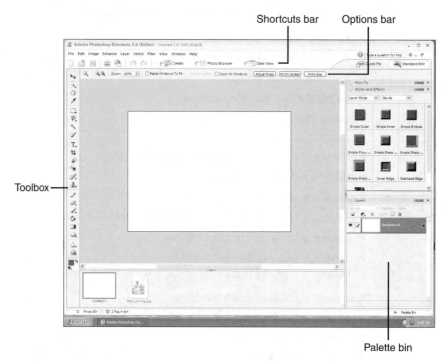

Toolbox

Palette bin

By the Way

It's possible that your toolbox and/or tool options bar may be hidden. You can toggle them on and off from the Window menu.

There may or may not be palettes open on the right side of the screen. As you learned in the last chapter, a palette is a kind of window that gives you information about your project or lets you choose from a display of colors or styles. We'll look at the menus and tools in a moment. For now, let's jump ahead a step to the Shortcuts bar.

Understanding the Shortcuts Bar

The Shortcuts bar, shown in Figure 12.2, simplifies your workflow by providing buttons that correspond to the most common functions located on other menus. If you've used other software with similar button bars (Microsoft Word, PowerPoint, and Excel have them, to name just a few) then these buttons will be very familiar. The icons on the buttons should help you remember what's what. The blank page icon, of course, means New Image, and the partly open file folder icon stands for Open. The same folder icon plus a magnifying glass initiates a search by opening the File Browser. (Windows users have a different Photo Browser icon, with an arrow and a page of images.)

FIGURE 12.2
The Shortcuts bars for Mac (top) and Windows (bottom), shortened to fit the page.

The floppy disk (well, maybe it's more like a Zip disk...) icon means Save. When you click it, a dialog box opens. You can choose to save the file in any location you like. The Printer icon, obviously, opens the Print dialog box. The combination envelope and globe stands for Attach Photo to E-mail. Clicking it opens the dialog box shown in Figure 12.3.

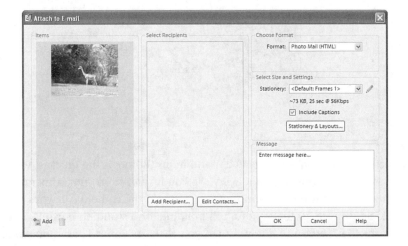

FIGURE 12.3
This uses your regular email program to look up addresses and to actually send the mail.

Enter your email message in the window provided, and specify the recipient. Photoshop Elements does the rest. It makes sending off those new baby pictures, or anything else you want to share quickly, as easy as clicking.

The Step Backward and Step Forward buttons are equivalent to the Undo and Redo buttons you may have used in other programs, such as Microsoft Word. With them, you can undo the last action, and then redo it if you don't like the result. If you need multiple undos, there's the Undo History palette, which we'll cover later on.

Clicking the Quick Fix icon (a stopwatch and photo) displays a large dialog box that shows you your picture and provides fast access to several image correcting tools. It's shown in Figure 12.4. The first thing you may need to do with this window is to go to the lower left and use the button to change the view so you can see both before and after views of your corrections.

FIGURE 12.4
Quick Fix streamlines the repair process when all you need is a little color work and maybe some red eye correction.

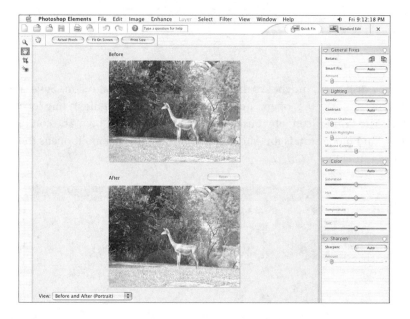

The General Fixes category offers two useful items. Rotate is the quickest way to make those vertical shots vertical. Every file you import from your camera comes in as horizontal, even though you may have turned the camera sideways to get the whole lighthouse, or the top of a tall building, or a standing portrait. This button turns them around for you. When you click the Smart Fix button, you let Elements take over and make the corrections it thinks are necessary. These

include color balance and saturation, as well as shadow and highlight detail. Use the slider below the button to fine tune the corrections. Don't overdo it.

Mac users: You'll see something that may horrify you in this, and some other Elements windows. Our familiar red, yellow, and green buttons are gone, replaced with a dreaded X in the upper-right corner, the mark of the Evil Empire. Unless you're ready to save and close the file you're working on, don't click the X. Use the Standard Edit icon to go back to the regular desktop.

Watch Out!

The Lighting category adjusts levels and contrast, either automatically to whatever standards the Elements programmers think is correct, or by using your own judgment to drag the sliders until the picture looks right. You can adjust shadows, highlights, and midtones separately.

The Color adjustments let you change hue, saturation, temperature, and tint. Saturation determines the strength of the color. In the "real" art world, it would be akin to how much actual pigment you mix with water in a water color painting. Increasing saturation gives you brighter colors. Changing hue can be fun for special effects, but it's less effective here when applied to the whole picture. I suggest using it from the Standard Edit view, where you can apply it only to selected objects or areas. Use the color temperature slider if you want to warm up the quality of light in a scene, or cool it down. Its effect is achieved by adding more red (warmth) or blue (coolness) to the picture. Tint does the same, only adding magenta or green instead of red or blue.

Last, but far from least, is the Sharpen button. It enhances the apparent sharpness of your pictures by increasing the contrast between adjacent light and dark pixels that are already significantly different. In other words, it looks for edges and enhances them. If you elect to use the slider to set sharpening, be careful. Over-sharpening looks ugly.

On the left side of the Quick Fix Window is a toolbox with four tools: the magnifying glass, which zooms in and out on your picture; the Hand tool, which moves it on the screen; the Crop tool, which lets you edit out part of the picture by dragging a frame around the part of it you want to keep; and finally, the Red Eye brush, which darkens eyes that appear to glow because they reflect the camera flash.

The Tool Options bar across the top of the frame lets you set options for these four tools. It changes according to the tool currently selected. When you're done with Quick Fix, click the X to open a Save dialog box, or click the Standard Edit icon to go back to the regular Elements desktop.

At the far right of the Shortcuts bar are two small icons that toggle back and forth between tiling all of your open images so you can see several at once, or showing them one at a time on the desktop. The palette bin, at the right side of the screen, holds as many individual palettes as you need to use when working on a picture. They can be opened and closed by clicking on their arrows, or removed from the bin by dragging. If you remove one, and then want it back, select it from the Window menu and double-click to reinstall it in the bin.

At the bottom of the screen is the Photo bin, another way to see all of the images you have open. You can close the bin if you'd rather have more space for the picture on which you are working, and reopen it from the Window menu.

Starting a New Image

In a little while we are going to need a blank image file to try some of our tools on. Let's create one now, using the Shortcuts bar. We'll work with other kinds of images and other ways to create them in the following chapters.

1. Point your cursor to the New button.

2. Click once to open the New dialog box shown in Figure 12.5.

3. Click on the Preset Sizes drop-down list and choose Default Photoshop Elements Size.

4. Check to see that the White option in the Contents area of the dialog box is selected.

5. Click OK or press Return and the new page will open.

FIGURE 12.5
Your dialog box should look like this.

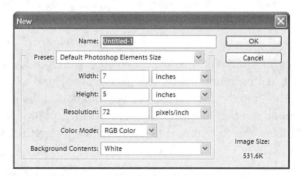

Now you have a blank image on your desktop, and we're about to look at the tools.... Go ahead and try them out. You can't break anything. Select something.

Draw something. Paint a heart and move it around the screen. Try some colors. When the image gets too full, press Cmd+A (Mac) or Ctrl+A (Windows) to select everything. Then delete it by pressing Delete and start over again.

Using the Tools in the Toolbox

Our next stop is the toolbox, at the left side of the screen. For reference, it is shown in Figure 12.6. It's like an artist's work table or paint box that holds all the tools you'll use to draw, paint, erase, and otherwise work on your picture. There are sets of tools to select, to draw and paint, to blur and sharpen, and to place type in the picture. The toolbox can be displayed as either a long single strip of tools or a shorter double strip. Either way, it has the same tools. Click the dots at the top of the bar to change the display.

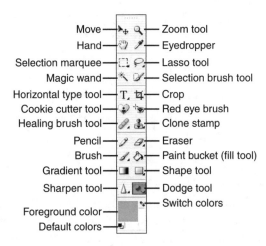

FIGURE 12.6
You must first click on a tool to select it.

The toolbox has additional tools hidden wherever you see a black arrowhead. Click and hold on any tool with an arrowhead, and the additional tools associated with it will pop out on a short menu. Figure 12.7 shows the tools that are normally hidden under the Type tool.

Utility Tools

If you look carefully at the tool box, you can see thin lines that divide it into different sections. The top section holds what I call utility tools: the Move tool, Hand tool, Zoom tool, and Eyedropper. The Move tool drags a selected object to some other part of the page. The Hand moves the entire page, or that portion of the

page that's shown on the screen in a magnified view. The Zoom tool enlarges or reduces the image. Click it on the picture to increase magnification. Hold down the Option/Alt key as you click to decrease it. When you zoom in, the picture is usually too big to see all at once. The Hand moves it within the window and is helpful after you use the Zoom tool to enlarge the picture. Use the Hand to slide the part of the picture you want to see or work on into a convenient spot. The Eyedropper picks up a sample of color, which you can make the active color or add to your Swatches palette.

FIGURE 12.7
You will learn about working with type in Chapter 19, "Adding Type."

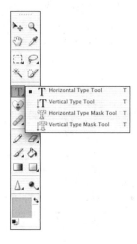

Selection Tools

The next section of the toolbox contains a group of tools called Selection tools. They are used to select all or part of a picture. There are four kinds: the Marquees, the Lassos, the Selection Brush, and the Magic Wand. When you select an area of the screen with the Marquee tools, a blinking selection border surrounds it. (The Marquee tools are named after the lights on movie theater marquees that flash on and off.) There are two marquee tools. Click the tool in the toolbox to open the pop-up menu that allows you to switch between the rectangle and ellipse. The Marquees make their selections as you click and drag the tool over the part of an image you want to select, drawing a box or circle.

The Lasso tools--three in all--draw a line as you click and drag the tip of the lasso across the page. Draw part of a free-form shape, and Elements will complete the shape automatically with a straight line from where you stopped back to the start. There are also Lassos to select by drawing straight path segments instead of a free-form line, and to select "magnetically" by separating an object from its

contrasting background. Figure 12.8 shows the selections that result from using these tools.

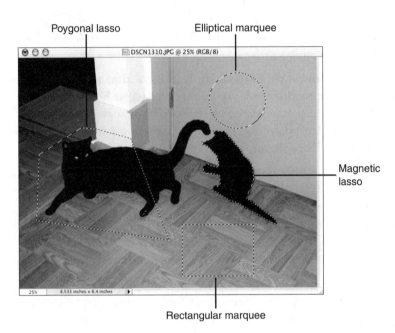

Poygonal lasso Elliptical marquee

Magnetic lasso

Rectangular marquee

FIGURE 12.8
Each Lasso tool makes a different kind of selection.

The Magic Wand tool selects by color. You can set the amount of similarity it demands, and just click to select all pixels of that color, or all adjacent pixels that match.

The Selection Brush simply selects anything you paint over. Given that there are hundreds of standard paintbrushes, plus any you design yourself, this tool can be enormously flexible. Select it and drag your paintbrush over anything you want to turn into a selection. This tool doesn't exist in the "big" Photoshop program. I wish it did. You can use it to create masks over areas you want to protect when you're changing another part of the image. For instance, say you're working on a portrait of a lady, and you need to lighten her hair without bleaching out her face. Paint around the hair, or if it's easier, paint only the hair and then invert the selection so you've selected everything but the hair. If that sounds a little confusing, don't worry. We'll work more with selections in Chapter 17, "Making Selections and Using Layers," and again when we get into photo repair.

Miscellaneous Tools

I'm not sure how to categorize this section of the toolbox. It has the Type tool, the Crop tool, the (new in this version) Cookie Cutter tool, the Red Eye Removal tool, the Healing Brush tool, and the Clone Stamp tool. You'll find yourself using these tools a lot for photo repair.

The Type tool puts type on the page. It uses the same fonts that your word processor and other programs use, and can set type either horizontally or vertically, and can "warp" it into arcs, waves, and other funky shapes. There's also a type mask tool that selects whatever's on the layer below as a selection marquee, so you can cut type out of a photo, filling the letters with pictures.

The Crop tool, which looks like the paper cropping frame you made back in Chapter 4, "Seeing Photographically," works just like the rectangular Marquee tool, in that you drag a bounding box to surround the part of the picture you are keeping. When you do so, the area outside the box turns gray. You can drag a side or a corner to make the bounding box bigger or smaller. When you're done adjusting the box, double-clicking in the box removes everything outside it.

The Cookie Cutter tool uses the same masking principle as the Type Mask tool. Instead of letters, though, it cuts shapes from your photo. Elements comes with a generous selection of shapes, all the way from animal silhouettes, to musical notes, ornate frames, and even cartoon characters. The shapes work with both the Cookie Cutter tool and the Shape tool. Don't confuse these two. The Cookie Cutter removes the background and leaves only the shape you cut from it, while the Shape tool draws a shape that you can stroke (leaving an outline) or fill.

The Red Eye Removal tool and the Healing Brush and Spot Healing Brush are very helpful for retouching. The Red Eye tool simply finds the odd color and replaces it with the correct eye color. Two clicks and your "devil eyes" photos can be pictures of saints. We'll cover their use in Chapters 18, "Working with the Brush Tools," and 22, "Removing Red Eye, Dust, and Scratches."

The Clone Stamp tool copies a piece of the existing picture and pastes it somewhere else. It uses the paintbrush tool's size and shape. You can stamp (or paint) with a soft-edged brush or a hard one, in any size from a single pixel on up.

Painting Tools

Elements has an impressive set of Painting tools: Brushes, a Pencil, an Eraser, and Paint Bucket and Gradient tools. These all apply color to the screen in one way or another, just like the real tools they imitate. You can change the width and angle

for the Pencil and Brush tools. The Brush tool and the Impressionist Brush share a space in the toolbox. The latter simulates different kinds of brushstrokes. Though there isn't a lot of use for it in photo correction or enhancement, it's fun to play with. Many of these tools are covered throughout this book, in chapters that discuss how to make specific types of repairs on photos.

There are also various erasers that, as you might expect, take away part of the picture. You can use a block eraser, or erase with any of the paintbrush or airbrush shapes. There are two special-purpose erasers, the Background and Magic Erasers. Use them to automatically erase a selected part of the image. The Paint Bucket, also called the Fill tool, pours paint (the foreground color) into any contiguous area you select. (If no area is selected, it'll fill the whole image.) The Gradient tool lets you create backgrounds that shade from one color to another, or even all the way through the color spectrum.

Lastly, there is a Vector tool that draws shapes (the Custom Shape tool) as vectors. These are shapes defined by their outline rather than as bitmaps (tiny dots that form a shape). When you use these tools, you don't get the jagged effect you otherwise would when building an object from individual pixels because a vector image can be resized and its resolution adjusted without any effect on the clarity of the image. Figure 12.9 shows the difference between bitmapped and vector text and drawn lines. As you can see, the bitmapped text is ragged around the edges, especially when it's enlarged. Look closely at the curves of the b, t, m, a, p, e, and d to see this effect. The bitmapped line shares the same fate--it has bumps along its sides. The vector text and line, on the other hand, is quite smooth, regardless of the size at which you view it. Similarly, the vector shape scissors are smooth. When I made them a bitmap, they turned into pinking shears.

FIGURE 12.9
Vector type versus bitmapped type.

Toning Tools

Toning tools are tools that sharpen, blur, and change the intensity of the image. The Blur, Sharpen, and Smudge tools change the level of focus and the Dodge, Burn, and Sponge tools change the degree of darkness or lightness and saturation of selected pixels.

Colors

Finally, there are two large blocks of color displayed at the bottom of the toolbox. Photoshop Elements calls them swatches. They are your foreground and background colors, and by default they are black and white, respectively. Change them by clicking once on the appropriate square to open the Color Picker. There, you can click to select any color you like. The foreground color (logically, the one on top) is the color you'll apply when you paint a brushstroke, place type, or do anything that leaves a mark on the page. You can, of course, also click on a color from the Color Swatch palette.

Tool Shortcuts

You can select any of these tools by clicking its icon in the toolbox, but Elements gives you another, even easier way to access the tools. Instead of clicking the tools you want to use, you can type a single letter shortcut to select each tool. To toggle through the available tools where there are pop-up menus, press Shift plus the shortcut letter until you reach the tool you want. Table 12.1 lists the tools with their shortcuts. Dog-ear this page so you can refer to the table until you have memorized the shortcuts.

TABLE 12.1 Tools and Their Shortcuts

Tool	Shortcut	Tool	Shortcut
Move	V	Pencil	N
Zoom	Z	Eraser	E
Hand	H	Brush	B
Eyedropper	I	Paint Bucket	K
Marquee	M	Gradient	G
Lasso	L	Shape	U
Magic Wand	W	Sharpen	R
Selection Brush	A	Blur	R
Type	T	Smudge	R
Crop	C	Dodge	O
Cookie Cutter	Q	Burn	O
Red Eye Brush	Y	Sponge	O
Healing Brush	J	Switch Colors	X
Clone Stamp	S	Return to Default Colors	D

Understanding the Options Bar

Every tool in the toolbox has many settings. For example, you're not stuck with a tiny little pencil and a big fat brush as your only drawing tools. You can make the exact tool you want by simply changing the way it behaves using the Options bar. You can change a tool's degree of opacity (the degree to which the tool obscures the part of the image you use it on) and blending mode (the degree to which the tool's color blends with the existing colors in the image), and select from libraries of shapes and textures and styles. You can also save and store your own brushes and reach them via the Options bar. Note that the Options bar changes with each different tool you select. For example, Figure 12.10 shows the Shape tool Options bar with a drop-down menu. This one displays part of the library of shapes included with Elements.

FIGURE 12.10
There are all sorts of pop-up menus and pull-out menus on each Options bar. Be sure to explore.

Typically, these drop-down menus will also have a submenu attached. To open it, click the right-pointing arrowhead at the top of the menu. As you explore Elements, try clicking arrows or buttons whenever you see them to find out what they do.

Using the Menus

If you have used any kind of computer software written in the past 20 years, you have used menus. The menus across the top of the Elements screen contain the commands that enable you to open and manipulate files. Access them by clicking the name of the menu to open it, and then selecting the desired command from the list. Whenever you see an arrow or an ellipsis (...) to the right of a menu command, it indicates that there is something more than just that command available. A right-pointing arrow indicates that there's a submenu. An ellipsis means that the menu item leads to a dialog box. Figure 12.11 shows the Elements File menu.

FIGURE 12.11
The Elements File menus for Mac and Windows. Note the arrows and ellipses.

It's no coincidence that you'll find the same set of commands, more or less, on any File or Edit menu, and that the Mac and Windows cut, copy, and paste commands are the same. One of the things that makes computers easy to use is the notion of a universal user interface. That's a fancy way to say that you do the same things the same way in all programs. Cmd/Ctrl+N always starts a new page, Cmd/Ctrl+Q always quits, and so on. This makes learning a new program simpler. Adobe's taken that even further, in that all Adobe graphics software uses the same tools and working methods. If you master using layers in Elements, as I am sure you will, you'll also know how to use layers in InDesign or Illustrator. As

you work your way through this book, you will get a head start on learning the rest of the Adobe software. Similarly, if you already use Illustrator or PageMaker, or even Premiere, you'll find that you already know a lot about Elements. Of course, there's always something new to learn.

Taking a Look at the File and Edit Menus

The first two Elements menus are File and Edit. The File menu lets you work with files: opening, closing, saving, importing, exporting, and printing them, and, of course, quitting the program. Here's where you can select several sequential shots to stitch together a panoramic photo. Here's where you can choose to email a picture to your friends.

The New option opens a blank screen on which you can paint or drag images from other open windows. Open will bring up a dialog box that lets you locate any specific graphics file and open it. Finding these files isn't always easy, however (especially if you're like me and forget what you called the shot the first time you saved it). That's why there's a browser.

Using the File Browser

You can open the File Browser by selecting Browse Folders from the File menu or File Browser from the Window menu, by using its key shortcut (Cmd+Shift+O [Mac], Ctrl+Shift+O [Windows]), or by clicking Browse for File in the Welcome Screen. Use it to locate and open your photos and other images. When you open the File Browser, you can search any of your graphics folders by selecting them. After you've selected a folder, thumbnail-sized views of all its pictures will appear as if they were slides on a sorting table. Figure 12.12 shows the setup. To open a picture, just double-click on it. If you select a picture and don't immediately double-click, you'll also see all the information available about the picture, including its size, color mode, date and time it was shot, make and model of camera used, whether the flash is enabled or not, shutter speed, and a lot more than you'll ever need to know. Slide the partitions to make the information window smaller, and then you can see more thumbnails at once.

You can change the order in which the images are sorted by clicking the Sort By button and making a selection from its menu. To change the size of the thumbnails, click the View By button and make a selection. You'll learn more about the File Browser in Chapter 13, "Handling Photoshop Elements Files."

Elements will also display disk icons, folders, applications, and whatever else it sees in the folder you select. Use the folder hierarchy to navigate down to the level where your picture is. The nice thing about the File Browser, as opposed to other image-indexing methods, is that when you find the image you need, you can just double-click, and you're ready to work.

FIGURE 12.12
You can find any photo you need with the File Browser.

What's on the Edit Menu?

The edit menu in Elements has a lot in common with the one in your word processor. Figure 12.13 shows both the Mac and Windows versions. You'll find Undo and Redo, Cut, Copy, Paste, Delete, and some other familiar commands. There are also the Stroke and Fill commands, which outline or fill a selection with the color or pattern of your choice.

You can also use the Edit menu to create a new brush or to add a pattern to the Pattern palette by selecting it and using the menu item to save it. Windows users should take note that their Preference dialog boxes are included in the Edit menu.

FIGURE 12.13
The Cut, Copy, and Paste commands are the same in all programs.

Taking a Look at the Image Menu

The Image menu has the commands to do what I'd consider "physical" things to the picture. Turn it sideways, flip it, rotate a single layer or the whole image, distort it, make it bigger or smaller.... You get the idea. Figure 12.14 shows the Mac and Windows Image menus.

FIGURE 12.14
The Image menu lets you make changes to the size, shape, and orientation of the image.

Rotate

Cameras and monitors are designed to work with horizontal rectangular images, or pictures that are wider than they are tall. But not all pictures have that shape. Suppose you are visiting New York and want a shot of the Empire State Building. First, you find a spot where you can see the whole building. If you hold your camera normally, you'll have to step backwards all the way to New Jersey before you'll be able to see the top of the building, and of course, you will have several blocks worth of other stuff on either side. Instead, if you turn the camera sideways, you change the format to vertical, and you can see a lot more of the tall building with a lot less of the neighborhood. Of course, when you get the photo

back home and open it up in Elements again, it's sideways. It's not very practical to rotate the monitor. For one thing, it weighs a lot more than a camera. That's why you'll use the Rotate commands shown in Figure 12.15.

FIGURE 12.15
Rotate the entire image or rotate one layer at a time.

As you can see, there are many Rotate options. For Custom, enter a number of degrees and choose left or right. You need to be aware of the difference between rotating and flipping. When you rotate, you move the picture around its center point. Flipping draws a midline axis and flips the image relative to it. The difference is apparent when you look at the examples in Figure 12.16.

FIGURE 12.16
The original image, on top, has been rotated 180 degrees on the left and flipped on the right.

Transformations

Transformations occur within the theoretical perspective of a bounding box and are used to warp an object or selection. A bounding box is very much like a marquee. It's a rectangular selection box placed over the object to be transformed.

Each corner and the center point of each side of the box has a small square called a handle. When you drag a handle, only the lines connected or related to it will move.

The Transformation options available in Elements are

▶ Free Transform—Apply multiple transformation techniques at one time, including skew, distort, and perspective

▶ Skew—Tilt the image horizontally or vertically

▶ Distort—Pull the image in any direction

▶ Perspective—Push the image backward or pull it forward along the third dimension

Figure 12.17 shows some examples. You can see in the bounding box at the bottom right that we're using perspective. The two side lines are of equal length, and the two angles on each side are complementary (they add up to 180°).

FIGURE 12.17
Upper Left: Original. Upper Right: distorted. Lower Left: Skewed. Lower Right: Perspective.

Even though these shapes look jaggy when you distort them, as soon as you simplify the layer they'll be rendered smooth. That's one of the advantages of vector art.

By the Way

Divide Scanned Photos

This command, new in Elements 3, is a very useful one, allowing you to scan a bunch of small photos or objects at the same time, and then cut them up into separate files.

Crop/Resize

Cropping is usually the single most important thing I do to a photo. You can't always stand where you should when you take a picture, so you may not be able to compose your shots in the camera. Cropping gives you a chance to correct them. It also lets you reshape a picture to emphasize a different part. We'll talk more about the theory and uses of cropping in Chapter 20, "Cropping and Resizing a Photo." Resizing is the process of changing the size of the image. When you resize an image, you make it bigger or smaller. Resizing the canvas adds space around the image or cuts away some of the picture, as if you'd used the cropping tool. There are many things you have to consider when you do this. Will your picture be seen in print or on the screen or both? Screen resolution becomes a factor here. There are right ways and wrong ways to resize. You can also keep the image the same size and in effect add more space around it by resizing the canvas. In Chapter 20, we'll also deal with shrinking and stretching the canvas.

Modes

Mode allows you to convert a full-color photo to grayscale or to indexed color, the kind used on the Internet. The four color modes available in Elements are bitmap (which is 1-bit black and white), grayscale (256 grays), RGB, and indexed color. When you work in color, as you will most of the time, stay with RGB. Indexed color is for web use, and since the adoption of JPEG compression, it isn't often used except for line art (simple drawings of relatively few colors) or spot color (a method of identifying the exact color desired in a section of a graphic image, typically by selecting a Pantone color from a chart).

Taking a Look at the Enhance Menu

As the name of this menu suggests, these tools will improve your pictures. A little brightening here, a more intense shadow there.... But that's not all. You will find yourself doing a lot of your photo corrections from this menu, too. The kinds of problems solved here are mainly things that went wrong inside the camera or scanner—bad exposures, dull colors, the wrong colors—and these are all things that you can fix with a few clicks. The first four menu items, as shown in Figure 12.18, are all automatic corrections. If you're not too fussy, these are usually okay. Elements studies the picture, does some esoteric math, and tries to bring everything up or down to an ideal set of numbers. Well, sometimes ideal isn't what you want, and sometimes the program's idea of perfection isn't yours. Try these settings, but be prepared to undo them. You can make the same changes yourself to the degree that you think right.

FIGURE 12.18
The Enhance menu for Mac and Windows.

Well, I don't know about you, but I'm kind of hard to please. I'd much rather make my own decisions. That's why I mainly use the last three items on the Enhance menu and avoid the Auto ones. If you're in a hurry, or not quite sure what you're doing, the auto corrections are generally pretty close.

Adjust Smart Fix

Adjust Smart Fix doesn't actually let you fiddle with the corrections, just the strength at which Elements applies them. If you try Auto Smart Fix, and think it's fixing things that ain't broke, you need to undo the auto correction and open Adjust Smart Fix. Use the slider to moderate the amount of correction. I find that the formula Elements applies is sometimes way overdone. This dialog box lets me back it down to something more reasonable.

Adjust Lighting

The submenu includes Brightness/Contrast, Highlights/Shadows, and Levels. The first two use sliders to apply correction. Levels is simply a histogram showing the range of lights and darks in an image. You can adjust the white and black points in a photo for optimum contrast.

Adjust Color

This is another very useful set of submenu items. Here you can remove a color cast, adjust hue and saturation, remove color from an image, or replace one color with another. Life handed you lemons and you want limes? Change them here. Color cast is the "official" name for the blue, red, or sometimes yellowish tint that old or improperly stored pictures can develop. Getting rid of it simply requires finding a bit of the picture that you know is supposed to be black or white and clicking on it. The rest happens by magic.

Color adjustments and lighting adjustments can be a big help, both when you are trying to rescue a badly lit photo, and when you are trying to create a scene from several composite photos or from scratch.

Color Variations is one of my favorite color adjustments. We'll deal with it in detail later on, but for now, you should know that it lets you see what your picture would look like with more or less red, green, or blue added, or made lighter or darker, or the colors more or less saturated. Since you can make all of these adjustments easily, by eye, it's probably the single most versatile tool in Elements, and in my opinion, the coolest.

Taking a Look at the Layer Menu

Layers are useful, so much so that they have an entire menu and a half chapter of this book devoted to them. That's plenty. If you have burning questions, jump ahead to Chapter 17, "Making Selections and Using Layers." You won't hurt my feelings.

Taking a Look at the Select Menu

You've already used the Selection tools. The Select menu (shown in Figure 12.19) has commands that will make them easier to work with. The Inverse command is especially useful, as it lets you make a selection and then invert it, selecting everything but the originally selected object.

FIGURE 12.19
The Select menu allows you to refine and alter selected elements of an image in various ways.

The ability to invert a selection can save you tons of time when you need to select a complicated object on a plain background. Instead of lassoing the object, click on the background with the Magic Wand tool. That selects it. If you need to combine several selections, press and hold the Shift key as you work. When everything but the object is selected, press Cmd+Shift+I (Mac) or Ctrl+Shift+I (Windows) to invert the area of selection.

Taking a Look at the Filter Menu

This is the fun menu. Expect to spend at least two of this book's chapters and many hours of practice time on the contents of the Filter menu, especially if you also add on some third-party filters. If you count the different kinds of Liquify, there are close to 100 filters on the Elements menu. You could learn one a week for the next two years and not run out of things to do.

> The Filter Gallery (at the top of the Filter menu) displays examples of each of the filters applied to a typical image. If you forget what a particular filter does, take a look here. You can also shop here for the filter look you want.

By the Way

In this version of Elements, there's a new addition to the Filter menu: Adjustment. The items on the Adjustment submenu are mainly used for special effects. Invert and Posterize are easily the most useful. Invert takes a positive image in black and white and coverts it to an artificial but correct negative. It also does strange and amazing things to color by rotating the color wheel 180°. Posterize reduces the image from full color to a given number of colors, based on the sum of the average number of colors being converted. All the fancy math can often result in a beautiful picture. Figure 12.20 shows four levels of posterization (four levels of brightness for each color channel: red, green, and blue). Reducing the levels of brightness for each color creates large areas of a single color, removing the subtleties of color from an image and making it appear flatter. Be sure to see this in the color section. You'll learn how to use posterization in Chapter 32, "Going Wild with Your Images."

In addition to the Elements filters, there are hundreds more. Some are shareware or freeware. Others can be bought from a computer store or online software vendor. After you have installed them, they also show up at the bottom of this menu.

FIGURE 12.20
The lower the number of levels, the more simplified the drawing becomes.

Taking a Look at the View Menu

You can't do much if you can't see what you're doing, especially in photo repair. Fortunately, you can zoom in and out on your pictures with a mouse click or a key combination. It's not an infinite zoom. Each mouse click enlarges or shrinks the image to a certain percentage of its original size. You can view at 25%, 50%, 66.7%, 75%, 100%, and so on up to 1600%. The menu also has a command to fit the picture to the screen, even though that may not be a precise percentage enlargement.

Grid and Rulers are also included in the View menu. The Mac and Windows versions are shown in Figure 12.21. The Grid has a "snap-to" feature that you can toggle on and off from the menu. When it's on, if you try to align a line of type to a certain point, the grid will move it to the closest vertical and horizontal lines. Depending on where you want the type, that may or may not be helpful. Turn it off if it's a nuisance.

FIGURE 12.21
These commands are used so often it saves time to learn their keyboard shortcuts.

Taking a Look at the Window Menu

The Window menu, shown in Figure 12.22, actually tells you what all those windows and palettes and things on the screen are. Images, the topmost item, lets you arrange the way multiple images are displayed on the screen. You can tile them, cascade them, match the degree of zoom in all of them, and so on.

Next, you have the option of toggling the toolbox and the Shortcuts and Options bars on and off. I suggest leaving them on, unless you have a good reason for not wanting them to clutter up the scenery.

In the next section of the Window menu, there's a list of all the palettes available in Elements. Because they are also conveniently docked in the palette bin, you needn't come here to open a palette. You can just double-click the desired palette in the bin and the palette will remain open as long as you need it. If a palette disappears from the bin, you can reinstall it by selecting it, and then dragging the palette back to the bin.

Taking a closer look at the Swatches palette in Figure 12.23 (which you can display by choosing Window, Color Swatches), you can see that there's more to it than a child's box of watercolors. Open the Swatches pop-up menu on the left to display a list of all the color libraries currently available to Elements.

FIGURE 12.22
The Window menu allows you to display, hide, and arrange screen elements.

FIGURE 12.23
The Swatches palette displays the swatches of color in the current palette.

Clicking the More button opens a menu that can name a particular swatch of color, or add one that's not part of the original set. If your company's logo has a particular shade of blue, for instance, you can scan the logo and then use the eyedropper to copy the color and add it into the Swatch palette.

At the bottom right of the palette is a trash can, for deleting unwanted swatches, and a New Page icon. You can add the current foreground color as a new swatch by clicking this icon. Although each palette has its own menus and lists and icons, they all do roughly the same things in relation to the function of the palette. For instance, the New Page icon on the Layers palette makes a new layer.

To prevent desk clutter, only open the palettes you need. I like to keep Undo History, Layers, and Swatches available, and leave the rest docked.

Using the Photo Bin

This is another new Elements tool, and a useful one if you work on several pictures at once. The Photo Bin, which you can toggle on and off from the Windows menu, shows thumbnails of any picture files that are open. Clicking a thumbnail brings that image to the front of the screen. If you need a larger working area, close the bin. You can always bring it back again.

Setting Preferences

You can get to the Preferences dialog boxes either by selecting Preferences from the Photoshop Elements menu on the Mac or the Edit menu in Windows or by pressing Cmd+K (Mac) or Ctrl+K (Windows). Once you're there, you'll find eight different sets of options relating to everything from using smart quotes to changing the color of the grid lines. Figure 12.24 shows the first in the series: General.

FIGURE 12.24
Too many choices?

Some of these truly are common-sense preferences. And as long as Show Tool Tips is checked, holding the cursor over any tool or button will display a short

explanation. My suggestion is to look through the Preferences screens and take note of what's there. If you prefer to think metric rather than measuring in inches, that's an easy change. If you'd rather see your grid in a different color, go ahead and change it. But leave the options you don't understand on their default settings. As you learn more about working with Elements, you can come back and adjust the Preferences to suit your needs.

As a general overview of the Preferences boxes, here's what you can expect to find in each window:

▶ General: Color Picker, Undo/Redo key combinations, options for program behavior.

▶ Saving Files: File saving options, file compatibility, length of Recent File list.

▶ Display and Cursors: Use Pixel Doubling (best left off), cursor size.

▶ Transparency: Adjust grid size and color.

▶ Units and Rulers: Set measurements for rulers, type, and print size; column sizes, New Document preset resolution (for print and screen).

▶ Grid: Change color, style, and spacing of grid lines.

▶ Plug-ins and Scratch Disks: Share a folder of plug-ins from another graphics programs. Assign scratch disks for extra memory, if you need it.

▶ Memory and Image Cache: Set cache level (4 is good), and adjust amount of RAM available to the program. (This depends on how many other applications are open at the same time.)

▶ File Browser: Sets size limits for files displayed, number of files listed in the pop-up menu, and thumbnail size. (The defaults here are your best choices.)

Summary

In one dizzying chapter, we have covered everything on the desktop. You looked at the tools, and probably tried them out on the page you opened. You then learned about the Options bar and how its options can affect the way a tool functions. Finally, we discussed menus. (And it's a good thing—I'm more than ready for a snack break.) The Elements menus lead you to more menus and submenus and dialog boxes that contain everything you need to work with your pictures.

Before you go any further, stop and explore. Try out some tools, see what's on the submenus. You can't break anything. Remember, this is supposed to be fun!

CHAPTER 13

Handling Photoshop Elements Files

What You'll Learn in This Chapter:

- ▶ Starting a New Image File
- ▶ Browsing for a File
- ▶ Saving Your Work
- ▶ Adjusting Resolution
- ▶ Saving for the Web
- ▶ Attaching Files to Email
- ▶ Exporting a PDF
- ▶ Undoing and Redoing
- ▶ Using the Undo History Palette

Handling files, in the context of this book, means finding them, opening and closing them, saving them, starting new ones, and undoing and redoing your actions. That's what this chapter is all about. Handling Elements files isn't especially tricky or complicated. But there are a few things you'll need to know, such as how to change the size and resolution of an image, and what that actually means.

Starting a New Image File

Let's take a quick look at the New dialog box before we move on. Here it is again, in Figure 13.1, just to refresh your memory.

FIGURE 13.1
The New dialog box
is used to create a
new image file.

FIGURE 13.1
The New dialog box
is used to create a
new image file.

Starting at the top, you have the option of immediately naming your image or leaving it untitled until you save it. Because I am almost always in a hurry, I skip that step and immediately consider page size. This dialog box has a pop-up menu of possible page sizes, shown in Figure 13.2. The default is horizontal, 7×5 inches.

FIGURE 13.2
Most of the stan-
dard American and
European page
dimensions are
included.

Choose a page size that's appropriate for what you want to do, remembering that screen formats are horizontal, while magazine covers and illustrations are more likely to be vertical. Landscapes and portraits dictate different orientations because of the shape of the subject. There are even sizes for different kinds of TV and video screens.

If you have something on the clipboard that's waiting to be pasted into your new image, the dialog box will open with that item's dimensions in place of whatever

other numbers might be there. You can still override it and choose a larger size, if you want.

Resolution is a tricky issue that we'll discuss in depth in the section, "Adjusting Resolution," later in this chapter. Meanwhile, if your art project is to be viewed on the screen, perhaps as part of a PowerPoint slideshow or on the Web, or if you are just playing, as we are now, use 72 pixels/inch as the resolution.

You have only three choices for mode in this dialog box. If you're working in color, you must choose RGB Color as the mode. Grayscale lacks color, and Bitmap means simply black or white pixels, with no grays at all. If you want to use Indexed Color mode, (used mainly for GIFs) you'll need to select that option from the Image, Mode menu after creating the file using RGB Color or Grayscale.

The Contents options refer to what appears on the first layer of the image when it's created for you. White is the usual choice. Background applies whatever color is the current background color in the toolbox. (By default, it's white.) Transparent backgrounds are normally indicated by a sort of gray and white checkerboard effect. (You can change its color in the Preferences.) Transparent backgrounds are extremely useful when you are creating web graphics.

> The background layer is the blank canvas or drawing pad on which you place a photo or paint a picture. You'll learn all about layers in Chapter 17, "Making Selections and Using Layers."

By the Way

When you're ready, click OK or just press Return to open the new image.

Browsing for a File

Most of the time, though, you won't be starting with a blank image. Instead, you'll have a photo that you want to work with. If you know where it is, you can press Cmd+O (Mac) or Ctrl+O (Windows), click on the Open icon, double-click the file, or do whatever you generally do to open a file.

If you don't know where on the hard drive your picture is, or what it is called, opening it becomes a little harder. That's one of the times when you'll turn to the File Browser. Another is when you've shot and downloaded a bunch of similar pictures and want to find the best of the bunch. You really need to be able to see what you've got.

Open the File Browser by choosing Browse Folders from the File menu or the Windows menu, or by pressing Cmd+Shift+O (Mac) or Ctrl+Shift+O (Windows).

You can select the thumbnail size from the More menu or by clicking the View By button. The File Browser can also show you the file hierarchy and the creation data or camera file info, as well as a larger thumbnail of a selected image, as in Figure 13.3. Normally, all information about a file is displayed in the Metadata window; to display only camera/scanner information, select EXIF from the menu on the lower right. As I mentioned in the previous chapter, you can change the sort order using the options on the Sort By menu.

FIGURE 13.3
The Metadata
window includes
creation date,
camera used, and
so on.

Something new has been added to the Mac version of the File Browser. You can add keywords to your pictures to help find them next time you go looking. We'll learn how to do this in Chapter 16, "Keeping Track of Your Pictures with Photoshop Album."

Use the top pop-up menu to locate the disk and folder you think the file is on, and just start scrolling through the folder list on the left until you find it. Drag it into an Elements window or double-click it, and it will open its own.

To rotate the selected image 90 degrees to the right, click the Rotate button. To delete the file from your computer, click the Delete File button.

Time for a little practice: The following steps will walk you through the process of browsing for some picture files on your hard drive:

1. Go to the Window menu and select File Browser.

2. After the window opens, use the scrollbar to review what's on the desktop.

3. Use the pop-up menu at the top of the browser to navigate to a different hard disk, disk partition, or other external storage device. Again, scroll through to see what's there.

If you can't find any other graphic file, try the Samples folder, located in the Photoshop Elements folder.

Did you Know?

4. The top-left browser window shows the file hierarchy. Scroll down until you locate the folder where a photo you'd like to select lives. Then click the file when it appears in the list on the right. It should be highlighted.

5. Read through the image information in the bottom pane. If it is a digital photo that you've shot and saved to the computer, you can find out a lot about it. What was your shutter speed? Did you use a flash? If you scanned it in, when did you do so? What's the resolution?

6. Double-click the file to open it, or drag it into the Elements window.

7. Notice that the File Browser remains open. If you like, explore your hard drive(s) and locate more pictures you want to come back to and work on later. When you're done, close the File Browser.

Saving Your Work

Saving is the most important step in any project, but you probably don't realize how important it is unless you have had a computer crash while you're working. It happens to everyone, and eventually most of us learn to save our work often, work on a copy of the original, or learn other tactics that end up saving our sanity as well as our words and pictures.

Elements has a couple of different Save options. You can save the image in the format of your choice with the File, Save As command, or you can save it optimized for the Web by choosing Save for Web from the File menu. The first time you save any file, you'll be asked to give it a name (if you didn't already do so when you created the file or imported the scanned or camera image).

Figure 13.4 shows the Save As dialog box. It looks a lot like the Save dialog boxes in other applications, with a few minor differences.

FIGURE 13.4
Be sure to use a
name that will help
you remember what
the picture is. Raw
camera filenames,
like the one about
to be saved here,
don't tell you much.

Choosing a File Format

The Format pop-up menu, which will indicate the current file format, lists about 16 different file formats you can use. How do you choose? That will depend on the kind of image you are working on, and what you intend to do with it. Most web browsers can only display images in three formats: GIF, PNG, and JPEG. You must choose one of the three if your picture is for web use. (Microsoft Internet Explorer 6 can also display a bitmap image, but you can't assume that everyone uses it.)

If you are going to place the picture into a page of text, such as a newsletter, advertisement, or brochure, you will need to save it in a format compatible with the word processing or desktop publishing program you plan to use. It must also be compatible with the printing system you'll be using. Finally, you must consider whether your image will be printed in black and white, in full color, or using "spot color."

Spot color refers to individual accent colors applied by an artist, as opposed to *full color*, as in a photograph. Spot color is printed with a separate offset plate and a precisely compounded colored ink for each color. Spot color is often used by graphic designers in places where a specific color must appear, such as on an official logo. Full color, also called process color or CMYK color, is printed with overlapping dots of cyan, magenta, yellow, and black inks.

The file format determines how the information in a file is compressed (if in fact it is compressed) and whether it contains data for multiple layers of the image as well as the color management system used and other important details. Elements can work with files in any of the types shown on its menu, but there are some you will probably never use.

Let's take a quick look at the formats available and what they actually do (the three-letter combination in parentheses after each format name is the file extension for that format):

▶ Photoshop (.psd)—This is the native format for both Photoshop and Elements documents. It saves all possible data about the picture, and is compatible with Adobe Illustrator and Acrobat as well as Photoshop itself. This is the best format to use while you are working, or if you intend to return to this image some other time.

▶ Bitmap (.bmp)—Bitmap is a standard graphics file format for Windows. Because it must describe each pixel on the screen, a bitmap file can be quite large.

▶ CompuServe GIF (.gif)—GIF stands for Graphical Interchange Format. It was first used (prior to the Internet) by the CompuServe online network to enable members to view each other's graphics. It is still in use as one of the three common graphics formats for web publishing. It compresses file size by limiting the number of colors. Because it is a compressed format, files are smaller and take less time to transfer. GIFs are also used for animation and for such things as logos and backgrounds because, unlike other formats, they can have transparent backgrounds.

▶ Photoshop EPS (.eps)—EPS stands for Encapsulated PostScript, a format developed by Adobe to go transparently cross-platform to many graphic, page layout, and illustration programs. For best results, use it when your work will be printed on PostScript-enabled printers.

▶ JPEG (.jpg)—JPEG stands for Joint Photographic Experts Group, the group that developed this format, which relies on 8-bit color (RGB only) and a "lossy" compression system (a system that selectively removes data from the file). It is a popular format for web publishing because it can produce small files, but each save results in further compression and files will deteriorate quickly. Use JPEG as a web format, but never as a working format.

▶ PCX (.pcx)—PCX is a common graphics format for IBM-compatible PCs.

▶ Photoshop PDF (.pdf)—Adobe's Portable Document Format is a system for creating documents that can be read cross-platform.

▶ PICT file (.pct)—This is mainly a Macintosh format, and is equivalent to PCX.

▶ PICT resource (.rsr)—This format is used by Macintosh for icons, sprites, and other graphic resources.

▶ Pixar (.pxr)—Pixar is the proprietary format used by high-end Pixar graphics workstations.

▶ PNG (.png)—PNG stands for Portable Network Graphics. It's a newer and arguably better format for web graphics than GIF or JPEG. It combines GIF's good compression with JPEG's unlimited color palette. However, older browsers don't support it and it hasn't really caught on.

▶ Raw (.raw)—This format saves image information in the most flexible format for transferring files between applications and computer platforms.

▶ Scitex CT (.sct)—This is another proprietary format for a brand of graphics workstation.

▶ Targa (.tga)—Another proprietary format, this one works with a specific kind of Truevision video board used by MS-DOS machines.

▶ TIFF (.tif)—TIFF stands for Tagged Image File Format. Files in this format can be saved for use on either Macintosh or Windows machines. This is often the preferred format for desktop publishing applications, such as PageMaker and QuarkXPress. Enhanced TIFF is a similar format that supports saving layers.

Photoshop format (.psd) is the default format in Elements, and is the best choice for saving a file that you intend to keep working on. As noted, it saves layers, layer style information, and color management information.

Watch Out!

> If you are opening a file in Elements that was created in Photoshop, you will not have access to unsupported features such as clipping paths or layer sets, but the data will remain with the file if you later reopen it in Photoshop.

Choosing Other Save Options

If you select the Save As a Copy option in the Save As dialog box, Elements will save a (closed) copy of the current image and allow you to continue working on the open one. Save As a Copy is especially useful for making a backup copy before you try a drastic change, such as reducing color depth or increasing JPEG lossiness (sacrificing clarity to reduce file size), or for saving the file in a different

format. Suppose that you create a logo for your business and want to use it in print and on the Web. You should save it as a TIFF or EPS file to print from, and save a copy as a JPEG, GIF, or PNG file for your web page. The word *copy* is automatically added to the filename.

If you select the Save Layers check box, your file format options are limited to the file types that can save layers separately. These are .PSD and .TIF. The ICC Profile (Windows)/Embed Color Profile (Mac) option will save a color profile with the image file if you choose particular formats that use them.

Adjusting Resolution

Resolution is an important concept to understand and can be just a little bit complicated because it means different things in different situations. Resolution determines the quality of what you see on the screen and what you see in print. You already know that your Elements images are bitmaps. A bit, in this case, is a pixel, an individual picture element. You can enlarge a piece of your image enough to take a good look at individual pixels. Figure 13.5 shows an image of flowers in various stages of enlargement up to 1600%. At that size, you can see that the image consists of little squares in different colors or shades of gray.

 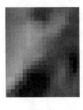

100% 200% 400% 1600%

FIGURE 13.5
A pixel is a pixel, however large or small it is.

When you shrink the squares down to a smaller size, let's say 1/72 of an inch, the pixels are too small to be seen individually. What you do see at that resolution is the picture as it appears on your monitor. Typical monitor resolution is either 72 or 96dpi (dots per inch). (72dpi is the traditional resolution of older Mac screens. New monitors are more likely to use 96dpi resolution for a clearer picture. However, most people still think in terms of 72dpi screen resolution. So will we.) In the case of 72dpi, a square inch of picture has 72 pixels, squared, or a total of 5,184 pixels per square inch.

When you go to print a picture, you'll see that your printer most likely has a much higher resolution than your screen. So an image displayed in a 1:1 ratio on

your monitor will appear smaller when printed because the dots of ink per square inch are more numerous and therefore smaller than screen pixels. Also, an image saved with a low resolution setting will not suddenly become more clear when printed with a high-resolution printer.

Of course, if you have a higher resolution image, you have a lot more data and a much sharper, clearer picture to work with. That also means a bigger file to store and work on. Your hard drive fills up faster. With a larger file, any operation you attempt in Elements will take longer. If you're applying a filter, for example, you're telling the computer to make a specific set of adjustments to each pixel. If the resolution is set to 72dpi, the computer has to change a little more than 5,000 numbers per square inch of image. If it's at 300dpi, it has to make the same changes an additional 85,000 times per square inch. That adds up.

So, the problem lies in deciding whether you want to work slowly on a large file with high resolution that will print well, or quickly on a smaller file that will look fine on the Web. If you already have plans for the picture, your choice is simple. If it's only going to be seen on the screen, you might as well work at 72dpi. If you are placing the photo into another document at something close to or smaller than snapshot size, or printing small copies at home on your inkjet printer, you can get away with using 150dpi as a working resolution. For more flexibility or larger prints, keep the resolution at 300 while you are cleaning it up, cropping, retouching, and so on. You can always save a low-res (lower resolution) copy later. For instance, if you're saving a copy of the picture for a web page, you can reduce the resolution when you convert it to a JPEG, and end up with a clear *and* very small file.

Most printers do a fine job of adjusting resolution, particularly if the printer's resolution is a close or exact multiple of the file it's printing. Typically, a home/office inkjet printer will have a resolution of 600, 1200 or even as much as 2400dpi. If you send a picture that's an exact multiple (for instance, 200, 300, or even 150dpi), the printed result should have nice even tones with smooth transitions from one color to another. You shouldn't see jagged edges or obvious blocks.

There are times when you have to change the image resolution, even though it may mean losing some image quality. If you have access to a high-end digital camera or scanner, it will present you with very large files at a very high resolution. You may find that you have to reduce the resolution of the image before you can work on it, especially if your computer is an older, slower one or doesn't have enough RAM to work on a large file.

Photoshop Elements does a pretty good job of changing resolution by *resampling* the image. When you *downsample* (decrease the number of pixels in an image

and thus decrease the image's size), you can reduce the size of the image, or the resolution, or both. Suppose you have a picture that's six inches square. You want it to be three inches square. You open the Image Size dialog box by choosing Image, Resize, Image Size, as shown in Figure 13.6, and change the numbers to make the image size 3×3 instead of 6×6. You don't change the resolution. When you click OK, the image shrinks to half the size it was on the screen. Because you haven't changed the resolution, the file size shrinks to a quarter of what it was.

FIGURE 13.6
You can change the size and/or the resolution in this dialog box.

If you change the resolution while keeping the image the same size, the screen display will double, because you are now looking at an "inch" that's twice as long (144 pixels instead of 72).

Downsampling condenses the file information into a smaller spread of pixels, so you won't lose detail in the image as you might when upsampling. When you increase the resolution, Elements has to invent new values for the pixels you're adding. There are three different ways it can do this, and you can choose which of the three to apply by selecting it from the Resample Image pop-up menu at the bottom of the dialog box. Your choices are

▶ Nearest Neighbor—This is the quickest method, because it essentially copies what's there, assigning a value to the next pixel based on the average of the ones on either side of it. It works best on edges that are not *antialiased*. (Antialiasing is a technique that's applied to artificially produced edges such as the curve of a letter or a drawn line. It adds bits of gray along the edge to smooth it out and make it less jagged in appearance.) It will also produce a smaller file. It may, however, result in lines that appear jagged because of the lack of antialiasing.

▶ Bilinear—This method, considered better than the nearest neighbor method, is based on averaging the four pixels above, below, and to the sides of a target pixel and assigning it the resulting value.

▶ Bicubic—Instead of taking an average of four pixels, the bicubic method takes an average of eight, surrounding the target pixel on all sides and corners, and giving you a smoother, sharper image. This method produces the best results but takes a longer time to complete.

Figure 13.7 shows the differences between these three methods.

FIGURE 13.7
This is approximately, but not mathematically, the way it happens.

Nearest neighbor

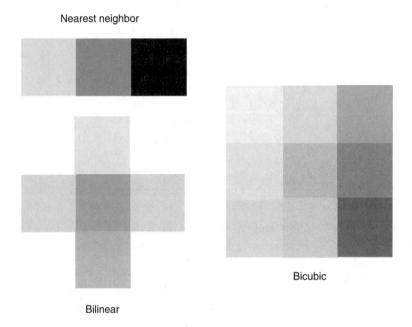

Bicubic

Bilinear

Remember, too, that the program goes through the entire set of calculations for each pixel in the image. When one is changed, all the ones around it must also change slightly.

Saving for the Web

The full-blown version of Photoshop ships with a second program called ImageReady, which is used to prepare images for the Web. It helps you find the best combination of file format, image size, and image quality to place the image

on a web page so it will load quickly and look as good as possible. Elements has a similar feature, which is simply called Save for Web and is found on the File menu. Figure 13.8 shows the Save for Web dialog box.

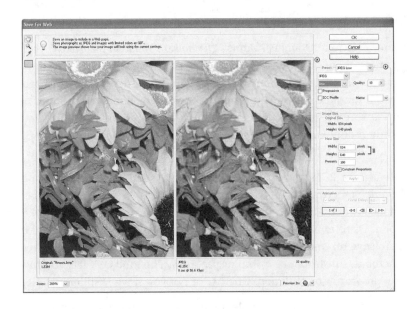

FIGURE 13.8
The two views of the image compare the original to the optimized version. It's often hard to see a difference.

Choose PNG or JPEG for full-color art and photographs. Choose GIF only if you are working with something that has a limited number of colors, such as a company logo or a drawing, graph, or chart. There's no need to include information on 256 colors if you are only using a handful. Be sure to watch the changes on the screen at different quality settings. You want to find the best compromise between quality and file size. If a file is large, it will load very slowly on an older, slower modem. Most people don't yet have a superfast Internet connection. In some parts of the country they're not even available. As a good cybercitizen, you want to make your pages as accessible as possible for all, and part of that is keeping the download time to a minimum.

Attaching Files to Email

On the File menu, you will also see an option called Attach to E-mail. Use this when you want to send out copies of the picture you've been working on via email. You'll be prompted to save the picture, if you haven't already done so, and then Elements will locate your email program and will open a blank email message with the photo already attached to it. The file will not be modified in any

way—its file type, size, and resolution are preserved as they were when you selected this command. Add a message and send it off.

Exporting a PDF

If you have ever read Douglas Adams's *Hitchhiker's Guide to the Galaxy*, you already know about babelfish. As the story goes, if you stick one in your ear, it acts as an automatic translation system, so you can understand what's being said in any given language from Abyssinian to Vogon. Too bad babelfish don't actually exist; software file formats could use such a device. Adobe's Portable Document Format, commonly known as PDF, comes closest. PDF files can be passed back and forth from PC to Mac to SGI workstation to Palm and Pocket PC devices.

There are generic PDFs and Photoshop PDFs. Photoshop creates single-image PDF files. Generic PDFs (which can contain multiple pages, pictures, and text) come from Adobe Acrobat, or from Illustrator, or from other programs that make use of the Acrobat Distiller. You can save a single-image PDF file using the regular Save As box. To save an image in Windows using Generic PDF format, you'll need Adobe Acrobat, Illustrator, or a similar program. The Mac OSX lets you save PDFs from any program's print dialog, whether or not you have Distiller installed.

As an alternative to creating a single-image PDF file, you can create a PDF slideshow. The slideshow will run on any computer system that has Adobe Acrobat or a similar PDF reader. The slideshow starts automatically when opened and displays the images you selected when you created the file, one at a time. To start, assemble a group of images in a folder, and then choose File, Automation Tools, PDF Slideshow. The PDF Slideshow dialog box is shown in Figure 13.9.

Click Browse and navigate to the folder you assembled. Select the files you want to use in the slideshow, and click Open to add them. Click Choose and type a name for the slideshow file, and then click OK. Choose the length of time that you'd like each slide to stay on the screen, and decide whether you want the show to run once and stop or to loop and run continuously. Finally, choose a transition. If you like surprises, choose Random Transition. When you're ready to create the file, click OK. Anyone with a PDF reader on any platform can open and enjoy your show.

FIGURE 13.9
Be sure to check out the Transition pop-up menu. There are 18 possibilities, ranging from Blinds and Wipes to Glitter Down.

Undoing and Redoing

Before I got my Apple keyboard, I had a third-party model that was cheaply made. The paint started to wear off the letters. As a writer and an artist who works mainly in Photoshop, I use the keyboard a lot, particularly the Cmd+Z combination. That's why the Z was one of the first keys to fade to black.

Mac users know that Cmd+Z means Undo. Windows folk know this combination as Ctrl+Z. Same deal. It undoes the last thing you did. To be able to undo with just a keystroke is a wonderful thing. It gives you the freedom to make mistakes—to experiment—and that is how you learn. (I often wish life came with an Undo key.) If the Shortcuts bar is displayed, you can also click the Step Backward button to undo the last action. To redo any change you've undone, click Step Forward or press Cmd+Y (Mac)/Ctrl+Y (Windows). To undo multiple changes, click Step Backward as many times as needed, or press Cmd+Z (Mac)/Ctrl+Z (Windows) multiple times.

> You can also find Undo at the top of the Edit menu, but the keystroke combination or the toolbar buttons are really easier to use.

By the Way

Using the Undo History Palette

For those people who like to experiment with their graphics, Adobe provides an Undo History palette, which makes it easy to back up step by step or jump back to an earlier state with just one click.

In Figure 13.10, you can see a typical Undo History palette. To display the palette, choose Windows, Undo History, or click its tab in the palette well if it's displayed there. The Undo History palette lists all the tools I have used on the image so far. It reflects each use of a tool. If I select a brush and paint several lines, each line shows up as a history step because I have to press and release the mouse button in between lines. If I were to paint one very long continuous line without releasing the mouse button, there would be only one history step to show for it.

FIGURE 13.10
Changes I've made to an image are stored on the History palette.

If I select a step that's several steps back on the palette, all the subsequent steps will be undone. They'll appear dimmed on the palette and will be kept in memory until I do something different to the image. At that point, a new step will replace the ones I backed out of. Figure 13.11 displays a picture of the History palette before and after some changes are undone.

If you go to the General panel of the Preferences dialog box, you can enter a number of steps for the Undo History palette to remember. The default is 20 steps. Depending on your working style, you might find that 10 steps are enough, or you may need as many as 50 if you like to draw with short pencil or brush strokes. The limit is 100. You can clear the history, if you are about to start a complicated revision to your picture and want to make sure you'll have enough space on the palette to keep track of the steps. Clear Undo History is on the pop-up menu that appears when you click the More button at the top of the palette.

FIGURE 13.11
I tried to use the selection brush and paint bucket to fix a bad spot, but it didn't look right, so I backed up and solved it a different way.

Summary

In this chapter, you learned about page sizes and background colors, and practiced using the File Browser to find your favorite images. We talked about the importance of saving your work, and how to do so. We listed the file formats Photoshop supports and what each one does, and covered file resolution and how it can be changed. You found that web images are saved differently than print images and learned how to find the most efficient way to save a web graphic. Finally, we covered undoing and redoing, and the Undo History palette, which lets you retrace your steps backward as you work on a picture.

Printing Your Pictures

What You'll Learn in This Chapter:

- ▶ Choosing a Printer
- ▶ Preparing the Image
- ▶ Printing the Page
- ▶ Making Contact Sheets and Picture Packages

By now, you've completed almost half of this book, and although we haven't talked much yet about how to improve your photos, you know how to shoot good pictures and how to import them into Elements, so you're probably eager to print them and show them off. In this chapter, you'll learn everything you need to know about printing.

Choosing a Printer

The kind of printer you use can and should influence how you work in Elements to prepare your image, because you want to create an image whose use of color is best suited to your printer. If you're shopping for a new printer, or have recently purchased one, this chapter might be especially important for you. Consider how you'll use the resulting prints. Do you need a printer that can handle larger sized paper or is standard 8 1/2 × 11 inches good enough? Do you want to print only small prints, the approximate size you'd get from the drug store or camera shop? Do you want to be able to print on "art" papers as well as ordinary paper and photo glossy paper? You can get a "wide body" printer that will hold either sheets or rolls of paper and print photos up to 13 by 44 inches.

By the
Way

> By the way, when I talk about *printers*, I mean the machines that put the image on the paper, not the people who run them. Some printers sit next to your computer; others reside in commercial print shops or service bureaus.

An entire book could be written about all the varieties of printers. In this section, we'll make do with a snapshot of what's available: inkjet printers, laser printers, dye-sublimation printers, thermal wax printers, and imagesetters.

Inkjet Printers

At the inexpensive end of the spectrum are home and office inkjet printers, almost all of which can deliver acceptable quality color printing. Examples of inkjets include HP's Deskjet, Designjet, and Photosmart series; Canon's Bubble Jets; Lexmark Colorjet; and Epson's Stylus and Stylus Photo printers.

Watch
Out!

> Not all inkjet printers support PostScript, the page description language that enables images to be printable at any resolution or color setting. Only certain models are capable of interpreting this language and reproducing images saved with this language. Most Elements images should not be saved in Photoshop EPS (Encapsulated PostScript) format unless you plan to import them into a page layout program such as Adobe InDesign, and then send the results out to a commercial print shop that has a PostScript-friendly printer.

Inkjet printers work by spraying microscopically small dots of colored ink onto a sheet of paper. The most common four-color inkjet models utilize a time-proven process of blending cyan, magenta, yellow, and black inks to reproduce most colors in the spectrum. Higher-end printers refine this model by adding light cyan and light magenta, for better, smoother rendition of sky, skin, and other pale and pastel tones. With the standard four-color process, large patches of a bright pastel hue—for instance, the sky—might not appear solid. Instead, the dots of cyan and magenta that compose such patches are visible. In other words, when limited to just four colors of ink, bright pastel colors may not reproduce well. The addition of the two lighter shades of ink (light cyan and light magenta) refines the appearance of brighter, blended tones, making the sky look like the sky, for example, and not a dotted mess.

Some printers, specifically some of the Epson models, have added a seventh color to the mix: a light black. They also make a matte black, which is designed for printing on matte surface paper. It can be interchanged with the photo black ink when a less glossy appearance is desired.

Naturally, a six- or seven-color printer will give you a better print than a four-color printer, all other things being equal. But all things are *never* equal, and you can get surprisingly good results from even the less expensive printers if you're careful about preparing the picture for printing. Figure 14.1 shows the inner workings of a typical inkjet printer.

FIGURE 14.1
The print head glides back and forth, spitting inks as it goes.

Inkjet printers aren't very expensive. You can get a perfectly adequate one for $100; some are even less. Currently, there's an HP Deskjet selling for only $40. Add on another $10 for the USB cable, not supplied with this printer, and you've got a good cheap printing solution for black and white or color. HP makes a huge selection of printing materials, including paper in various surfaces, labels, T-shirt transfers, cards, and more. The big cost, for whatever brand of printer you buy, is not the printer, but the supplies. Ink cartridges get used up quickly. Even if you seldom make prints, the ink in the cartridge dries out and is useless. Worse yet, most of the lower-end printers use a combination cartridge for cyan, magenta, and yellow, so if you print a lot of pictures with blue skies and ocean you'll use up the blue long before the other colors are gone. That means replacing the whole cartridge, about $25 or more.

You can buy cartridge refill kits with bottles of ink and a device to squirt it into your empty cartridge. Don't waste your money. These are seldom satisfactory, and could damage your printer and void the warranty. The print cartridge isn't just an

inkwell. It has a print head and electronics included. If these are bad, adding more ink won't help.

For your very best work, consider looking for a service bureau with an Iris printer. In the art world, Iris prints are very highly prized. (Art dealers may also call them giclée prints—*giclée*, pronounced *gee-clay*, is French for "squirted.") High-end inkjets, such as the Iris, can cost tens of thousands of dollars but are perfect for graphics professionals. Iris and similar art-quality printers are sometimes found at service bureaus or art studios. They can produce very large prints, up to 33×46, with remarkable detail and quality. You can have an Iris print made of your work, but prints tend to be expensive. Prices average around $150 for a single 16×20 print, but this is money well spent if the picture deserves the extra expense and effort. Some do.

All in One Printer/Scanner/Copier Combinations

There's an old saying about "Jack of all trades—Master of none...." Fortunately, it doesn't apply to the all in one printer/scanner copier units that have recently become popular. They do a pretty good job of color printing, and can make color copies as well as scans. Some even send faxes! Most also accept the memory card from your digital camera, and will print a "contact sheet" with thumbnails of all the images on the card so you can decide which pictures you want to print. Figure 14.2 shows two of these combination printers.

FIGURE 14.2
The HP PSC1350 and the Epson CX 6400. Both are small but effective.

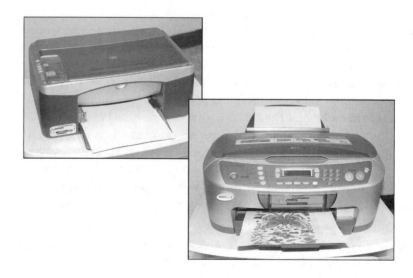

Every printer needs software to make it work. These programs are called *drivers*, and they come with the printer in versions for both Macintosh and Windows OS. Drivers are frequently updated, so make a point of checking your printer manufacturer's website occasionally to be sure you have the latest and best driver for your printer. Installation instructions are provided when you download a driver or use the CD that comes with the printer.

Laser Printers

The laser printer is the professional standard for black-and-white printing and a good balance of price, quality, and speed. Laser printers abound from well-known companies such as Hewlett-Packard, Lexmark, and Xerox. Laser printers work by heat-fusing powdered toner to the paper. Color lasers use a four-color toner cartridge, or four separate one color cartridges. As with the inkjet printers, color laser toner is very expensive. Color laser prints can be very good if you like bright colors and don't mind the shiny surface that you're likely to get in areas where the toner is quite dense.

The HP Color Laserjet shown in Figure 14.3 is typical of home/office color laser printers. With a street price just under a thousand dollars, it's not cheap, but it's fast and accurate.

FIGURE 14.3
The HP 1500 Color Laserjet printer. (Photo copyright HP. Used by permission.)

Most laser printers produced today output at up to 2400dpi, and are particularly good with halftone and grayscale images. Some can subtly alter the size of the printed dots, thus improving quality. Laser printers are generally faster than inkjet printers, but they tend to be more expensive. They can use standard copier paper for everyday printing, as well as higher quality, heavier weight papers for more serious work.

Dye-Sublimation Printers

Times change. When I first got into digital photography, the only dye-sublimation printers were very expensive photographic-quality printers. You got what you paid for: Image quality was/is superb. These printers use special ink on ribbons and special paper. The dye sublimation process itself is based on heat diffusion: A dye-ribbon containing the three basic colors, cyan, magenta, and yellow, is heated and the vaporized dye is absorbed by the paper. The color and its intensity is determined by the amount of heat the dye-ribbon is subjected to. This heat is generated by the thermal print head. Most manufacturers give a resolution spec for dye-sub printers in dpi, usually 300dpi. Those are individual dots. The difference is that a dot can be almost any color imaginable, rather than just a single ink color. This makes the image look smoother (if you look closely enough), because it takes only one dot to produce a color, rather than a clump of primary-color dots that the eye blends together. Also, dye-sublimation printers print by continuous tone, while inkjet printers print by half tone, which means that pixels are stacked on top of each other to determine color density and different colors. You can't use ordinary photo paper with them, and the specially coated paper is expensive.

You can often find large dye-sub printers at a service bureau, where you can get a single print for a modest fee. If you're satisfied with small but perfect prints, look into the new desktop dye-sublimation printers. Several companies make them at reasonable prices. The drawback is that they only make 4×6 prints, but they can also make stickers and postcards. The Olympus P-10 digital photo printer, shown in Figure 14.4, is typical of these small dye-sub units. It can be operated directly from an Olympus camera or from your computer.

Olympus sells combination packs of paper and ribbon. There's no point in buying the ribbons and paper separately because one's no good without the other.

FIGURE 14.4
The Olympus P-10 and its accessories; ribbon, paper carriers, and AC adaptor.

Imagesetters

Imagesetters are printers used for medium- or large-scale commercial printing jobs. These large, expensive machines burn the image onto photographic film or paper. That film is then developed and used to make printing plates that are used for the actual printing. We're talking high resolution here: 1,200–2,400dpi, or even better.

Imagesetters don't print in color, per se. Instead, you have to create a separate image for each color you want printed. These are called *separations*. There's no reason you need to deal with these unless you're doing a full-color printing job like a catalog or color brochure. If so, talk to your printer shop or service bureau about what you'll need and how to prepare it.

Preparing the Image

Professionals know the value of having color-compensated monitors and color-printing profiles, which guarantee that what you see on the screen is as close as possible to what you will see on paper. Because the process of mixing colors for a screen is inherently different from the process of mixing colors for print, what seems to be just the right color for an object when you chose it onscreen may appear altogether wrong on paper. Likewise, if you're designing graphics for use on the Web, the proper colors for one brand of monitor or even one color depth may appear completely wrong when seen on another monitor or at another color depth.

Elements solves this problem by giving you the power to invoke a background process called *color management*. This process translates the color you see when you're creating your image into a color that's as close to the original as possible for the finished product. For color management to work, you first have to turn it on. Doing so is a one-time process that is very simple and applies to all your work in Elements from that point on—or at least until you turn color management off. Here's how to turn it on:

1. Choose Edit, Color Settings (Windows) or Photoshop Elements, Color Settings (Mac), or press Cmd/Ctrl+Shift+K. You'll see a box like the ones in Figure 14.5.

2. In the Color Settings dialog box, select a color management option:

 Limited Color Management enables Elements to translate the colors you see for web users with high-end monitors.

 Full Color Management is your best choice. This gives Elements the clearance it needs to optimize the colors you use for the printer that will render your image. You'll notice that it takes a little longer to prepare a file for printing, because the program is going through a lot of extra math, but the color accuracy is worth the extra few seconds.

3. Click OK.

FIGURE 14.5
The Mac and Windows Color Settings dialog boxes.

With that done, you can set up any image you edit for optimal printing or display on a wide variety of media, including your own printer. But first, let's talk about some other issues such as choosing the right paper, selecting your page setup options, and previewing an image.

Choosing a Paper Type

What you print on makes almost as much difference as how you do the printing. You can get various types and weights of paper for all kinds of printers. There are special papers for inkjet and laser printers. If you want your picture to resemble a photograph, invest in a pack of photo-weight glossy paper. It's a thick paper with a glossy surface that really does help make your inkjet picture look like something that came out of a real darkroom rather than a computer.

You can get coated papers for printing color on inkjet printers. These give you photo-quality prints with a matte surface, rather than a glossy one. Transparency paper is clear acetate film, specially treated to accept the inks. Use it to make overhead projection slides and overlays.

You can also get art papers for some kinds of inkjet printers. These are heavy rag papers, much like artists watercolor paper. One place to find these is http://www.inkjetmall.com/. I've had very good luck printing on Somerset Smooth and Somerset Velvet with the Epson Stylus Photo printers. Epson repackages the Somerset Velvet art papers with their own label, and you can usually find it at a good computer store or office supply store. These fine art papers are ideally suited to printing pictures that you've converted to imitation watercolors, pastel drawings, and so on because they are the same papers generally used for those techniques. If you use a heavy art paper, feed in one sheet at a time and set the printer for thicker paper (if it has such an option). Inexpensive drawing papers from the art supply store can also work quite well. I bought a pad with 24 sheets of Academie drawing paper for less than $2, and am quite happy with the prints it makes.

For some kinds of art projects, printing on canvas or foil is ideal. You can find treated pieces of thin canvas with a paper backing that will go through the printer very well at many art or office supply stores. There are also foils treated to accept inkjet ink. You can even buy sheets of sugar and edible inks, and put your photos on cakes or cookies. These might be suitable for birthday parties or other celebrations; I'm sure you've seen photos on cakes at your local grocery store bakery. (Check out http://www.icingimages.com for these materials, or for preprinted versions of your photos that come ready to apply and eat.)

Iron-ons have been around for quite a while now, and are good for all kinds of craft projects, not just T-shirts and mouse pads. If you have an object that's hard to decorate, such as a hat or something else that's not flat, iron your design onto a plain white cloth, and glue or sew it on by hand. Follow the instructions that come with the paper and don't forget to flip any text in the image before you print it so that it reads correctly.

Did you
Know?

I used to use inexpensive photocopying paper for most of my work. Such paper is fine for printing a quick proof to see how a picture comes out. For serious proofing, though, you need to use the same paper that you'll use for the final print. Otherwise, you aren't proving that the combination of color and paper works. For work that a client will see, I use a coated inkjet paper such as Weyerhaeuser Satin because the colors are brighter and don't bleed into each other. If I want the picture to look more like a darkroom photo, I'll pay the high price per sheet to print it on special glossy paper.

Selecting Page Setup Options

You can make minor changes to your printed output from the Page Setup dialog box. Choose File, Page Setup to display it. Figure 14.6 shows the Elements Page Setup dialog box for Windows. It's fairly simple. If you're a Mac user, Page Setup is also a "plain vanilla" Mac window.

FIGURE 14.6
Your dialog box will look different on the Mac.

Each printer's Page Setup dialog box looks a little different, but they all provide the same basic functions. Here's a list of some of the more typical options:

▶ Printer—In Windows, clicking this button takes you to a Printer Page Set Up window where you can choose a printer. (See Figure 14.7.) Click the Properties button to actually confirm the choices for paper size, layout, printer resolution, and halftone settings for your print job.

▶ Paper Size—Choose the size of the paper on which you're printing.

▶ Source—If your printer has two paper trays or gives you a choice of tray or single-sheet feed, or a choice of sheet or roll, you can choose the paper source that you want the printer to use.

▶ Orientation—Choose how you want the printed image to be placed on the page: portrait (the narrow edge of the page at the top) or landscape (the wide edge at the top).

▶ Margins—Use these settings if they're available to adjust the space between the image and the edge of the page.

▶ Settings—Mac users also have a pop-up menu called Settings, which lets you enter a custom paper size, if yours isn't on the list of choices.

FIGURE 14.7
This is the second Page Setup dialog box in Windows.

When you choose Print on the Mac, however, you'll get there by way of a Print Preview box that has a lot of options, such as the following ones. The same options in Windows are reached through the Print command. Print Preview for Mac is shown in Figure 14.8.

▶ Print Size—This shows the current size of the picture. You can reset it to make prints of a specific standard size, or resize to fit the paper, or enter a custom size that's none of the above.

▶ Scale Size—This enlarges or reduces your image by a set percentage.

▶ Position—Determines where on the page the image is printed. Center Image does precisely that.

▶ Show Bounding Box—Draws a non-printing black border around the image, with handles you can drag to enlarge or reduce it.

▶ Border—Places a border around the image. If you select Border, you will need to enter a width in the window and click the swatch (currently white) to select a border color.

▶ Show More Options—Checking this extends the dialog box, giving you access to Labels, Color Management, and Transfer. Check Transfer if you're printing a T-shirt iron-on and want the image reversed. You can place a file name at the top of a picture and/or a caption under it. (These should be entered into the File Info dialog box *before* you begin the printing process.)

FIGURE 14.8
The Mac's Print Preview window opens when you choose Print from the File menu or press Command+P.

When Windows users click on the Properties button in the Page Setup window, you'll see a dialog box looking like the one in Figure 14.9. Notice the tabs at the top of the dialog box. We'll get to those in a moment. Your property options are quite similar to those in the Mac world, meaning that you can change paper orientation, size, source, and so on. You also have a Print Quality option in this window. Choose Photo or Best Photo for any kind of artwork. Best Photo is slower, but uses a higher resolution.

Clicking the Page Layout tab opens a second Properties dialog, shown in Figure 14.10. Here you have the same reduce/enlarge and mirror image options that Mac folks have, along with some others that are pretty much self-explanatory.

FIGURE 14.9
The Windows Properties box changes according to the printer you use, but will be similar to this one.

FIGURE 14.10
The Page Layout tab allows you to decide whether you want the image centered or reversed.

By the Way

When you actually print the image (we'll get there soon, I promise), you might run into a problem with files that are especially large. If the image dimensions are larger than the dimensions of the paper you're printing on, Elements will warn you. You can then choose to print anyway, resulting in only part of the image being printed, or you can cancel and adjust the Reduce or Enlarge value so that the whole image fits on the page.

Previewing an Image

After making page setup adjustments, if any, it's time to preview your image as it might look when printed. If you have a Mac, you've already seen it, of course. In Windows, you'll see it when you choose Print or press Control+P. Take a look at the Print Preview dialog box in Figure 14.11.

FIGURE 14.11
Notice the options in my Print Preview dialog box.

The first option here is Print Size, as it is in the Mac Print Preview window. Notice that you have a warning that the image will print in low resolution. You can decrease the size and increase the resolution to get a better print, if necessary. Scaling allows you to resize by a percentage rather than to a specific measurement. You can scale the image by typing a percentage into the Scale field. Scaling is done relative to the original image size. If you have a photo that's 6 inches wide and you want it to print 9 inches wide, scale it to 150%. Next comes Position. If you uncheck Center Image, which is checked by default, the image will print wherever it appears on the page in the preview window. If you then turn on the Show Bounding Box option, you can slide the picture around on the

page, placing it wherever you want. If you drag a corner of the image, you can also rescale it. The Scaled Print Size values will change accordingly. To scale the image to fit the size of your page, select the Scale to Media option.

If the Print Selected Area box is checked and you have a rectangular area currently selected in your Photoshop image, you can print just that area. This works only with rectangular selections created with the Marquee tool, and it doesn't work for feathered selections.

When you click Show More Options, you can choose Label options and Color Management options.

Earlier, I explained how to turn on color management within Elements. But to get it to work with the current image, you must select a *profile* for your image. The profile instructs Elements with regard to how it should translate colors for output on its intended medium. To display the Color Management options, click Show More Options in the Print Preview dialog box, and then you can see them.

The area marked Source Space lists the native color management profile in use by the current image. Generally, there is none, so it will most frequently show something like "Untagged RGB." From the Profile list, choose the profile that best suits your printer, or the device you intend to use to render the image. Figure 14.12 shows a part of this very long list. Toward the bottom of this list, you'll see dozens of printers and monitors—some branded, some generic. You may very well find your printer in this list. In any event, here's generally what you should choose, and why:

▶ Choose your printer model (if available) when you intend to print your image on your own printer.

▶ Choose your monitor model if you intend for your graphics to be used over the Web and seen on your monitor.

▶ Choose a generic monitor for everyday web graphics, or a high-end monitor (such as a Trinitron) for highest-quality web graphics.

▶ Choose Printer Color Management (second in the list) to have your own printer driver handle the job of color management. Most major brands of color inkjet printers sold today include their own color management options, which are accessible through their drivers' Print dialog boxes.

 Leave this option set to Same As Source if your image is saved using a newer format that includes its own print profiles. You can find out whether your image uses such a format by checking the Source Space area for the name of this profile.

FIGURE 14.12
And there are
about 30 more...

After selecting your options and previewing your image, you're ready to print.

Printing the Page

Okay, now we're finally ready to print the image. I told you there were a lot of variables involved in printing, didn't I? One more thing before you print—consider making your image *file* (though not necessarily the image) smaller before sending it to your printer. This not only speeds up printing, but also reduces the chances that the printer will quit halfway through the print job. To reduce a file's size, flatten all the layers into one by choosing Layers, Flatten Image. You can also reduce the resolution and the image size by choosing Image, Resize Image. When you're ready to print, choose File, Print or click the Print button.

The Print dialog box for my Epson printer is shown in Figure 14.13. This dialog box's appearance varies depending on the printer you have, the platform you're running on, and the mode of the image. Select the number of copies to print, set other options as available, and click OK to print the image.

So that's how to print from Elements. But as you'll probably discover, printing directly from Elements doesn't happen as often as you might expect. Most of the time, images created here are put into another application for final placement and output. Most often these are page layout applications, such as Adobe PageMaker and QuarkXPress, or even word processors, like Microsoft Word. Elements images can even be put into other image-editing, painting, or drawing applications, such as Procreate Painter and Adobe Illustrator, and printed from there.

FIGURE 14.13
The ultimate dialog box: Print.

The main thing to watch for when you're printing Elements images from other applications is the format of your file. Make sure that it's compatible with the program you're putting it into. If it's not, believe me, you'll know! Other than that, any settings related to the image, such as custom colors or dithering options, are brought with the image automatically.

> Dithering is a method of simulating the colors in an image by mixing colors actually stored in the file. When you reduce the colors in an image, you reduce its size, and dithering helps you make up for that loss.

By the Way

Making Contact Sheets and Picture Packages

In this automated world, it's only fair that our computers should provide ways to automate some of the more mundane tasks that we must occasionally do, such as making contact sheets and picture packages.

Did you Know?

When you start to really use your digital camera, or to scan and store lots of regular photos on your computer, it's time to invest in a good photo organizer. Windows users now have an organizer built into their version of Elements. For the Mac, I recommend iPhoto. It does the same things and is part of the excellent iLife bundle for Mac OS X.

Contact Sheets

If you have a background in darkroom photography, as I do, you're already used to making contact sheets of every roll of film you process. When you download images from a digital camera, you might use a transfer program that displays your photos as slides in a sorter, or you might simply copy them from your card or camera directly to your hard drive. If you follow the latter course, you really can't tell what you have until you open each picture in the Elements Browser and study it. That takes time. Fortunately, Elements enables you to simply scan thumbnails of your pictures and choose the ones you want to use without having to decipher the cryptic filenames from the camera or open each picture separately. Better yet, it lets you print these pages and index them to the hundreds of CDs full of photos you've taken. Much easier? You bet.

All you need to do is save the images for the contact sheet into a folder. You can even place several subfolders inside one main folder. Then select File, Contact Sheet to open the dialog box shown in Figure 14.14 and select the folder you want to make contacts of.

FIGURE 14.14
Click Include All Subfolders if you want their contents to be included in the contact sheet.

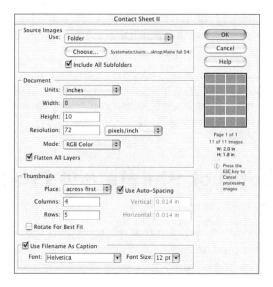

If you're going to print your contact sheets, be sure that the document size is no larger than the paper in your printer. Low resolution (72dpi) is usually good enough to see what's going on, and saves time and space. The Flatten All Layers option has to do with the finished thumbnail file, not your images. It's typically best to select this option, unless you plan to manipulate the individual thumbnails for some reason.

Decide how many thumbnails you want per page, and arrange them across or down as you prefer. Finally, if you want their filenames to appear on the contact sheet (which I strongly recommend), click the Use Filename As Caption check box and select a font and size for the caption. When you click OK, Photoshop will automatically open your files one at a time, create thumbnails, and paste them into a new document. You can then save and print this contact sheet just like any other page. Figure 14.15 shows a typical contact sheet. Note that the pictures are in alphabetical order. Filenames, if too long, will be truncated.

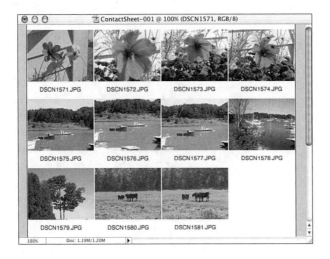

FIGURE 14.15
Each little photo has its filename as its title.

Picture Packages

Remember school pictures? You got a page with one 5×7 print, a couple of "stick-on-the-fridge"-sized pictures for the grandparents, and several wallet-size photos for mom and dad. Around the holidays, your local discount store or department store offers similar deals. You don't need to bother with them. You can do your own and save a bundle.

Use File, Print Layouts, Picture Package to open the dialog box. There's a menu in the Source area that lets you locate the photo you want to package, or you can

use whatever's already open. Choose a paper size based on what your printer can handle. In Photoshop Elements 3, you have options for 10×16 and 11×17 paper as well as 8×10. Figure 14.16 shows the dialog box with a layout selected.

Label your photos, if you want to, with the name of the subject, your studio name and copyright notice, date, proof warning, or whatever else you want. Choose a font, size, color, and opacity for this type, and decide where on the page it should go. Unfortunately, you are limited to only a few fonts, most of which are more suitable for copyrighting or captioning than for adding an elegant title.

Set the resolution as appropriate for your printer, and click OK. Elements will assemble the package for you in a new file, just as it does with the contact sheets. When you're ready, save and/or print it.

FIGURE 14.16
Portrait sizes, wallet sizes, even passport sizes—what more could you want? (Photo courtesy of Linda Standart.)

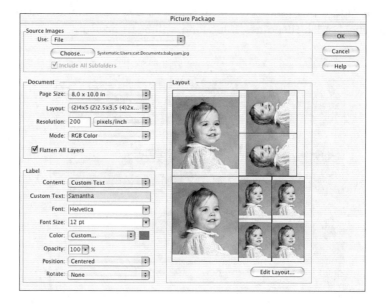

Summary

Printing pictures is fun and easy, once you know how. In this chapter, you learned about the process of printing your pictures. You learned about the different kinds of printers and how they work. You learned about the various color systems, and about different kinds of printing materials. You worked through the relevant dialog boxes, from Page Setup to Print. You learned to select between landscape and portrait orientation, and to set paper size and type. Finally, you learned how to create contact sheets for picture collections, and to print picture packages with a single image.

CHAPTER 15

Posting Your Work on the Web

What You'll Learn in This Chapter:

- ▶ Internet Limitations and What They Mean to You
- ▶ Optimizing Images for the Web
- ▶ Optimizing a Graphic Step by Step
- ▶ Preparing Text for the Web
- ▶ Preparing Backgrounds
- ▶ Making Transparent Images
- ▶ Making Pages Load Faster
- ▶ Creating a Web Gallery
- ▶ Emailing a Picture

Ever since the web got started, ordinary people as well as multinational conglomerates have made it their own. Why not you? Service providers typically offer a reasonable amount of web storage space for free, so why not use it to post your own web page, share photos, or advertise your business? If you plan on using images on the web, however, there are some things you should know. In this chapter you'll learn how to prepare an image for the web and how to upload it to a web page, forum, or email, as well as to one of the several services that archive and display your photos so that your family and friends can order prints.

Internet Limitations and What They Mean to You

You've surfed the with your favorite browser—Internet Explorer, Netscape, or one of the lesser known programs such as Mozilla or Firefox. You have email and probably even your own home page. But, do you know what's really going on out there in cyberspace? First of all, although the web is what you might call a *virtual space*, meaning that it creates the illusion of space and distance, it also exists in a physical space. It is made up of computers called *servers* that send files to programs that request them (such as your browser), across networks that stretch around the world. The server computers can be anything from supercharged SPARC stations to minis and mainframes—or a machine not unlike the one sitting on your desktop. These machines run software that can talk with your computer via what are known as *protocols*. A protocol is a set of rules that define the exchange of information—in this case, the downloading of web pages, files on a server, email messages, and so on.

Thus, when you type a URL (uniform resource locator) into your browser to access a website, a message made up of electronic pieces of information called *packets* goes out to these remote machines. These machines then send back the files for which you have asked. The files that make up all the sounds, pictures, and text of the web then have to travel across phone lines or down a cable TV line or other connection.

This creates a problem that you have to keep in mind as you create pages for your website. Phone lines are slow, and only so much information can travel through them at a time. If you are lucky enough to have a fast connection, such as a cable modem or an ISDN, DSL, or T1 connection, you have nothing to worry about regarding speed. If you use a dial-up modem attached to an ordinary phone line, you have a much slower connection. web pages, even your own, will take longer to load. Because a lot of people are still using dial-ups rather than high-speed connections, it's courteous to keep the files that make up your web pages small so they will load reasonably fast. Fortunately, there are ways to optimize your web graphics so that you get the most bang for the bit, so to speak.

By the Way

To optimize a graphic is to adjust the image size and number of colors to get the best quality possible with the smallest file size.

Putting together a web page is more than just assembling graphics. You need a concept. You need a reason to have the page up, even if it's only to post pictures of the new baby or to sell your hand-knitted potholders and tea cozies. After you

have a purpose in mind, you can start to think about what goes on the page(s) and how to put them together.

The most popular language used to publish documents on the web is still HTML (Hypertext Markup Language). HTML isn't really a computer programming language, so relax. It is, as its name suggests, a *markup* language. A series of relatively simple *tags* enables you to specify how text appears in the browser, as well as images and links to other sites. HTML isn't difficult to learn, but you really don't need to. (If you decide to get into it, look for *Sams Teach Yourself HTML and XHTML in 24 Hours* by Dick Oliver and Michael Morrison. It's an excellent reference.)

There are programs, including desktop publishing programs, web browsers, and word processors you might already own, that can translate your pages into HTML with just a couple of mouse clicks. All you need to do is lay out the page the way you'd like it to look with your Elements pictures pasted in. You do have to make sure that the images are in a web-compatible format, though. Because web pages can be viewed on all kinds of computers, the graphics have to be in a format that's common to as many as possible.

And don't forget: Some people surf the web from a Palm, cell phone, or other low-bandwidth devices. Cell phones will soon get faster, but some older models still present a special problem, because their users won't see your pictures at all, and some cell phones that *do* display graphics do not show them in color. To avoid confusing cell phone surfers, or the many thousands of blind or low-vision web surfers, add a line of text (which can be hidden under the picture) explaining what the image is. This is especially important if your graphic is a title or logo.

Optimizing Images for the Web

Elements makes optimizing a photo or a graphic easy and almost automatic. Instead of saving your work in the usual way, choose File, Save for Web or click the Save for Web button. You'll open a dialog box like the one in Figure 15.1.

Here you can try out different ways of saving your picture, and see which method gives you the smallest file with the least degradation to the image. Yes, degradation—every time you save a picture as a file smaller than it was originally, you lose some data. If you save the same picture several times in a compressed format, you can end up with so much loss—and so little data remaining—that your photo starts to look like a seventh-generation photocopy, barely visible. This is *not* a good thing to do. Always save the original image in a noncompressed format like PSD. When you convert it for the Web, compress it and save it only once.

FIGURE 15.1
You can see how your changes affect the quality of the art, and decide what's acceptable. (Photo by Linda Standart.)

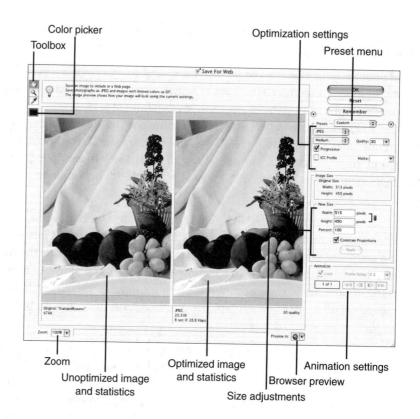

Color picker
Toolbox
Optimization settings
Preset menu

Zoom
Unoptimized image and statistics
Optimized image and statistics
Size adjustments
Browser preview
Animation settings

There are three formats that all web browsers can open automatically: JPEG, GIF, and PNG. If your browser has a QuickTime plug-in installed, it can also open TIFF files, but there's no guarantee that everyone with whom you want to share your pictures has QuickTime available.

After displaying your image in the Save for Web dialog box, Elements suggests a suitable image format compatible to the Web. You can change to a different format if you don't like the displayed results. I'll get to those formats shortly, but first let me explain a bit more about the dialog box.

The left pane shows your unoptimized image. On the right is your image as it might appear after optimization. Your considerations don't stop there, however. By clicking the right-pointing arrow and opening the Preview menu, you can change to various modes that simulate how your graphic will look when optimized and then displayed on a generic Windows monitor, a Mac monitor, or with its color profile. (You might select this if you are using a profile and you want to see how the image will look when printed.) See Chapter 14, "Printing Your

Pictures," for more information on color profiles and the role they play in preserving color information for printing. Notice that the file size for both the original and optimized images is displayed underneath each pane. Also from the Preview menu, you can adjust the download time to match what you think most of your visitors will be using. By default, 28.8Kb modem speed is used to calculate the download times shown below the optimized image. You can change this setting too, by using the menu that pops out from the right-pointing arrow next to the top-right corner of the optimized image pane.

You can zoom in or out of the image using the Zoom list at the bottom left. You can also zoom in by selecting the Zoom tool from the toolbox in the upper left and clicking with it on the image. Press Option/Alt and click with the Zoom tool to zoom out, so you can see more of the image. You can move the image within the frame by dragging with the Move tool, to view hidden sections of it. If you have more than one web browser installed (which you might, if you are seriously testing graphics for the Web), you can switch from one to another using the Preview In list on the lower right.

Finally, after adjusting the view, you're ready to change from one optimization type to another. Select the type you want, such as JPEG Medium, from the Settings list. The options displayed in the Optimization Settings area have been set to values that typically provide the best quality image for that setting. However, you can still adjust the individual options as needed. In the following sections, I'll explain each of these options.

JPEG (Joint Photographic Experts Group)

JPEG is the most commonly used web file format. Depending on your needs, JPEG is probably the best file format for you, too. It is great for photographs and other *continuous tone* (full-color) images, primarily because it lets you use 16 million different colors. (Of course, some older monitors, along with PDAs and cell phones, can't handle that color depth. Instead, they display a reasonable approximation of your artwork.) JPEG maintains color information, but does however employ a *lossy* compression scheme, which means that you can adjust and reduce the file size—at the expense of the image quality. It does this by examining adjacent pixels and averaging them against those closest.

When you select JPEG High, JPEG Medium, or JPEG Low format from the Settings list, the options shown in Figure 15.2 appear. The differences between High, Medium, and Low relate to the quality of the result, and thus, the amount of lossy compression. With Low, you'll get a smaller file, but with a greater loss of

clarity. If your image will only be seen in a very small format, that may not be a big deal, and with some graphics, even Low compression results in a nice-looking image.

FIGURE 15.2
By changing the
setting from Low to
High, I'll get better
image quality but a
larger file.

After selecting the JPEG format you want from the Settings list, you can change other options as desired. You can choose Optimize to compress the file as much as possible in that format; however, you should be aware that some older browsers do not support this extra-optimized JPEG format. Adjust the Quality level (compression level) by opening the list and dragging the slider. Choose Progressive to display the image in a browser, first at low quality, then gradually improving until the image is displayed in its saved format. Select ICC Profile to save the color profile (assuming you're using one) with the image; some browsers can use the profile to do simple color corrections for the user's monitor on the fly. If your image includes areas that are transparent, they must be filled with some color because JPEG format doesn't support transparency. Open the Matte list and select a color that closely matches your web page background.

GIF (Graphics Interchange Format)

If you save an image as a GIF file, you lose color information. The millions of colors present in a photograph are reduced to a palette of only 256 colors. That's how GIFs shrink files. If your picture happens to have relatively few colors—for instance, if it's a drawing rather than a photo—you won't lose any quality. In fact, if you know that there are only six colors, you don't even need to save the other 250. Obviously, GIF is not as good as JPEG for continuous tone art, but it's great for line art, logos, and anything with limited color. GIF also lets you save files with transparent backgrounds, which is extremely useful when you are creating web buttons or other round graphics and you want the background of the web page to appear around the edge. Furthermore, you can animate a GIF.

Even though GIF supposedly uses 256 colors, the reality is that there are only 216 of them that Mac and Windows computers have in common. These are said to be "web-safe" colors, because they'll look the same on both kinds of machines. So in the process of converting to GIF, a color table of the most common 256 colors in

the image is generated. When a color exists in the image but not on the table, a close color is chosen.

When selecting GIF from the Settings list, your first consideration is whether or not to use dithering. *Dithering* was what my dear Aunt Celia used to do whenever a decision was required. "Should I? Shouldn't I?" She wobbled back and forth until the lines of the situation were so blurred that it didn't really matter what she decided. And that's essentially what dithering is all about.

In Elements, and in other graphics programs, dithering mixes colors so that when you convert an image to a GIF or to an 8-bit PNG, you don't notice the missing colors. When you select a GIF that uses dithering (or a PNG, as you'll see in the next section), you can select the dithering method and the dither amount. A higher amount dithers more colors, but might increase file size. After selecting a GIF dithering option from the Settings list, you can select the following dither options from the drop-down list in the Optimization Settings area:

- ▶ None—Does not dither, but instead uses a color from the color table that comes as close as possible to the missing color. This tends to result in sharp transitions between shades of the same color, rather than the gradual ones achieved through dithering.

- ▶ Diffusion—Uses a method that produces a more random dither than the Pattern option. Applying a less-patterned dither to an image softens the effects over an area. To protect colors in the image that match those in the color table from being changed, select Preserve Exact Colors. You'll want to use this option if your image contains text or fine lines, which you quite naturally wouldn't want "fuzzified."

- ▶ Pattern—Uses a variation of a halftone pattern to simulate colors not found in the color table. Halftone is a process of dithering that uses circles of various sizes to simulate the intensity of a color—the more intense the color, the larger its dot. The Pattern option uses squares rather than dots, but the principle is the same: the more intense the color, the larger the square. Halftone dithering is used a lot in newspaper photos, because it's effective in images with large patches of the same color.

- ▶ Noise—Uses a random pattern to dither, like the Diffusion option, but without dithering adjacent pixels. Instead, it dithers pixels in the "neighborhood." This dithering method reduces the "seams" that sometimes appear in the Diffusion method, especially along the edges of image slices. An image slice is just what it sounds like: a slice or section of an image saved in a separate file. You can slice an image into various color regions and save them each as GIF files, and each file can have its own 256-color table. Thus,

more colors are saved from the original image. Place each of these slices into an HTML table, and they can be reassembled into a single cohesive image. Choose this option if you plan to slice the image for placement in an HTML table. (You can't slice and reassemble GIF images in Elements, but you can in other graphics editors such as Photoshop and Paint Shop Pro.)

After selecting a GIF with or without dithering, adjust the individual options if desired. Select Interlaced to display a lower-resolution version of the image quickly, while the higher-resolution version is downloading. Choose a method for generating the list of colors for the color table from the second drop-down list. You have these choices:

- ▶ Selective—This is the default. This option adds web colors (the 216 colors shared by Windows and Mac operating systems) to the table over other colors that may be present. Colors that appear in large patches are added to the table over other colors as well.

- ▶ Perceptual—Chooses colors for the table that the eye normally sees with the greatest accuracy.

- ▶ Adaptive—Looks for the most commonly occurring hues, then adds a proportionate sampling of those colors to the table.

- ▶ Web—Uses the 216-color palette common to Windows and Mac operating systems.

- ▶ Custom—Saves the current palette of colors and doesn't update it even if you change colors within the image.

In the Colors box, you can enter a number lower than 256 and reduce the number of colors in the color table, and thus the file size. The Web and Custom color table methods allow you to select Auto from the Colors list in order to have Elements tell you the optimal number of colors that provides the best quality in a small file size. To preserve transparency in your image, you must turn on the Transparency option; otherwise, transparent and semitransparent pixels are filled with the Matte color you select. Turning on Transparency creates jagged edges on round objects, so you might consider leaving it off, and instead selecting a Matte color that closely matches your web background color. For animated graphics, make sure the Animate option is selected.

PNG (Portable Network Graphics)

There are two kinds of PNG files: 8-bit and 24-bit. The PNG-8 format uses 8-bit color, which means that each image can contain only 256 different colors. Like

GIF, PNG-8 compresses solid areas of color very well while preserving sharp detail, such as that in line art, logos, or illustrations with type. Because PNG-8 is not supported by older browsers (although it is supported by the not-so-old versions of those same browsers), it might be a good idea to avoid this format for situations in which your image must be accessible to as much of the web-viewing audience as possible. The PNG-8 format uses a *lossless* compression method, with no data discarded during compression. However, because PNG-8 files are 8-bit color, optimizing an original 24-bit image—which can contain millions of colors—as a PNG-8 will degrade image quality. PNG-8 files use more advanced compression schemes than GIF, and can be 10%–30% smaller than GIF files of the same image, depending on the image's color patterns.

The PNG-24 file format uses 24-bit color and is suitable for continuous tone images. PNG-24 also uses a lossless compression scheme. However, PNG-24 files can be much larger than JPEG files of the same image. The PNG-24 format is recommended only when working with a continuous tone image that includes multilevel or variable transparency, such as you'd have in an anti-aliased image on a transparent layer—an image whose edges are blurred with varying levels of transparency so that the edges are smoother and less jagged. You might also use varying levels of transparency to blend the edge of an object with its background, again smoothing out the transition. (Multilevel transparency is supported by the PNG-24 format, but not the JPEG format.)

If you'd consider GIF for an image, consider PNG-8 as well. It might give you a smaller file, and can do the job well. If you're thinking about JPEG, consider PNG-24 if your picture has multilevel transparency. If it's a straight image, JPEG will probably give you a smaller, more efficient file than PNG-24.

If you select PNG-8 from the Settings list, you'll be presented with options similar to those described in the GIF section. If you select PNG-24 instead, you'll see only some of those options listed. Choose Interlaced to display a lower-resolution version of your image while the higher-resolution one is downloading. Select the Transparency option to preserve transparency in your image, or select a Matte color with which to fill them.

Optimizing a Graphic Step by Step

Let's work through this process, one step at a time. Start by finding a photo that you'd like to send someone or post on your own web page.

1. Open Photoshop Elements, and open the image you want to work with.

2. Make sure the picture is ready for "prime time." Crop, adjust colors, retouch.... Do whatever is necessary to make the image as good as you can. You'll find step-by-step directions for making image improvements in upcoming chapters, so you don't have to try them out now, but you won't harm anything if you play around. If you'd rather just optimize the picture right now, choose File, Save for Web, or click the Save for Web button in the shortcuts bar. That opens the dialog box shown in Figure 15.1.

3. The dual panes show both the original and optimized images in the Save For Web dialog box. Thus, you can compare the two images and decide which optimization settings work the best. If the entire picture isn't visible in the view area, use the Hand tool to move the important part of the image (such as a face) into view. You can also use the Zoom tool to magnify or reduce the view.

4. Decide which format to use. In a limited color environment like this one, GIF is the obvious choice. Use the Settings pop-ups to select GIF and 8 colors (because there are obviously no more than that used in the picture). See Figure 15.3.

FIGURE 15.3
The changes you make in the Settings box determine how your picture will be saved.

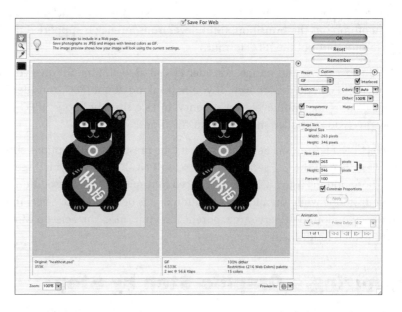

5. Now look at the information under the pictures. The notes for the original image show the filename and file size. The notes for the optimized image show the optimization options you chose, the size of the optimized file, and the estimated download time using the selected modem speed. (You can select a modem speed in the Preview pop-up menu.) In this case, we've reduced the file size from 355KB to 4KB, or by nearly 100%. It will load in considerably less than a second, no matter what the estimate says.

6. If you think you've found the right combination, check it out for yourself by clicking the Preview In arrow at the bottom of the screen. The pop-up menu will detect all the browsers installed on your computer. Choose one from the menu and open it by clicking on the browser logo. You'll see your full-size picture, along with the HTML tags to place it on the page. Figure 15.4 shows an example.

You can simply copy these lines of HTML code and paste them into the text version of your HTML page, after you add the image to the appropriate folder and upload everything to the web host, or you can use your favorite web page editor and let it do all the work.

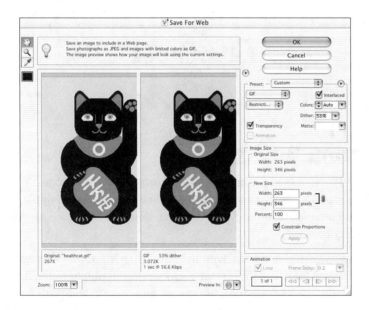

FIGURE 15.4
If you're concerned about color accuracy, check your picture on both Mac and Windows platforms, if possible.

Preparing Text for the Web

You searched high and low and finally found the ultimate font that expresses the essence of *you*. Or maybe you had a custom font made up of your handwriting.

What could be more personal than that? (You can do it at www.execpc.com/ ~adw/ for just under $100.)

So, naturally, you want to use your favorite font on your web page. Well, guess what? Only the handful of folks who have that particular font installed will see your words your way. Worse yet, if it's your very own big buck custom font, *nobody* will see it. Instead, they'll see whatever their browser decides is a close match to the font you selected. Can you do anything about this? Sure. Set your type in Elements, convert it to a GIF, and then paste it into the page. Because it's now a graphic instead of text, it'll look like your original. But it will take longer to load than regular text, so use it for titles rather than for entire pages. (If it's your actual handwriting, or a very funky font, be sure it's readable.)

Figure 15.5 shows an example of a logo I made up and converted for one of my web pages, combining type and a drawing. I also tried this with a photo of a cat in approximately the same position, but the line drawing turned out easier to read as well as being a smaller file.

FIGURE 15.5
Because the colors are very limited, I saved this file as a GIF. It loads faster than you can blink.

Preparing Backgrounds

I admit that I have mixed feelings about backgrounds on web pages. They can really add personality to a website, but they can also make reading the text of your site difficult and frustrating. To quote web designer David Siegel, "Gift-wrap makes poor stationery."

That said, however, if you use backgrounds with discretion, they can add to a site's presence and look. Because HTML includes the capability to tile any image as a background, your background file can be quite small. You just have to make sure that it doesn't have obvious edges or pictures/shapes that end abruptly at the edges—unless that's what you want. In Figure 15.6, I've created a simple tile for a web page background. After creating the simple pattern, I saved it as a JPEG file optimized for the web using the Save For Web dialog box in Elements.

FIGURE 15.6
Simple back-
grounds are less
distracting.

This pattern was very easy to achieve. First, I filled a square with pale blue, and then added a small amount of noise (Filter, Noise, Add Noise). After trying both options, I found the Gaussian distribution method worked better than Uniform, and that Monochromatic noise looked muddy. You'll learn how to apply the Noise filter yourself in Chapter 27, "Using the Improvement Filters."

Converting the single tile into a background is easy. You simply open a page in your favorite web page layout program and import the image. Depending on the program, you can import it as an image and click a check box in the dialog box to make it a background. Some other web page layout programs have a specific dialog box for placing backgrounds. I use Netscape Communicator to lay out simple pages. The Communicator dialog box is called Page Colors and Background, and is shown in Figure 15.7.

You can also use the tiling feature to create a background with one or more verti-cal stripes or other designs. Make the tile as many pixels high as necessary, but the full width of the page. The browser will have no problem at all tiling in only one direction. Figure 15.8 shows a background tile that will produce a multicol-ored background accent stripe down the left side of the page (see Figure 15.9). I created it in less than a minute by applying brush stripes of related colors from the Swatches palette (a palette of the colors in an image; choose Window, Color Swatches to display it) and then using Liquify (Filter, Distort, Liquify) to blur the stripes in only one direction. We'll play with the Liquify filter in Chapter 32, "Going Wild with Your Images."

FIGURE 15.7
The background image will tile smoothly because the edges are no different from the middle of the square.

FIGURE 15.8
Choose colors that harmonize so they won't distract the reader from the real message of the page.

FIGURE 15.9
Here's the result of tiling the background shown in Figure 15.8 on a web page in Netscape Composer.

You can also use a photo as your web page background, if you're willing to make a few changes to make it a better backdrop for text and to reduce its file size. First, resize or crop the graphic to fit the size of a standard web page: It should be about 680–800 pixels wide by 480–600 pixels tall. Next, colorize your image— reduce it to a single hue (color) such as blue. To do this, choose Enhance, Adjust Color, Hue/Saturation, and turn on the Colorize option. Turn on the Preview option so you can see how your adjustments will look on the final image, then move the Hue slider until the image is the color you want. Adjust the Saturation and Lightness values to wash out the image so that your text will be easy to read on top of it. Finally, optimize your image by choosing File, Save for Web. For a photo such as this, JPEG is typically the best choice. You can use JPEG Low since you don't need a high quality image as your background—after all, the focus should be on the text in front of the image.

Making Transparent Images

If you've designed a custom background for your pages, or even just assigned them a color, the last thing you want is to paste down a graphic and have it show up in a white or colored square instead of on your page background. Figure 15.10 shows what this looks like.

White image background oncolored page background

Transparent image background

FIGURE 15.10
A white image background is one of biggest problems beginners face, and it's also one of the easiest to solve.

To make a transparent GIF, follow these steps:

1. Place the object on a transparent background by selecting and deleting the current background. You can use an eraser to remove the background or select the object and copy it to a new image file or a new layer that you have set up with a transparent background. (If you copy the object by itself to a layer that has a transparent background, you can remove the other layers in the file.) You'll know it's transparent when you see the gray checkerboard pattern. See Figure 15.11.

FIGURE 15.11
I copied this image to a new page with a transparent background.

2. Save the transparent version of the image as a GIF or PNG file using the File, Save for Web command. Make sure you remember to check the Transparency option. Then apply whatever tool your page assembly program uses to locate and place the image on a web page. In Netscape Composer, it's simply the command Insert, Image.

Making Pages Load Faster

The bottom line for making web pages load faster is—you can't. The page will load only as fast as the server can send it and the recipient can receive it. Those are both factors beyond your control.

What you can do, though, is make sure that your page is arranged so that there's something to see while your graphics load. Bring up a Welcome headline first, and then add the background. If there's a graphic that will take some time to load, bring up a block of text before the graphic appears. The load time for the picture will seem much shorter if the person waiting has something else to read or think about. You can make these changes and others using your web page editor.

Keep your images small or put up thumbnails and link the full-size pictures to them, so visitors have the option of waiting to see the big picture. Remember

some people use text-based web browsers or cell phones and don't see images at all. If the content of your picture is important, put a text description of it on the page, too. If you learn HTML, you can use the `alt` tag to place an image description in place of the image.

Creating a Web Gallery

Elements has an easy and elegant method of converting your stacks of photos into a web-ready gallery that will display thumbnails of your pictures. Visitors clicking on a thumbnail will open up a full-page view of the image to appreciate it more fully. There are several different gallery styles you can choose from, ranging from simple to elaborate. I've chosen the Spotlight style for this collection of photos from a trip to Nevada. Figure 15.12 shows the web gallery as it appears in a browser.

FIGURE 15.12
Desert colors are amazing, especially when displayed in a web gallery.

To access this feature on the Mac, choose File, Create Web Photo Gallery. In Windows, open the Organizer and select Create, Web Gallery. You'll see the dialog box shown in Figure 15.13. First, though, make sure your pictures are all in one folder and are ready for viewing. Because they will be listed in alphabetical order by default, if you'd prefer some different arrangement, add numbers to the front of their filenames. Choose a Gallery Style from the drop-down list at the top of

the dialog box and then click Browse and select your folder. Choose whether or not to include subfolders as well. Click Destination, and tell Elements where to place the completed gallery.

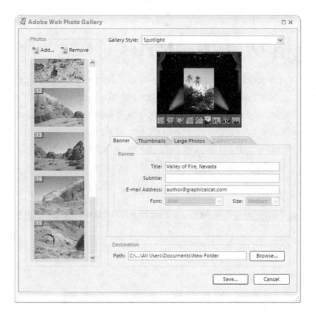

Some gallery styles have options; others do not. Here's a list of the options you may be able to set by selecting their category from the Options list:

▶ Banner—Enter information that will appear in the text banner at the top or bottom of the gallery. The site name appears in the browser's title bar.

▶ Large Images—Set the size of the images when they are selected from the home page, which displays the images as thumbnails. You can establish a size used for all images, or select a height or width and allow the other dimension to be set proportionate to the image's original size. You can also select the JPEG quality used in the large displays. Add a border around the large version of each image by entering a value in the Border Size box. Select what you want to display as the title of the large image pages from the Title Use list.

▶ Thumbnails—Set the options for the home page, where images are displayed as thumbnails. Select a size for the thumbnails, add a border around each thumbnail with the Border Size box, and select a title for the thumbnail page(s) from the Title Use list. If you select the Simple, Table, or Web

gallery style, choose the number of columns and rows for each thumbnail page.

▶ Custom Colors—Select the colors you want to use for each element of the gallery by clicking the appropriate color swatch and choosing a color from the Color Picker.

▶ Security—Protect your images from unauthorized use by selecting an option from the Content list. If you choose Custom, enter the text you want to use.

If you select the Table gallery style, you can choose your own graphic to use as the background by clicking the Background button. Click OK after choosing all your options to create the gallery. The home page opens in your browser so you can try out your creation. The destination folder you select will contain folders with the thumbnails and larger pictures, plus the HTML code to go into your web page editor. Follow the usual procedures for adding pages to your website.

I find it easier to work with a folder that has only a few images in it, and to preview the results in my web browser. Because Elements only has to prepare a few images, this process doesn't take very long. If I want to change some of the options after viewing them, I return to Elements and perform the steps again, making the changes I want to try out. Elements will ask you if you want to override your files, so click Yes to proceed. Repeat this process until you've created the perfect gallery, then copy all your images into the folder and perform these steps one last time to convert all the files.

Did you Know?

Emailing a Picture

You might not want to share a ton of pictures with everyone on the planet. Maybe you just have one that you'd like to send to one special person, attached to an email. Elements can do this for you, without even making you open up your mail program yourself. Just open the picture you want to send and choose File, Attach to E-mail, or click the Attach to E-mail button. If the file isn't currently saved as a JPEG, you'll be asked whether you want it converted. You probably do, unless you're quite sure the recipient has the software to see it in whatever format you are sending.

Your usual message window will open. The file is already attached, so all you need to add is the address, subject, and a message. Then click the Send button to send it off.

Summary

The Internet is a remarkable place, not only for what's already out there, but because we can use it ourselves to share our ideas and photos. In this chapter, we have taken a look at what we can do with pictures to make them ready for the Internet. You learned how to prepare images of all kinds for web use, from photos to drawings to type. You learned about the formats that are compatible with web browsers and how to optimize an image for efficient web use. You learned about custom backgrounds and how to create and tile them. You learned about Elements's web galleries, and finally how to attach a picture to your email. There's a lot more you can learn about web graphics and web design, and there are many good books from Sams Publishing to help you.

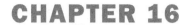

CHAPTER 16

Keeping Track of Your Pictures

What You'll Learn in This Chapter:

▶ Photoshop Elements Organizer

▶ iPhoto for Macintosh

By now, you've taken or scanned dozens, if not hundreds of pictures. How can you possibly keep track of them all? More importantly, how can you find the one you want to work on? If you download your pictures from the camera to your hard drive, you might either have one overstuffed folder called *My Images*, or you might have a whole bunch of folders labeled *cats*, *cats playing*, *cat July*, and so on. Worse yet, unless you've renamed the pictures as you download then, you have folders full of files with names like *DSGF0046.jpg*. That's a big help, NOT!

What you need is a way to organize this stuff. Professionals call it *resource management*, and there are a number of programs that can help you organize your images. The good news for Windows users is that Elements includes an organizer that will let you manage all of your picture files, assign keywords, and keep the files available for convenient browsing. The Mac version of Elements doesn't include the Organizer because the operating system Mac OS X includes an application named iPhoto that works in a very similar way to the Elements Organizer and does all the same tricks. I'll cover the Elements Organizer first, so you Mac users can feel free to jump ahead to the second part of this chapter and learn about iPhoto.

Photoshop Elements Organizer

Shortly after the last version of Elements was released, Adobe introduced a stand-alone program named Photoshop Album. It was a big success with Windows users

because Windows doesn't have anything like Apple's iPhoto. Organizer is that program, but now it's integrated into Photoshop Elements for Windows. If both are open, you can switch back and forth between Organizer and the Elements Editor workspace by clicking an icon on the Windows task bar. To open Organizer, select View and Organize Photos from the Elements Welcome screen, shown in Figure 16.1.

FIGURE 16.1
The Welcome screen is the most direct route to Organizer in Windows.

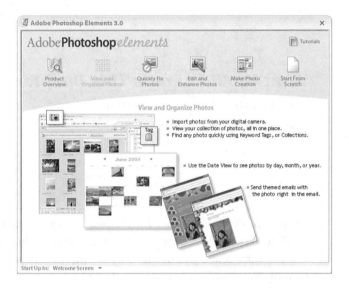

> **By the Way**
>
> You can also select, from the bottom-left side of the Welcome screen, whether Elements opens with the Welcome screen or goes directly to Organizer or the Editor.

Understanding Organizer

Organizer is more than a photo browser, although you can certainly use it as one. And the File Browser is still an important part of Elements. The difference between the Organizer and the File Browser lies in the way your image files are tracked and accessed. When you use the Browser, you navigate through the folder hierarchy until you reach the particular folder you're looking for, and then open it to display the images as thumbnails. Naturally, the Browser can find only files that are currently available to it on your hard drive or on a mounted CD-ROM, DVD, or other active peripheral device.

When you put images in Organizer, you actually are making entries into a catalog that notes the location of the image; its creation date; any titles, tags, keywords; and any other information you have entered for that image. (This info is called *metadata*.) The neat feature of this comprehensive catalog is that you can search for a particular image by filtering the catalog data so that you see only what's relevant, and if the photo is on a CD-ROM or other storage device that's not presently in use, Organizer can still tell you where it is. Organizer can also keep track of video clips and sound files, as well as images you create in the Editor.

There are, of course, several different ways to put your pictures and other items into Organizer. How you'll do it depends mainly on where they're coming from. But first, let's look at Organizer itself. As you can see in Figure 16.2, it has a menu bar, a shortcuts bar, and buttons to switch between Date view and Photo Browser view. There's also an Organize bin, which has two sections. The first enables you to assign tags to images, and the second sorts your image files into collections.

Menu bar Shortcuts bar Photo Browser button Date View button

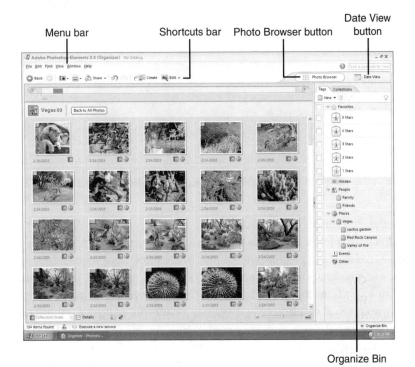

FIGURE 16.2
Windows Organizer in Photo Browser view.

Organize Bin

The shortcuts bar has buttons for moving backward and forward between views and arrangements in either the Photo Browser or Date view, for getting photos from your digital camera or other sources, for printing photos, for sharing photos, undoing and redoing edits, making creations, and editing photos. The question-mark icon denotes the Help system. If you type a question into the small window next to it, you'll be taken to the appropriate help page. The two icons at the right of the shortcuts bar make it possible for you to switch between the Browser view shown in Figure 16.2 and the Date view, shown in Figure 16.3. You can choose to display your photos in Organizer either one at a time or in a grid of thumbnails.

FIGURE 16.3
Organizer in Date view.

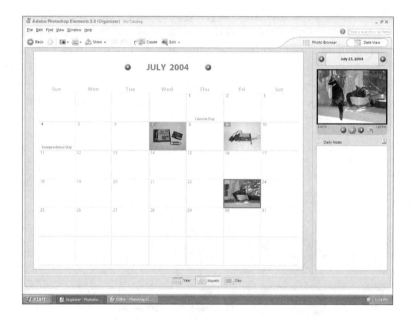

Date view sorts your photos according to when they were shot. It's especially handy if you do a lot of travel photography and end up, as I often do, not really sure where some of the pictures were taken. You can go back to your itinerary and find out whether you were in Scotland or Ireland on March 15. Elements gets this information from the camera files when you upload digital photos. If you're using a scanner and entering old pictures, the date will, of course, be the day they were scanned, not the day they were shot. When you select a particular day, the calendar will show the first of the images from that day. To scan through the rest of them, look at the thumbnails in the window to the right of the calendar. The arrow buttons move you back and forth through that day's pictures. To see a different day, click it on the calendar, and the thumbnails will change accordingly.

By the
Way

I remember a funny movie from many years ago, "If It's Tuesday, This Must Be Belgium." Perhaps the Adobe engineers saw it too, and were thus inspired to create this useful tool.

If you make changes to an image and resave it within Organizer, the date will not change. The file will be saved using the same name with the word *edited* appended to it, and will be displayed instead of the original version, but both the original and the edited versions will be kept on the hard drive.

Starting an Album

To start a new album, open Organizer in either Photo Browser or Date View and select File, Catalog, New. Determine a location for your catalog and give it a name.

The next step in organizing your photos is to bring them into Organizer. How you'll do this depends on where they are coming from. Images already on your hard drive or on an external drive such as a CD, DVD, or Zip disk can be imported singly or in folders. Images can be downloaded directly from a digital camera or a card reader, from a cell phone with a camera built in, or from an online photo-sharing service. If you have previously built photo albums with Adobe ActiveShare or Adobe PhotoDeluxe (both now discontinued), you can transfer those albums into the Elements Organizer, too.

To import one or more pictures into the Elements Organizer, choose File, Get Photo and locate the correct source on the submenu, shown in Figure 16.4.

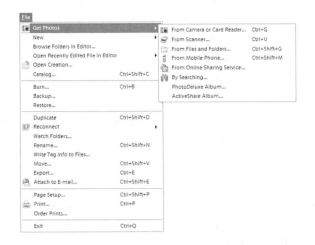

FIGURE 16.4
Locate and select the source for the pictures you want to bring into Organizer.

Nothing could be easier than downloading photos from a camera, card reader, or scanner. Simply make sure that the device is plugged into a USB port, turn it on, and choose File, Get Photos, From Camera or Card Reader. A window like the one in Figure 16.5 will open, displaying all the pictures on the memory card. Note that each photo has a small box with a check mark beneath it. Uncheck the pictures you don't want to download, and they'll be ignored.

By the Way

Photoshop Elements recognizes most, but not all, digital cameras and card readers. If it doesn't see yours, use the Windows Camera Wizard to import your photos into a folder, and then add the folder to your Organizer catalog.

FIGURE 16.5
Only the checked photos will be downloaded. If there are some that are no good, just don't check them.

You can also use this import window to rename the pictures as you import them. Because this download was a mixture of several different photo sessions and subjects, I decided to wait and rename them later.

To import pictures from an existing folder, choose Get Photos, From Files or Folders and navigate to the files you intend to import. Use the Look In drop-down menu and other navigation tools at the top and left of the window. Hold the mouse pointer over a file to see information about that file, or select it to see a preview on the right side of the window. To get a single photo, select it. To get several at once, Control-click each one; or, if they are consecutive, click the first file in the list, and Shift-click the last file to select the bunch. After you've found the one(s) you want, click the Get Photos button. They'll open in the Organizer, ready

to work on, or to assign tags and categories. Figure 16.6 shows the Get Photos from Files and Folders window.

FIGURE 16.6
Remember that you're not actually moving these files. Elements is cataloging their current location.

Another convenient way to bring photos into Organizer is to simply drag them from the desktop into the Browser window. Elements will create a new file for the picture and display it in the Browser as a new picture. To return to the rest of the Browser photos, click the Back To All Photos button.

Maintaining Links in Organizer

If you move or rename the actual file or folder after you have entered it into Organizer, you'll break the link it has formed. When this happens, you'll see a File Missing icon in the Browser instead of the item you're looking for. The icon looks like a photo torn in half, and appears at the bottom of the thumbnail view.

Files get lost in any of several ways. One way happens when you move them on your hard disk without using the Browser to do so. If you must move a file to a different folder or drive, use the Browser's File, Move command. Another way to lose a file is to rename it outside of the Browser. Instead, use File, Rename. If you delete a file from the hard disk, you need to delete it from the Organizer catalog, too. You can do this using the File, Delete From Catalog command, or the Reconnect Missing Files dialog box shown in Figure 16.7.

FIGURE 16.7
To reconnect to a
missing file, navi-
gate to the new
location of the file.
To delete a catalog
entry, click the
Delete From
Catalog button.

By default, Elements will automatically try to locate missing files when you call
for them. It searches for files with the same creation date, size, name, and type.
You can turn this function on or off in the Preferences dialog box. The Reconnect
Missing Files dialog box is most useful if you want to search for missing files in a
particular location. If you have a missing file, you'll see a large question mark
instead of a thumbnail. If the file is still available but the link is broken, you'll
see the thumbnail with a small icon of a picture torn in half, as described above.
Double-clicking either of these icons opens the Reconnect Missing Files dialog
box.

Finding Your Photos

Now you have a bunch of photos that you have imported into Organizer. But
they're still just a bunch of photos. Finding the one you want is no easier than
before, unless you remember the day you took it or scanned it. So, rather than
having to search through all those pictures each time, you can simplify the task
by assigning tags to them. You can make up as many tags as you need. For
example, as you have probably guessed from the illustrations in this book, I have
several cats. When I enter a photo of the cats, I tag it first as *cats*, and then with
the name(s) of the cat(s) in the picture. This takes only a few seconds to do and
saves a lot of search time later.

You can create and apply tags in Organizer. By default, there are five kinds of tags: Favorites, People, Places, Events, and Other. You can create and organize your own tags under these categories. Take another look at the Organizer in Figure 16.8.

Custom tags

Tags palette

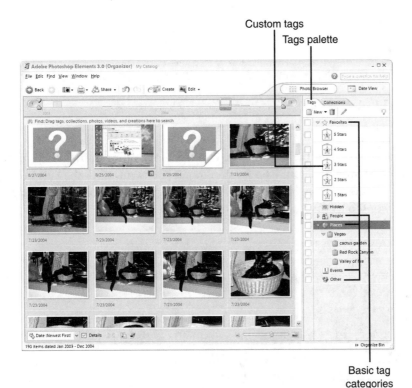

FIGURE 16.8
Look at the right side of the Organizer window for the Tags palette.

Basic tag categories

As you can see, the categories are denoted by icons as well as by names. When you add your own subcategories, you have the option of adding a custom icon as well. To add a new tag, click the New button at the top of the Tags palette. You'll open a dialog box like the one in Figure 16.9.

By the way, the icons at the top of the Tags palette represent deleting a tag (the trashcan) and editing a category (the pencil). The light-bulb icon opens up a small window with tips for using the tool or palette.

By the Way

FIGURE 16.9
I've chosen to put
the Cats tag under
the Other category.

Choose a category for the new tag, and then enter its name in the box provided.
You can even add a custom icon for that tag, if you want. Click the Edit Icon but-
ton to open the window in Figure 16.10 and navigate to a photo or other piece of
art you want to use as the icon. I selected a photo for mine.

FIGURE 16.10
Some of my tags
just have names.
This one has an
icon, too.

To apply a tag, simply select it from the Tags palette and drag it to the appropri-
ate photo. If you have a bunch of pictures that get the same tag, you can apply it
to all of them at once by selecting the first photo in the list and then Shift-clicking

the last in the list to select all the images and dragging the tag icon to one of the selected items. The tag will be applied to all the selected items.

By the Way

> Because Organizer can handle video and audio files in addition to photos, you can apply the same kinds of tags to other media files as well. I now have file tags for *Celtic*, *Jimmy Buffett*, and *Bach*, among others.

To create a new category or subcategory, click the New button at the top of the Tags palette and choose Category or Subcategory. You can enter a name for it and select an icon from the dialog box shown in Figure 16.11.

FIGURE 16.11
Even though you can select any photo for a tag image, you're limited to the icons that Elements provides for a category.

You can apply as many tags as you need to a single photo. Tag icons are shown beneath the picture they're attached to, as you can see in Figure 16.12.

FIGURE 16.12
These photos are all tagged as cats, and some as favorites.

If you've gotten over-enthusiastic about creating tags, and created more than you need or want, you can merge them. For example, suppose that I made up two tags, Dan and Danny, for photos of my son and assigned some photos to each. To merge them, I'd simply select both tags, right-click the mouse, and choose Merge Tags from the context menu. Choose the tag from the list that you want the merged tags to appear under. Click OK when you're done.

Making Photo Collections

A collection is essentially a photo album. Using the Browser, you can drag and drop photos into a collection in a specific order. Then you can display the album as a slideshow, or turn it into a creation such as a web photo gallery, calendar, video CD, or any of several other possibilities. To make a collection, start by clicking the Collections tab in the Organizer bin. This brings the Collections palette forward, as in Figure 16.13.

FIGURE 16.13
The icons for your collections are little books with a tiny image of the first photo in the collection.

To start a new collection, click the New button in the Collections palette of the Photo Browser, and choose New Collection Group. Type a name for the collection in the Collection Group Name text box. Use the Parent Collection Group drop-down menu to choose a group in which to nest your collection group. Click OK. The new collection will appear in the Collections palette under the collection group you selected. When you place photos into a collection, they'll also be available in the main catalog. You can put the same photo in as many collections as you want. Because the catalog and collections are really just lists of the photo locations, they don't even take up very much disk space. To see what's in a collection, click its name in the Collections palette.

Searching for a Photo

If you do a careful and thorough job of applying tags when you import your pictures, you'll soon discover that finding the shot you're looking for becomes much easier. To find a tagged photo, just double-click on the appropriate tag in the Tags palette or click the box to the left of it in the list or drag the tag to the Find box. The Find box is in the upper-left corner of the screen, marked by an icon that resembles a pair of binoculars. Click it to open the Find box. You'll see the same icon next to the list of tags when you have selected a category to search. When you do so, the Browser will display only the photos with that tag. When I add more cat photos to my catalog, I can also create tags with the name of each of the cats in the photo. Then I will be able to look at, for example, all the pictures of Charley without having to look at any of the other cats in the catalog.

If you know the approximate date the photo was taken (if digital) or scanned in, searching is simply a matter of going to Date view and navigating to the correct month and year.

Working with the Photo

You've found the photo you were looking for. Now what? You can use Quick Fix to touch it up if necessary, or open it in the Editor if it needs more serious work. Of course, you can print it or email it, but why not turn it into something more? Make a creation. (Imagine a sound effect of heavenly chimes here.)

Creations are predesigned templates that you can access through Organizer or the Editor. They include wizards which, as you know from other Windows software, are a sort of mini-application that guides you step by step through a process, making it essentially goof-proof.

Click the Create button in the shortcuts bar to open the Creation Wizard and select a project, as I have in Figure 16.14. The next step is to choose a style for the project, from the dozen or so that are supplied.

I chose a southwestern theme for the calendar I'm going to create because I had a bunch of pictures from the Nevada desert. I selected thirteen of them, including one for the cover. Step 2 of the Create a Wall Calendar Wizard was to import them into the wizard and then arrange them in an order that seemed appropriate. Figure 16.15 shows this step.

FIGURE 16.14
You can surprise
your family and
friends with custom
calendars made
just for them.

FIGURE 16.15
You can drag the
pictures around to
change the order.

You can preview your calendar by the page (as shown in Figure 16.16), or see all
pages at once. You could also add photo captions on each page if you want, by
just typing them into the space provided. Look for a line of type under the pre-
view photo that says "Double-click to insert caption".

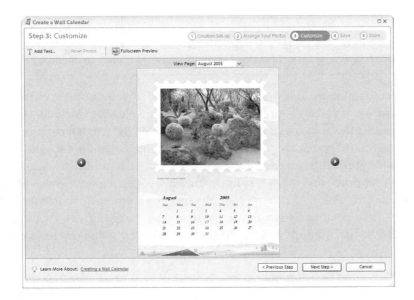

FIGURE 16.16
Use the arrow buttons to scroll between pages.

When your creation is complete, save it and print it. Of course, if you have chosen to create a web gallery or video CD, you'll be burning a disc or publishing on the Internet, not printing. In any event, the final wizard screen, shown in Figure 16.17, enables you to save a printed project as a PDF file or print it directly from this screen. You can also email the creation to someone.

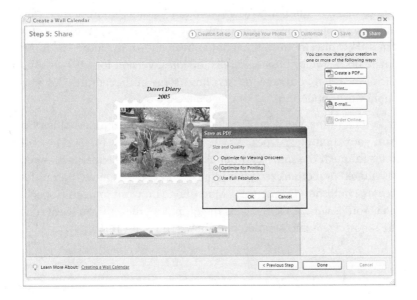

FIGURE 16.17
Saving the calendar as a PDF.

By the Way

Remember that your creation exists only as a template and list of photos in the Organizer catalog. If you erase or move the pictures, you won't be able to print your work, which is why you should make a point of saving your print creations as PDFs.

The other Creation wizards work just like the Create a Wall Calendar Wizard. You select a project and a style for it, and then choose the photos to include. The wizard assembles the photos as a catalog entry, including the template and any text you've added. If appropriate, you can even add sound. Organizer includes a selection of MP3 music files, and you can add your own to the catalog. You can keep track of your music and video files in Organizer, too. Just import them as you would any other file: by locating or simply dragging them in. To search for one, open the Find menu and select the option to find by file type. Elements can display only the first frame of a video clip, but it can play a sound clip in its entirety.

Adobe Photoshop Elements has an excellent set of help screens for the various Organizer functions. If there's anything you're unclear about, just look it up and follow the step-by-step instructions.

iPhoto for Macintosh

Macintosh computers ship with *iLife*, a suite of applications that turns the Mac into a powerful multimedia machine. Along with iMovie, iDVD, iTunes, and GarageBand, there's iPhoto. Mac users can use iPhoto to organize their photos, make albums and slideshows, order prints and bound books, email a picture, and even burn a DVD directly from the iPhoto screen shown in Figure 16.18. Apple updates iLife on a regular basis and sells the latest version for $49—less than $10 per application—so, if your copy doesn't have some of the features described here, it's probably worth updating.

iPhoto is located in the Mac's Applications folder and its icon probably also appears on your computer's Dock. As you can see in Figure 16.18, iPhoto displays your photos in much the same manner as the Photoshop Elements Browser. After you have entered and organized your photos, you can designate a graphics program such as Photoshop Elements for Mac when you want to open a specific picture to edit. You designate Elements as the graphics program you want iPhoto to use in the iPhoto Preferences dialog box shown in Figure 16.19.

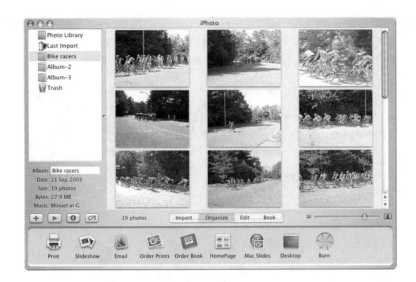

FIGURE 16.18
iPhoto works like
the Elements
Organizer.

FIGURE 16.19
If you choose
Elements as the
graphics editor for
iPhoto, double-click-
ing on an image
will open the pro-
gram.

iPhoto also has some, admittedly limited, photo-editing tools, for those times
when you're in a hurry and very little editing is needed.

Importing Photos

There are several ways to bring photos into iPhoto, depending on where they are
to start with. If you use a digital camera with a USB connection, simply plug it
into a convenient USB port on your Mac. (I use the one on my keyboard.) Turn on

the camera. When the Mac detects the presence of a digital camera, it automatically opens iPhoto for you and prepares to download your pictures when you click the Import button. Figure 16.20 shows the download set up.

FIGURE 16.20
If iPhoto is already open, click the Import button to start the download.

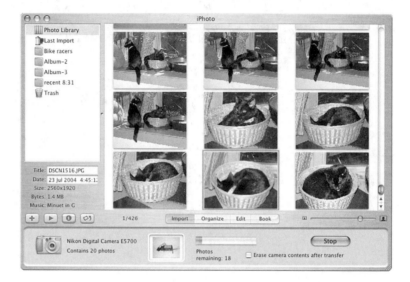

iPhoto shows the make and model of the camera you are using and a thumbnail of the picture it's currently downloading. The progress bar tells you approximately how far you've gotten with the download. You have the option of automatically erasing the contents of the camera memory card after you have finished downloading.

By the Way

> If you use iPhoto, you don't need to install the software that came with your camera. As soon as you click the Import button, iPhoto will import your pictures and display thumbnail versions of them.

If you have a camera that uses film, have your film processed by a company that offers digital photo services and ask to have your photos put on a CD-ROM. You can also arrange to have your photos sent to a website from which you can download them.

If the pictures are on a hard drive, CD-ROM, or other storage device, go to the File menu and choose Import or press Cmd+Shift+I to open the Import Photos dialog box, shown in Figure 16.21. From there, you simply navigate to the file or folder you want to import. iPhoto shows a thumbnail of the photo and some information about it. When you click the Import button, iPhoto does the rest.

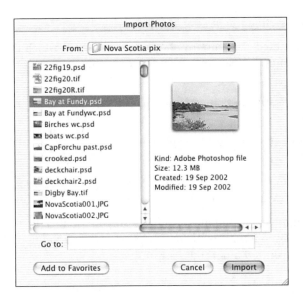

FIGURE 16.21
You can also import files and folders by dragging them into iPhoto's library.

After the photos have been uploaded or transferred from another disk location, iPhoto stores your pictures in a folder named Pictures, located in your User folder. If several people share the same computer, each will have his or her own username and Pictures folder within the Users folder.

Arranging and Sorting Your Pictures

iPhoto displays your pictures in the order in which you imported them. This is hardly ever the most convenient way to view them, so you'll probably want to rearrange them and move them into different albums. To sort photos, go to the View menu shown in Figure 16.22, select Arrange Photos, and then choose a sort method.

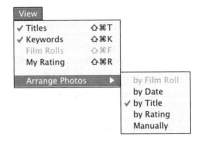

FIGURE 16.22
Use any of these methods to sort your photos.

Your options for sorting images are as follows:

- ▶ Sort by Film Roll. This groups photos in the order in which they were imported. Film roll markers indicate photos that were imported at the same time.

- ▶ Sort by Date. This option arranges the photos in the order they were shot or scanned.

- ▶ Sort by Title. If you have titled your photos, they'll be shown in alphabetical order, otherwise by the number the camera assigns.

- ▶ Sort by Rating. This option arranges your photos by a personal zero-to-five-stars rating you've assigned to each one.

- ▶ Sort Manually. This option is available only in albums. It enables you to drag pictures to rearrange them. It's helpful when you are putting together a web page or making a slideshow or book.

By the Way

To rate a photo, select its thumbnail in the iPhoto window and choose Photos, My Rating or press Cmd+0, Cmd+1, Cmd+2, or similar key combinations up to Cmd+5 to assign the photo zero to five stars.

After you have sorted the pictures, you have options for how you want to view them. You can see them by any combination of the categories shown on the View menu. View by film roll and title, by date and title, or whatever seems the most logical method to find the picture you are looking for.

If you view by film roll, you'll see separators between the groups of pictures, along with the date each was uploaded. See Figure 16.23.

Use the slider at the bottom right of the iPhoto window to adjust the size of the thumbnails on the screen. You can display them one at a time or as many as you can fit, depending on your monitor.

If you click on a specific photo, its title and date will be displayed at the left of the window. For more complete information about the image, press Cmd+I or select Show Photo Info from the File menu. In case you're curious about how and when you shot a particular image, what camera you used, and what settings, all of this information and more is available to you with this command. Figure 16.24 shows the Photo Info window. Click the Exposure tab to see what shutter speed and aperture the camera was set to, and other technical details.

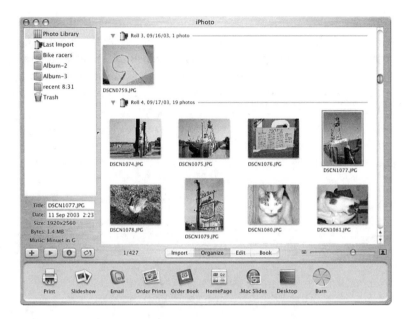

FIGURE 16.23
Each upload is considered to be a new "roll" of film.

Editing a Photo

As I mentioned earlier, iPhoto has a small set of correction tools. You can crop, automatically adjust color and contrast, fix red eye, retouch spots, convert a color photo to black and white or add a sepia tone, and tweak the brightness and

contrast to suit your taste. All of these tools become available at the bottom of the window when you click on the Edit button. However, for anything more than a minor correction, you'll be happier working in Photoshop Elements. To apply any of the iPhoto correction tools, first select the photo you want to work on and use the slider to make it larger within the window. Then click on the tool you want to apply. The automatic tools just go ahead and do what they do. To crop, you'll drag crosshairs to draw a box, and then you can adjust the sides of the box until you like the result. iPhoto grays out the part of the picture that you are cropping off, as shown in Figure 16.25.

FIGURE 16.25
Click the Crop button again to complete the edit when you have the cropping box where you want it.

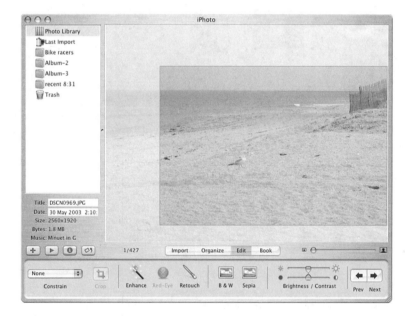

Use the Retouch brush by placing the crosshair cursor over a spot you would like to make disappear. Click the mouse, and the spot is gone. (Actually, you might have to click several times.) This magical instrument works by evaluating the differences between the spot and the space around it, and making the pixels match. It's not good for large areas, but if there's just a speck or a pimple you want to lose, this tool does the job quite nicely.

Creating Albums

As you bring more and more photos into iPhoto, it will probably become more difficult to remember where a particular set of photos might be. You can scroll through until you spot what you're looking for, or you can simplify the task by

assigning your photos to albums. To make a new album, just click the button with the plus sign at the lower-left side of the iPhoto window. Give your album a descriptive name, such as *Danny's 6th birthday* or *Paris, 2002*. To rename an album, select the album name in the list on the left side of the iPhoto window and enter its new name in the Title text box below the album list.

To add pictures to the album, make sure that you are in the Organize view (click the Organize button), select the picture(s) you want to put in that album, and drag the photos to the album name on the left side of the iPhoto window. As you do, a faded version of one of the images appears behind your mouse pointer, and you will also see a red symbol showing how many pictures you have moved. Images in the albums are still present in the main iPhoto library. What you actually do is create aliases to them for the album.

You can also enter keywords to help you locate specific kinds of pictures. Make the keywords as general or as specific as you like, depending on how you like to search. For example, I use *cats* as a keyword, but also key the photo according to which of our several cats are in it. To assign or remove keywords, press Cmd+K or select Keyword from iPhoto's Edit menu.

Sharing Your Photos

In the Organize view, the bar at the bottom of the window provides several ways in which you can share your pictures. You can print them yourself, or you can connect to websites which will make prints for you and send them by regular mail. You can even make up a book and have it professionally printed and bound. If you decide to make a book, remember that you need to have at least 10 pages in it (10 is the minimum; you'll pay extra for more). But if there are fewer than 10 photos, you'll have blank pages at the back of the book. To make up one of these photo books, click the button and follow the instructions on the screen.

If you have a .Mac account, you can upload your pictures to your homepage account and let your friends view them online or download them. If you don't have a .Mac account and want one, go to www.apple.com to sign up.

You can email individual photos by selecting the picture(s) you want to send from an album or the library and clicking the Email button. This action will open your regular email program so that you can send the photos as attachments. You can burn a CD of the photos you select by clicking the Burn button. You don't need additional software; iPhoto will handle the CD process for you. You can enjoy your pictures at your own desktop either as a slideshow or by turning one of your photos into a desktop background. Click the Slideshow button to assemble your

show, adjust timing, and select music to play with the pictures. Click the Desktop button to make a selected image into wallpaper for your desktop.

Summary

Keeping track of your digital assets is almost as important as keeping track of your financial ones. If you're on the Windows platform, Photoshop Elements includes Organizer, which will help you classify and sort your pictures and make it easier to find the one you're looking for. If you use a Mac, you don't need the Elements Organizer because you have Apple's iPhoto, which serves the same purpose.

In this chapter, you learned how to import your pictures from your digital camera or from another source such as a CD or internal or external hard drive. You learned how to sort photos by date and title, and how to apply convenient tags or keywords to help you search for the right picture. We also discussed some of the many ways you can share your photos with your family and friends, both as printed pictures and as slideshows and web pages. Remember that putting a picture into Organizer or into iPhoto is only half the job. The other half is to add the tags or keywords that will help you find it, and perhaps to break your photos down into albums or collections by category. The more ways you have to search for something, the easier it will be to find it.

PART IV

Working with the Tools

CHAPTER 17 Making Selections and Using Layers **331**

CHAPTER 18 Working with the Brush Tools **353**

CHAPTER 19 Adding Type **367**

CHAPTER 17

Making Selections and Using Layers

What You'll Learn in This Chapter:

- ▶ Using the Selection Tools
- ▶ Modifying Selections
- ▶ Working with Layers

Now we're getting into the real nitty-gritty business of working with Photoshop Elements. The ability to make selections and add extra layers to your photo gives you some very powerful tools. Instead of making a change to the entire picture, you can work on pieces of it, segregating them, so that the rest is preserved as it was. For instance, you can clean up or remove a background while leaving the subject of the picture intact. You can make subtle changes, such as fixing the skin tones of a woman in a pink dress without changing the color of the dress. You can move parts of the picture around, stack things on top of each other, and control the amount that the bottom one shows through the top. If you read only one chapter in this book, this is the one to read.

Using the Selection Tools

All the selection tools are conveniently located in the same section of the toolbox. You have four kinds of selection tools:

- ▶ Marquees—Rectangular and elliptical
- ▶ Lassos—Regular, polygonal, and magnetic
- ▶ The Magic Wand
- ▶ The Selection Brush

Probably the first thing you will notice when you go looking for these tools is that you can see only one lasso and one marquee. The others are on a pop-up menu that will appear when you click the small black triangle, as in Figure 17.1.

FIGURE 17.1
I wish that I could find the hidden tools on my real desktop this easily.

Making Selections with Marquees

Using the marquees is quite simple. Select the proper tool for the job—either the rectangle or the circle—and position it at the start of the selection. Press the mouse button and drag until your selection is complete. You'll soon see why they're called *marquees*. They have dashes running around the perimeter, much like movie marquees used to do. This flashing dashed line is also called *marching ants*. By adding selections to an existing selection, you can build quite elaborate shapes, as I have in Figure 17.2.

FIGURE 17.2
It's not the Taj Mahal.

To constrain the shape to a perfect square or circle, press the mouse button and as you start dragging, press and hold the Shift key. This gets tricky because pressing the Shift key *after* you have made a selection enables you to continue to add more pieces to the selection. If you have trouble with these combinations, don't worry; you can accomplish the same thing by using the buttons on the Tool Options bar, shown in Figure 17.3. (This figure shows both the Mac and Windows versions of the toolbar.)

From the left, choose either the square or circle as the marquee shape. Then choose from the set of four small icons according to what you need to do: New Selection, Add to Selection, Subtract from Selection, or Intersect with Selection. Or

else press the Shift key to add part of a selection, or the Option/Alt key to delete a part of the selection.

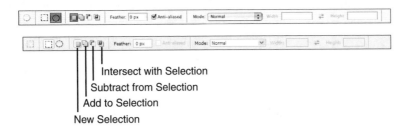

Intersect with Selection
Subtract from Selection
Add to Selection
New Selection

FIGURE 17.3
Use the key commands or these buttons; it's your choice.

Instead of pressing the Shift key as you drag to constrain proportions, you can choose a mode, such as Fixed Aspect Ratio, and enter 1:1 for a square or circle or any other pair of numbers for constrained rectangles and ovals. To drag a marquee from its center out, press and hold Alt (Windows) or Option (Mac) after you begin dragging.

Let's practice this before we move on. Start a new image.

1. Select the Elliptical Marquee tool. Starting near the top left of the image, drag the crosshairs down and to the right, pressing the Shift key as you drag. This will give you a perfect circle. Make this circle whatever size you want.

2. Holding down the Option/Alt key, draw a smaller circle inside the first. You can also click the Subtract from Selection button before you draw the inner circle if you'd rather keep your left hand free.

3. Select the Paint Bucket tool from the toolbox and pour a nice medium-brown paint into the area between the two circles.

4. Press Cmd/Ctrl+D to deselect and chase away the marching ants. Enjoy your donut.

Selecting with the Lasso Tools

Marquees are great when you have to select something with nice neat edges, or if you want to draw and fill a shape. But for selecting small bits of a picture or pulling one flower out of a bunch, they're not the best tools for the job. That's when you need a lasso. Use the Lasso tool to draw a selection line that is a single pixel wide around any object. As long as you're dragging the mouse while holding down its button, the Lasso tool will draw a line where you want it. As soon as

you release the mouse button, the two ends of the line automatically connect, giving you a selection box in the shape you've drawn.

In addition to the regular lasso, you have two other choices: the Polygonal Lasso and the Magnetic Lasso. The Polygonal Lasso tool Options bar is shown in Figure 17.4.

FIGURE 17.4
I've selected the Polygonal Lasso.

The Polygonal Lasso is useful both for selecting objects and for drawing shapes to be filled or stroked. To use it, first select it from the Tool Options bar. Place the cursor where you want to start drawing, and click once. Move the cursor and click again. You've drawn a straight line between the two points where you clicked. Each time you move the cursor and click, you add another line to the shape. When you're ready to place the last point to join the ends of the shape, the cursor changes to the one shown in Figure 17.5, adding a small circle to the right of the lasso. You can close the shape yourself, or double-click to draw a line between the point where you double-click and the beginning of the shape.

FIGURE 17.5
The next click will join the ends of the selection together.

The Magnetic Lasso is one of the tools I use most often. However, it's very useful when you need to make a specific or detailed selection of something that's not all one color. The tool detects the edge of an image near the spot where you click or drag, based on the degree of sensitivity you select. If the area you're trying to select contrasts well with its surroundings, you can set a large Width (click/drag

area) value and a high Edge Contrast value in the tool's Options bar and drag quickly and quite roughly around the image, and Elements will select the area you want. If the area does not contrast well with its surroundings, set a smaller Width value and a lower Edge Contrast value, and click or drag more carefully around the selection. In Figure 17.6, I'm using the Magnetic Lasso to trace around the apple. Each time I click, Elements places a square box to anchor the line in place. After the entire object has been selected, the line will change to the familiar marching ant marquee.

FIGURE 17.6
This tool works by looking for differences in pixels. Contrasting objects are easiest to select. (Photo by Linda Standart.)

Making Selections with the Magic Wand

The Magic Wand is, in many ways, the easiest of the selection tools to use. It selects by color, and can be set to select all pixels of a particular color or range of colors in the entire image, or only those pixels that qualify and are adjacent to each other. It's the perfect tool for tasks such as selecting the sky prior to turning it from gray to blue, and for what I'm attempting in Figure 17.7, which is to select one of the three lemons without selecting the cut one in front of it.

The Magic Wand's tool Options bar has check boxes for Antialiased and Contiguous selections, and for selecting through all layers or just the top one. These are obviously going to be useful, but the truly important option is to set a degree of tolerance for the wand. With a Tolerance setting of zero, you'll select only the few pixels that are identical to the one you clicked the wand on. (If Contiguous is checked, the selected pixels must also be touching each other.) If you set a very generous tolerance, perhaps as much as 100, you will find yourself selecting much of the image with just one click. That's probably not what you wanted to do. Try a Tolerance setting between 10 and 35 for tasks such as picking up the lemon. After setting the options you want, simply click on a pixel of the color you would like to select. Don't forget that you need to keep the Shift key

pressed to add to your wand selections, just as you do when drawing multiple marquees. When you accidentally select more than you wanted, Undo or Cmd/Ctrl+Z will immediately subtract the last pixels you selected.

FIGURE 17.7
Selecting the lemon took about six clicks because there were many shades of yellow included. As you can see, I set the Tolerance to 20.

Did you Know?

You can combine selection methods, too, with the help of the Shift key. If you use the Magic Wand and get most of your lemon, but not the highlight in the center, you can circle that part with the lasso while keeping the Shift key pressed, and add it right in.

Using the Selection Brush Tool

If you have a steady hand, and possibly a drawing tablet and pen instead of just a mouse, you might find the easiest selection method, at least for some things, is to paint over them with the Selection Brush tool. It looks like a paintbrush, and in some circumstances, it works like one. To understand what it does, you need to think of making a selection as a way of isolating the part of the picture you're working on from the parts you don't want to change. With the Selection Brush tool, you can either select the area you want to work with, or select the area you *don't* want to use by covering it with a mask.

Using the Selection Brush is like using any other brush. You have a choice, however, as to whether you are painting to mask the area around an object, or to select the object itself. The Options bar for the Selection Brush is shown in Figure

17.8. If you choose Selection from the Mode list, the area you drag over adds to the selection, outlined by the familiar marching ants of the selection marquee. If you choose Mask, the area you drag is subtracted from any existing selection (adding to the mask, or the area you don't want to affect). What this actually means is that when you make a selection and then activate the Selection Brush with Mask Mode selected on the Options bar, with your first brush click, the image is completely covered with a layer of mask, which appears as a layer of transparent red over the image. Each subsequent brush stroke adds to the selection by erasing some of the mask. Select the brush type, size, and hardness of the edge from the lists on the Options bar. Then drag to select or mask part of the image. To erase part of the mask, press the Option/Alt key as you drag the brush.

FIGURE 17.8
Select the options you want to use with the Selection Brush.

Red isn't always the best choice for a mask, especially if you're working on a picture that has a lot of red or pink in it. Change the mask to a different color or opacity by clicking the swatch on the Tool Options bar, and use the Color Picker to find a more effective color. Change the opacity by entering a different percentage. Higher numbers are more opaque.

Did you Know?

In Figure 17.9, I have changed the mask color to blue for better contrast with the lemon, and I'm in the process of selecting it with the paintbrush. It's very easy to make an accurate selection this way, especially if you enlarge the image and work with a small brush.

Selecting and Deselecting All

In addition to the selection tools, there's another quick and easy way to make a selection. To select the entire image rather than dragging a marquee around it or repeatedly clicking the Magic Wand, just press Cmd/Ctrl+A to select everything. To deselect whatever is selected, use Cmd/Ctrl+D. If you want to clear the image and start over, select all and press the Delete key. To erase part of the image, draw a marquee the size and shape you want to erase and press the Delete key. Memorize these commands. They will save you tons of time.

If you reach a point at which Elements seems to freeze or doesn't do what you want it to, try pressing the deselect keys. You might have accidentally selected a single pixel, and not noticed it.

FIGURE 17.9
In Photoshop, this feature is called *quick masking*.

Modifying Selections

After making a selection, you might want to modify it somewhat by expanding or shrinking it, or by softening its edge. You'll learn how to do all this and more in this section.

Inverting a Selection

There are many ways in which you can modify your selections. Take a look at the Select menu in Figure 17.10. You've already learned to select all and deselect. Adding the Shift key to the deselect combination (Cmd/Ctrl+Shift+D) will reselect your last selection in case you accidentally dropped it.

Inverse is an incredibly useful command. Suppose that you have something with very complicated edges on a simple background; perhaps a baby lying on a blanket, or a sunflower on a table. You can use one of your lassos to trace around it. You can use the Selection Brush and paint neatly around the edges. Or, you can use the Magic Wand once or twice to pick up the entire, plain background, and then select Inverse, or press Cmd+Shift+I (Mac) or Ctrl+Shift+I (Windows). Rather than selecting the background, you've inverted the selection and gotten the baby or flower, or whatever it is instead.

FIGURE 17.10
I find it easier to use the commands instead of the menu whenever possible.

Feathering a Selection

Feathering a selection makes it appear to fade away instead of having a hard edge. This isn't something you will want every time you drag a marquee, but under the right circumstances, it's very useful. The right circumstances can be anything from making a portrait vignette so that it fades into the background, to copying some grass to paste over the trash in a park picture. Figure 17.11 shows the vignette effect, one of the more obvious uses for feathering. In this case, I drew the oval selection marquee where I wanted it, and then feathered it by 10 pixels. How much you should feather a selection is going to be something to experiment with. It depends on the size of the image, and on what you're planning to do with the result. Just a couple of pixels of soft edge might be all you need to make something fit into its new background.

FIGURE 17.11
Feathering the edges of a portrait is called vignetting. (Photo courtesy of Judy Blair.)

Apply feathering after you have made the selection. Choose Select, Feather and type an appropriate number into the dialog box shown in Figure 17.12.

FIGURE 17.12
There's no right or wrong number of pixels to choose for feathering.

By the Way

> Feathering is also an effect that you can accomplish with any of the brush tools. To make a soft brush, select the Brush tool and click More Options on the tool's Options bar. In the window that opens, set the brush hardness to 50 or less. Save your brush with a name such as Soft Brush. Then you can use it with any of the other tools that use brush shapes.

Changing Your Selection with Modify, Grow, Similar

Choosing Modify from the Select menu gives you four ways to modify your selection. Each requires entering a pixel value in the dialog box. Your choices include the following:

- ▶ Border—Places a second selection line outside of the first, at a distance you specify, making the selection into a border or frame.

- ▶ Smooth—Evens out lumpy lasso and brush selections.

- ▶ Expand—Adds as many pixels outward from the selection as you specify, enlarging it.

- ▶ Contract—Subtracts the number of pixels you specify, shrinking the selection.

Choosing Grow from the Select menu expands the selection outward to pixels of similar color. The Similar option locates and selects pixels located anywhere in the image that are similar in color and value to the ones already selected. Prior to choosing these commands from the Select menu, set the tolerance level for matching similar pixels by clicking the Magic Wand tool first and changing its Tolerance value.

Saving and Loading Selections

After you've gone to the trouble of making a complex selection, it seems a shame to lose it, especially if it's something you might want to work on again later. If

you stroke the selection outline or fill it with color as explained in the next section, you can save that information as well. Fortunately, you can save your selection with the file and use it whenever you want it. At the bottom of the Select menu are two commands named Save Selection and Load Selection. Selections are saved only with images stored in Photoshop (PSD) format.

To save a selection, choose Select, Save Selection to open the Save Selection dialog box. Give the selection a name, and click OK. To open and reuse it, use the Load Selection box, shown in Figure 17.13, to locate and activate your selection. To display this dialog box, choose Select, Load Selection. Remember, you can also start a new image with just the selection if it's something you expect to use often.

FIGURE 17.13
Save unique selections so that you can reuse them.

Stroking and Filling Selections

No matter how you've made your selections, you have the option of filling or stroking them to make them objects in their own right. Let's say I need to draw some abstract shapes to use as part of a logo. I can use any of the selection tools to select a shape, and then Elements can turn the selection into an object by filling it with color or pattern, or by stroking it with a colored line.

The Stroke and Fill commands are both found under the Edit menu. *Stroking* places a line, of whatever color and thickness you determine, over the selection marquee. *Filling* places your choice of color, gray, or a pattern into the selected shape. In Figure 17.14, I'm preparing to fill a complex shape with my foreground color. Create a selection using your tools of choice. If you want to fill the selection with a particular color, click the Foreground or Background icon at the bottom of the toolbox, and select a color from the Color Picker. Then choose Edit, Fill.

Select the color (foreground, background, white, black, or 50% gray) or pattern you want from the Use list. If you choose Pattern, you can select the exact pattern you want from the Custom Pattern palette. When you open this palette, it displays a small selection of patterns. To display a different selection, click the right

arrow and choose a set of patterns from the list. Choose a blending mode and a level of opacity if you like. Because blending is a pretty advanced concept, I'll spend more time on it in Chapter 31, "Making Composite Images." As for opacity, it's pretty easy to grasp. Basically, it's the strength of the fill—with a low percentage of opacity, the color or pattern already within the selection (if any) will show through the fill color or pattern you're applying. A higher percentage of opacity creates a more solid fill, with less of the original color/pattern within the selection still apparent. If you choose 100% opacity, you'll completely replace any color/pattern in the selection with your new choice. You can use the Paint Bucket instead of the Edit, Fill command to fill a selection—I'll discuss this tool in a moment.

FIGURE 17.14
Create a shape with a selection tool, and fill it with a color or pattern.

To stroke the outline of your selection, choose Edit, Stroke instead. Select the width of the border you want. To choose a color, click the Color box and select one from the Color Picker. Next, choose the location for the line—on the inside, outside, or centered over the selection marquee. Once again, you can change the blending Mode and Opacity settings.

Stroking a line isn't necessarily a one-time event. You can build some very interesting designs by using different colored strokes and by placing narrow ones over wider ones. Figure 17.15 shows a few of the possibilities. These were all drawn with the selection tools, and then stroked and filled. To create the first object, I used the Rectangular and Elliptical Marquee selection tools, and filled and stroked the resulting compound selection. To create the second object, I used the Polygonal Lasso selection tool to create a star, and then filled it with a pattern and stroked it several times with lines of varying widths, positions, and colors. To create the third object, I drew a shape with the polygonal lasso, and then filled

and stroked the resulting selection. For the fourth object, I created a square with the Rectangular Marquee tool, and used the Elliptical Marquee tool to bite off the corners. After filling it with medium blue, I drew a heart inside the square, stroked it with dark blue, and then filled the inner shape with green. How many of these can you re-create?

FIGURE 17.15
It's easy to get carried away.

Using the Paint Bucket Tool to Fill a Selection

Earlier, I mentioned that you could fill a selection with the Paint Bucket tool. Using the tool is fairly simple: First select the tool, and then from the Fill list on the Options bar, choose either Foreground or Pattern. If you select Foreground, the current foreground color will be used. If you don't like the current foreground color, you can change it. If you choose Pattern, you can select the pattern you want from the pattern list. As before, you can display additional patterns by clicking the right arrow and selecting the set of patterns you want to view. Select the blending option from the Mode menu (to learn about blending, see Chapter 31), and set the Opacity level you want.

The rest of the options are the same as those described earlier for the Magic Wand tool. The Tolerance option defines the type of pixel to be filled—a low tolerance tells Elements to fill only pixels within the selection that are very close in color to the one you click with the tool. A high tolerance is not as picky. The Antialiased option softens the edge between the filled selection and its background. The Contiguous option has no effect unless you have made at least two noncontiguous selections. Then, if you choose Contiguous, only the applicable pixels within the selection you click will be changed. Turn off this option to fill pixels in all selections. The All Layers option enables you to fill the selection within all layers; we'll get to layering in the next section.

After setting options for the Paint Bucket tool, click on a pixel within the selection. The pixel you click might or might not affect the outcome, depending on the selections you've made.

Working with Layers

Layers sound complicated, but they're not. They're really quite simple, if you've ever seen an animated cartoon. Animators work with two kinds of materials: sheets of white Bristol board or something similar as backgrounds, and sheets of heavy transparent acetate called *cells*. (In the beginning, they were made of cellophane, hence the name.) The background holds the things that don't change, such as trees, grass, Marge's kitchen walls, and Homer's couch. There are up to four or five cell layers for each character. Hands and feet move more than heads and trunks, so the bodies are dismembered and placed on different layers. If Homer is to wave, for example, three or four drawings will be done of just his arm in different positions, from down to up. Then the sequence will be photographed with a different arm in each frame of film. It's layers that make it possible to create a movement.

Working with layers enables you to build up multipart collages of many images, paint over an original photo without destroying it, make color corrections that you can apply selectively to parts of the picture, stack picture elements behind others, and... I can go on and on.

When you open a new image in Elements, it has a Background layer. No others. If you then paste into that image something you've copied to the Clipboard, you'll automatically make a new layer. You can use the Layers palette to keep track of your layers. Think of it as a sort of command center for layer management. You can add and remove layers from the palette itself and manage them with its menu.

In Figure 17.16, I've assembled a page with a bunch of different layers. Type goes on a separate layer, indicated with the T symbol. Adjustment layers enable you to correct color and exposure, with the advantage of enabling you to also control how much of the correction you want to apply. A layer can change both opacity and blending mode as needed.

You can start a new layer in any of several ways. Whether you're pasting something in, or dragging it from another open file, the new part of the image will automatically be placed on a new layer. As soon as you position the Type tool on the picture and start entering letters, you've created a type layer to set them on.

Because they are on their own layer, you can move the words around, correct spelling, even erase them and try different words or a different font, without risking the rest of the image. However, if you want to paint on a new layer over your image, create a new layer manually by selecting New from the Layer menu, or by clicking on the small New Layer icon at the top of the Layers palette.

New Layer icon

FIGURE 17.16
From the top: two type layers (the top one has a layer style), an adjustment layer, a transparent layer, a pattern fill layer, and a background layer.

As you add more and more layers to your document, you'll probably need to give them more descriptive names so that you can easily identify their content. To change the name of a layer, double-click it to open the Layer Properties dialog box. Type the name of the layer in the text box and click OK. You can also simply double-click the name in the Layers palette and type the new name right there. Press the Enter key when you're done.

Let's try working with layers.

1. Start a new image (default size is fine). Open the Layers palette by clicking its tab in the Palette Bin (if not its not in the Palette Bin, select it from the Window menu).

2. Click the New Layer icon at the top of the palette. Now, you have Layer 1 on top of the background.

3. Go back to the Background layer for a moment by clicking on the word *Background* on the Layers palette, and pour a color into it. To do this, set the foreground color to something light by first clicking its swatch in the toolbox and then choosing a color from the Color Picker. Select the Paint Bucket and click on the background. (Yes, you can use the Paint Bucket to fill a layer with color just as you can use it to fill a selection marquee or drawn object. You can also use the Edit, Fill command to fill a layer.)

4. Notice that, on the far left, the palette shows a brush on the active layer, and each layer has an open eye, indicating that both layers are visible. Click Layer 1 again, and see the brush move up to it. The Brush icon tells you that this is the active layer.

5. Draw a large star on Layer 1 with the Polygonal Lasso tool and fill it with a color that is darker than your background. To do this, click the arrow on the Lasso tool and select the Polygonal Lasso tool. Click once in the layer to establish the first star point. Click to draw each side of the star and double-click to complete the last side. To fill the star with color, select a darker foreground color, click the Paint Bucket, and then click inside the star. At this point, your screen and Layers palette will look something like Figure 17.17.

FIGURE 17.17
Layer 1 is active because that's where the brush is.

6. Click the eye icon next to the Background thumbnail on the Layers palette. The eye icon disappears, and you can't see the background any more. It is replaced by a gray checkerboard indicating transparency. That happens because Layer 1 is transparent. (Think cellophane.) Of course, you have placed a distinctly nontransparent star on it, so you'll see that, too. If you look closely at the thumbnail for Layer 1, you will see the star you painted. Click the empty square next to the Background layer in the Layers palette again to bring back the eye icon and make the background visible. Save and close your star image.

Managing Layers

There are two ways to manage layers. The Layer menu, shown in Figure 17.18, allows you to add and delete layers, rename them, group and ungroup them, and eventually merge them and flatten the image. The Layers palette has a very help-ful menu (you can access it by clicking the palette's More button), as shown in Figure 17.19. This menu has many of the same commands as those in the Layer

menu. Although the Layer menu and the Layers Palette menu provide access to all the commands you need to manage layers, you can perform most of the more common tasks by simply clicking buttons and manipulating items in the Layers palette, shown in Figure 17.19. If your image has multiple layers, you can see and manipulate them here. As I mentioned earlier, the eye icon on the far left of a layer's thumbnail means that the layer is visible, and the brush icon tells you which layer is active. You can have all of your layers visible—or invisible, if you want—but only one layer can be active at a time.

FIGURE 17.18
The Layer menu contains all the layer commands.

FIGURE 17.19
The Layers palette with the More menu shown extended on the right.

Adding a New Layer

There are, of course, several different ways to create a new layer. Whenever you copy and paste an object into your picture, it comes in on a new layer. If you add text using one of the type tools (covered in Chapter 19, "Adding Type") or add a shape with a shape tool (which you'll do in Chapter 29, "Creating Art from Scratch"), a new layer is created automatically.

You can also add layers manually when needed. When you click the New Layer button at the top of the Layers palette, you create a new layer above the current layer. Objects placed on the new layer can obscure objects placed on lower layers. If you click the black-and-white circle icon at the top of the palette, you have the choice of opening a fill layer (solid, gradient, or pattern) or an *adjustment* layer (a layer in which adjustments such as brightness or color changes reside, without permanently affecting the image itself—you'll learn more about adjustment layers in Chapter 31). When you choose Layer, New, Layer, or select New Layer from the Palette menu, or press Cmd/Ctrl+Shift+N, you open a dialog box that gives you access to some extra settings for the new layer. This box is shown in Figure 17.20.

FIGURE 17.20
The New Layer dialog box.

If you use the dialog box, you can name the layer, adjust its opacity and blending mode, and group it with the previous layers as you're creating it. We'll discuss grouping in a moment.

If you don't display the New Layer dialog box when creating a new layer, you can access most of those functions from the palette. You already know how to rename a selected layer. You can make changes to its opacity or its blending mode by making the layer active and choosing options from the drop-down lists at the top of the Layers palette.

Moving or Removing a Layer

Layers play an important role in the final image because objects on one layer can obscure all or part of an object on a lower layer. If needed, move layers up or down in the stack. The easiest way to move a layer on top of another is to grab it on the Layers palette and drag it to its new location.

In a perfect world, file size wouldn't matter because we'd all have fast computers with unlimited memory. Well, we're not quite there yet. Layers add to the size of the file, and with a lot of layers, you can end up with a file big enough to choke computers with modest resources. So, you need to use layers wisely. Good layer management means discarding layers you aren't going to use, and merging the rest when you are done using them. This will happen automatically and unexpectedly unless you're careful; not all file formats can handle layers. The only formats that do are TIFF and the native Photoshop format (PSD). If you save your image for the web, it will be flattened as part of the process. To remove a layer manually, drag it to the trash or click the Delete Layer icon (the trashcan at the top of the Layers palette) after selecting the layer you no longer want.

Grouping Layers Together

When you group two or more layers together, they work in concert with each other. If you place an object such as a star on the bottom layer, place a photo such as a flower on a higher layer, and then group them, the flower image will appear to be star-shaped. In other words, the flower will show only within the star outline.

> When you group layers, the higher one is affected by the lower one. Normally, the ungrouped higher layer would simply cover the lower one.

By the Way

Grouped layers must be in succession. You can group a new layer with the previous one, or ungroup them, using either key commands or the Layers menu. To group a layer with the one directly below it, select the top layer and press Cmd/Ctrl+G or select Layer, Group with Previous. You can also press Cmd/Alt and click on the line separating the two layers in the Layers palette to group them. To ungroup layers, select one of the grouped layers in the Layers palette and press Cmd/Ctrl+Shift+G or select Layer, Ungroup. You can group together as many layers as you need. The maximum number of layers Elements can handle is 8,000, but your computer might not have enough memory to handle that many.

The base layer (lowest layer) is preceded by a bent, downward-pointing arrow. Its name is also underlined. The base layer defines the boundaries for what's displayed from the upper layer(s). Upper layers in the group are indented above this base layer in the list. If you look back at Figure 17.19, you can see that Layer 1 is the star. Layer 2, which is grouped and indented, has the flowers. Layer 1 controls the opacity and mode settings for the group.

You can also link layers to treat them as a group for purposes of moving, copying, pasting, and applying transformations in a single step. Please note, however, that linking is different from grouping. Linking connects the layers without making them dependent on each other. To link layers, select a layer to make it the active layer, and then click in the first column to the left of the layer you want to link to this active layer. A link icon (a chain) appears in front of the layers you select. Later, if you select a layer that's linked to others, the other layers will be highlighted by this link icon, reminding you that they are linked. To unlink a layer, click any other layer in the linked group, and click its link icon to turn it off.

Changing Layer Opacity

Being able to control the opacity of individual layers gives you enormous flexibility, especially as you start to get into multilayer, multi-image composites, as we will in later chapters. Opacity adjustments are also useful for making minor color changes. Suppose that you have a landscape with a pale blue sky, and you'd like the blue to be a little more intense. Select the sky and copy it to a new layer. Then choose Layer, Fill Layer, Solid Color. (If you instead click the New Layer icon at the top of the Layers palette, you won't have the option of linking the fill layer to the sky copy layer, and this is something you need to be sure to do. If you don't link the fill layer to the sky selection layer, the color correction will apply to the entire picture.) Type a name for the layer, and select the Group with Previous Layer option in the New Layer dialog box. You can guess at the opacity level now, but it's best to adjust it later when you can see the result. Click OK to open the Color Picker so that you can select an appropriate sky color. Click OK. In the Layers palette, use the Opacity slider to bring in just enough of the additional color so that the image looks right. Figure 17.21 shows the Layers palette with a color fill applied only to the sky.

FIGURE 17.21
You can also use this technique to apply gradients and pattern fills.

In the figure, the photograph is located on the Background layer. I selected the sky and copied it to Layer 1. You can see its white outline at the top of the gray-checkerboard thumbnail. The solid Color Fill 1 layer, which is linked to Layer 1, is just above it. I could have used a pattern or gradient fill instead of a solid color to create a strange sky effect.

If you'd like some further practice with layers before we move along, go to the Sams website at www.samspublishing.com. Navigate to the page for this book by entering its ISBN number in the window provided. Download the file named "cheeseburger." Unzip and extract its contents into a new folder so that the images will be easy to find.

1. Start a new image (the default size at 72 dpi is fine). With the Elliptical Marquee tool, drag a circular marquee big enough to just fit comfortably on the page. Fill it with light blue paint: Choose light blue as a foreground color by clicking on the foreground swatch and using the Color Picker to find a nice pale blue. Then click with the Paint Bucket tool to fill the selection with pale blue paint. This is the plate for your cheeseburger.

2. Open the file called Bun 1.psd. Type Cmd/Ctrl+A to select all. In this case, you'll select the bottom of the bun. Copy it to the Clipboard and paste it onto the middle of the plate.

3. Open the Lettuce.psd file. Be sure you can see the window showing the bun on the plate. Use the Move tool to drag the lettuce from its window onto the bun. It also appears on a new layer. Slide it around until it's centered.

4. Use File, Place to locate and open the tomato (Tomato.pdf). It will appear with a white background. Select the white edges with the Magic Wand and delete them.

5. Click the New Layer icon on the Layers palette. Use the Lasso tool to draw a hamburger shape on top of the bun. Using the Paint Bucket tool, fill it with a nice beefy brown color.

6. To add some texture to the hamburger, create a new layer that's grouped with the burger layer, and fill it with the Red Rocks pattern. To do this, choose Layer, Fill Layer, Pattern, and use the Pattern window's right pointing arrow to navigate to the Rock patterns. Set the opacity for the texture layer to around 50%.

7. Add another new layer by pressing Cmd/Ctrl+Shift+N. This time, you'll be asked to name the layer. Call it Cheese. Draw a square marquee and fill it with "American cheese orange" or whatever color you think cheese ought to be. If you like Swiss, drag some holes with the Elliptical Marquee tool while pressing Option/Alt, before you fill the square with color. At this point, your picture should look like Figure 17.22.

FIGURE 17.22
Swiss or
American—it's your
choice.

8. How about some mustard? First, let's get rid of some of these layers. Go to the Layer menu and select Merge Visible. Notice how the file size drops (the file size is displayed at the bottom of the active window).

9. Add a new layer and choose the Selection Brush tool. Choose a nice fat brush, such as the Soft Round 27-pixel style. Make sure the Mode option is set to Selection, and draw a nice squirt of mustard all over your burger. Use the Paint Brush tool to fill your selection with bright mustard yellow. Now you have a cheeseburger worthy of Jimmy Buffett. Save the file with the name "My Cheeseburger" and enjoy!

Summary

Now you understand selections and how to work with layers. These two concepts are the basis for practically everything else you'll do with Photoshop Elements. First, you learned about the selection tools, and how to use them not only to select an object, but also as drawing and mask making tools. You learned about marquees, lassos, the Magic Wand, and the Selection Brush. You learned how to add to a selection and to remove parts of one. Stroking and filling were covered in this chapter, along with inverting, expanding, and feathering selections. Then you learned about the importance of layers and how to create, delete, copy, link, and group layers as needed. You also learned how to adjust a layer's opacity, and how to use a fill layer to control the color of an object in another layer.

Working with the Brush Tools

What You'll Learn in This Chapter:

▶ **The Brushes Palette**
▶ **Brushes**

In this chapter, we're going to have some fun. Photoshop Elements, as I'm sure you realize, is mainly an image editor. It was created for that purpose, and it accomplishes its purpose very elegantly. Yet there is more to Photoshop Elements than just editing. You can also create artwork from scratch, just as in any good graphics program. The Elements art tools include the following:

▶ Brush, Impressionist Brush, and Color Replacement Brush

▶ Airbrush

▶ Healing Brush and Spot Healing Brush

▶ Eraser, Background Eraser, and Magic Eraser

▶ Clone Stamp and Pattern Stamp

▶ Pencil

▶ Blur, Sharpen, and Smudge

▶ Dodge, Burn, and Sponge

▶ Paint Bucket

▶ Selection Brush

Technically, the Selection Brush is a selection tool rather than a painting tool, but because it uses brush shapes, it deserves a mention here. Figure 18.1 shows the painting tools. We'll look at the most important ones—the Brushes, Pencil, Clone

Stamp, and the Eraser—in this chapter. We'll cover the others as we need them in the next couple of chapters.

FIGURE 18.1
Tools for painting
and drawing.

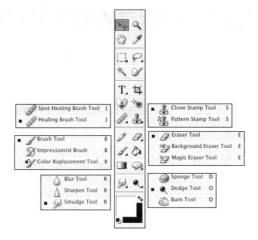

Spot Healing Brush Tool J
Healing Brush Tool J

Brush Tool B
Impressionist Brush B
Color Replacement Tool B

Blur Tool R
Sharpen Tool R
Smudge Tool R

Clone Stamp Tool S
Pattern Stamp Tool S

Eraser Tool E
Background Eraser Tool E
Magic Eraser Tool E

Sponge Tool O
Dodge Tool O
Burn Tool O

Each tool is highly configurable. You can adjust such settings as diameter, hardness, roundness, angle, opacity, and so on. It's easy, too. You'll learn about this in the next few pages.

The Brushes Palette

Before discussing specific brushes, take a brief look at the Brushes palette, which you can pull down from the Tool Options bar after you've selected a tool that uses brush shapes. To open it, click on the downward-pointing arrow next to the window that shows the current brush shape. Although each tool has its own set of options, the Brushes palette (shown in Figure 18.2) works with all the art tools, from the Airbrush down to the Dodge tool. (Only the Pencil's brushes are different.) It gives you the ability to select any of Elements' preset brush shapes.

Just click to select one of the preset brush shapes. The shape you see in the box is the shape of the brush. The numbers beneath indicate the diameter of the brush in pixels. You can use the Size slider in the Options bar to change the size of the brush without changing any of its other characteristics. A brush can be up to 999 pixels wide. Remember, clicking a brush shape doesn't select a brush tool. You have to do that in the toolbox or by typing a letter shortcut. The Brushes palette just influences the shape of the tool you select.

Photoshop Elements comes with many different kinds of brushes. You can install the additional brush sets by using the pop-up menu on the Brushes palette. To view the brush shapes by name or by the shape of the stroke they make, use the fly-out menu.

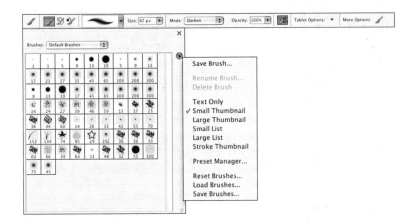

FIGURE 18.2
The Brushes palette, with the default brushes and the fly-out menu.

Brush Options Dialog Box

The Brush Options dialog box is shown in Figure 18.3. Open Brush Options by first selecting any brush tool and then clicking the More Options icon on the Tool Options bar.

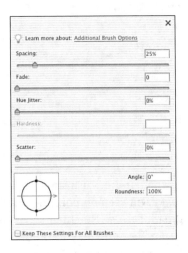

FIGURE 18.3
The Brush Options dialog box enables you to design custom brushes.

With this dialog box, you can select the qualities of each brush you alter or develop from scratch. Here you can select the diameter, hardness, spacing, angle, and roundness of the brushes.

The first brush qualities to consider are the angle and roundness. Define the shape of the brush by dragging the crosshairs on the brush tip diagram to the appropriate angle and roundness you want. Angled brushes give your brush strokes a calligraphic quality, like using a flat-angled pen nib for lettering. Figure 18.4 shows examples of both round and angled brushes.

FIGURE 18.4
The round brush stroke has an even thickness. The angled brush varies between thick and thin.

Use the Spacing slider in the Brush Options dialog box to set a standard spacing of paint. It won't change, no matter how fast you drag the mouse. What you're actually setting is the overlap between spots of paint. Anything around 25% or less should give you a very smooth line. As you increase the percentage (either by dragging the slider or entering a number into the box), the spaces increase. Spacing adjusts from 0 to 1000%. With spacing numbers greater than 100%, you paint spots rather than a line. In Figure 18.5, you can see the differences that result when I've changed the Spacing slider.

FIGURE 18.5
Spacing set at 25%, 100%, and 200%, respectively, from top to bottom.

The Fade slider determines whether the brush stroke will fade away like a real brush running out of paint, or will keep on painting until you release the mouse button or lift the pen off the tablet. The Hue Jitter slider switches the paint color back and forth between the foreground and background colors you've set. It's fun when you're using one of the special brushes to paint stars or blades of grass or flowers because each brush stroke comes out a slightly different color.

Next, set the Hardness slider. This is one of the more important and useful settings. The harder a brush is (closer to 100%), the more defined the edges of paint will be. A brush with a Hardness setting of around 20% has a much more diaphanous or translucent appearance.

Scatter, like Hue Jitter, is best saved for the special brushes. Instead of painting a straight line, it literally scatters the brush dots in an area around the cursor. Your setting here determines how many dots are scattered and how widely.

> Play around with the settings in the Brush Options dialog box. With a little experimenting, you can end up with a brush that behaves just as a real brush does—painting thicker and thinner depending on the angle of your stroke, or planting a garden of multihued flowers with the same single stroke.

Did you Know?

When you build a brush you are pleased with, save it. Use the Brush Name dialog box to give it a name, and it will be available to you from then on (see Figure 18.6). If you make up an assortment of brushes, you can save them as a group. There's a pop-out menu on the right side of the Brushes palette. (Look for the right-pointing triangle.) Select Save Brushes to save a brush set.

FIGURE 18.6
The Brush Name dialog box.

Using the Opacity Slider

The single most important control in the Tool Options bar is the slider that sets the opacity. Click and hold the right-pointing arrow next to the Opacity field to enable the slider. A low setting applies a thin layer of paint—nearly transparent. The closer you come to 100%, the more concentrated the color is. Figure 18.7 contains some examples of different opacities. I've drawn lines on top of the gradient with both a soft and hard brush, and changed the percentage of opacity for each set of lines. See this figure in color in the color plate section.

Tablet Options

In addition to the brush shape options, Elements also gives you some options for brush behavior. Unfortunately, unless you have a graphics tablet, you won't be able to enjoy the full effects of these options. The brush behavior options are

accessed as check boxes, allowing you to choose whether stylus pressure affects one or more of the settings you made in the Brush Options dialog box.

FIGURE 18.7
I've applied magenta stripes over a blue gradient. The opacity percentage is listed below its stripes.

If you use a graphics tablet, you'll probably have software with it that gives you many additional options for custom pen and mouse control. I use a Wacom tablet. Figure 18.8 shows the Wacom settings window and some of the many settings that affect the mouse and pen response.

FIGURE 18.8
If you use a Wacom tablet, you received this software with it. Look under Applications, Wacom if you can't find the settings window.

By the Way

Wacom tablet adjustments affect such things as stylus and eraser pressure, double-click speed, and what specifically happens when you press any of the five mouse buttons. The dialog box is quite easy to understand, and comes with a good set of help screens.

COLOR GALLERY

COLOR PLATE 3.1

Back-lit subjects can be difficult to photograph.

Page 55

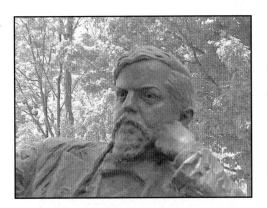

COLOR PLATE 5.9

This montage captures the excitement of Las Vegas. (Photos by Naomi Rose.)

Page 115

COLOR PLATE 5.12

This picture in monochrome could have been taken in 1904 instead of 2004. **Page 119**

COLOR PLATE 12.20

The lower the number of levels, the more simplified the drawing becomes. **Page 242**

COLOR PLATE 18.7

I've applied magenta stripes over a blue gradient. The opacity percentage is listed below its stripes.

Page 358

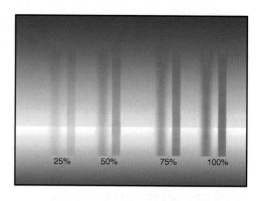

COLOR PLATE 18.12

Blue, yellow, orange, and pink grapes—why not?

Page 362

COLOR PLATE 19.6

Don't be afraid to experiment. Page 374

Color Plate 19.7

I added a drop shadow to help separate the letters from the sky. Page 375

COLOR PLATE 21.7

The original photo and my best version. Page 413

COLOR PLATE 21.8

Auto Smart Fix applied. Not much changed. Page 414

COLOR PLATE 21.9

Auto Levels applied. Contrast improved in midtones.
Page 414

COLOR PLATE 21.11

Auto Color Correction applied. Colors are warmer.
Page 415

COLOR PLATE 21.10

Auto Contrast applied. Very little difference from Auto Levels. Page 415

COLOR PLATE 21.13

Fortunately, there was a white seagull in with the Canada geese. Losing the color cast was the only change needed. Page 417

COLOR PLATE 21.16

Why not purple sunflowers? Page 420

COLOR PLATE 21.18

Here's my final version of the flowers, gone from yellow to red-orange. Page 423

COLOR PLATE 21.20

You can't put it in the scrapbook looking like this. (Photo courtesy of Carole Harrison.) Page 424

COLOR PLATE 21.22

When all you need are subtle changes, alter the settings a little bit at a time. Page 426

COLOR PLATE 21.23

This looks much better than before. Page 427

COLOR PLATE 22.4

The final version of the photo, after clean up. Page 433

COLOR PLATE 22.8

One click just about does it. Page 437

COLOR PLATE 22.11

Now she looks quite normal. (Photo by Judy Blair.)
Page 439

COLOR PLATE 22.16

Don't try to catch every little spot. If it's too perfect, it doesn't look authentic. **Page 443**

COLOR PLATE 23.3

The sepia tint helps add grain to the image. **Page 451**

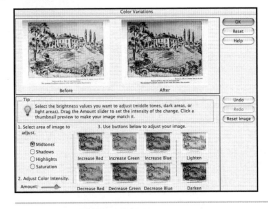

COLOR PLATE 24.14

This one's been seriously beaten up and damaged. (Photo courtesy of Judy Blair.) **Page 468**

COLOR PLATE 24.25

Even though there's no color in the picture, Color Variations tries to add some. **Page 476**

COLOR PLATE 25.4

I shot this during a Tall Ships regatta in Boston Harbor. **Page 483**

COLOR PLATE 25.1

This would be great if it weren't so brown. (Photo by Carole Harrison.) Page 480

COLOR PLATE 25.3

Correcting the color makes the picture much better.

Page 482

COLOR PLATE 25.10a

These colors look washed out.

Page 489

COLOR PLATE 25.10b

Now the colors look much better.

Page 489

COLOR PLATE 25.17

Don't get bogged down in details. In a picture of this size, you wouldn't see eye color or small details such as the bear's button eyes.

Page 494

COLOR PLATE 27.8

Now the sand looks better, and the gull doesn't get lost in the texture. Page 519

COLOR PLATE 27.19

By changing the amount of noise, you could change each of these confetti images to something quite different.

Page 527

Color Plate 30.2

This is just an average beach.

Page 575

COLOR PLATE 30.5

That's better. To make some filters work properly, you often must make changes to the original image that you wouldn't accept otherwise. Page 577

COLOR PLATE 30.9

This definitely looks painted.

Page 580

COLOR PLATE 30.11

Here's what the beach scene looks like after I've worked on it. Page 582

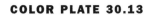

COLOR PLATE 30.13

Here is an example using the Wide Sharp Brush. Page 584

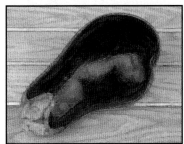

Color Plate 30.23

We've created neon clown fish! Page 592

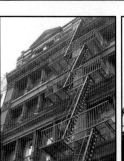

Color Plate 30.24

Cast a sinister look over a scene with Neon Glow. Page 593

Color Plate 32.2

This posterization was done with two levels. Page 633

COLOR PLATE 32.8

A more colorful building.

Page 638

COLOR PLATE 32.46

Some of the color remains, but the background goes black.

Page 665

COLOR PLATE 32.10

This could be interesting if combined with some other effect. Page 640

COLOR PLATE 32.53

Ghost Orb created with a combination of Adobe and third party filters (Art by Samantha Nocera.)

Page 671

Brushes

Now turn your attention to the painting tools themselves. For the rest of this chapter, we'll be working with the Brush, Eraser, and Pencil tools.

Let's try a bit of freehand brushwork. Follow these steps:

1. Open a new image, making it big enough so that you have some elbow room. Adobe's default size, 7×5 inches, is fine.

2. On the right side of the screen, look for the Swatches palette. Click on the tab to bring it forward, if necessary. If it's not visible, open it from the Window menu. Click Swatches to open an electronic paintbox. For now, just click any color you like.

3. Press B to select the Brush from the toolbox.

4. Click on the down-pointing triangle next to the Brush icon in the Options bar to open the Brushes palette. Choose a brush.

5. Press and hold the mouse button as you drag the brush over the canvas to paint.

6. Try the Pencil and Eraser Tools, too. Press Shift+B to toggle the Brush and Pencil and press E for the Eraser. See what changing the settings in the Options bar does for each tool.

The Airbrush

The Airbrush is represented as an icon on the Options bar for the Brush tool. Simply click the icon to change the brush behavior to that of an airbrush. It applies paint by spraying, rather than brushing. It's like an artist's airbrush that uses compressed air to blow paint through an adjustable nozzle. The Airbrush applies paint with diffused edges, and you can control how fast the paint is applied. You can adjust it to spray a constant stream or one that fades after a specified period. Experiment with different amounts of pressure and different brush sizes and shapes.

Remember that the longer you hold the Airbrush tool in a single spot, the darker and more saturated a color becomes, just as if you were spraying paint from an aerosol can.

Figure 18.9 shows a drawing done with just the Airbrush. The spotty effect comes from using a blending mode called Dissolve. (You'll learn about blending modes in Chapter 31, "Making Composite Images.")

FIGURE 18.9
Varying the pres-
sure and changing
brush sizes gives
the picture some
variety.

The Brush

The Brush tool is the workhorse of all the painting tools in Photoshop Elements. Press B to use the Brush, or select it in the toolbox. The Brush behaves very much like the Airbrush, except that paint is applied more evenly. That is to say, if you hold the mouse clicked in one area, paint does not continue to flow onto the canvas.

By the Way

Although you can press the Caps Lock key to get a precision painting cursor, there is an even better way. Instead select Edit, Preferences, Display & Cursors. In the dialog box that appears, look in the Painting Cursors section. There's an option that enables you to select from the following choices: Standard, Precise, and Brush Size. Choose Brush Size because doing so changes your painting cursor from a paintbrush or a crosshair to a shape that is the actual size of your brush.

If you need to paint a straight line, constrained either vertically or horizontally, hold down the Shift key as you drag the brush. To draw a straight line between two points, click once on the canvas to set the first point, and then Shift+click to mark the endpoint. A line draws itself between the two points. Figure 18.10 shows some work with the Photoshop Elements brushes. I started with a gradient. Then I used a smooth, small brush for the boat, and finally I used a brush that simulates grass. These brush tips are included in the default brush set.

FIGURE 18.10
This picture was
painted with
several different
brushes.

The Impressionist Brush

You'll find the Impressionist Brush and the Color Replacement brush in the toolbox, if you click the tiny black triangle next to the Brush tool. I have to admit, I've never found a reasonable use for this tool. It *is* fun to play with, though. Select a style from the More Options icon on the Options bar. You can choose from long, medium, or short curls, dab, and tight or loose curls. Every time you click the brush on a photo, it's as if a miniature tornado attacked the pixels, scrambling them in curly strips. Figure 18.11 shows an example. The settings I used for this effect are Loose Curl, Long. Long, tight curls imitate Van Gogh at his wildest; Dab does Monet; and Loose Medium resembles a Renoir. Experimenting with these settings is fun!

The Color Replacement Brush

This tool is new in Elements 3 and promises to be a fairly useful one. It functions like any other paintbrush, except that when you paint over an existing scene, it replaces the predominant color with whatever happens to be the foreground color in the toolbox. More importantly, it changes only the color, not the saturation or value. If you had a blue sky with lots of white fleecy clouds, and you wanted an orange sky with the same white clouds, no problem. Choose your shade of orange and apply the brush to the sky. Go ahead and paint right over the clouds. The orange won't affect them except to the same natural degree that the blue did.

You can also set the brush to change hue, saturation, or luminosity. You can set the brush sensitivity on the Tool Options bar. You can also change the way Elements selects the color to replace. I find it easiest to Shift+click the item to be

changed with the Eyedropper tool and make it the background color, then select Background as the sampling mode. In Figure 18.12, I am recoloring a bunch of grapes. Be sure to see this one in the color plate section.

FIGURE 18.11
I've only done part of this picture, so you can see the effect compared to normal.

FIGURE 18.12
Blue, yellow, orange, and pink grapes—why not?

The Eraser

The next tool that we'll investigate in the toolbox is one that most of us, unfortunately, have to use far too often: the Eraser tool. You'll quickly learn that the command key to select the eraser is E. One nice thing about the Eraser is that it, too, can be undone, so if you happen to rid the canvas of an essential element that you wanted to keep, just choose Edit, Undo to restore.

The Eraser tool is unique in that it can replicate the characteristics of the other tools. It can erase with soft edges as if it were a paintbrush painting with bleach. It can erase a single line of pixels as if it were a pencil, or it can erase some of the density of the image as if it were an airbrush. Of course, it can also act as an ordinary block eraser, removing whatever's there. The Options bar enables you to determine how the eraser will work: whether it will be a block or a brush, how much you want to erase, and whether you want to erase to the background or use the Magic Eraser. The Eraser's Options bar is shown in Figure 18.13.

FIGURE 18.13
The Eraser and its options.

The other two erasers in the set are the Background Eraser and Magic Eraser. They share space in the toolbox with the regular Eraser. These erasers make it easier for you to erase sections of a layer to transparency. This can be helpful, for instance, if you need to delete the background area around a hard-edged object. The Background Eraser tool allows you to erase pixels on a layer to transparency as you drag. You can use as large a brush as you like with this tool because it looks at only the single pixel in the hot spot where the crosshairs at the center of the brush meet. It will erase only pixels the same color as that pixel. So, when you have a well-defined object such as a bottle or a piece of fruit, you can erase without damaging the edges of the object. You can choose to erase only contiguous pixels or all similar pixels on the current layer. In Figure 18.14, I am using the Background Eraser to select and erase the background behind the wine bottle.

When you click in a layer with the Magic Eraser tool, the tool automatically erases all similar pixels to transparency. Let's practice with the Magic Eraser. Pick any image that has an area of fairly even color, such as a sky.

FIGURE 18.14
You have to be extra careful if the foreground object has colors similar to the background.

1. Select the Magic Eraser. The Options bar will change to show its options.

2. Enter a Tolerance value. The tolerance defines the range of colors that can be erased. A low tolerance erases pixels within a range of color values very similar to the pixel you click. A high tolerance erases pixels within a broader range of colors.

3. Specify the opacity to define how much is erased. An opacity of 100% erases pixels to complete transparency. Lower opacity erases pixels to partial transparency.

4. Set up the remaining options as needed:

 ▶ Select Anti-Aliased to smooth the edges of the area you erase.

 ▶ Select Contiguous to erase only pixels of the same color contiguous to the one you click, or leave it unselected to erase all similar pixels in the image.

 ▶ Select Use All Layers if you want to sample the erased color using combined data from all visible layers.

5. Click in the part of the layer you want to erase. All similar pixels within the specified tolerance range will be erased to transparency.

In Figure 18.15, you can see the results of using the Magic Eraser tool. I've clicked only twice to remove the entire sky. You might have to make several selections to

erase all the area you want to remove. You might also need to use the regular Eraser to clean up pixels that the Magic Eraser misses. But this tool is by far the fastest way to remove the background from an image. You'll use it a lot in Chapter 31.

FIGURE 18.15
The Magic Eraser removes all pixels that are similar to the one you click.

The Pencil

The Pencil tool, in large measure, works like the Brush tool, except that it can create only hard-edged lines—that is to say, lines that don't fade at the edges as paintbrush lines can. Click the Pencil tool in the toolbox or press N to select it. The Pencil tool shares space in the toolbox with the Brush. Selecting it activates its options on the Options bar, as shown in Figure 18.16.

You can set the diameter of your Pencil in the Brushes palette. Use an HB pencil or a 4B. You can also set all the other options, just as you have with all the other tools up until now—I won't bore you with a recap.

The Pencil tool does have one option, though, that you haven't seen in the tools we've looked at so far. In the Tool Options bar, there is a check box for Auto Erase. When you turn on Auto Erase, any time you start to draw on a part of the canvas that already has a pencil line on it, your Pencil becomes an Eraser and will erase until you release the mouse button.

FIGURE 18.16
This drawing of the
cat was done with
a one-pixel pencil.

Summary

The painting tools in Photoshop Elements are easy and fun to use. In this chapter,
you took a look at the Airbrush, Brush, Impressionist Brush, Color Replacement
Brush, Pencil, and Eraser tools. Brush shapes apply to all these tools, not just to
the Brush. You can alter the brush shape or its behavior by using the controls on
the Options bar for the particular tool. You learned to activate the Brush, Pencil,
or Eraser by pressing a single keyboard letter. You learned about some of the tool
options and how they affect the quality of the brush stroke.

CHAPTER 19

Adding Type

What You'll Learn in This Chapter:

▶ Using the Type Tools
▶ Using the Type Mask Tools
▶ Working with Layer Styles and Text
▶ Warping Text

When Photoshop first appeared many years ago (at least "many" by software standards), it didn't do much with type. You could choose a color and a font and a size, and put the type more or less where you wanted it on the page, but that was all. For some, that was enough. Other users demanded more flexibility. And bit by bit, we've gotten it. The good news for you as an Elements user is that most, if not quite all, of big brother Photoshop's type capabilities have been brought over intact.

Your type can be set horizontally or vertically. You can fill the letters with a picture, or cut them out of a picture, using the Type Mask tool. You can stretch and distort your lettering, as well as apply any of the filters Elements provides. Elements has a set of tools to warp type into waves, flag shapes, or even fish.

Type will always appear on a new layer. This is because Elements handles type as vector art, meaning that it is set as descriptions of shapes composed of lines that have a particular radius or direction and distance from point to point. This means that the type can be resized, stretched, and twisted without degradation to the final image because all the manipulation is done with math and geometry. When the type is exactly the way you want it, it must be rendered, or simplified, into a bitmap (raster data) to match the rest of the Elements image.

Using the Type Tools

The Type tool is actually four tools in one. As you can see in Figure 19.1, the tool-box holds both horizontal and vertical Type tools in both letter and mask modes. The masks allow you to do some very cool tricks with type and photos.

FIGURE 19.1
There are four Type tools.

To use the Type tool, simply select it and click on the page where you want the type to begin. Before you do, however, you'll probably need to adjust the settings on the Options bar (see Figure 19.2).

FIGURE 19.2
Set your type options before you begin typing. (The bar has been cut in half so that it will fit on the page.)

The first choice on the bar, the kind of type to set, is the same as in the toolbox: horizontal or vertical, masked or not. Next, a drop-down menu offers type styles. This menu will change according to the font you have selected, but generally you can choose from regular and italic, and often light, bold, or demibold, as well. The next drop-down menu displays a list of installed fonts, and the menu after that offers a selection of point sizes. If you don't see the size you want, enter numbers into the window.

The next button, which looks like two *a*'s, is important. It determines whether to antialias the type. Antialiasing smoothes out jagged type. It's important to apply antialiasing if your work will be seen onscreen. Few things look worse, or less professional, than jagged type. Figure 19.3 shows the difference.

If your type is to be printed, however, turn off antialiasing. The same process that makes it look better onscreen adds a blur when the page is printed.

I am antialiased.
I am not antialiased.

FIGURE 19.3
Notice the curves
in the type that is
not antialiased.
They appear lumpy,
as if made of
bricks.

The next four choices in the Type tool Options bar give you false (or *faux*) bold,
italic, underlined, and strikethrough type. The bold and italic options can be used
to enhance a plain font or to increase the boldness and/or slant of already bold
or italic faces.

> Strikethrough and underline have very limited uses, as far as I can see. Underlining
> was a way of indicating emphasis, back in the days of the typewriter, but it was
> always understood to be read as italic. Because you now have lots of options for
> italics, underlining isn't typographically correct. Nor is strikethrough, since the inven-
> tion of the Delete key. Use them if you think you must, but don't tell me about it.

By the Way

The icons with little stacks of lines indicate alignment: flush left, centered, or
flush right. Justified type, set flush left *and* right, is unfortunately not an option in
Elements. Elements isn't a word-processing program, after all. Its type functions
are mainly intended to add a few words to a picture, not to typeset a newsletter or
advertisement.

The icon with two letter *a*'s provides access to a drop-down list of antialiasing
methods. Antialiasing smoothes type that will be viewed on the computer screen.
If your creation is going to be part of a web page, select an antialiasing method.
Use the one that looks best with the type and size you have selected. If your work
is going to be printed, you can ignore the antialiasing settings.

The color swatch, black by default, allows you to choose a type color independent
of the foreground and background colors. Just click it to open the usual Color
Picker.

The sort of twisted letter with the curved line under it takes you to one of the
more interesting aspects of setting type in Elements: warped type. I'll come back
to it later in this chapter. But first, let's finish off the Options bar. The final button
lets you change horizontally set type to vertical type and vice versa. It's most
useful if you tend to use type as a design element rather than a means of com-
munication. Simply click it to change a selected string of letters or symbols from
reading left-right to up-down.

Finally, the slashed O ("no" symbol) and check symbol, which you see only after you start to place type, allow you to cancel or accept any editing you do to the type. For instance, if you set a line of type and then decide to increase its font size, after you've made the change and decided you don't like it, you can click the no icon to undo the size change. These two buttons are important because you can't undo type changes in the normal way (Cmd/Ctrl+Z) while you are working with type.

Adding Horizontal and Vertical Type

Horizontal type is what we're used to seeing in the English-speaking world. Other cultures use different alphabets and different typographic styles. Outside of short words on neon signs, we rarely see English, French, or similar horizontal languages positioned to be read vertically. It's unnecessarily difficult, which doesn't mean you can't do it—just that you might want to think before you do.

To set type vertically, follow these steps:

1. Choose a legible font. Decide on a size and color, and make the settings on the Options bar. Be sure to click the Vertical Type tool.

2. Position the cursor where you want the first letter.

3. Start typing. If your word(s) runs off the image, try a smaller font.

To set type horizontally, do the following:

1. Make the appropriate settings as you did when placing type vertically, choosing the Horizontal Type tool.

2. If you've chosen flush left justification, position the cursor where the type starts. If you've chosen flush right, position it where the type ends. Position it at the midpoint if you want the type centered.

3. Start typing.

Type is always set on its own layer. Each time you position the cursor and start typing, you create a new type layer. You can edit the type and apply layer commands to it. You can change the orientation of the type, apply or remove antialiasing, and warp the type into a variety of shapes. You can move, copy, and change the position or layer options of a type layer just as you would with a normal layer. To change the type's font size or color, or to edit the message, activate the type layer and click within the type to edit, or select all the type by dragging over it and then make your changes. You can also select all the text in the text

layer by clicking on the layer in the Layers palette and double-clicking the T thumbnail icon. After editing text, be sure to click the checkmark button on the Options bar to let Elements know you're done and that you want to keep the changes.

> Edits involving distortion or perspective (found on the Image, Transform menu) can't happen until the type is *simplified,* or rendered in bitmap form. In addition, you can't apply filters to text until that text has been simplified. To simplify text, click the type layer in the Layers palette, and choose Layer, Simplify Layer. After text has been simplified, it is no longer editable.

Watch Out!

Choosing Fonts

Literally hundreds of thousands, if not millions, of fonts are available. And that's before we start adding styles and special effects to them. But when you install Elements, the only fonts you'll see are the ones you've already installed. You can find fonts all over the Internet, as well as in your local computer store, catalogs, and so on. Some you can get for free; others cost money. I've found several CDs full of useful fonts advertised in the back pages of computer magazines, at very reasonable prices. And of course, there's Adobe, with everything from the classics to fonts made of bones or kids on skateboards. Figure 19.4 shows a few of the stranger examples.

Jazz **Fat Man**
Baskerville
BLOOD FEAST
Chalkboard
COMIX *Diner*
COPPERPLATE
Grumble. Skia
HERCULANEUM
Space Woozies Helvetica
Knots **Diploma**

FIGURE 19.4
Not all of these fonts are right for all occasions.

How many fonts do you need? That depends on what you intend to use them for. Certainly, you already have some useful ones, including classic serif fonts such as Palatino or Times. (*Serifs* are short lines that finish the ends of letters, like this: T. They make it easier to read small type.) You probably have one or two sans serif faces such as Helvetica or Arial. (*Sans serif* means *without serifs*, and looks like this: T.) You have something like Courier, which imitates a typewriter, and you probably have one or two script fonts, such as *Zapf Chancery* or **Dom Casual**. Beyond that, why not wait and see what you need? Adding dozens of fonts can actually make your computer run more slowly.

Did you Know?

With all those fonts waiting for you, it's hard not to get carried away and lose sight of the real reason for the type. Words mean something. You're putting type into your picture for a reason, and most of the time it's to help communicate an idea. Maybe it's a title. Maybe it's the headline for an ad, or the greeting on the greeting card. Whatever it is, you want people to be able to read and understand it. Otherwise, why clutter up the art?

Using bizarre fonts and too many special effects gets in the way of communication. If the words are hard to read, only the most devoted readers will even try. If the message is *Get Well*, but the font came from a circus poster, there needs to be a reason. Otherwise, you've just given the reader one more thing to make his headache worse.

Keep the type in proportion to the picture, sizewise as well as stylistically. Don't let one element overpower the other, unless you have reason to do so. Don't make the type too small to read, either. Print a copy and see whether you can read it from five feet away without your glasses. If so, other folks probably can, too.

Using the Type Mask Tools

Photoshop Elements' Type Mask tools are fun to use and can create some really cool effects. Unlike the Horizontal and Vertical Type tools, which create type you can fill with color, the Type Mask tools create a selection in the shape of the type, which you can fill with an image or pattern. You can also use the Type Mask tools to punch type out of a picture (leaving a blank area in the shape of the type) or to mask the rest of the picture (leaving nothing but letters filled with the picture). Half the battle is finding a picture to work with. The other half is finding a nice fat typeface that leaves plenty of room for your picture to show through. Let's try filling some type.

To use the Type Mask tool, first select it from the toolbox. Set your font, size, and any other options you like. Faux Bold is often useful here because big bold letters

work best as cutouts. When you position the cursor and start to place the letters, something surprising happens. The screen goes into Mask mode and turns pink. As you enter the letters, they appear to be in a contrasting color, but when you finish typing and deselect the Type Mask tool, they turn into paths and the temporary mask goes away. Figure 19.5 shows how this looks onscreen. Don't forget that this is essentially another Selection tool, rather than a Type tool, so you won't be working on a type layer. Your letters appear on whatever layer is selected.

FIGURE 19.5
Now you have the letters as selection outlines. (Photo by Carole Harrison.)

What you do with your text selection from this point on is up to you. You can fill it with a pattern or stroke it just like any other selection (see Chapter 17, "Making Selections and Using Layers"). You can use the selection to cut the letters out of the image on which it was typed, essentially "punching out" the letters. Use Cmd/Ctrl+X to cut the letters out. You can paste them into another document or on a different layer, or leave them as cutouts so that a lower layer can show through. You can invert the selection and cut the image away from the text, leaving the text filled with a portion of the image (assuming that you typed the text onto an image layer). Regardless of how you fill the selection, you can add some layer styles and effects as I have in Figure 19.6. I applied the Wow Chrome, Shiny Edge layer effect and the Drop Shadow, Hard Edge layer effect to the top text; the Drop Shadow, High and Complex, Molten Gold effects to the middle text; and Bevel, Simple Pillow Emboss and Drop Shadow, Soft Edge to the bottom text. Be sure to check these images out in the color plate section, too. (You can also add layer effects to horizontal or vertical type, by the way.)

FIGURE 19.6
Don't be afraid to
experiment.

You can group two layers (one with the type mask, the other with an image) and cut out letters to reveal a picture that's actually on the layer behind them, as I have in Figure 19.7. I placed the image on one layer, copied the water part of the picture and put it on a layer behind the original. Then I placed the Type Mask tool on the sky and started typing. When I finished, I had the type outline in the sky. I pressed the Delete key to remove the center of the letters and the water showed through. Because the Type Mask tool is considered a Selection tool rather than a Text tool, you can't apply normal type effects like drop shadows to the letters. So, I used the regular Type tool, in a nice contrasting hot pink, and set the same letters again on a type layer over the cut-out ones. Then I applied a Layer Style called Drop Shadow to the type. After simplifying the type layer, I used the Magic Wand to select the pink letters, and deleted them, leaving the shadow in place. Again, be sure to see this in color.

FIGURE 19.7
I added a drop shadow to help separate the letters from the sky.

Working with Layer Styles and Text

Layer styles might not have been exclusively meant for working with type, but they do it so well that I nearly always use at least one, and sometimes more. That's why, although I intend to come back to using layer styles in Chapter 31, "Making Composite Images," I want to tell you a bit about them here.

A *layer style* is a special effect such as a shadow or glow that affects all the objects on a layer. You can combine layer styles, such as an outer glow and chrome, to create a complex effect. If you want to use a layer style to format just the type in an image, that type must be on its own layer. With the Horizontal and Vertical Type tools, that's not a problem because Elements creates a new layer whenever you use the tool. But if you use the Type Mask tools to create a type selection, make sure that you first create a new layer to put the text on.

When you have some type or a type mask on a layer, to apply a layer style, open the Styles and Effects palette. If it's not in the Palette Bin, you can display it by choosing Window, Layer Styles. Open the drop-down list and select a category such as Drop Shadow. The palette displays a list of layer styles for that category. Click a style to apply it to the text on that layer.

When you apply a layer style, it shows up in the Layers palette as a cursive letter *f* to the right of the layer name, as shown in Figure 19.8. Because the Undo History palette tells you only that you've applied a style, and not which one,

you'll need to pay attention to what you are doing. Also, if you select another layer style, it's added to the first style. Thus, it's easy to get confused about which styles you've added. To remove all styles from a layer, use the Undo History palette to revert back to an earlier state.

FIGURE 19.8
I suppose the layer style symbol is meant to be a stylish *f*.

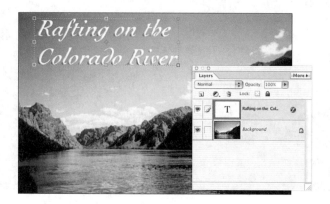

The most effective layer styles to use with text include Drop Shadows, Bevel (which provides bevel and emboss styles), Wow Chrome, and Wow Neon, to name a few. For example, you can improve the appearance of most type with a drop shadow, which adds dimension. Just don't overdo it. In Figure 19.9, you can see what a difference a simple shadow makes.

FIGURE 19.9
This is the preset shadow called Low.

<div align="center">

Me and My Shadow...

Me and My Shadow...

</div>

You can vary the effect of these layer styles by changing the blending modes and varying the opacity. As always, the best way to see what they do is to experiment with different settings.

Editing Layer Styles

If a layer style gives you almost, but not quite, what you want, you can go back and edit the settings. You can reach the Style Settings dialog box either by choosing Layer, Layer Style, Style Settings, or by double-clicking the style symbol (the cursive *f*) on the Layers palette. The Style Settings box is shown in Figure 19.10. You can change the position of the light, which determines the direction in which shadows are dropped, glows are cast, textures are lit, and so on.

FIGURE 19.10
Items that don't relate to a particular style setting are grayed out and can't be changed.

You can also apply global light, which is a very clever way of keeping your shadows in line. Global light dictates that the light setting (in degrees) that you make here—or in any of the other dialog boxes that deal with light or shadow direction—will remain constant. If you put type with a drop shadow on another layer, the new shadow will match the old one. If you add a shape with a reflected glow, it will be lit from the same source.

This is more important than it sounds at first. We live on a planet that has a single sun as its main light source. One light source produces one shadow, and that's what we are used to seeing. When you come inside and turn on a couple of lamps plus maybe the overhead fluorescent bulb, you've complicated things. Now there are several possible directions in which the shadow can go. The strength of the brightest light determines what you actually see. Designating a global light in your composition forces all the shadows you apply to fall in line. With the Style Settings dialog box, you can also change the height and size of a bevel, glow, or shadow.

To practice applying a style to text, follow these steps:

1. Start with a new image. Use the default size, with a white background and RGB color.

2. Click the Horizontal Text tool in the toolbox. Using the Options bar, select a serif font and set the point size to 128. Set the font color to blue by clicking the color swatch at the end of the Options bar and choosing blue from the Color Picker.

3. Click along the left side of the image and type your name. Click the checkmark button to indicate when you have finished typing. (If your name is too long to fit, change the text size using the Options bar.)

4. Open the Layers palette. Notice that Elements has created a new text layer for you, as indicated by the T thumbnail on the left.

5. Make sure that the text layer is active, and then open the Styles and Effects palette. Select Drop Shadow from the list. Click the Soft Edge icon to apply a soft shadow.

6. Select Glass Buttons from the list and click the Yellow Glass icon. Notice how the text changes to green when the yellow color is placed on top of blue. Some layer styles completely override the text color, while others add to it.

7. Use the Undo History palette to remove these styles.

8. Select Outer Glows, and click the Heavy icon. Hmmm. Nothing seems to have happened.

9. In the Layers palette, change to the background layer. Use the Paint Bucket tool to fill the layer with red paint. Ahhh. Now we can see the glow. It just needed something to contrast with.

10. In the Layers palette, change back to the text layer. Choose Layer, Layer Style, Style Settings. Reduce the Outer Glow Size to 10.

11. Save the image and close it.

Warping Text

One of the major complaints about Photoshop used to be that you couldn't set type on a path within the program. If you wanted, say, a wavy line of text, you could either position the letters one by one or set the type in Illustrator or something similar and import it into Photoshop. It was a nuisance, at best. Photoshop, and now Elements, have finally added a feature named *warped type*. You can find it on the Type Options bar. Click the icon with the curved line under the angled T to open it.

It's not totally flexible. Rather than drawing your own path, the Warp Text dialog box lets you select from 15 preset paths. You can also warp and distort the paths as necessary. Figure 19.11 shows a list of the presets. The Arch, Wave, Flag, and Rise presets are typically the best ones to choose when you have multiple lines of text, although any of the presets will work.

The Warp Text dialog box settings, shown in Figure 19.12, are a bit tricky at first. Use the sliders to increase the amount of bend applied to the path. Moving to the right bends words up; moving to the left (negative numbers) bends them down. Distortion makes the line of type appear to flare out on one end (horizontal distortion), or from top to bottom (vertical distortion).

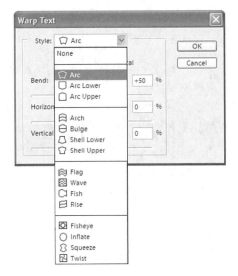

FIGURE 19.11
Select a warp path.

FIGURE 19.12
Move the sliders left or right to change the settings.

In Figure 19.13, I've applied some of the warp styles to various bits of type. The best way to master this tool is to play with it. Set a line or two of type and try the different kinds of warp on it. Try it with and without layer styles added. Move the settings sliders around. You can't break anything.

FIGURE 19.13
The only thing to watch out for is that the type stays legible.

Summary

Elements doesn't have all the type capabilities of a more traditional desktop publishing program, but it can handle most of your typographical needs, whether producing a single headline or a small block of text precisely placed over a photo. Of course, getting the letters into the picture is only the beginning. You can warp the text, punch it out of a graphic, or make the letters out of a picture. With Elements, your words can come alive. However, don't lose sight of your goal. Type is more than just a word or two pasted on your picture. It's there to communicate. Even though you can go completely wild with Elements and a few dozen fonts, try to resist. If you can't read the words, why put them there?

PART V

Simple Improvements

CHAPTER 20 Cropping and Resizing a Photo **383**

CHAPTER 21 Too Light/Too Dark: Adjusting Brightness, Contrast,
 and Color **407**

CHAPTER 22 Removing Red Eye, Dust, and Scratches **429**

CHAPTER 20

Cropping and Resizing a Photo

What You'll Learn in This Chapter:

- ▶ Cropping
- ▶ Thinking About Good Composition
- ▶ Resizing
- ▶ Rotating an Image
- ▶ Straightening Images
- ▶ Skewing Selections
- ▶ Distorting Selections
- ▶ Changing the Perspective of a Selection

It would be pretty unusual to have your pictures come out of the camera perfectly composed, showing nothing more than the subject as you'd visualized it. Even the fanciest cameras with the biggest and best zoom lenses can't always give you what you want. Maybe you're standing on a cliff, about to slide into the Grand Canyon, as I was in one of the examples that follow. Maybe there's something in the way of where you needed to stand to get that perfect shot. Maybe you just couldn't get close enough. (Those darned security guards....) Maybe you shot the picture as a landscape, and then found out you could sell the middle part as a magazine cover.

There's an easy solution for making the subject of the picture bigger, changing its orientation, getting rid of the junk at the edges, and generally improving the composition. It's called *cropping*. Ideally, composition is on your mind when you shoot a picture. Sometimes, though, it's not possible to get the composition you want when you shoot. Your lens won't zoom in far enough, or there's something in the picture

that doesn't need to be there, such as a fire hydrant, telephone wires, or even a person in the wrong place. That's when you take the picture anyway, as best you can, and know that you can fix it up later. Cropping allows you to recompose your photo to make it communicate better.

Cropping

Cropping is the artists' term for trimming away unwanted parts of a picture. The Crop tool icon looks just like the kind artists use to visualize a crop before they start cutting: a pair of overlapping L shapes that form a frame (see Figure 20.1).

FIGURE 20.1
The Crop tool and its Options bar.

When you drag a cropping box around the part of the image you want to keep, the Options bar changes, as you can see in Figure 20.2. Instead of the text boxes into which you can enter dimensions, you have options for the color and opacity of the part of the picture that's grayed out when you position the cropping box.

FIGURE 20.2
The Crop tool and its alternative Options bar.

Did you Know?

Activate the Shield option on the tool's Options bar to make the rest of the screen go dark so that it's easier to see what's going on. Of course, you can also crop by making a selection with the Rectangular Marquee and then using the menu command Image, Crop to trim the picture.

To crop a picture, open your image and follow these steps:

1. Select the Crop tool from the toolbox or press C on the keyboard. (The tool looks like two overlapped pieces of L-shaped mat board—the same tool artists use to help compose paintings.)

2. Drag across the picture, holding the mouse button down.

3. Use the handles on the cropping box to fine-tune the selection. The area outside the box will be dimmed so that you can see what you're removing.

4. After you have the cropping box placed where you want it, double-click inside it or press Enter/Return to delete the area outside the box.

Remember, if you crop too much of the picture, you can undo what you have just done. If it's too late to undo because you have already done something else, just go back to the Undo History palette and click the uncropped picture. You can also choose File, Revert to go back to the last saved version of your picture. As long as you don't close the file, you can keep cropping and undoing it as much as you want.

Thinking About Good Composition

I can talk for days about what makes good composition, but I'll try to keep it to only a few minutes. Composition is what makes the difference between a merely good picture and a great one. Composing the picture correctly means making sure that the viewer sees the same scene that you, the artist, see. This should be important to you because as an artist your task is to capture and share your unique vision of the world around you, whether it's the smile on your baby's face, the magnificence of the Grand Canyon at sunset, or a stormy day at the beach. How do you do this?

First of all, think about what you're seeing. If it's the smiling baby, where is he or she in relation to the camera? If she's halfway across the room, the real subject of the picture, which is the smile, is going to be lost in space. So, rule number one: Get close to small things. If you fill the frame with a baby's face, you'll get the full effect of the smile: flashing eyes, chubby pink cheeks, and those first few teeth peeking out. Use your zoom lens, if you have one, to come close without actually sticking the camera up the baby's nose. That would get rid of the smile in a hurry. Otherwise, crop the picture tightly.

Now suppose that you are trying to get a shot of the Grand Canyon that express-es how big it is. You're standing at the railing at one of the many scenic over-looks, staring downward a mile or so to the canyon bottom, and across to the other end of the canyon. It's a great view, but a lousy picture. Why? Well, when you're standing there, you can feel the space around you. You can look down at your feet, and then keep looking down and outward just a little, and the next horizontal surface is a long way down. If you're like me, you turn slightly green

and find yourself hanging onto the fence. If the picture is going to work, you need to find a way to provide some sense of "out there, back here." In other words, perspective.

To help give a sense of perspective, sometimes I bring a tree branch when I go out to shoot landscapes. My husband or a friend can hold it right at the edge of my shot. That helps define the difference between *here* and *there*. (It's cheating, of course, but it works.) Because I didn't have a branch with me on this particular trip, I moved on to the next overlook. This one had a patch of snow on the ground, and an old tree right next to the fence, with a nice collection of distant rocks blazing with color as the sun started to go down. The tree gave me the sense of perspective I wanted, and the colors on the rocks were an additional bonus. Rule two: If your subject is space, keep it in perspective. Rule two and a half: Be patient.

The ancient Greeks brought us the third, and final, rule of composition. They called it the "Rule of Thirds" (being Greek, they pronounced it rather differently). It works by applying geometry to discover the ideal placement of the center of interest within a picture. If you divide the shape of the picture into thirds horizontally and vertically, you'll have four spots where the lines intersect (see Figure 20.3).

FIGURE 20.3
These four spots are where your eye naturally goes.

Open any of your best pictures and check them out for the Rule of Thirds. Chances are good that if the subject isn't centered, it's touching one of these four spots. I've superimposed this grid on one of my own favorite shots in Figure 20.4, and the upper-right dot hits the pussycat right in the ear. (Actually, she's a Siberian Lynx and would not be amused at anyone bopping her in the ear or elsewhere.)

Your eye is naturally drawn to certain objects more than others. From the moment he's born, a baby seeks to identify faces—his mother's first and then others. That remains true for the rest of our lives. We also look for contrasts: a man-made object against natural ones, something radically different in color from its surroundings, anything that seems out of place. Psychologists have tested this over and over again, theorizing it's a survival skill of some sort. The tests also prove that we first look in the four intersections of thirds, and then in the middle of a page. They've found this to be valid about 75% of the time. And I'm not going to argue with a psychologist.

FIGURE 20.4
Pretty darn close to the magic spot.

Resizing

Elements makes it easy to change the size of the picture, or of anything in it. Resizing is often necessary. For instance, say you import pictures from a digital camera and accidentally set them to import at 72 dpi. With multi-megapixel cameras, your picture can easily be 14×17 inches or more.

You have two options: resizing the image or resizing the canvas. Resizing the image makes the picture bigger or smaller. Resizing the canvas makes the picture *area* bigger, while leaving the image floating within it. You resize the canvas if you need more space around an object without shrinking the actual image.

Resizing an Image

In Chapter 13, "Handling Photoshop Elements Files," I talked about changing resolution. The resolution of an image is measured by the number of pixels it contains per inch. Obviously, the more pixels per inch, the more data, and the clearer the image. Resolution and size are tied together. If you increase the resolution of an image, shrinking the pixels so that there are more of them per inch, the image's size is shrunk as well. If you want to have your cake and eat it too (that is, increase the resolution of an image [the number of pixels per inch] while maintaining its size), Elements has to come up with more pixels per inch than actually exist. It does so through a process called *sampling*—educated guesswork, as it were.

To resize an image, open the Image Size dialog box (shown in Figure 20.5) by choosing Image, Resize, Image Size. Here's where you decide whether or not you want to *resample*—that is, add more pixels to an image based on the colors of the neighboring pixels. Resampling typically results in a loss of clarity, or general fuzziness, but you have to weigh that against your intentions. If you want a higher resolution in order to get a better printout, but the printout will be no good to you if the image is 2 inches by 2 inches, you'll have to resample. However if you don't care about the final dimensions of an image and you just want good quality, don't resample.

FIGURE 20.5
The Image Size dialog box lets you resize your image.

After opening the Image Size dialog box, turn on or off the Resample Image option as desired. Resampling, by the way, will either enlarge or reduce a file's size, depending on whether the image size increases or decreases. If you turn on Resample Image, select the type of resampling you want Elements to use—refer to Chapter 13 for a complete description of each option.

In this dialog box, you can see the pixel dimensions in pixels (logically) or percentages, by choosing the appropriate option from the pop-up menu. If you turn off the Resample Image option, however, the Pixel Dimensions area becomes grayed because you won't be changing the total number of pixels. Regardless of whether you're resampling, you can still enter the desired image print size (in the Document Size section of the dialog box) in inches, centimeters, points, picas, or columns; you can also set percentages by selecting that option from the pop-up menus. As I mentioned earlier, if your desire is to change the resolution and not bother with the resulting image size, you can adjust the Resolution value instead. Of course, if the Resample Image option is turned on, changing either the image size or its resolution will result in a change in the total number of pixels (and the file size).

The easiest way to enlarge or reduce the image is to make sure that the Constrain Proportions option is checked at the bottom of the dialog box, and then simply enter a value in any one of the fields and click OK. As if by magic, the other numbers will change to give you the correct matching values. Changing the percentage to 200% doubles the size of the picture, for example. Unfortunately, if you choose to also resample in order to maintain the current resolution, it quadruples the file size.

As you make changes in the Image Size dialog box, Elements automatically updates the file size at the top of the dialog box so that you know before you commit to a change how that change will affect your file's size.

> If you resample an image and it looks fuzzy, try using the Unsharp Mask filter (described fully in Chapter 22, "Removing Red Eye, Dust, and Scratches") to bring it into better focus.

Did you Know?

Resizing a Canvas

Resizing the canvas to a larger size gives you extra workspace around the image; it does not change the size of the image. Because resizing uses the current background color to fill in the added space, be sure that it's a color you want. I almost always resize with white as the background color. Resizing the canvas to a smaller size is another way of cropping the picture by decreasing the canvas area. It's not recommended because you can accidentally lose part of the picture and not be able to recover it.

To resize the canvas, open the Canvas Size dialog box by choosing Image, Resize, Canvas Size and specify the height and width you want the canvas to be (see

Figure 20.6). You can specify any of the measurement systems you prefer on the pop-up menu, as you saw in the Image Size dialog box earlier. Elements calculates and displays the new file size as soon as you enter the numbers. If you turn on the Relative option, you can enter the size of the border you want. For example, if you enter 2 inches in the Width box, the edge of the canvas is set 1 inch from the sides of the image (for a total of 2 inches). Enter the same value in the Height box, and you have a nice, even border around the image that you can fill with color or pattern to create a frame.

FIGURE 20.6
By adding an inch to the height and width of the canvas, I've given it a 1/2-inch border all around. (Photo by Carole Harrison.)

Use the anchor proxy to determine where the image will be placed within the canvas. Click in the middle to center the image on the enlarged canvas, or in any of the other boxes to place it relative to the increased canvas area. When you're ready, click OK to change the canvas size.

If that's too confusing, there's an even easier way to put extra space around your picture. Drag the window or zoom out to 50% or whatever size enables you to see some work area beyond the edges of the photo. Use the Crop tool to select the entire image, and then drag the sides or corners of the cropping frame out into the gray work surface as in Figure 20.7. Now you can put a title over or under the picture or add a frame or do whatever you like. You can also just leave the white margin so it looks like a "drugstore" print.

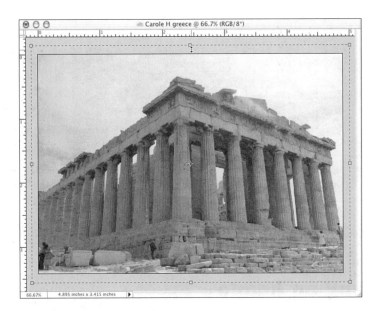

FIGURE 20.7
Drag the cropping frame larger than the picture to add a margin. (Photo by Carole Harrison.)

Resizing a Portion of an Image

You can also resize a portion of any image. To do so, first select the object or a piece of the image to be resized, using the most convenient Selection tool. With the selection marquee active, choose Image, Resize, Scale. This command places a bounding box that looks like the cropping box around your selected object (see Figure 20.8). Drag any of the corner handles on the box to change the size of the object/image within the selected area while holding down the Shift key to maintain its proportions. If you drag the side handles of the box, you'll stretch the selection's height or width accordingly. If you don't like having to hold down the Shift key as you drag, you can click the Maintain Aspect Ratio button on the Options bar to maintain the proportions of the image/object within the selection. You can also enter a percentage in the Width and/or Height boxes on the Options bar to resize the selection without dragging.

> You can resize everything on an entire layer if you choose Select, Deselect to deselect everything first, activate the layer you want to resize, and then choose Image, Resize, Scale.

Did you Know?

FIGURE 20.8
Remember to keep
the Shift key
pressed to retain
the proportions.

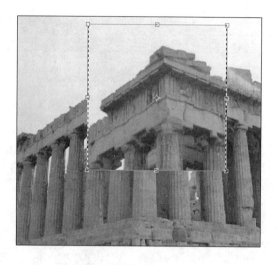

Rotating an Image

Under the Image, Rotate menu shown in Figure 20.9, you've got more ways to turn things around than you're likely to ever need. However, if you have a scanned picture or a digital camera image that should be vertical but opens as a horizontally oriented picture, you'll need these rotation options to straighten things out. Actually, this is a common occurrence when you use a scanner because it's usually quicker to scan with the picture horizontal, regardless of its normal orientation.

FIGURE 20.9
More turns than a
figure skater....

Choose 90° right (clockwise) or 90° left (counterclockwise) to straighten up a sideways image, or choose 180° if you somehow brought in a picture upside down. Until I realized that my new scanner worked backward from the old one, I did that a lot.

Flipping Images

Flipping is not just for pancakes. The Flip options on the Rotate menu allow you to flip an image vertically or horizontally, as if it were a piece of paper. If you have a picture of a girl facing left, for example, and you flip it horizontally, she'll face right. This might come in handy if you need her to look at some text or something on a page that's located to the right of her image. If you flip the image vertically instead, she'll stand on her head!

Sometimes you need to flip an image before you print it so that it will read correctly. For instance, suppose that you're making a sign printed on acetate, which is transparent. If you simply print it as is, the ink can come off when anyone touches the sign. If you flip the text horizontally first, and then print it on the back of the acetate so that the text is read through the acetate, the ink is protected by whatever you have mounted the sign on. You can even sponge off the fingerprints left by those wise guys who try to scratch it and fail.

If you want to print to T-shirt iron-on media, as shown in Figure 20.10, the image actually gets flipped twice: once in Elements before you print it and again as it is ironed face down on the shirt. When you are finished, the image reads correctly.

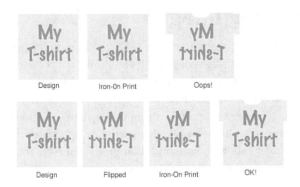

FIGURE 20.10
Sometimes you have to flip images.

You can rotate and flip a selection or layer instead of an entire image if you want. Just select the area/layer you want to flip or rotate, and then choose one of the flip/rotate selection commands from the Image, Rotate menu. Remember this

feature. It will come in very handy when you start making composites of elements from several different pictures. For instance, you can make a quick reflection of an object by copying it onto a second layer and then flipping the copy (the layer) vertically. You can create a cool reflection effect by using a combination of flipping and skewing type. I'll tell you more about skewing and distortions in a minute.

By the Way

> The Free Rotate command does exactly that: You can click a corner of the selection box and drag the contents around in a circle—as much or as little as you want in either direction.

Rotating by Degrees

To rotate the image by something other than a right angle, choose Image, Rotate, Custom to open the dialog box shown in Figure 20.11. Enter the number of degrees to rotate. If you're not sure, guess. You can always undo or reopen the box and rotate more, or even change the direction if needed. Click the radio button to indicate the rotational direction: right or left. Then click OK to perform the rotation.

FIGURE 20.11
You can even rotate by fractions of a degree.

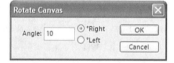

Straightening Images

The last two items on the Rotate menu are the Straighten and Crop Image command and the Straighten Image command. You might use these commands to straighten an image that was scanned in rather crookedly, but you should be careful when using them. I don't know what criteria Adobe's creative department used to determine whether an image is straight. These two commands are automatic and just happen while you wait. However, they don't seem to work very effectively. Figure 20.12 shows before and after views of a New York street scene, with Straighten Image applied.

The Straighten Image command apparently looks for a diagonal near the edge of the picture and rotates the entire image to make that line straight. Sometimes it works fairly well. Sometimes, as in this example, it guesses wrong. The Straighten and Crop Image command does the additional chore of removing the background

exposed by rotating the photo. Personally, I'd rather make my own decisions about cropping.

FIGURE 20.12
I've applied a grid over the "after" image to see where the vertical lines were assumed to be.

If your horizon's just a tiny bit tilted, the Straighten Image command might eventually get you flattened out, but it usually works in very small increments. One trick that helps is to increase the canvas size first, so that Elements has a better idea where the edges of the image are. Still, it's much quicker and easier to do the job yourself.

Straightening and Leveling "By Hand"

You've probably seen hundreds of snapshots of buildings that look like they could easily tip over, and horizons that appear to run downhill. It happens, and most of the time it's unavoidable. The photographer might have been standing on the deck of a bouncing boat or on the side of a hill. The "tiltin' Hilton" effect is caused not by shoddy construction but by wide-angle lenses that make vertical objects at the edges of the photo lean toward the middle. What separates the pros from the amateurs is that the pros know how to fix these little details, and they never show off their work without doing whatever it takes to make the picture perfect.

The crooked horizon line is one of the most common problems, and one of the easiest to fix. Open an image that needs straightening. Figure 20.13, my example, can be downloaded from the book's website. (Look for the file called 20fig13.tif.)

FIGURE 20.13
The horizon's not
supposed to run
downhill.

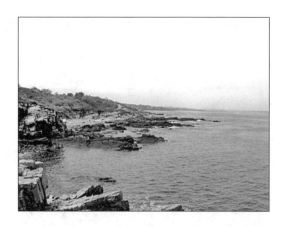

1. Start by selecting the entire image (Cmd+A on the Mac, Ctrl+A in Windows) and applying Image, Transform, Free Rotate.

2. Click and drag a corner of the image while you watch the horizon line. Stop when it's parallel to the top of the screen.

3. Crop away any revealed edges or other leftovers, as are visible in Figure 20.14.

FIGURE 20.14
When we're done
with this, you won't
get seasick looking
at it.

Use the same procedure any time you have to fix something that's off-kilter, vertically or horizontally. Here's the same trick applied to a lighthouse, in Figure 20.15. If you have trouble telling when it's straight, add a grid over the screen. Choose View Grid from the View menu, but be sure that the Snap to Grid option is turned off.

FIGURE 20.15
The grid gives me a reference point for getting the horizon straight.

Straightening Selections

There are frequently going to be times when you need to straighten just part of the picture. It might be a perspective problem, or perhaps the furniture really *is* crooked. Antiques frequently lean a little. In the following example, I love the effect of the wide-angle lens on the old LaSalle, but not on those brass posts holding up the rope around it. My choices are to get rid of the posts and the rope, which would be a lot of work, or to straighten the posts. Being lazy, my course is clear. I'll just fix the posts. Here's the basic car in Figure 20.16.

FIGURE 20.16
The brass posts don't look right.

The posts lean in different directions, so I'll have to fix them separately. The first thing to do is select one. The Magnetic Lasso tool is ideal for this kind of job. After tracing carefully around the post, I can use the Free Rotate command to move it back to vertical. Figure 20.17 shows this step.

FIGURE 20.17
Just a little kick to the left and it's straight again.

Then all I need to do is to fill in where it was. The Rubber Stamp tool is a good choice for this job. Two things will help you. First, zoom in close enough so that you can see what you are doing. This sounds obvious, but many people tend to forget about the magnifying glass and just squint or leave noseprints on the monitor. Pressing Z and clicking the part you want to see close up makes the job much easier.

Another simple trick when you need to work in close quarters replacing a background is to select the area you need to work on. Use the Magic Wand tool to do this. After the area has been selected, it's just as if you'd masked everything around it: You can stamp like crazy and only the selected area picks up the color. Figure 20.18 shows the selection trick applied to a zoomed-in section of the car.

If I crop off the tilting signs on the left of the original image, I can forget about the red velvet rope and leave the rest of the photo as it is, at least for now. Figure 20.19 shows the final picture.

FIGURE 20.18
Working only on the selection is much easier.

FIGURE 20.19
All done, and much less distorted.

Skewing Selections

There's a certain amount of confusion about skewing and distorting. Mainly, which is which? When you *skew* an object, you place a bounding box around the object, just as if you were going to rotate it, but you can drag the corners only up and down, not around. To apply the Skew command, go to the Image menu and select Transform, Skew. Figure 20.20 shows some examples of skewed objects.

FIGURE 20.20
You can skew anything you can select.

You can, of course, use the Skew command instead of Free Transform when you are straightening the furniture or propping up a tilting house.

Distorting Selections

Distortion, as opposed to skewing, enables you to pull on any of the bounding boxes, even crossing over the edge to put a twist in the object. Distorting can also help you put someone on an instant diet, or—if you're mean—add a bunch of pounds.

When you distort an object in Elements, you can do more than just slant it. The Distort command, found on the Image, Transform, Distort submenu, allows you to twist your selection in all possible directions. Just click the handles and drag the selection. Click the toolbox to apply the setting, double-click inside the selection, or press Enter/Return.

In the examples that follow, the woman in the first picture (Figure 20.21a) is as she was. In the second picture (Figure 20.21b), I used the Distort command to

shrink her down a size or two. Before doing so, I selected her, with a combination of the Lasso and Magic Wand tools, and cut her out of the photo (Cmd/Ctrl+X) and then pasted her (Cmd/Ctrl+V) to a new layer. Because there was less of her, I had to do some Clone Stamping on the background to fill in the gaps. Figure 20.21c shows just the background layer, after filling in. As you can see, it doesn't have to be perfect because the layer containing the woman will cover over the irregular edges made by the Clone Stamp tool.

FIGURE 20.21A
This is before....

FIGURE 20.21B
This one's after....

FIGURE 20.21C
The background,
filled in.

Changing the Perspective of a Selection

When you're changing the perspective of an image, you also use the bounding box handles, but as you drag one, the opposite handle moves in the opposite direction. Changing perspective is a way to salvage some of those unfortunate pictures that the camera just couldn't handle. In Figure 20.22, I was obviously standing much too close to the building I wanted to photograph. This image can be saved, believe it or not. If you'd like to work along, the original photo (the file is called perspective20.22) is at the book's website, as listed in the Introduction.

FIGURE 20.22
Is the building falling over backward, or am I?

1. The first step is to correct the perspective so that all the windows are pointing the same way. You might want to extend the canvas, as I have, so you will have some elbow room. (That's Image, Resize, Canvas Size, in case you've forgotten.) Select the entire picture, and then select Image, Transform, Perspective. Drag a lower corner until the windows are more or less parallel, see Figure 20.23. In this case, I had to move the lower-right corner in; sometimes you'll move it outward instead, depending on the angle.

FIGURE 20.23
When I drag one
corner, the opposite
one moves with it.

2. Then simply switch to free transform (press Cmd/Ctrl+T) and rotate the image until the edge of the building is vertical. Expect the sides of the image to be crooked or lop-sided, as in Figure 20.24.

FIGURE 20.24
When you rotate or
distort a picture,
strange things hap-
pen to the edges of
the image area.

3. The distortion left us with a strangely shaped image. I'll have to crop it back to normal. Figure 20.25 shows the final, much improved version.

FIGURE 20.25
I also beefed up
the contrast a little.

There are special cameras made for shooting architecture that permit you to make these corrections when you take the picture, by tilting the lens in relation to the film plane. Photoshop Elements makes this correction easier and a whole lot less expensive.

By the Way

Summary

This chapter talked about cropping, resizing, and rotating your images, and some of the things you can do with the skew and perspective commands. When you crop, you actually trim away the unneeded parts of the picture. Cropping can make a big difference in the composition, by encouraging the viewer to look at

what you want her to see. You can also convert a picture by careful cropping from landscape to portrait orientation, or to a square, a long rectangle, or another shape. Resizing the image makes it bigger or smaller on the screen and for printing. Resizing the canvas provides more room around the image so that you can add other things to it as well. You learned how to rotate an image, or a portion of it, when needed to correct errors or to create interesting effects. We looked at using the Skew command to stretch or shrink part or all of a photo, and finally, you learned how to use the Perspective command to straighten out crooked buildings.

Too Light/Too Dark: Adjusting Brightness, Contrast, and Color

What You'll Learn in This Chapter:

- ▶ Quick Fix
- ▶ Using the Automatic Correction Tools
- ▶ Adjusting by Eye with Color Variations
- ▶ Adjusting Color with Color Cast
- ▶ Adjusting Color with Hue/Saturation
- ▶ Removing and Replacing Color

Digital cameras generally give you good, accurate color, but a lot depends on the amount of light available. Pictures shot outdoors toward the end of the day as the sun goes down often take on an orange tone. Rainy day pictures might be as drab as the weather itself. Indoor photos can pick up all kinds of color casts depending on the lighting in the room. A scanned photo can have an added color shift caused by the scanner. Or maybe you've scanned old, faded prints in hopes of saving them in Elements. You'll be amazed at what you can do by just making some small adjustments to an image's brightness, contrast, and color.

Quick Fix

Quick Fix is a new addition to Photoshop Elements, and it promises to be a very useful one, particularly for photos that are pretty good to start with. To open Quick Fix, select it from the Shortcuts bar, and your photo will open on a new screen with a new set of tools and palettes. Figure 21.1 shows the Quick Fix layout.

Quick Fix gives you easy access to most of the same options that you will find on the Enhance menu in Standard Edit mode, so rather than discuss them twice, I'll save those explanations and talk first about the unique features of Quick Fix. One of the best is that you can elect to see your picture in before and after views, so you can evaluate the effect that the corrections are having on it. The pop-up menu shown in Figure 21.2 is found at the bottom left of the screen.

FIGURE 21.1
It looks a little like the Standard Edit window, but Quick Fix just gives you the bare essentials for image correction.

FIGURE 21.2
Select Portrait for tall pictures and Landscape for wide ones.

The toolbox on the left side of the screen has limited options. The Zoom tool and Move tool allow you to look at specific parts of the image close up or see the whole picture. The Crop tool and Red Eye Correction tool work just as they normally do in Standard Edit mode.

On the right side of the screen, the General Fixes palette has two tools. You can rotate an image 90 degrees left or right by clicking the appropriate icon. And you can apply Smart Fix, which automatically applies color and lighting corrections with a single click. In the other palettes, you can correct Lighting and Color and even sharpen a fuzzy photo. You have the option of simply clicking the Auto button and letting Elements do the correcting, or—but not for all controls—using the

sliders to make your own adjustments as you compare the "before" and "after" images. You can't apply any special effects or type in the Quick Fix window, and you don't have access to some of the items on the Enhance menu, but Quick Fix is quick and easy. More importantly, if you aren't really sure what you're doing, it's a good way to learn what effect these changes will have.

Using the Automatic Correction Tools

Being somewhat lazy, I always start to fix a problem image by trying anything that says *Auto*. Elements offers four such commands in the Standard Edit window. Auto Smart Fix, Auto Levels, Auto Contrast, and Auto Color Correction are all found on the Enhance menu, along with the other color correction tools we'll be looking at later in this chapter. Figure 21.3 shows the Enhance menu.

Enhance	
Auto Smart Fix	⌘M
Auto Levels	⇧⌘L
Auto Contrast	⌥⇧⌘L
Auto Color Correction	⇧⌘B
Adjust Smart Fix...	⇧⌘M
Adjust Lighting	▶
Adjust Color	▶

FIGURE 21.3
The top four Enhance commands are the automatic ones.

> Remember that all these corrections can be applied to the entire image, to a selection, or to one or more layers. You must, however, make a selection in regular Edit mode before invoking Quick Fix.

By the Way

When you select any of these Auto commands, the changes simply happen. You simply wait while Elements does the math and changes the image to what it thinks you want. Unfortunately, there's no software yet that can read minds, and what you want, or what I want, might be quite a bit different from what the Elements programmers think we ought to want. So, Auto isn't necessarily the way to go.

Auto Smart Fix

This tool is new in Elements 3, and corrects colors and improves shadow and highlight detail, all at once. If there's not much wrong with your picture, or if there's a lot wrong with it and you merely hope to end up with something recognizable, this could be the right tool for the job. There are two ways to apply it: Auto Smart Fix and Adjust Smart Fix. If Auto doesn't seem to do what you want,

does too much, or not quite enough of it, you can undo it and select Adjust Smart Fix instead.

The Adjust Smart Fix dialog box, which is shown in Figure 21.4, gives you a single slider so that you can apply as much or as little fixing as you think your photo needs instead of simply applying what Elements thinks is right. The slider ranges from 0% to 200%. Remember that it's still trying to fix everything at once. If your colors are already correct, you might be better off using a different command.

FIGURE 21.4
The Adjust Smart
Fix slider ranges
from 0% to 200%.

Auto Levels

It's certainly worth a click. Auto Levels automatically adjusts the tonal range and color balance in your photo to make sure that there is a range of values (shadows, midtones, and highlights). It defines the lightest and darkest pixels in an image, and then redistributes the intermediate pixel values proportionately. If Elements doesn't think the levels need adjusting, it won't change anything. If it does, the screen will blink and your image will reappear, looking better (one hopes...). If you don't like the changes, click Undo.

If you don't like the result of Auto Levels, but you agree that the picture could use some tweaking, choose Enhance, Adjust Lighting, Levels to open the Levels dialog box, shown in Figure 21.5, and do it yourself. What you're looking at is called a *histogram*, and it's essentially a graph of the number of pixels at each level of brightness from 0 to 255.

By the Way

If you've ever taken a course in statistics, you already know that a histogram is a kind of graph. In Photoshop Elements, it's a graph of the image reduced to grayscale, with lines to indicate the number of pixels at each step in the grayscale from 0 to 255.

You might wonder why this is important. The main reason is that you can tell by looking at the histogram whether there's enough detail in the image, so that you can apply corrections successfully. If you have an apparently bad photo or a bad scan, studying the histogram will tell you whether it's worth working on or whether you

should throw away the image and start over. If all the lines are bunched up tight at one end of the graph, you probably can't save the picture by adjusting it. If, on the other hand, you have a reasonably well spread-out histogram, there's a wide enough range of values to suggest that the picture can be saved.

The Histogram command has another use, which is to give you a sense of the tonal range of the image. This is sometimes referred to as the *key type*. An image is said to be low key, average key, or high key, depending on whether it has a preponderance of dark, middle, or light tones, respectively. A picture that is all middle gray would have only one line in its histogram, and it would fall right in the middle.

All you really need to know is that, when you look at the histogram, you should see a fairly even distribution across the graph if the image is intended to be an average key picture. If the picture is high key, most of the lines in the histogram are concentrated on the right side with a few on the left. If it is low key, most of the values are to the left with a few to the right.

The image represented by the histogram in Figure 21.5 has a fairly even spread all the way across the spectrum—just enough light and dark spots, and not too many boring middle tones.

FIGURE 21.5
Levels aren't hard to adjust.

There are several ways to use the Levels dialog box. The easiest, of course, is to click the Auto button. The next easiest is to move the Input Levels sliders (the up arrows) just under the histogram until you like the result. Just be sure that you have checked the Preview box, so you can see the effect of your changes on the picture.

More scientifically, you can drag the sliders to the points at either end of the scale where the histogram begins to rise steeply. Typically, these will have numerical input values somewhere between 0–30 and 225–255. Then move the middle slider, which represents the midtones, to about halfway between the two. This remaps the values; narrowing the range increases the contrast while widening the range decreases it.

Drag the Output Levels sliders at the bottom of the dialog box to adjust the range of shadows and highlights. This increases or decreases the amount of contrast and brightness in an image.

You can also use the eyedroppers to adjust the levels. Click the Set White Point eyedropper (on the right) and click the lightest part of your image. Then click the dark-tipped eyedropper (Set Black Point, on the left) and click the darkest point on the image. If you have an area in the image that seems to be right in the middle, click it with the midrange eyedropper (Set Gray Point, in the middle).

You can even adjust levels by color. The Channel pop-up menu at the top of the dialog box gives you access to the three color channels: red, green, and blue. You can use this feature to adjust the amount of a single color in the image, and to keep shadows and highlights from getting muddy or developing a color cast.

The Reset button takes you back to your original image, undoing any changes in levels that you have made.

Auto Contrast

Auto Contrast works in a similar manner to Levels, but doesn't attempt to adjust color channels separately, so it often gives a different (and in my experience, more satisfactory) result (no color cast). It also doesn't seem to overcorrect, as Auto Levels can. But, of course, a lot depends on the image to which you're applying it. Some images need more careful tweaking than any automatic adjustment can make. To try out Auto Contrast, choose Enhance, Auto Contrast. Again, if you don't like the result, click Undo.

You can also adjust brightness and contrast in an image by using the Brightness/Contrast dialog box shown in Figure 21.6. Choose Enhance, Adjust Lighting, Brightness/Contrast. Just move the sliders to the right to increase the amount of brightness and/or contrast, or to the left to decrease them. Experiment until you like the result. Remember that you can apply any of the corrections discussed in this chapter to a selected area of your image. To lighten or darken parts of an image, you can also use the Dodge and Burn tools described in Chapter 24, "Repairing Black-and-White Pictures."

FIGURE 21.6
Be sure the Preview
box is checked.

Auto Color Correction

I like really bright, saturated color. The person who wrote the algorithm for Auto
Color Correction apparently prefers a more subdued palette. I'm seldom really
happy with the results of Auto Color Correction, but—as they say—your mileage
may vary. It might be just right for the image you're working on, so don't hesitate
to try it by choosing Enhance, Auto Color Correction. We'll cover various ways
you can adjust color levels yourself in just a minute.

Just for fun, in Figures 21.7, 21.8, 21.9, 21.10, and 21.11, I've taken the same pic-
ture and applied each of the four automatic corrections to it. (They're also includ-
ed in the color plate section.) Judge for yourself which worked, and which did
more harm than good. Figure 21.7 also shows my "after" version, custom
tweaked with several of the Enhance menu's nonautomatic commands.

FIGURE 21.7
The original photo
and my best ver-
sion.

FIGURE 21.8
Auto Smart Fix
applied. Not much
changed.

FIGURE 21.9
Auto Levels
applied. Contrast
improved in mid-
tones.

FIGURE 21.10
Auto Contrast
applied. Very little
difference from
Auto Levels.

FIGURE 21.11
Auto Color
Correction applied.
Colors are warmer.

Adjusting by Eye with Color Variations

Sometimes if you want something done right, you have to do it yourself. This truth applies to color correction as much as to any other endeavor. Figure 21.12 shows the Color Variations dialog box. You can find it in the Enhance, Adjust Color submenu. Use the Color Variations command to add or remove red, blue, or green to or from the shadows, midtones, or highlights in an image; lighten or darken the shadows, midtones, or highlights; and increase or decrease the intensity (saturation) of color.

FIGURE 21.12
The small images represent what the picture would look like with the specified color added or removed.

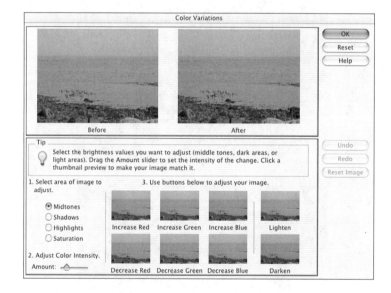

To use the Color Variations dialog box, first decide whether you need to correct the shadows, midtones, or highlights, or the color saturation, which will affect all three equally. Move the Adjust Color Intensity slider if you think you need more or less correction, and finally, click the small image that looks most like the kind of adjustment you want. (You might want to use a magnifying glass. Because the previews are so small, subtle changes are hard to see.) If you like the direction it's going, but need more correction, just click the same image again. You can undo as many changes as you like by clicking the Undo button more than once. The Reset Image button removes all changes.

Adjusting Color with Color Cast

Color cast is the term experts use when an image has too much of one color in it. Sometimes an image will get a cast from poor lighting, bad scanning, or as an aftereffect from some other adjustment such as Auto Levels. The Remove Color Cast dialog box, shown in Figure 21.13, removes color casts by having you locate a point in the picture that should be pure white, middle gray, or black, and then adjusting the color so that that point actually is white, gray, or black. To adjust the target color (and thus, the other colors in your image), the Remove Color Cast command adds the color *opposite* the target color on the optical color wheel to cancel out or neutralize whatever color is too strong in the black or white or gray. In this example, the water and gaggle of geese were much too yellow. Remove Color Cast adds blue (yellow's opposite on the color wheel). You can see the before and after versions in the color plate section.

To correct a color cast, choose Enhance, Adjust Color, Remove Color Cast. Then use the eyedropper to click a point in your image that should be pure white, pure black, or medium gray.

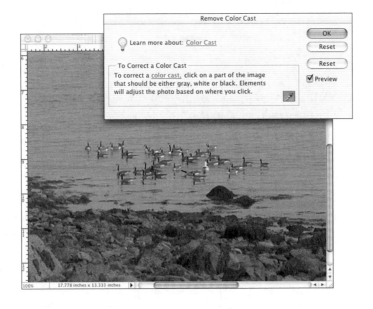

FIGURE 21.13
Fortunately, there was a white seagull in with the Canada geese. Losing the color cast was the only change needed.

If you don't like the result the first time, try a different black or white spot, with or without clicking Reset first. The results will vary according to the color strength of the pixel you select.

Adjusting Color with Hue/Saturation

The Hue/Saturation dialog box is the most complicated of the lot, mainly because it has three sliders instead of two. Display it by choosing Enhance, Color, Hue/Saturation. As you can see in Figure 21.14, it also has a pop-up menu that allows you to adjust a single color rather than all of them at once. (This is also the only place in Elements where you can do anything at all with cyan, magenta, and yellow, the key components of the CMYK color model.) However, I'd suggest sticking with the Master option until you start to understand how the algorithm works.

FIGURE 21.14
The Hue/Saturation dialog box.

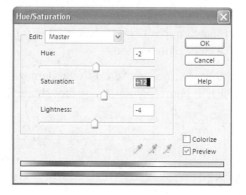

As always, check the Preview option so that you can see the effects of your changes in the picture you're working on.

There are three sliders: Hue, Saturation, and Lightness. The Hue slider moves around the color wheel from color to color. With Master selected, you can move all the way from red (in the middle of the slider), left through purple to blue or blue-green, or right through orange to yellow and green.

The Saturation slider takes you from 0% in the center, to 100% saturated (pure colors) on the right, or 100% unsaturated (no color, or essentially a grayscale image) on the left. When you move the slider from right to left, the colors opposite the image colors on the optical color wheel are added, so the image colors move toward gray.

The Lightness slider enables you to increase or decrease the brightness of the image, from zero in the center, to +100 on the right (pure white), or –100 (pure black) on the left.

As you move these sliders, watch the two spectrum strips at the bottom of the window, as well as the image itself. The upper strip represents the current status of the image, and the lower one changes according to the slider(s) you move. If you move the Hue slider to +60, for example, you can see that the reds in the picture turn quite yellow, and the blues turn purple. Also, the reds in the upper spectrum line up with the yellows in the lower spectrum. In effect, what you are doing is skewing the color spectrum by that amount. If you move the Saturation slider to the left, you'll see the lower spectrum strip become less saturated. If you move the Lightness slider, you'll see its effects reflected in the lower spectrum strip as well.

If you select a color instead of selecting Master from the Edit drop-down menu, the dialog box changes slightly, as you can see in Figure 21.15. The eyedroppers are now active, enabling you to select colors from the image, and the adjustable range sliders are centered on the color you have chosen to adjust. You can move these sliders back and forth to focus on as broad or narrow a range within that color as you want. This might not seem like a big deal, but it's really very powerful. For example, I was trying to adjust a picture of a girl wearing a dark magenta shirt. Her skin seemed too pink to me, but the shirt seemed almost right. So, I selected Reds from the Edit list, and moved the sliders to narrow my definition of red so that it fit her skin tone but not her purplish-red shirt. Then I adjusted the saturation level to remove red from her skin, leaving it a more natural color.

I could have used the eyedroppers to be more precise in selecting my range, by taking samples of color from various points on her skin. To do this, you start with the first eyedropper on the left. Click on a point on her skin that's a middle-tone color, not too light and not too dark. Then use the middle eyedropper to add other samples to the range, lighter and darker. Use the eyedropper on the right to remove colors from the range, such as the red in her shirt.

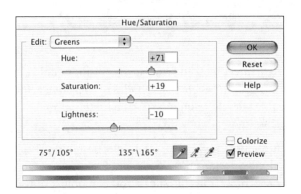

FIGURE 21.15
This tool could make your brown eyes blue.

Suppose that I want to change a single color within a picture. Let's say I want to convert one of the yellow flowers in Figure 21.16 to some other color. All I need to do is select the flower I want to change, open the Hue/Saturation dialog box, and choose Yellows from the Edit drop-down menu at the top. Then I can move the Hue slider around until I find a color I like, maybe a nice purple. Because I'm working on a selection, only the selected flower will change color. However, this flower has a brownish center that is included in the Yellows range, so when I change the Hue to purple, the brown center takes on a bluish cast. That's not what I want, so I set the sliders back to the center and start over. This time I subtract the brown centers from the range by first dragging the left slider to the right, eliminating oranges, and clicking on various spots within the brown centers using the third dropper. Look at Figure 21.16 in the color plate section to see the effect.

FIGURE 21.16
Why not purple sun-flowers?

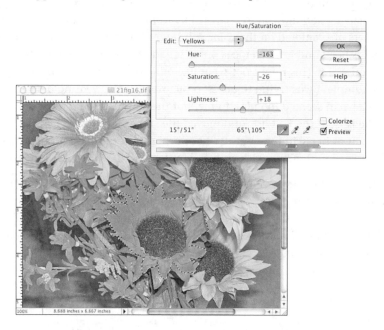

You can create a neat effect by using the Hue/Saturation dialog box to colorize a photo, essentially turning it into various shades of the same color such as red or blue. You can use this technique on a grayscale image as well, if you first convert it to RGB by choosing Image, Mode, RGB.

In the Hue/Saturation dialog box, select the Colorize option. The colors in the image are changed to variations of the current foreground color. To select a different color as your base, move the Hue slider. You can adjust the Saturation and

Lightness levels as well, if you like. This is a nice technique to "dull down" an image to make it suitable for use in web backgrounds, stationery, business cards, and so on. Try it sometime!

Removing and Replacing Color

The Remove Color command is easy to understand and easy to use. When you select it from the Enhance, Adjust Color submenu, it simply removes all the color from your picture, converting it to grayscale, but without changing the color mode to grayscale, too. Why is that important? Because having turned the picture to grays, you might want to paint back some colors, perhaps different ones, or paste things in color on layers over it, or...who knows? It's your picture. By the way, you can use the Remove Color command on a selection, removing color from just an area of an image. You might select the background and remove the color from behind a person, for example, to make her stand out in an interesting way. This technique is used in advertising all the time to draw attention to products.

The Replace Color command, on the other hand, is—in my opinion—the least comprehensible dialog box in any form or version of Photoshop. You can use Replace Color to replace one color in an image with some other color. For example, you can change all the yellow roses in a photo into red ones, or try out a new paint color on your house. Still, the dialog box is a bit intimidating. I've taught you an easier way to do it using the Hue/Saturation dialog box, but in case you really want to try out Replace Color, the following steps will lead you through it:

1. To make the change apply to every instance of the color you're replacing, make sure nothing is selected. If you want to change only a single flower, area, or object, select it.

2. Choose Enhance, Adjust Color, Replace Color. You'll see the dialog box in Figure 21.17. You can work in Mask mode (Selection) or Image mode. In Mask mode, a black mask appears over the areas of the image that you don't want to replace. Partially masked areas indicate those regions that will be only partially replaced with the new color. The unmasked areas (shown in white) indicate the parts of the image that match the foreground color to the degree you specify. At any time, you can remove the mask and look at the entire image by clicking the Image radio button. This helps you verify that all the areas you do not want to affect are masked.

FIGURE 21.17
The mask covers
the areas that
won't be affected.

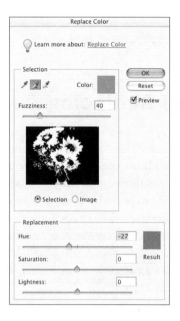

3. Using the first eyedropper, click in the document window on the color you want to change. The mask in the sample window changes to mask just the areas that don't match the color you clicked on. If the sample is not the midrange of the color you want to change, try again.

4. Use the plus eyedropper to select additional colors or shades of the same color to change. Elements adjusts the mask based on your selections. Use the minus eyedropper to deselect colors you don't want to change.

5. You can use the Fuzziness slider to control the sensitivity of the range of colors masked, in the same way you'd use the Tolerance setting to control the sensitivity of the Magic Wand. As you move the slider, you'll see more or less of your mask. Higher Fuzziness numbers are more tolerant.

6. When you're ready to replace the unmasked areas with another color, move the Hue slider right or left to locate the new color. You'll be able to see it in the sample swatch. Modify it with the Saturation and Lightness sliders until it's just what you want. Click OK.

7. The new color will replace the old one in the areas you have selected.

Well, okay, maybe it's not all that complicated. I think I'd use my Hue/Saturation method for changing a single selection, and the Elements Replace Color method for globally changing, let's say, all the yellows to pinks. For the most realistic

look, go through the process several times, changing some of the yellows to pinks at each pass, but each time selecting slightly different ones. Figure 21.18 shows my final flowers, gone from yellow to red-orange.

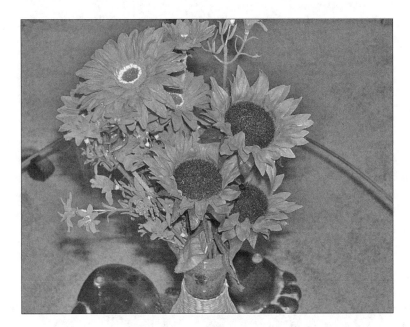

FIGURE 21.18
Be sure to look for this figure in the color plate section.

Compensating for Lighting Mistakes

When light comes from behind a subject, it can make the subject a bit dark. But it can also make for a strong contrast between your subject and its background. If you adjust the exposure so that the subject is properly lit, you risk making the background overexposed. To compensate for washed-out skies, sun-kissed lakes, and other light backgrounds in your images, use the Shadows/Highlights tool. It lets you adjust the shadows, midtones, and highlights in the image independently of each other, meaning that you can lighten or darken the background without affecting the subject too much. Figure 21.19 shows the dialog box.

Drag the sliders as necessary until the image looks right, and then click OK. You can select a specific area if you want your changes to affect only that portion of the image.

FIGURE 21.19
You can tweak each
range of tones until
the contrast is per-
fect everywhere in
the picture.

FIGURE 21.19
You can tweak each
range of tones until
the contrast is per-
fect everywhere in
the picture.

Correcting an Image, Step by Step

The photo shown in Figure 21.20 has a lot of relatively minor things wrong with
it. But it's basically a very good picture, and worth saving. This is an old Polaroid
photo, somewhat overexposed, and the colors have shifted to blue. The building
(the Celsus Library in Ephesus, Turkey) is also tilting a bit downhill. Let's try fix-
ing it. In case you want to work along, you can find the picture (titled "Ephesus")
at this book's page on the Sams Publishing website.

FIGURE 21.20
You can't put it in
the scrapbook look-
ing like this. (Photo
courtesy of Carole
Harrison.)

1. Open up the image in Quick Fix mode. Remember, you can click the button
 on the Shortcuts bar to get there, if you're in Standard Edit mode. Set the
 view to show you "before" and "after" images.

2. The first step is to try Smart Fix. I think it overdid the correction a bit. It's a
 blue Mediterranean sky, but maybe not that bright. Instead of using Auto, I
 clicked the Reset button, and instead dragged the slider until the picture
 looked about right. My setting was halfway between the first and second
 tick marks on the scale, but if your monitor is not adjusted the same way

mine is, you might see it differently. Remember that you have to click the checkmark that appears on the palette tab to confirm the changes you make. If you don't like the change, click the "No" symbol. (The checkmark and "No" symbols show up only when you have made a nonautomatic correction.)

3. Let's see what Auto Levels and Auto Contrast can do for us. In the Lighting palette, click the Auto button next to the Levels label; the darks and lights begin to sort themselves out. This makes a big—and helpful—difference, as you can see in Figure 21.21.

FIGURE 21.21
This is looking much better already.

4. When I tried Auto Contrast, I decided I didn't like it. So, I used the Undo command and moved the Lighten Shadows, Darken Highlights, and Midtone Contrast sliders around instead. I was able to bring out the detail in the shadows and improve the midrange contrast.

5. Now that the contrast and brightness seem to be about right, let's start working on the color. In the Color palette, I slid the Hue slider to the right just a little to make the sky more blue and less cyan. Then I increased the Saturation just a little, and tweaked the Temperature slider to the red side to warm up the colors a little. Finally, I added just a bit of magenta to the mix, using the Tint slider. Now it looks right. The changes, shown in Figure 21.22, definitely help. Notice that the checkmark and No symbol move to the tab of the palette you're currently using.

FIGURE 21.22
When all you need
are subtle changes,
alter the settings a
little bit at a time.

6. What about focus? The last tab in the palette bin sharpens the picture. Be careful not to oversharpen because the process can make a picture look grainy or even blocky. I tried clicking the Auto button, but it didn't sharpen enough. So, I nudged the slider just a little bit to the right.

7. I could correct the tilt, but I think I'll leave it. It adds to the antiquity. (If you need a refresher on straightening buildings, turn back to Chapter 20.) We're done. It's not a great photo, but compare the final version in Figure 21.23 to the original in Figure 21.20. Be sure to look at these in the color plate section, too.

Did you
Know?

As you are making any of the adjustments that require dragging sliders, make sure that you stop and release the mouse button before you attempt to judge the result of your change. For some reason, Elements doesn't complete those changes while the mouse button is down. This is not a problem in the individual dialog boxes, only in Quick Fix mode.

FIGURE 21.23
This looks much better than before.

Summary

You learned a lot about color correction in this chapter. We covered how to correct color problems in both the Quick Fix and Standard Edit modes, and we reviewed all the items on the Enhance menu. You learned about the automatic color correction features in Elements, and that they don't always work as you'd hoped. So, you learned how to make the same changes yourself. You found out all you need to know about histograms, and how to use the Levels dialog box. You mastered fixing contrast, and learned to use color variations to fix off-color pictures. You learned about color cast and how to cancel it out. You learned how to use the Hue/Saturation dialog box for maximum control, and finally you learned how to remove and replace colors, and how to work through color correcting a sample photo. Color is fun to play with, too. Try changing colors in some of your own photos. Turn a cloudy day to a bright blue sky. You have the tools and now you know the tricks.

CHAPTER 22

Removing Red Eye, Dust, and Scratches

What You'll Learn in This Chapter:

▶ Making Basic Cleanups

▶ Fixing Red Eye

▶ Removing Dust and Scratches

Good photos can suffer from a host of easily fixed problems. Dust and scratches are most common on old pictures, and particularly on scans of them. Red eye is seen mainly on pictures taken with a flash camera, but it can happen at any time if the subject's eye catches the sun or an indoor light. And nearly every picture needs a little bit of cleanup, especially outdoor shots that can be spoiled by litter on the ground, dead leaves, or whatever is there that shouldn't be. If you didn't have the foresight, or a flexible assistant, to remove the "schmutz" before you took the picture, you can still take it out in Elements. All you need is patience and a steady hand.

Making Basic Cleanups

The basic cleanup should be your first step when working on any picture. Study the picture. Ask yourself some questions:

▶ Would cropping help improve the composition? If so, see Chapter 20, "Cropping and Resizing a Photo," for help.

▶ Is it crooked? Do you need to straighten the entire picture or just a piece of it? Again, see Chapter 20 for help with straightening the picture.

▶ Is there something in there that doesn't belong? If the unwanted element in your picture is large, skip to Chapter 29, "Creating Art from Scratch," to learn how to use the Eraser tools to remove it. If it's a small item that's wandered into the background, stay tuned to this chapter, where you'll learn how to remove the object with the Clone Stamp tool.

▶ If it's a scanned photo, was the glass in the scanner clean? You can pick up dust, pet or human hair, and all sorts of scuzz in your pictures if you don't keep the scanning surface clean. Find out how to remove dust, hairs, and similar small items from your scanned images in this chapter.

Here's a photo I just scanned for these examples (see Figure 22.1). This picture was taken at a safari park in Canada. I couldn't get out of the car to clean up the grass, but the cats look happy, and I think the picture is worth spending some time on.

FIGURE 22.1
Sometimes a telephoto lens can literally save your life.

As you can see, this is definitely in need of some cleaning up. First, I'll crop out the black edges from the scanner. The photo looks pretty straight, so we won't mess with rotating it. There are a lot of twigs, dead leaves, and scraps of paper on the ground. This would definitely look better with less clutter.

Removing Small Objects with the Clone Stamp Tool

When small objects wander into your photographs uninvited, use the Clone Stamp to get rid of them. The Clone Stamp works by copying the color of nearby

pixels onto the pixels you drag over with the tool. So to fix my photo, I used the tool to copy the colors of the grass nearby, and to stamp with those colors over the trash, thereby removing it. Figure 22.2 shows this step completed.

FIGURE 22.2
If you hold the mouse still as you click to stamp, you'll copy the texture as well as the color. Dragging blurs the texture.

To use the Clone Stamp tool, zoom in on the area you're trying to fix, then select the tool from the toolbox. Choose a brush from the drop-down list in the Options bar. Typically, a soft-edged brush is best because it will soften the effect and make it less obvious. Next, select a brush size. Choose a brush that's large enough to cover the telephone wire, tree branch, or stray dog you want to remove, but not too big. Select a blend mode and opacity. For this kind of repair, I usually leave these options set to Normal and 100%. Turn on the Aligned option if you want to copy colors from nearby pixels. Turn it off if you want to copy the colors in one area of the image to several different places. If you want to "mix your paint" using colors from all layers, turn on the Use All Layers option.

After setting options, press Cmd/Alt and click in the image to take a sample of the colors there. If you move the mouse as you stamp, you'll get a blurred copy, but if you hold it still you'll get a precise copy, just like using a real rubber stamp. Sometimes the smudged effect is helpful. When you are stamping something with a definite texture, like the foreground grass in this photo, you need to be careful not to smudge it.

If the Aligned option is checked in the tool's Options bar, you'll paint with colors taken from a spot that's roughly the same distance from the mouse pointer as the original spot and the place where you first began painting. The spot where your colors are coming from is marked with a big *X*. If the Aligned option is not on, your paint color will come from the place where you first clicked to take a sample.

Removing Small Objects with Copy and Paste

Using the Clone Stamp is easy when you're working on relatively small areas. It can be time-consuming if you have larger areas to cover. Fortunately, there's a better way.

When you want to cover something in an area of your image that should look like another area of the image, why not simply copy the good section and paste it over the bad? You can fix large areas with a single click using this method. Of course, you'll have to soften the edges of the pasted area, but that's not a problem.

To remove those bare spots on the ground behind the left lioness, I copied some of the good grass and digitally reseeded the area. Elements automatically creates a new layer for the pasted data, which is placed exactly above the spot on the image where I copied it. This makes the pasted area a bit tough to see, so I temporarily hid the main image layer by clicking its eye icon in the Layers palette. Then I used the Move tool to position the patch as carefully as I could. I repeated this process a few times, because I needed several different patches of grass to cover the dirt. I could also have accomplished this by lowering the opacity of the layer so I could see what was under it. When I was done, I merged all the layers by selecting Layer, Merge Visible. Then I used the Clone Stamp to sample the correct grass color nearby, and paint it over the edges of my patches, hiding them (see Figure 22.3).

With my careful copying and pasting, and some help from the Clone Stamp, the junk is gone in no time. Now I'm ready to go on to color corrections, lighting changes, and any other major changes. I might try applying a watercolor filter (which makes the photo appear as if it were painted with watercolors), the Chalk & Charcoal filter (which simulates that artistic effect), or Spatter (which spreads out the colors in a spattered pattern). On the other hand, I might just leave it as it is, which isn't bad (see Figure 22.4). See this photo in color in the color plate section.

FIGURE 22.3
Zoom in so you can
see what you're
doing.

FIGURE 22.4
The final version of
the photo, after
cleanup.

Fixing Red Eye

You've seen it a thousand times—that "devil eye" look that spoils pictures of
everyone from grandma to the new baby, puppy, or cat. Usually the eerie glow is
red, but it can be green, blue, or even yellow. It's caused by light reflecting back to
the camera lens from the inside of the eye, which can happen only if the pupil of
the eye is open—as it would be in a dimly lit room, or outside in full shade. Red
eye appears red in humans because of the network of blood vessels back there.
Our four-footed friends are more likely to display green or yellow eye, although
normally blue-eyed Siamese cats eyes will also glow fiery red. Figure 22.5 shows
an especially awful example, with both eyes affected.

FIGURE 22.5
She's really a very
gentle cat.

A Pound of Prevention...

The easiest way to cure red eye is to prevent it in the first place. Most cameras with on-board flash, both digital and film cameras, have an anti–red eye flash mode. It uses one or more quick pre-flashes to decrease the size of the subject's pupils before the main flash goes off. It's usually at least partly successful.

The second way to avoid red eye is to increase the ambient light. Turn on all the room lights, rather than relying on the flash. Brighter lights will narrow your subject's pupils and also allow the use of a lower flash setting to dim the reflex.

A less common problem is alcohol/drugs, though certainly alcohol and its results have affected a great many wedding pictures. Both alcohol and narcotics will further dilate the users' pupils, and that will make red eye even worse. Besides, there's nothing attractive about being blotto.

Try having your subjects look away from the lens. It might help, but it also might make the composition a little strange, unless you can also show what they're looking at. Sometimes, just a few degrees are enough to make a difference. If you know you've got a red eye problem, start by having the subject look at your shoulder instead of the camera, and increase the head turn if necessary. Get closer to your subject to widen the flash-subject-lens angle and thereby avoid the reflection. The longer the camera-subject distance, the greater lens-flash distance must be to avoid red eye.

If your camera can sync to an external flash (not all models can), use an external flash positioned at least three feet away from your camera lens to change the angle of the light entering the eye. You can also bounce the flash off the ceiling or a white card or reflector before it reaches the subject to redirect the reflection away from your lens.

A Couple of Cures

Either your attempts at prevention failed, or these are old pictures, shot before you learned that red eye is sometimes avoidable. Anyway, you've got it bad. Now what can you do? Elements has an "automatic" red eye repair tool called the Red Eye Removal tool. It's in the toolbox, shown in Figure 22.6 along with its Options bar.

FIGURE 22.6
Pay attention to the Options bar settings.

The brush, which used to be at best semi-automatic, has been greatly improved in Elements 3. And there are How To directions to tell you how to use it. To find them, look in the palette bin or under the Window menu for How To and locate Remove Redeye (see Figure 22.7).

FIGURE 22.7
It's simple when you have the recipe in front of you.

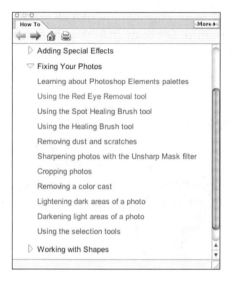

Did you Know? Whenever you are using a palette, drag it down the screen to disconnect it from the toolbar. Otherwise, it will automatically close whenever you click somewhere else on the screen.

From there, you simply follow the directions, which tell you to do the following:

1. Select the Red Eye Removal tool from the toolbox.

2. Click in a red part of the eye, or drag a selection rectangle around the red area. (This may be easier if you zoom in.)

3. Wait a few seconds. The red part of the pupil will change to black. In Figure 22.8, I've done one eye and am about to do the second.

4. If the tool doesn't completely remove the red eye, experiment with the Pupil Size and Darken Amount sliders in the Options bar.

That's the official Elements way to remove red eye. It's quick, easy, and mostly effective. Figure 22.8 in the color plate section shows the before and after versions. The only problem with this tool is that it specifically looks for red, and the effect we call red eye can as easily be yellow, green, or even blue eye in some of our animal friends. So it's useless on photos like the one in Figure 22.9.

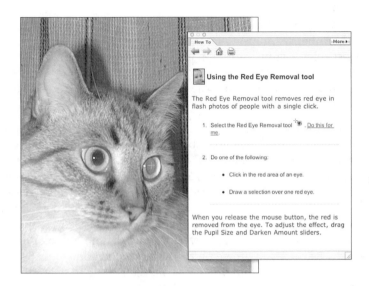

FIGURE 22.8
One click just about
does it.

Fixing Red Eye from Scratch

When the official Elements method doesn't do it, here's another way to remove red eye that's almost as easy, and generally more effective. Just follow these steps:

1. Zoom in to make the eyes as large as possible. (You can work on one eye at a time.) Use the Magic Wand to select the off-color parts of the pupil. Usually, they are the same color or close to it. (Adjust the Tolerance value as needed to select as much as you can.) Leave the small white circles in the middle of the eyes. Those are "catchlights" from the flash. See Figure 22.9.

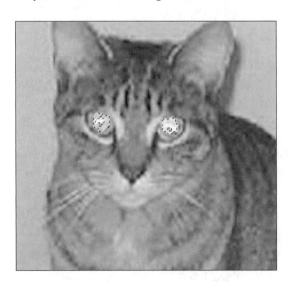

FIGURE 22.9
Select as much of
the red as you can.

2. Press Ctrl+Shift+U (Windows) or Cmd+Shift+U (Mac) (or select Remove Color from the Enhance, Adjust Color menu) to desaturate the selection. Now the incorrect color is gray. Saturation is the intensity of a color. By removing it, you take out the color hue, and reduce the selection to gray tones similar to what you might see in a grayscale image. The lightness and darkness are still there, just not the color.

3. Make sure the foreground color is set to black or very dark gray. Switch to the Brush tool (located in the toolbox), select a large soft brush from the drop-down list in the Options bar, and click the Airbrush icon on the Options bar (it's on the far right). Set the blend Mode to Darken and the Opacity to no higher than 20%. Although we'll cover blend modes in Chapter 31, I can tell you now that the Darken mode will darken only the pixels that are lighter than the foreground color. Pixels darker than that color are not touched. Brush in layers of black, letting the color build up naturally. Because you turned on the Airbrush function, you'll be spraying only bits of color each time you drag over the eye. Continue until it looks right, zooming out to see it in context. If you make a mistake, you can use the Undo History palette as shown in Figure 22.10.

FIGURE 22.10
Use the Undo History palette to step backward if you go too far.

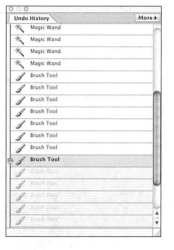

4. Repeat with the other eye. Figure 22.11 and the corresponding color plate show the final result.

FIGURE 22.11
Now she looks quite normal. (Photo by Judy Blair.)

Removing Dust and Scratches

Here's another case where prevention beats cure. Always try to clean your scanner and photos before you start scanning. A soft cloth and some careful work with a paintbrush might have saved a lot of work on the example you are about to see. Even after you clean your scanning equipment, if your scanned photo doesn't come clean, you can clean it with Elements.

Using the Dust & Scratches Filter

The Dust & Scratches filter can be a tremendous time-saver when you're doing basic cleanup on a photo, particularly an old scanned one. If you're not careful, though, it can ruin the picture by overcompensating for the spots and losing detail. The filter works by adding a slight blur, which you can carefully adjust to produce a good compromise between spots and sharpness. To use it, choose Filter, Noise, Dust & Scratches.

Figure 22.12 shows the filter's interface, applied to an old photo. As you can see, there are large chunks of dirt, as well as smaller bits of dust and at least one hair running through the picture. But it's a good, clear scan, and worth the time it will take to clean it.

The filter has two sliders, one for the radius of the area it examines for differences, and one for how much different in color or value the pixels in that area must be in order to be noticed and removed. You want to keep the Radius value fairly low to avoid over-blurring your image. Also, keep in mind that a Threshold range of 0–128 seems to work best for the majority of photos. You can set the Threshold to 100 and select a small Radius, and then lower the Threshold value gradually until you achieve a balance between removal and sharpness.

FIGURE 22.12
This photo would
be a lot nicer with-
out the specks.

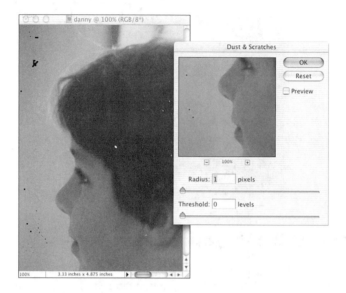

FIGURE 22.12
This photo would be a lot nicer without the specks.

Using this filter to remove the large pieces of dirt in this particular image would require such a degree of blur that you wouldn't be able to see the details of the picture. In Figure 22.13, I've raised the Radius of the particles slightly (increasing the individual areas to be examined for differences) and lowered the Threshold a good deal so that more pixels will qualify for removal, and now, just as we begin to see some differences in the spottiness, the detail is rapidly disappearing. One way to compensate for this is to isolate the area you want to change. Because most of the scratches, dust spots, and so on are in the sky, I could select the entire background and use the filter on just it. Or I could try a completely different method—applying the Despeckle filter.

Using the Despeckle and Unsharp Mask Filters

So, perhaps the Dust & Scratches filter is not the right tool for this job. Unfortunately, most of the time the only way to tell is to try it. Still, the picture certainly needs cleaning up. What other options might we have? Despeckle? It's just above Dust & Scratches on the Filter, Noise submenu. The Despeckle filter looks for areas in the image where sharp color changes occur, such as the areas you might find in our sky dotted with dust. Then it blurs the area, but not its edges. This helps to preserve the sharpness in a photo, while removing dust and dirt. The filter is also helpful in photos that have banding—visible bands of con-trast that often appear in digital captures and scans of magazine photos and

other slightly reflective material. To try the filter, choose Filter, Noise, Despeckle. There are no options, so Elements applies the filter right away. If you don't like the effect, click Undo to remove it. Applied several times to our photo, it had no visible effect, so let's try something else.

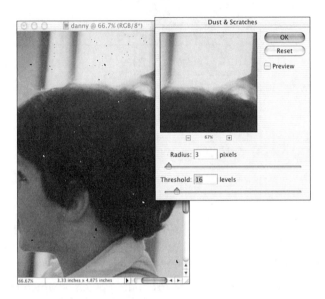

FIGURE 22.13
Compare the large picture with the previous one. Some of the sharpness is lost.

The Unsharp Mask filter (Filter, Sharpen, Unsharp Mask) definitely did some good, as shown in Figure 22.14. Not only did it remove some of the smaller dust spots, it added contrast and sharpness to the photo, making it even more worthwhile to take the time to remove the dirt by hand.

The Unsharp Mask filter is one of the most useful, and most misunderstood, filters in the bunch. Unsharp masking is a traditional technique that has been used in the printing industry for many years. It corrects blurring (sharpens the edges) in an original image or scan, as well as any blurring that occurs during the resampling and printing process. The Unsharp Mask filter works by locating every two adjacent pixels with a difference in brightness values that you have specified and increasing their contrast by an amount that you specify. Because it perceives the dust spots as very slightly darker blurs, you can manipulate the settings so that it removes the smallest spots. At the same time, it does tend to accentuate the larger ones, sometimes even placing a white band around a particularly large black spot. That's actually not a problem, because we'll be using the Clone Stamp tool to cover the big ones—and their "halos."

FIGURE 22.14
Unsharp masking is
going to help a lot.

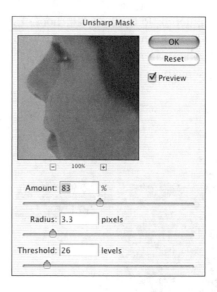

Start by setting the Amount value, which tells Elements how much to increase the contrast of the pixels that qualify. Typically, a number between 150 and 200 is about right (one and a half to two times their original brightness).

The Radius control sets the number of surrounding pixels to which the sharpening effect is applied. I suggest that you keep the Radius fairly low—around 2–3. The Threshold setting controls how different the pixels must be to be sharpened. The lower the setting, the more similar the pixels can be and still be affected by the filter. The higher the setting, the greater Photoshop's tolerance of difference will be. A value less than 20 usually works best. Of course, as always, feel free to go wild and try all the settings. That is the best way to learn. Be sure that you check the Preview box so that you can see the effect of your changes in the original image. When you like it, click OK.

Removing Dust and Scratches with the Clone Stamp

The best way to cover all the spots, tedious though it may be, is to stamp them out. Switch to the Clone Stamp tool; select a large, soft-edged brush; and be sure to press Alt and click as close to the spot as possible, because skin tones can vary quite a lot, and you want to copy a good area (see Figure 22.15). Be sure you have not checked the Aligned option. Although Aligned is helpful when you need to copy something, it's not right for this kind of cover-up job. Figure 22.16 shows

the final photo, looking pretty darn good for something so badly messed up. You can see this photo in the color plate section, too.

FIGURE 22.15
The Clone Stamp tool selecting a color.

FIGURE 22.16
Don't try to catch every little spot. If it's too perfect, it doesn't look authentic.

Summary

This was a short but very important chapter. You learned the steps for basic photo cleanup, something you should do with every image you open, before you get fancy by applying filters, changing colors, or using any of the hundreds of tricks Elements can do. You learned to remove small objects that might distract from the subject of your photo. You learned all about red eye, in both people and critters. We discussed what causes it, how to prevent it, and two different ways to remove it. Then we talked about some ways to remove dust and scratches from

your photos. You learned about the Dust & Scratches and Despeckle filters, and that they don't always work. You also learned about the Unsharp Mask filter, and how it can help with a dusty scan while adding extra sharpness and contrast.

PART VI

Photo Rescue

CHAPTER 23 Using How Tos and Tutorials **447**

CHAPTER 24 Repairing Black-and-White Pictures **459**

CHAPTER 25 Making Color Repairs **479**

CHAPTER 26 Removing and Replacing Objects **495**

CHAPTER 27 Using the Improvement Filters **511**

Using How Tos and Tutorials

What You'll Learn in This Chapter:

▶ Using How Tos
▶ Doing a "To Do"
▶ Following a Tutorial
▶ Going Online for Help and Inspiration

Adobe has made many of the complicated photo rescue and enhancement procedures much easier for you by supplying easy-to-follow "how-to" recipes for them. If you follow a recipe, your results are pretty well guaranteed to be good. What other software would make that promise? For that matter, what cookbook would dare? Possibly the late, great Julia Child's *The Way to Cook*, which really is the best cookbook ever written. But I digress….

If you need more help than a simple recipe provides (or you can't find a recipe to fix the problem), try out one of the online tutorials or get help online from people who have been there and know how to get back. At the end of this chapter, I'll refer you to several excellent sources for online help.

Using How Tos

When you first start Elements, the How To palette presents itself and opens in the work window. If for some reason it doesn't, or if you've already closed it to make room to work, you can open it by selecting How To from the Windows menu, or by clicking its tab in the palette well on the Shortcuts bar, if that's active. (By the way, you can also activate the Shortcuts bar, or shut it off, from the Windows menu.) The How To palette is shown in Figure 23.1.

FIGURE 23.1
You'll find the
recipes in the How
To palette.

After you open the How To palette, use the drop-down menu to locate the kind of recipe you want, and then click on the recipe to open it (see Figure 23.2).

FIGURE 23.2
Click on a topic to
see what's in it.

The arrow icons at the top of the window scroll you back and forth through the steps in a topic. The house icon brings you back "home" to the main topic screen, and the printer icon prints a selected set of instructions, so you can follow it without tying up screen real estate with the How To menu.

There are several different How To categories. Here are the kinds of recipes you'll find:

▶ Adding Special Effects—Learn about giving photos an old-fashioned look, changing colors, restoring a faded photo, eliminating noise from cell phone camera shots, working with the brush tools, and understanding file formats.

▶ Fixing Your Photos—Look here for quick ways to fix problems with color and light in a photo. Learn to master the Spot Healing Brush, the Healing Brush, and the Crop and Selection tools. Sharpening and removing dust and scratches are also covered.

▶ Working with Shapes—Working with custom shapes and adding layer styles to shapes.

▶ Working with Text—How to do neat things to type, such as adding a bevel, filling it with a gradient or image, and adding a shadow.

Once you have opened the recipe that you want, be sure to drag the palette down the screen a little, to keep it visible. Otherwise, it's hard to see the steps if you have several palette windows open.

Read the recipe. Make sure it sounds like it will do what you want. Prepare the image to which you want to apply it or, if it's something that will stand alone, start a new page in Elements.

With some of the steps in a recipe, you may find a Do This for Me link. Clicking here tells Elements to complete the step for you. This is good to use when a step is confusing to you, or if you don't want to spend time clicking through menus.

At the bottom of some recipes, you'll find links to related recipes. Click one if you wish to view that recipe. Go back to the previous recipe and eventually to the category list—the list of recipes for that category—by clicking the left arrow. Go forward to recipes you've viewed in that category by clicking the right arrow. The Home icon takes you back to the category list.

Doing a "To Do"

Just for fun, let's try following a recipe. "Creating an Old Fashioned Photo" sounds interesting. By following the recipe, you'll work with the Remove Color

and Color Variations dialog boxes to take the color away from a picture and tint it sepia. Then, as a final step, you'll add grain to the photo.

First select a picture that you think would look good rendered in a sepia tint. I've chosen the little boy from the previous chapter.

1. To display the recipe, select the Adding Special Effects category, then click on Creating An Old Fashioned Photo. If needed, move the How To palette to an area of the screen where you can read all of its text while you work. Resize the palette as needed.

2. Given that the recipe asks you to start by changing the color mode, it clearly assumes there's already an image or at least a blank page open. (It's always a good idea to read through the recipe before you do anything else, so you can get a sense of the assumptions it makes.) Open any image you want to work on and save it with a new name if you don't want to make permanent changes to it.

3. The first step in the recipe instructs you to select Image, Mode, RGB color. If you are working with a digital or scanned color photo, the chances are good that the image is already in RGB color. If you click the Do This for Me link, Elements checks to see that the image is in the correct mode.

4. The next step removes the color from the image. Even if your photo is black and white to start with, this step will remove any existing color cast it may have picked up.

5. Follow the next step in the recipe by opening the Color Variations dialog box, or clicking Do This for Me, to have Elements open the box for you. Set the box to Midtones and choose Add Red and Decrease Blue, giving you a brown sepia tint. Feel free to move the sliders around until you have a shade of brown that looks right to you.

6. Finally, open the Add Noise filter, or let Elements open it for you. Slide the slider around until the photo looks grainy, as an old picture from the 1900s would. My finished example is shown in Figure 23.3. Be sure to see this in the color plate section.

There are, of course, several ways you could do the same thing on your own. You could change the color mode to grayscale to remove the color from the picture, and then change it back to RGB. You could open the Hue/Saturation dialog box and experiment with the Colorize option. You could open the Enhance menu and select Adjust Color, Remove Color. The choice is up to you. Are you a recipe-follower, or do you like to improvise? If you can't cook without a rack of spices, a handful of fresh herbs, and a cabinet with exotic oils and vinegars, you aren't

going to be satisfied for long with Adobe's recipes. The best solution is to master the tutorials included with Elements and then improvise your own recipes. Unfortunately, you can't save them as To Do's in Elements, but if you decide to upgrade to Photoshop, you'll be able to write and save as many as you want. Photoshop calls them Actions, and you can have one for every step you take in fixing a picture.

FIGURE 23.3
The sepia tint doesn't show in black and white, but you can see the added grain.

There are sure to be more To Do recipes written and posted, if not at the Adobe website, at some of the many sites that cater to Elements users. Check out the list at the end of this chapter.

By the Way

Following a Tutorial

Sometimes you'll need to create an effect for which there's no recipe and no short-cut. The best way to master the techniques that will eventually make you a great photographer or digital graphics artist is to go through the Elements tutorials, which you probably installed along with the program. Assuming you did an Easy Install, they'll be in a folder called Tutorials, inside the main Elements folder. To open a tutorial, go to the Help menu and choose Tutorials, as shown in Figure 23.4. or open them from the Welcome screen when you first open Elements. The Welcome screen is shown in Figure 23.5.

FIGURE 23.4
Tutorials are hidden here...

FIGURE 23.5
...and here.

When you select Tutorials, a help screen window like the one in Figure 23.6 will open with a list of what's available. Choose an interesting topic from the pane on the right, and click to open it.

FIGURE 23.6
These tutorials, and the entire Photoshop Elements help system, run in a window with click-able links, much like a browser window.

Tutorials are longer and more conversationally written than How To recipes, and come with the image files you'll need to follow along. There are no Do It for Me links, so you'll have to read carefully and follow the directions closely. Figure 23.7 shows a typical page from a tutorial. This one, called "Harness the Power of Layers," happens to be all about layers, and if you're having trouble using them, I recommend reading through it.

FIGURE 23.7
Tutorials take you through specific exercises, unlike recipes, which work with your own pictures.

Going Online for Help and Inspiration

There are more tutorials at Adobe Online, along with many other useful things. This is also where you'll go to look for updates, bug fixes, and enhancements to make Elements run better. The quickest way to get there is to select Photoshop Elements Online from the Help menu. You can also just open your browser to www.adobe.com and navigate from there to the Photoshop Elements pages. Once there, you can find all kinds of interesting stuff including more downloads, a user forum, the latest news from Adobe, tryouts of other Adobe products, and more. The user forum is a good place to get questions answered. The people who actually write these programs read and respond to comments there frequently, and the help you get from them is reliable and actually helpful.

If you choose Support from the Help menu, you'll go directly to Adobe's Online Support pages. Choose Photoshop Elements from the pop-up menu for Desktop

Products. You'll find all sorts of good things including more tutorials, answers to installation questions, even a place where you can volunteer to be a "usability tester" for Adobe products.

The Support page, shown in Figure 23.8, also has a Support pull-down menu that takes you to Downloads and other useful places. When Adobe releases an update to any of its software products, you can find it here. Instructions are provided for downloading and installing the updates.

FIGURE 23.8
Like every good website, Adobe changes their pages frequently. By the time you see this, it will probably look different, but the information will still be there.

Websites for Ideas and Help

Naturally, you'll start at Adobe for help with Adobe products, but that doesn't mean you should stop there. If you do a web search for Photoshop Elements tutorials, you'll find literally hundreds, perhaps thousands (I didn't stop to count) of references. Even weeding out the ones in Japanese, Italian, and other languages I don't speak, there were far too many to chase down. But I did find some good ones, and even some that were specifically dedicated to Elements, rather than Photoshop. However, you shouldn't ignore the Photoshop sites, especially the ones that offer downloadable free filters and plug-ins. Any plug-in that works with Photoshop also works with Elements.

Check out some of these websites for more help and ideas:

▶ Jay Arraich's Photoshop Elements Tips—Jay's a longtime photographer and Photoshop user, and was one of the beta testers for Elements 3. His tutorials are excellent; they're easy to follow and interesting.

http://www.arraich.com/elements/psE_intro.htm

▶ myJanee.com Graphic Creations and Photoshop Resources—Excellent Photoshop tutorials in a well laid-out, accessible website. Most of Janee's tutorials apply to Elements as well as to Photoshop. This site also has a very good question and answer section.

http://www.myjanee.com/

▶ Phong.com—Phong's tutorials are a little more complex, and a little more off-the-wall than most, but they are fun to read and will definitely give you ideas about what to try in Elements.

http://www.phong.com/tutorials

▶ Photoshop Café—Another very good site aimed more toward Photoshop than Elements, but with some good ideas that you can use or adapt.

http://www.photoshopcafe.com/

▶ Photoshop Wire—More good tutorials and some shareware/freeware downloadable plug-ins.

http://photoshopwire.tripod.com/tutorial/photoshop_elements.htm

▶ The Photoshop Guru's Handbook—The guru is pretty good. His tutorials are divided into three levels, for beginning, intermediate, and experienced users.

http://photoshopgurus.info/

▶ Planet Photoshop—Last, but far from least, is this excellent site for all things Photoshop. In addition to a daily tutorial—which actually changes several times a week, if not daily—there's a news section to keep you up to date with the latest in tools, industry gossip, and more. There are downloads, user forums, a resources list with loads of great sources for filters and plug-ins, and so much else that I'm sure I haven't discovered it all yet. It's a commercially run site, so there are ads, but even those are all related to graphics and digital photography.

http://www.planetphotoshop.com/

Photoshop Elements User Newsletter

Finally, there's a newsletter just for Elements users. Learn step by step how to do everything from color correcting and sharpening your photos, to creating the

most requested photographic special effects and presentations. Each issue is packed with tips and tricks from some of the best-known Photoshop gurus, but all aimed directly at Elements users. A one-year subscription (8 issues) is only $49 (U.S. only). To subscribe, call **800-201-7323** or visit www.photoshopelementsuser. com. If you check out the website, you can even get a sample copy of the newsletter for free.

The National Association of Photoshop Professionals

Don't be put off by the name. This group welcomes beginners, too, and has a lot to offer. Your dues ($99 U.S.) bring you access to the association's members-only website (www.photoshopuser.com), with job listings, discussion groups, weekly live chat, discounted training videos and seminars, and a member gallery where you can post your own work and see what others are doing. You get 8 issues of *Photoshop User Magazine* (not available by subscription otherwise), discounts on all kinds of hardware and software, and access to the Help Desk, a confidential Q & A service run by my good friend Pete Bauer. And you get a discount on tickets to the PhotoshopWorld Expo, plus an invitation to the members-only Saturday night party. You can also find discounts on car rentals, travel and hotels, and access to Smart HR, a one-source solution for human resource issues (health insurance, 401(k) and Section 125 plans, payroll and payroll taxes, employee manuals, and unemployment paperwork to name a few). Whew! I'm sure there's even more that I haven't even mentioned.

It's worth joining just for the magazine. Look for the Beginners' How To column in each issue, demystifying some aspect of Photoshop, and a column of easy tips for faster, more creative work. Check the magazine out at www.photoshopuser.com, and sign up for a free sample issue. Even though the magazine is aimed at Photoshop users, most of it translates directly into Elements.

Summary

The theme of this chapter has been "learning how and where to learn." First, we looked at resources inside Elements. You learned how to find and follow a recipe. Then you learned about tutorials, which are more detailed and less automated than recipes. The purpose of a tutorial is to teach you to use the tools yourself instead of clicking a Do It for Me link. First you learned about Adobe's tutorials

that come with the program. Then you learned how to go directly to the Adobe website to see more. Then we looked beyond Adobe to see what else is on the Web. You learned about some excellent web pages dedicated to Photoshop and Elements, and about the National Association of Photoshop Professionals.

Repairing Black-and-White Pictures

What You'll Learn in This Chapter:

- ▶ Easy Fixes
- ▶ Preparing an Old Photo for Repair by Removing Sepia
- ▶ Repairing Serious Damage
- ▶ Applying Vignetting
- ▶ Cleaning Up a Picture, Step by Step
- ▶ Applying Tints

Why is it that the pictures you care about most are the ones that inevitably fade, get wrinkled, get chewed up by the dog, or fall prey to so many other disasters? It probably has some relation to Murphy's Law—if something can go wrong, it will.

The good news, though, is that you're not totally stuck when your kid smears peanut butter on the only decent picture of great-grandma, or the cat thinks your parents' wedding photo is a new cat toy. First, as soon as you discover the damage, wipe off any residual cat slobber or other foreign substances, if you can do it without damaging the photo any more. The second thing is to scan it into your computer.

Of course, you should have already done that with all the most important family photos and documents, making two CD-ROM copies, and giving one to a friend or distant family member for safekeeping. Floods, fires, and peanut butter happen. If you've protected your most precious memories, you can always make new prints.

Depending on the size of the photo, scan it at the same size. If it's a tiny snapshot, size it larger—you might as well be able to see what you're doing. 300dpi is plenty for most uses, especially if it's an old photo. The film grain will be about that size, too.

Easy Fixes

Some pictures need a little help; others need a lot. Let's start with things that can be easily fixed. Figure 24.1 is a Polaroid photo from some time in the 1950s, back in the days when the photos had to be coated with goop from an applicator to preserve the image. Whoever did the coating on this one either missed a spot or overdid it. There's a light streak through the man's face and hair. There's also a general lack of contrast and some spots that could be removed. But it's worth saving.

FIGURE 24.1
Great expression, and not too much wrong. We can save this one.

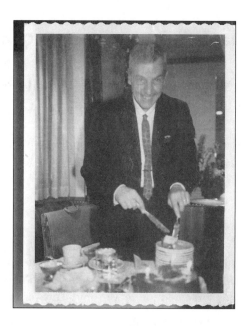

The first step, as always, is to straighten and crop. This one is pretty straight and well composed, but we don't need the white edges. Cropping can often take away some of the stuff we'd otherwise have to retouch, saving us some time and effort. Look for tips on how to crop and straighten your old photos or scans in Chapter 20, "Cropping and Resizing a Photo."

Now that those edges are gone, let's examine another obvious problem—lack of brightness and contrast. To do this, choose Window, Histogram. Looking at the histogram (see Figure 24.2) tells us that there's plenty of detail (lots of pixels) in the middle darks, and that's what we need to work on, so we're good to go. I'll use Levels (Enhance, Adjust Lighting, Levels) to remap the grayscale. As you can see in Figure 24.3, I've moved the black and white points (the triangles at either end,

just below the histogram) in toward the center of the scale, to the points at which the graph indicates more activity. Then I moved the middle gray point to the place where there's the steep rise in darks. This spreads the lighter grays over a greater area of the graph and compresses the darks, giving the photo more light grays and increased contrast. For help in making this type of adjustment, see Chapter 22, "Too Light/Too Dark: Adjusting Brightness, Contrast, and Color."

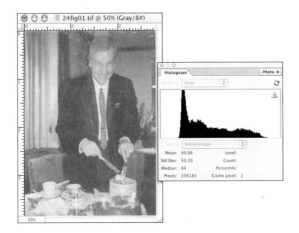

FIGURE 24.2
The histogram shows good detail in the darks.

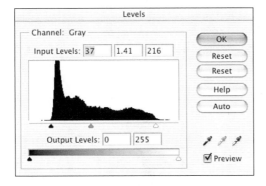

FIGURE 24.3
Use Levels to improve the contrast.

As a last step, I'll get rid of the dust with the Clone Stamp tool, choosing a brush just big enough to cover the spots, and setting the Blend mode to Darken for the light spots and to Lighten for the dark ones. That way, the surrounding areas aren't changed. And I'll touch up the smudge on his hair. And there he is, in Figure 24.4, nearly as good as new. If you need help using the Clone Stamp, see Chapter 22, "Removing Red Eye, Dust, and Scratches."

FIGURE 24.4
The birthday boy,
looking much
better.

Correcting Lack of Contrast

As you saw in the picture of the gentleman cutting the cake, lack of contrast is one of the most common problems with older photos. They fade over time, of course, but many didn't have much contrast to start with. That's obviously the case with Figure 24.5, shot in bright sun and looking very washed out. Notice the black streaks down the middle, probably caused by light leaking into the camera. We'll have to try to lighten them or hide them, too.

FIGURE 24.5
This photo is too
light to see details.

As before, first we'll crop, and then look at the histogram to see what we've got to work with. This histogram, shown in Figure 24.6, is unusual in that it's shifted so far toward the light shades. There are very few darks, but there seems to be plenty of detail in what's there, so we should be able to improve this photo.

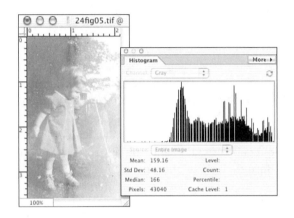

FIGURE 24.6
This histogram shows that we still have something to work with.

We'll start with Levels (Enhance, Brightness/Contrast, Levels) again, and shift the black-and-white points to where the action begins on the histogram. This time, though, I'll use the eyedroppers to set the black and white points. First, I click the white eyedropper up in the sky (a part of our photo that should be white) to set the white point. I chose the upper-right corner of the picture for this because it seems to be the lightest area. Then I click the black eyedropper on the darkest spot, which is behind the child, in her shadow. That sets the dark point. Now I can slide the midpoint back and forth until I find a middle gray point that looks right to me, and reveals as much detail on the child's face as possible. After all, she's the subject, and although it's nice to have detail everywhere, it's most important there. Figure 24.7 shows my settings, and the result.

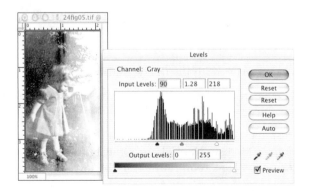

FIGURE 24.7
Better, but not there yet....

Dodging and Burning

There are still a few more tricks we can use on the photo of the little girl. The Dodge and Burn tools are based on darkroom photography techniques that have been used for 100 years or more. Dodging means putting your hand, or some sort of dodging tool, in between the enlarger light and the printing paper while you're making the exposure. This blocks the light from hitting the paper and leaves that area of the print less exposed, and therefore lighter. You have to keep the dodging tool in motion, so you only block some of the light and not all of it. Otherwise, you'd simply have a white spot. The usual dodging tool is a cardboard circle on a flexible wire handle, which looks like a lollipop. Not surprisingly, it's also the Elements icon for the tool. The burning tool has the opposite effect. You can use a sheet of cardboard with a small hole in the middle, or simply hold your hand so a small beam of light gets through, while the rest is blocked—again, this is just like the Tool icon. Burning is done after the initial exposure of the paper, and means turning the enlarger lamp back on and giving additional light to a part of the picture, darkening the area you re-exposed.

To use the Dodge tool to lighten or the Burn tool to darken, select the one you want to use from the toolbox. Both tools have the same options. Select a brush size that's appropriate for the area you want to affect—you can change the brush style too, but I find that the soft round brush, which is the default, typically works well. Next, select the tonal Range you want to affect: highlights, midtones, or shadows. Then select the amount of exposure you want. For the most subtle changes, I typically use a large soft brush that I can sweep through my photo in a quick motion. I also set the exposure to a low level, and select a tonal range opposite of what I'm trying to add. For example, if I want to darken an area, I choose the Burn tool and select the highlight or midtone range. I choose the shadow range to have the quickest effect. When using the Dodge tool, I choose the shadow range for the most subtle changes.

I can use the Dodge and Burn tools to even out the exposure on this photo. I'll dodge behind her to lighten the trees, and burn around her face to darken that area and increase the detail. Figure 24.8 shows the final version of the photo.

Before we go on, let's practice with the Dodge and Burn tools.

1. Open a new page in Elements. Make sure it has a white background. The default size is fine.

2. Click the Brush tool. Choose a medium large paintbrush from the drop-down list, and set Mode to Normal and Opacity to 100%. Select a paint color by clicking the Foreground swatch in the toolbox. Use middle gray or a

medium value of any color you want. Click on the image and drag to make a squiggle of paint across the page, as in Figure 24.9.

FIGURE 24.8
Still not perfect, but much better. Compare it to the original.

FIGURE 24.9
You can use a blank image for practice.

3. Select the Dodge tool. Because it uses brush shapes, choose a large soft brush and set the Range to Midtones and the Exposure to 50%, as shown in Figure 24.10.

FIGURE 24.10
Setting the Dodge tool options.

4. Hold down the mouse button as you move the tool a few times up and down across the line. Each time you go over an area it lightens more. In Figure 24.11, I've nearly erased a piece of the line.

FIGURE 24.11
The tool only works when it's moving.

5. Now switch to the Burn tool, keeping the same options. Drag it over a different piece of the line. See how each pass darkens the line. (It's actually increasing the saturation of color, which has the effect of making the line look darker.) Figure 24.12 shows what this looks like.

FIGURE 24.12
The rule to remember: Burning darkens; dodging lightens.

6. Practice with both the Dodge and Burn tools. See if you can put back the area you dodged out, and lighten the burned area to match the rest.

Painting Over Small Blotches

Some pictures need touching up with a brush. Dust spots and cracks are almost inevitable in old photos. There are several ways to fix such problems—you can use the Clone Stamp to paint nearby colors over a rip or a large splotch, as we will on a badly damaged photograph later in this chapter, but you can simply paint over small dots or blemishes.

Using the Brush tool, which you'll learn more about in Chapter 29, "Creating Art from Scratch," is not terribly difficult. Select a brush style, size, and color, then drag over the area you want to paint. When trying to brush color onto a photo to cover a small blotch, the hard part is picking a color that matches the one that is missing. Do you know how to select the right color to do the touch-up? You probably can't do it from the Color Picker. Perhaps one person in a hundred thousand is good enough at color recognition to select a perfect match for a given color. And even then, it would be as much luck as knowledge, because every pixel on the Color Picker is slightly different from its closest neighbors. Instead, select an exact match from the photo itself with the Eyedropper. Look at the picture and find an area with the exact shade you need. (Usually, it will be immediately adjacent to the damage you're going to repair.) Figure 24.13 shows this step. Then, just click it with the Eyedropper to make it the foreground (active) color. If you press Option/Alt as you click, the color will instead become the new background color. You can then use the brush to touch up spots of uneven or missing color.

FIGURE 24.13
Choosing a foreground color.

Preparing an Old Photo for Repair by Removing Sepia

One of the characteristics that really distinguish old photos is the brownish tone they have. It's called sepia, and it comes from dipping the finished print in a bath of squid ink and water. Sepia toning was done to give the print a rich, warm quality rather than the original drab gray. This process also had the effect of stabilizing the print, making it last longer.

I find it harder to work on sepia-colored pictures, so I always remove the color before I start editing them. It's easy to replace it afterward. You'll learn how later in this chapter, when we talk about duotones.

There are several ways to remove color. Probably the easiest is to use the Remove Color command that we discussed in Chapter 22: choose Enhance, Adjust Color, Remove Color, or press Cmd/Ctrl+Shift+U. You could also convert the picture to grayscale, which would have the same effect, but doing so would require you to convert back to RGB mode if you wanted to add back the sepia when you finished. Another option is to open the Hue/Saturation dialog box and move the saturation slider all the way to the left to completely desaturate the picture, again removing all color. All three methods produce the same results; I typically use the Remove Color command if I plan to restore the sepia later, change to grayscale if I don't intend to use the sepia again, and use the Hue/Saturation command to put the sepia back (although you can use this command to remove the sepia as well).

Removing color also can get rid of coffee and tea stains, colored ink smudges, and many of the other things that get spilled on a photo. Even if removing the stain color leaves a gray blob; that will be easier to cover than the stain itself.

Repairing Serious Damage

So far, all the pictures we've looked at have been easy to fix. Let's try one that is more difficult. Take a critical look at Figure 24.14. This one's much too dark, and the sepia is turning sort of greenish. It's also scratched and torn, and needs some spotting. You can see these problems more clearly if you look at the photo in the color plate section.

FIGURE 24.14
This one's been seriously beaten up and damaged. (Photo courtesy of Judy Blair.)

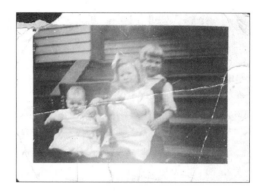

FIGURE 24.14
This one's been seriously beaten up and damaged. (Photo courtesy of Judy Blair.)

First Steps

This will actually be easier than it looks. First, I'll remove the color by choosing Enhance, Adjust Color, Remove Color. Then I'll crop away as much of the damage as I can. Then I'll reset the levels using the Enhance, Adjust Lighting, Levels command. Just these small adjustments improve it a lot, as you can see in Figure 24.15, but we still have cracks and scratches to cover. The perfect tool for this job is the Clone Stamp tool.

FIGURE 24.15
We're already at least half done.

Repairing Tears

You learned how to use the Clone Stamp tool in Chapter 22, but let me remind you of a couple of things. First of all, make sure you are using the right size brush. One that's too big will cover too much of an area, possibly leaving a

smooth spot or color that doesn't quite match. Using one that's too small will make you go over and over the same spot, building up dark bits wherever the stamps overlap. When repairing a small tear, set the brush size to just cover it. With larger tears, you'll want to go more slowly, with a smaller brush. Also, make sure that it's a soft-edged brush for most general purposes.

For this repair, do not check the Aligned option in the tool's Options bar. If you use that option here, you might accidentally copy the folds of a dress or the edge of a sleeve to someplace where they don't belong. Better to copy the colors you want, and put them into the places where they belong.

> When you're using any of the brush-related tools, go to Preferences, Display & Cursors and make sure that the Painting cursor is set to show brush size. It will help a lot in placing the stamp if you can see where its edges are.

Did you know?

Remember that you can zoom in on small areas to make them easier to see. In Figure 24.16, I have come in close on the girl's sleeve to show you a trick. Here, there's a crack running through the sleeve. I can go above it, to where there's an untouched piece of sleeve, and copy it as a source. Then, when I move the stamp tool down over the damage, I'm replacing it with a good piece of the same sleeve. As long as I am careful to stay centered on the seam as I move the stamp, the original and the repair will stay aligned and the sleeve will look right, as it does in the After view.

FIGURE 24.16
Before and after stamping.

After cleaning the picture up with the Clone Stamp tool, we can use the Dodge tool with a very light pressure to lighten the girls' faces. I've also applied the Despeckle filter (Filter, Noise, Despeckle) at its lowest settings to suppress some of the dust. A filter, you may recall, applies a series of changes in a single step—for instance, the Unmask filter sharpens all the edges. As you learned in Chapter 22, the Despeckle filter (Filter, Noise, Despeckle) is a handy tool for removing dust

and dirt from an image. It works by looking for areas of sharp contrast (such as dark spots on a light background), and then blurring such areas into their surroundings, without blurring edges.

Figure 24.17 shows the final, much-improved version. But I might not stop there; I might use the Burn tool to darken the scooter the girls are sitting on, but I don't want to do too much, or I'll remove the charm of this old photograph.

FIGURE 24.17
This version looks much better.

Applying Vignetting

Vignetting was a technique frequently used in the early days of photography to make up for deficiencies in both the camera lens and the glass plates used for negatives. Not much was understood about the art and science of lens grinding, except that the lens tended to be sharpest in the middle and the focus would fall off rapidly as you moved from the center to the edges of the resulting photo. Photo plates were prepared by brushing plain glass with a solution of gum arabic or some other colloidal (sticky stuff) and silver nitrate. (Chemists, don't come after me. I'm sure there was more in the mix, but those were the important elements.) The gunk seldom went on evenly, especially near the edges of the plate, so the edges of the photo would be correspondingly messy. Today, that messy-edge look is considered a special effect, and is frequently seen in black-and-white digital photography.

Anyway, both of these factors resulted in pictures that were okay in the middle and both fuzzy and messy at the edges. Soon, the better photographers figured out a way to disguise the bad parts, while making it look like an extra fancy

effect. They invented the vignette. It's simply a mask that fades from the edges of the picture toward the middle, so that the photo appears to be fading out at the edges.

I have an old photo of a friend's grandmother that's a perfect candidate for a vignette. Grandma Thomas appears in Figure 24.18.

FIGURE 24.18
This picture needs some help. (Photo courtesy of Don Maynard.)

Old vignettes were typically oval, so that's what we'll apply here. But with Elements, you can use this technique with any shape.

Ordinarily, we'd start by cropping, but we'll be vignetting this one, and we'll want the extra space for the vignette mask. Thus, we'll ignore that step, and just remove the yellow color (with the Remove Color command) and the dust and spots (with the Clone Stamp). Correcting the levels and adding some contrast (Enhance, Adjust Lighting, Levels) helps, too. In Figure 24.19, I've started the vignette process by placing an oval marquee where I want the frame to start. To make marquee placement easier, click the Elliptical Marquee tool, select Fixed Aspect Ratio in the Style pop-up menu on the tool Options bar, and designate a ratio. I prefer W = 2, H = 3 for a tall oval frame. To make a vignette marquee, I find that it's often easier to drag outward from the middle, rather than from the edges in. So, press Cmd/Ctrl and click on the center of her face (the location of the cross in Figure 24.19) and drag the oval outwards until you've selected the

area you wish to feature with the vignette. Then invert the selection (Select, Inverse, or Cmd/Ctrl+Shift+I). That means that the edges are selected instead of the area in the middle.

FIGURE 24.19
It's easier to drag
the marquee from
the center outward.

We also need to feather the selection by about 25 pixels. (I could have done this when I dragged the marquee, but I wasn't sure at the time how much edge I would need.) We want a soft edge on the vignette, but not too soft. To create such an edge, choose Select, Feather, type 25 as the amount, and click OK. Next simply double-check to make sure that the background color is set to white, then press the Delete key and the background disappears. Figure 24.20 shows the finished portrait. Now all we need is a nice semi-gloss print and an oval silver frame.

FIGURE 24.20
Here it is, a less
cluttered, more
interesting portrait.

Cleaning Up a Picture, Step by Step

This task is going to require that we use just about everything you've learned about working with Elements. The photo in Figure 24.21 dates back to about 1906, and it's had a hard life. There are a couple of stains, and someone or something chewed on an edge, leaving holes. It has dust. It's faded and needs more contrast. It's crooked, too, or else the porch was. And the sepia toning has taken on a greenish cast. Download the picture called "Grandma 1906" from this book's page on the Sams Publishing website and follow along.

FIGURE 24.21
The original Grandmas photo, circa 1906.

1. As usual, we'll start by cropping and straightening. As we did in Chapter 20, we'll straighten first, then crop. Use the Image, Rotate, Free Rotate command to rotate the picture until the porch is horizontal and its posts are vertical. Remember that you can draw guidelines on a disposable layer to help you level the image.

2. Once that's done, use the Crop tool to select the area to keep, removing the chewed up edges, but keeping as much usable area as possible. Jump back to Chapter 20 if you need a refresher course on straightening or cropping.

3. Next, use the Enhance, Adjust Color, Remove Color command to get rid of the faded sepia and the pink stain. Figure 24.22 shows the result of these steps.

4. Next, open the Levels dialog box (Enhance, Lighting, Levels) and work on the contrast. As you can see in the histogram in Figure 24.23, all the grays were bunched in the middle of the range. Resetting the black-and-white points enables us to spread them out more, while making black really black and white actually white, resulting in much better contrast throughout.

FIGURE 24.22
It's too bad we can't crop out the holes.

FIGURE 24.23
It's looking better already.

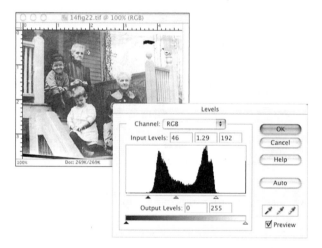

5. Now we need to do some Clone Stamping. We can add back the edges we lost when we straightened the picture (look at the top right and bottom left), and get rid of those holes. The dust can go, too. Don't forget to zoom in when you need a closer look at what you're working on.

6. As almost the final step, use the Dodge tool on all three of the boys' faces. I tried the Despeckle filter (Filter, Noise, Despeckle) on the photo, but it added an unacceptable amount of blur, so I canceled it. Give the brightness and contrast a final tweak in the Brightness/Contrast dialog box we discussed in Chapter 21 (Enhance, Adjust Lighting, Brightness/Contrast), and then we're finished. Figure 24.24 shows the final image—a major improvement over the original.

FIGURE 24.24
I like the picture better without the sepia, but you can add it back, if you want.

Use these same techniques to restore your old photos. They might work on other photos too, even ones that are not so old! Just remember that you can always undo changes that you make using the Undo button. To undo a series of changes that simply didn't work out, use the Undo History palette. As a safeguard, I always back up my originals to CD, so that any changes I make will never be irreversible no matter what I do. Of course, if you like the result of your changes, back up the updated file as well.

Another technique we haven't talked much about yet is adjustment layers, which let you make specified adjustments to parts (or all) of an image. If you don't like the changes, you can always delete the adjustment layer. You'll learn more about adjustment layers in Chapter 31, "Making Composite Images."

Did you Know?

Applying Tints

Working with strictly black-and-white images can get boring. Sometimes it's fun to turn the black into a different color, especially if the image is a drawing, map, or other line art. Here's a quick trick I often use on grayscale images, using the Color Variations dialog box we discussed in Chapter 21. First, change the color mode from grayscale to RGB (Image, Mode, RGB). Then choose Enhance, Adjust Color, Color Variations, as I have in Figure 24.25. (Be sure you look at this in the color plate section.)

With the Midtones option selected, choose any one of the thumbnails that you like. I chose Decrease Green, which gave me a sort of purple-toned image. You can also lighten or darken the picture if necessary. Click OK to save the change. The result is a line drawing with a "color look."

The capability to create duotones isn't included in Elements, although it is in Photoshop. A duotone adds a color to black, or combines any two colors, giving

you a much richer-looking image. It's commonly used to replace sepia in a corrected black-and-white photo. In Chapter 21, I showed you one way to re-create that sepia look using the Colorize option in the Hue/Saturation dialog box. Here's a way to get a duotone effect in Elements:

FIGURE 24.25
Even though there's no color in the picture, Color Variations tries to add some.

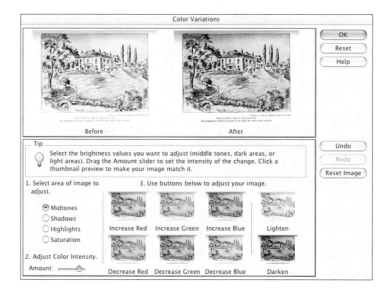

1. Open the black-and-white photo and convert it from Grayscale mode to RGB Color mode. Select the entire image (Select, All or Cmd/Ctrl+A). Then use Edit, Copy or Cmd/Ctrl+C to copy it, and immediately choose Edit, Paste or Cmd/Ctrl+V to paste. The copy of the image will appear on a new layer. Rename this "color layer" by double-clicking its name in the Layers palette and typing a new name, if you think you'll forget which is which.

2. With the color layer active, go to the Layer menu and choose New Adjustment Layer, Hue/Saturation. Be sure to check the Group with Previous Layer option. Click OK to open the Hue/Saturation dialog box. This step adds a new layer for adjusting the hue and saturation levels of the grouped layer, which in this case is the "color layer" we added. Our adjustments will not affect the original layer.

3. Use the Hue/Saturation dialog box to add color to the image. Check both the Colorize and Preview options so you can see what you're doing (see Figure 24.26). The Hue slider will change the basic color, and the Saturation slider will make it more or less intense. Be careful about using the Lightness slider because decreasing lightness will turn the background "paper" dark,

along with the image. A small increase (less than 6) in lightness, however, will make your "paper" look whiter without substantially affecting the image. When you like what you see, click OK.

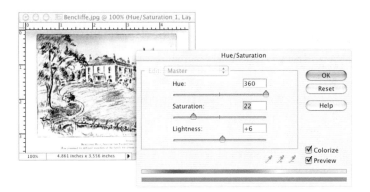

FIGURE 24.26
When you check Colorize, Elements automatically adjusts the saturation to 25%.

4. Go back to the color layer and adjust the opacity of the layer using the slider at the top of the Layers dialog box to somewhere between 50% and 75%. This allows the black to show through and combine visually with the color to give the effect of the duotone. Be sure to see the final image in the color plate section.

Summary

This has certainly been a busy chapter. You learned about black-and-white retouching. First, you learned to make simple fixes. You learned how to read a histogram, and how to set levels on a black-and-white photo. You learned about dodging and burning and how to use these effects. Then we looked at more complicated damage. You learned to use the Clone Stamp tool to replace dust, scratches, and other damage with a good piece of the picture. You learned about removing color to get rid of sepia toning and spilled coffee. You learned to use the Eyedropper tool, and how to make a vignette. Finally, you learned a couple of ways to put back color. You learned how to imitate a duotone, and how to colorize a drawing. That's a lot for one chapter, so be sure to practice your new skills before you move on.

CHAPTER 25

Making Color Repairs

What You'll Learn in This Chapter:

▶ Correcting Color Cast
▶ Lightening Shadows and Improving Contrast
▶ Making Selective Color Adjustments
▶ Image Correction Tools
▶ Adjusting Saturation
▶ Making Repairs When Nothing's Really Wrong
▶ Hand Coloring a Black-and-White Photo

Color repairs are apt to be easier than black-and-white repairs, for several reasons. First, the pictures aren't as old, so they are somewhat less likely to be physically damaged. The paper tends to be heavier, and with its glossy coating is sturdier and less prone to tearing. Very old sepia-tinted photos get brittle with age in a way that pictures printed after about 1950 almost never do.

The single biggest problem I've seen with color photos from the late 40s and 50s is color cast, or in its more severe form, color shift. When this happens, the entire photo can take on what looks like an overdose of a single color (often pink or purple, but any color can be affected). It's generally blamed on heat or exposure to sunlight, but having seen it happen to pictures that were tucked away in an album or used as a bookmark, I don't think that's necessarily the case. The dyes used back then just weren't stable. Bad processing or letting the film sit in the camera outdoors on a warm day were enough to throw off the color, perhaps not immediately, but as the photos aged.

Of course, bad things can happen to recent pictures, too. The sun ducks behind a cloud just as you shoot, and the colors look washed out. The flash doesn't go off as

expected. Nothing is immune to spilled drinks, dog/cat/kid damage, and all the other perils of daily life.

You can't save them all. Some photos are just too far gone, or the data (color, detail) was never there in the first place. But with Elements, you can pull off some pretty amazing rescues.

Correcting Color Cast

Elements makes color cast correction nearly automatic. Figure 25.1 shows an old photo that's so badly yellowed, it's almost brown. Be sure to look at this example in the color plate section.

FIGURE 25.1
Can this one be saved? (Photo by Carole Harrison.)

I typically start by straightening and cropping an image. This one doesn't really need much. I think it might be a more interesting photo if I trimmed off a bit of the sides, making it more of a square. It's already straight, so I can use the Crop tool to crop the image down a bit, and I'm ready to begin color correcting.

To correct this kind of color cast, choose Enhance, Adjust Color, Color Cast. You probably remember this command from our discussion in Chapter 21, "Too Light/Too Dark: Adjusting Brightness, Contrast, and Color." Figure 25.2 shows the very simple Remove Color Cast dialog box. This tool evaluates the amount of

color in what ought to be a black or white pixel. It then applies the same amount of the opposite color on the color wheel to cancel out the overdone one. In this case, the color cast is yellow, so Elements adds an equal amount of blue. If the color cast turned the picture red, it would add cyan. If the cast were green, it would add magenta, and so on. Knowing this, you will probably realize that it's quite possible for Elements to guess wrong. Be prepared to undo and try again in a different spot, or try to find a black pixel if the white ones aren't getting you the correction you need. In this case, it took several tries to find a spot that didn't turn the picture green.

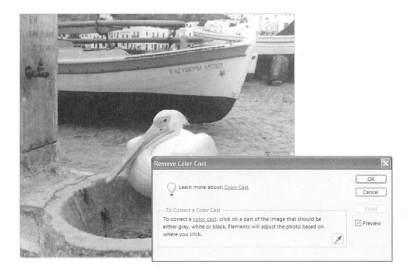

FIGURE 25.2
Try to find the darkest black or the whitest white.

To judge whether the correction has worked or not, find part of the picture that's critical, color-wise, or that you have a pretty good idea as to what color it ought to be. Of course, if nothing works, click Cancel to undo its attempts to remove the color cast. In Chapter 21, you learned about alternatives you can use to remove the color cast manually. For this particular photo, the best correction I found was the easiest—Auto Color Correction.

Lightening Shadows and Improving Contrast

This photo was shot on a bright overcast day. You can tell because the shadows are very faint. A little more contrast between the shadows and the midtones would help a lot. To open the dialog box shown in Figure 25.3, select Enhance,

Adjust Lighting, Shadows/Highlights. As you can see, I have just moved the sliders up a little, to lighten the picture and increase the overall color saturation a small amount.

FIGURE 25.3
If the photographer had used a fill flash, we wouldn't need this step.

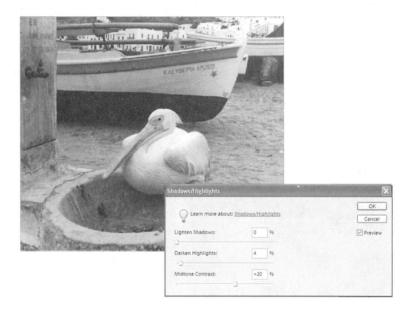

And that's really all this photo needs. Be sure and see the improved version in the color plate section.

Making Selective Color Adjustments

Now let's take a look at a different kind of problem in Figure 25.4. The colors in the original photo aren't bad, except for the very dreary sky. (Yes, the ship really did have green sails!)

The only way we are going to turn the sky blue is to select it and force the change. So that's what we'll do. We can select the sky with either the Magic Wand or the Lasso tool, or a combination of both. Because the sky is mostly one color, the Magic Wand is the best tool for selecting it. Using the Lasso tool might prove more difficult because of the irregular edges of the sky area. So I clicked with the Magic Wand tool on a representative part of the sky. Just adjust the Tolerance value so that when you click, most of the sky is selected. Then hold the Shift key down or select the Add to Selection button and continue to click on unselected spots to keep on adding to your selection. If you select a piece that you don't

want, immediately undo (just once) and the rest of the selection will remain selected. You can also click the Subtract from Selection button and click the area you don't want. With the entire sky selected, I can open the Hue/Saturation dialog box (see Figure 25.5) by choosing Enhance, Adjust Color, Hue/Saturation, and make the sky as blue as I want it. In this case, because the rest of the colors are quite subtle, I'll resist the urge to improve the weather and go with a pale blue.

FIGURE 25.4
I shot this during a Tall Ships regatta in Boston Harbor.

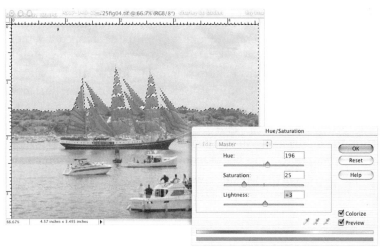

FIGURE 25.5
"Blue skies, smilin' at me...."

That worked so well, and looks so good, I'll do the same thing with the rest of the picture, inverting the selection so everything but the sky is selected and then simply using Smart Fix to beef up the colors and contrast. Figure 25.6 shows the final image, but you really need to go to the color plate section and compare it to what we started with.

FIGURE 25.6
Our much-improved color photo.

Image Correction Tools

The Elements toolbox has several image correction tools, grouped together. Only one is visible at a time unless you click the mouse button to expand that section of the toolbox. If you look at the bottom section of the toolbox, just above the color swatches, you'll see a pair of focus tools: Blur and Sharpen. Blur looks like a drop of water. Sharpen looks like the tip of a pencil or some other sharp instrument. With them is the Smudge tool, a hand with an extended index finger. (Considering the millions of smudged fingerprints I've wiped up over the years, this is a very appropriate icon.) Below them are the Sponge tool, which looks like a natural sponge, and the Dodge and Burn tools, which were discussed in detail last chapter.

Blur and Sharpen

If you spill a drop of water on a watercolor painting or an inkjet print, the colors will run together and blur. That's what the Blur tool does. (Well, more or less. It actually blurs individual pixels by lowering the contrast between them and their adjacent neighbors.) Using brush shapes, sizes, and blend modes, you can design a blur to hide a background, to remove graffiti from a fence, or to make faces in a crowd less obvious. When you're trying to pretend your subject is out in the forest, you can blur the cell phone tower and power lines showing though the trees. You can blur the gum wrappers and soda cans in an otherwise pristine landscape.

To use the Blur tool, select it in the toolbox or click and hold down the Sharpen or Smudge icon and choose Blur from the menu that appears. Choose your brush tip from the drop-down list in the Options bar, and set the brush size. Choose an Effect mode (essentially the Blend mode—the various types are described in Chapter 31, "Making Composite Images"), and then set the strength of the blur. You can drag the Blur tool over a hard edge to soften it or over an image area to eliminate detail.

In the photo of the carriage horse in New York's Central Park, (see Figure 25.7), the background was very distracting. With the Blur tool set to a large, soft brush at 75% strength, I was able to put most of the background out of focus with just a few swipes of the tool. When I reached the area around the horse's head, I changed to a very small, hard-edged brush so I could move in close and blur right next to his face, without the risk of removing his nose.

Another way to do this would be to use the new Spot Healing Brush tool. Select a brush just big enough to cover the spot you want to get rid of, and click the brush over it. Elements will look at the pixels around the spot, average them, and replace the spot with an average of the adjacent colors. It's really pretty cool. Try it on freckles, moles, or zits, as well as stuff in the grass or on the sidewalk. It works well.

The Sharpen tool is theoretically and literally the opposite of the Blur tool. Instead of decreasing the contrast between adjacent pixels, it increases it. The additional contrast has the effect of making the image appear sharper. To use the Sharpen tool, follow the same steps as before: Select the tool, choose a hard or soft brush tip, adjust the brush size, select an Effects Mode (see the discussion of blend modes in Chapter 31), and adjust the strength of the sharpening effect. Then simply drag over the part of your image you want to sharpen.

FIGURE 25.7
Before I started blurring, the entire sidewalk looked like the piece between the horse's neck and the reins.

Figure 25.8 shows a nice arrangement of fruit and flowers. Unfortunately, because it was shot with plenty of light and a camera with an excellent lens, everything is in focus. I'd like to try to give it some depth of field by sharpening the flowers and blurring the embroidery and the grapes up front. This is definitely a case for the Blur and Sharpen tools, with a fairly small brush and medium strength for the flowers and a big soft brush for the fruit.

The one thing to watch out for when you use the Sharpen tool is that you don't overdo it. Figure 25.9 has two examples: first, the flowers correctly sharpened, and second, the flowers over-sharpened. As you can see, when you over-sharpen, the image eventually breaks down to a random pattern of black and white, as the tool keeps on increasing the contrast until nothing else is left.

FIGURE 25.8
Right now, there's no real center of interest. Sharper flowers and less emphasis on the fruit would create one. (Photo by Linda Standart.)

FIGURE 25.9
Here's proof that you *can* have too much of a good thing.

The fun doesn't stop here; there are other ways to blur and sharpen an image, as you'll learn in Chapter 27, "Using the Improvement Filters."

The Sponge Tool

The sponge represents a piece of photographic history. Darkroom photographers often kept a clean sponge next to the jug of developer. When the picture in the developing tray wasn't "coming up" fast enough, they'd grab the sponge and the jug, and slosh some fresh chemical on the paper. The combination of fresh developer and the friction from the sponge rubbing it in were generally enough to darken the image and save the print. In your digital darkroom, the Sponge tool does much the same thing. Because this sponge works in color, rather than merely darkening whatever it touches, it changes color saturation. Unlike the sponge in the darkroom, though, it can desaturate as well as saturate, making colors either less intense or more intense. If the image is grayscale, the Sponge tool will increase or decrease the contrast as it raises or lowers the intensity of the gray pixels.

To use the Sponge tool, select it and choose a brush tip and sponge size. To increase color/gray value intensity (saturation), choose Saturate from the Mode list. To tone down colors/gray values, choose Desaturate instead. To control how much the tool adjusts saturation, change the Flow value. To smudge all visible parts of the image rather than just the current layer, turn on the Use All Layers option.

By the Way

By the way, if you're looking for a way to make an image look as if it had been painted with a sponge, try the Sponge filter. You'll learn more about it and the other Artistic filters in Chapter 30, "Using the Artistic Filters."

Adjusting Saturation

Figure 25.10, which you can download from the book's website, was shot on a dreary day with natural light, and looks like it. Let's see whether we can put some sun back in the flowers. If you don't download this file (it's called Flowers) and work along, at least be sure you see the after version in the color plate section.

1. Open the Hue/Saturation dialog box and add a small amount of saturation and lightness to the picture. I used 9 as the setting for both. Because no two monitors are quite alike, your best settings may be different.

2. Select the Sponge tool. On the tool Options bar, set the Mode to Saturate and the Flow to 50% or less. Choose a soft-edged brush in a size that's comfortable for working with the pink flowers. Hold down the mouse button as you drag the Sponge over the pink parts. See how the color intensifies? Now try it on the purple flowers, but be careful not to overdo.

FIGURE 25.10
These colors even
look washed out in
black and white.

3. Change the mode to Desaturate, and choose a smaller brush if necessary. Then remove the pale yellow from the flowers in the upper-right corner, leaving them white.

The Smudge Tool

It's easy to get the Blur tool and the Smudge tool mixed up. They sound as if they might do the same thing, but they don't. The Smudge tool picks up the pixel(s) where you click and moves them where you drag. If you imagine dragging your finger through wet paint, you'll get an idea of the effect the Smudge tool reproduces. In Figure 25.11, I have drawn a line with some sharp up V's and down V's using a hard-edged brush. On the left, I've blurred the two V's at 50% strength using the Blur tool. On the right, I've smudged the two other V's at the same strength using the Smudge tool. There's quite a difference.

To use the Smudge tool, select it and then choose a brush tip and size. Choose Normal as a blend mode (again, because blend modes are a pretty advanced topic, I've left them until Chapter 31). Adjust the Strength to control the effect—a lower value creates less smudging. To smudge all visible parts of the image rather than just the current layer, turn on the Use All Layers option.

FIGURE 25.11
There's a big differ-
ence between
using the Blur tool
and using the
Smudge tool.

The Smudge tool also has a setting called Finger Painting. It places a brush full of paint (the foreground color) on the screen, and then smudges it as you drag. The effect you get when using the Smudge tool is a combination of brush size and softness, along with the Strength setting. Higher Strength numbers drag a longer tail behind the brush. Figure 25.12 shows the effects of using the Smudge tool on a photo.

FIGURE 25.12
Smudging can give
you interesting
effects.

Making Repairs When Nothing's Really Wrong

Every now and then you'll come across a photo that looks technically fine. The exposure's correct; the colors are okay. But you know there's something that's just not right. It could be better, if you could only figure out what's wrong with it. Figure 25.13 shows an example, taken on a trip through one of those animal safari parks. There's something about this picture that bothers me. It's not the zebra poop, though I'll certainly clean that up before I print. No, it's that zebra with his back to the group.

FIGURE 25.13
It's that darned nonconformist zebra....

Well, there's only one thing to do—turn him around. Fortunately, the background is very generic, so I don't even need to select him carefully. I'll just draw a selection box loosely around him with the Lasso tool and then cut and paste him to a new layer. Then, I can apply Image, Rotate, Flip Layer Horizontal from the Elements menu bar to turn him around. Figure 25.14 shows that step. When I position him, I just have to be careful to line up the top of the fence behind him.

A little work with the Clone Stamp to fill in the gaps, and he's almost where he belongs. I do, however, still need to move his shadow back so it lines up with his front hooves, just as the other zebra shadows do. Using the Clone Stamp in Aligned mode is ideal here. I can copy the shadow and when I run out of shadow, I'll simply be placing grass where the old shadow is. In Figure 25.25, the circle represents the stamp and the crosshairs are the current source. I simply selected the Clone Stamp tool, turned on the Aligned option, and pressed Cmd/Alt as I

clicked on the grass just behind where his shadow was. Then I moved the mouse over, and clicked at his feet. Dragging to the right copies his old shadow to its new location in front of his feet.

FIGURE 25.14
About, face!

FIGURE 25.15
Using the Clone
Stamp in Aligned
mode to copy the
zebra's shadow.

As a final touch, I'll clean up the piles of zebra doo-doo. It's so much easier with the Clone Stamp than with a bucket and shovel. Now what? Should I tint each pair of striped pajamas a different color? No, but I could.... Figure 25.16 shows the final photo.

FIGURE 25.16
Now he's just one
of the gang.

Hand Coloring a Black-and-White Photo

The art of hand-coloring or hand-tinting photographs dates back to the 1920s, or perhaps even earlier. A black-and-white or sepia-toned print would be painstakingly hand-colored with a very thinned out wash of either oil paint or watercolor. Oils were preferred for their longer working time. Watercolors would dry on the paper before they could be properly spread, but they were used nonetheless.

The main characteristic of a hand-colored photo is that the colors are very transparent. There is little or no attempt to paint in detail, as that comes through from the underlying photo. You can easily achieve this effect in Elements. Start with any black-and-white photo that lends itself to this technique. Though this technique is generally used on portraits, a hand-colored landscape might be interesting, too.

You'll paint with the Brush tool, which is explained in full detail in Chapter 29, "Creating Art from Scratch." Choose light colors for the effect (change brush colors by changing the foreground color) and set the brush opacity to 20% or less. Always paint on a new layer (Layer, New Layer), not on the background. That way, if you go outside the lines, you can simply erase your mistake and continue. I like to keep each color on its own layer so I can adjust the opacities individually, using the Opacity slider on the Layers palette. For instance, if I have chosen a shade of pink for a lady's blouse and then find it's too pink, I can set the opacity to 12% instead of 20%, making it paler, and not have to repaint the color. Figure 25.17 shows a colorful little girl. I haven't collapsed the layers yet, but I have added about all the color I'm going to use. If it's not subtle, it doesn't look right. Be sure to flip to the color plate section to see this one.

FIGURE 25.17
Don't get bogged
down in details. In
a picture of this
size, you wouldn't
see eye color or
small details such
as the bear's but-
ton eyes.

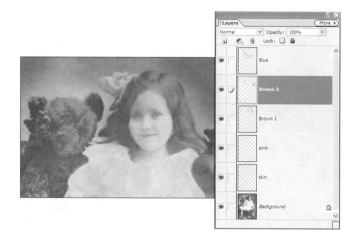

Summary

We spent this chapter on color. We focused mainly on color photo restoration, but
also on working with hand-colored photos and using the color selection tools. You
learned all about color casts—what causes them and how to remove them—and
about selective color correction. We improved a photo by coloring the sky, fixing
the color cast, and lightening the shadows. You learned how to use the Blur and
Sharpen tools to work on small parts of a picture, and how to use the Sponge to
change saturation. We talked about how to use the Smudge tool to gently soften
a line, and how to use it in Finger Paint mode to really push pixels around. You
learned about fixing composition problems in a color image. Finally, we covered
hand-coloring, and how to apply it so that it looks right.

CHAPTER 26

Removing and Replacing Objects

What You'll Learn in This Chapter:

- ▶ Drag-and-Drop Copying
- ▶ Removing a Person
- ▶ Replacing a Face
- ▶ Putting Back What Was Never There

It's easy enough to use the Clone Stamp to hide small objects in a picture, but what happens when the object you want to hide is a large one? You can't use the same tools and techniques on something big. Fortunately, there are other ways to get rid of unwanted parts of the picture and replace them with something else, even when they're right in the middle of it.

Drag-and-Drop Copying

The simplest way to hide something is to cover it up. The trick I'm about to show you is an easier method of hiding something than the one we used in Chapter 22, "Removing Red Eye, Dust, and Scratches," to hide the litter. I call this trick drag-and-drop copying. You simply select something that has the right color and shape to cover up what you want to hide. Then, you select the Move tool and press the Option/Alt key. This tells Elements that you want to copy *and* move the original selection instead of simply moving it. Thus, when you drag the selection with the Move tool, you're actually dragging a copy of it, so the original stays where it was, and the copy fits nicely over the object, person, or whatever you wanted to hide. Figure 26.1 shows a simple example. If the edges of your copy are obvious, undo the

dragging and feather the edges of the selection (Selection, Feather) by a few pixels before you move it, to help hide them. To do this, I needed several different pieces of sidewalk, some with sun and some with deep shade.

FIGURE 26.1
The second horse (hiding behind the carriage) just looks wrong. I lassoed pieces of sidewalk and completely replaced him.

Maybe it's me, but I don't like the sloppy kids in Figure 26.2. Removing them will be a lot more difficult than losing the horse because there's a lot going on behind them that we'll have to patch up.

I'll start with the feet. Dragging a sort of boot-shaped piece of brick sidewalk and concrete background, I align it using the line between brick and concrete near the kid's leg, and get rid of one leg very quickly. Figure 26.3 shows a close-up of this move.

FIGURE 26.2
The baggy shorts look may be "in" this year, but by next year it will be laughable.

FIGURE 26.3
A little more work, and he won't have a leg to stand on.

Using pieces of the sidewalk and the next granite post, I can hide his other leg and rebuild the post. Note the tiny shadow at the bottom right of the post in

Figure 26.4. I copied that with a small Clone Stamp. I then copied some of the concrete pavement to cover his upper leg, as shown in the figure.

Now I'm going to have to improvise. I have one end of the bench behind our guy. This time I'll have to do something different, though. Instead of dragging a selection, I'll copy and paste it, and then flip the copy, as I did with the zebra last chapter. Remember that when you copy and paste, the pasted object will appear on a new layer, directly over the old one. This sometimes causes confusion because it looks as if nothing has happened. Take the Move tool and drag it over the copied and pasted area. You should be able to drag the copy off the original. If not, check the Layers palette to make sure it actually copied. After flipping the bench and putting it back, so the sign legs line up with the right side of the sign, I can do a little Clone Stamping to cover some more of the student. Figure 26.5 shows the end of this step.

FIGURE 26.4
The body is trickier. I don't know where the bench ends or what's on the sign.

I can use the same copy-and-flip technique to replace most of the sign. Figure 26.6 shows a close-up of the photo. Some final rubber stamping, and he's completely gone. Figure 26.7 shows the final version of this one. What about that other kid? You can download this photo from the book's website and take them both out yourself. Look for BU chapel.jpg.

FIGURE 26.5
I still have work to do.

FIGURE 26.6
Not much more to go with this guy.

FIGURE 26.7
All gone, and good
riddance.

Removing a Person

It seems as though every time a group gets together to take pictures, there's bound to be a wise guy. Or maybe someone steps into the photo who doesn't belong there. Maybe it's your daughter's green-haired boyfriend, or your former spouse who you'd like to see out of the picture, both literally and figuratively. There's no reason that you can't remove him or her.

Figure 26.8 is a nice photo of a band on parade. I'm not really sure where it was taken, but that guy in the blue sweater obviously stepped in front of the photographer at just the wrong moment. Let's remove him.

I'm going to remove the guy with a slice of the band and building behind him and move the other one over to fill in the space. I will also clean up the rest of the picture, brightening up the color. The first step, of course, is to get the wise guy out of the way. To do so, I'll drag a selection marquee through the center of the picture. Notice that he's placed himself perfectly so that I can remove one building column and window and not be stuck with a half window to replace.

FIGURE 26.8
Some people just have no manners. (Photo by Carole Harrison.)

FIGURE 26.9
One click of the Delete key and he's gone.

This next piece is even easier. I'll simply cut the side of the picture with the man we're keeping, and slide it over the other one. Architecturally, it will still make sense, but I'll have to do some vertical stretching to make the brick patterns line up. Figure 26.10 shows the picture before and after sliding him over.

FIGURE 26.10
All gone. Now we just have to fill in the gaps.

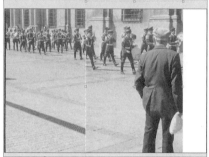

A close look reveals that one of our flautists is missing a leg. I'll just borrow one from the guy next to him, along with some hip and elbow. Fortunately, they march in precision, so all I'll have to do is stretch it a little vertically to make it fit. Figure 26.11 shows the leg replaced.

FIGURE 26.11
All the legs are at the same angle and wearing the same pants, so borrowing an extra leg is easy.

From here, all we'd need to do is a little clone stamping to make the shadows line up and a bit of color correction, and it's done.

Replacing a Face

When it's not possible to cut somebody out of the picture, you might consider replacing him or her. Instead of your ex-husband, maybe you could sit next to Tom Cruise or Matt Damon or even your current husband, in all those old family photos. You could turn your ex-wife into Julia Roberts or Granny from the Beverly Hillbillies, if you can find a photo to work with.

The difficult part of replacing a face is finding the right one to put in its place. You need to find another head shot with more or less the same lighting conditions (shadows falling in the same direction) and at the same angle, though the angle is not as critical. You can always do a 180-degree flip, if you need to, and then rotate the head so it's straighter or more tipped, as necessary. Figure 26.12 is a photo of a magician and his two assistants, one young and beautiful, the other his mother. For publicity purposes, he'd rather have two young and beautiful girls. Maybe a young Doris Day....

FIGURE 26.12
Show business takes its toll. (Photo courtesy of Carole Harrison.)

I got lucky and found an Internet fan page with a picture that works. It's facing the right way, but is not quite the right size or at the right angle, but those are easy problems to solve. Fortunately, this happens to be a black and white photo, so I don't have to match skin tones. If you do, use color variations on the incoming face and adjust until it looks right. In Figure 26.13, I've reduced Doris and removed some of the background.

Before you apply color variations to a photo, remove any color cast that affects the whole picture. Remember that the slider controls the amount of color added or subtracted. Small changes are usually enough.

FIGURE 26.13
She's ready for her new starring role.

In Figure 26.14, I've moved her face and tilted it to the right angle. Don't try to position the replacement perfectly until you've made sure that major features line up. In this case, Doris has to rotate several degrees. By reducing the opacity of the new layer, I can line up the nose and eyebrows perfectly. Next, I will continue with the task of blending her in using the Clone Stamp and the Smudge tools. (I used Smudge to fix her chin so it blended into the older woman's neck.)

FIGURE 26.14
From here on, it mainly takes patience and the Clone Stamp.

Because Doris's face is on a separate layer, I can add adjustment layers over her to reduce the contrast and brightness until she blends right in. In Figure 26.15, you can see the final result.

FIGURE 26.15
This one would probably get him more work.

Putting Back What Was Never There

Sometimes you need to hide a large part of a picture, and simply don't have enough material to do so. Maybe the photo got torn too much at the edge, or it has a hole. If you use the Clone Stamp to stamp the same piece of grass, tree, or brick wall over and over, it will quickly take on a repeating pattern that you probably didn't even see in the original. The presence of the pattern sends a clear signal that you're hiding something, but not very well.

So what can you do to avoid this? In Figure 26.16, I have a pair of seagulls. The one showing us his backside really doesn't look very good. Suppose I want to stamp it out?

FIGURE 26.16
He just wouldn't turn around.

Even if I choose the most generic piece of grass I can find, there's the pattern, showing clearly in Figure 26.17. What you have to do to avoid this is to clone a little bit at a time and keep changing the stamp source. I did this in the second try, with much better results.

FIGURE 26.17
Sometimes you'll want to keep a pattern, like a brick sidewalk. Mostly, you'll want to avoid them.

Did you Know?

If necessary—if there's not enough grass or whatever you need to cover—you can start a new document, stamping a couple of times. Then, select the stamped area, flip it upside down, copy and paste (using the Paste command will place the copy on a new layer). Select it again, and flip sideways, and paste that. When you have a good-sized patch of covering material, flatten the layers, and copy the whole thing or as much as you need back into the original picture.

If you are a person who likes to plan ahead, as I am, you can get into the habit of photographing things such as sandy beaches, sky, and fields of grass, wheat, or flowers to use as backgrounds or copying sources. I shot that seagull both for the winter grass he was on and for the pose he was in, which seemed like it would combine nicely with a pier and fishing boats (it did). I keep my source files in a folder on the hard drive, so they're ready when I need them. It's like having a couple of emergency meals on the pantry shelf. It saves worry, since I know I'll almost always be able to salvage the picture.

If you don't have specific source files, or don't yet have the one you need, look through your other pictures for something that could work. If you're trying to save a portrait, and all else fails in fixing the background, you can always select and copy the subject and relocate him or her somewhere else. Some years ago my

sons asked me to shoot a photo so they could see who was taller. I picked up the closest camera and shot them in front of a wall of messy, overflowing bookcases and office clutter. But the photo turned out to be one of the best portraits I had of the two of them—after I removed them from the scene and let them stand in front of the Golden Gate Bridge. More recently, I found a cute photo of a friend, seated on a camel, on a trip to Egypt. You can see it in Figure 26.18.

FIGURE 26.18
Nice portrait, nice camel, lousy background. (Photo courtesy of Carole Harrison.)

Unfortunately, the photo was taken in a parking lot, and she appears to have a radio antenna sticking out of her head and shoulders. If I removed the antenna, it still wouldn't be a really great photo, but how about removing Carole and her camel and putting them somewhere else?

This is a job for the Zoom tool and Magnetic Lasso. I'll have to trace very carefully around both Carole and the camel, and then zoom in and refine my selections even further. Remember, to subtract from a selection, hold the Option key as you drag a lasso around the parts you want to subtract. In Figure 26.19, I've completed selecting the woman and camel and then inverted the selection so the background was selected. Then I made the photo into a layer instead of a background layer by changing its name to Layer 0, and deleted the antenna and parking lot, leaving them in limbo.

FIGURE 26.19
The checkerboard pattern indicates transparency.

Now I can put her anywhere I want her. Maybe in the Arizona desert? Or riding down Broadway in New York City? Or in front of the Museum of Fine Arts in Boston? All I have to do is paste her in, and then adjust the color and lighting to match the location (see Figure 26.20).

FIGURE 26.20
She does get around.... I wonder how the camel is for mileage.

You already know how to adjust color, but there are a few tricks you can play to make the lighting conditions more nearly match the conditions that prevailed when you shot the background picture. First, decide where the sun is coming from. Then open the Lighting Effects dialog box (Filter, Render, Lighting) shown in Figure 26.21.

FIGURE 26.21
This looks a lot more complicated than it is.

Outdoor photos can't have more than one light source, since we live on a planet with only one sun. So, choose Spotlight as the Light Type, and then simply drag the light's axis around until the light strikes your subject from the same direction it strikes the intended background. You can flare the circle wider or narrower as necessary, and adjust the strength of the light. You don't need a perfect match, just a reasonably believable one.

The real trick in making any of these "photo saves" work for you is to be creative. Think about what could be removed to make the picture better, and what could be put in. If you start by realizing that nothing is impossible, you have a lot of possibilities to try.

Summary

Not all photo repairs involve fixing color or cropping and straightening. Sometimes what's wrong with the picture is what's in it that shouldn't be. In this chapter, you learned how to edit a photo, how to remove unwanted people or things. You learned about drag-and-drop editing to cover a large area with a piece copied and dragged over the background. You learned to combine different methods to replace a complicated background. Then, you learned how to remove someone from a group by simply cutting him out and bringing the edges back together. You learned how to replace a face while keeping the rest of the picture intact, and then you learned about the problems of Clone Stamping and how to avoid them. Finally, you learned about keeping source files handy for quick photo repair, and how to make the subject fit into the new background.

CHAPTER 27

Using the Improvement Filters

What You'll Learn in This Chapter:

▶ Working with Filters

▶ Using the Sharpen Filters

▶ Using the Blur Filters

▶ Adding or Removing Noise

▶ Using the Render Filters

▶ Adding Texture

▶ Adjusting the Effect of Filters

I'm not sure whether Adobe actually invented the concept of filters or just took the ball and ran with it. It really doesn't matter. Filters are one of my favorite Photoshop Elements tools. Elements has all the Photoshop filters on board, and you can also load third-party filter sets to do everything from framing your pictures in your choice of materials to changing the weather in the scene to creating strange abstractions based on fractal geometry.

Working with Filters

Filters are also called *plug-ins*, or sometimes *plug-in filters*. You can install them very simply by copying them into the Filters folder. Elements is compatible with all the third-party Photoshop filters and with most plug-ins that work with other graphics programs such as PaintShop Pro or Painter. If you already have filters installed in another Photoshop-compatible graphics program, you don't need to reload them.

You can designate a second plug-ins folder by going to the Preferences dialog boxes (Edit, Preferences in Windows or Photoshop Elements, Preferences on the Mac), displaying the Plug-Ins & Scratch Disks options (shown in Figure 27.1), clicking Choose, and locating the folder containing the additional plug-ins you want to use. When you restart Elements, you'll see the new ones listed at the bottom of the Filters menu.

FIGURE 27.1
Choosing a second plug-ins folder.

The filters we're going to be working with in this chapter are all "corrective" filters. They are used to change focus, add or remove noise and speckles, and add special effects such as 3D mapping, clouds, and lens flare.

All the filters in this chapter and in upcoming chapters will be applied to the current layer, or to a selection within the current layer. When using a selection, it's usually best to feather the edge to create a better transition between the affected area and the rest of the image. If your image has multiple layers, you can apply the filter to each layer and blend the effects by adjusting each layer's opacity.

In most cases, if you want to apply a filter, your image must be using RGB mode. (Some filters may be applied to images using Grayscale mode as well.) Filters are found on the submenus of the Filter menu. Some filters are applied without making any selections at all, while others let you make adjustments before applying them. The last filter you used, with the exact settings you selected, will be listed at the top of the Filter menu. To reapply it with those settings, simply choose the filter from there rather than from the submenu.

You can compare filters visually using the Filter Gallery, shown in Figure 27.2. It's near the top of the Filter menu. Change from one category to another using the drop-down list. The filters in each category are displayed in sample thumbnails so you can compare them. If you select a filter that has setting options, they will be

displayed in the panel at the right of the screen. If this is one of the filters with no options to set, such as the Blur or Blur More filters that you'll learn about later in this chapter, Elements will simply go ahead and apply it.

Some types of filters do not appear in the Filter Gallery, specifically the Adjustments, Blur, Noise, Pixelate, Sharpen, Render, and Video filters. These can only be applied from the Filter menu.

FIGURE 27.2
Browse through the many filters using the Filter Gallery.

Using the Sharpen Filters

There are four filters in this set: Sharpen, Sharpen More, Sharpen Edges, and Unsharp Mask. You'll find them all on the Filters, Sharpen menu. The first three are very straightforward—there are no options to set (see Figure 27.3). You select them from the Filter menu, and your picture changes accordingly. Sharpen More gives twice as much sharpening as Sharpen, and Sharpen Edges only sharpens areas where there is a lot of contrast between adjacent pixels—such as the edges of the flower next to the dark background, the shadow in the center, and the light-colored stamen. The Sharpen Edges filter treats these contrasting pixels as edges, and increases the contrast between them. It does not increase the contrast everywhere, as Sharpen and Sharpen More do.

The Unsharp Mask filter is a lot more complicated. It also visually sharpens the photo by seeking out edges and adding contrast to them, like Sharpen Edges, but with the variables involved, it can do a much more selective and therefore better job. Choosing Filters, Sharpen, Unsharp Mask opens the dialog box shown in Figure 27.4.

FIGURE 27.3
You can try applying any of these filters a second time if the first application doesn't do enough. Just be careful not to over-sharpen.

Original Sharpen

Sharpen Edges Sharpen More

FIGURE 27.4
The Unsharp Mask dialog box.

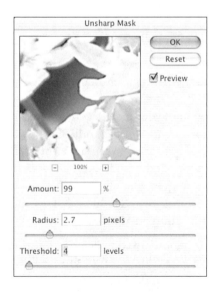

As you can see, there are three settings you must deal with: Amount, Radius, and Threshold. Amount refers to the degree of contrast (sharpness) you'll be adding to the edges of objects in the picture. Radius determines the size of the area that will be sharpened. A large radius sharpens a large area around each perceived edge. A small one sharpens a smaller area. What's best? If the picture has small, delicate detail, you'll need to use a small radius. If not, watch the preview as you increase it. You'll be able to see when to stop. Threshold lets you determine how much of a difference there should be between adjacent pixels before Elements treats them as an edge and enhances them. When you have areas with only minor differences in color, such as sky or skin tones, a very low Threshold setting can make them look blotchy. Still, you want to keep the Threshold as low as you can without letting it add unwanted noise or spottiness to the picture.

Sharpening with any of the filters, and particularly with the Unsharp Mask, should always be the very last thing you do to your picture before saving it. Before you use the sharpening filters, straighten and crop as needed, check for proper tonal level and adjust it, adjust color saturation and remove color cast if present, change the brightness and contrast, and perform the other routine tasks we've already discussed. Then, as a last step, you can add the crispness you want without affecting your ability to make further changes. If you were to sharpen an image first, and then make additional changes, you would probably make the sharpness that Elements put in stick out like a sore thumb.

Before we move on, let's practice with the Unsharp Mask filter.

1. Open an image in Elements and make whatever corrections or alterations it needs. Zoom in or out so the picture is at its full size on the screen. (This will let you see the effects of sharpening, without exaggerating them.) When you're satisfied with everything except the sharpness, open the Unsharp Mask dialog box (Filter, Sharpen, Unsharp Mask).

2. Set the Amount to 500% to start with. This is the maximum, and starting here will help you see and understand what the other two variables are doing.

3. Set the Radius to 1 pixel, and the Threshold to 0. The picture won't look right—it will probably look very grainy—but this is our jumping-off point.

4. If there is obvious grain or noise, increase the Threshold. Start with 2, and then try 5, 8, 12, and so on until the noise disappears.

5. Now, we'll work with the Radius. Increase the Radius until the picture just starts to lose detail, and then back it off a bit. Figure 27.5 shows my image at this stage. (Don't worry about the white halos around edges. We'll lose them next.)

FIGURE 27.5
We'll lose the halos
in the next step.

6. Now, reduce the Amount until the picture looks good. You want to get rid of the white edges, but still keep the sharpening effect. You'll probably find that the correct setting for Amount is somewhere between 100 and 250. Of course, it also depends on the amount of contrast and fuzziness in the picture you're working on. If you're not going to use the image onscreen (on the Web, for example), and you're just trying to get the sharpest image you can for printing, you may want to over-sharpen the image just a bit.

7. Finally, save the picture and print it, or put it on your web page, or do whatever you'd planned. It's as sharp as it's ever going to be.

Lack of sharpness in either a scanned image or a digital photo is a very common problem, and part of the reason for it is the process. The picture is saved as a series of dots. Inevitably, there are spaces between the dots, and if you have a low-resolution scan or a low-resolution camera (anything less than 1 Megapixel), the spaces will be large enough that the software will add blur to fill them in. That's why the pictures look fuzzy, and why adding contrast at the edges fixes it.

Using the Blur Filters

The Blur filters logically ought to be the direct opposite of the Sharpen filters. Some are. Blur and Blur More have the same global, one amount fits all, method of application. Choose either one of these two filters from the Filter, Blur menu, and the filter is applied automatically, without options.

Did you
Know?

I actually tried a sequence of Blur, Sharpen, Blur More, and Sharpen More on a picture, and aside from some obvious quality loss, I got back to about where I started. However, I don't recommend this as a technique. The image loses some detail at each step.

Blurring, generally, is *not* something you want to do to the entire image. If you are applying a combination of filters for a special effect, Blur could certainly be one of them, but most of the time we want our pictures sharp. Blurring *part* of the image, though, is a very useful technique. When you blur an object against a sharp background, you create the illusion that it's in motion. When you blur a background, you create the illusion of depth of field, where the subject is in focus, but the background is so far away that you can't see all the details. Blur and Blur More are best applied to selections.

Smart Blur

In Figure 27.6, I'm going to use one of the Blur tools to clean up the beach. The heavy shadows on the sand from too many footprints create a texture that nearly hides the seagull. I've selected the sand and everything on it *except* the gull.

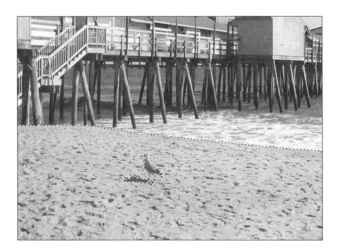

FIGURE 27.6
Before blurring the
sand.

Now I'll open the Smart Blur dialog box (Filter, Blur, Smart Blur). Smart Blur has the most flexibility of any of the Blur tools. In its dialog box, which is shown in Figure 27.7, you can set Radius and Threshold, just as you can for Unsharp Mask. You have a choice of Quality settings: High, Medium, or Low. High creates more blur than Low. You also have a choice of effects modes: Normal (which applies

the effect to the entire layer or selection), Edge Only (which applies the effect to the edges), or Overlay Edge (which also applies the effect at the edges). The difference between Edge Only and Overlay Edge is the effect—Edge Only makes the image or selection black and the edges white, while Overlay Edge doesn't change the colors in the image, but makes the edges white.

FIGURE 27.7
The Smart Blur
dialog box.

Setting the Radius and Threshold here are the same in theory as setting them for Unsharp Mask. The Radius determines how much of the area around the perceived edge is blurred. The Threshold determines how much difference there needs to be between adjacent pixels before Elements will interpret them as an edge and apply the blur to the area.

Some photos are harder to correct than others. This one, because there's so much contrast in the sand, is especially difficult. The solution is to go back and reduce the contrast and brightness of the sand before trying the Smart Blur filter. I can use the Undo History palette to move backward to the point where I'd made the selection but hadn't yet added the blur. Then I can use the Levels dialog box to adjust the levels to de-emphasize the difference between light and dark. This generally means moving the midpoint toward the darker end of the scale. When there's less contrast, I can use the filter without making the sand look as if it's been processed. (Jump back to Chapter 21 if you need a refresher course on the Levels dialog box.) I can also use the Healing Brush tool to get rid of more of the darker spots around the seagull.

The Healing Brush works much like the Clone Stamp tool. Just select (Option/Alt+click) a smooth piece of sand and click the brush to copy it over a dark spot.

Figure 27.8 shows the final version of this picture. Be sure to see it in color, too.

FIGURE 27.8
Now the sand looks better, and the gull doesn't get lost in the texture.

Gaussian Blur

The Gaussian Blur filter is less adjustable than Smart Blur. Its only adjustment is for Radius. What makes it so useful, though, is that it has a built-in randomness factor that varies the amount of blur applied. This gives it a much more natural look, so you can actually use quite a lot of blur without it being obvious. Gaussian Blur is a wonderful tool for portraits. It evens out skin tones, removes fine lines and wrinkles, and takes years off with a single click.

In Figure 27.9, I've applied it to a picture of a young man with stray hairs and slightly blotchy skin. It doesn't take much blur to make a difference. I've turned off Preview so that you can see the before version on the main Elements screen and the after version in the filter dialog box. When using a tool such as this one, you should wait to apply it until after you've already made any other needed corrections. Use the Clone Stamp to get rid of any major spots, so a small amount of blur will be sufficient to take care of the rest. Too much blur tends to make skin look as if it were made from plastic.

FIGURE 27.9
Use the Gaussian
Blur lightly.

Radial Blur

The Radial Blur filter is just plain fun, especially when you apply it to a round
object. The only drawback to using it is that there's no way to preview, so you
have to be prepared to do and undo your changes several times until you find the
right setting. Figure 27.10 shows the Radial Blur dialog box. There are two differ-
ent methods of blur available: Spin and Zoom. Spin simply rotates the pixels
around the center point (which you can move). Zoom blurs them outward from
the center (again, you can move this spot). Both effects are interesting, if not par-
ticularly useful. Figure 27.11 shows examples of both. The Spin amount was only
10, but the Zoom amount was 50. Zooming requires much more "travel distance"
within the image to see the full effect.

To use Radial Blur, select the type of blur—Spin or Zoom—and the Amount of
blur you desire. To adjust the center point of the blur effect, click in the Blur
Center box and drag the center point.

FIGURE 27.10
The Radial Blur
dialog box.

Spin

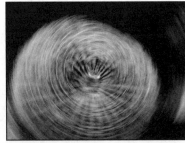

FIGURE 27.11
Three flavors of
cactus: Original,
Spin, and Zoom.

Original

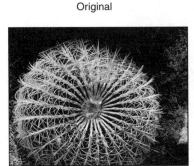

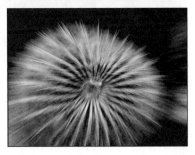

Zoom

Note the quality settings in the dialog box, too. They determine how quickly, and how carefully, the blur is applied. The Draft setting works very quickly, and leaves some rough edges. Good is sort of a compromise between speed and smoothness, and Best, which is noticeably smoother, can take several minutes to apply on an older, slower computer.

Figure 27.12 shows all three settings applied to a Zoom blur. There's not much difference in this example between Draft and Good, but Best is definitely best.

Because there's no preview available with Radial Blur, you can try different settings on a large image in Draft Quality mode quickly, undo and tweak until you're happy, then render the final version in Best Quality mode.

Did you
Know?

FIGURE 27.12
Here we have the
zoom in Draft,
Good, and Best.

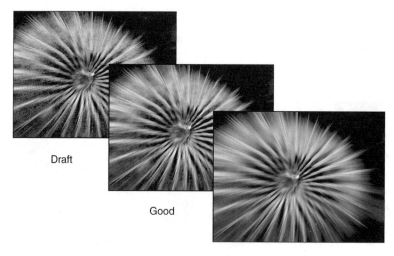

Draft

Good

Best

Motion Blur

When we see lines drawn behind a car, a cat, or a comic strip character, we instinctively know that the subject is supposed to be in motion. Those lines represent *motion blur*, which is actually a photographic mistake caused by using a slow shutter speed on a fast subject. The image's subject appears totally or partially blurred against the background because the subject actually traveled some distance during the fraction of a second that the camera shutter was open.

In the early days of photography, motion blur was a common occurrence, primarily because shutter speeds were slow and film was not very sensitive. Today, motion blur is unusual, unless the photographer is trying to capture the subject this way on purpose by using the least-sensitive film available or by using a small lens opening (aperture or f-stop) and a correspondingly slower shutter speed. If you want to try to approximate the effect of motion blur, however, Elements gives you a tool that can do it.

The Motion Blur filter (Filter, Blur, Motion Blur) can add the appearance of motion to a stationary object by placing a directional blur for a predetermined distance. In the Motion Blur dialog box, shown in Figure 27.13, you can set both the distance and direction of the blur according to how fast and in what direction you want the object to appear to be traveling. The Distance sets how much of a blur is applied—or how far the original image is "moved." The Angle sets the direction of the blur. To adjust, drag the directional bar in the circle, or enter precise values into the Angle box next to it. The trick is to select the right area to

which to apply the Motion Blur. To get a convincing blur, you need to blur the space where the object theoretically was, as well as the space to which it has theoretically moved. You don't want to blur the entire image, so you might want to select the area to blur before using the Motion filter.

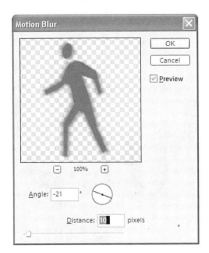

FIGURE 27.13
Using the Motion Blur filter is tricky at best.

The Motion Blur filter doesn't do much for most photos. After all, the blur caused by the camera shaking is the kind of thing we usually try to avoid—not add. But, for some special effects, and for doing tricks with type, it has interesting possibilities. Figure 27.14 shows one possible use. First, I entered the type and applied the Perspective transformation (Image, Transform, Perspective) to give it some depth. Adding Motion Blur let me jog a bit faster, but I could take this even further.

FIGURE 27.14
You can't run while standing still.

For Figure 27.15, I set the type differently, placing each letter on a separate layer. I then used a different Distance setting (increasing left to right) to each Motion Blur, from 5 pixels on the R to 20 pixels on the N. The resulting image almost seems to be running off the screen.

FIGURE 27.15
Using layers lets you apply different filters or different degrees of the same filter to an image.

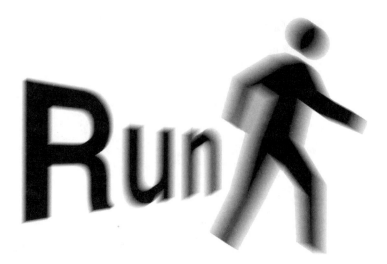

Adding or Removing Noise

The Noise filters have nothing to do with sound. The kind of noise we're dealing with here is electronic noise. It's displayed on a TV screen or computer monitor as a pattern of random dots, usually in color. It's also called *snow*, and before we all got cable TV, it was common whenever you tried to tune in a TV station that was too far away.

Noise doesn't sound like a useful tool, but rather something you'd like to get rid of. Three of the four Noise filters are, in fact, designed to remove noise. It's fairly obvious from the names what Despeckle and Dust & Scratches are trying to remove, but what about Median? Median reduces noise by looking for individual pixels that are too bright or too dark and changing them to the median brightness value of the pixels around them. Sometimes you don't want to remove noise, but add it, and of course, that's what the Add Noise filter is for.

Despeckle

Despeckle is the easiest of the filters to use. All you have to do is select it from the menu. It automatically looks for areas that have sharply contrasting pixels, and

blurs the "misfits" to blend into the pixels around them. If you have a scan from a magazine that's showing visual banding or other noise, this filter will usually remove it. But be careful about using it on photos with fine detail. The Despeckle filter is likely to blur the detail.

Dust & Scratches

The Dust & Scratches filter, unlike Despeckle, has a dialog box with Threshold and Radius settings. This makes it much more useful, in that you can set the Threshold to the amount of blur you're willing to tolerate, and still get rid of dust, cat hair, and whatever else is messing up the picture. The Radius setting controls the size of the area that's examined for dissimilarities. As an example for this fil-ter, I have scanned an old photo with many scratches and cracks in the paper.

Finding the right combination of Threshold and Radius settings simply requires patience and a willingness to experiment, but as you can see in Figure 27.16, it is possible to get rid of all but the heaviest scratches without losing too much sharp-ness. The remaining crack can then be easily Clone Stamped out of the picture. Typically, it's best to try keeping the Threshold at the lowest value possible (to avoid losing too much detail) while gradually increasing the area to examine (the Radius).

> If you can't seem to find a proper balance with the Threshold and Radius settings, try selecting the area that contains the largest amount of dust and dirt, and applying the filter just to that area.

Did you Know?

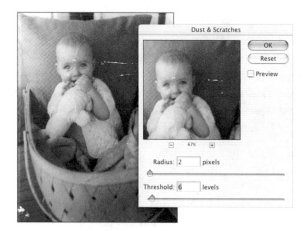

FIGURE 27.16
This sure beats stamping out every line.

Median

As I mentioned earlier, the Median filter removes noise caused by neighboring pixels that vary too much in lightness or darkness. This filter blurs details even at very low levels, so be careful when using it. I use it sometimes to even out skin tone, reduce freckles, and the like. It seems to work better than applying any of the blur filters, at least when I select a small area, as shown in Figure 27.17.

FIGURE 27.17
Median is useful when removing unevenness in tone from small areas. Be careful, though; it does add blur.

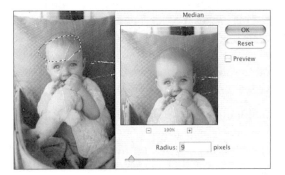

To use Median, select the area you want to affect, then choose Filters, Noise, Median. There's only one option to set—the Radius of the area that's examined for discrepancies. You'll want to leave this set very low to avoid losing detail. Of course, if you lose some detail, you may be able to put it back using the Unsharp Mask.

Add Noise

Given that Elements offers you so many tools to *remove* noise, why would you want to *add* any? Actually, noise can be very helpful. I use it a lot when I am creating backgrounds from scratch, as part of the process of turning photos into paintings, or to cover up areas I've retouched a lot. You can apply noise to a picture, as I've done in Figure 27.18. In this case, I want the finished product to look like a hand-colored steel engraving. Adding monochromatic (black) noise and then using the Find Edges filter will give me the look I want, with very little work.

If you apply noise to a blank canvas, and then apply another filter (or two or three), you can create some beautiful textured backgrounds for web pages or anything else you might think of using them for. In Figure 27.19, I've used Gaussian colored (non-monochromatic) noise to put down a layer of confetti (shown here in the upper left), and I've added some other filters to change the original confetti. See if you can identify the Stained Glass, Colored Pencil, Sumi-e, Mosaic Tiles,

and Crystallize filters. You'll get to play with these filters yourself in Chapter 30, "Using the Artistic Filters." Please don't forget to look at this figure in the color plate section.

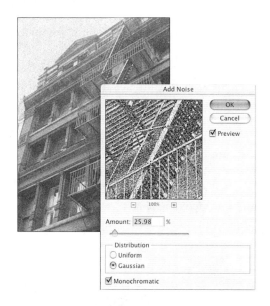

FIGURE 27.18
Choose colored or monochrome noise, and Uniform or Gaussian distribution.

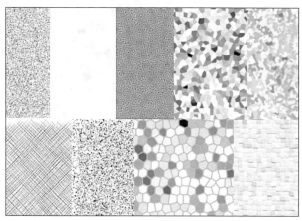

FIGURE 27.19
By changing the amount of noise, you could change each of these confetti images to something quite different.

Using the Render Filters

The Render filters can create some awesome special effects. You can add lens flare, lighting effects, clouds, and textures, and even map your art onto three-dimensional objects. You'll find these amazing filters on the Filters, Render menu.

Clouds

The Clouds filter is one of the most useful of the Render filters. Quite often, you'll be shooting pictures outdoors and not even notice that the sky is overcast or a very pale blue and essentially featureless. That's when you apply the Clouds filter to the selected area of the sky. First, set the foreground and background colors to something appropriate. Use blue and white for a traditional sky, two shades of purple for a storm about to break out, even yellow and green if you're on a different planet. You can pick up some of your existing sky color using the Eyedropper tool if you like. It doesn't seem to make any difference which is the background and which is the foreground color, because the filter uses a random selection of colors between those two to render the clouds. Just choose the colors you want to use, then select Clouds from the Render submenu. If you press Option/Alt while selecting the Clouds command, you'll get a starker, less serene look. There are no options: The filter is applied right away. Figure 27.20 shows some typical clouds acting as a background for the globe. Note that if you choose two colors that are similar in tone (brightness), the cloud effect may be too subtle to see.

FIGURE 27.20
These are ordinary blue and white clouds.

By the Way

This photo of Earth from the Apollo 17 crew is one of many at the NASA website that you can download and use, royalty free. Your tax dollars paid for this stuff; you might as well enjoy it. Check out http://antwrp.gsfc.nasa.gov/apod/ for the Astronomy Picture of the Day. Some of these photos will absolutely knock your socks off. There's an archive and even a search engine.

Difference Clouds

The Difference Clouds filter takes the existing colors in the image or selection and inverts their brightness (making light colors dark, and dark colors light) to create a cloud pattern. It then uses the colors opposite from the foreground and background colors on the color wheel to color the sky, giving you strange, dark skies with oddly colored clouds. This is good if you're illustrating a science fiction book…. Again, there are no options to this filter; just select the opposites of the colors that you want to appear and choose Difference Clouds from the Render submenu. If you choose two colors that are already opposites, such as magenta and green, you won't see much difference between Clouds and Difference Clouds, except that the lighter and darker portions are inverted.

Lens Flare

Lens flare is one of those things photographers generally try to avoid. It happens when the sun or some other source of bright light reflects back into your lens and bounces off the layers of glass inside. The resulting circles of light can be an artistic effect, or can ruin the picture, depending on where they happen to land. The Elements advantage is that you can position your lens flare wherever you want it, and also control the brightness and size of the flare.

The Lens Flare dialog box, shown in Figure 27.21, has several settings. The Brightness setting determines the diameter of the flare. If you set it to anything higher than 150, it's likely to overpower the picture so all you'll see is flare. Drag the Flare Center crosshairs in the preview box to position the center of the flare where it looks best. Finally, decide what kind of lens is theoretically causing the flare. Prime lenses, which have only one focal length, cause single flares, while the zoom lens, which has several moveable elements, causes flares with several circles.

Lighting Effects

Lighting Effects is a very powerful filter, with many adjustable settings, and many possible results. What it does is lighten the picture in the same way that adding a couple of floodlights or a flashlight or any of the other preset lighting patterns would do. Figure 27.22 shows the rather complicated interface, which I covered very briefly in Chapter 26, "Removing and Replacing Objects." This filter gives you a lot of control, but at a price. You really need to spend a while playing with it to get a sense of what it can do.

FIGURE 27.21
Lens flares can add
interest to a photo,
if done right.

FIGURE 27.22
The Lighting Effects
dialog box. (Photo
by L. Standart.)

First, select a lighting style. Some give you yellow light like that of an incandescent bulb, while others give you white light, which doesn't change the colors in your image. Some styles use multiple lights; others use only one. You can find a

complete description of each lighting style in Help, although most of them are pretty obvious. If a lighting style has more than one light, you can reposition and adjust each light separately. To turn off a light, click its center in the preview window, then deselect the On option.

Next, select a light type:

▶ Omni—Shines a light down onto the image from above. You can move the center of an Omni light by dragging it. To create a smaller or larger circle of light (that is, to simulate the effect of moving the light closer to the image or farther away), drag the handles on the circle.

▶ Directional—Shines the focused beam of light from an angle that you can adjust. Move the center of the light by dragging it. Change the direction of the light by dragging the handle; you can shorten the line to bring the light closer or make the line longer to pull the light farther away. Adjust the intensity of light within the circle with the Intensity slider.

▶ Spotlight—Also shines the light from an adjustable angle, but with a flare whose radius you can adjust from wide to narrow, just like a flashlight. Drag the center to move the light focus, and change the angle by dragging the handle. If you shorten the handle, you'll bring the light closer to its focus. If you want to change the angle without changing the light's distance, press Cmd/Ctrl while dragging the handle. To change the size of the light flare, drag a handle on the ellipse; if you don't want to also adjust the angle, press Shift as you're dragging. Adjust the intensity of the light within the ellipse using the Intensity slider. A negative intensity can actually take light away from the image. To control how much of the ellipse is filled with light, adjust the Focus slider.

For each of the light types, you can set other variables as well. To change the color at the center of the light, click the top color swatch and choose a new color from the Color Picker. To change the color at the edges of the light (the ambient light source, as noted in the following list), change the second color swatch. Here's a description of the options in the Properties area:

▶ Gloss—Use this option to adjust the amount of light reflection coming back from the image. The available choices are similar to the paper choices for actual printed photos. Matte is less reflective than Shiny.

▶ Material—Sets additional reflection. Plastic reflects the color of the light, while Metallic reflects the color of the object.

▶ Exposure—Increases or decreases the amount of light.

▶ Ambience—Adjusts the light for another light source, such as light from a window or a table lamp. The color of this ambient light is set with the second color swatch, as noted earlier. If you set this value to 100, the ambient light is removed completely; set it to –100 to use only the ambient light and not the light source.

To change how light reflects off particular colors in an image, add a texture. Select the color you want to raise to create the texture from the Texture Channel list. (You can also use the current layer's transparency to create an effect by selecting it from the Texture Channel list.) To raise the light hues of your chosen color, select the White Is High option. Otherwise, you'll raise only the dark hues. Then set the height of those areas to determine how the light reflects off them. If you select Mountainous, for example, expect more shadows, because the light reflects off the areas of the selected color/transparency in your image as if they were mountains.

Texture Fill

This filter is fairly straightforward; it doesn't do any of the fancy tricks its cousins do. Basically, you use the Texture Fill filter to fill a layer or a selection with a texture. You might do this, for example, to create a Mac/Windows desktop background, some pretty patterned paper, or a special effect within a selected area of your image. To use this command, you'll need a Photoshop/Elements-compatible file (a .psd file). You can create such a file yourself by copying a selection such as grass, hay, fur, or any other textured surface from an image and then pasting the selection into a new file and saving it. You can save color with the texture if you want; it depends on the effect you're going for.

Did you Know?

> You can also create a homemade texture by painting random strokes with the Brush tool in a new file, and adjusting the contrast or applying filters (such as the Find Edges filter) to bring out its texture. Elements has a few ready-to-use texture files; you'll find them in the Photoshop Elements 3/Presets/Patterns folder.

To use the Texture Fill filter, select the area or layer you want to fill. Choose Filters, Render, Texture Fill, then choose the Photoshop-compatible (.psd) file you want to use as a texture, and click OK. The entire layer or selection is filled with the texture. Anything in the layer or selection is completely replaced.

3D Transform

Using the 3D Transform filter, you can take an image and convert it into a 3D object, such as a cube, sphere, or cylinder. You can then manipulate the image using a wire frame, twisting and rotating it as you like. You can change the shape of the 3D object using the wire frame, creating other shapes such as a wine bottle, hourglass, or baseball bat. You can create multiple shapes and manipulate them together.

To get the best results from this filter, you may want to skew and distort your image so that it fits the rough shape of a cube, sphere, or cylinder. Then, when you're ready to use the 3D Transform filter, choose it from the Render submenu. The 3D Transform dialog box appears, as shown in Figure 27.23.

Selection — Direct Selection
Cube — Sphere
Cylinder — Convert Anchor Point
Add Anchor Point — Delete Anchor Point
Pan Camera — Trackball
Dolly Camera — Zoom

FIGURE 27.23
Create and manipu-late a 3D rendering of your image using these controls.

Start by clicking the button for the shape you want to create and then dragging in the pane to create the wire frame. Before making any adjustments, click Options to select the options you want to use. Select the Resolution you want; if you select High, you'll wait longer for the rendering to finish, but you'll get better results. Turn on aliasing, which will help make curves in the image smoother. Finally, select Display Background if you want to display the full image behind the 3D object.

Adjust the wire frame so that it fits the image as well as it can, using any of these techniques:

▶ To move the frame's position over the image, choose the Selection tool and drag the frame.

▶ To resize the frame, drag it inward or outward by one of the anchor points (the small handles on the frame).

▶ To move an anchor point's position on the frame, choose the Direct Selection tool, then drag the anchor along the frame.

▶ Bend the shape of a cylinder frame by adding anchors. Anchors are added in pairs—one on the left and one on the right. To add a pair of anchors, choose the Add Anchor tool and click on the right side of the frame. The matching left anchor is added for you. After adding a pair of anchors, you can bend the cylinder shape inward or outward at that point by dragging the right anchor.

▶ New anchor points are smooth, which means that they bend the frame in or out at the point where you add them in a gentle curve. To change the anchor point to a corner anchor point, click it with the Convert Anchor tool. You can convert the anchor back to a smooth one by clicking it again with this tool.

▶ Remove an anchor point by clicking it with the Delete Anchor Point tool.

While manipulating the wire frame, you may find it helpful to adjust its angle in relation to the image. To do that, drag the Field of View slider. This compensates for the field of view (the angle) originally used to take the picture.

After fitting the wire frame to the image, you can manipulate the three-dimensional object by doing any of the following:

▶ Moving the object within the window by choosing the Pan Camera tool and dragging it.

▶ Rotating the object by choosing the Trackball tool and dragging it.

▶ Zooming the object in or out by choosing any of the bottom four tools and dragging the Dolly Camera slider.

After manipulating the object as you like, click OK to apply the filter. Figure 27.24 shows an image after 3D transformation.

FIGURE 27.24
The 3D Transform filter is great for product mock-ups.

Adding Texture

We've already discussed one way to add texture to an image: using the Lighting Effects filter. There are other methods you can use as well, but none is quite so easy as using the Texture filters. They are all applied to an entire layer or a selection with a similar dialog box, shown in Figure 27.25. All the Texture filters (Craquelure, Grain, Mosaic Tiles, Patchwork, and Stained Glass) allow you to adjust the size of the texture and its effects so you can achieve a look that is either subtle or not-so-subtle.

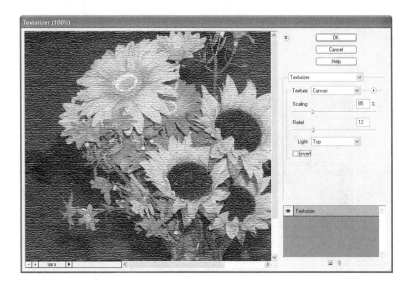

FIGURE 27.25
Add a canvas texture to your image.

To use any of the Texture filters, select the layer or area you want to affect, then choose your filter from the Filters, Texture submenu. Adjust the size, spacing, intensity, depth, brightness, and other options as desired, using the preview window as your guide. Then click OK to apply the effect.

The Texturizer filter allows you to apply other textures to create your effect. You can apply brick, burlap, canvas, or sandstone, or load any other texture file and adjust its effects using the dialog box. Again, if you use your own texture file, it must be in .psd format. You'll find a few premade texture files for your use in the Photoshop Elements 3/Presets/Patterns folder.

Adjusting the Effect of Filters

In Photoshop, you have the ability to apply a filter and then fade it out by a percentage. Unfortunately, Elements lacks this feature (for now—the next edition will probably have it). But you can create a fairly good imitation of the effect by copying the image to a new layer before you apply the filter. Filter the top layer, and then adjust the opacity of that layer until you have just enough of the effect, with the unfiltered background layer showing through and putting back as much of the original image as you want it to. In Figure 27.26, I've applied the Dust & Scratches filter too generously to a copy of the picture.

FIGURE 27.26
Oops, that's too much blur.

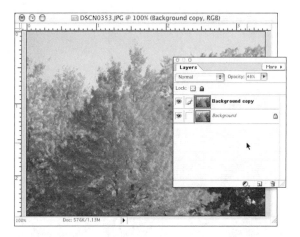

By reducing the opacity of that layer to about 50%, I can get what I wanted— enough blur to wipe out the spottiness of the leaves, but not so much that they're out of focus. Figure 27.27 shows close-ups without the filter, with the filter applied at 100% opacity, and finally, with it reduced to 50% opacity.

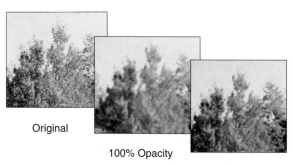

Original

100% Opacity

50% Opacity

FIGURE 27.27
From left to right: the original trees, the filter applied at 100% opacity, the filter opacity reduced to 50%.

Summary

This chapter covered some of the plug-in filters that Photoshop and Elements both use. Filters can be applied to an entire image or to selected parts of it. First, you learned about the Sharpen filters. You learned how to use Unsharp Mask to take the blur out of digital photos and scanned pictures. Then, we looked at the Blur filters. There are several kinds that do different things to the picture. Blurring is useful for de-emphasizing a background or some unwanted part of the image. The Radial and Motion Blurs give the illusion that the picture, or the part of the picture they're applied to, is moving. Next, we explored the Noise filters. There are three filters that remove noise and one that adds it. You learned that adding noise to a blank page and then using another filter can create some interesting background textures. Then, we looked at some of the Render filters. You learned to make clouds to enhance a drab sky. You learned about lighting effects, and about lens flares. You also learned how to render an image onto a 3D shape. Finally, you learned a trick to fade the effect of a filter.

Getting Creative

CHAPTER 28 Color Modes and Color Models **541**

CHAPTER 29 Creating Art from Scratch **553**

CHAPTER 30 Using the Artistic Filters **573**

CHAPTER 31 Making Composite Images **599**

CHAPTER 32 Going Wild with Your Images **631**

Color Modes and Color Models

What You'll Learn in This Chapter:

▶ Color Models

▶ The Modes and Models of Color

▶ Calibrating Your Monitor

You've been working with color for a while now. It's fun, especially when you can do something cool like changing lemons to limes, or brown hair to blond. But how much do you really know about color? What *is* color? How does the color you see get translated into binary bits in the camera and computer, and how do millions of different colors get displayed on a monitor that actually has only three colors? More importantly, how does the color get converted from the RGB monitor to the CMYK printer?

Color is all around us, a blessing few of us take time to think about or recognize. It is as common as the air we breathe, but when you become aware of its presence, you become aware of the minute variations that exist in every color. Notice the shades of green on the tree outside your window. Notice how those greens differ from the green of the grass. Watch the play of light and shadow. It becomes fascinating.

In this chapter, we are going to investigate the different properties of color—both in Photoshop Elements and in life. Some of the information at the beginning might seem a little esoteric, but, in the long run, it's useful to know. After all, the more you know about color and how Elements addresses it, the better off you'll be. But don't worry, I'll try to be as brief and painless as possible.

The first thing to know is that Photoshop Elements addresses color in terms of models and modes. *Models* are methods of defining color. *Modes* are methods of working with color based on the models.

Color models describe the different ways that color can be represented on paper and on the computer screen. The color models are as follows:

- ▶ RGB (Red, Green, Blue)
- ▶ CMYK (Cyan, Magenta, Yellow, Black)
- ▶ HSB (Hue, Saturation, Brightness)

We will examine these models for displaying and describing color, and then we will turn our attention to the Photoshop Elements modes, which are the ways Adobe provides for you to work with color.

Color Models

Figure 28.1 shows the Adobe Color Picker. You can reach it by clicking either of the large blocks of color at the bottom of the toolbox. The Color Picker has a thin vertical rainbow from which you can choose a color, and a large graduated block from which you can click different saturations and brightnesses of that color. View the text-entry fields to see the numbers for any chosen color in two color models, plus the web color closest to what you've chosen.

FIGURE 28.1
The Photoshop Color Picker. Currently, it's set to bright red.

By the Way

If your Color Picker doesn't look like this one, open Preferences and reset the Color Picker to Adobe. For Windows users, the path is Edit, Preferences, General; for Mac users, it's Photoshop Elements, Preferences, General, or simply press Cmd/Ctrl+K.

If you're put off by the infinite variations available in the Color Picker, Photoshop Elements gives you a simpler way to find the color you want: the Color Swatches palette shown in Figure 28.2. You could think of this as akin to a child's paint box, with little pats of pre-selected colors. Clicking one of these swatches sets the foreground color to that color. If it's not exactly right, you can then open the Color Picker to fine-tune your color selection.

FIGURE 28.2
The Elements Swatches palette.

The Swatches palette displays several different sets of colors. The Default set is the smallest and most limited, but the pop-up menu at the top gives you better choices. If you use a Mac, you'll want to use the Mac swatches. Windows users should use Windows swatches. If you are putting your work on the Web, choose Web Safe colors.

> Web Safe colors are common to both the Mac and Windows color set. Using them pretty much guarantees that your document will look the same on both platforms.

By the Way

All of the swatches are individual colors that can be easily described in a color model. When you look at a photograph, of course, you're not just seeing the colors in the swatches. You're seeing millions of different colors, but they are all combinations of various shades and strengths of the three primary colors, which, when we're dealing with color on a screen rather than color on paper, are red, green, and blue. Which brings us to the RGB color model.

RGB Model

The RGB model, which computer monitors and TV screens use for display, assigns values on a scale of 0 to 255 for each of the three RGB primaries. *Value*, in this usage, means the relative strength of the color. As an example, pure red (as you can see in Figure 28.1) has green and blue values of 0, and a red value of 255. Pure white places the values of all three RGB primaries at 255. Pure black places the values of the RGB primaries at 0. The reason that this makes sense is that the RGB model defines color as light. Black, which is no light, is zero. Pure white light, the total of all three primaries, has the maximum amount of all three. When you combine all three primaries at a value of 128 (about as close as you can get to half of 255), you get medium gray.

CMYK Model

The CMYK model, used for printing, defines colors according to their percentages of cyan, magenta, yellow, and black. These are the four colors of printing inks, both in your home inkjet printer and in the fancy, high-resolution color laser printers and printing presses that service bureaus and commercial printers use. As you learned in the chapter on printing, there are now six-color inkjet printers that add light cyan and light magenta, and even an eight-color printer that adds red and green.

HSB Model

When artists talk about color, they generally define it by using a set of parameters called HSB. Photoshop Elements also includes this color model. H stands for *Hue*, which is the basic color from the color wheel; for example, red, blue, or yellow. It's expressed in degrees (0–360°), which correspond to the positions on the color wheel of the various colors. S is *Saturation*, or the strength of the color, and it's a percentage of the color minus the amount of gray in it. Pure color pigment with no gray in it is said to be 100% saturated. Neutral gray, with no color, is 0% saturated. Saturated colors are found at the outer edge of the color wheel, and saturation decreases as you approach the center of the wheel. If you look at the Apple Color Picker in Figure 28.3, it's a little easier to understand this concept. *Brightness*, the relative tone or lightness of the color, is also measured as a percentage, from 0% (black) to 100% (white). Brightness is equivalent to the value used by the RGB model.

FIGURE 28.3
The Apple Color
Picker uses a stan-
dard color wheel.

The Modes and Models of Color

The difference between the modes and the models is simple. The models are methods of defining color. Modes are methods of working with color based on the models. HSB is the only model without a directly corresponding mode. CMYK and RGB have corresponding modes in Photoshop, but in Elements, you don't have to deal with CMYK. (It's not available.) There are also modes for black-and-white, grayscale, and limited color work.

The Photoshop Elements modes available under the Image, Mode menu are as follows:

- ▶ Bitmap
- ▶ Grayscale
- ▶ Indexed Color
- ▶ RGB Color

There are only three of these color modes that you'll use often: Grayscale, RGB, and Indexed Color. Let's take a closer look at them.

Bitmap and Grayscale

We'll start out here with the most basic of the color modes available within Photoshop Elements—Bitmap and Grayscale.

The Grayscale mode offers 256 shades of gray that range from white to black, whereas the Bitmap mode uses only two color values to display images—black and white (see Figures 28.4 and 28.5 for examples).

Notice the vast difference in quality. The Grayscale image has a smooth transition between values, especially noticeable on the wood floor, whereas the Bitmap image does not. There are, however, a number of ways to convert to Bitmap mode, which we'll discuss later in this chapter.

Whenever a picture is printed in black and white or grayscale—for instance, as part of a newsletter or brochure—it makes sense for you to work on it in Grayscale mode. Doing the conversion yourself, rather than sending a color photo to the printer, gives you the opportunity to make sure that the picture will print properly. You can tell by looking at it whether the darks need to be lightened or the light grays intensified to bring out more detail. You can adjust the overall level of contrast as well as working on individual trouble spots.

FIGURE 28.4
A photo rendered in the Grayscale mode.

To convert a color photo to Grayscale, simply choose Image, Mode, Grayscale. You'll be asked for permission to discard the color information. Click OK to confirm, and the picture is converted to grays. To convert an RGB picture to Bitmap

mode, as you might want to do for certain effects, you must first convert to Grayscale and then to Bitmap. First select Image, Mode, Grayscale, and then choose Image, Mode, Bitmap.

FIGURE 28.5
The same image in the Bitmap mode.

RGB

RGB is the color mode for working on pictures that will be viewed on a computer screen. It's not your only choice for working in color in Elements. There's also Indexed Color, which is used for GIF files and has advantages for web graphics. But even if your work is only going on the Web, I still recommend doing the color adjustments in RGB and then converting the picture to Indexed Color if you choose to save it as a GIF in its final form. Also, if you work in Indexed Color, you can't use Photoshop's filters or layers. That's too much of a limitation!

Indexed Color

Indexed Color, when it can work for you, is a wonderful thing. Because of cross-platform compatibility issues, web designers are theoretically limited to the 216 colors shared by Macintoshes and PCs. Indexed Color is a palette or, rather, a collection of colors—256 to be exact. With this mode, you know exactly what you are getting, and if you don't like any of the palettes Adobe supplies, you can build your own. Many web designers stick to Indexed Color palettes to ensure

consistent color. Others use any colors they want, knowing that most users don't calibrate their monitors anyway.

Indexed Color is perfect for the World Wide Web. The Indexed Color mode includes a specific web palette. Indexed Color doesn't really limit you to 216 colors, however. Dithering takes place in Indexed Color images. From RGB mode, choose Image, Mode, Indexed Color to take a look at the Indexed Color dialog box (see Figure 28.6).

FIGURE 28.6
The Indexed Color dialog box.

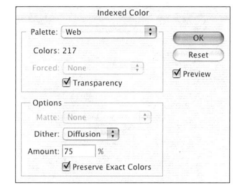

Dithering means that certain colors are combined; that is, adjacent pixels are interspersed, visually blending onscreen to create a new color although the pixels retain their original color—or the closest index equivalent—when viewed at a large magnification.

You are given a number of palette choices when you work with Indexed Color. They are as follows:

▶ Exact—This option takes the colors that are in the RGB version of the image for its palette. This works only if there are fewer than 256 colors in the original image.

▶ System (Mac OS)—This option uses the Macintosh System palette. If you are a Mac user, this palette will give you the most color options.

▶ System (Windows)—This option uses the Windows System palette. If you are a Windows user, this palette will give you the most color options.

▶ Web—This palette uses the 216 colors discussed above. If you are planning to publish your work on the World Wide Web, this is the "safe" palette. Otherwise, you might have problems with incompatible colors dropping out when an image is viewed with a web browser.

▶ Uniform—The Uniform option bases the colors in the palette on a strict sampling of colors across the color spectrum.

▶ Perceptual—This option creates a custom palette by giving priority to colors for which the human eye has greater sensitivity.

▶ Selective—The Selective palette creates a color table similar to the Perceptual color table, but favoring broad areas of color and the preservation of web colors.

▶ Adaptive—This is your best bet for most work in Indexed Color. During conversion, this option samples the most frequently used colors from the original image. Adaptive usually provides you with the closest match to the original image.

▶ Custom—If none of the other options suit you, you can always build your own palette. See the Photoshop manual for instructions.

▶ Previous—This option simply remembers and reverts to whatever option you chose last time you did a conversion to Indexed Color.

Just for fun, why don't we dive in with a hands-on exercise before we go any further? Because the pictures in the book are mostly in black-and-white, working through this exercise will give you a better idea of the concepts and ideas we have been talking about. Let's look at a colorful image and examine how the modes affect the way the color appears.

1. First, find a colorful picture and open it. You can download the photo in Figure 28.7 from the Sams website. The image is called Balloons.jpg. To get to the website, point your web browser to http://www.samspublishing.com/. In the Search box, type "Photoshop in 24". Find this book in the list that appears, and click the link. On the book's main page, find and click the Related Materials link to get to the files. If your picture doesn't have the letters *RGB* in parentheses after the title, choose Image, Mode, RGB Color. This is your starting point. If your monitor is correctly adjusted, you should see very good color.

FIGURE 28.7
Balloon Festival
from mid-air. (Photo
by Linda
Pendleton.)

2. Select Image, Mode, Grayscale. A dialog box appears, asking whether you want to discard the image's color information. Click OK. Photoshop then examines your image and assigns all the colors to 256 shades of gray that range from white to black.

Notice in the status bar at the bottom of the picture how the size of your file diminishes. This is because the amount of information or data in a color image is much greater than that required to display a Grayscale image.

If you have a color printer, you might want to revert to RGB (Edit, Revert to Saved) and print your picture and compare it to what you see on the screen. Does it look OK? If so, you're in luck. Your monitor is accurately calibrated. If not, you need to calibrate your monitor so that the images onscreen accurately display the colors as they print. See "Calibrating Your Monitor," later in this chapter.

By the Way

The human eye is extremely sensitive to even the slightest variation in color. Think for a moment about something familiar—a can of Coca-Cola. I'll bet that if you were shown two swatches of red you could, without much hesitation, select the Coke's red and differentiate it from, say, the red used on the cover of Time magazine. If you

saw cans of Coke displayed with a slightly off-color red, you'd probably think they were either outdated or perhaps counterfeit. Most people are very much aware of even slight color changes. That is why color becomes so important in the branding of products through advertising.

Color Bit Depth and Why It Matters

Bit depth is a way to describe how much color information is available about each pixel in an image. It's also called *color depth* or *pixel depth* and, as with so many other things, more is better. Greater bit depth (more bits of information per pixel) means more available colors and more accurate color representation in your digital pictures. Consider this: a pixel with a bit depth of 1 has only two possible values: It's either black or white. A grayscale pixel with a bit depth of 8 has 2 to the 8th power, or 256 possible values. And a pixel with a bit depth of 24 has 2 to the 24th power, or about 16 million possible values. Common values for bit depth range from 1 to 64 bits per pixel. You will find that your Photoshop Elements images tend to be primarily 16-bit color, because they are imported as such from your digital camera or scanner. More information means larger files and longer working times, of course, but it also means truer color.

It's actually a little bit misleading to call 8-bit color by that name. Depending on the color mode you've chosen to work in, you have anywhere from 8 to 32 bits of information for each pixel. In RGB mode, you have 8 bits each of the red, blue, and green color channels, making 24 bits of color information. You can reduce a 16-bit color file to 8-bit color in the Image, Mode menu.

In previous versions of Photoshop Elements, not all of the tools and filters worked with 16-bit color. Even though Elements can work in 16-bit color, your monitor can't show you all the millions of colors your image has. And your home/office inkjet or color laser printer can't possibly reproduce them. Within a year or so, this may change as new HDTV monitors and better printing inks come on the market. Adobe has, in effect, raised the bar, and now makers of monitors and printers will have to jump that much higher. But for now, you can save time and storage space by converting 16-bit images to 8-bit color before working on them in Elements. Keep important originals on a CD-ROM somewhere, and work on them again when you've got a monitor and printer that can handle the additional quality.

Calibrating Your Monitor

Your monitor will display color more accurately if you use color management. Many printers come with ICC profiles, a set of directions that translate what you see on the screen into what combination of ink dots the printer uses to reproduce that color. Calibrating your monitor means setting it to a standard that the ICC profile can then interpret and work with.

By the Way

> If you have an LCD monitor, skip the calibration. Use the generic profile that came with the monitor.

Before you attempt to calibrate the monitor, make sure it's been turned on for at least a half hour, and that the room lighting is whatever it normally is when you are working. Differences in light can affect the way colors appear.

In Windows, you can use the Adobe Gamma software that installed along with Elements. It's located in the Windows Control Panel. Choose the wizard to calibrate step by step. Just follow the steps on the screen. Mac users—open Applications, Utilities, Display Calibrator Assistant, and follow those steps.

Summary

Color is fun to play with, but it's also rather complicated to understand. The world in general, and Elements in particular, uses color models as a way of describing colors. The Elements color models are HSB, RGB, Indexed Color, Grayscale, and Bitmap. There are also color modes, which enable you to work with color. RGB is the most useful color mode because it's the one your monitor displays. CMYK mode and Grayscale modes are used for printing, but Elements and your print driver can handle any necessary conversions.

In this chapter, we discussed the color modes and the specific color models in Photoshop Elements. We also looked at a few of the more salient issues regarding converting between modes.

Creating Art from Scratch

What You'll Learn in This Chapter:

- ▶ Choosing Colors
- ▶ Using the Shape Tools
- ▶ Using the Brush Tool
- ▶ Adding New Elements to an Existing Picture
- ▶ Using the Pencil Tool
- ▶ Using the Eraser Tools

Up to now, we've mostly talked about how to correct existing images such as photographs. Sometimes, you need to create your own images, such as logos and web buttons. Using the painting and drawing tools in Elements, it's easy to create your own art. In this chapter, you'll learn about some of the painting tools, including the Eraser and the Shape tools.

Choosing Colors

The tools in Elements use the foreground color, the background color, or a combination of both. So before you use most tools, you should set these colors. Some tools give you the option of selecting a color for use with just that tool, as you'll see shortly.

The most flexible way to select a color for the foreground or background, or for exclusive use with a particular tool, is to click the appropriate color swatch at the bottom of the toolbox or in a tool's Options bar, and then choose a color from the Color Picker (more on this in a moment). The swatches in the toolbox set the foreground and background colors; a separate swatch may appear on a tool's Options

bar; if so, click it to display the Color Picker so you can change the color used with that tool.

Using Color Pickers

You actually have a choice of Color Pickers. Which one you use (Adobe, Apple, or Windows) depends on which one you selected in the Preferences dialog box. You can always open the General Preferences to see which is selected, if you forget. Adobe's Color Picker, shown in Figure 29.1, is probably your best bet. It gives you the most options.

FIGURE 29.1
Select a color with
the Adobe Color
Picker.

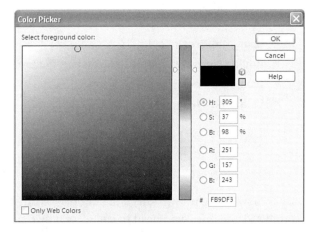

The original color appears in the top swatch on the right of the Color Picker; the color you're about to change it to appears beneath. To select a new color, you've got lots of options. To select a color visually, adjust the narrow color slider so that the range of colors from which you want to select appears in the large color field. Then just click the color you want, or drag the Color Selector pointer around until the exact color you're looking for appears in the bottom Selected color swatch.

If you'd rather not select a color visually, you can choose a color by entering values into either the HSB or the RGB boxes, to the right of the color slider. You can also enter the hexadecimal value for the number in the # text box at the very bottom of the list if you prefer—this is the same number you would enter within your HTML code to specify a particular color. If you're one of those people who can think of colors in terms of numbers, one of these non-visual methods is probably for you. If you want a refresher course on the various color models used by Elements, jump back to Chapter 14, "Printing Your Pictures," and Chapter 28, "Color Modes and Color Models."

Notice the warning cube just to the right of the Selected color swatch in Figure 29.1. It appears whenever the color I've just selected is not one of the web-safe colors—the 216 colors shared by the Windows and Mac operating systems. If I'm not going to display this image on the web, I can safely ignore this warning. However, if I want to limit my choices to only web-safe colors, I can select the Only Web Colors option. This prevents non-web–safe colors from appearing in the color field.

> If you click the small color block just under the warning cube, Elements will switch the selected color to the closest web-safe equivalent.

By the Way

After choosing the color you want to use, click OK.

Using the Swatches Palette

Another method for selecting the color you want to use is to click it within the Swatches palette, shown in Figure 29.2. The palette, as you can see, looks like a sort of paint box. The Swatches palette helps you build and store a consistent set of colors for use in refining an image. To display the Swatches palette yourself, click its tab in the palette bin, or if it isn't there, choose Color Swatches from the Window menu.

FIGURE 29.2
The Swatches palette has several different sets of colors, including web-safe colors and Windows OS colors.

Elements comes with seven different sets of swatches, which you can select from the pop-up menu at the top of the palette. The Default swatch set contains a sample of the most often used colors, but you can add colors to this set or any of the other swatch sets if you'd like. To add the current foreground color as a new swatch to the displayed swatch set, just click in the empty area of the Swatches palette. You'll be asked whether you want to give the new color a name, and then it will be saved for you at the bottom of the palette. If you want to replace a swatch with the current foreground color, press Shift as you click the swatch. To remove a swatch from a set, drag it to the trash can icon at the bottom of the palette or Option/Alt-click it.

After opening the Swatches palette and choosing a swatch set to display, you can select a color for use as the foreground color by simply clicking it. To select a color as the background color, press Cmd/Ctrl as you click it.

Other Tips for Selecting Colors

If the image itself contains the color you want, there's a simple method for choosing it. Simply click with the Eyedropper tool on the color in the image, and the foreground color will immediately be changed to match. You can click with the Eyedropper in any open image, even if it's not the one you're working on. To change the background color using the Eyedropper, press Option/Alt and click within the image.

If a tool has its own color swatch, you can change its color by changing the foreground color. You can also change the tool color with the Eyedropper. Just select the tool you want and press Option/Alt as you click in the image. This action changes the foreground color and the tool color at the same time. If you want to change only the tool color, you'll need to use the Color Picker method, by clicking the Tool color swatch.

If the colors you want to use as the foreground color and the background color are reversed, switch them by clicking the Switch Colors icon in the upper right, as shown in Figure 29.3, or by pressing X. To set the foreground color and background color to the default colors (black and white), click the Default Colors icon in the lower left or press D instead.

Switch colors

Foreground color

Background color

Default colors

FIGURE 29.3
The current foreground and background colors appear at the bottom of the toolbox.

Using the Shape Tools

Using the various shape tools, you can create rectangles, ellipses (circles and ovals), lines, polygons (shapes with flat sides such as diamonds), special shapes such as musical notes, dog paw prints, word balloons, and even custom shapes (I'll show you how in a few pages). When you create a new shape, it's placed on a new layer by default. You can override this setting whenever you want to place more than one shape on a layer. You might want to group shapes this way to make them easier to format and place within an image.

You can also combine shapes on one layer to create a single shape. Or you can choose to display only the area where the shapes intersect, or to exclude this overlapping area. For example, if you draw a square and then add a second square that overlaps it partially, using the option to display only the area where the two shapes intersect, that intersecting area will be the only portion of the two squares that is retained. If you draw the second square using the Exclude option, the only portions retained will be the areas where the shapes *do not* overlap.

To draw a shape, follow these general steps:

1. Click the Shape tool button (the fourth one down on the left if you have a single-column toolbox, or the middle one on the right if your screen displays a double-column toolbox—The Shape tool looks like a blue pillow when the mouse is over it) and select the specific shape you want to draw, such as Rounded Rectangle, from the left end of the tool's Options bar. You can also select the Shape tool by pressing the letter U, or select the shape you want to draw by clicking and holding down the Shape tool button and choosing a shape from the pop-out menu that appears.

2. Set your options on the Options bar. We'll discuss each of these options in a moment.

3. Drag in the image to create the shape. Typically, I click at the upper left and drag down and to the right to create a shape.

Changing the Style

The preceding steps describe how to draw a single shape using the current settings, which will typically draw the shape without a border and fill it with the color shown in the Tool color swatch (which initially matches the foreground color).

But as you can see on the Shape tool's Options bar (shown in Figure 29.4), there are many settings you can adjust. Some settings you can change after the fact, as you will see later in this section. But first, let's take a look at the settings you might change before you draw your shape.

FIGURE 29.4
Set your options before drawing your shape.

The simplest option to change is whether or not the shape has a style, such as a border of some sort, a shadow, or a textured fill. You select a style from the Style list (before or after drawing a shape—the Style setting affects the current selected shape, but if none is selected, it affects the shape you're about to draw), which is located toward the right end of the Options bar. Initially, the style is set to None, which means you'll get a shape filled with the tool color, and with no border. Click the down arrow on the Style list to reveal a group of styles, such as the Bevel styles, which add a bevel edge to a shape. You can display a different group of styles by clicking the right arrow at the top of the palette and choosing another set from the menu that appears, as shown in Figure 29.5. To return to drawing shapes without a style, select Remove Style from the menu.

FIGURE 29.5
If you apply a style to a shape as you draw it, think of how much time you're saving.

You cannot use the Edit, Stroke command to add a border to a shape, as you can to a selection or a layer. That's because the shape is editable. If you first simplify the layer on which you've drawn shapes (Layer, Simplify Layer) or click the Simplify button on the Options bar, you can use one of the selection marquees to select the shape's outline and stroke it. But first try out some of the many style options explained here; you may find exactly what you're looking for, and with less trouble.

Did you Know?

Setting the Geometry Options

You might also want to change the geometry options before (but not after) drawing a shape. These options control how a shape is drawn and can help you draw a shape with more precision. The geometry options vary with the type of shape you've chosen from the left side of the Options bar. To display the Geometry Options palette, click the Geometry Options down arrow at the end of the shapes palette.

The only way to explain the geometry options is to take them one shape at a time. The Rectangle, Rounded Rectangle, and Ellipse tools share similar geometry options:

▶ When you select Unconstrained, your dragging motion determines the shape.

▶ If you select Square or Circle, you can determine the size by dragging, but the shape will be drawn as a perfect square or circle.

▶ Select the From Center option to draw the shape from the center out, rather than from the upper-left corner to the lower-right corner.

▶ Select the Snap to Pixels option to help you draw a rectangle/rounded rectangle with borders that sit on the pixels' boundaries.

▶ To constrain the shape to a particular height/width, select Fixed Size and enter one or both values.

▶ To retain a particular proportion to the shape as you drag, select the Proportional option and enter the proportions in either or both boxes. The resulting shape will be proportionate to the size of the shape you drag to create. For example, if you enter a 2 in the W box and a 1 in the H box, your shape will be twice as wide as it is high.

The Rounded Rectangle tool has one other option on the Options bar itself, and that's Radius. The value you enter here determines the curve at the corners of the rectangle you draw.

The Polygon tool has its own set of geometry options: The Radius value sets the exact distance from the center of the polygon to its corners; by changing this value, you can draw a polygon of an exact size. The Smooth Corners option renders a polygon with rounded corners rather than sharp angles. To draw a star, select the Star option and then set related options: Indent Sides By sets the angle of the points by forcing the sides to fit the proportion you enter, and Smooth Indents adjusts the angle of the points even further, to lessen the inside angles. The Polygon tool has one other option, displayed on the Options bar but not on the Geometry Options palette: the Sides value. As you may have guessed, this value tells Elements how many sides of equal length you want your polygon to have.

As you can see from the Geometry Options palette for the line shape shown in Figure 29.4, you can add an arrowhead at the beginning or end of the line by choosing Start, End, or both. After turning on either arrowhead, set the arrowhead's width and length, which are proportionate to the width and length of the line itself. Curve the sides of the arrowhead by entering a Concavity value other than zero. The Line tool has one other option as well that is not shown on the Geometry Options palette, but appears on the Options bar: the Weight option, which controls the thickness of the line. Fat lines, anything over three pixels thick, are filled with the foreground color.

By the
Way

If you want to draw a shape, fill it with one color, and stroke it with a different color, you can do so. First draw the filled shape. Simplify it, and select it. Then you can stroke it with as many colors as you want.

Now that you know a bit about drawing each type of shape, let's discuss the other settings on the Options bar that appears for most shape tools.

Drawing Additional Shapes

After drawing one shape, you may want to draw another. After all, most shapes are actually made up of many ellipses, rectangles, lines, polygons, and so on. To change to a different shape tool so you can draw a different shape, click the shape's button (located at the left end of the Options bar). Then change any geometry options you want, and change any additional settings we've already talked about. You're now ready to click in the image and drag to draw the new shape. Before you do, however, you might want to consider how that shape will affect the other shapes in your image.

The shape area buttons to the left of the color swatch in the Options bar (see Figure 29.6) require a bit of explanation before you use them. The first button in that set is Create New Shape Layer. If this is selected (which it normally is by default), a *new* layer will be created automatically when you draw the shape. If you choose any other option, you'll draw the new shape on the *current* shape layer. The next button, Add to Shape Area, dictates not only that the shape you draw will appear on the current shape layer, but that the two shapes will be treated as one shape for the purposes of formatting, resizing, moving, and so on. If you select Subtract from Shape Area, the second shape will not be filled and the area where the two shapes overlap will be removed from the original shape. Think of this option as cutting away part of the original shape with a shape tool.

If you select Intersect Shape Areas, only the intersection of the two shapes is filled. If the second shape doesn't intersect the first, neither shape is filled. The last button, Exclude Overlapping Shape Areas, is the exact opposite; the area where the two shapes intersect is left unfilled, and other non-overlapping areas are filled.

Subtract from shape area

Create new shape layer

Exclude overlapping shape areas

Add to shape area

Intersect shape area

FIGURE 29.6
Use these buttons to control how a new shape affects other shapes.

There's one last thing you need to consider before you draw additional shapes: the fill color. When you draw your first shape, it's filled with the tool color shown in the color swatch at the right end of the Options bar. Initially, this color is set to the foreground color, but you can change it before you draw the shape in any of the ways discussed earlier in this chapter.

When you're ready to draw additional shapes, *do not change the tool color or the style, unless you're starting a new shape layer*. Otherwise, you'll change the fill color or style of the shape you just drew. Instead, draw the shape, and then, while it's still selected, change the color or style as desired.

To remove a style, select the shape that has the style applied, and choose Remove Style from the Styles pop-out menu on the Shape tool's Options bar.

Finding More Custom Shapes

To create a custom shape such as a rabbit, choose the Custom Shape tool from the Shape tools list; it looks like a comic-strip dialog balloon. On the Options bar,

open the Shapes list; a palette of default shapes appears. If the shape you want to draw is not shown, click the right-pointing arrow to open a menu of other shape groups. To draw a rabbit, for example, click the arrow and select Animals. Then click the rabbit shape in the palette.

After selecting the custom shape you want to draw, set other options as desired, such as the color and shape area options. Then drag in the image to create a shape.

Unfortunately, Photoshop Elements doesn't have a way for you to create and save your own custom shapes, logos, and so on. (You can do this in Photoshop CS. It's one of the few good reasons to consider upgrading.)

Selecting a Shape

Use the Shape Selection tool (the arrowhead pointer located to the left of the shape buttons on the Options bar) to select a shape so you can move, copy, delete, rotate, or resize it. Just click the tool and then click the shape you want to select. *Handles* (small open squares) appear around the selected shape, as shown in Figure 29.7. Drag the handles outward or inward to resize the shape. Dragging a corner handle maintains the *aspect ratio* (the width in relationship to the height). To change only the horizontal or vertical width, drag a side handle. To resize a shape by a certain amount (that is, to *scale* it), enter the appropriate values in the boxes on the Options bar. You can enter a value in the Set Horizontal Scale box, and click the Maintain Aspect Ratio button to automatically adjust the Vertical value by a proportionate amount. When you're done, click the check mark to commit the change.

With the Shape Selection tool, click the center handle (which looks like a cross) to move the shape. If you want to move all the shapes on a layer together, use the Move tool instead. Click the Move tool, then click anywhere on the shape layer. Drag the selection to move the shapes as a group.

You can also rotate, skew, or distort a selected shape using the techniques you learned in Chapter 20, "Cropping and Resizing a Photo."

FIGURE 29.7
Handles appear around the select-ed shape(s).

For a bit of hands-on practice, let's use the shape tools to create a small object: an umbrella. Start a new image using default size, RGB color, and a white background.

1. Select the Ellipse shape tool. Select a bright color for your umbrella, such as blue or yellow. Make sure that the Create New Shape Layer button is selected in the Options bar.

2. Click in the image and drag to create an oval umbrella shape.

3. Click the Subtract from Shape Area button. Then click the Rectangle tool and use it to cut out the bottom of the oval, flattening it.

4. With Subtract from Shape Area button still selected, click the Ellipse shape tool again. Draw small circles with the Ellipse tool that cut out portions of the flattened bottom of the umbrella shape, creating its scalloped edge. Your shape should look roughly like the one shown in Figure 29.8.

FIGURE 29.8
Our umbrella is
taking shape.

5. Select the Rectangle tool and click the Create New Shape Layer button in the Options bar.

6. Draw a small rectangle at the top of the umbrella. Draw a long, thin rectangle at the bottom of the umbrella for the handle.

Did you Know?

Remember that you can move a selected shape by dragging it. This will help you get all the pieces of your umbrella in line. To select a shape, click on it with the Shape Selection tool.

7. Select the Ellipse tool, and draw a small circle at the base of the thin rectangle, creating the bottom of the curved handle.

8. Click the Subtract from Shape Area button in the Options bar and draw a smaller circle slightly above the first circle, creating the upper part of the curved handle. At this point, your image has several layers; that's okay. Your umbrella should look roughly like the one shown in Figure 29.9.

9. Name your drawing file umbrella.psd and save it. You will be refining it later in this chapter.

FIGURE 29.9
Let a smile be your
umbrella.

Using the Brush Tool

With the Brush tool, you can paint color on an image with hard or soft brushes of various widths and degrees of opacity. There are also brushes with special tips for painting with stars, grass, leaves, and other shapes. You can even imitate chalk, charcoal, hard pastels, oil pastels, dry brush, watercolor, oils, and other artistic techniques.

> When you paint with the Brush tool, the paint is applied to the current layer, so make sure you change to the layer you want to use before painting.
>
> Also, if you paint on a layer containing text or a shape, that layer will need to be simplified first, which means that the text/shape will no longer be editable. In such a situation, Elements will typically ask you if you want to simplify the layer, and all you'll need to do is click Yes to proceed. If you want to simplify a layer yourself, select it from the Layers palette and choose Layer, Simplify Layer.

Setting Brush Options

To use the Brush tool, click it or press the letter B and then choose the color you want to paint with (the foreground color). Set your options from the Options bar, shown in Figure 29.10. Choose the brush tip you want from the first drop-down list. Adjust the size as needed.

Choose a blending mode and a level of opacity if you like. Blending is rather complex, so it's explained in detail in Chapter 31, "Making Composite Images." Opacity, as explained in Chapter 17, "Making Selections and Using Layers," adjusts the strength of your paint—with a low Opacity value, the paint color will

not cover any color or image beneath it. A higher Opacity value creates a more solid paint that covers any color or pattern you paint over.

FIGURE 29.10
Set the brush options before you start.

Blending mode Airbrush

Opacity

If you click the Airbrush button, you'll be able to control the flow of paint by varying the amount of time you press the mouse button down and remain in one spot. The Airbrush button is on the Brush tool's Options bar, and looks like an airbrush—a pen with a hose attached.

After making selections, paint with the brush by clicking on the image and holding the mouse button down as you drag. Release the mouse button to stop painting.

Painting with the Impressionist Brush

The Impressionist Brush doesn't paint, so you won't use it to create art. Instead, you use this brush to change the texture of an image to simulate the look of an impressionist painting or a pastel drawing. The effect is that the brush creates a wet paint–like pattern by borrowing the colors that are already present in the image. The brush makes the image look as if it were painted using a freestyle technique, as shown in Figure 29.11.

FIGURE 29.11
Give your images the look of a classic painting with the Impressionist Brush. This painting combined the dab and short loose strokes options.

Because the Impressionist Brush doesn't paint new colors onto the existing image, the current foreground and background colors are set aside. Instead, this tool samples the pixels in the area you define, and then uses a brush tip the size you specify to fill the area with a mix of the sampled colors.

To begin, click the arrow on the Brush tool in the toolbox and choose the Impressionist Brush tool. Select a brush tip and size. A small brush tip works best for me, but feel free to experiment. Set the blending mode and opacity. The blending mode controls how the pixels painted by the brush are blended with the original pixels—again, you'll learn more about blending in Chapter 31. If you want more definition in the finished image, set a low Opacity value so the brush doesn't completely obscure the sharp edges in the image underneath.

Before you begin painting, click the More Options button to set these options: the Style menu controls the style of the brush stroke, from tight, short strokes to loose and curly strokes. The Area value controls the area of pixels painted by the brush. If you enter a large number, a large number of pixels surrounding the brush tip will be changed. A smaller area provides more control, but requires you to paint more strokes to change a large portion of an image. Finally, set the Tolerance level: With a low Tolerance setting, you'll change only pixels that are very close in color to the ones you brush over. A higher Tolerance value allows more pixels in the designated area to be changed, as long as they are sufficiently similar to the pixels you paint over.

After setting options, drag over the image to change pixels of similar color within the designated area.

Adding New Elements to an Existing Picture

Remember that umbrella you created a few pages back? Let's put it to use as we practice a new technique. Let's make it rain. There are many ways in which you might create a rain effect for an image. We'll use the Brush tool to create a simple effect.

1. If it's not already open, open the umbrella.psd file.

2. Open the Layers palette and make the Background layer active.

3. Select the Brush tool. Choose a 14-pixel Spatter brush tip (you'll find Spatter near the middle of the brush tip drop-down list—just rest the mouse pointer on a brush tip style in the list, and its name appears). Use Normal blending mode and 100% Opacity. Set the foreground color to a light grayish blue.

4. Draw diagonal lines close together, in the manner of wind-swept rain. Make sure you don't draw rain under your umbrella!

5. Click the Impressionist Brush button on the Options bar. Click the More Options button, and set the Style to Loose Medium, the Area to 20 pixels, and the Tolerance to 0.

6. Drag back and forth over your rain streaks, softening them. Your image will look something like the one shown in Figure 29.12.

7. Save the image and leave it open.

FIGURE 29.12
A little rain never hurt anybody.

Using the Pencil Tool

Using the Pencil tool is remarkably like using the Brush tool. With the Pencil tool, you can draw hard-edged lines on an image in your choice of color.

Setting Pencil Options

Simply click the Pencil tool or press the letter N, and select a color for the tool by changing the foreground color. Select a pencil tip from the first drop-down list in the Options bar, adjust the width of the drawn line, set the blending mode, and change the opacity as desired. Then click on the image, hold the mouse button down, and drag to draw a line.

Selecting the same tip with the Brush tool and the Pencil tool produces different results, as you can see in Figure 29.13. The brush line is much smoother and more subtle than the pencil line.

Replacing One Color with Another

You can replace one color with another using the Pencil tool and the Auto Erase option. First, change the foreground color to the color you want to replace. Remember that, after opening the Color Picker, you can click anywhere in the image with the eyedropper pointer to "pick up" or choose that exact color. After selecting the color to replace, set the background color to the color you want to replace it with. Then choose your pencil tip and set your options. Be sure you select the Auto Erase option at the right end of the Options bar. Then draw by dragging over the image. If you start with the pencil over an area that contains the foreground color, that area of color will be replaced by the current background color. Other parts of the image will remain unaffected even if you drag over them. Even if the Auto Erase option is selected, if you start drawing with the pencil over some color *other* than the foreground color, the pencil will act as if Auto Erase is turned off.

Now, let's finish that umbrella. With the Pencil tool, it's easy to draw some ribs on your umbrella.

1. With the umbrella.psd file open, click the Pencil tool.

2. Create a new layer above the others by clicking the New Layer icon in the Layer palette.

3. Set the foreground color to one that's slightly lighter than the umbrella color, such as a light yellow or light blue.

4. Select the Hard Round brush tip style from the list, set the tip size to 3 pixels, and draw ribs from the top of the umbrella to each of its points. The result is a rather whimsical rendition of an umbrella in the rain, shown in Figure 29.14. Just for fun I added a duck.

5. Save and close the image file.

FIGURE 29.14
The final version of
our umbrella.

Using the Eraser Tools

All the Eraser tools change pixels in your image in a particular way. You've learned that you can replace one color with another by choosing the Auto Erase option and drawing with the Pencil tool. In this section, you'll learn about two of the other tools Elements provides for erasing parts of an image: the Eraser tool and the Background Eraser tool. In Chapter 32, "Going Wild with Your Images," you'll learn how to use the Magic Eraser tool.

Erasing with the Eraser Tool

When you drag over pixels with the Eraser tool, the pixels are removed and made transparent so that lower layers can show through. If you use the Eraser tool on the Background layer or any other layer with locked transparency, the result is different. Instead of erasing pixels and making them transparent, the tool replaces the pixels you drag over with the background color.

To use the Eraser, activate the layer you want to erase a portion of, and click the Eraser tool or press the letter E. Select from one of three Modes using the pop-up menu on the Options bar: Brush (which provides a settable brush tip), Pencil (which provides the harder-edged pencil tip), or Block (which uses a square blocky tip). If you choose Brush or Pencil, select the exact tip to use from the drop-down list and adjust the size. With the brush or pencil tips, you can also adjust the Opacity setting to limit the strength of the eraser—a lower Opacity level causes the brush to erase to only partial transparency or to the background color, depending on which layer you are erasing on.

After setting options, click and drag on the image to erase pixels, as shown in Figure 29.15.

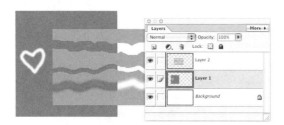

FIGURE 29.15
Erase on a layer and let the background shine through.

Erasing with the Background Eraser Tool

You use the Background Eraser tool to erase or remove the background from around an object without erasing part of that object in the process. The theory behind its operation is that an object's color generally differs greatly from the color of the background that surrounds it. As you click and drag the brush over the image, the Background Eraser continually samples the color under the *hotspot* (the small cross in the center of the tool's pointer), and sets that color as the background color. It then erases only colors that closely approximate this background color as you drag the eraser over them.

You can safely set the eraser to a large size (the pointer will then look like a wide, transparent circle). The large size is safe to use because the Background Eraser does not erase all the pixels in that circle (under the eraser); instead, it erases only the pixels within the circle that match or nearly match the one under the hotspot. To erase all the background pixels surrounding any object—for instance, a car on a street, or a single flower in a garden—you carefully drag the eraser with its hotspot *near*, but not *inside*, that object. If the circle area of the eraser should fall within the object's border, the object remains safe, so long as the hotspot rests over a color that's substantially different. So if you drag this eraser entirely around an object whose color stands out from its background, you'll erase only the background and leave the object intact.

To use the Background Eraser, click the arrow on the Eraser tool button in the toolbox and select this tool. Adjust the size of the eraser as desired in the Options bar, and then select one of the two options from the Limits menu: Contiguous erases pixels under the eraser that match the sampled color and that are touching, or contiguous to, the hotspot itself. If you select Discontiguous instead, any pixel under the eraser whose color closely matches the sampled hue will be erased. You can control how closely pixels must match the sampled pixel by

adjusting the Tolerance value. A lower value limits the number of pixels that match the sampled pixel. A higher value allows you to erase a greater variety of pixels. After setting the options you want, click on the background to sample its color, then drag with the Background Eraser on the image to erase the background, as shown in Figure 29.16.

FIGURE 29.16
Use the Background Eraser to separate an image from its background.

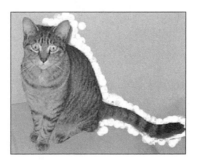

Summary

With the drawing tools in Elements, it's easy to create simple images such as logos and clip art, or to edit an existing graphic so that it suits your needs more exactly. The options for each tool give you control, while allowing you the freedom to experiment as you wish. Please take some time to play with these tools and get to know what they can do. You'll be very glad you have them some day when you need to disguise a double chin or add a highlight to a piece of chrome.

Using the Artistic Filters

What You'll Learn in This Chapter:

▶ Using the Watercolor Filters
▶ Simulating Oil Painting
▶ Working with Pastels, Chalk, Charcoal, and Pen
▶ Creating a Neon Effect with Glowing Edges
▶ Texturizing with Grain
▶ Sponging an Image

One of my favorite activities in Photoshop, and in Elements, is to turn some of my less spectacular photos into fine art. I am constantly surprised at the effects I can get by combining several filters, or by changing the order in which I apply them. The artistic filters will enable you to mimic most of the available art media, from oil painting to neon tube sculpture. You can rescue a "bad" picture or create a real masterpiece from a good one. More to the point, it's fun. One of my sons once told me that he thought Photoshop was "the best video game ever." And that was at least four versions back.

Under the general heading of "Artistic Filters," I've chosen to also include the Brush Strokes, Pixelate, Sketch, and Stylize filters. Each category includes filters that mimic a specific art style or medium.

The best way to see what specific filters can do, other than applying them to your own photos, is to look at the examples provided in the Filter Gallery. You can open the Filter Gallery from the Filter menu. You also have the option of seeing it or not when you open any filter dialog box. As you can see in Figure 30.1, the middle panel of the Filter Gallery dialog box lists the various types of filters by category. When you click on a folder tab, the filters in that category are displayed. If you

select a filter from the Gallery to apply to your picture, the right panel shows the variable settings for that filter. If no filter is selected, the panel is blank, as in the figure.

If you select a filter, either by using the Gallery or from the Filter menu, you can use the arrow button to toggle the Gallery display on or off. When it's off, you can see a much bigger area of the image instead of just a slice of it.

Using the Watercolor Filters

Artists who work in other media have a great deal of respect for those who can paint with watercolors. It's arguably the most difficult medium, because you have to work quickly, before the paint dries. But you also have to avoid working with your paint or paper too wet, or else you'll end up with nothing but a puddle. Digital paint is, of course, much neater to work with. It doesn't get under your fingernails or leave a mess to clean up. And if you take your picture a step too far, you can always undo.

Elements has one specific watercolor filter (Filter, Artistic, Watercolor). It gives you one style of watercolor, which is kind of dark and blotchy. There are ways to make this filter work better, and there are other filters that also create watercolors in other styles, but we'll start with the official one. First of all, let's look at the photo that will eventually be a watercolor (see Figure 30.2 and the color plate

section). As a photo, it's not very exciting. The composition and focus are okay, and it's well exposed, neither too dark nor too light.

FIGURE 30.2
This is just an average beach.

The Watercolor filter, like most filters, has a dialog box with several options, which are shown in Figure 30.3. You can set the Brush Detail, Shadow Intensity, and Texture. Brush Detail ranges from 1 to 14, with greater detail at the high end of the scale. Shadow Intensity can be set from 1 to 10, again with much deeper shadows as the numbers get bigger. Texture ranges from 1 to 3, but there's not a lot of difference between the settings.

In Figure 30.3, I have applied the filter with a Brush Detail of 11, a Shadow Intensity of 1, and Texture of 1. But I am not very happy with the result. It's too dark. What would happen if I went back to the original photo, lightened it, and then applied the filter? That would change how the filter was calculated, and might give me a better result. In Figure 30.4, I lightened the original photo by about half using Enhance, Adjust Lighting, Brightness/Contrast, and then applied the filter. It still came out darker than I wanted, so I went to the Levels dialog box (Enhance, Adjust Lighting, Levels) and brightened it there. The result is Figure 30.5. It's looking much better now, but I think that what I really need is a different kind of watercolor.

FIGURE 30.3
The Watercolor fil-
ter dialog box.

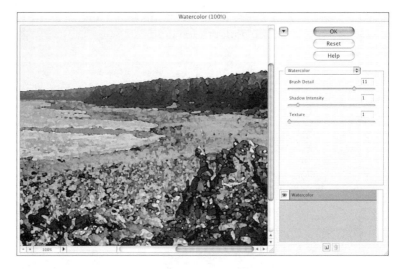

FIGURE 30.4
Ugh, it's too dark.

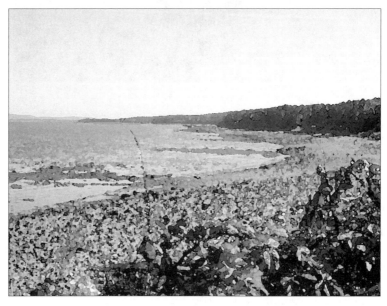

FIGURE 30.5
That's better. To make some filters work properly, you often must make changes to the original image that you wouldn't accept otherwise.

Dry Brush

The Dry Brush filter (Filter, Artistic, Dry Brush) simulates a watercolor technique that, as the name suggests, uses less water and more pure pigment. It's good for detail and doesn't darken the picture the way the Watercolor filter does. With this filter, you can set the Brush Size, Brush Detail, and Texture. Brush Size controls the level of detail—with a larger brush, you'll get bigger splotches of color and you'll lose the parts of the image with small areas of color. Brush Detail increases the number of tones, softening the edges. If I set Brush Detail to a high value, for example, I'll see more shades of brown and gray used in the rock areas of my photo. This will also provide more detail than a big spot of gray or brown would. Texture again ranges from 1 to 3, and it controls the level of contrast. The highest setting, 3, makes the areas of individual color more apparent.

In Figure 30.6, I have applied the Dry Brush filter with a Brush Size and Texture of 2, with Brush Detail set to 9. Because this is so close to the look I wanted, I spent an extra minute lightening the bushes and adding a little extra color to the rocks with the Sponge and Dodge tools. Remember, just because you have used one tool doesn't mean you can't go on and use others. The point is not to master perfect technique with only one kind of filter, but to make a picture that pleases you, no matter *what* you have to do to get there.

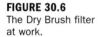

FIGURE 30.6
The Dry Brush filter
at work.

Spatter

Spatter is an interesting filter, which can be used for a different watercolor style or perhaps to simulate a gouache painting. (Gouache is a thicker, water-soluble paint, more opaque than typical watercolors.) Spatter is located on the Filter menu under Brushstrokes. The Spatter dialog box has only two settings: Spray Radius and Smoothness. If you imagine that you're using an airbrush, you'll soon get the idea: Spray Radius adjusts the range of the spray, while Smoothness adjusts the density or coverage of the spray, and hence, its smoothness. I'm going to try it on a slightly different seascape, which has more detail.

Figure 30.7 shows the Spatter dialog box, and indicates that we might have a problem using the Spatter filter with this particular subject.

The problem that shows in the preview window is that horizons are supposed to be flat, no matter how rough the water is. After all, you can't see the detail of the waves from three miles away, which is about how far the horizon is if you're at sea level and about 6 feet tall. So rather than give up on this filter, we'll simply mask the horizon line and let the filter apply to the rest of the image. The easiest way to do so is to drag a marquee along the horizon line in the original image, and then to invert, so everything except the horizon is selected. Figure 30.8 shows this step.

FIGURE 30.7
Spatter makes the water look nice and wet.

FIGURE 30.8
This is the simplest kind of masking.

Now, when I apply the filter, the horizon stays unspattered, and looks much more realistic. The final version in Figure 30.9 is also in the color plate section.

FIGURE 30.9
This definitely looks
painted.

Simulating Oil Painting

There are as many styles of oil painting as there are people who paint; all the
way from ultrarealistic, tight little brush drawings to big, splashy, abstract swipes
of color. Traditional painters begin a new canvas by creating an underpainting,
which lays out the scene with a big brush in blocks of color showing little or no
detail. When they have the basic underpainting done, they go back with smaller
brushes and add detail.

Underpainting

In Figure 30.10, I'm applying the Underpainting filter to the same photo I just
spattered. To use the Underpainting filter yourself, choose Filter, Artistic,
Underpainting. Select a Brush Size from the filter's dialog box—a big fat brush for
larger splotches of color and less detail, or a smaller, finer brush for more detailed
work. The Texture Coverage setting adjusts the thickness of the paint and its cov-
erage of the texture you select.

Unlike some of the other filters, which give you only a few adjustments, this one
includes resettable textures. The defaults are Burlap, Brick, Canvas, and
Sandstone, but you can also load in any texture file (in .psd format) and use it
instead. You can size the textures by adjusting the Scaling percentage, and also

by setting the Relief or "lumpiness" (higher numbers will make the texture more intense). In addition, you can decide from which direction to have the light strike the texture by changing the Light Dir setting. To reverse the direction of the light quickly, without changing the Light Dir setting, click Invert.

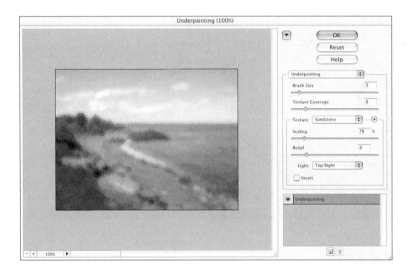

FIGURE 30.10
I like to paint on Sandstone; the Canvas option is too rough.

Having done the underpainting with a click, it's now time to actually pick up a brush and start painting. For this, I will use the Brush tool and a very small, hard-edged brush, and I will select colors either from the Swatches palette (which contains a sample of all the colors in the image) or with the Eyedropper (which will change the foreground color to the color I click on).

Pressing the Option/Alt key while any Brush tool is active temporarily converts it to an Eyedropper, for quick color selection.

Did you Know?

In Figure 30.11, I've been working with the brush for a while, putting back detail and straight lines where the filter has softened the edges too much, and inventing some people for my beach scene—one lying on the beach and another swimming out in the water.

FIGURE 30.11
Be sure to see this
in the color plate
section.

Palette Knife

Other oil techniques include painting with a palette knife, with thick brushes, and using strongly directional strokes. When painting with a palette knife, you spread paint over the canvas with the flat side of the knife. The result is a painting with thick, flat strokes. To start, choose Filters, Artistic, Palette Knife. Adjust the Stroke Size—a larger stoke gives you large, flat areas of color, and you'll lose the areas of the image with smaller patches of color. Next, select the Stroke Detail. This setting controls the number of tones used in areas of similar color, thus reducing or increasing the detail. Finally, select the Softness you want. This option adjusts the "edge softness" of the stroke, or the level of contrast at the edge of the stroke. You won't see a lot of difference here between the high and low settings.

In Figure 30.12, I have used the Palette Knife filter, with Stroke Size and Detail of 9 and 3, respectively, and a Softness of 10.

FIGURE 30.12
After applying the
Palette Knife filter, I
went back and
painted in the
flowers.

Paint Daubs

The Paint Daubs filter (Filters, Artistic, Paint Daubs), which simulates the look of
a painting, either works well with your picture or not at all. It breaks up the
image into blobs of color. Its dialog box, shown in Figure 30.12, has a pop-up
menu for Brush Type as well as sliders for Brush Size and Sharpness. If you are
willing to spend some time experimenting, you can discover combinations that
do amazing things to a still life or landscape. However, this is one filter I do not
recommend for portraits.

After opening the Paint Daubs dialog box, set your Brush Size. A larger size will
give you larger daubs of paint and less detail. Next, adjust the Sharpness (level of
contrast). Finally, select the Brush Type—your choices include a regular Simple
brush, a Light Rough brush (which emphasizes the light values in an image), a
Dark Rough brush (which emphasizes dark values), a Wide Sharp or Wide Blurry
brush (which uses wide strokes), or a Sparkle brush (which produces a twirly
effect). Figure 30.13, in the color section, shows the results of applying this filter.

FIGURE 30.13
There are six brush-
es available in the
Brush Type pop-up
menu.

FIGURE 30.13
There are six brush-
es available in the
Brush Type pop-up
menu.

Working with Pastels, Chalk, Charcoal, and Pen

The next category of art media that we'll consider is pastels, chalks, and char-
coals. These are all drawing or sketching materials rather than painting materi-
als, so the look is completely different than you get with oils or watercolors. The
image is created from lines rather than blocks of color. Thus, these media lend
themselves to pictures with delicate detail rather than areas of flat color. They are
good for portraits, because the level of abstraction they provide disguises small
flaws and makes anybody look good.

Rough Pastels

It would be convenient if these tools were at least lumped into the same category.
Because they aren't, you will have to go hunting for them. The first filter we'll try
is Rough Pastels, which simulates the look of chalky pastels on a rough surface,
such as canvas. With this filter, you'll see more texture in the dark areas than you
will in the light. It's on the Filter, Artistic menu. Rough Pastels is one of those
amazing filters that make anything look good. In Figure 30.14 I've applied it to a
photo of some summer flowers.

Let's look at the interface for the Rough Pastels filter. Start by adjusting the Stroke
Length. Pastels are brushed on the surface using the edge of the pastel stick and
long, smooth strokes. You can adjust the contrast as well, and make the strokes
more apparent by adjusting the Stroke Detail slider.

FIGURE 30.14
Flowers rendered in
rough pastels.

Like the Underpainting filter we looked at earlier this chapter, the Rough Pastels filter allows you to change the texture of the surface on which the pastels are applied. The background texture is critical for filters like this one because the amount of color added varies based on the perceived roughness of the surface. Choose the one you want from the Texture list, or select a texture file you've created. You can size the textures by adjusting the Scaling percentage; for example, you can set the size of the bricks used in the Brick texture. A higher value creates larger bricks. You can also adjust the roughness of the texture by adjusting the Relief value (higher numbers will make the texture more noticeable). As before, you can adjust the direction of the light source with the Light Dir setting. To reverse the direction of the light, click Invert.

Smudge Stick

The Smudge Stick filter also looks good on almost any picture. It's smoother than the Rough Pastels filter and makes the image look as if it has been carefully rendered in soft crayon or pastel, and then the dark areas carefully smudged with a soft cloth or fingertip in a suede glove. You can see the full effect in Figure 30.15.

Choose Filters, Artistic, Smudge Stick. A smudge stick is used in a manner similar to a hard pastel, in long strokes whose length you can adjust using the Stroke Length slider. Adjust the range of values to be lightened with the Highlight Area slider. The higher the value, the broader this range of values. To brighten the values defined by the Highlight Area value, drag the Intensity slider.

FIGURE 30.15
Smudge Stick is a
nice soft look that
reveals textures
and details.

Chalk & Charcoal

The Chalk & Charcoal filter (Filters, Sketch, Chalk & Charcoal) works with whatever colors you have set as the foreground and background colors. Chalk, the background color, is used to render the light areas of your image. Charcoal, the foreground color, is used to render the dark areas. The medium tones in the image are not rendered, but are displayed as a simulated medium gray paper. Being somewhat traditionally oriented, I usually choose to use a combination of black and white, although you could just as well use pink and green or any other colors you want.

After displaying the Chalk & Charcoal dialog box, widen the range of dark values rendered with charcoal (the foreground color) by raising the Charcoal value. Lowering this value narrows the dark range. Adjust the range of light values rendered with chalk (the background color) by dragging the Chalk slider. Adjust the Stroke Pressure as desired. More pressure leaves more of the foreground/background color on the paper, increasing or decreasing the contrast.

The Charcoal filter (Artistic, Sketch, Charcoal) is not as effective as the Chalk & Charcoal filter unless you're looking for lots of contrast. When rendering your image in charcoal, Elements draws the edges of high contrast with a strong, bold stroke. Areas filled with midtones are drawn with a lighter, diagonal stroke. The color of the charcoal is the same as the foreground color. The paper used with this filter is not a medium gray; instead, it's the same as the background color.

In the Charcoal dialog box, adjust the thickness of the stroke using the Charcoal Thickness slider. The Detail slider controls the range of values rendered in charcoal. By default, only the dark tones in an image are rendered; with a high Detail

value, more of the midtones will be rendered as well. Light values are left unrendered and are filled with the background color. The Light/Dark Balance slider controls how strong a stroke is used—a strong, dark stroke or a light, medium stroke.

Figure 30.16 shows examples of the same image, rendered with both filters.

FIGURE 30.16
On the left, the Chalk & Charcoal filter. On the right, plain Charcoal.

Conté Crayon

I *love* this filter—it's done good things to every picture I have ever used it on. Conté Crayon (Filters, Sketch, Conté Crayon) is a soft, compressed chalk-and-graphite crayon, typically used on medium gray or brown paper in earthy colors.

Like the Chalk & Charcoal filter described previously, the Conté Crayon filter uses the foreground color to render the dark tones in an image, and the background color to render the light ones. For an authentic look, use a dark iron oxide (blood red), black, or sienna brown crayon for your foreground color. As your background color, use white, another earthy color, or a light-toned version of the foreground color.

After displaying the Conté Crayon dialog box, adjust the range of dark values rendered with the foreground color using the Foreground Level slider. Lowering this value narrows the dark range. Adjust the range of Background Level values rendered with the background color by dragging the Chalk slider. You can also change the texture of the background from canvas to something else, in a manner similar to the Rough Pastels dialog box: Choose the texture to use from the

Texture list, or select a texture file you've created. Adjust the size of the texture with the Scaling box. Change the roughness of the texture by adjusting the Relief value. Change the direction of the light source with the Light Dir setting. To reverse the direction of the light, click Invert.

Figure 30.17 shows my black-and-white cat rendered in Conté Crayon on a sandstone background. I chose black as my foreground color and white as my background color because the cat is black and white, but feel free to use your imagination. Hot pink or lime green could be just what your photo needs.

FIGURE 30.17
Conté Crayon filter applied.

Graphic Pen and Halftone Pattern

The Graphic Pen and Halftone Pattern filters (both located on the Filter, Sketch submenu) do very similar things. Both reduce the image using whatever foreground and background colors you set. Graphic Pen then renders the image in slanting lines, whereas Halftone Pattern renders it in overlapping dots. On the proper subject, the Graphic Pen filter can be very effective, although I can't decide whether it looks more like an etching or a pen-and-ink drawing. Take a look at Figure 30.18 and see what you think. Halftone Pattern, shown in Figure 30.19, looks like a bad newspaper photo.

FIGURE 30.18
It's a drawing. No, it's an etching.

FIGURE 30.19
Create the "high-quality" look of real newspaper!

To use the Graphic Pen filter, set the foreground color to the color of the ink you want to use; set the background color to the color of the paper you want to draw on. Next, choose Filters, Sketch, Graphic Pen. Adjust the Stroke Length as desired. Adjust the range of tones that the pen renders by dragging the Light/Dark Balance slider. If you drag it left toward the light side, the pen will render more light tones; drag it to the right to narrow the range. Finally, select a direction for the pen strokes—choose a direction in which your eye seems to move through the picture.

To use the Halftone Pattern filter, choose it from the Filters, Sketch submenu. The pattern is rendered in newspaper photo style, using dots of various shades of gray. Change the pattern to concentric circles or horizontal lines by selecting that option from the Pattern Type list. Adjust the size of the dots, circles, or lines using the Size slider. Adjust the range of tones rendered by the pattern using the Contrast slider.

Did you Know?

> When you're working in Grayscale mode, you notice that many of the filters are grayed out. To get access to these filters again, just change your image back to RGB mode (Image, Mode, RGB Color) and apply your filter. Then, switch back to Grayscale mode and click OK when asked to discard color information.

Sumi-e

Sumi-e is the very old Japanese art of brush painting. It has a loose, free style that can only be achieved by painting with a wide, wet brush. As few strokes as possible are used to convey the subject, which is typically rendered in black ink on white rice paper. A carefully chosen photo should be an ideal medium for sumi-e. You want something that has textures, but is not too complicated (not too much detail, not too many edges) and not too dark. Because a lot of sumi-e art is black and white or uses only muted colors, you might want to adjust the hues in your image (the filter will not replace them). The filter will blur areas of similar color together, while adding dark strokes along edges of different colors, and within dark areas.

Many of the Elements filters, including this one, tend to darken a picture. If I know I'm going to continue working on an image after I've done the basic corrections, I'll often create a light version or one with extra contrast just for the filtering process.

I shot these clownfish (see Figure 30.20) at an aquarium. Fish don't like to pose, so I added a couple of extras when I did the basic clean up on the photo by copying, resizing, and flipping two of them. Can you find which two? The changes produced a better photo, but it still didn't say what I wanted it to about the colors and the joys of life on a coral reef. Although the colors in this photo aren't typically used in a sumi-e painting, the fish seem to be screaming for an Oriental technique.

As shown in Figure 30.21, the Sumi-e filter softened the shapes, as if a big, wet brush had painted them. It intensified the colors and turned the shapes just abstract enough to make them interesting.

FIGURE 30.20
Send in a couple
more clowns....

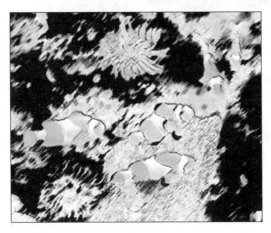

FIGURE 30.21
Adding the Sumi-e
filter produced
exactly what I
wanted.

To use the Sumi-e filter yourself, choose Filters, Brush Strokes, Sumi-e. Select the
width of the brush strokes with the Stroke Width slider. Adjust the Stroke Pressure
as well; a greater pressure will increase the darkness of the brush strokes. The
Contrast slider adjusts the level of contrast in the image. Typically, you'll want to
lower the contrast to achieve the soft look found in sumi-e paintings.

Creating a Neon Effect with Glowing Edges

I saw an interesting art show recently where all the work was done in neon tub-
ing. Some, of course, looked cartoonish, but one artist had mounted her tubing

against black velvet, and had used many small pieces in different colors rather than one long, single-colored line. It occurred to me that the Glowing Edges filter (Filter, Stylize, Glowing Edges) might do much the same thing. Its dialog box is shown in Figure 30.22.

FIGURE 30.22
The Glowing Edges dialog box.

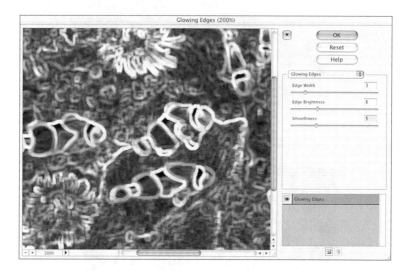

The filter works by looking for edges and placing a white or colored line on each edge it detects. The amount of contrast between the edge and what it's next to determines the color of the line applied to it. The tropical fish did prove to be a good image for this filter. Figure 30.23, and the color plate section, show the final result.

FIGURE 30.23
We've created neon clown fish!

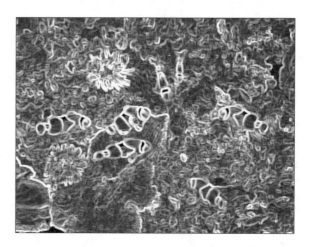

Display the Glowing Edges dialog box by choosing Filters, Stylize, Glowing Edges. Set the size of the neon edging by adjusting the Edge Width slider. Adjust the brightness of the neon glow with the Edge Brightness slider. The Smoothness slider defines the range of contrast that must exist between neighboring colors before an "edge" of neon is placed between them. If you raise this value, only strong, contrasting edges will use neon; if you lower this value, practically every edge in your image will use neon.

Adding a Neon Glow

You can find a filter similar to Glowing Edges on the Filters, Artistic submenu. It uses a combination of the foreground, background, and a neon color you select to recolor your image and add the neon effect. The effect, in this case, is less like neon tubing, and more like a subtle glow, as shown in Figure 30.24.

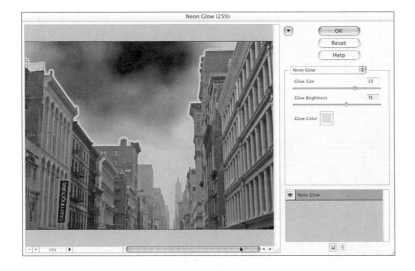

FIGURE 30.24
Cast a sinister look over a scene with Neon Glow.

First, select the color you want the filter to use when rendering dark tones by changing the foreground color. Select the color to use for midtones by changing the background color. The defaults of a black foreground and a white background are perfect for this filter. The highlights will be rendered by the neon color you choose from the dialog box.

Display the Neon Glow dialog box shown in Figure 30.24 by choosing Filters, Artistic, Neon Glow. Next, select the glow color you want to use by clicking on the Glow Color swatch and choosing a color in the Color Picker. I like a nice toxic

chartreuse for this shot. Adjust the range of values rendered by the glow color (the range of values considered to be highlights) by dragging the Glow Size slider. A lower value will narrow the highlight range; a higher value will widen it. A negative value will invert the range, causing the neon color to replace the dark values, and the foreground color to replace the highlights. Change the Glow Brightness as desired—low values cause the glow color to be used at the edges of its defined area; higher values move the glow farther into its area. Be sure to check this one out in the color plate section.

Texturizing with Grain

Although I talked about the Texture filters in general in the last chapter, I want to talk specifically about the Grain filter (Filters, Texture, Grain) in this chapter, because it can be used to create the artistic effect of a pointillist painting or a stippled engraving. Basically, the Grain filter adds noise to an image, in a pattern determined by the type of grain you decide to use. As you can see in Figure 30.25, the Grain dialog box has a pop-up menu that gives you a choice of 10 different types of grain, from Soft to Clumped to Speckle.

FIGURE 30.25
Use the pop-up menu to choose a type of grain.

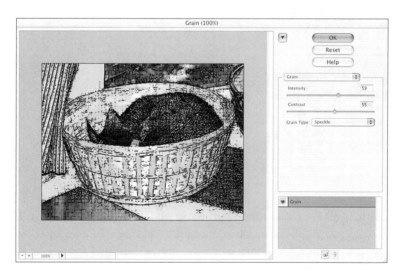

Some kinds of grain will retain the original colors of the picture, and some won't. In this case, I first tried Speckle, which gave a sort of woodblock-print effect. Then I applied Stipple, which took out the original colors and looks like an etching. The final result is shown in Figure 30.26. Some of the other grain textures

duplicate other artistic media. For example, to re-create the look of a pointillist painting by George Seurat, try the Regular, Soft, or Enlarged grain type. The Speckle and Clumped grain types also add an interesting artistic look to an image. Give them all a try!

FIGURE 30.26
Now I could add back some light transparent color and have a hand-tinted etching effect.

Sponging an Image

Before closing this chapter, I'd like to mention one more filter on the Filters, Artistic submenu: Sponge. With it, you can create a kind of watercolor effect that looks as if it were done with a sponge rather than a paintbrush. This filter blends areas of color but retains the edges to give some detail to the image.

Open the Sponge dialog box, shown in Figure 30.27. Adjusting the Brush Size slider changes the size of the individual areas of color used to render the image. It correspondingly changes the size of the sponge pores, which paint tiny bits of gray all over the image. The Definition slider adjusts the darkness of the paint used on the sponge—from light gray to dark gray. With the Smoothness slider, you can change the amount of blending between the areas of color that make up the image and the gray spots left by the sponge. Figure 30.28 shows the finished photo, which is a good deal more interesting than the original one.

FIGURE 30.27
Sponging creates a
blurry, soft effect.

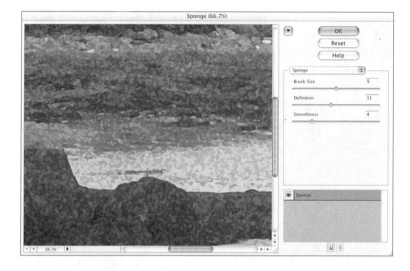

FIGURE 30.28
The final picture.

Summary

I hope you enjoyed this chapter; I did. Making photos into "art" of various kinds
is one of my favorite things, and I like sharing the tricks and techniques I've
picked up over the years. In this chapter, we looked first at watercolors and at sev-
eral ways to simulate different styles. You learned a quick and easy way to mask

a horizon—or any part of the picture that needs to remain a straight line. Then we took up oil painting. You learned about underpainting, and about going back and adding detail after converting the picture to a painting. You learned about using a palette knife effect, and about the Paint Daubs filter. Then, we did some work with Chalks, Charcoals, Pastels, and Conté Crayon. After that, we got a little more into exotic media, with Japanese brush painting and neon tubing. Finally, we worked with the Grain filter, proving that all art can be taken for granite.

Elements includes many filters, as you've probably guessed from looking at the Filter menu. And, as I mentioned earlier, you can import other filters you might find on the Web. I can't cover the details about every filter, but they work more or less as you've already seen—some apply their effect as soon as you select them, while others allow you to make adjustments in a dialog box. Either way, use a copy of a favorite photo to play with each of the remaining filters. Some of them are pretty amazing. Imagine the situations in which you might use each filter, and make a mental note of the ones you like. They'll come in handy some day—believe me.

CHAPTER 31

Making Composite Images

What You'll Learn in This Chapter:

▶ Working with Lighting and Scale
▶ Using Layer Styles to Create Composites
▶ Using Adjustment Layers to Fix Image Problems
▶ Understanding Blend Modes
▶ Applying Effects
▶ Using Distortions to Blend Composite Images
▶ Putting Together Stitched Panoramas

Whenever you combine elements from more than one source, you're said to be making a *composite*. The process of creating a composite can include something as simple as adding a gradient, or as complex as making a montage of half a dozen pictures, plus type and effects. How you want to use the technique is up to you. Some people create wonderfully surrealistic photos. Others simply improve the composition by throwing extra sheep in the meadow or fish in the aquarium. Still others use it simply to put a drop shadow behind the type on a title page. But regardless of how you end up applying these techniques, I guarantee that you'll find them useful as you work with your pictures.

Working with Lighting and Scale

When combining images, the two main things to watch out for are lighting and scale. If the shadows and highlights on the imported image don't match those on the original, you might not immediately recognize why the picture doesn't look right, but you'll know that it doesn't. This will happen if the light source for one photo doesn't come from the same direction as the light source in the photo you

want to combine with it. Of course, if the shadows aren't exactly in the right place, you can use the Clone Stamp and the Brush to move them where they need to be, as we did with the zebra photo in Chapter 25, "Making Color Repairs." However, this is rather tricky (not to mention tedious) business, so avoid the problem as much as possible by selecting photos that have their sources of light coming from the same direction whenever possible.

Scale is an even trickier question. You *can* create very funny photos by having the family cat cowering behind a three-foot-high mouse, or some similar scene, but should you? It's a gimmick. It's not art, which is not to say I don't do it myself. My cat Reebok would have sworn the rat shown in Figure 31.1 was at least three feet tall.

FIGURE 31.1
The rat has, of course, been resized, and I've added Gaussian blur and a small drop shadow.

Less exaggerated differences in scale are harder to spot, but you'll probably notice that the picture isn't quite right, even if you can't immediately see why. If you're going to photograph your kids in front of the Golden Gate Bridge, they shouldn't be taller than it is. Nor should they be tiny, or set so far back that they have nothing to stand on. Scaling them to fit is easiest if you put them on a new layer and then select Image, Resize, Scale. Press Shift as you drag on the bounding box to keep the proportions correct as you rescale the image to fit the scene. Don't forget that you can also use this command to make things smaller by dragging toward the center of the bounding box.

Using Layer Styles to Create Composites

Layer styles apply a style such as a shadow, bevel, or metallic fill to all the objects on a layer. There are 14 different kinds of layer styles, ranging from Bevels, Glows, and Drop Shadows to Glass Buttons, Patterns, and Wow Chrome. As you learned in Chapter 19, "Adding Type," they are most often used with type, to make it stand out from the rest of the image, but you can apply layer styles to any kind of object on any layer except the Background layer.

Before I show you some of the ways you can use layer styles with objects to create composite pictures, let's review what we know about layer styles. A layer style is a special effect, and when you add it to a layer, it's applied to all the objects on that layer—text, shapes, or the outer edge of an image. So be sure to move objects you don't want affected to other layers before you proceed, and if working with an image, make sure you resize it so you can see the edge effect (if any) for the layer style you select. For example, you won't see a drop shadow on your image if that image takes up the entire layer.

Adding a layer style is fairly simple: First, change to the layer you want to affect by clicking its name in the Layers palette. Then, open the Layer Styles palette (Window, Styles and Effects, Layer Styles pop-up), choose a category from the list (such as Drop Shadow, Bevel, Photographic Effects, or Wow Chrome), and when the palette opens to display a list of the styles in that category, click on the thumbnail of the particular style you want to apply. The cursive f appears after the layer name on the Layers palette to remind you that the layer is using a layer style.

You can combine styles if you want. Some styles, you'll find, completely overlay any layer styles you have already applied, leaving few if any remnants of them. Others combine well to create interesting effects. The only way to know which layer styles work well together is to play around with various combinations and make note of the ones you like. To remove all styles from the current layer, click the Clear Style button at the top of the Layer Styles palette. There is no way, unfortunately, to remove one style without removing the rest, unless you want to remove the last style you applied, in which case you can simply click Undo.

Here's a quick summary of the various layer styles you can use. Most of them, as I mentioned before, are probably best used with text, unless your idea is to create a rather surreal-looking image. However, you never know what layer style might prove useful, given a particular situation:

▶ Bevels—Puts a sharp or soft edge on the sides of an object. This edge appears to raise or lower the object above or below the surface of the layer. The emboss styles produce a softer effect than the bevel styles.

▶ Drop Shadows—Adds a soft- or sharp-edged shadow behind objects.

▶ Inner Glows—Adds a soft glow to the inner edges of objects, so they seem to glow inside.

▶ Inner Shadows—Adds a shadow to the inner edges of objects, so they seem to fall below the surface of the layer.

▶ Outer Glows—Adds a soft glow to the outside edges of objects.

▶ Visibility—Softens the fill color of objects, or hides them entirely. Click Show to redisplay the fill color at full saturation.

▶ Complex—Combines several layer styles to create a unique effect. There are too many styles here to list them all, but some of the more notable ones are Chrome—Fat, Molten Gold, Rivet, Star Glow, Diamond Plate, and Paint Brush Strokes.

▶ Glass Buttons—Fills an object with the color you choose, and makes it appear slightly opaque like glass and raised like a button.

▶ Image Effects—These layer styles are probably most useful for working with objects rather than text, although they can be applied to either. Here you'll find such things as Fog, Rain, Snow, Water Reflection, Night Vision, and Circular Vignette, which is similar to the vignette technique we used in Chapter 24, "Repairing Black-and-White Pictures."

▶ Patterns—A collection of interesting textures you can apply, including fabric textures such as Batik, Satin Overlay, Tie-Dyed Silk, Blanket, and Denim; surface textures such as Painted Wallboard, Brushed Metal, Ancient Stone, Asphalt, Stucco, Marble, Brick Walk, Dry Mud, and Wood; and unique effects such as Nebula, Abstract Fire, and Smoke. There are too many to mention them all, so be sure to check out this category.

▶ Photographic Effects—From the name, you can probably guess that these layer styles are especially well suited for working with images. Here you'll find such styles as Negative, Sepia Tone, and Teal Tone.

▶ Wow Chrome—Applies various chrome textures to objects. I like the Wow Chrome - Shiny Edge the best, especially when combined with Wow Chrome - Reflecting.

▶ Wow Neon—Adds a neon-like glow in your choice of colors. The neon tubing can appear to be either on or off, depending on your selection. When you apply these styles, the fill color is removed from any objects.

▶ Wow Plastic—Replaces the fill color with plastic in your choice of colors. This layer style is similar to, but not the same as, the Glass Buttons style.

In the example in Figure 31.2, I've applied various layer styles to a simple rectangle shape. I simply created the rectangle on one layer, and then used Layer, Duplicate Layer to copy it several times. After each copy, I used the Move tool to move each rectangle into a unique position within the image so I could see them all. Then I applied a layer style of some category to each rectangle so I could compare the effects. How many can you identify? The rectangle I drew was bright yellow. Notice how some of the styles completely replaced the fill color, while other styles look as if they are laid on top of the color.

FIGURE 31.2
Which layer style do you like best?

As I mentioned earlier, you can add a layer style to text if that text is on its own layer; otherwise, all objects on the layer will be affected. You can add layer styles to shapes as well. Again, though, if you want to apply the style to only one shape, that shape must be on a separate layer. To make the set of examples in Figure 31.2, I needed 14 layers.

Using Adjustment Layers to Fix Image Problems

Adjustment layers are used to make particular types of adjustments to the layers below the adjustment layer, or to the layers grouped with it. After I list the types of adjustments you can make, we'll talk about controlling which layers are affected.

With an adjustment layer, you can adjust the levels, brightness/contrast, and hue/saturation. These adjustments correspond to the commands you learned how to use on an entire image in Chapter 21, "Too Light/Too Dark: Adjusting Brightness, Contrast, and Color." You can also add a gradient map (a layer that blends one color into another), invert colors (by switching them for their opposites on the color wheel), apply a transparent colored filter, adjust the threshold (convert the affected layers to high-contrast black and white), or add a posterize effect (which lets you limit the number of tones or shades used in all three color channels, creating a flatter look with less subtlety). You'll learn about the Posterize and Threshold adjustments in Chapter 32, "Going Wild with Your Images."

Adding an Adjustment Layer

To create an adjustment layer, click in the Layers palette on the layer where you want to add the adjustment layer. Then choose Layer, New Adjustment Layer and choose the adjustment type from the submenu that appears. Or click the Create Adjustment Layer icon on the Layers palette. It's the one that looks like a half black/half white circle. You'll see a pop-up menu like the one in Figure 31.3. Choose the kind of adjustment layer you want to add. The adjustment layer will be placed above the current layer and will affect that layer and all layers below it unless you choose the Group with Previous Layer option. The dialog box corresponding to the type of adjustment you selected then appears. (For example, if you're creating a hue/saturation adjustment layer, the Hue/Saturation dialog box appears.) Make the adjustment you want and click OK.

Did you Know?

If you click the Create Adjustment Layer button in the Layers palette, you won't be able to name your layer or group it with the previous layer.

FIGURE 31.3
Choose the type of
adjustment layer
from the menu.

After you add an adjustment layer, you'll see it appear in the Layers palette, just above the layer you clicked before you inserted the adjustment layer. The adjustment layer looks like the one shown in Figure 31.4. The first icon on the left tells you that this layer is visible, or in this case, active—the adjustment is being applied. If you click this icon to hide it, the adjustment layer will no longer be in effect. The next icon, the Mask icon, tells you that a mask is being used to partially obscure the effects of the adjustment to the layers below. A mask is simply a selection. If you have selected something on the current layer or the layers below the adjustment layer (assuming that you're not limiting the adjustment to a single layer), only the selected area on that layer will be affected by the adjustment. You can actually edit this mask, refining the area you want to affect (more on that later).

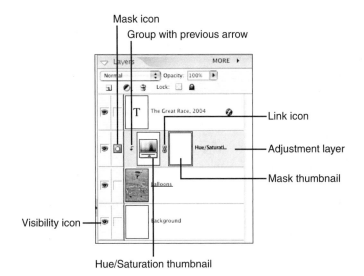

Mask icon
Group with previous arrow
Link icon
Adjustment layer
Mask thumbnail
Visibility icon
Hue/Saturation thumbnail

FIGURE 31.4
The adjustment
layer is listed sepa-
rately in the Layers
palette.

> Masks are also used on fill layers, to hide or partially obscure some of the fill.

The next icon, a bent arrow, will only appear if you chose the Group with Previous option. It tells you that this adjustment layer is grouped with the layer below it. Next is the adjustment thumbnail, which depicts an icon that shows you what kind of adjustment has been made. Here, a Hue/Saturation adjustment layer (selected) was used. If you want to change the adjustment settings, double-click this icon and the dialog box you originally saw (in this case, the Hue/Saturation dialog box) will be redisplayed. Make your changes and click OK. The next icon, the link, tells you that a layer mask is linked to its underlying layer. The final thumbnail, the Mask thumbnail, shows you the shape of the mask that's in place.

If you selected the Group with Previous Layer option in the New Layer dialog box, the adjustment layer is grouped with the layer just below it, and the adjustments affect only that layer. To add the layer immediately below the bottommost grouped layer to the group, press Option/Alt and click the line that separates the two layers in the Layers palette.

Editing the Adjustment Layer Mask

Unless you made a selection prior to inserting an adjustment layer, the adjustments will apply to all objects on the affected layers. In such a case, the Mask thumbnail on the Layers palette will be completely white, which indicates that the mask is not blocking any part of the adjustment.

To mask part of the adjustment's effects or to adjust a mask that's already in place, click on the adjustment layer in the Layers palette to select it. Then display the mask on the image so you can see it. To display the mask in grayscale, press Option/Alt and click the Mask thumbnail in the Layers palette. To display the mask in red, press Shift+Option/Alt and click the Mask thumbnail. If you started with no mask and you're adding one, the mask will not be displayed because there isn't one to show.

Initially, a mask is white. White areas indicate where adjustments are in effect. Black areas block the adjustment effects, and gray areas block the adjustments only partially, based on how dark the gray is. To add or change a mask, you simply paint with white to expand the area of the adjustment's effects, or with black to mask it. Paint with any tone of gray to partially obscure the adjustment.

When you select the adjustment layer in the Layers palette, Elements automatically changes the foreground and background colors to get ready for any changes to the mask you might want to make. Click the Brush or Pencil tool, choose a brush tip, size, blend mode, and opacity from the tool's Options bar, and paint to create or change the mask, as shown in Figure 31.5. You can also use a shape tool to fill an area with white or black. In addition, you can select an area to work on with any of the selection marquee tools, and then when you paint, you'll only affect that area—this is a nice way of making sure you don't erase parts of the mask you want to keep. When you're done making adjustments, press Option/Alt and click the Mask thumbnail to reveal the image again. Elements will update the display and show you the outline of the current mask.

You can use a gradient fill in black and white to create the mask; see Chapter 32 for tips on creating a gradient. You can also partially obscure the entire adjustment layer by changing its opacity and/or blend modes (which you'll learn about later in this chapter). To turn off the mask, press Shift and click the Mask thumbnail. Repeat this step to turn the mask back on so that the effects of the adjustment are once again partially obscured.

Here's an example of using an adjustment layer on an image. The balloon race photo needed to be lightened to accommodate the type I wanted to add to it, but I didn't want to affect the color of the biggest balloon. So I masked the balloon, and then worked with the colors on the rest of the image. Figure 31.5 shows the mask.

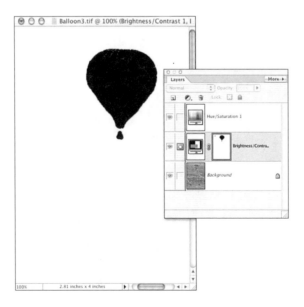

FIGURE 31.5
Paint with white to add to the mask, and with black to subtract.

The first thing I want to do to this photo is to brighten up the colors. If I simply call for Auto Contrast, I'll get whatever the folks at Adobe think is an acceptable amount of contrast based on the differences between the darkest pixels and lightest pixels on the page. That might be okay. After all, they're experts. However, this is *my* picture and I'm the expert on what I want to do with it, so the auto correction probably isn't quite right.

I can go back up to the Enhance menu and choose Enhance, Adjust Brightness/Contrast, and tweak the sliders myself to get a better, closer correction. But for maximum flexibility, I'll make the correction on an adjustment layer. Then I'll have greater control over the correction—for instance, if I think I've gotten the right brick color but the rest of the image seems too bright, I can reduce the opacity of the layer and thereby reduce the strength of the correction.

Now I'm ready to add some type and a drop shadow behind the letters.

If you look closely at the Layers palette in Figure 31.6, you can see the mask I've placed (the black area) in the Mask thumbnail of the adjustment layer.

FIGURE 31.6
The advantage to working this way is that you can control the amount of the adjustments you apply to each part of an image.

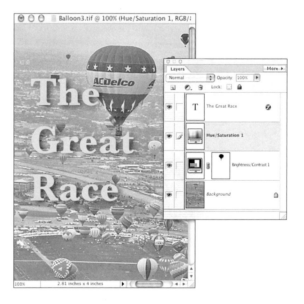

Understanding Blend Modes

In the real world, when you place a second brush full of paint over paint that's already there, the effect depends on the color of the paint you're applying, how opaque it is, whether the first layer is wet or dry, and so on. In Elements, you can

control all these factors by using what are called *blend modes*. Blend modes apply to layers (controlling a layer's effect on the layers below it) as well as to all tools that can draw or paint, including the Brush, Pencil, Clone Stamp, and Paint Bucket, just to name a few. You'll find the tool blend modes on the Mode menu on the tool's Options bar, and the Layer blend modes on a similar menu on the Layers palette, as shown in Figure 31.7. As you can see, there are quite a few different modes. Not all are available with all the tools. Let's take a quick look at the blending modes and what they do.

Suppose that you're working with only two colors. One is the *base* color—the one that's already in place. The second is the *blend* color—the color that you're applying with your tool, or the color on the layer(s) below the one whose blending mode you're adjusting. Depending on the blending mode you choose, you get a third color, a *result* that varies according to how you blend the first two.

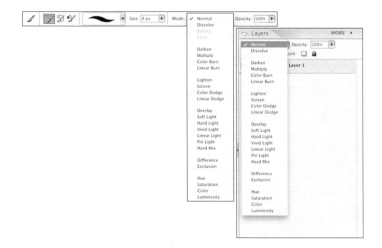

FIGURE 31.7
The tool's Options bar shows the Brush blend modes; the Layers palette offers its own selection of blend modes.

Figures 31.8 through 31.32 show what happens when you choose each of the blending mode options. (The examples with stars were painted with a firm brush in hot pink on a pale lime green background. The examples with other squiggles were painted with the colors reversed, because the original difference was too subtle to see.) In most cases, the blend mode was applied to the pink brush on a single layer. Where the results of applying the blend to a separate layer are different, I have shown both.

I would urge you to set up a similar color scheme and try these experiments yourself. It's really hard to see a black-and-white picture and try to imagine what the colors are doing.

FIGURE 31.8
Normal—This is the default mode. The blend color replaces the base color.

FIGURE 31.9
Dissolve—A random number of pixels are converted to the blend color. This option gives a splattered or "dry brush" effect.

FIGURE 31.10
Dissolve—Applied with a normal brush to a second layer at 50% opacity. This can be a very useful effect.

FIGURE 31.11
Darken—Evaluates the color information in each channel and assigns either the base color or the blend color, whichever is darker, as the result color. Lighter pixels are replaced, but darker ones don't change. Notice the darker areas where strokes overlap.

FIGURE 31.12
Multiply—Multiplies the base color by the blend color, giving you a darker result color. The effect is like drawing over the picture with a Magic Marker. Where the background is light, you see the original blend color.

FIGURE 31.13
Color Burn—Darkens the base color to match the value of the blend color. This effect is very subtle. It does not change the hue of the base color.

FIGURE 31.14
Linear Burn—Darkens the base color to reflect the blend color by decreasing the brightness. Blending with white produces no change.

FIGURE 31.15
Lighten—Evaluates the color information in each channel and assigns either the base color or the blend color, whichever is lighter, as the result color. Darker pixels are replaced, but lighter ones don't change. This is the exact opposite of Darken. Very subtle effect unless there are large differences in the values of the two colors. Note build-up of effect where lines overlap.

FIGURE 31.16
Screen—Multiplies the base color by the inverse of the blend color, giving you a lighter result color. The effect is like painting with bleach. I drew this figure with a soft-edged brush.

FIGURE 31.17
Color Dodge—Brightens the base color to match the value of the blend color.

FIGURE 31.18
Linear Dodge—Brightens the base color to reflect the blend color by increasing the brightness. Blending with black produces no change.

FIGURE 31.19
Overlay—Evaluates the color information in each channel and assigns either the base color or the blend color, whichever is darker, as the result color. Lighter pixels are replaced, but darker ones don't change. Overlapping lines double the effect.

FIGURE 31.20
Soft Light—Darkens or lightens depending on the blend color. The effect is said to be similar to shining a diffused spotlight on the image. With a light blend color, it has very little effect.

FIGURE 31.21
Hard Light—Multiplies or screens the colors, depending on the blend color. The effect is similar to shining a harsh spotlight on the image. Overlaps do not double the effect.

FIGURE 31.22
Vivid Light—Burns or dodges the colors by increasing or decreasing the contrast, depending on the blend color. If the blend color (light source) is lighter than 50% gray, you can lighten the image by decreasing the contrast. If the blend color is darker than 50% gray, you can darken the image by increasing the contrast.

FIGURE 31.23
Linear Light—Burns or dodges the colors by decreasing or increasing the brightness, depending on the blend color. If the blend color (light source) is lighter than 50% gray, you can lighten the image by increasing the brightness. If the blend color is darker than 50% gray, you can darken the image by decreasing the brightness.

FIGURE 31.24
Pin Light—Replaces the colors, depending on the blend color. If the blend color (light source) is lighter than 50% gray, pixels darker than the blend color are replaced and pixels lighter than the blend color do not change. If the blend color is darker than 50% gray, pixels lighter than the blend color are replaced and pixels darker than the blend color do not change. This is useful for adding special effects to an image.

FIGURE 31.25
Hard Mix—Reduces colors to closest value of white, black, green, red, blue, cyan, magenta, or yellow depending on combination of base and blend color.

FIGURE 31.26
Difference—Compares brightness values in the base and blend colors, and subtracts the lighter. Overlaps are interesting in this mode. They cancel the previous action.

FIGURE 31.27
Exclusion—This is similar to the Difference mode, but has a softer effect.

FIGURE 31.28
Hue—Gives you a result combining the luminance and saturation of the base color and the hue of the blend color.

FIGURE 31.29
Saturation—Gives you a color with the luminance and hue of the base color and the saturation of the blend color. Unless you choose significantly different colors, nothing shows.

FIGURE 31.30
Color—Combines the luminance of the base color with the hue and saturation of the blend color. This option is useful for coloring monochrome images because the Color mode retains the gray levels. In this example, the usual green background and pink paintbrush had very similar luminances (gray levels).

FIGURE 31.31
Luminosity—Gives a result color with the hue and saturation of the base color and the luminance of the blend color. This mode and the Color Blend mode produce opposite effects.

It's hard to understand why the designers of Elements bothered with some of these blend modes. Others are obviously, and immediately, useful. Spend some time playing with the effects of Darken, Lighten, and Dissolve. These modes seem to be the ones I use the most.

Applying Effects

Effects are a time-saver. You'll find them on the Styles and Effects palette. There's really nothing included in the Elements effects package that you couldn't do yourself from scratch, but why bother, when applying an effect is so simple? In all, there are 52 effects on the palette. Figure 31.32 shows the palette expanded to show all of them.

FIGURE 31.32
The complete
Styles and Effects
palette.

In the palette, you can view each effect's result as it is applied to the sample image (a green apple) marked *Original*. Effects that apply only to type are applied to the letter T. To apply an effect, double-click it. You can watch the progress of most of these effects on the Layers palette. Elements follows its internal scripts, creates layers needed for the effect, performs the required actions, and then merges the layers when the effect is completed. Some effects can take a minute or more to apply. Don't assume the effect isn't working if nothing happens immediately.

Did you Know?

Did you know that you can drag any of the palettes out of the palette bin and leave them open and expanded on the desktop? Just click the tab and drag to detach them. Then you can stretch them or shrink them as needed.

As you browse through the effects list, you'll notice that some of the effects are labeled "(Text)." These effects can be applied to text on a text layer, but not to text created using a text mask. Some effects are labeled "(Selection)," and can only be applied to a selected area. Some are labeled "(Layer)," and can only be applied to an entire layer. Finally, some effects can only be applied to a flattened image. When you choose them, you'll be asked whether you want to flatten your image. Click OK to proceed.

To limit the display of effects in the palette, select a category from the second drop-down list. Here's a description of the various categories:

▶ Frames—Adds a frame around the edge of the current layer or a selection (if the effect is marked with the "(Selection)" label).

▶ Textures—A collection of various textures. The effect is applied to a new layer above the current layer, but it can be partially masked by a selection first.

▶ Text Effects—Effects suitable only for use on a text layer.

▶ Image Effects—Effects applied to a copy of the current layer. If you combine several image effects, you may be prompted to flatten the image before proceeding.

Some effects create extra layers; some don't. Adding the Rusted Metal effect to an image makes it look as if it's covered in reddish-orange rust. Actually, Rusted Metal and some of the other image effects simply add a layer filled with color and pattern. If you really want to see your image through the rust, you must go to the Layers menu and change the opacity for the effects layer so the image under the Effects layer shows through. This is also a really good time to play with layer blend modes. In Figure 31.33, I've applied an effect called Neon Nights to a picture of granite slabs, changed the layer's Opacity to 75% so we could actually see the rocks, and chosen Hard Light as the layer blend mode. The results are a lot more interesting than either the original or the effect as it was first applied.

FIGURE 31.33
Effects don't turn into art until you work with them.

The biggest drawback to using effects is that, with the exception of layer opacity and blend modes, there is no way to customize them. The wood grain in the frame always runs in the same direction and is always the same sort of light oak. The Glass effect is only available in one color combination, and you can't even preview it. However, because a lot of the effects are simply filters or combinations of filters, you may be able to achieve a similar effect with customized results by applying the filters manually. As an effect is applied, you can see the various steps involved, including the names of any filters. So just as you wouldn't buy a "one size fits all" bathing suit, don't feel that you have to be stuck with an all-purpose effect.

Making an Effect from Scratch

Let's see how we can recreate the Neon Nights effect first shown in Figure 31.33. First, I'll open the same photo that I used the effect on and duplicate the layer. Then I'll apply the Glowing Edges filter (Filter, Stylize, Glowing Edges). Figure 31.34 shows this step.

FIGURE 31.34
The Glowing Edges filter puts the outlines around the rocks.

To achieve that glowing look, I'll try the Solarize filter (Filter, Stylize, Solarize). Very dark, but definitely going in the right direction. So, I'll adjust the levels (Enhance, Adjust Lighting, Levels) to brighten it, and the try the same reduced opacity (down to 75%) as before.

Now, I can have some fun with the layer blend modes. Normal doesn't do much. The Overlay mode seems to give the closest approximation of the Rusted Metal effect, without darkening the image too much. Figure 31.35 shows samples of all four of these modes. Be sure to look at this image in the color plate section.

FIGURE 31.35
From left to right, Normal blend mode at 65% opacity, Overlay, Vivid Light, Hard Light. You'll have to look carefully to see the differences. The photo is divided into four equal vertical slices.

Now that you know how to use the built-in features of Elements, let's try a bit of painting. I've already set up a blank Elements page, 5×7 inches with a white background.

1. First, we need a background. Open the Styles and Effects palette. Select the Layer Styles pop-up and browse through the Patterns and Complex categories in the second pop-up menu. They both cover the layer with a pattern, so styles in either category will work here. Click the one you like. Because Elements won't allow you to put a style on a background layer, you'll have to approve changing the background to Layer 0. (Elements automatically suggests an alternative whenever you try to do something unacceptable.)

2. Now you can place the pattern on the background. I chose the Complex style, Purple and Magenta (see Figure 31.36). Just click the pattern's thumbnail in the palette, and the screen automatically fills with purple marble.

3. Okay, let's go for the gold. Add a new layer, and choose a comfortably sized brush. Because you're going to be painting with a hard-edged medium (metal), you need to use a hard-edged brush.

4. Paint whatever you like. I'm partial to cats. When the painting is at least partially done, apply the Complex, Molten Gold layer style. The paint will turn to gold. (I sure wish that worked on my bank account.) Use the Brush and Eraser tools as needed to refine the picture.

FIGURE 31.36
Create a purple marble background in preparation for a metallic feline.

5. The cat seems a little flat. Fortunately, you can access the Style Settings dialog box (by double-clicking the cursive *f* on the Layers palette or by choosing Layer, Layer Style, Style Settings) and make some changes. These will also affect the pattern of light and shadow on the gold. I raised the Bevel Size to 120 and the Shadow Distance to 12. Then I cropped the picture, changed to Layer 0, opened the Style Settings dialog box again, and raised the Bevel Size of the purple background to 24. Figure 31.37 shows the result.

FIGURE 31.37
No cats were harmed in the making of this picture.

In Figure 31.38, I've assembled a strange collection of stuff, starting with an all-over batik pattern (Layer Styles, Pattern, Batik). Then I used a paintbrush on a new layer and styled my strokes with Paint Brush Strokes, from the Complex collection. I added another layer, and a few strokes with Satin Sheets. Then I drew

and filled a bunch of shapes, putting each one on a different layer with a different effect applied to each layer.

FIGURE 31.38
Something psychedelic....

At this point in the construction of my psychedelic composite, I have about 16 layers, so I need to stop and flatten them before the file gets too large and too difficult to print. Each new layer adds to the file size, and all of these unrelated objects add to the visual confusion. If you've just started plopping things on a page, without having a real idea of where the picture's going, or what it's about, this is also a good time to weed out elements that don't make sense in the context of the rest of the image.

By the Way

When you use the layer styles, you have about as much flexibility as you need for most purposes. But sometimes, you'll just want to go a few steps further than Elements wants to take you. Suppose you want an outer glow in chartreuse, or a gray drop shadow instead of black? There's no good reason you can't re-create any of these effects yourself. Once you see how easy it is to do so, you'll probably make your own more often than not.

Creating Drop Shadows from Scratch

According to my friend Scott Kelby, editor of *Photoshop User Magazine*, type *always* needs a drop shadow applied. Personally, I always try to steer clear of words such as *always* and *never*, but you can certainly improve most type with a little shadow. Here's a quick way to apply a shadow without using a Drop Shadow layer style. (You might not be able to use a layer style in some cases, but this method *always* works.)

First, set your type. Make a copy of the text on a new layer (Layer, Duplicate Layer). Slide the duplicate under the original until it's in a good position for a

shadow. Reduce the Duplicate layer's opacity to about 50% or whatever looks right to you. Add some blur (Filter, Blur, Gaussian Blur) to the Duplicate layer and you have a drop shadow (see Figure 31.39).

FIGURE 31.39
A simple but effec-
tive drop shadow.

Adding shadows to type is easy. How about adding shadows to objects? That's really not much more difficult. For this example, I have photographed an apple. I used a strong light, right on the middle of the fruit, so there was no shadow. Now, I want one. I'll set my foreground color to gray so I can create a light shadow.

I will duplicate the layer, then select the background using the Magic Wand and invert the selection so the apple is selected. This step is shown in Figure 31.40.

FIGURE 31.40
Select your object
first.

Then I feather the selection by about 20 pixels (Select, Feather). The next part is a tiny bit tricky. I'll select the Paint Bucket tool and make sure the preferred shadow color is the foreground color. I will position the tool just outside the edge of the

apple and click once. Figure 31.41 shows the resulting shadow. For a larger shadow, set the feather distance to a larger number. Although you can add a shadow to an object using one of the Drop Shadow layer styles, you can't get the light directly above an object with the shadows on all sides, as shown here, and you can't change the shadow color. Learning how to create these effects yourself will come in handy some day, believe me.

FIGURE 31.41
This time I left the shadow centered on the apple.

Glows are basically colored shadows, and they usually extend on all sides of an object like the shadow shown in Figure 31.41. To create a glow from scratch, follow the steps you'd use to make a shadow, but choose a light or bright glow color.

Making Reflections

Let's stop and reflect for a moment. Adding a reflection to an object can make it seem more three-dimensional, because, like a shadow, a reflection interacts with the space around the object.

Figure 31.42 shows a very basic reflection. All I did was duplicate the type on another layer and flip it 180 degrees. This makes it look as though the word is sitting on a floor that has a reflective surface. I blurred the reflection a little because my floors are never really clean. I also reduced the layer's Opacity setting to 80% and distorted the reflection just a tiny bit to add some perspective. To sit the reflection on water, I could add the ripple filter or just drag through it a couple of times with light pressure on the Smudge tool.

FIGURE 31.42
This kind of reflection is used for water, shiny floors and tabletops, and sheets of ice.

Reflections can face forward or backward, depending on the position of the reflective surface. Sometimes they can do both. The simplest reflections are created by flipping a layer 90 or 180 degrees. More complicated reflections, such as the ones shown in Figures 31.43 and 31.44, are a matter of applying transform, skew, and perspective until you get what you need. See Chapter 20, "Cropping and Resizing a Photo," for help in making these transformations.

FIGURE 31.43
One reflection in each direction.

FIGURE 31.44
And one reflection in both directions at once.

Using Distortions to Blend Composite Images

Distortions are mainly used when you need to wrap something around something else. You can stretch type around a can of soup or show how a design will look on a mug. This kind of composite is more practical than artistic. If you're wrapping type, you may be able to use the Warp Text button on the Type tool's Options menu. Otherwise, if you're trying to wrap an image or shape around an object,

Distort (or possibly Skew) is what you need. (Both are on the Image, Transform menu.) Chapter 19 can help you with the basics of warping text. Let's try warping some type around a can.

In Figure 31.45, I've drawn a can and set some type to go on it.

Boston Baked Beans

FIGURE 31.45
A basic can of beans.

After looking at the available Warp Text styles shown in Figure 31.46, I realize that I need to choose Arch, rather than Arc, so that all three lines will be set on the same curve. (Arc sets them in a fan shape with the bottom line smallest and everything fanning outward.)

When I slide the words into place with the Move tool, the default bend amount is obviously too much. The can has less than a 50% bend. By gradually reducing the bend of the text using the Bend slider in the Warp Text dialog box, and comparing the angle of the top word with the angle of the top of the can, I can get a fairly accurate curve for the letters. Figure 31.47 shows the curved letters.

FIGURE 31.46
There are lots of warp choices.

FIGURE 31.47
Align the letters
with the top of the
can.

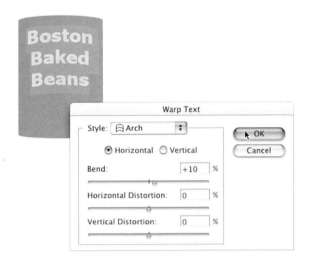

Now, all we need to finish up the job is a little glow around the letters to empha-
size them, the company logo (also with a glow), and a gradient on the can to add
some more roundness. (You'll learn to work with gradients in Chapter 32.) In
Figure 31.48, we've put it all together.

FIGURE 31.48
The finished can. It
looks good enough
to eat.

Putting type on a box is also easy to do by eye. Draw the box. Set the type in two
pieces so you can maneuver each piece separately. Align the first piece of type to
the lower-left edge of the box using the Skew command. Move it around until it
looks correct. Then do the same for the rest of the type. My effort appears in
Figure 31.49.

Next, I'll try a can with an image on it. I could use the Distort command to twist
the image to fit, but because my shape is a can (essentially a cylinder), I can use
the 3D Transform filter (Filters, Render, 3D Transform). The result appears in
Figure 31.50.

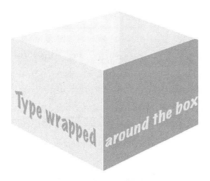

FIGURE 31.49
Remember that the type needs to remain vertical and should be skewed in one direction only.

FIGURE 31.50
Add an image to a can if you can.

Putting Together Stitched Panoramas

People have been sticking photos together to create panoramic images for close to a hundred years, with varying degrees of success. The scissors and glue method rarely succeeds. Shooting a panorama all in one photo with a wide-angle lens seems to work, until you notice that the ends of the Grand Canyon are very fuzzy, or that the two outermost bridesmaids in the wedding lineup appear 50 pounds heavier than they actually are. Distortion is the main problem. Wide-angle lenses aren't good choices in situations where you want to avoid distortion. The more curve you apply to the front of the lens, the more glass the image has to pass through. Glass adds distortion.

The more logical way to shoot a panorama that stays in focus from one end to the other is to take a series of pictures and splice them together. Prior to computers, that was exceptionally difficult, although it certainly was done. Now, thanks to clever software, it's easier than ever to get good results with panoramic photography.

Working with Photomerge

Photomerge is a plug-in that automates the process of assembling a panorama. After you've gone out and taken the photos, you plug your camera or memory stick into the computer and download the pictures. Then you open Elements and Photomerge (File, New, Photomerge), and tell it where to find the pictures you want to use. The Photomerge dialog box is shown in Figure 31.51. Click Browse and navigate to the folder in which your separate images are contained, select the pictures you want to use, and then click OK.

FIGURE 31.51
It's easiest if you download the pictures for your panorama to a single folder. That way you don't have to go hunting for them.

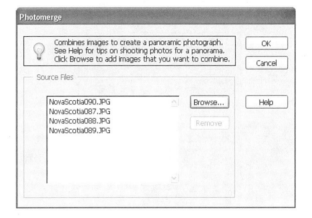

When you click OK, the magic begins. First, Elements opens all the photos you specified, and opens a new image file. Then it arranges them in order, matching the edges where images overlap. It opens a window similar to the one shown in Figure 31.52, so you can watch its progress.

The pictures appear to come in at 50% opacity, so the computer can easily line up areas of major contrast. In this series of pictures, the horizon seems to be the major point of reference for matching. Pictures that Photomerge can't match are left at the top of the strip, so you can drag them from the box at the top of the window into the work area at the bottom of the window and match them later. When all the pictures have been merged (see Figure 31.53), Photomerge continues the process by adjusting the brightness and contrast of each pair of pictures so you have a consistent exposure from one end to the other. If the sun has gone behind a cloud and emerged again, as it did for me, you'll have to do some extra tweaking. Apparently, the Photomerge command can only cope with *logical* changes.

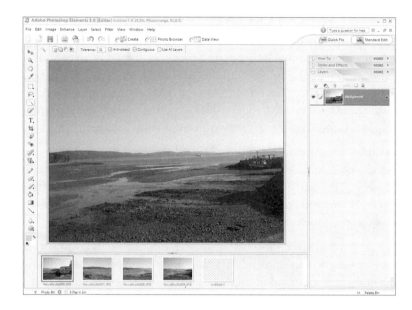

FIGURE 31.52
A panorama in
progress.

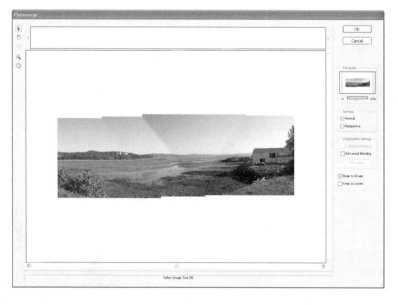

FIGURE 31.53
Processing the
exposures.

You can do some tweaking using the tools in the Photomerge dialog box. Drag a
corner of any image in the work area with the Rotate Image tool to rotate it.
Move the panorama within the work area by scrolling or by dragging it with the
Move View tool. Zoom in with the Zoom tool.

By clicking Perspective in the Settings pane, you can make some other adjustments. To establish which image contains the vanishing point (which image contains the highest point on the horizon, and therefore should be treated as the "middle" image), click that image with the Vanishing Point tool. It will be highlighted with a blue border. The other images will be adjusted in relation to this new vanishing point. If needed, make your own adjustments by clicking the Select Image tool and scooting the non-vanishing point images up or down.

There are other options you can choose as well. The Cylindrical Mapping option transforms the panorama as if it were on a cylinder, reducing the bow-tie effect sometimes seen. This transformation brings the viewer closer and into the panorama a bit, but you'll gain a lot of extra image space for cropping, so it's worth a look to see which view you prefer.

If your panorama has some inconsistencies with brightness and contrast, try the Advanced Blending option. It blends together areas of color, while retaining detail. The effect is a softening of these differences, making the panorama seem more like a whole image rather than a collection of images.

After choosing Cylindrical Mapping, Advanced Blending, or both, click Preview to view the results. Click Exit Preview to return to Normal view. When you're through making adjustments in the Photomerge window, click OK. If your files are large, actually assembling the Panorama may take several minutes.

The finished product is an untitled file (see Figure 31.54) with all the pictures assembled and matched as well as possible. Unfortunately, when you get it, the image has already been flattened, making it difficult to adjust the exposure of one frame that's a little "off." This one could use a bit of tweaking with the Airbrush or Clone Stamp, but on the whole, it's pretty good.

FIGURE 31.54
The edges suggest that this is more than one photo.

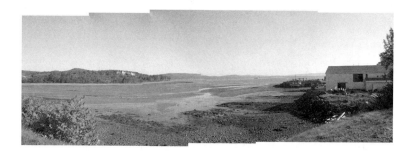

It's still up to you to crop the picture, if you want to. Some photographers argue that the slanting edges and unevenness of the "raw" panorama somehow add to the experience. Others, myself included, prefer to crop. A lot depends on whether, and how, you intend to print the picture. The four images I assembled for this test of Photomerge produced a strip 4 inches high by 36 inches long. At 300dpi resolution, that's a 37MB file. I can print it myself if I want to do so; one of my inkjet printers takes banner paper. But I'd prefer to go to a service bureau and come home with a strip 8 inches high by 6 feet long on a nice shiny, heavy poster paper.

Considerations When You Shoot a Panorama

Obviously, the main thing to consider when you shoot pictures for a panorama is that you should hold the camera steady at one height. Don't take it away from your eye while you're shooting. If you get interrupted mid-sequence, start again. Better yet, if possible, use a tripod to keep the camera steady. Remember, digital photos don't waste film. Stay away from the focus and zoom buttons. Autofocus the first picture and let that one dictate the focus for the rest.

Practice the "panorama shuffle." Start shooting with your body aimed at one end of the scene. Take small steps circling to your right as you shoot your pictures from left to right.

Don't use a flash. Particularly, don't use auto-flash, as it will throw varying amounts of light as it sees a need. These lighting variations make the exposure all but impossible to correct.

Use a normal lens for best results. Set your zoom lens about halfway between zoom and telephoto, and leave it there. Don't use a wide-angle or fish-eye lens. Such lenses defeat the purpose of the panorama, which is to have everything in the same focus and not distorted. Nothing distorts more than a fish eye.

Make sure you have enough overlap between pictures, but not too much. Somewhere around 31% is good. As you pan across the scene, remember what was on the right side of each picture you take, and just cover it again on the left of the next shot.

Take a picture of something clearly different between shooting panorama sequences. That way you won't try to assemble pictures that don't go together. Keep each set of pictures in a separate file as you download from the camera.

Have fun creating your panorama!

Summary

This chapter has been about making composite images. Composites are pictures from two or more sources, either two different images or an image plus type. The trick to creating a successful composite is making the images relate to each other. This can be done with reflections, cast shadows or glows, and other tricks that you can apply. You learned how to use layer styles to add a quick glow or drop shadow, and how to use them as part of the image, taking a background pattern or a frame to add to your own picture. You learned about bevels and how to paint with three-dimensional substances such as gold.

You also learned how to create adjustment layers and layer masks to control how particular adjustments affect your image. You learned that blend modes can apply to layers as well as to the brush tools, and some give unexpected results. You learned about the Styles and Effects palette, and how to work with it. There are type effects, frame effects, and image effects. Many of these are easy to create from scratch, and doing so gives you much more flexibility. You learned about mirror images, and about distortions. Finally, you learned how to use Photomerge to create panoramic pictures.

Going Wild with Your Images

What You'll Learn in This Chapter:

- ▶ Posterizing Colors
- ▶ Adjusting the Threshold
- ▶ Liquifying an Image
- ▶ Replacing Colors with Gradient Map and Invert
- ▶ Animating a GIF
- ▶ Setting Type in a Circle
- ▶ Using the Magic Eraser
- ▶ Adding Metallic Effects
- ▶ Using Weird Effects
- ▶ Pixelate Filters
- ▶ Stylize
- ▶ Combining Filters
- ▶ Third-Party Filters
- ▶ Orbs

Now it's time to emulate Emeril and "Kick it up a notch!" You've seen the good things Elements can do in cleaning up damaged photos and saving the ones that weren't so great. You've learned how to recompose a picture and how to add contrast and brighten up a dull day while keeping things realistic.

Well, a little reality goes a long way. Let's see what happens when we set aside realism. We can reduce the number of colors in the picture to just a handful. We can turn the picture into a puddle of wet paint and play with it until it's beyond recognition. We can turn people green or skies yellow. We can render a scene in brushed

copper or polished silver. We can make animated GIFs for the Web and lots more. Think of this chapter as your key to the playground parts of Elements. Let's have some fun!

Posterizing Colors

Posterizing, in effect, means reducing the number of colors available in the image. You'll find the Posterize command on the Filter, Adjustments submenu. When you posterize a photo, instead of pixel-by-pixel full color, you see large flat areas, making it look rather like a silk-screen print. The dialog box shown in Figure 32.1 lets you specify the number of tonal levels (or brightness values) for the three channels (red, green, and blue) in the image and then maps pixels to the closest matching level. For example, choosing two tonal levels in an RGB image gives a total of six colors: two shades of red, two of green, and two of blue, plus black and white.

FIGURE 32.1
Start with a small
number of levels.

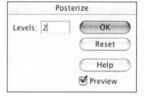

Figure 32.2 shows before and after views of fire escape that has been posterized. Be sure to see both versions in the color plate section, too.

Note that posterizing can also be applied to an adjustment layer, making it a no-risk method for changing a picture. If you don't like what posterizing does, simply delete the adjustment layer. See Chapter 31, "Making Composite Images," for more about adjustment layers.

Posterization can be applied to both color and grayscale images, of course. Applying it directly to color gives a more random, but usually a more interesting choice. As you play with the posterizing effect, you'll notice that lower numbers of tonal levels are apt to give you more satisfactory results. With too many levels of posterization, you can't really tell that much has changed.

 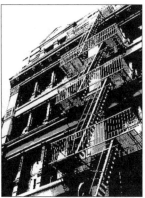

FIGURE 32.2
This posterization
was done with two
levels.

If you want a specific number of colors in your image, convert the image to grayscale and specify the number of levels you want in the Posterize dialog box. Then convert the image back to RGB mode, and replace the various gray tones with the colors you like.

Remember also that you're not stuck with what you get using the Posterize command. First of all, you can select an area of an image to posterize, rather than the whole thing. You can posterize a single layer, or add a posterized adjustment layer to affect just the layers below it. After posterizing, you can change colors selectively, repaint the sky if it got lost in translation, use the Sponge tool to intensify small areas of color, and add a textured surface to the image. You've already mastered a whole arsenal of Elements tools. Think about what they can do in combination. For example, I love what Posterize has done to my fire escape photo, but the sky seems a little boring. I could make it more interesting by selecting it and rendering some clouds, which I'd also posterize....

Adjusting the Threshold

Like Posterize, the Threshold command is one of several you can use by itself or on an adjustment layer. It converts the image into a black-and-white photo with very high contrast. You set the threshold, which determines which pixels are white and which ones are black.

To convert an entire image, choose Filter, Adjustments, Threshold. There's only one control in the dialog box that appears; it works like the Levels dialog box. Use the slider to set the Threshold value as desired. Pixels with a lower tonal value than the threshold setting are changed to white; pixels with a higher tonal

value are changed to black. Figure 32.3 shows an image converted to black and white using the Threshold command. Be sure to check Preview so you can see what effect your changes create.

FIGURE 32.3
Use Threshold to convert an image to high-contrast black and white.

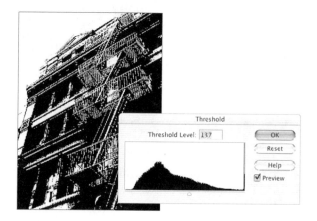

> **By the Way**
>
> If you have used an earlier version of Photoshop Elements, you may be used to looking for Posterize, Threshold, and other similar commands on the Image menu. They've been moved to the Filter menu in this edition. If you can't find an image-related command, check Filter, Adjustment. It's probably there.

Liquifying an Image

The Liquify filter (Filter, Distort, Liquify) is also fun to play with, though not especially practical. It distorts images, not geometrically as the Distort command does, but as if they've softened and run together. Salvador Dalí would have loved it. By now, you know that you can use the Smudge tool to drag some pixels around, approximating a finger painting. This is different. Liquify gives you tools to warp, twirl, pucker, bloat, shift, and reflect, and a Reconstruct tool for those times when you get carried away. You can apply masks to control what gets liquified. As with other filters, you can apply Liquify to a selection or the entire layer. Even if you start off without a selection and make the entire layer available to Liquify, you can freeze parts of the image you like by simply not using the Liquify tools on them, and continue to liquify the rest. Liquify is a promising tool for creative photo editing.

I have the most fun with this filter when I start with something really abstract, such as a patterned background. Other people enjoy using it on faces, pets, and

so on. Let's get wild and see what happens when you use the Liquify filter on a human subject. In Figure 32.4, I'll apply it to a not-so-great picture of a guy eating his lunch in a park.

There are two tools I use most often regardless of whether my subject is living or inanimate: Warp (the hand with extended index finger) and Turbulence (waves). I used Warp to push out the man's cheeks, and to stretch his sandwich. You can see the original in the inset photo.

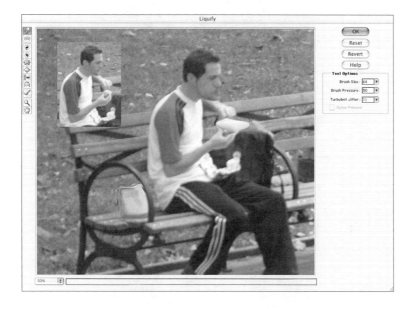

FIGURE 32.4
Warping in short strokes gives you the most control.

I can use the Turbulence tool in the Liquify window to create wind in the picture, so strong that it almost blows his clothes off (see Figure 32.5). To add to the wind effect, I could have pushed his hair out gently with the Warp tool, or twirled it with the Twirl Clockwise tool.

In Figure 32.6, I've used Liquify with a picture of two fish. Use the Bloat tool with a very large brush for a fish-eye lens effect, or with a small brush for a fish-eye lens on a fish. You can also use Bloat and a medium brush to make the fish look fatter, while the Pucker tool can make them look thinner.

FIGURE 32.5
It's windy out there!

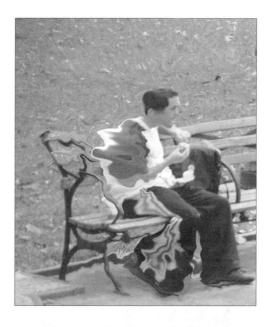

FIGURE 32.6
There's something
very fishy about
these fish.

Even if a person or other living creature is the subject, you can always use Liquify
to create an interesting background. As for using Liquify to create an abstract,
nothing could be easier. Start with some color on the page—a photo, an effects

pattern, or even just a good dose of noise—and then use the tools to distort it as I've done in Figure 32.7.

FIGURE 32.7
All you need is something to move. Colored noise is the basis for this image.

Replacing Colors with Gradient Map and Invert

We looked at a couple of ways of replacing color back in Chapter 21, "Too Light/Too Dark: Adjusting Brightness, Contrast, and Color." You learned then about the Replace Color dialog box, and how to shift one color to another. There are some other ways to do it, which you'll find if you go poking around the Filter, Adjustments menu.

Using Gradient Map

One of the commands you can use to replace colors in an image is Gradient Map. A gradient, you may recall, is a gradual transition from one color to another—for example, from red to yellow—and all the gradations in between. Some of the preset gradients that come with Elements involve a gradual blending between more than two colors. The Gradient Map command temporarily converts the image to grayscale and maps the grayscale steps in the image to the steps in a gradient you have selected. If you select a red-yellow gradient, shadows will be mapped to the starting color (red), and the highlights will be mapped to the ending color (yellow). Midtones in the image will be mapped to the gradient colors in between.

The Gradient Map command (Filter, Adjustments, Gradient Map) is capable of some really awesome effects. In Figure 32.8 (which is reproduced in the color plate section), I have applied a full spectrum gradient from the presets that come with Elements. To choose a gradient, click the down arrow next to the Gradient

swatch on the tool's Options bar to display a palette of gradients. Choose one of these by clicking it. To display the gradients in a different category, click the right arrow on the Gradient palette and select a category from the menu that appears. After selecting a different category, click the gradient you want to use from the new palette of choices. Once you click a gradient, its colors are immediately mapped to the tones in your image so you can see the result.

If you choose the Dither option, you may be able to get rid of any color banding that appears in the image by adding some random noise to the gradient fill. Clicking the Reverse option can bring on some surprising, and often wonderful, results because it turns the gradient around so the darkest shades in the image are mapped to the color at the opposite end. Depending on the colors or shades in the gradient, this might give you a negative look or just an unexpected color shift. It's always worth trying.

FIGURE 32.8
A more colorful building.

Creating Your Own Gradient

If none of the preset gradients exactly meets your needs, you can create your own. Display a gradient that's close to what you want, then click it to open the Gradient Editor dialog box, shown in Figure 32.9.

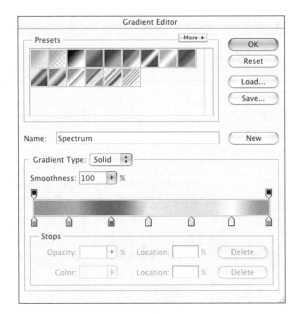

FIGURE 32.9
Create your own
gradient or modify
an existing one.

Click the color stop on the left and select the color you want to start with. You can
use the foreground or background color by selecting the appropriate option from
the menu that appears, pick up a color from the gradient bar or the image itself
using the Eyedropper pointer, or click the swatch to select a color from the Color
Picker. Define the ending color the same way, using the color stop on the right.
You can drag any color stop along the gradient bar to adjust its value. For exam-
ple, you can drag the midpoint color stop to define the point where the start and
end colors are evenly mixed. Add more color stops to the gradient if desired by
clicking below the gradient bar at any point. Select a color and adjust its mid-
point as desired.

You can refine the gradient a bit by adjusting its Smoothness value, which tells
Elements how smooth to make the transitions from one color to the next. To
adjust the opacity of the left and right stop colors, simply click the appropriate
Opacity stop (shown above the gradient bar), and enter an Opacity percentage.
When you're through making all your adjustments, type a name in the Name
box, and click New to save it. Click Save to save the entire palette of gradients.

This is the same Gradient Editor you'll use if you want to apply a gradient to a layer
by using the Gradient tool in the toolbox.

Using Invert

Invert is another color change command in the Adjustments submenu, and although you have essentially no control over it, the results are often worth keeping. It replaces each color in the image with its color wheel opposite. Skin tones turn odd colors such as bluish-green or bluish-gray, though, and some other color pairs don't swap well. Figure 32.10 (check it out in the color plate section) shows what happens when I invert a yellow flower. It turns deep cobalt blue against a violet (formerly green) center.

FIGURE 32.10
This could be interesting if combined with some other effect.

Now, if you take the inverted flower and posterize it, or try some of the effects or filters, you might end up with a very interesting piece of art.

Animating a GIF

Animated GIFs are those little bits of art that twirl around, blink, or wave back at you from web pages and forum signatures on the Web. If they aren't too big and flashy, they can be cute.

Animation is done, as it was 50 years ago, in layers. The difference is that for a GIF animation, each layer must be a complete frame with the entire picture in it. In the old days, you could put the body on one layer and the arms, which moved, on a different layer. Now, because the animation is accomplished by scrolling through the layers, everything needs to be kept together or you will see an arm-less torso, followed by waving arms.

Figure 32.11 is my animation model, a Japanese Happy Cat. This one, I believe, represents good health. I'm going to make him wave at you in a very simple three-step animation.

FIGURE 32.11
This cat will soon wave his paw.

The first step is to copy the cat into a new image file. (If you want to work along, the cat file [with the filename "cat for gif"] is in the collection of images you can download from this book's companion website. See the Introduction if you've forgotten where the downloads are.)

Duplicate the layer twice, so you have three in all. The bottom layer is the "resting" state for the animation, so you don't need to do anything to it. It will be the first frame in our animation. The second layer is the "transition" state and the third layer is the "final" state. You can insert as many transition layers as you need. More steps will give you a smoother animation, and a much larger file. Unfortunately, it may not play well on some computers, or if the Internet is running slowly, as it sometimes does.

Move to the top layer and make the changes necessary to take the picture to the final state. It will be much easier to see what you're doing if you make the layers you're not currently working on invisible. (Click the eye icon to hide a layer.) In Figure 32.12, you can see that I have moved the cat's paw to a fully extended wave position. To do so, I cut it loose with the Lasso, rotated it, and filled in the gaps in black and green with a small brush.

Next, move to the middle layer. Because this is a small animation and the cat's paw has to move only a short distance, one middle step is enough. If the paw had farther to travel, we could put in more transitional steps, but the animation will

look fine with just one step here. Cut the paw loose and rotate it halfway between where it is on the first and third layers. Again, use a small brush to fill in any gaps. Now your animation should look like Figure 32.13. The "art" part of the job is done.

FIGURE 32.12
The waving cat.

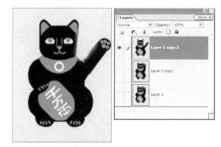

FIGURE 32.13
The cat in
mid-wave.

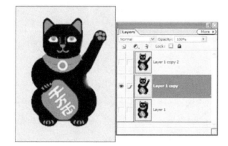

The final step in creating an animated GIF is to choose Save For Web on the File menu. You don't need very many colors for this particular example, so you can make it a 16-color GIF with no noticeable change. Be sure to check the Animate option in the upper settings pane. The picture was too large to fit where I wanted to put it, so I scaled it down to 50%. In the Animation box at the bottom of the window, check Loop if you want the animation to go continuously. Otherwise, it will run its steps once and stop. (If you want a limited number of repeats, add the additional steps as extra layers on the original animation.) You can add a delay between each frame in the animation by setting the Frame Delay value. Figure 32.14 shows the final settings for the animation.

Click OK and save it as a GIF. But before you do, you may want to preview your animation. There are two ways to do so: You can preview each frame using the frame controls in the Animation pane in the Save For Web dialog box, or select your favorite browser from the Preview In list and click the button. If you choose the latter option, you'll see both the waving cat and the HTML code to put him

on your web page or wherever he's going. By the way, it's a good idea to check out GIFs and anything else for the Web in other browsers as well. After all, you want to make sure everyone can enjoy your work.

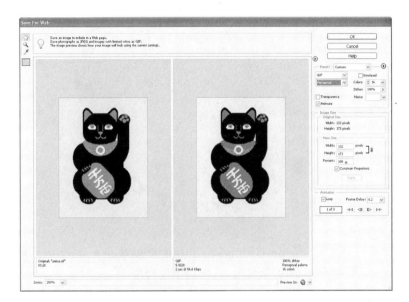

FIGURE 32.14
Finishing the ani-
mation.

Setting Type in a Circle

You've probably heard that setting type in a circle is impossible in Elements. You can set type on a path, any kind of path—freeform, circular, around the edges of a shape, in Photoshop CS, and in Adobe Illustrator. Since Elements doesn't include vector graphics among its tool sets, you have to approach the problem a little differently. The workaround, since Adobe introduced limited type on a path, has been to set your type in two arcs and position them to form a circle. That doesn't really work, though.

When you set type in an arc, it reads left to right, as it should in most languages. Setting the line of type twice, and making one line arc upward and the other arc downward does in fact give you type in a circle, more or less (see Figure 32.15).

But if you look carefully, you'll realize that the bottom line, although it reads correctly, is upside down with regard to its baseline. It doesn't follow the circle as it should. You could set the upper half of the circle, copy it, rotate it 180 degrees, and then move it into position. But there's an easier and more creative way. It's done with the Polar Coordinates filter, one of the most obscure filters in Elements.

FIGURE 32.15
Is it in a circle, or isn't it?

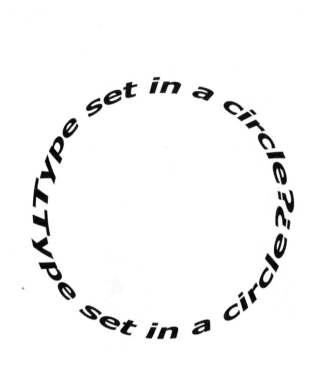

Start with a square image file. (This is significant: If your page is rectangular, you'll convert your type into an oval, rather than a circle.)

Place your type, or whatever you're using, from edge to edge near the bottom of the page. Figure 32.16 shows an example.

FIGURE 32.16
Give the type plenty of headroom.

From the Filter menu, choose Distort, then Polar Coordinates. You'll be warned that you must simplify the type in order to proceed. After you check your spelling, click OK. In the resulting dialog box (see Figure 32.17), select the Rectangular to Polar option. Figure 32.18 shows the resulting circle of text.

The Rectangular to Polar option takes the top of the image, compresses it, and places it in the center. Then it takes the bottom edge of the image and stretches it in a circle until the ends meet. For our example, the effect is perfect. For a rather strange distortion, try this on a photo of a person, landscape, flower, or other object. Just remember that the image or selection should be square for best results.

The other option, Polar to Rectangular, has the opposite effect. It takes the center portion of the image and stretches it across the top of the canvas. It then pulls the left and right sides of the image down toward the bottom edge. It takes the top half of the image, cuts it in half, and pushes it to the left and right across the top of the canvas.

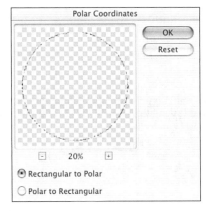

FIGURE 32.17
The Polar Coordinates dialog box.

FIGURE 32.18
Voilà! Type in a
circle.

You might notice, however, that the type is somewhat squashed. You can correct
this by stretching the type to about twice its height *before* you filter it. Figure
32.19 shows the result with stretched type.

FIGURE 32.19
See how much
stretch it needed?

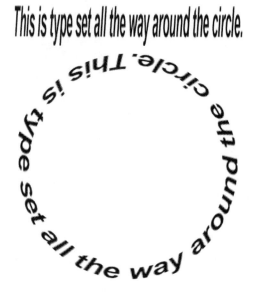

Suppose you want to make a circle of images. In Figure 32.20, we have a row of little people from the Webdings font. I've scaled them to 200% of their original height, so they will remain vaguely human. Notice that they are evenly spaced from one edge of the frame to the opposite edge. This prevents a gap in the line when we apply the filter.

FIGURE 32.20
Some people are
dingbats; some are
Webdings.

After applying the filter, I simply inserted one of NASA's awesome photos of our home planet, as shown in Figure 32.21.

FIGURE 32.21
We're all one world;
let's make it a
peaceful one.

Using the Magic Eraser

Magicians have lots of ways to make things disappear. There is an Elements tool that can do a similar kind of magic. It is called, appropriately, the Magic Eraser. It can remove a simple background with just a few clicks, leaving a transparent background for web use or for layering in a composite. If the layer is locked for transparency, however, the Magic Eraser will replace the pixels with the background color.

To reach the Magic Eraser, click and hold on the regular Eraser in the toolbox to open the menu. The Magic Eraser is the one that has the sparkly part of the Magic Wand tool attached to it (see Figure 32.22).

FIGURE 32.22
The Magic Eraser
and the picture
we'll use it on.

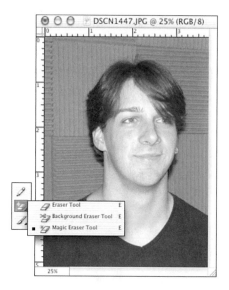

The background in this photo is textured acoustic paneling, with two distinct areas: ridges and recesses. To remove it, first set a reasonable amount of tolerance on the tool Options bar. Tolerance here works just as it does with the Magic Wand. The higher the setting you give it, the greater the range of pixels it will select with each click. If you overdo the tolerance, you may find yourself erasing part of your subject as well. You may need to experiment with several settings to find the best one.

To erase, simply click *once* on the part of the picture you want to erase. The Magic Eraser erases pixels similar in color (within the Tolerance you set) to the one you clicked. If you turned on the Contiguous option, only matching pixels surrounding the pixel you click will be erased; otherwise, matching pixels throughout the layer will be erased. To leave a few pixels at the edges of the background you're erasing (and smooth the edges there), turn on the Anti-Aliasing option. Adjust the strength of the eraser by changing the Opacity. Figure 32.23 shows the result of one click with a tolerance of 30.

That removed most of the wall, and unfortunately a piece of Dan's neck as well. So, 30 is too much. Let's try 15, instead. This will take several clicks but it will do a more careful job of removing the wall. Figure 32.24 shows the result after a dozen more clicks. It's not perfect, but a couple of strokes with the regular Eraser will finish the job quite nicely.

FIGURE 32.23
Just one click!

By the way, when you make part of a Background layer transparent, as I've done here, the name of the layer automatically changes to Layer 0 and it loses its background status, so you can paste it over another background. (If you don't want the background layer converted to a regular layer, use the Eraser tool instead of the Magic or Background Erasers.) Figure 32.25 shows my son, out of the studio and into the mountains.

If you have a photo with a complicated background, Elements has another eraser that will do the job for you. You learned about it in Chapter 29, "Creating Art from Scratch." It's called the Background Eraser, and appears on the same menu as the Magic Eraser. Its icon is an eraser coupled with a pair of scissors. Unlike the Magic Eraser, which only requires clicking, the Background Eraser makes you do the erasing by dragging the mouse pointer. However, because the tool samples and removes a range of background colors (instead of pixels that closely match the color of a single pixel), it's practically mistake-proof.

FIGURE 32.24
I never liked that
wall color.

FIGURE 32.25
A nicer setting for a
portrait.

Figure 32.26 shows a summer squash on a granite countertop. The granite is gray with black-and-white specks. This would be rather difficult to select with the Magic Wand or the Magic Eraser because of all the spots. But in this case, the Background Eraser is clearly the right tool for the job.

FIGURE 32.26
Fresh from the Farmer's Market.

First, I'll choose a fairly large brush, just to make the work go quickly. The tool allows me to get in close without erasing my subject, which means that I don't have to be so careful with my often-shaky hand. I'll set the tool options to a fairly low tolerance (about 5). Setting the Background Eraser to Contiguous means that it will only erase matching pixels adjacent to the point that's being sampled. (The sample point is represented by the crosshairs in the center of the brush.) Again, you don't have to be too precise here; just make sure that the crosshairs never move onto your subject, or you'll erase part of it. By choosing a large brush size, you can easily prevent that catastrophe.

Figure 32.27 shows the squash, with the counter mostly erased in less than a minute. Notice that I can bring the eraser right up to the edge of the squash without biting into it. That's because the contrast in color between the squash and the background is sufficient to fall outside the 5% tolerance.

FIGURE 32.27
Now to find some-
place more suit-
able.

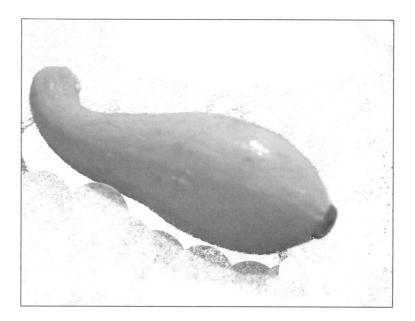

There are always going to be a few bits left to do by hand after you're done with the Background Eraser. Now, I need to find a better background. I think maybe I'll move it out to the cactus garden in Nevada, and I'll change the color to pink so it fits in (see Figure 32.28). Using Enhance, Color, Replace Color, it's very easy to shift this vegetable from yellow to the same sort of pinky color as the cactus leaves.

FIGURE 32.28
This squash looks
like it came from
some other planet.

Adding Metallic Effects

I think I must have been King Midas in an earlier life. I just love turning things to gold. There are, of course, a lot of ways to do this. The Molten Gold effect, actually a layer style, has to be applied to the whole layer. Suppose I want instead to pour it over some type or create a golden daisy? It's not very difficult. First, let's gild some type.

1. Open a new page and set some appropriate type. In this case, *appropriate* means fairly heavy. If you're going for gold, go for lots of it. It doesn't really matter what color you make it, because it's going to change.

2. Set the foreground color to bright yellow and the background color to light brown.

3. Select the type with the Magic Wand tool. Select the Gradient tool and choose the first default gradient, which is Foreground to Background (see Figure 32.29). Unlike the Gradient Map, which switches colors in an image, the Gradient tool applies a gradient fill to the current selection or active layer.

FIGURE 32.29
Choose the
Foreground to
Background
gradient.

FIGURE 32.29
Choose the
Foreground to
Background
gradient.

4. Use the Gradient tool to draw a vertical line over the type, from the top down. You should have nice light-to-dark gold letters, as in Figure 32.30.

FIGURE 32.30
Golden words.

Golden Ages

5. But I want a bit of texture on my letters. Go to Filter, Texture, Craquelure, and apply it with the settings shown in Figure 32.31.

FIGURE 32.31
Even better....

6. Go to the Styles and Effects palette and choose Layer Styles to add some depth. I like the look of the Simple Sharp Inner Bevel, so I'll use that, plus a small drop shadow. Figure 32.32 shows the final piece of molten gold lettering.

Golden Ages

FIGURE 32.32
This looks really
good when printed
on glossy paper.

There are, of course, other metals in our arsenal. Brass is very similar to gold, except that the darker brown has a touch of green in it, and the yellow should be lighter and brighter for gradient blending purposes. Adding a small amount of Gaussian noise with the Add Noise filter gives the brass a nice texture, and of course, we'll do the bevel and drop shadow thing, giving us the result in Figure 32.33.

A lotta brass...

FIGURE 32.33
Brass is duller than
gold. Hence the
noise.

Copper, shown in Figure 32.34, is also similar, except that the colors tend more toward red/pink. Set the gradient with a dark pinkish brown and a dark reddish brown. Copper tends to be shiny, so no noise is needed, but a simple pink glow around the edges adds authenticity. Glow is a Layer Effect.

Copperplate

FIGURE 32.34
Copper should
shine.

Using Weird Effects

Elements has many useful filters and effects. It also has a few that I haven't yet found a use for, and some others that are strange but interesting. Let's take a look at some of the stranger ones.

Plastic Wrap

One unusual filter, Plastic Wrap (Filter, Artistic, Plastic Wrap), pours a layer of plastic over your picture. The effect on the building photo in Figure 32.35 is to turn it into something resembling bas-relief. The plastic wrap is actually quite thick, and forms puddles as it goes down, but accents definite edges such as the roof line.

Did you Know?

If I wanted to do this picture properly, I'd undo the filter and clear out any obvious texture in the sky before trying again to apply the filter, in an effort to eliminate the gray oatmeal look it has gotten from the filter texture.

The interface is fairly simple. Smoothness determines the degree of shine on the plastic, and Detail determines how closely the plastic follows the contours of the image. Highlight Strength controls the intensity of the light shining down on the plastic, and therefore, the lightness of the highlights.

FIGURE 32.35
Wrapped in plastic, or drowning in it?

Diffuse Glow

This filter (Filters, Distort, Diffuse Glow) uses the background color and dumps what looks like powder onto the highlights of the image. If it's a light color, it'll look like powdered sugar. If it's dark, it will come closer to mildew. In Figure 32.36, I tried for snow, but got baby powder instead. It's still interesting; just not what I wanted. You'll find as you work with this program that this happens a lot. What you get is not what you wanted, but it's kind of cool anyway.

Use the Graininess slider to adjust the smoothness of the "powder," from a smooth hazy glow to a noisy rough surface. Use the Glow Amount to control the range of tones that are considered highlights, and thus are replaced with the background color. Higher values widen the range. Control how much the non-

highlighted areas are covered with the background-colored powder. Higher values narrow the range. If you play with these values, you'll almost always end up with a really cool image.

FIGURE 32.36
A powdered daisy.

Ocean Ripple

As a longtime sailor, I'd be very afraid if I saw the ocean start to behave like this filter (Filters, Distort, Ocean Ripple). It makes a definite rippling, even bubbly, effect. But it's a lot more like an eggbeater in a bowl of club soda than anything the ocean does unless there's an underwater earthquake. That said, it can be gorgeous on the right subject. In Figure 32.37, I'm trying it on the fruit basket, and it's much like viewing the fruit through a sheet of pebbled glass. Because the effect is irregular, unlike the glass filters in Elements, it manages to keep a sparkly quality that the glass filters lose. This filter, in my mind, fits into the "weird but useful" category.

You have two settings with this filter. The Ripple Size value controls the number of ripples—with the highest value, you'll get fewer ripples, but of larger size. Ripple Magnitude controls the height (amplitude) of the ripples. The higher the value, the taller the ripples become.

FIGURE 32.37
A bubbling bowl of
fruit.

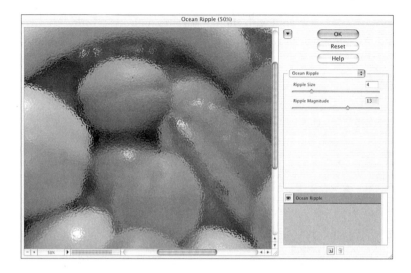

Wave

The Wave filter (Filters, Distort, Wave) is really strange. First of all, you need to be
an engineer to understand the interface, shown in Figure 32.38. Its purpose is to
create an undulating wave pattern on a layer, making it appear as if the image is
underwater. The Sine option gives you the most even undulation, with smooth
upside-down U-shaped waves. The Square option creates vertical or horizontal
rectangular waves of color, like sharp-edged tubes into which the picture has been
poured, and the Triangle option creates M-shaped waves with sharp corners.

FIGURE 32.38
A thoroughly con-
fusing dialog box.

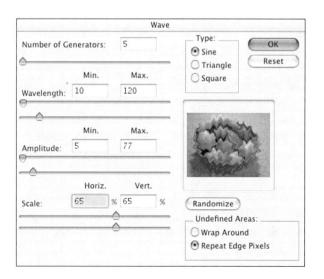

To set the number of waves, use the Number of Generators slider. You can have as many as 999, but lower numbers are less destructive to the image. The Minimum and Maximum Wavelength values determine their length. Keep the numbers the same or close to each other for symmetry or spread the difference for more irregular waves. The Amplitude sliders dictate the wave height. The Horizontal and Vertical Scale sliders adjust the distortion. If you click Randomize, you will see various wave patterns generated with the same settings.

The Wrap Around option wraps pixels pushed off the canvas by the waves onto the opposite side of the layer/selection. The Repeat Edge Pixels option cuts off the pixels pushed off by the waves and fills the holes with a color close to the pixels on the edge.

Solarize

The Solarize filter (Filters, Stylize, Solarize) uses a darkroom trick, imported from the film world to the digital world. Solarizing a photo means exposing it to light in the middle of the developing process. The results are usually unpredictable, and often worthless, as the entire picture turns black. But if it's done at the right second, with the right amount of light, you'll partially invert the colors in the picture, with interesting results. With the Solarize filter, the values in the image are changed: The highlights become shadows, and light midtones become dark midtones. The values of shadows and dark midtones are left unchanged. Then colors are swapped for their opposites on the color wheel, producing an interesting effect.

There are no options with this filter. But because solarized pictures can turn dark, you may need to readjust brightness and contrast levels after you solarize. Figure 32.39 is a photo you have seen before, but not like this. I first solarized, and then simply applied auto-levels.

There are many other interesting filters, and you can pile one strange effect on another until you get something that has artistic possibilities, or until you destroy the image completely.

FIGURE 32.39
Solarize inverts the
colors in an image.

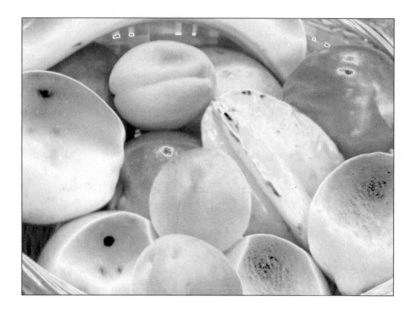

Pixelate Filters

When one is "pixilated," according to my dictionary, he's intoxicated, but in a charming, bemused, whimsical, pixyish way. Pixelation can be equally whimsical and bemusing, if applied to the right subjects. Misused, it just turns everything into a bunch of dots. *Pixelation* happens when similarly colored pixels are clumped together to form larger units, which might be square (pixel-shaped), round, or rounded off by anti-aliasing to whatever form they take. It happens, unasked for, if you're printing a picture at too low a resolution. You end up with large pixels forming jagged shapes that look like they were built out of a child's plastic block set.

When controlled, the effect can be quite interesting. Photoshop includes a set of Pixelate filters that produce different effects all based on the notion of clumping together similar pixels. It's best to apply these effects to simple subjects and to those with strong contrasts, such as the photo of the flower in Figure 32.40.

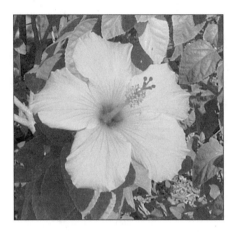

FIGURE 32.40
Hibiscus in bloom.

Crystallize

Most of the Pixelate filter set looks best if the effect is applied with the Cell Size quite small. Otherwise, the crystals, facets, and so on become so big that the image becomes unrecognizable. In Figure 32.41, I applied the Crystallize filter at a Cell Size of 8. It adds reasonable distortion without destroying the shape of the flower. In Figure 32.42, I pushed the Cell Size up to 50, destroying the picture. You can even set the Cell Size as high as 300, but it turns the entire picture into one or two cells.

FIGURE 32.41
The Crystallize filter applied.

FIGURE 32.42
Same filter,
overapplied.

Pointillism and Mosaic

As a former art student, I think it's fun to go back and recall the first time I was introduced to the work of Georges Seurat. It was a revelation (especially after studying some of the "sloppier" French impressionists) to see these dabs of paint all neatly clustered, forming elegant scenes from a distance and forming equally elegant abstract patterns up close. It would be nice if the Pointillism filters did the job as neatly and scientifically as M. Seurat. They don't.

This is, however, one case where the smallest setting doesn't work as well as some of the larger ones. I first tried the picture using 3 pixels as the Dot Size. I got a spotty picture, as I expected, but it looked more like video noise than pointillism. Using a slightly larger Dot Size (8) produced an image a little closer to what I was looking for. But when I tried a much larger size, approximately 25, I ended up with baseballs. Figure 32.43 shows all three effects. Be sure to set your background and foreground colors to something appropriate to the image because Photoshop uses them in creating the dots.

There's a Mosaic setting in the Pixelate effects, but all it does is to make larger pixels out of the smaller ones. The result is the sort of thing used to hide the faces of the people being arrested on all those late-night police shows (see Figure 32.44).

FIGURE 32.43
From top to bottom, Dot Sizes 3, 8, and 25.

FIGURE 32.44
Alleged perpetrator, concealed by the Mosaic filter.

Stylize

The Stylize filter family offers some wonderful effects. They are creative, and you can use them to add final effects or touches to an image. This section touches on the most interesting of the filters, including the Find Edges filter, the Glowing Edges filter, and the Wind filter.

Find Edges, Glowing Edges, and Trace Contour

These three effects sound as if they should look alike. They actually do look somewhat alike, with Glowing Edges and Find Edges being much more dramatic than Trace Contour. The Find Edges filter removes most of the colors from the object and replaces them with lines around every edge contour. The color of the lines

depends on the value at that point on the original object, with lightest points in yellow, scaling through to the darkest points, which appear in purple. The picture looks like a rather delicate-colored pencil drawing of itself. Find Edges works best, naturally, on photos that have a lot of detail for the filter to find. In Figure 32.45, I've applied it to a digital photo of a hot dog cart. Find Edges sometimes becomes more interesting if you apply it more than once to the same picture. If you apply it once and don't like the result, try it again before you move on to a different filter, or increase the contrast in the original photo before you try again. Touching up areas afterward with the Sponge tool can bring out colors you hardly knew were there.

FIGURE 32.45
Notice how Find Edges picks up the detail of the sidewalk and the soda can collection.

Unfortunately, you cannot set the sensitivity of the Find Edges filter. In practical terms, this means that you have to prepare the picture before you trace it. Begin by running the Despeckle filter (in the Noise submenu) so that Photoshop won't attempt to circle every piece of dust in the background. If you don't want the background to show, select and delete it, or select your object and copy it to a separate layer first. You can also use the Edit, Fade command to back off the strength of the filter. Using this filter with different blending modes can produce some spectacular effects.

Glowing Edges is more fun because it's prettier, and because you can adjust it to have maximum impact on your picture. Glowing Edges turns the edges into

brightly colored lines against a black background. The effect is reminiscent of neon signs. You can vary the intensity of the color and the thickness of the line.

In Figure 32.46, I've applied Glowing Edges to the same picture of the hot dog cart. It works especially well with busy pictures with lots of edges. The more it has to work with, the more effective the filter is. Be sure to check this one out in the color plate section. Black and white doesn't do it justice.

FIGURE 32.46
Some of the color remains, but the background goes black.

Trace Contours, like several of the previous filters, works better on some pictures if you apply it several times (see Figure 32.47). The Trace Contours dialog box has a slider setting for the level at which value differences are translated into contour lines. When you move the slider, you are setting the threshold at which the values (from 0–255) are traced. Experiment to see which values bring out the best detail in your image. Upper and Lower don't refer to the direction of the outline. Lower Outlines specifies where the color values of pixels fall below a specified level; Upper Outlines tells you where the values of the pixels are above the specified level.

I like to use this filter to place different tracings on different layers and then to merge them for a more complete picture.

FIGURE 32.47
The image was
traced several
times with different
settings.

FIGURE 32.47
The image was
traced several
times with different
settings.

Wind

The Wind filter creates a neat directional blur that looks, strangely enough, like wind. You can control the direction and the amount of wind in the dialog box (see Figure 32.48). This is a great filter for creating the illusion of movement and for applying to type. It works best when applied to a selected area rather than to the entire picture.

FIGURE 32.48
The Wind filter and
its dialog box.

The Wind filter can also create a brushed metal effect, if you apply it once from each direction to a block of flat metal color, or a metallic gradient, like the one we used to make the liquid gold lettering.

Emboss

Occasionally, you come across a photo, like this picture of a lion, which almost begs to be turned into a corporate logo or advertising image. In such cases, the Emboss filter can do wonders to make the picture just abstract enough to be useful. However, it does remove most of the color from the photo in the process. In working with this photo, I found that the angle at which the filter is applied can make a major difference. Figure 32.49 shows the interface and the picture to which I'm applying the filter.

FIGURE 32.49
A corporate lion, perhaps?

Combining Filters

Some people like things plain. I'm not one of them. I want the whipped cream, marshmallow, nuts, and cherry on my ice cream, and I'm seldom satisfied with using just one Elements filter. And with an arsenal of 99 different filters (plus dozens of third-party add-ons), why shouldn't we take advantage of as many as possible? In the remaining few pages of this chapter, let's look at some interesting combinations.

Texturizer

You can add a texture to any photo, no matter what you have already done to it. The Texturizer filter (Filter, Texture, Texturizer) places a pattern resembling canvas, burlap, brick, or sandstone over your image, making it look as if it's on paper with that texture. The Canvas texture is particularly nice if reduced in scale. Figure 32.50 shows a photo of some fishing boats, first treated with the Dry Brush filter and then texturized, and finally treated with the Dry Brush filter a second time.

FIGURE 32.50
To keep the sky from getting muddy, I selected everything except the sky for the second application of the Dry Brush filter.

Rough Pastels and Film Grain

The Rough Pastels filter adds a strong directional quality to Figure 32.51, another view of the same harbor. A single filter is applied to it. However, since the Rough Pastels includes a texturizer, it's effectively two filters.

In Figure 32.52, I kicked it up a notch by adding Film Grain over the pastels, which lightened the image, and came up with what I think is an even more interesting result.

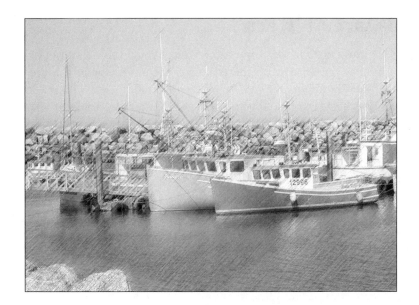

FIGURE 32.51
Rough Pastel harbor scene.

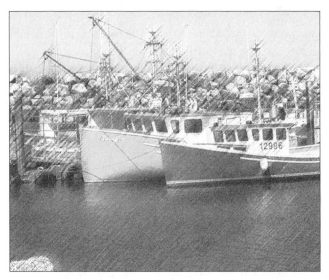

FIGURE 32.52
The harbor with added Film Grain.

The possibilities are endless. If you can imagine a style or treatment for a picture, chances are excellent that Elements can do it.

Third-Party Filters

Elements has close to 200 filters, styles, and effects. You'd think that would be enough. Think again. There are hundreds more. Because Elements can use the same filters that Photoshop and Jasc Paint Shop Pro use, there's a huge selection to choose from. Start your search with Corel's KPT Collection. These two dozen filters range from goo and gel to a fractal tool, a shape shifter, and scatter, which lets you import a single particle, object or shape, or a grid of them, and then randomly scatter them over your image, or have them land in a pattern or spiral if you choose. See these filters at www.corel.com.

AlienSkin (www.alienskin.com) has several packages of effects, texture creators, and filters for Elements. Check out Eye Candy, Xenofex, and Splat! You can even download demo versions of these from the company's website. There are some very far out effects, as well as more useful ones like smoke, fire, fur, and grass.

AutoFX has seven different sets of filters. Dream Suite 1 and 2 are my favorites. Download demo versions at http://www.autofx.com/demo_center.asp and let your imagination out to play.

Flaming Pear Software has 16 different sets of filters and downloadable demos. They also have free textures that you may download and enjoy. Visit them, and try out some of their filters at http://www.flamingpear.com/products.html.

These are just a few of the many makers of filters and plug-ins for Photoshop and Elements. You can find these packages anywhere that software is sold. You can also find even more. Do a Google search on Photoshop Filters, and you'll be taken to sources for even more.

Orbs

Here's a final treat for you, and a unique approach to filters. My friend, artist and writer Samantha Nocera, has a series of creations she calls Orbs. Working in Photoshop Elements, with some third-party filters as well as the Adobe ones, she starts with any kind of symmetrical image and then abstracts it into a sort of a mandala (an image used as a focus for meditation). Figure 32.53 shows her "Ghost Orb."

FIGURE 32.53
Be sure to see this in the color section. (Art by Samantha Nocera.)

Here, in Sam's words, are the steps she took to create this one:

1. Open a square image. I tend to use 900×900 pixels. The resolution on this one is 100.

2. Add a new layer that you can delete later and turn on the rulers. Draw two guides that cross in the middle of the page so you can easily tell where the center of your image is.

3. Decide on a background. In this case, I rendered some clouds using the built-in feature in Photoshop Elements (Filter, Render, Clouds), applied them to each other, and then touched them up with a Soft Light brush in green here and there, and then stuck the built-in Glass Distortion filter over the whole colorful mess.

4. Choose your first shape layer. I have a bunch of weird pre-made shapes; some come from the Roly Poly font, others are pre-mades I found as freeware while wandering around the web at 3 a.m. There are also some good possibilities in the Elements shape collection. Almost any symmetrical thingie will work. Place the shape in the middle of the page. Delete the guide layer.

5. Simplify the shape so you can pound on it with some filters and effects. I clobbered the first shape with the Gel filter from Kai's Power Tools, and then stuck a gradient glow from the Eye Candy filters on there.

6. Then I added another shape, used the Chrome filter from Eye Candy, and then went over it with color dynamics applied to a Soft Light brush. Then I went into the Layers palette and lowered the opacity on the shape, and added the same type of gradient glow (from Eye Candy) that the first shape had.

7. I then took a sort of ring shape, chromed it, and then brushed it with a little Soft Light color. This one got a Corona rather than a gradient from Eye Candy.

8. Finally, I flattened the whole thing in order to add a lens flare.

I'm not suggesting that you replicate these steps and make a copy of Sam's Orb. The point is simply to show you how to build something out of nothing much, by adding layers and filters, and using your imagination. At the risk of sounding like a broken record, let me leave you with a final reminder to keep experimenting. You never know what a filter or combination can do to a particular picture until you try it. The way that Photoshop calculates the filter effects means that some filters can look very different, depending on the kind of picture to which they are applied. You can't always predict what will happen, but the unexpected effects are frequently wonderful.

Summary

We took a different approach this chapter and went poking in some of the darker corners of the Elements menus. We were rewarded with several strange and unusual effects. First you learned to posterize, then to liquify. Then we looked at some special color effects. You learned about gradient mapping and color inversions. We played alchemist, turning things to gold and other pretty metals. Finally, we dug into some strange-looking filters such as Neon Glow, Solarize, Glowing Edges, and Wind. Some of these work by themselves, while others practically beg to be used as part of a set of changes. We looked at combining filters, and ended up with a masterpiece of image manipulation.

PART VIII

Appendixes

CHAPTER A Glossary **675**

CHAPTER B Photoshop Elements Menus **695**

CHAPTER C All the Shortcuts… **701**

APPENDIX A

Glossary

Acquire: To transfer an image from a digital camera to a computer or to import it from another format into a program such as Photoshop.

Acrobat: A set of applications developed by Adobe to create and view PDF files. Acrobat is used to create the PDF files, and the freeware Acrobat Reader is used to read the PDF files.

Airbrush: Pen-shaped tool used by non-digital artists to spray a fine mist of ink or paint to retouch photos and create continuous-tone illustrations. In Elements, an airbrush tool can be selected from the Options bar for the Brush tool.

Aliasing: Aliasing occurs when a computer monitor, printer, or graphics file does not have a high-enough resolution to represent a graphic image or text. An aliased image has jagged edges as if it were made from bricks, and is often said to have the "jaggies." (See also *Anti-Aliasing*.)

Alignment: The positioning of a block of text. Text can be placed to the left, right, or center of a page and can be justified (except not in Elements), so both margins are even. Otherwise, type set flush left is also ragged right, and type set flush right is ragged left.

Analogous colors: Any three colors that are side by side on a 12-part color wheel (one that includes tertiary colors), such as yellow-green, yellow, and yellow-orange. (See also *Color wheel*, *Complementary colors*, and *Tertiary colors*.)

Angle of view: Measured in degrees, the width of the area a lens can see.

Anti-Aliasing: Smoothing or blending the transition between pixels in line art or type by using intermediate colors. This fools the eye into seeing a smooth edge rather than a jagged one.

Aperture: Opening, used interchangeably with f-stop to denote the diaphragm opening that allows variable amounts of light to reach the lens.

Artifact: Misinterpreted or false information caused by a process. In a compressed image, it can result in distorted colors or shapes.

Auto focus: A technique that uses an infrared light beam or sonar to measure the distance between a camera and the subject and automatically set the focus.

Available light: The light present in the room (or outdoors) without adding additional strobe or photoflood lights.

Bas-relief: In digital photography, an effect created by a specific Photoshop filter making the image look as if it were slightly raised from the surface.

Bevel: Adding a beveled effect to a graphic image gives the image a raised appearance. You do this by applying highlight colors and shadow colors to the inside and outside edges.

Bit: Short for *binary digit*, the smallest unit value that can be stored or manipulated by a computer: It can be set to either 1 or 0.

Bit depth: Refers to the color or grayscale of an individual pixel. A pixel with 8 bits per color gives a 24-bit image. (8 bits times 3 colors is 24 bits.) CCDs are colored in a pixel-by-pixel method, using the following guidelines:

- ▶ 30/32-bit color is billions of colors (only supported with high-end CPUs).
- ▶ 24-bit color resolution is 16.7 million colors.
- ▶ 16-bit color is 32,000 colors (this is the Macintosh standard).
- ▶ 8-bit color is 256-color (this is the Windows standard).
- ▶ 8-bit grayscale is 256 shades of gray.
- ▶ 4-bit, 64 colors or grays.
- ▶ 2-bit, black or white.

Bitmap: A graphic image stored as a specific arrangement of screen dots; the opposite of vector graphics. All digital photos are bitmaps. Web graphics are usually saved as bitmap images with some form of data compression. Also known as raster graphics. Common types of bitmap graphics are GIF, JPEG, Photoshop (PSD), PCX, TIFF, Macintosh Paint, Microsoft Paint, PNG, FAX formats, and TGA.

Bleed: To print without margins. When a page or a cover design extends to the edge of the paper, it is called a *bleed*.

Blow-up: Slang for enlargement.

BMP: The standard filename for Windows Bitmap graphics files, represented by the extension .bmp.

Bounce light: Light that is bounced off a reflective surface, such as a white card, aluminized reflector, wall, or ceiling.

Box camera: Simplest kind of camera, consisting of a lens, shutter, film holder, and a viewfinder.

Browser: Short for *web browser*. Software used to access web pages by interpreting hypertext and hyperlinks. Commonly used browsers include Mozilla, Firefox, Safari, Netscape Explorer, and Microsoft Internet Explorer. Web pages often appear differently when viewed using different browsers, depending on the brand and version number of the browser intended to view them in.

Burning in: To darken all of the color values in a small area of a picture. Comes from a photographic printing technique, where most of the print is masked while a specific section gets additional exposure.

Byte: Eight bits read together by a computer as a single word, for a range of 256 possible values.

Caption: The line or lines of text that provide information identifying a picture or illustration.

Card storage: Memory system used in many digital cameras to store pictures; often can be removed from the camera and read directly by a computer.

Catchlight: Light placed to reflect as tiny white dots in a portrait subject's eyes.

CCD (Charged Coupled Device): This device converts varying amounts of light into a proportional electrical charge on a pixel. The two main types of CCDs are linear arrays, used in flatbed scanners and digital copiers, and area arrays, used in cameras. The charges are scanned by the device and converted into a string of digital values.

Clip art: Simple graphics, both in color and in grayscale, that you can find online and in computer programs to print out and use. Clip art began as generic illustrations sold to newspapers and advertising designers, who would literally "clip" the picture they needed to drop into their layout. Computers, the Internet, and CD-ROMs have made finding the clip art you need for a specific theme very easy. While clip art is usually protected by copyright, it almost always comes with a license letting you use it in your own creations.

Close-up lens: Lens that can maintain focus when very close to the subject, also called a *macro lens*.

CMYK: Abbreviation for cyan, magenta, yellow, and key (black), the four ink colors used in process printing and many inkjet or color laser printers. (Some low-cost inkjet printers don't use black ink, but instead use a mixture of the other three primaries.)

Color balance: Means of compensating for too much of one color in a photo by adding its opposite. For example, if a photo is too red, you can add cyan.

Color temperature: Measurement of the relative redness or blueness of a light source, measured in degrees Kelvin. This is important because while your eye can automatically interpret ambient light as "white," a camera can't. Indoor incandescent lighting is usually around 3200°K, which a camera sees as having a reddish tint, while sunlight—at approximately 6500°K—is captured as being much bluer.

Color wheel: A circle showing the relationship between colors. Green, blue, and red are the primary colors of light that appear on a computer screen, and are located 120° from each other on the circle. Between each are the secondary colors, the result of blending the primaries (for example, violet is the secondary color located between blue and red). Tertiary colors are the result of mixing adjacent secondary ones, and so on. Note that the color wheel for inks is different: cyan, magenta, and yellow being the primaries.

Complementary colors: Any two colors which are directly opposite each other on a color wheel; an example for a color wheel of glowing computer pixels would be the primary green and the secondary violet. Complementary colors create strong contrast when used next to each other.

Composition: In graphic design, the arrangement of type, graphics, and other elements on the page.

Compression: A method of packing data in a format that saves disk storage space or download time. Some compression methods are *lossy*, and delete unimportant information to save space. Other methods are *lossless*, and use mathematical techniques to encode and decode the data without changing it.

Continuous tone: An image where variations of brightness appear uninterrupted, instead of broken into visible steps. Each pixel in a continuous tone image file uses one byte for each of the three primary colors. This permits 256 density levels per color or more than 16 million colors when the primaries are mixed.

Contrast: A measure of the rate of change of brightness in an image. High contrast implies rich blacks and bright whites with little in between, medium contrast implies a good spread from dark to light with plenty of intermediate colors, and low contrast implies very little variation between the darkest and lightest colors in the image.

Copyright: A legal protection given to creators of original art (or photos, or music, or any other work that can be saved in a fixed form), giving the creators control of all subsequent use of that art for a number of years. It's reasonable to assume that non-commercial, private use of any art or photo—that is, where no money changes hands and viewing is restricted to your personal circle of friends—is exempt from this protection. Otherwise, if any portion of a copyrighted image is identifiable, a license is required from the copyright owners.

Crop: Discarding outer parts of an image to improve composition, or to allow more important central parts of the image to be enlarged to fill a space.

Cropping tool: In digital image software, a tool used to simulate the traditional knife or scissors used to crop a photo.

Cyan: With magenta and yellow, the three primary colors of additive or "print" color.

Daguerreotype: Antique photo process developed by Joseph Daguerre, producing a very grainy gray or sepia-toned (brownish) image.

Data: The generic name for anything input to, output from, or stored or manipulated in a computer. All data must be in digital format.

Default setting: Any setting in a computer program that has been stored by the programmers, but can be changed by the user.

Definition: The clarity of detail in a photograph, dependent on resolution (pixel size) and contrast.

Depth of field: Means of describing the area of a photograph that is in focus.

Desktop publishing: Technique of using a personal computer to design images and pages, and assemble type and graphics, and then using a laser or inkjet printer to create small quantities of finished pages, or sending the computer files to a print shop for larger quantities.

Diffusion dithering: A method of dithering that randomly distributes pixels instead of using a set pattern.

Digital: Any system or device in which information is stored or manipulated by on/off impulses, so that each piece of information has an exact and repeatable value. Digital information is stored in bits, each bit representing on/off or one/zero.

Digital camera: A device that captures an image on a Charge Coupled Device or CCD so that it can be downloaded to and manipulated by a computer, or sent to an inkjet printer. It might also be called a "filmless" camera.

Digital image: Visual data stored electronically, as on a computer hard drive, rather than an image that is produced chemically or physically, as a photograph or a drawing. Digital images can be made using digital cameras, video recording devices, scanners and other input devices that capture and store images without film, or be drawn into a computer program using a mouse or stylus. Digital images can be manipulated using computer software, transferred over the Internet, or output on film or paper.

Digital zoom: A feature on cameras that has the effect of getting closer to the subject by enlarging pixels in the image. Since no additional pixels are being scanned, resolution suffers. (See also *Optical Zoom*.)

Digitization: The process of converting analog information into digital format for use by a computer.

Disc: Term used to describe optical storage media (DVD, CD-ROM, compact disc), as opposed to magnetic storage systems.

Disk: Term used to describe magnetic storage media (floppy disk, diskette, hard disk), as opposed to optical storage systems.

Dither: To create the appearance of shades or tints of color that don't exist in a system by using adjacent pixels or dots of related existing colors. For example, the grays in a newspaper photo are dithered from tiny dots of black ink and white space. Dithering is often used when converting computer images with high bit-depths (that is, thousands or millions of colors) into formats with a limited palette such as GIF, which can support only 256 colors.

Dodging: Also called "holding back." In traditional darkroom work, sections of the photograph that shouldn't get too dark are masked by a moving piece of cardboard or the technician's hand. This keeps light from the negative from reaching the print. The effect, whether done in a darkroom or on a computer, is to lighten part of the image without affecting the rest.

Download: The transfer of files or other information from one piece of computer equipment to another.

DPI (Dots Per Inch): The measurement of resolution of a printer or video monitor based on dot density. For example, most desktop printers have a resolution between 300 and 1,200dpi, while most monitors are 72dpi. The measurement can also relate to pixels in an input file or screen dots in a prepress output film.

Driver: A software utility that tells a computer how to operate a specific external device. Drivers are usually installed at the system level, and programs call on them when they need to access a printer, scanner, or camera.

Drop shadow: A patch of black or color placed behind and slightly offset from an object and shaped like the object. The effect is to give the object depth by creating an apparent shadow behind it.

Duotone: The application of two colors to provide a richer sepia or other colored tone than a single-color image, usually grayscale, can provide. A good duotone image can simulate a wider range of the color spectrum than two colors used separately.

Dye-sublimation: Printing technique that uses varying amounts of heat to transfer color from a special ribbon to a matched paper. It is capable of almost infinite color variation.

Embossing: Creating the effect of a relief image, adding dimension to it by making the image appear as if it were carved as a projection from a flat background.

EPS (Encapsulated PostScript): A type of graphics file that can contain vectors to efficiently describe graphics or text as well as bitmaps.

Export: To save a file in a different format than the native one used by a program. For example, Elements PSD files can be exported to the web formats GIF or JPG.

Exposure: "Taking" a picture, from exposing film to light. Also, a method of determining how much light and for how long.

Exposure meter: A device that measures the light in a scene and computes the settings for a camera to put the optimal amount of light on the film or CCD.

Eye Candy: Photoshop plug-ins from Alien Skin.

F-stop: Measure of width of diaphragm opening, determining how much light passes through the lens. Smaller numbers are wider openings. f3.5 is three times wider than f8.

Feathering: Gradually dissipating the edge of an image or selection, making the transition look blurry.

Fiber-optics: An optical system that uses glass or transparent plastic fibers as light-transmitting media.

File: A collection of information—such as text, data, or images—saved on a hard disk or other storage medium.

File extension: Three or four letters at the end of a filename, separated from the main part of the name by a period (often called a dot), to indicate what format a file is in. Almost all computers recognize three-letter extensions such as .jpg, .gif, .htm, and .psd, though unless the computer has appropriate software it might not be able to open the file. Four-letter extensions are less common, though most web browsers recognize the extension .html.

File format: A standardized method of storing and locating data in a file. Some common image file formats include TIFF, PICT, and EPS.

File server: A computer that serves as the storage and addressing component of a network. Files can be kept on a server's hard disk, or on a CD-ROM mounted on the server, and then can be accessed by any user on the network.

Film recorder: A device that can record a digital image onto photosensitive film, used to create high-resolution negatives for offset printing.

Filter: A tinted glass or plastic lens that fits in front of a camera lens.

Fish-eye lens: Extreme wide-angle lens.

Fixed-focus lens: Lens in which the focus is preset and not variable. It usually has a depth of field from about 10 feet to infinity.

Flash memory: A type of memory chip that can retain data after power has been removed. Digital cameras with flash memory can keep their images even if the batteries are worn out or removed; flash memory cards can be removed from the camera and stored separately or read by a computer and some inkjet printers.

FlashPix: Trade name for a multi-resolution image file format jointly developed by Kodak, HP, Microsoft, and Live Picture.

Flatbed scanner: An optical scanner in which the original image is held flat and remains stationary while the sensor (usually a CCD linear array) passes over or under it.

Floppy disk: A removable computer storage medium consisting of a flexible plastic disk, coated with a magnetic material on both sides. In early personal computers, floppy disks were sheathed in light cardboard and could bend. Today, almost all floppy disks are in rigid plastic containers, but the name stuck.

Flush left: Text aligned along the left margin of the column.

Flush right: Text aligned along the right margin of the column.

Focal length: Distance to the focal point of a lens. Determines whether the lens is telephoto (long) or wide-angle (short).

Focal point: In design, an element of a page where lines converge. The eye is naturally drawn to the focal point of an image or a page design. In optics, the point where light rays converge from a lens.

Font: A complete set of text characters of a particular design and style. This includes the letter set, the number set, and all of the special character and diacritical marks you get by pressing the Shift, Option, or Cmd/Ctrl keys. Depending on the system, fonts may contain bitmaps of the characters in specific sizes, or computer instructions for rendering the characters in any size desired.

Frame: Imaginary rectangle in which you compose a picture.

Freeware: Software distributed for free by the author, often via the Web. It may be protected by copyright or not, depending on the author's preference. (See also *Shareware*.)

FTP: File Transfer Protocol, a standard method for transferring files of any format or length via a network. The method requires a specially configured server at one end, and a browser or other client software at the other. FTP transfers are less prone to errors than email attachments, and are often used to send large artwork files to a print shop.

GIF: Image compression technique developed by CompuServe for its online service. GIF—short for Graphics Interchange Format, and having the extension .gif—has become popular for displaying graphics on websites because files can be very small. GIF uses a limited palette of 256 or fewer colors, and a data-packing scheme. If the original image has a similarly limited palette, as with logos and some screenshots, the process is completely lossless.

GIF89A: GIF format developed for the Web, that supports interlaced graphics and transparency. The former draws the image in multiple passes, giving the user a hint of what's there before the download is complete; the latter can let the graphic background of a web page show around an image's irregular border.

Glow: The opposite of a shadow in that it creates a highlight around an image. A high radiance creates a soft, subtle glow and a low radiance creates a hard, bright glow, such as a neon glow.

Gradient: A gradual transition of colors. Many metallic images are gradients. Web images that use gradient fills as a special effect need to be saved in a JPEG rather than a GIF format to preserve the subtle transition without dithering. (See also *Dither*, *GIF*, and *JPEG*.)

Graphic background: The bottom-most layer on a web page with a design or solid color; text and images appear overlaid on it. A small graphic can be tiled to create a repeating background design.

Graphic design: Arrangement of type and visual elements along with specifications for paper, ink colors, and printing processes that, when combined, convey a visual message.

Graphics: Visual elements that supplement type to make printed messages more clear or interesting.

Grayscale: An application of levels of black ink (for print) or shades of the color black (on the screen) that simulate a range of tones between black and white. Grayscale images have no hue (color). In print design, a grayscale graphic image appears to be black, white, and shades of gray, but only uses the black ink in your printer. Grayscaling assigns each dot within an image a specific shade of gray, using between 16 and 256 shades. Basically, the more levels the better, but with correspondingly greater memory requirements.

Green eye: Condition seen in photos of cats, caused by light reflecting from the back of the eye. (See also *Red eye*.)

Grid: A systematic division of a page or image by parallel horizontal and vertical lines, to help alignment of objects and keep pages consistent.

GUI (Graphical User Interface): Computer technology that lets you manipulate images and icons on a screen, instead of being restricted to plain text. Without a GUI, computerized photo editing would be impossible. Popularized by Macintosh in 1984, and by Windows some years later.

Halftone: An image reproduced through a pattern of black dots of various sizes to simulate shades of gray in a photograph or drawing.

HiCon: Short for *high contrast*.

Highlights: Lightest portions of a photograph or piece of artwork, as compared to midtones and shadows.

HTML: Abbreviation for *Hypertext Markup Language*, the universal language of the World Wide Web. HTML uses a system of abbreviations within a text file that tell a browser how to format and display a web page, where to download images and other objects on the page, and where to take the user when a link is clicked.

Hue: The actual color of an object. Hue is measured as a location on a color wheel, expressed in degrees. Hue is also understood as the names of specific colors, such as blue, red, yellow, and so on.

Import: To use data that's not in a program's native format, such as a JPEG or GIF file instead of PSD in Elements. Most graphic programs are capable of importing files in a variety of file formats. The opposite of export. (See also *Export*.)

Indexed color: File storage technique that maps specific colors in an image to an 8-bit shorthand, reducing storage space and download time. If the image has 256 or fewer colors, no information is lost.

Inkjet printing: Computer printing technique that sprays tiny drops of black or colored ink on a page to build up the picture. Inkjet printers are generally less expensive than laser printers, though supplies may be more expensive per page; some low-cost inkjet printers are capable of photographic quality. The print produced by an inkjet printer can be smudged or damaged by water unless special inks are used.

Interchangeable lenses: Found on high-end digital cameras. A photographer will often change lenses to get a particular focal length or other feature.

Jaggies: Slang term for the stair-stepped appearance of a curved or angled line in digital imaging. The smaller the pixels and the greater their number, the less apparent the jaggies. Also known as *pixellization*.

JPEG (Joint Photographic Experts Group): The committee that designed a method of making image files smaller, and the file format named after it. JPEG reduces image file size by selectively eliminating detail—a lossy compression—and then mathematically packing the reduced data. Images with few details and soft focus can be compressed to very small files, while images with a lot of detail result in larger files. The file size is also affected by a user-specified quality setting, between 0 and 100. At higher numbers, the compressed image may be virtually indistinguishable from the original. At very low numbers, details and sharp edges will be lost. JPEG files, which have the extension .jpg, support up to 16 million colors or 256 shades of gray.

Justify: The alignment of text along both the left and right margins of a column. This is achieved by adjusting the spacing between the words and characters as necessary so that each line of text finishes at the same point.

K, KB: In computer hardware, K or KB stands for Kilobyte, 1,024 bytes of data, as in 256KB of RAM (Random Access Memory). In print technology, K stands for the black ink in the CMYK (Cyan, Magenta, Yellow, and Black) color process. (See also *CMYK*.)

Kerning: To adjust the horizontal spacing between letters. Some pairs of letters look better when closer, because their lines fit well together. An example would be the combination AV, where the right side of the A can tuck under the left side of the V.

Key light: The main light in a photograph, usually from above and in front of the subject but slightly to one side. The highlights and shadows from this placement help bring out the contours of the subject.

Landscape: Any page orientation in which the width used is greater than the height.

Laser printing: Computer printing technique that draws the image as light on a photosensitive drum. Where light strikes the drum, a static charge is built that attracts tiny particles of dry ink; where there's no light, no ink is picked up. The particles of ink are then dropped on paper, and fused to the paper with heat. Laser printers—particularly color ones—are more expensive than inkjet printers but are faster and generally cost less per print.

Layout: A sketch of a page showing the position of text and illustrations, exploring color options, and giving general instructions before final design decisions are made, or the process of actually creating the page

Leading: (Pronounced to rhyme with "sledding".) The vertical spacing between lines of text. In early typesetting, strips of lead were placed between lines of metal type to achieve the spacing, hence the name.

Long lens: Another name for a telephoto lens.

Lossless compression: A mathematical data-packing technique where the file size is reduced but quality is preserved and no detail is lost. Lossless compression is most efficient when there's only a limited amount of data to begin with, such as with the 256-color palette of a GIF file.

Lossy compression: A technique of shrinking the size of detailed files by first eliminating some of the detail, and then applying lossless compression to the result. Detail lost by this process can never be recovered, but when the process is done cleverly, as with JPEG image files and MP3 music files, the result can be perfectly acceptable for a specific use. Almost all lossy compression schemes let the user adjust how much detail will be lost, but even at their highest-quality setting the files are still significantly smaller than the original.

LPI (Lines Per Inch): The frequency of horizontal and vertical lines in a halftone screen.

Mask: A defined area used to limit the effect of image-editing operations to certain regions of the image. In an electronic imaging system, masks are drawn manually (with a stylus or mouse) or created automatically—keyed to specific density levels or hue, saturation, and luminance values in the image.

Megapixel: 1,048,576 pixels. In a digital camera, having more megapixels means that more details are captured, and the image can be enlarged without appearing jaggy. Of course, the quality of the lens and the file-storage scheme also affect how much detail will be captured.

Montage: A single image formed by assembling several smaller images or pieces of images to reflect a consistent theme.

Morphing: A special effect used in motion pictures and video to produce a smooth transformation from one object or shape to another.

Neon glow: Type of glow around elements of an image to give the appearance of neon lighting.

Normal lens: A lens that sees approximately the same angle of view as the human eye.

Offset printing: Almost always short for *offset lithography printing*. A thin metal or plastic plate is exposed to an image or scanned by a laser, and then processed so the white parts of the image will absorb water. The plate is then dampened and dipped in oil-based ink. Since oil and water don't mix, the ink adheres only where water wasn't absorbed. (That process, by itself, is known as *lithography*.) The plate is then rolled against a rubber blanket, transferring the pattern of ink, and the blanket is rolled against a piece of paper—that's the *offset* part. Despite the complicated description, the process is fast and inexpensive when a lot of copies are needed. Most commercial printing, including this book, is offset.

Optical zoom: A feature on cameras that lets you change the size of the area being photographed without changing the distance to the subject, and without losing resolution. (See *Digital zoom*.)

Outline: In graphic design, tracing the outer edge of text or a graphic image. If the outline is feathered, the effect is generally referred to as a glow.

PCX: File format occasionally used by Windows computers for graphics.

PDF: Portable Document Format, sometimes called an Adobe Acrobat file. Created by Adobe Systems as a universal cross-platform file format and supported by many programs. The format uses both lossless compression of text and some images along with selected lossy compression on highly detailed images to achieve very small file sizes. PDF files can be read by the standalone Adobe Reader software or by a plug-in in a web browser. Both the software and the plug-in are available free from Adobe's website.

PICT: File format used by Macintosh for graphics.

Pixel: Short for *picture element*; refers to the smallest possible point that can be displayed in a screen image. In a computer screen, pixels are actually made of three smaller dots—one for each primary color—that are individually varied in brightness to produce the full palette of colors.

Pixellation: A special effect based on altering groups of pixels by color or value. (Also refers to a form of live-action animation developed by Canadian filmmaker Norman MacLaren.)

Plug-in: A software extension that adds capabilities to a host program. In the case of Photoshop Elements, plug-ins apply particular (and often very interesting) transformations to an image. In the case of a web browser, plug-ins let the program display animations, movies, and sound.

PNG: Portable Network Graphics format, and pronounced "ping." PNG is used for lossless compression and displaying images on the Web or transferring them between computers. The advantage of PNG is that it supports images with millions of colors and produces background transparency without jagged edges. The disadvantages are that PNG files do not show up on older browsers, do not support animation, and tend to be larger than other compressed formats. (See also *GIF* and *Lossless compression*.)

Point size: A measurement of height used in typesetting. Type of the same point size may appear larger or smaller, depending on how much of that size is devoted to the body of the letter and how much to ascenders and descenders. Text set in an all-capital headline font will often display letters across its full point size; text set in a book font will have much smaller lowercase letters. In printing, one point equals 1/72 of an inch; on a computer screen, a point is often one pixel and its actual size depends on how the system is set up.

Pointillism: Style of painting popularized by Georges Seurat but dating back to China several centuries B.C. The image is composed of small dots of color, which appear to blend together as the viewer looks at them.

Portrait: An upright image or page where the height is greater than the width. Opposite of a landscape.

Posterization: Consolidating all the grays in a grayscale picture down to just a few levels, which can then be colorized to give areas of flat color.

PPI (Pixels Per Inch): A measurement of resolution used for digital devices, including cameras and scanners, as well as for monitors.

Primary colors: Three colors that can't be made by combining other colors, but can mixed in various proportions to create any other color. In traditional art theory, the primary colors are red, yellow, and blue. In light and on computer screens, the primaries are red, green, and blue. For printing or inkjet inks, the primaries are magenta, cyan, and yellow. (See also *Color wheel*.)

RAM: Random Access Memory, where a computer temporarily stores data that it will need to access quickly. All other things being equal, computers and printers with more RAM can perform many tasks more quickly.

Raster: What your image is when using most paint programs; also called a *bitmap image*. Raster images are composed of individual picture elements or "pixels" that, when viewed from a distance, appear to form a complete image. You can tell if you are looking at a raster image by the extension on the filename. The extensions `.bmp`, `.pcx`, `.gif`, `.tga`, `.jpg`, `.png`, and `.tif` are common raster image filename extensions. Raster images can appear to lose resolution when they're enlarged, because each pixel of the original is now displayed on two or more pixels of the screen. (See also *Vector graphic*.)

Rasterize: To convert an image from a vector graphic to a bitmapped graphic. (See also *Vector graphic*.)

Red eye: An effect that happens when the flash of a camera hits the back of the eye and reflects through the pupil. Human eyes will have red dots in their centers when this happens. (Some animal's eyes reflect green or yellow, because of different chemicals in their retinas.) Red eye can easily be corrected on the computer, or avoided by moving the camera light away from the lens, or flashing it briefly to constrict the pupil before taking the photograph.

Resolution: The measurement of how much detail is in an image or printout, usually expressed in dots or pixels per inch. Additional resolution not only lets you see more of what's in a picture; it also means the screen or printer can render text and lines more smoothly. Computer screens are nominally 72 pixels per inch, but many can be set for a higher resolution. Desktop print-ers range between 300 and 1,200 dots per inch; the lower resolution is usually adequate for most purposes.

Retouching: A means of altering art-work or photographs to correct faults and enhance the image. Retouching is much easier on the computer than on an actual paper photo, and believe me, retouching a paper photo is *a lot* easier than retouching a film negative.

RGB: Abbreviation for red, green, blue, the primary colors of light. In web design and design for computer moni-tors, all colors are described as varying amounts of these primaries.

ROM (Read Only Memory): Permanent memory that can't be changed by the user. In a computer, it stores the basic instructions that oper-ate the hardware on start-up, before the system is read from the hard drive. In a camera, it stores all the software for taking pictures.

Sans-serif: A style of typeface that means "without feet": the lines that make up the character are finished without any embellishment. Sometimes also called *Gothic*. Common sans-serif typefaces include Arial, Helvetica, Avant Garde, and Verdana.

Saturation: The color intensity of an image. An image high in saturation appears to be very bright. An image low in saturation appears to be duller and more neutral. An image without any saturation is also referred to as a grayscale image.

Scaling: A means of calculating the amount of enlargement or reduction necessary to accommodate a photo-graph within the area of a design.

Scanner: A device that attaches to a computer and scans or digitizes a page using light sensitivity to translate a pic-ture or typed text into a pattern of dots that can be manipulated in software and stored by the computer. (See also *BMP* and *Resolution*.)

Screen: In printing, a very fine pattern of dots and whitespace that simulates intermediate grays and colors from black or primary-color inks.

Secondary colors: Colors that are made by mixing two primary colors equally. (See also *Primary colors* and *Color wheel*.)

Serif: A type style that has "little feet," embellishments (often short perpendicular lines) at the ends of principal lines of a character. Also refers to the "foot" itself. Thought to come from ancient Roman masons who would chisel serifs to neaten lines of characters as they were carved into stone. Common serif typefaces include Times Roman, Garamond, and Palatino. (See also *Sans-serif.*)

Shade: Hue made darker by the addition of black; the opposite of a tint. (See also *Tint.*)

Shareware: Copyrighted software distributed by its creator using an honor system of payment. Most shareware is free of charge, but the author usually requests a small fee or other contribution if you like the program or use it regularly. By paying the fee, you become a registered user: This may mean you are eligible for support, can receive updates, or that additional program features are turned on when you enter the registration code. Anyone can copy shareware and pass it to friends, so long as it is in the same format as the original distribution. Including shareware on a CD-ROM or at a website usually requires permission of the creator. (See also *Freeware.*)

Sharpness: Refers to whether or not an image appears to be in focus. Sharpness can be enhanced in programs such as Elements by increasing the contrast of pixels on the edge of an object.

Shutter: Device that opens and closes to allow light to pass through the lens.

SLR (Single Lens Reflex): A type of camera where the photographer composes the picture by looking directly through the main lens, rather than through a viewfinder or LCD screen. Usually used on 35mm interchangeable lens cameras, though there are some digital cameras that use the same arrangement.

Speed (ASA/ISO): A way of rating how light-sensitive a film is. ASA stands for the American Standards Association, and ISO stands for the International Standards Organization, which determine the standards for film speeds. Digital cameras rate their CCD sensitivity as being equivalent to a given ISO.

Strobe: Electronic flash that can be part of camera or separate and triggered by the camera shutter.

Tertiary colors: Colors formed by mixing secondary colors that are adjacent on a color wheel, or by mixing a secondary color with its adjacent primary. (See also *Color wheel*, *Primary colors*, and *Secondary colors.*)

Thumbnail: A small low-resolution version of a larger graphic image, often used in image browsers to display multiple images on a single screen. Some software also creates thumbnails that are displayed when an image is displayed on the computer desktop, or as a fast-loading link to larger images on a web page. (See also *HTML.*)

TIFF (Tagged Image File Format): Computer file format used to store bitmap images. Typically uses lossless compression to decrease file size. TIFF files can be any resolution and support black and white, grayscale, and all color depths. The default file extension for TIFF files is `.tif`. (See also *File extension* and *Lossless compression*.)

Tint: A hue made lighter by the addition of white. (See also *Shade*.)

Twain: A standard for communications between scanners, imaging devices, digital cameras, and computer programs. Twain lets you capture an image directly to your software.

Typeface: A family of fonts. For example, the typeface Arial includes the fonts Arial, Arial Bold, Arial Italic, and Arial Bold Italic. (See also *Font*.)

Value: The shade (darkness) or tint (lightness) of a color. Also called *brightness*, *lightness*, *shade*, and *tone*.

Vector graphic: A graphic image or typographic character drawn by geometric formulas that represent shapes and lines. The letter characters in many word processors, as well as unsimplified text in Adobe Elements, are vector graphics. So are the outputs from many drawing programs. (The computer temporarily rasterizes these graphics when they're displayed on the screen, but they're stored as vectors.) The advantage of vector graphics is that they usually require less computer memory or download time than bitmaps, they can be resized and otherwise manipulated without distortion, and their final resolution can be tailored to the output device.

Vignette: Similar to cropping, but can be any shape and the edges of the desired part of the image gradually fade to the background color. The typical "kiss within a gauzy heart shape" in a wedding album is an example of a vignette.

Waterless printing: A variation on offset printing that uses a silicone substrate on the plate, instead of water, to reject ink. Capable of finer screens and more subtle color variation than convention offset. (See *Offset printing*.)

Wide-angle lens: A lens that sees more area of a scene than the human eye would from the same distance. The effect is somewhat the same as moving the camera farther back, though some distortion can occur.

WYSIWYG: Pronounced "wiz-zee-wig", and abbreviation for *What You See Is What You Get*. A popular feature in desktop publishing, a WYSIWYG program shows you onscreen exactly how the document will appear when printed. Photoshop Elements is always WYSIWYG.

Zoom lens: Lens on which you can change the effective focal length optically. Many cameras can zoom from a wide-angle view to a telephoto view. (See *Optical zoom* and *Digital zoom*.)

Photoshop Elements Menus

All together in one place, here are the main Photoshop Elements menus. If you forget where some command is hidden, you can find it here. I've included both Mac and Windows versions. The menu items and their locations are the same on both platforms, but the usual differences in key modifiers apply. The Cmd key on the Mac is the same as the Control key in Windows, and the Option key on a Mac is the same as the Alt in Windows.

Mac Menus

Edit

Undo Brush Tool	⌘Z
Redo	⌘Y
Revert to Saved	
Cut	⌘X
Copy	⌘C
Copy Merged	⇧⌘C
Paste	⌘V
Paste Into Selection	⇧⌘V
Delete	
Fill Selection...	
Stroke (Outline) Selection...	
Define Brush from Selection...	
Define Pattern from Selection...	
Clear	▶
Preset Manager...	

Image

Rotate	▶
Transform	▶
Crop	
Divide Scanned Photos	
Resize	▶
Mode	▶

- 90° Left
- 90° Right
- 180°
- Custom...
- Flip Horizontal
- Flip Vertical

- Free Rotate Layer
- Layer 90° Left
- Layer 90° Right
- Layer 180°
- Flip Layer Horizontal
- Flip Layer Vertical

- Straighten and Crop Image
- Straighten Image

Enhance

Auto Smart Fix	⌘M
Auto Levels	⇧⌘L
Auto Contrast	⌥⇧⌘L
Auto Color Correction	⇧⌘B
Adjust Smart Fix...	⇧⌘M
Adjust Lighting	▶
Adjust Color	▶
Adjust Color	▶

- Shadows/Highlights...
- Brightness/Contrast...
- Levels... ⌘L

- Remove Color Cast...
- Adjust Hue/Saturation... ⌘U
- Remove Color ⇧⌘U
- Replace Color...
- Color Variations...

Select

All	⌘A
Deselect	⌘D
Reselect	⇧⌘D
Inverse	⇧⌘I
Feather...	⌥⌘D
Modify	▶
Grow	
Similar	
Load Selection...	
Save Selection...	
Delete Selection...	

Layer

New	▶
Duplicate Layer...	
Delete Layer	
Rename Layer...	
Layer Style	▶
New Fill Layer	▶
New Adjustment Layer	▶
Change Layer Content	▶
Layer Content Options...	
Type	▶
Simplify Layer	
Group with Previous	⌘G
Ungroup	⇧⌘G
Arrange	▶
Merge Down	⌘E
Merge Visible	⇧⌘E
Flatten Image	

- Layer... ⇧⌘N
- Layer From Background...
- Layer via Copy ⌘J
- Layer via Cut ⇧⌘J

Filter

Last Filter ⌘F
Filter Gallery...

Adjustments ▶
Artistic ▶
Blur ▶
Brush Strokes ▶
Distort ▶
Noise ▶
Pixelate ▶
Render ▶
Sharpen ▶
Sketch ▶
Stylize ▶
Texture ▶
Video ▶
Other ▶

Digimarc ▶

Equalize
Gradient Map...
Invert ⌘I
Posterize...
Threshold...
Photo Filter...

View

New Window for Untitled-5

Zoom In ⌘=
Zoom Out ⌘-
Fit on Screen ⌘0
Actual Pixels ⌥⌘0
Print Size

Selection ⌘H
Rulers ⌘R
Grid
Annotations

Snap to Grid

Window

Images ▶

✓ Tools
✓ Tool Options

Color Swatches
Histogram
How To
Info
✓ Layers
Navigator
✓ Styles and Effects
✓ Undo History

✓ Palette Bin
Reset Palette Locations

✓ File Browser
Welcome

Photo Bin

menus.tif
Untitled-3
Untitled-4

Maximize Mode
Cascade
Tile
Minimize ^⌘M
Bring All to Front

Match Zoom
Match Location

Help

Photoshop Elements Help... ⌘?
Glossary of Terms...
Tutorials...

System Info...
Online Support...
Registration...
Photoshop Elements Online...

Windows Menus

APPENDIX C

All the Shortcuts...

No matter where we were going, my father always knew a shortcut. It's a lesson I've taken to heart. Shortcuts are good.

So, for all you Elements users, here it is: one complete and comprehensive list of shortcuts: tools, key commands, all the things you really need to know. If you're not up for memorizing all these, photocopy these pages and post them next to the computer. I guarantee it'll save you tons of time and energy.

TABLE A.1 Tools and Their Shortcuts

Tool	Shortcut	Tool	Shortcut
Move	V	Pencil	N
Zoom	Z	Eraser	E
Hand	H	Brush	B
Eyedropper	I	Paint Bucket	K
Marquee	M	Gradient	G
Lasso	L	Shape	U
Magic Wand	W	Sharpen	R
Selection Brush	A	Blur	R
Type	T	Smudge	R
Crop	C	Dodge	O
Cookie Cutter	Q	Burn	O
Red Eye Brush	Y	Sponge	O
Healing Brush	J	Switch Colors	X
Clone Stamp	S	Return to Default Colors	D

TABLE A.2 Selecting Tools

Shortcut	Mac	Windows
Cycle through hidden tools	Option-click+tool	Alt-click+tool
Cycle through tools with the same shortcut key (Enable Shift Key for Tool Switch in General Preferences)	Shift+press shortcut key (for example, to cycle through erasers, press Shift+E)	Shift+press shortcut key
Release existing selection (that is, "select nothing")	Cmd+D	Ctrl+D

TABLE A.3 View Commands

Result	Action (Mac)	Action (Windows)
Fits image on screen	Double-click hand tool, or Cmd+0 (zero)	Double-click hand tool, or Ctrl+0 (zero)
100% magnification	Double-click Zoom tool, or Cmd+Option+0 (zero)	Double-click Zoom tool, or Alt+Ctrl+0 (zero)
Toggle between normal view and full screen (hides palettes)	Tab	Tab
Zooms in or out	Cmd+plus key or minus key from keypad	Ctrl+plus key or minus key from keypad
Toggle zoom tool from Zoom In to Zoom Out	Option while clicking Zoom tool	Alt while clicking Zoom tool
Zoom tool in or out	Cmd+spacebar (in); Option+spacebar (out)	Ctrl+spacebar or Alt+spacebar
Zooms in on specified area of an image	Cmd+drag over preview in Navigator palette	Ctrl+drag over preview in Navigator palette
Scrolls image with hand tool	Spacebar+drag, or drag view area box in Navigator palette	Spacebar+drag, or drag view area box in Navigator palette
Scrolls up or down one screen	Page Up or Page Down	Page Up or Page Down
Scrolls left or right one screen	Cmd+Page Up or Page Down	Ctrl+Page Up or Page Down
Scrolls up or down 10 pixels	Shift+Page Up or Page Down	Shift+Page Up or Page Down

TABLE A.3 Continued

Result	Action (Mac)	Action (Windows)
Scrolls right or left 10 pixels	Shift+Cmd+Page Up or Page Down	Shift+Ctrl+Page Up or Page Down
Moves View to upper-left corner	Home	Home
Moves View to lower-right corner	End	End

TABLE A.4 Selecting and Moving Objects

Result	Action (Mac)	Action (Windows)
Repositions marquee or shape while selecting or drawing	Any marquee tool +spacebar+drag	Any marquee tool+spacebar+drag
Adds to or subtracts from selection	Any selection tool+Shift or Option+drag	Any selection tool+Shift or Alt +drag
Intersects a selection	Any selection tool+Shift+ Option+drag	Any selection tool+Shift+Alt +drag
Constrains marquee or shape to square or circle	Shift+drag	Shift+drag
Draws marquee or shape from center	Shift+Option+drag	Shift+Alt+drag
Shift to Move tool	Cmd key (except when Hand tool or any shape tool is selected)	Ctrl key (except when Hand tool or any shape tool is selected)
Switch from Magnetic Lasso to Lasso	Option+drag	Alt+drag
Switch from Magnetic Lasso to Polygonal Lasso	Option+click	Alt+click
Moves copy of selection or shape	Move Tool+Option+drag selection	Move Tool+Alt+drag selection
Move Selection Area by one pixel	Selection+Arrow key (one click per pixel)	Selection+Arrow key (one click per pixel)
Move selection shape, selected image, or layer one pixel	Move Tool+Arrow key (one click per pixel)	Move Tool+Arrow key (one click per pixel)

TABLE A.4 Continued

Result	Action (Mac)	Action (Windows)
Moves layer 1 pixel when nothing selected on layer	Cmd+Arrow key	Ctrl+Arrow key
Accepts cropping or exits cropping without changing picture	Crop tool+Return or Esc	Crop tool+Enter or Esc

TABLE A.5 Painting

Result	Action (Mac)	Action (Windows)
Switch to Eyedropper tool	Any painting tool or shape tool+Option (except Impressionist Brush)	Any painting tool or shape tool +Alt (except Impressionist Brush)
Selects background color	Eyedropper+Option+click	Eyedropper+Alt+click
Sets opacity, pressure, or exposure for Painting mode	Any painting or editing tool+number keys (for example, 0 = 100%, 1 = 10%, 4 then 5 in quick succession = 45%)	Any painting or editing tool+ number keys (for example, 0 = 100%, 1 = 10%, 4 then 5 in quick succession = 45%)
Cycles through blending modes	Shift+plus or minus key on keypad	Shift+plus or minus key on keypad
Fills selection/layer with foreground or background color	Option+Delete or Cmd+ Delete	Alt+(Backspace or Delete), or Ctrl+(Backspace or Delete)
Displays Fill dialog box	Shift+Delete	Shift+Backspace or Delete
Locks transparent pixels on/off, or last applied lock	/ key	/ key
Connects points with a straight line	Any painting tool+Shift+ click	Any painting tool+Shift+click

TABLE A.6 Type Editing

Result	Action (Mac)	Action (Windows
Moves text in image	Cmd+drag text when type is selected	Control+drag text when type is selected
Aligns left, center, or right	Horizontal Text Tool+Shift +Cmd+L, C, or R	Horizontal Text Tool+Shift+Ctrl +L, C, or R

TABLE A.6 Continued

Result	Action (Mac)	Action (Windows
Aligns top, center, or bottom	Vertical Text Tool+Shift+ Cmd+L, C, or R	Vertical Text Tool+Shift+Ctrl +L, C, or R
Selects one character left/right, one line down/ up, or one word left/right	Shift+Arrow key or Cmd +Shift+Arrow key	Shift+Arrow key or Ctrl+Shift +Arrow key
Selects characters from insertion point to mouse click point	Shift+click	Shift+click
Moves one character left/right, one line down/ up, or one word left/right	Arrow keys or Cmd+Arrow keys	Arrow keys or Ctrl+Arrow keys
Selects word or line	Double-click or triple-click	Double-click or triple-click
Shows/Hides selection on selected text created with a Type Mask tool	Cmd+H	Ctrl+H
Decreases/increases font size of selected text 2 pts./px.	Cmd+Shift+< or > (add Option key to increase 10 pts/px)	Ctrl+Shift+< or > (add Alt key to increase 10 pts/px)

Index

Symbols

3D Transform filter, 533-534
8-bit color, 551
16-bit color, 551
24-bit color, 551
72 dpi (resolution), 255

A

AA batteries, 75
AC adapters, camera maintenance, 75-76
accent lights, studio lighting techniques, 155
accessing
 File Browser, 233-234, 249
 menus, 232
 Undo History palette, 262
activating adjustment layers, 605
adaptive interlacing (GIF images), 292
Add Noise filter, 526-527
adding
 layers, 345-348
 noise to images, 524-527

Adding Special Effects category (How To palette), 449
Adjust Smart Fix command (Enhance menu), 239
Adjust Smart Fix dialog box, 410
Adjustment command (Filters menu), 241
adjustment layers, 344, 604
 activating, 605
 creating, 604-606
 grouping, 606
 masks, 605-606
 editing, 606-608
 posterizing colors, 632
Adobe Color Picker. See also Color Picker
 colors, selecting, 554-555
Adobe Gamma utility, monitor color calibration, 552
Adobe Online tutorials, 453-454
Adobe Photoshop Elements. See Photoshop Elements
Advanced Blending option (Photomerge), 628
advertisements
 digital photo uses, 23
 type enhancement, 142-144
aerial perspective, 93

Airbrush tool (Photoshop Elements), 359
albums
images
importing (Organizer), 309-310
transfers, 184
iPhoto
creating, 326
image additions, 327
keyword assignments, 327
Organizer, searching, 317
alcohol/drugs, red eye effect, 434
AlienSkin website, 670
alkaline batteries, 75
Amber Alerts, digital photo uses, 23
ambience property (Lighting Effects filter), 532
angles, Dutch, 85
animals, portrait shots, 170
farm/zoo animals, 173
pets, 172-173
wildlife, 174-175
animation
backgrounds, 344
cels, 344
GIFs, 640-643
layers, function of, 344
previewing, 642
Anti-Aliasing option (Magic Eraser), 648
anti-fraud measures (photo uses), 20
antialiasing type (Photoshop Elements), 368-369
aperture, 62
automatic exposure system, 63-64
f/stops, 62-63
Apple Color Picker, 544
applying
effects, 613-616
layer styles, 601
metallic effects, 653-655

Arraich's Photoshop Elements Tips website, 455
art papers, 273
artificial light, balancing daylight with, 151
Artistic filters
Chalk & Charcoal filter, 586-587
Conte¢ Crayon filter, 587-588
Glowing Edges filter, 591-593
Grain filter, 594-595
Graphic Pen filter, 588-590
Halftone Pattern filter, 588-590
Neon Glow filter, 593-594
Oil Painting filters, 580
Paint Daubs filter, 583
Palette Knife filter, 582
Underpainting filter, 580-581
Rough Pastels filter, 584-585
Smudge Stick filter, 585
Sponge filter, 595-596
Sumi-e filter, 590-591
Watercolor filters, 574-577
Dry Brush filter, 577
Spatter filter, 578-579
aspect ratios of shapes, resizing, 562-564
Astronomy Picture of the Day website, 528
attachments (email), 259-260
Auto Color Correction tool (Photoshop Elements), 413-415
Auto Contrast tool (Photoshop Elements), 412, 415
Auto Erase option (Pencil tool), color replacement, 569

Auto Levels tool (Photoshop Elements), color balance repair, 410-414
Auto Smart Fix tool (Photoshop Elements), shadow/color correction, 409, 414
autofocus capabilities (camera lenses), 29, 55
focus lock, 55
passive autofocus, 55
problems, 55
AutoFX website, 670
Automatic Correction tools (Photoshop Elements)
Auto Color Correction, 413-415
Auto Contrast, 412, 415
Auto Levels, 410-414
Auto Smart Fix, 409, 414
opening, 409
automatic exposure control, 63-64
available light
advantages, 147
daylight, balancing with artificial light, 151
diffused light, 148
disadvantages, 148
hard light, 150
sensitivity of photographic material measures, 148
shadowless light, overcast days, 148
soft light, 148-150

B

babies, portrait shots, 170-171
backdrops, indoor settings, 131-132
all occasion prop, 132-134
interesting backdrops, finding, 132

background colors
 selecting, 553-556
 swatches, 230
Background Eraser tool
 (Photoshop Elements), 363,
 649-651
 backgrounds, erasing,
 571-572
background layers, 344
background light, studio light-
 ing techniques, 155-158
backgrounds
 erasing (Background
 Eraser tool), 571-572
 natural portraits
 clothing and makeup,
 136-138
 food photography,
 139-141
 indoor settings,
 129-134
 nature improvements,
 134-136
 outdoor portraits,
 126-129
 type and image
 enhancement,
 142-146
 neutral, center of interest,
 90
 replacing in pictures,
 505-509
 web galleries
 banner category, 302
 creating, 301-303
 custom color category,
 303
 large image category,
 302
 security category, 303
 thumbnail category,
 302
 web pages
 color adjustments,
 299
 design guidelines,
 296-299
 pattern creation, 297

pixel sizes, 299
tiling images, 297
transparent GIF
 images, 299-300
balance and symmetry (per-
 ception), 100-102
barn doors, studio lighting
 techniques, 155
base color, 609
Basic resolution setting, 39
batteries
 AA, 75
 alkaline, 75
 camera maintenance,
 75-76
 Lithium Ion, 16, 75
 NiCad, 75
 rechargeable, 16
BeagleWorks program, 14
Bevels layer style, 602
Bicubic method (resampling),
 258
Bilinear method (resampling),
 258
binary digits (bits), 38
bit depth (color), 37-39, 551
bitmaps, 211
 .bmp format, 189, 253
 color mode, 238,
 545-547
bits (binary digits), 38, 255
black-and-white laser print-
 ers, 269
black-and-white photographs
 hand-coloring, 493
 repairing, 460-461
 lack of contrast,
 462-463
 small blotches, 466
 via Burn tool, 464-466
 via Dodge tool,
 464-466
 tints, applying, 475-477
blemishes in black-and-white
 photographs, painting over,
 466
blend color, 609

blend modes, 608-613
 changing (Photoshop
 Elements toolbox), 231
blotches in black-and-white
 photographs, painting over,
 466
Blur filter, 516-517
Blur More filter, 516-517
Blur tool, pixels, applying,
 229, 485
.bmp (bitmap) file format,
 189, 253
bold type (Photoshop
 Elements), 369
borders on image modifying
 (Photoshop Elements), 340
bright light, flash
 workarounds, 70
brightness (color wheel), 115
broad lighting (portraits), 169
Browse Folders command
 (File menu), 233-234
browsing (File Browser), 214
 files, 249-251
 accessing, 233-234,
 249
 file hierarchy, 251
 image rotation, 250
 keyword searches, 250
 Samples folder, 251
 sort order, 250
 thumbnail size selec-
 tion, 250
 using scrollbar, 250
 web pages via cell
 phones, 287
Brush Name dialog box
 (Photoshop Elements), 357
Brush Options dialog box
 (Photoshop Elements)
 custom shapes, 355
 dot scatter settings, 357
 edge hardness settings,
 357
 opacity slider, 357
 paint fade settings, 356
 paint spacing options,
 356

quality settings, 356
tablet options, 357-358
Brush tool (Photoshop Elements), 229, 360
 Airbrush options, 359, 566
 Background Eraser, 363
 blending mode, 565
 Color Replacement Brush, 361-362
 converting to Eyedropper, 581
 Dry Brush filter, 577
 Eraser, 363
 existing pictures, adding new elements, 567-568
 freehand brushwork, 359
 Healing Brush tool, 228
 Impressionist Brush tool, 361
 appearance of, 566
 blending mode, 567
 stroke length options, 567
 tip size, 567
 tolerance settings, 567
 Magic Eraser, 363-365
 opacity levels, 565
 paint flow, 566
 painting features, 565
 palette
 fly-out menu, 355
 opening, 354
 preset shapes, 354
 size adjustments, 354
 Pencil, 365
 Selection Brush tool, 227
 Spot Healing brush, 228
 tip size, 565
built-in flash light
 disadvantages, 152
 low light situations, 152
 red-eye, 152
bulbs, studio lighting, 154
Burn tool, black-and-white photographs, light exposure, 464-466

burning CDs (iPhoto), 327
burning tool (Photoshop Elements), 214

C

cables, digital cameras to PC connections, 179-180
calendars, creating (Organizer), 317-320
calibrating colors for monitors, 552
Calibrator Assistant (Mac), monitor colors, 552
camcorders, still photos, 50
cameras. See also digital cameras
 digital
 advantages/disadvantages, 30-33
 bit depth, 37-39
 cable connections to PC setup, 179-183
 care for, 73-76
 CMOS chips, 34
 color management in, 35-36
 discussed, 27-28
 image transfers, 183-198
 intermediate models, 45
 Nikon Coolpix 5200, 45
 lenses, 29-30, 53-73
 manufacturers, 43
 memory cards, 49
 package instructions, 48
 pixels, 34-35
 practice shots, 48
 professional models, 45-47
 resolution, 39-42
 semiconductors, 33

 single-use, 48
 snapshot models, 35, 43-44
 video cameras, still photos, 50
 traditional
 creating from scratch, 28
 digital cameras versus, 33
Canon EOS 1Ds, 16
Canon EOS-1D Mark II digital camera, 46-47
canvas papers, 273
Canvas Size dialog box, 389-390
canvases, resizing, 389-390
carbinated effects, tabletop lighting techniques, 160
card readers, image transfers, 186-187
cases (digital cameras), 73
Casio's Exilim digital camera series, 44
catalogs, type and image enhancement, 144-146
CCDs (charge couple devices), 33
CDs, storage media, 194
cell phones, web pages, browsing, 287
cellophane tape, 136
center of interest, picture format considerations, 90
CES (Consumer Electronics Show), 43
CF (CompactFlash) flash memory cards, 49
Chalk & Charcoal filters, 586-587
charge coupled device (CCD), 33
cheese myth, smiling for portraits, 169
children's portrait shots, 170
 babies, 170-171
 older kids, 171-172
 toddlers, 171

circles, type, setting, 643-647
circles of confusion (depth of field), 61
claim forms (photo uses), 20
cleanups (photographs)
 dust/scratches, removing, 439-443
 guidelines, 429-430
 red eye
 prevention measures, 434-435
 removing, 433-438
 small objects, removing
 Clone Stamp tool, 430-432
 copy and paste method, 432
clip-on lights, studio lighting, 154
Clone Stamp tool, 228
 dust/scratch removal, 442-443
 small objects, removing from pictures, 430-432
clothing for portraits
 costume rentals, 138
 footwear, 138
 glamour drapes, 137-138
 what to wear, 136
clouds, using as diffused light sources, 148
Clouds filter, 528
CMOS chips, 34
CMYK (Cyan, Magenta, Yellow, Black) color model, 252, 544
 photographs, storytelling, 116
collections (Organizer)
 creating, 316
 searching, 317
color
 adjustments
 by eye with Color Variations, 416
 via color cast, 416-417
 via hue/saturation, 418-421

Adobe Color Picker, selecting from, 554-555
advertising, 550
Auto Color Correction tool (Photoshop Elements), 413-415
Auto Levels tool (Photoshop Elements), balance repair, 410-414
background, selecting, 553-556
base, 609
bit depth, 38-39, 551
bitmap color mode, 238
blend, 609
CMYK (Cyan, Magenta, Yellow, Black) color model, 252, 544
color cast, repairing, 480-481
digital camera components
 color filters, 35
 color of light, 35-36
 embedded color filters, 36
dithering, 281
Elements Swatches palette, selecting from, 555-556
enhancements, 239-240
foreground, selecting, 553-556
full color, 252
grayscale color mode, 238
images
 histogram analysis, 410
 selecting from (Eyedropper tool), 556
 selecting with Magic Wand tool, 335-336
indexed color mode, 238
monitors, calibrating, 552
painting features (Brush tool), 565

photographs, storytelling considerations
 CMYK model, 116
 color palettes, limiting, 116
 color wheels, 115-116
 HSB parameters, 115
 monochrome, 118
 muddy colors, 115
 muted colors, 115
 neon lighting, 115
 pleasure colors, 114
 pure colors, 115
 RGB model parameters, 116
 tonality, 117-118
posterizing, 632-633
process color, 252
product branding, 550
removing from images, 421
replacing, 421-423, 637
 Gradient Map, 637-638
 gradients, creating, 638-639
 Invert command, 640
result, 609
RGB color mode, 238
saturation levels (Sponge tool), 488-489
selective adjustments via Magic Wand tool, 482-484
sepia, removing from old photographs, 467
spot color mode, 238, 252
web-safe, 290
color adjustments (Quick Fix icon), 223
color cast
 correcting, 480-481
 modifying, 416-417
color laser printers, 269
color management (printers), 272

How can we make this index more useful? Email us at indexes@samspublishing.com

color models, 542
 CMYK (Cyan, Magenta, Yellow, Black), 544
 Color Picker, variations of, 542-543
 Elements Swatches palette
 Default set, 543
 web-safe colors, 543
 HSB (Hue, Saturation, Brightness), 544
 RGB (Red, Green, Blue), 544
 versus color modes, 545
color modes, 542
 Bitmap, 545-547
 Grayscale, 545-547
 Indexed Color, 547-551
 Adaptive option, 549
 Custom option, 549
 dithering, 548
 Exact option, 548
 Perceptual option, 549
 Selective option, 549
 System (Mac) option, 548
 System (Windows) option, 548
 Uniform option, 549
 Web option, 549
 new image files, 249
 RGB, 547
 versus color models, 545
color photographs, converting to grayscale, 546
Color Picker
 Apple version, 544
 variations of, 542-543
Color Replacement Brush tool (Photoshop Elements), 361-362
color separations, imagesetter printers, 271
Color Swatches palette (Adobe Photoshop Elements), 215
color temperature, light sources (white balance), 65

Color Variations dialog box, 416
ColorStudio, 14
combining
 filters, 667
 Film Grain filter, 668
 Rough Pastels filter, 668
 Texturizer filter, 668
 layer styles, 601
commercial work, natural backgrounds, 127
communication in photographs, 107
 contrast ratio, 110
 lighting considerations, 110-114
 shared experiences, 109
 symbolism, 108
CompactFlash (CF) flash memory cards, 49
Complex layer style, 602
composites
 adjustment layers, 604
 activating, 605
 creating, 604-606
 grouping, 606
 masks, 605-606
 masks, editing, 606-608
 blend modes, 608-613
 creating layer styles, 601-603
 defining, 599
 distortions, creating, 622-625
 effects
 applying, 613-616
 creating, 616-619
 drop shadows, creating, 619-621
 reflections, creating, 621-622
 lighting, 599-600
 panoramas, creating (Photomerge), 626-629
 scale, 599-600

composition (pictures)
 contrast, 387
 overview, 385
 perspective, 386
 photographically thinking, 81-83
 Rule of Thirds, 386
compression
 file sizes and formats, 192
 lossless, 190
 lossy, 188-190
 PKZip utility, 192
 Stuffit utility, 192
Consumer Electronics Show (CES), 43
contact sheets, 281
 printing, 282-283
Conté Crayon filters, 587-588
Contiguous option (Magic Eraser), 648
contracting images, 340
contrast
 adjusting, 481
 black-and-white photographs, correcting, 462-463
 image composition, 387
 ratios, mood enhancements in photographs, 110
converting color photographs to grayscale, 546
convex camera lenses, 53
Cookie Cutter tool (Photo Element toolbox), 228
cookies, studio lighting techniques, 158-159
copy and paste method, small object removal from pictures, 432
Copy command (File menu), 234
copyrighted characters in natural backgrounds, 127
correcting images, step-by-step example, 424-426

correction tools
 Blur, 485
 Quick Fix Icon, 222-223
 Sharpen, 485-487
 Smudge, 489-490
 Sponge, 488-489
costume rentals for portraits,
 138
couples, portrait shooting
 guidelines, 167-168
Craquelure filter, 535-536
creating
 adjustment layers,
 604-606
 composites, layer styles,
 601-603
 distortions, 622-625
 drop shadows, 619-621
 effects, 616-619
 gradients, 638-639
 layer styles, 601
 layers, 344-346
 masks in gradient fills,
 607
 Orbs, 670-672
 panoramas (Photomerge),
 625-629
 reflections, 621-622
Creation Wizard (Organizer),
 calendar projects, 317-320
crepe tape, 136
crooked images, straighten-
 ing, 395-396
Crop tool, 223, 228
 images
 cropping, 384-385
 dragging across,
 384-385
Crop/Resize command
 (Image menu), 238
cropping
 images, 238, 384-385
 Picture It! software, 202
crossed lights, tabletop light-
 ing techniques, 160
Crystallize filter, 661
cursor preferences, setting,
 246

custom interlacing (GIF
 images), 292
Custom Shape tool (Photo
 Element toolbox), 229
custom shapes, selecting,
 561-562
Custom Shapes tool, 561-562
Cut command (File menu),
 234
Cylindrical Mapping option
 (Photomerge), 628

D

darkroom technology, 13
Date View button (Organizer),
 308
dates of images, sorting by
 (Organizer), 308-309
daylight, balancing with
 artificial light, 151
delayed shooting time in
 digital cameras, 16
Delete File button, 250
deleting
 files, 250
 layer styles, 601
department store close-outs,
 props, locating, 133
depth of field, 59-61
depth perception, 81
deselecting image portions,
 337
desktop (Adobe Photoshop
 Elements), 214
 menu bar, 220
 Options bar, 220
 palettes, 220
 opening, 614
 Photo bin, 224
 Shortcuts bar, 220
 Crop tool, 223
 email options, 222
 Hand tool, 223
 magnifying glass, 223

 new images, starting,
 224
 Printer icon, 221
 Quick Fix icon,
 222-223
 Red Eye brush, 223
 Save icon, 221
 Step Backward button,
 222
 Step Forward button,
 222
 Tool Options bar, 223
Despeckle filter, 524, 664
 launching, 440
device resolution, 39-42
Difference Clouds filter, 529
Diffuse Glow filter, 656-657
diffusers (lighting), 148
 floodlights, 130
 indoor settings, 130
diffusion of GIF images,
 dithering levels, 291
digital cameras, 16
 advantages/disadvan-
 tages, 30-33
 autofocus cameras, 29
 bit depth, 37-39
 camera to computer
 setup, 179-183
 Canon EOS 1Ds, 16
 care for, 73
 batteries and AC
 adapters, 75-76
 lens caps, 74
 lens cleaning tissues,
 73
 protective casing, 73
 wrist and neck straps,
 73
 CMOS chips, 34
 color management
 color filters, 35
 color of light, 35-36
 embedded color filters,
 36
 costs, 16
 delayed shooting times,
 16

Dycam Agricultural, 21
film quality, 16
fixed-focus cameras, 29
flash workarounds, 69-71
intermediate models, 45
lenses
 cleaning tissues for, 73
 convex, 53
 depth of field, 59-61
 distortion, 59
 exposure control, 62-65, 71-73
 focal length, 55-57
 focal planes, 54
 focusing, 29-30, 54-55, 62, 66-69
 refracted light rays, 53-54
 visual angle, 56-57
 zoom versus prime, 57-59
manufacturers, 43
memory cards, 49
Nikon Coolpix 5200, 45
Nikon D2h, 16
package instructions, 48
pixels, resolution quality, 34-35
practice shots, 48
professional models, 45
 advantages of, 47
 Canon EOS-1D Mark II, 46-47
 Nikon D-70 Digital SLR, 47
 zoom capabilities, built-in, 47
purchasing extra, 49
rangefinders, 30
resolution
 Basic setting, 39
 device, 41-42
 Fine setting, 39
 High-Quality setting, 39-40
 image, 39
 Normal setting, 39-40
 resolution chart, 42
semiconductors, CCDs (charge coupled devices), 33
single-use, 48
snapshot models, 35, 43
 Casio Exilim series, 44
 EX Z4U, 44
 Olympus D-540, 43
traditional cameras versus, 33
video cameras, still photos, 50
viewfinders, 30
weight, 16
Digital Darkroom (Silicon Beach Software), 13
digital graphics, 211
Digital Memories, Scrapbooking With Your Computer, 25
digital photography. See also digital cameras; photographs
 advantages, 14-15
 disadvantages
 camera costs, 16
 camera weight, 16
 delayed shooting time, 16
 film quality, 16
 film versus, 14-15
 technological advances, 13
 computer program options, 17-18
 graphics options, 13-14
 making versus taking pictures, 18-19
Directional light type (Lighting Effects filter), 531
directional lighting, hard lighting sources, 150
disguising unflattering features for portraits, 166
display preferences, setting, 246
distort transformations, 237
distortions
 camera lenses, 59
 creating, 400-402, 622-625
Dither option (Gradient Map), 638
dithering
 colors, 281
 images (GIF)
 diffusion option, 291
 halftone pattern option, 291
 noise option, 291
Divide Scanned Photos command (Image menu), 237
Dodge tool (Photo Element toolbox), 229
 black-and-white photographs, exposure modifications, 464-466
dodging tool (Photoshop Elements), 214
dots per inch (dpi), 41-42
 laser printers, 270
double-stick tape, 136
dpi (dots per inch), 41-42
 laser printers, 270
drag-and-drop copying, objects, hiding, 495-500
dragging
 across images (Crop tool), 384-385
 marquees, 333
drawing
 multiple shapes, 560-561
 shapes, 557
Drawing on the Right Side of the Brain, 87
drop shadows, creating, 619-621
Drop Shadows layer style, 602
drum scanners, 196
Dry Brush filter, 577
duct tape, 136

dulling spray, 134-135
duotone effects, applying to black-and-white photographs, 475-477
Dust & Scratches filter, 525
 launching, 439
 slider options, 439-440
Dutch angle, 85
DVDs, storage media, 194
Dycam Agricultural digital camera, 21
dye-sublimation printers
 costs, 270
 dpi output, 270
 locating, 270
 printing process, 270

E

earth tones, color palettes, limiting, 116
Edit menu (Photoshop Elements)
 Copy command, 234
 Cut command, 234
 Fill command, 234
 Paste command, 234
 Redo command, 234
 Stroke command, 234
 Undo command, 234, 261
editing
 gradients, creating, 638-639
 images in iPhoto, 325-326
 masks, adjustment layers, 606-608
 photographs, 199-200
 Adjust Smart Fix command, 239
 Adobe PhotoPlus 5.5, 208
 Adobe Photoshop Elements, 206-208

cropping, 202
GraphicConverter program, 208
lighting, 239
moral and ethical issues, 200-201
Paint Shop Pro software, 204-205
Picture It! software, 202-204
straightening tool, 205
VCW VicMan's Photo Editor, 208
type, simplified status, 371
effects
 applying, 613-616
 creating, 616-619
 drop shadows, creating, 619-621
 Frames, 615
 Image, 615
 Layer, 614
 metallic, applying, 653-655
 reflections, creating, 621-622
 Selection, 614
 Text, 614-615
 Textures, 615
electronic photo albums, digital photo uses, 24
Elements Swatches palette, 543
 colors, selecting, 555-556
 Default set, 543
 web-safe colors, 543
Ellipse tool (Geometry Options palette), 559-560
ellipsis in menus, 232
Elliptical Marquee tool (Photoshop Elements), 332-333
email
 attaching files to, 259-260
 pictures, sending, 303
 shortcuts, 222

embedded color filters, 36
Emboss filter, 667
Encapsulated PhotoScript (.eps) file format, 189, 253
Enhance menu (Photoshop Elements), 238
 Adjust Smart Fix command, 239
 color adjustment, 239-240
 lighting options, 239
.eps (Encapsulated PhotoScript) file format, 189, 253
Epson CX 6400 printer, 269
Eraser tool (Photoshop Elements), 229, 363
 pixels, erasing, 570-571
erasers, Wacom tablet brush settings, 357-358
erasing tools
 Background Eraser, 571-572, 649-651
 Eraser, 570-571
 Magic Eraser, 647-649
EX Z4U digital camera series, 44
existing pictures, adding new elements to with Brush tool, 567-568
exporting files, 260
exposure control
 aperture, 62
 automatic exposure system, 63-64
 f/stops, 62-63
 camera setting workarounds, 71-73
 shutter issues, 64
 white balance, 65
exposure property (Lighting Effects filter), 531
Eyedropper tool
 Brush tools, converting to, 581
 colors, selecting from images, 556

F

f/stops, 62-63
face powders, use in natural portraits, 134
faces, replacing in pictures, 503-505
fade/strengthen percentages of filters, modifying, 536
farm animals, portrait shots, 173
fashion photography, color palettes, limiting, 116
fast moving subjects, blur filter usage (Photoshop Elements), 175
feathering image selections, 339-340
File Browser
 accessing, 233-234, 249
 versus Organizer (Photoshop Elements), 306
File Browser (Adobe Photoshop Elements), 214
file formats
 .bmp (Bitmap), 189, 253
 .eps (Encapsulated PostScript), 189, 253
 .gif (Graphical Interchange Format), 253
 .jpg (Joint Photographic Experts Group), 189, 253
 .pct (PICT), 189, 254
 .pcx, 189, 253
 .pdf (Portable Document Format), 253
 exporting, 260
 .png (Portable Network Graphics), 254
 .psd (Photoshop), 189, 253
 .pxr (Pixar), 254
 .raw, 188, 254
 .rsr (PICT resource), 254
 saving files, 252-254

 .sct (Scitex CT), 193, 254
 .tga (Targa), 254
 .tif (Tagged Image File Format), 188-189, 254
File menu commands (Photoshop Elements), 233
 Browse Folders, 233-234
 New, 233
 Open, 233
 Save As, 251
 Save for Web, 251, 259
file space, saving
 image transfers, 189-191
files
 attaching to email, 259-260
 browsing, 249-251
 file hierarchy, 251
 image rotation, 250
 keyword searches, 250
 Samples folder, 251
 sort order, 250
 thumbnail size selection, 250
 using scrollbar, 250
 Delete File, 250
 deleting, 250
 exporting, 260
 formats and sizes, 187-191
 naming, 248
 resolution, adjusting, 255-258
 saving, 251
 format selection, 252-254
 preferences, 246
 Save As a Copy option, 254
 Save As command, 251
 Save for Web command, 251
 Save for Web dialog box, 258-259
 Save Layers check box, 255
 searching for, 250-251

 size, selecting, 248-249
 Undo feature, 261
 Undo History palette, 262
Fill command (File menu), 234
fill layers (masks), 606
fill light, studio lighting techniques, 155
Fill tool (Photo Element toolbox), 229
filling image selections, 341-344
fills, gradient, creating, 607
film
 digital photography versus, 14-16
 scanning, 196
Film Grain filter, combining with Rough Pastels filter, 668
Filter Gallery
 filters, viewing, 512-513
 opening, 573
Filter Gallery command (Filters menu), 241
filters (plug-ins), 511
 Blur, 516-517
 Blur More, 516-517
 Chalk & Charcoal, 586-587
 combining, 667
 Film Grain filter, 668
 Rough Pastels filter, 668
 Texturizer filter, 668
 Conte¢ Crayon, 587-588
 Crystallize, 661
 Despeckle, 664
 Diffuse Glow, 656-657
 Dry Brush, 577
 Emboss, 667
 fade/strengthen percentages, modifying, 536
 Film Grain, combining with Rough Pastels filter, 668
 Find Edges, 663-664
 Gaussian Blur, 519

Glowing Edges, 591-593, 664-665
Grain, 594-595
Graphic Pen, 588-590
Halftone Pattern, 588-590
images, RGB mode requirement, 512
installing, 511
Liquify, 634-637
Motion Blur, 522-524
Neon Glow, 593-594
Noise, 524
 Add Noise, 526-527
 Despeckle, 524
 Dust & Scratches, 525
 Median, 526
Ocean Ripple, 657
Oil Painting, 580
 Paint Daubs filter, 583
 Palette Knife filter, 582
 Underpainting filter, 580-581
Orbs, creating, 670-672
Paint Daubs, 583
Palette Knife, 582
Pixelate, 660
 Crystallize filter, 661
 Mosaic option, 662-663
Plastic Wrap, 655-656
Polar Coordinates, 643-647
Radial Blur, 520-521
Render
 3D Transform, 533-534
 Clouds, 528
 Difference Clouds, 529
 Lens Flare, 529
 Lighting Effects, 529-532
 Texture Fill, 532
Rough Pastels, 584-585
 combining with Film Grain filter, 668
Sharpen, 513-515
Sharpen Edges, 513-515
Sharpen More, 513-515

Smart Blur, 517-519
Smudge Stick, 585
Solarize, 659
Spatter, 578-579
Sponge, 595-596
Stylize, 663
 Emboss filter, 667
 Find Edges filter, 663-664
 Glowing Edges filter, 664-665
 Trace Contours filter, 665
 Wind filter, 666-667
Sumi-e, 590-591
Texture
 Craquelure, 535-536
 Grain, 535-536
 Mosaic Tiles, 535-536
 Patchwork, 535-536
 Stained Glass, 535-536
Texturizer, 668
third-party, 511, 670
Trace Contours, 665
Underpainting, 580-581
Unsharp Mask, 513-516
viewing (Filter Gallery), 512-513
Watercolor, 574-577
 Dry Brush filter, 577
 Spatter filter, 578-579
Wave, 658-659
Wind, 666-667
Filters menu (Photoshop Elements)
 Adjustment command, 241
 Filter Gallery command, 241
Find Edges filter, 663-664
Fine resolution setting, 39
fixed-focus cameras, 29, 54
Fixing Your Photos category (How To palette), 449
flags, studio lighting techniques, 158-159

Flaming Pear Software website, 670
flash card memory chips, 49
flash lighting, built-in
 disadvantages, 152
 glare disadvantages, 152
 low light situations, 152
 pre-flashes, 434
 red-eye, 152
 prevention measures, 434
 when to use, 152
flash workarounds (camera settings), 69-71
flat lighting, 55
flatbed scanners, 194
flattening image layers, 280-281
flipping
 images, 393
 rotating versus, 236
floodlights
 indoor settings, 129
 studio lighting, 153
fluorescent lights, camera setting workarounds, 72
focal length (camera lenses)
 long lens, 57
 optical infinity, 56
 short lens, 57
 telephoto lens, 55-56
 theoretical infinity, 56
 wide angle lens, 55
focal planes, 54
focusing
 autofocus, 29, 55
 fixed-focus cameras, 29, 54
 flash workarounds, 69-71
 flight lighting, 55
 macrofocus, 62
 passive autofocus, 55
 problems, 55
 rangefinders, 30
 variable focus cameras, 54
 viewfinders, 30
 workarounds, 66-69

foil papers, 273
folders, searching, **233**
fonts
 readability of (Photoshop Elements), 372
 sans serif, 372
 selection criteria (Photoshop Elements), 371-372
 serif, 372
 type enhancement, 142
 web pages
 design criteria, 295-296
 selection criteria, 295-296
food photography, 139
 palettes, limiting in photographs, 116
 food stylists, 140
 shared experiences in photographs, 109
 tricks, 140-141
foreground colors
 selecting, 553-556
 swatches, 230
formats
 .bmp (Bitmap), 189, 253
 .eps (Encapsulated PostScript), 189, 253
 .gif (Graphical Interchange Format), 253
 .jpg (Joint Photographic Experts Group), 189, 253
 .pct (PICT), 189, 254
 .pcx, 189, 253
 .pdf (Portable Document Format), 253
 exporting, 260
 .png (Portable Network Graphics), 254
 .psd (Photoshop), 189, 253
 .pxr (Pixar), 254
 .raw, 188, 254
 .rsr (PICT resource), 254
 saving files, 252-254
 .sct (Scitex CT), 193, 254

.tga (Targa), 254
.tif (Tagged Image File Format), 188-189, 254
formatting pictures (perception)
 center of interest, 89-90
 display medium considerations, 83
 horizontal format, 84
 image shape considerations, 83-85
 landscape photographs, 83
 portrait photographs, 83
 positive/negative space considerations, 86-87
 print and screen format considerations, 88-89
 rule of thirds, 89-90
 subject shape considerations, 85
 vertical pictures, 84
free transformation, 237
freehand brushes, use tutorial, 359
full color, 252

G

gaffer tape, **136**
galleries (Filter), opening, **573**
garage sales, props, locating, **133**
Gaussian Blur filter, **519**
General Fixes category (Quick Fix icon), **222**
geometry options, shapes, setting, **559-560**
GIF (Graphics Interchange Format), **253, 290**
 animating, 640-643
 images
 dithering, 291
 interlacing, 292
 number of colors, 290

 saving as, 290-292
 transparency options, 292
 transparencies
 creating, 299-300
glamour drapes, natural portraits, 137-138
glare
 built-in flash lighting, 152
 flash workarounds, 70
Glass Buttons layer style, 602
gloss property (Lighting Effects filter), 531
Glowing Edges filter, 591-593, 664-665
glycerin, food photography tricks, 141
gobos, studio lighting techniques, 158-159
Gradient Editor
 gradients, creating, 638-639
 maps, color replacement, 637-638
gradient fills, creating, 607
Gradient tool (Photo Element toolbox), 229
Grain filter, 535-536, 594-595
Graphic Pen filters, 588-590
Graphical Interchange Format. See GIF
GraphicConvert program, 208
graphics
 digital photography technical advances, 13-14
 GIF format
 dithering option, 291
 interlacing option, 292
 number of colors, 290
 saving as, 290-292
 transparency options, 292
 JPEG format
 High/Medium/Low compression, 289
 lossy compression, 289
 saving as, 289-290

optimized versus unopti-
mized comparison,
288-289
optimizing, 286-295
PNG-8 format, saving as,
292-293
PNG-24 format, saving as,
292-293
progressive levels, 290
Save for Web dialog box,
optimization options,
287-288
web pages
background selection,
296, 299
background tiling, 297
color adjustments,
299
load speed optimiza-
tion, 300-301
pixel sizes, 299
grayscale
color mode, 238,
545-547
masks, displaying in, 606
grids and rulers
preferences, setting, 246
snap-to-feature, 242
grouping
adjustment layers, 606
layers, 349-350
group portraits, shooting
guidelines, 168
growing images, 340

H

hair considerations, natural
portraits, 137
Halftone Pattern filters,
588-590
halftone patterns in GIF
images, dithering levels,
291

Hand tool (Photoshop
Elements Shortcuts bar),
223
hand-coloring black-and-white
photographs, 493
hard light
available lighting, 150
daylight, balancing with
artificial light, 151
Healing Brush tool (Photo
Element toolbox), 228
heavy rag paper, 273
help
How To palette
Adding Special Effects
category, 449
Creating an Old
Fashioned Photo
recipe, 449-451
Do This for Me link,
449
Fixing Your Photos cat-
egory, 449
launching, 447
recipes, viewing, 449
topic searches, 449
Working with Shapes
category, 449
Working with Text cate-
gory, 449
National Association of
Photoshop Professionals
Newsletter, 455-456
Photoshop User Magazine,
456
tutorials
Adobe Online,
453-454
launching, 451-453
websites, 454
Arraich's Photoshop
Elements Tips, 455
myJanee.com, 455
Phong.com, 455
Photoshop Café, 455
Photoshop Guru's
Handbook, 455

Photoshop Wire, 455
Planet Photoshop, 455
Help button (Photoshop
Elements), 218
hiding objects via drag-and-
drop copying, 495-500
High Quality resolution set-
ting, 39-40
Hints and How To's palette
(Adobe Photoshop
Elements), 215
histograms, color correction
analysis, 410
History palette (Adobe
Photoshop Elements), 215
horizons, linear perspective
example, 92
horizontal lines, symbolism in
photographs, 108
horizontal placement, scale
considerations, 84, 98-99
horizontal type
adding (Photoshop
Elements), 370
formatting (Photoshop
Elements), 370
letter mode (Photoshop
Elements), 368
mask mode (Photoshop
Elements), 368
hot spots in studio lighting,
155
How To palette
categories
Adding Special Effects,
449
Fixing Your Photos,
449
Working with Shapes,
449
Working with Text, 449
launching, 447
recipes, 447
Creating an Old
Fashioned Photo,
449-451
Do This for Me link,
449

related topics, 449
viewing, 449
topic searches, 449
How To palette (Photoshop
Elements), 216-217
HP 1500 Color Laserjet
printer, 269
HP PSC1350 printer, 269
HSB color model (Hue,
Saturation, Brightness), 544
photographs, storytelling
in, 115
HTML (Hypertext Markup
Language)
Sams Teach Yourself HTML
and XHTML in 24 Hours,
287
web pages
publishing, 287
translation/layout
programs, 287
hue
color adjustments (Quick
Fix icon), 223
color wheel, 115
modifying, 418-421
Hue/Saturation dialog box,
slider options, 418-421

I/O port, camera to computer
setup, 181
IcingImages.com website, edi-
ble photographic images,
273
identification systems (digital
photo uses), 20
iLife, suite components, 320
illusion of reality, 91
aerial perspective, 93
contrast in sharpness
93-94
linear perspective, 92

overlapping perspective,
95-96
vertical location, 94-95
image correction tools
Blur, 485
Sharpen, 485-487
Smudge, 489-490
Sponge, 488-489
Image effects, 615
Image Effects layer style, 602
image enhancement
catalogs, 144-146
natural portraits, 142-144
Image menu (Photoshop
Elements), 235
Crop/Resize commands,
238
Divide Scanned Photos
commands, 237
Modes commands, 238
Rotate command,
235-236
Transformation com-
mands, 236-237
image resolution, 39-40
Image Size dialog box,
388-389
image transfer
albums, 184
compression, 192
file formats and file sizes,
187-189, 193
file space, saving,
189-191
Nikon interface, 185
Olympus Camedia soft-
ware, 183-185
scanned images
connections, 195
drum scanners, 196
film scans, 196
flatbed scanners, 194
memory card print
features, 196
object scans, 196,
198
storage media, 193-194

thumbnail views, 183-184
using card readers,
186-187
images. See also composites;
photographs
3D Transform filter,
533-534
albums, importing to
(Organizer), 309-310
areas
masking with Selection
Brush tool, 336-337
selecting with lasso
tools, 333-335
selecting with marquee
tools, 332-333
Bitmap color mode,
545-547
color bit depth, 551
color cast, modifying,
416-417
color variations, manual
adjustments by eye, 416
colors
removing, 421
replacing, 421-423
selecting with Magic
Wand tool, 335-336
composition
contrast, 387
overview, 385
perspective, 386
Rule of Thirds, 386
contact sheets, 281
printing, 282-283
correction process, step-
by-step example,
424-426
cropping, 238, 384-385
dates, sorting by
(Organizer), 308-309
feathering selections
(Photoshop Elements),
339-340
flipping, 393
GIF format
dithering option, 291
interlacing option, 292

number of colors, 290
saving as, 290-292
transparency option,
 292, 299-300
Grayscale color mode,
 545, 547
hue/saturation, modify-
 ing, 418-421
Indexed Color mode,
 547-551
 Adaptive option, 549
 Custom option, 549
 dithering, 548
 Exact option, 548
 Perceptual option, 549
 Selective option, 549
 System (Mac) option,
 548
 System (Windows)
 option, 548
 Uniform option, 549
 Web option, 549
inverting selections
 (Photoshop Elements),
 338
iPhoto
 album additions, 327
 album creation, 326
 burning CDs, 327
 default graphics editor,
 320-321
 editing, 325-326
 importing, 321-323
 keyword assignments,
 327
 rating, 324
 screen appearance,
 320
 sending via email, 327
 sharing, 327
 slideshows, 327
 sorting, 323-324
JPEG format
 High/Medium/Low
 compression, 289
 lossy compression,
 289

progressive levels,
 290
saving as, 289-290
layers
 adding, 345-348
 adjustment, 344
 background, 344
 creating, 344-346
 examples, 344
 flattening, 280-281
 function of, 344
 grouping, 349-350
 linking, 350
 management of,
 346-347
 moving, 348-349
 opacity levels,
 350-352
 removing, 348-349
 tracking, 344
 transparent, 344
lighting, correcting, 423
modifications
 borders (Photoshop
 Elements), 340
 contracting (Photoshop
 Elements), 340
 growing (Photoshop
 Elements), 340
 smoothing (Photoshop
 Elements), 340
new elements, adding to
 with Brush tool,
 567-568
optimized versus unopti-
 mized comparison,
 288-289
Organizer (Photoshop
 Elements)
 albums, starting,
 309-310
 calendar creation,
 317-320
 cataloging features,
 307
 collections, creating,
 316
 Date View button, 308

links, 311-312
menu bar, 307
Photo Browser button,
 308
searching, 317
shortcuts bar, 307-308
tags, 312-315
versus File Browser,
 306
Welcome screen, 305
PNG-8 format, saving as,
 292-293
PNG-24 format, saving as,
 292-293
printing, 280-281
printing preparations, 273
 color management
 activation, 271-273
 page setup options,
 274-278
 paper selection, 273
 preview options,
 278-280
repair tools
 Auto Color Correction,
 413-415
 Auto Contrast, 412,
 415
 Auto Levels, 410-414
 Automatic Correction,
 409
 Automatic Smart Fix,
 409, 414
 Quick Fix, 407-409
resizing, 238, 387-389
 portions of, 391
RGB color mode, 547
 filter requirements,
 512
rotating, 235-236, 250,
 392-394
royalty-free, 528
Save for Web dialog box,
 optimization options,
 287-288
selecting/deselecting all
 (Photoshop Elements),
 337

selections
 distorting, 400-402
 filling (Photoshop Elements), 341-344
 loading (Photoshop Elements), 340-341
 perspective changes, 403-405
 saving (Photoshop Elements), 340-341
 skewing, 400
 stroking (Photoshop Elements), 341-343
sending via email, 303
sorting, 233
starting new, 247-249
straightening, 394-396
 portions of selections, 397-399
textures
 Craquelure filter, 535-536
 Grain filter, 535-536
 Mosaic Tiles filter, 535-536
 Patchwork filter, 535-536
 Stained Glass filter, 535-536
transformations, 236-237
web galleries, creating, 301-303
web pages
 background selection, 296, 299
 background tiling, 297
 color adjustments, 299
 load speed optimization, 300-301
 pixel sizes, 299
 potential limitations, 286
web transmission process, 286
imagesetter printers, color separations, 271

importing images
 to albums (Organizer), 309-310
 in iPhoto, 321-323
Impressionist Brush tool, 361
 appearance of, 566
 blending mode, 567
 stroke length options, 567
 tip size, 567
 tolerance settings, 567
Indexed Color mode, 238, 547-551
 Adaptive option, 549
 Custom option, 549
 dithering, 548
 Exact option, 548
 Perceptual option, 549
 Selective option, 549
 System (Mac) option, 548
 System (Windows) option, 548
 Uniform option, 549
 web option, 549
indoor portraits, 129
 backdrops and props, 131-132
 all occasion props, 132-134
 interesting backdrops, finding, 132
 diffusers, 130
 floodlight use, 129
 polecat poles, 130
 tabletop studios, 129
 tripods, 130
infrared technology (digital photo uses), 21
injury reports (digital photo uses), 21
inkjet printers
 4-color, 266
 6-color, 266
 7-color, 266
 cartridge costs, 267
 color spectrums, 266
 Iris prints, 268
 iron-on printers, 274

 paper types
 edible options, 273
 inexpensive, 274
 PostScript support, 266
 printing process, 266
 range of, 266
 typical cost, 267
InkjetMall.com website, 273
Inner Glows layer style, 602
Inner Shadows layer style, 602
Install Shield Wizard (Windows), 181
installing filters, 511
interchangeable lenses, 59
interlacing images (GIF), 191
 adaptive method, 292
 custom method, 292
 perceptual method, 292
 selective method, 292
 Web method, 292
intermediate digital camera models, 45
intersecting shapes, 560-561
Inverse command (Select menu), 240
inverting
 image selections, 338
 selections, 240
iPhoto
 images
 albums, adding to, 327
 albums, creating, 326
 burning CDs, 327
 editing, 325-326
 importing, 321-323
 keyword assignments, 327
 rating, 324
 sending via email, 327
 sharing, 327
 slideshows, 327
 sorting, 323-324
 screen appearance, 320
 versus Photoshop Elements Organizer, 320
Iris prints, inkjet printers, 268

iron-on transfer papers, 274
italic type (Photoshop Elements), 369

J - K

jagged lines, symbolism in photographs, 108
Jasc Paint Shop Pro, 204-205
jewelry photos, tabletop lighting techniques, 161-162
JPEG (Joint Photographic Experts Group), 188-189, 253, 289
continuous tone, 289
images
High/Medium/Low compression, 289
progressive levels, 290
saving as, 289-290
lossy compression, 289

key light, studio lighting techniques, 155-157
back lighting, 157-158
side lighting, 157-158
keyword searches, browsing files, 250
keywords, assigning to images (iPhoto), 327

L

landscape pictures, 83
aerial perspective, 93
center of interest considerations, 90
vertical location perspective, 95

laser printers
black-and-white, 269
color, 269
dpi output, 270
Lasso tool, 226, 333-335
selective color adjustments, 482-484
law enforcement, digital photo uses, 23
lawsuits, release forms, 122
Layer menu (Photoshop Elements), 240
layer styles, 601-603
applying, 601
combining, 601
composites, creating, 601-603
removing, 601
text
applying, 375-376
editing, 376-378
Layer Styles palette, 601
layers
adjustment, 604
activating, 605
creating, 604-606
grouping, 606
masks, 605-608
posterizing colors, 632
effects, 614
erasing (Eraser tool), 570-571
fill masks, 606
function of, 344
images
adding, 345-348
adjustment, 344
background, 344
creating, 344-346
examples, 344
flattening, 280-281
grouping, 349-350
linking, 350
management of, 346-347
moving, 348-349
opacity levels, 350-352

removing, 348-349
tracking, 344
transparent, 344
type
activating, 370
modifying, 370
Layers palette (Photoshop Elements), 215, 346-347
Lens Flare filter, 529
lenses (digital cameras)
autofocus cameras, 29
caps, 74
cleaning, 73-74
convex, 53
depth of field, 59-61
distortion, 59
exposure control
aperture, 62-63
automatic exposure system, 63-64
camera setting workarounds, 71-73
shutter issues, 64
white balance, 65
fixed-focus, 29
flash workarounds, 69-71
focal length
long lens, 57
normal lens, 56
optical infinity, 56
short lens, 57
telephoto lens, 55
theoretical infinity, 56
wide angle lens, 55
focal planes, 54
focusing
autofocus, 55
fixed-focus cameras, 54
flat lighting, 55
macrofocus, 62
passive autofocus, 55
problems, 55
variable focus cameras, 54
workarounds, 66-69
functions of, 29
interchangeable, 59

rangefinders, 30
refracted light rays, 53-54
viewfinders, 30
visual angle, 56-57
zoom versus prime, 57-59
lettering, type enhancement, 142-144
leveling images from crooked states, 395-396
Light Dir option (Underpainting filter), 581
light exposure in black-and-white photographs
adjusting (Burn tool), 464-466
adjusting (Dodge tool), 464-466
light rays, refracted, 53-54
light sources (white balance), color temperature, 65
light stands, 154
lightening of shadows, 481
lighting
available light
advantages, 147
daylight, balancing with artificial light, 151
described, 147
diffused light, 148
disadvantages, 148
hard light, 150
sensitivity of photographic material measures, 148
shadowless light, overcast days, 148
soft light, 148-150
backdrops and props, 131
compensating for errors, 423
composites, 599-600
dulling spray, 135
enhancements, 239
flash, built-in
disadvantages, 152
glare disadvantages, 152

low light situations, 152
red-eye, 152
when to use, 152
floodlights, 129
Lighting Effects filter, 529-532
ambience properties, 532
Directional type, 531
exposure properties, 531
gloss properties, 531
material properties, 531
Omni type, 531
Spotlight type, 531
mood enhancements in photographs, 110-114
neon color, 115
outdoor portraits, 126
portraits, flattering tips, 168-169
studio light, 153
accent lights, 155
background light, 155
barn door suggestions, 155
cookies, 158-159
fill light, 155
flags, 158-159
floodlights, 153
gobos, 158-159
hot spots, 155
key light, 155-158
low-cost solutions, 154
photo store lights versus hardware store lights, 154
quartz broadlights, 155
selection considerations, 154-155
snoots, 155
spotlights, 153

tabletop
carbinated effects, 160
crossed lights, 160
jewelry photos, 161-162
plexiglas use, 160
portrait subjects, 159
shiny object photos, 161-163
special shooting tables, 160
tent usage, 161-163
Lighting category (Quick Fix icon), 223
Lighting Effects filter, 529-532
ambience properties, 532
Directional type, 531
exposure properties, 531
gloss properties, 531
material properties, 531
Omni type, 531
Spotlight type, 531
linear perspective, 92
lines
Custom Shape tool, 229
drawing (Pencil tool), 568
linking layers, 350
links in images, maintaining (Organizer), 311-312
Liquify filter, 634-637
lithium batteries, 75
loading
image selections, 340-341
web pages, speed optimization, 300-301
location considerations
natural backgrounds, 127-128
photo essays, 119
viewpoint selection, 99-100
lossless compression, 190
lossy compression, 188-190

M

.Mac account, images, uploading to, 327
Mac version (Adobe Photoshop Elements), 213-214
macrofocus, 62
magazines
 digital photo uses, 21-23
 photo manipulation, ethical and moral issues, 200
 type enhancement, 142-144
Magic Eraser tool (Photoshop Elements), 363-365, 647-649
Magic Wand tool (Photoshop Elements), 227, 335-336
 selective color adjustments, 482-484
Magnetic Lasso tool (Photoshop Elements), 333-335
magnifying glass (Photoshop Elements Shortcuts bar), 223
makeup for natural portraits, 134-136
Marquees tools (Photoshop Element toolbox), 226, 332-333
masking image areas (Selection Brush tool), 336-337
masking tape, 136
masks
 adjustment layers, 605-608
 creating gradient fills, 607
 displaying in grayscale, 606
 fill layers, 606
material property (Lighting Effects filter), 531
Median filter, 526

medical uses (digital photo uses), 20
megapixel resolution, 34-35
memory, RAM (random access memory), 211
memory cards, 196
 digital photography advantages, 15
 flash card memory chips, 49
 purchasing extra, 49
 storage, 49
Memory Stick (MS) flash memory cards, 49
menu bar (Organizer), 307
menu bar (Photoshop Elements), 220
 accessing, 232
 Edit menu, 234
 ellipsis, 232
 Enhance menu, 238-240
 File menu, 233-234
 Filters menu, 241
 Image menu, 235-238
 Layer menu, 240
 overview, 232
 preferences, setting, 245-246
 Select menu, 240
 View menu, 242
 Window menu, 243-245
metallic effects, applying, 653-655
miscellaneous tools (Photoshop Elements toolbox), 228
missing children, digital photo uses, 23
MMC (MultiMediaCard) flash memory cards, 49
modes
 bitmap, 238
 blend, 608-613
 grayscale, 238
 indexed color, 238
 RGB, 238
Modes command (Image menu), 238

monitors, color calibrations, 552
monochrome photographs, 118
mood in photographs
 contrast ratio, 110
 lighting considerations, 110-114
moral and ethical issues, editing photographs, 200-201
Mosaic option (Pixelate filters), 662-663
Mosaic Tiles filter, 535-536
Motion Blur filter, 522-524
moving layers, 348-349
MS (Memory Stick) flash memory cards, 49
muddy colors in photographs, 115
MultiMediaCard (MMC) flash memory cards, 49
multiple shapes, drawing, 560-561
muted colors in photographs, 115
myJanee.com website, 455

N

naming files, 248
National Association of Photoshop Professionals Newsletter, 455-456
natural portraits, 125
 clothing and makeup
 costume rentals, 138
 footwear, 138
 glamour drapes, 137-138
 what to wear, 136
 food photography, 139
 food stylists, 140
 tricks, 140-141

indoor settings, 129
 backdrops and props,
 131-134
 floodlights, 129-130
 polecat poles, 130
 tabletop studio, 129
 tripods, 130
nature improvements,
 134
 dulling spray, 134-135
 face powders, 134
 tape, 136
 touch-up, 134
outdoor
 advantages of, 126
 commercial work, 127
 copyrighted charac-
 ters, 127
 digital tricks, 128-129
 location considera-
 tions, 127-128
 type and image enhance-
 ment, 142-144
 catalogs, 144-146
Nearest Neighbor method,
 resampling, 257
neck straps, digital camera
 maintenance, 73
neon colors in photographs,
 115
neon effects
 Glowing Edges filter,
 591-593
 Neon Glow filter, 593-594
Neon Plastic layer style, 603
neutral backgrounds, center
 of interest, 90
New command (File menu),
 233
new image files, starting,
 224, 247-249
New Layer dialog box, 348
news events, release forms
 and, 123
newsletters, 455-456
newspapers
 digital photo uses, 21-23
 photo manipulation, ethi-
 cal and moral issues,
 200

Ni-Cad batteries, 75
Nikon Coolpix 5200 digital
 camera, 45
Nikon D-70 SLR digital
 camera, 47
Nikon D2h, 16
Nikon interface for image
 transfers, 185
Noise filters, 524
 Add Noise, 526-527
 Despeckle, 524
 Dust & Scratches, 525
 Median, 526
noise patterns in GIF images,
 dithering levels, 291
Normal resolution setting,
 39-40
nude photos, model release
 forms, 124

O

objects
 hiding via drag-and-drop
 copying, 495-500
 scanning, 196-198
obscenity laws, model release
 forms, 124
Ocean Ripple filter, 657
OCR (Object Character
 Recognition), 197
Ofoto website, 24
Oil Painting filters, 580
 Paint Daubs filter, 583
 Palette Knife filter, 582
 Underpainting filter,
 580-581
old photographs
 cleanup exercise,
 473-475
 look, creating, 449-451
 sepia, removing, 467
 seriously damaged, repair-
 ing, 467-470
 tears, repairing, 468-470
 vignetting, 470-472

older kids in portrait shots,
 171-172
Olympus Camedia software
 image transfers, 184-185
 Transfer Image From
 Camera option, 183
Olympus D-540 camera, 43
Olympus P-10 digital photo
 dye-sublimation printer, 270
Omni light type (Lighting
 Effects filter), 531
opacity degree, changing,
 231
opacity levels (layers),
 350-352
Open command (File menu),
 233
opening
 Filter Gallery, 573
 palettes, 243, 614
 photographs, 233
optical infinity (focal length),
 56
optimized graphics versus
 unoptimized graphics,
 288-289
optimizing
 graphics, 286-295
 web pages, load speeds,
 300-301
Options bar (Photoshop
 Elements), 220, 231
orbs, creating, 670-672
Organizer (Photoshop
 Elements), 305
 albums
 image links, 311-312
 starting, 309-310
 calendars, creating,
 317-320
 cataloging features, 307
 collections, creating, 316
 Date View button, 308
 images
 searching, 317
 tags, 312-315
 menu bar, 307
 opening, 305

Photo Browser button, 308
shortcuts bar, 307-308
Tags palette, 313
versus File Browser, 306
versus iPhoto, 320
Welcome screen, 305
outdoor lights, hard lighting sources, 150
outdoor portraits
advantages for, 126
commercial work, 127
copyrighted characters, 127
digital tricks considerations, 128-129
location considerations, 127-128
wildlife photography, 174-175
Outer Glows layer style, 602
overlapping, perception issues, 95-96

P

packages (pictures), 281
school-type, printing, 283-284
Page Setup dialog box
Margins tab, 275
Orientation tab, 275
Paper Size tab, 275
Print Quality tab, 276
printer output, 274-278
Settings tab, 275
Source tab, 275
paint, gouche, 578
Paint Bucket tool, 229
image selections, filling, 343-344
Paint Daubs filter, 583
Paint Shop Pro software, 204-205

paintbrush tools (Photoshop Elements), 214
painting
shapes (Brush tool), 565
tools (Photoshop Element toolbox), 228-229
Palette Knife filter, 582
palettes, 215, 220
How To palette, 216-217
Layer Styles, 601
opening, 243, 614
Undo History, 262
panoramas, creating (Photomerge), 625-629
paper types
art, 273
canvas/foil options, 273
heavy rag, 273
inexpensive, 274
InkjetMall.com, 273
iron-on, 274
printers, selecting, 273
transparency, 273
parallel zones, linear perspective, 92
passive autofocus, 55
Paste command (File menu), 234
pastel shades
color palettes, limiting, 116
Rough Pastels filter, 584-585
Patchwork filter, 535-536
paths, warping text along, 378-379
patterns, perception considerations, 105-106
Patterns layer style, 602
.pct (PICT) file format, 254
.pcx file format, 189, 193, 253
PDF Slideshow dialog box, 260
PDF (Portable Document Format) file format, 253
exporting, 260

Pencil tool, 229, 365
Auto Erase option, color replacement, 569
launching, 568
lines, drawing, 568
perception
aerial perspective, 93
balance and symmetry, 100-102
composition, 81-83
contrast in sharpness, 93-94
depth perception, 81
illusion of reality, 91-96
linear perspective, 92
overlapping perspective, 95-96
pattern considerations, 105-106
picture format, 83-90
proximity, 102-104
scale considerations, 97-100
texture considerations, 104
vertical location, 94-95
perceptual interlacing (GIF images), 292
persons, removing from pictures, 500-503
perspective. See perception
Perspective option (Photomerge), 628
perspective transformations, 237
pets in portrait shots, 172-173
Phong.com website, 455
photo albums, digital photo uses, 24
Photo Bin
magnifying glass, 224
toggling on/off, 245
Photo Browser button (Organizer), 308

photo essays
 model release forms,
 122-124
 storytelling considera-
 tions, 119
 location considera-
 tions, 119
 revealing moments,
 120
 shooting, 120-121
**Photographic Effects layer
style, 602**
**Photographic Marketing
Industry show (PMAI), 43**
**photographically thinking
(perception).** *See also*
perception
 aerial perspective, 93
 balance and symmetry,
 100-102
 composition, 81-83
 contrast in sharpness,
 93-94
 depth perception, 81
 illusion of reality, 91
 linear perspective, 92
 overlapping, 95-96
 patterns considerations,
 105-106
 picture format
 center of interest,
 89-90
 display medium con-
 siderations, 83
 horizontal format, 84
 image shape consider-
 ations, 83-85
 landscape pho-
 tographs, 83
 portrait photographs,
 83
 positive/negative
 space considera-
 tions, 86-87
 print and screen for-
 mat considerations,
 88-89
 rule of thirds, 89-90

 subject shape consid-
 erations, 85
 vertical pictures, 84
 proximity, 102-104
 scale considerations
 comparisons, 97-98
 horizontal placement,
 98-99
 viewpoint selection,
 99-100
 texture considerations,
 104
 vertical location, 94-95
photographs
 backgrounds, replacing,
 505-509
 black-and-white
 hand-coloring, 493
 lack of contrast, fixing,
 462-463
 repairing, 460-461,
 464-466
 tint application,
 475-477
 cake icing images, 273
 cleanup guidelines,
 429-430
 color, converting to
 grayscale, 546
 color cast, correcting,
 480-481
 color saturation, adjusting
 (Sponge tool), 488-489
 contact sheets, printing,
 282-283
 contrast, adjusting, 481
 dust/scratches
 removing (Clone
 Stamp tool),
 442-443
 removing (Despeckle
 filter), 440
 removing (Dust and
 Scratches filter),
 439-440
 removing (Unsharp
 Mask filter), 441-442

 editing, 199-200
 Adjust Smart Fix com-
 mand, 239
 Adobe Photoshop
 Elements, 206-208
 cropping, 202
 GraphicConverter
 program, 208
 lighting, 239
 moral and ethical
 issues, 200-201
 Paint Shop Pro soft-
 ware, 204-205
 PhotoPlus 5.5, 208
 Picture It! software,
 202-204
 straightening tool, 205
 VCW VicMan's Photo
 Editor, 208
 faces, replacing, 503-505
 formatting (perception)
 center of interest,
 89-90
 display medium con-
 siderations, 83
 horizontal format, 84
 image shape consider-
 ations, 83-85
 landscape pho-
 tographs, 83
 portrait photographs,
 83
 positive/negative
 space considera-
 tions, 86-87
 print and screen for-
 mat considerations,
 88-89
 rule of thirds, 89-90
 subject shape consid-
 erations, 85
 vertical pictures, 84
 natural portraits, 125
 clothing and makeup,
 136-138
 food photography,
 139-141
 indoor settings,
 129-134

nature improvements, 134-136

outdoor, 126-129

type and image enhancement, 142-146

new elements, adding to with Brush tool, 567-568

objects, hiding via drag-and-drop copying, 495-500

old

cleanup exercise, 473-475

sepia removal, 467

vignetting, 470-472

old-fashioned, creating, 449-451

opening, 233

persons, removing, 500-503

pixels

blurring (Blur tool), 485

dragging (Smudge tool), 489-490

sharpening (Sharpen tool), 485-487

red eye

prevention measures, 434-435

removing (from scratch method), 437-438

removing (Red Eye Removal tool), 435-436

selective color adjustments, 482-484

seriously damaged, repairing, 467-470

shadows, lightening, 481

small objects

removing (Clone Stamp tool), 430-432

removing (copy and paste method), 432

storytelling

color considerations, 114-118

communication, 107-114

model release forms, 122-124

photo essays, 119-121

subjects, repositioning, 491-492

tears, repairing, 468-470

uploading

camera to computer setup, 179-183

image transfers, 183-198

plug and play, 179

uses for

advertising/TV photography, 23

Amber Alerts, 23

anti-fraud measures, 20

claim forms, 20

electronic photo albums, 24

identification systems, 20

infrared technology, 21

injury reports, 21

law enforcement, 23

magazines, 21-23

medical uses, 20

newspapers, 21-23

scrapbooking, 25

traditional uses, 19

web publishing, 24

weddings, 23

web galleries, creating, 301-303

Photomerge, panorama creator, 625-629

PhotoPlus 5.5 software, 208

Photoshop (.psd) file format, 253

Photoshop Cafe¢ website, 455

Photoshop Elements

art tools, 353-354

Automatic Correction tools

Auto Color Correction, 413-415

Auto Contrast, 412-415

Auto Levels, 410-414

Auto Smart Fix, 409, 414

opening, 409

blur filter, 175

Brush Name dialog box, 357

Brush Options dialog box

custom shapes, 355

dot scatter settings, 357

edge hardness settings, 357

opacity slider, 357

paint fade settings, 356

paint spacing options, 356

quality settings, 356

brush tools

Airbrush, 359

Background Eraser, 363

Brush, 360

Color Replacement Brush, 361-362

Eraser, 363

freehand brushwork, 359

Impressionist Brush, 361

Magic Eraser, 363-365

Pencil, 365

Brushes palette

brush size adjustments, 354

fly-out menu, 355

opening, 354

preset shapes, 354

canvases, resizing, 389-391

Crop tool, 384-385

desktop
 menu bar, 220
 Options bar, 220
 palettes, 220
 Photo bin, 224
 Shortcuts bar, 220-224

File Browser, 214

files
 attaching to email, 259-260
 browsing, 249-251
 exporting, 260
 new images, starting, 247-249
 resolution, adjusting, 255-258
 saving, 251-255, 258-259
 Undo feature, 261
 Undo History palette, 262

graphics, optimization process, 287-289, 293-295

images
 border modifications, 340
 changing perspective of selections, 403-405
 color cast, 416-417
 color removal, 421
 color replacement, 421-423
 color variations, 416
 contracting modifications, 340
 distorting selections, 400-402
 feathering selections, 339-340
 filling selections, 341-344
 flipping, 393

grow modifications, 340
hue/saturation adjustments, 418-421
inverting selections, 338
light/shadow correction, 423
loading selections, 340-341
resizing, 388-389
resizing portions of, 391
rotating, 392-393
rotating by degrees, 394
saving selections, 340-341
selecting/deselecting all, 337
skewing selections, 400
smooth modifications, 340
straightening, 394-396
straightening portions of selections, 397-399
stroking selections, 341-343

layers
 adding, 345-348
 creating, 345-346
 grouping, 349-350
 linking, 350
 management of, 346-347
 moving, 348-349
 opacity levels, 350-352
 removing, 348-349

menus
 accessing, 232
 Edit menu, 234
 ellipsis, 232
 Enhance menu, 238-240
 File menu, 233-234

 Filters menu, 241
 Image menu, 235-238
 Layer menu, 240
 overview, 232
 preferences, setting, 245-246
 Select menu, 240
 View menu, 242
 Window menu, 243-245

Organizer, 305
 albums, image links, 311-312
 albums, starting, 309-310
 calendar project, creating, 317-320
 cataloging features, 307
 Date View button, 308
 menu bar, 307
 opening, 305
 Photo Browser button, 308
 photos, collections, 316
 photos, image tags, 312-315
 photos, searching, 317
 shortcuts bar, 307-308
 versus File Browser, 306
 versus iPhoto, 320
 Welcome screen, 305

overview, 211-212

purposes of, 212

Quick Fix
 image correction options, 407-409
 opening, 407-409

selection tools
 desktop location, 331-332
 Elliptical Marquee, 332-333
 Magic Wand, 335-336
 Magnetic Lasso, 333-335

Polygonal Lasso, 333-335

Rectangular Marquee, 332-333

Regular Lasso, 333-335

Selection Brush, 336-337

text

 layer styles, applying, 375-376

 layer styles, editing, 376-378

 warping, 378-379

toolbox

 blending mode degree, changing, 231

 Blur tool, 229

 Brush tools, 229

 Clone Stamp tool, 228

 color tools, 230

 Cookie Cutter tool, 228

 Crop tool, 228

 Custom Shape tool, 229

 display, changing, 225

 Dodge tool, 229

 Eraser tools, 229

 Eyedropper tool, 225

 Fill tool, 229

 Gradient tool, 229

 Hand tool, 225

 Healing Brush tool, 228

 Lasso tools, 226

 Magic Wand tools, 227

 Marquees tools, 226

 miscellaneous tools, 228

 Move tool, 225

 opacity degree, changing, 231

 Options bar, 231

 Paint Bucket tool, 229

 painting tools, 228-229

 Pencil tool, 229

Red Eye Removal tool, 228

Selection Brush tool, 227

selection tools, 226-227

Shape tool, 228

Sharpen tool, 229

shortcuts, 230

Smudge tool, 229

Sponge tool, 229

Spot Healing brush tool, 228

swatches, 230

toning tools, 229

tools, displaying, 225

Type tool, 228

utility tools, 225-226

Zoom tool, 225

tools

 desktop, 214

 Help button, 218

 How To palette, 216-217

 paintbrush tools, 214

 palettes, 215

 question mark button, 218

 recipes, 216-217

 Shortcuts bar, 215

 tool tips, 215-216

Type Mask tool

 fill and pattern options, 373

 layers, cut out effect, 374

 selection outlines, 372-373

 text, copying/pasting, 373

type tools

 alignment options, 369

 antialiasing, 368-369

 bold, 369

 font readability, 372

 font selection, 371-372

horizontal, adding, 370

horizontal, letter mode, 368

horizontal, mask mode, 368

italic, 369

overview, 367

type formatting options, 370

underlined, 369

undo feature, 370

vertical, adding, 370

vertical, letter mode, 368

vertical, mask mode, 368

warped, 369

Wacom tablets, brush settings, 357-358

web galleries, creating, 301-303

Welcome screen

 Mac version, 213-214

 Windows version, 213

Photoshop Elements Online, tutorials listing, 453-454

Photoshop Elements User website, 455

Photoshop Guru's Handbook website, 455

Photoshop User Magazine, **456**

Photoshop Wire website, 455

PhotoShopUser.com website, 218

PICT (.pct) file format, 189, 254

Picture It! Software, photo manipulation, 202-204

picture packages, 281

 school-type, printing, 283-284

pictures

 albums, importing to (Organizer), 309-310

 backgrounds, replacing, 505-509

black-and-white
 hand-coloring, 493
 lack of contrast, fixing,
 462-463
 repairing, 460-461,
 464-466
 tint application,
 475-477
blurring filters
 Blur, 516-517
 Blur More, 516-517
 Gaussian Blur, 519
 Motion Blur, 522-524
 Radial Blur, 520-521
 Smart Blur, 517-519
cleanup guidelines,
 429-430
color cast, correcting,
 480-481
color saturation, adjusting
 (Sponge tool), 488-489
contrast, adjusting, 481
dust/scratches
 removing (Clone
 Stamp tool),
 442-443
 removing (Despeckle
 filter), 440
 removing (Dust and
 Scratches filter),
 439-440
 removing (Unsharp
 Mask filter), 441-442
faces, replacing, 503-505
new elements, adding to
 with Brush tool,
 567-568
noise filters
 Add Noise, 526-527
 Despeckle, 524
 Dust & Scratches, 525
 Median, 526
 Noise, 524
objects, hiding via drag-
 and-drop copying,
 495-500

old
 cleanup exercise,
 473-475
 sepia removal, 467
 vignetting, 470-472
old-fashioned, creating,
 449-451
persons, removing,
 500-503
pixels
 blurring (Blur tool),
 485
 dragging (Smudge
 tool), 489-490
 sharpening (Sharpen
 tool), 485-487
red eye
 prevention measures,
 434-435
 removing (from scratch
 method), 437-438
 removing (Red Eye
 Removal tool),
 435-436
rendering filters
 3D Transform,
 533-534
 Clouds, 528
 Difference Clouds, 529
 Lens Flare, 529
 Lighting Effects,
 529-532
 Texture Fill, 532
selective color adjust-
 ments, 482-484
sending via email, 303
seriously damaged, repair-
 ing, 467-470
shadows, lightening, 481
sharpening filters
 Sharpen, 513-515
 Sharpen Edges,
 513-515
 Sharpen More,
 513-515
 Unsharp Mask,
 513-516

small objects
 removing (Clone
 Stamp tool),
 430-432
 removing (copy and
 paste method), 432
special effects
 3D Transform filter,
 533-534
 Clouds filter, 528
 Difference Clouds
 filter, 529
 Lens Flare filter, 529
 Lighting Effects filter,
 529-532
 Texture Fill filter, 532
subjects, repositioning,
 491-492
tears, repairing, 468-470
texture filters
 Craquelure, 535-536
 Grain, 535-536
 Mosaic Tiles, 535-536
 Patchwork, 535-536
 Stained Glass,
 535-536
pinhole cameras, creating, 28
Pixar (.pxr) file format, 254
Pixelate filters, 660
 Crystallize filter, 661
 Mosaic option, 662-663
pixels, 211
 background, erasing
 (Background Eraser
 tool), 571-572
 blurring (Blur tool), 485
 color bit depth, 551
 dragging (Smudge tool),
 489-490
 erasing (Eraser tool),
 570-571
 images, resizing, 388-389
 resolution quality, 34-35
 sharpening (Sharpen
 tool), 485-487
pixels per inch (ppi), 39
PKZip utility, 192

PlanetPhotoshop.com
website, 218, 455
Plastic Wrap filter, 655-656
pleasure colors, in pho-
tographs, 114
plexiglas, tabletop lighting
techniques, 160
plug and play, uploading
pictures, 179
plug-ins. See also filters
Photomerge, 625-629
preferences, setting, 246
PMAI (Photographic
Marketing Industry) show,
43
.png (Portable Network
Graphics) file format, 254
PNG-8 (Portable Network
Graphics, 8-bit), 292
images, saving as,
292-293
PNG-24 (Portable Network
Graphics, 24-bit), 292
images, saving as,
292-293
Polar Coordinates filter,
643-647
polecat poles, indoor settings,
130
political figures, photo
release forms, 123
Polygonal Lasso tool
(Photoshop Elements),
333-335
Portable Document Format
(.pdf) file format, 253
Portable Network Graphics
(.png) file format, 254
portraits, 83
cheese myth, 169
fill light, studio lighting
techniques, 156
key lights, studio lighting
techniques, 156
posing guidelines
animals, 170
babies, 170-171
children, 170

couples, 167-168
farm/zoo animals, 173
fast moving subjects,
175
flattering light tricks,
168-169
groups, 168
head position, 166
older kids, 171-172
pets, 172-173
profile shots, 166
purpose of, 166
retouching, 169
stools, 165
studio mood, 167
subject comfort, 165
tables, 166
toddlers, 171
wildlife, 174-175
tabletop lighting, 159
unflattering features,
disguising, 166
vignetting, 339
posing for portraits
animals, 170
babies, 170-171
children, 170
couples, 167-168
farm/zoo animals, 173
flattering light tricks,
168-169
groups, 168
head position, 166
older kids, 171-172
pets, 172-173
profile shots, 166
purpose of, 166
retouching, 169
stools, 165
studio mood, 167
subject comfort, 165
tables, 166
toddlers, 171
wildlife, 174-175
positive/negative space con-
siderations, 86-87
posterization, 241
posterizing colors, 632-633

ppi (pixels per inch), 39
preferences, setting
(Photoshop Elements), 246
Preferences dialog box, 245
Preset Sizes drop-down list
(New dialog box), 224
preventing red eye in pho-
tographs, 434-435
previewing
animations, 642
images prior to printing,
278-280
prime lenses versus zoom
lenses, 57-59
print and screen formats,
88-89
Print Preview (Mac)
Border option, 276
Position option, 275
Print Size option, 275
printer output, 275
Scale Size option, 275
Show Bounding Box
option, 276
Show More Options
option, 276
Print Preview dialog box,
278-280
Color Management tab,
279-280
Print Selected Area tab,
279
Print Size tab, 278
Scaling tab, 278
Show More Options tab,
279
Printer icon (Shortcuts bar),
221
printers
all-in-one printer/scan-
ner/copier models,
268-269
dye-sublimation
costs, 270
dpi output, 270
locating, 270
printing process, 270

images
color management, 272
preparations, 271-280
imagesetters, color separations, 271
inkjet
4-color, 266
6-color, 266
7-color, 266
cartridge costs, 267
color spectrums, 266
Iris prints, 268
paper types, 273
PostScript support, 266
printing process, 266
range of, 266
typical cost, 267
laser
black-and-white, 269
color, 269
dpi output, 270
selection criteria, 265-266
printing
images, 280-281
contact sheets, 282-283
photographs, school picture packages, 283-284
process color, 252
product branding, importance of colors, 550
professional digital camera models, 45
advantages of, 47
Canon EOS-1D Mark II, 46-47
Nikon D-70 Digital SLR, 47
zoom capabilities, built in, 47
profiles, shooting, 166
props for indoor settings, 131-132
all occasion props, 132-134
interesting backdrops, finding, 132

protocols (web), 286
proximity and perception, 102-104
publishing web pages (HTML), 287
.psd (Photoshop) file format, 189, 253
.pxr (Pixar) file format, 254
pure colors in photographs, 115

Q - R

quartz broadlights, studio lighting techniques, 155
question mark button (Photoshop Elements), 218
Quick Fix (Photoshop Elements)
image correction options, 407-409
opening, 407-409
quick masking (Selection Brush tool), 337

Radial Blur filter, 520-521
RAM (random access memory), 211
rangefinders, 30
rating images in iPhoto, 324
RAW file format, 188
reality illusion
aerial perspective, 93
contrast in sharpness, 93-94
linear perspective, 92
overlapping perspective, 95-96
vertical location, 94-95
rechargeable batteries, 16
recipes (Photoshop Elements), 216-217
Reciprocity Law, 64
Rectangle tool (Geometry Options palette), 559-560

rectangular frames, balance and symmetry, 101
Rectangular Marquee tool (Photoshop Elements), 332-333
red eye
alcohol/drug effect on pupils, 434
ambient lighting, 434
built-in flash lighting, 152
flash workarounds, 70-71
prevention measures, 434-435
removing, 433
from scratch method, 437-438
via Clone Stamp tool, 442-443
via Despeckle filter, 440
via Dust and Scratches filter, 439-440
via Red Eye Removal tool, 435-436
via Unsharp Mask filter, 441-442
Red Eye brush (Photoshop Elements Shortcuts bar), 223
Red Eye Removal tool, 228
Options bar, 435
removal process, 436
Redo command (File menu), 234
reflections
creating, 621-622
dulling spray for, 135
reflective lights, flash workarounds, 70
refracted light rays, 53-54
Regular Lasso tool (Photoshop Elements), 333-335
release forms, photo essays, 122-124
Relief option (Underpainting filter), 581

removing
 colors from images, 421
 dust/scratches from
 photographs
 Clone Stamp tool,
 442-443
 Despeckle filter, 440
 Dust and Scratches fil-
 ter, 439-440
 Unsharp Mask filter,
 441-442
 layer styles, 601
 layers, 348-349
 noise from images,
 524-527
 persons from pictures,
 500-503
 red eye from photographs,
 433
 Removal Eye Removal
 tool, 435-436
 scratch method,
 437-438
 sepia from old pho-
 tographs, 467
 small objects from
 photographs
 Clone Stamp tool,
 430-432
 copy and paste
 method, 432
Render filters
 3D Transform, 533-534
 Clouds, 528
 Difference Clouds, 529
 Lens Flare, 529
 Lighting Effects, 529-532
 Texture Fill, 532
rendered type, editing status, 371
repair tools (Photoshop Elements)
 Automatic Correction, 409
 Auto Color Correction,
 413-415
 Auto Contrast, 412, 415

 Auto Levels, 410-414
 Auto Smart Fix, 409, 414
 Color Cast, 417
 Color Variations, 416
 Hue/Saturation sliders, 418-421
 Quick Fix, 407-409
 Remove Color command, 421
 Replace Color command, 421-423
 Shadows/Highlights tool, 423
repairing
 black-and-white pho-
 tographs, 460-461
 lack of contrast, 462-463
 small blotches, 466
 via Burn tool, 464-466
 via Dodge tool, 464-466
 photographs
 cleanup exercise, 473-475
 seriously damaged, 467-470
 tears, 468-470
replacing
 backgrounds in pictures, 505-509
 colors in images, 421-423
 gradients, 637-640
 faces in pictures, 503-505
repositioning subjects, 491-492
resampling, resolution adjust-ment, 256-258
resizing
 canvases, 389-390
 images, 238, 387-391
 shapes via selection han-dles, 562-564
resolution, 34-35
 72 dpi, 255

 Basic setting, 39
 bits, 255
 device, 39-42
 Fine setting, 39
 high, 256
 High Quality setting, 39-40
 images, 39
 pixel adjustments, 388-389
 low, 256
 new image file considera-tions, 249
 Normal setting, 39-40
 reducing, 256
 resampling images, 256-258
 resolution chart, 42
result color, 609
retouching portraits, 169
Reverse option (Gradient Map), 638
RGB color model (Red, Green, Blue), 238, 544, 547
 filter use, 512
 parameters, 116
Rotate command (Image menu), 235-236
rotating
 flipping versus, 236
 images, 235-236, 250, 392-394
Rough Pastels filter, 584-585
 combining with Film Grain filter, 668
Rounded Rectangle tool (Geometry Options palette), 559-560
royalty-free images, 528
Rule of Thirds
 image composition, 386
 picture format considera-tions, 89-90
ruler preferences, setting, 246

How can we make this index more useful? Email us at indexes@samspublishing.com

S

Samples folder, file searches, 251

Sams Teach Yourself HTML and XHTML in 24 Hours, 287

Sams Teach Yourself Photoshop CS in 24 Hours, 206

sans serif fonts, 372

saturation (color), 115
 adjusting (Sponge tool), 488-489
 color adjustments (Quick Fix icon), 223
 modifying, 418-421

Save As a Copy option (Save As dialog box), 254

Save As command (File menu), 251

Save As dialog box, 254

Save for Web command (File menu), 251, 259

Save for Web dialog box, 258-259
 optimization options, 287-288

Save icon (Shortcuts bar), 221

Save Layers check box, 255

saving
 files, 251
 format selection, 252-254
 preferences, 246
 Save As a Copy option, 254
 Save As command, 251
 Save for Web command, 251
 Save for Web dialog box, 258-259
 Save Layers check box, 255

graphics
 GIF format, 290-292
 JPEG format, 289-290
 PNG-8 format, 292-293
 PNG-24 format, 292-293
 image selections, 340-341

scale considerations
 comparison, 97-98
 composites, 599-600
 horizontal placements, 98-99
 viewpoint selection placements, 99-100

Scaling option (Underpainting filter), 580

scanned media
 connections, 195
 drum scanners, 196
 film scans, 196
 flatbed scanners, 194
 memory card print features, 196
 object scans, 196-198

school picture packages, printing, 283-284

Scitex CT (.sct) file format, 254

scrapbooking
 Digital Memories, Scrapbooking With Your Computer, 25
 digital photo uses, 25

screen formats, 88-89

scrollbar, use in file searches, 250

.sct (Scitex CT) file format, 193, 254

SD (Secure Digital) flash memory cards, 49

searching
 files, 249-251
 file hierarchy, 251
 image rotation, 250
 keyword searches, 250
 Samples folder, 251

sort order, 250
thumbnail size selection, 250
using scrollbar, 250
folders, 233

seascapes, scale considerations, 98

Secure Digital (SD) flash memory cards, 49

selecting
 folders, 233
 printers, guidelines, 265-266

Selection Brush tool (Photoshop Elements), 227, 336-337

Selection effects, 614

selection handles, shapes, resizing, 562-564

selection tools (Photoshop Elements), 226-227
 desktop location, 331-332
 Elliptical Marquee, 332-333
 Rectangular Marquee, 332-333
 Magic Wand, 335-336
 Magnetic Lasso, 333-335
 Polygonal Lasso, 333-335
 Regular Lasso, 333-335
 Selection Brush, 336-337

selections (image portions)
 border modifications, 340
 contracting, 340
 feathering, 339-340
 filling, 341-344
 growing, 340
 inverting, 338
 loading, 340-341
 saving, 340-341
 smoothing, 340
 stroking, 341-343

selections (images)
 distorting, 400-402
 inverting, 240
 perspective changes, 403-405

skewing, 400
straightening, 397-399
selective interlacing (GIF images), 292
semiconductors (digital cameras), 33
sending
images (iPhoto), 327
pictures via email, 303
sepia coloring, removing from old photographs, 467
serif fonts, 372
seriously damaged photographs, repairing, 467-470
servers (web), 286
Shadow Intensity option (Watercolor filter), 575
shadows
drop, creating, 619-621
lightening, 481
perception considerations 105
studio light techniques, 159
Shadows/Highlights tool, 423
Shape Selection tool, 562-564
Shape tool, 228
Geometry Options palette, 559-560
Options bar, 558
shapes, drawing, 557
shapes
custom, selecting, 561-562
Custom Shape tool, 229
drawing, 557
formatting considerations, 83-85
geometry options, setting, 559-560
handles, selecting, 562-564
intersecting, 560-561
multiple, drawing, 560-561

resizing, 562-564
styles
applying, 558
removing, 558
umbrella example, drawing, 563-564
shareware utilities, web publishing, 24
sharing images (iPhoto), 327
Sharpen button (Quick Fix icon), 223
Sharpen Edges filter, 513-515
Sharpen filter, 513-515
Sharpen More filter, 513-515
Sharpen tool (Photo Element toolbox), 229
pixels, applying, 485-487
sharpness, 93-94
Sharpness option (Paint Daubs filter), 583
shiny objects, tabletop lighting techniques, 161-163
shooting
panoramas, 629
photo essays, 120-121
portraits, fast moving subjects, 175
short lighting (portraits), 168-169
shortcuts bar (Organizer), 307-308
Shortcuts bar (Photoshop Elements), 215, 220-221, 230
Crop tool, 223
email options, 222
Hand tool, 223
magnifying glass, 223
new images, starting, 224
Print icon, 221
Quick Fix icon, 222-223
Red Eye brush, 223
Step Backward button, 222
Step Forward button, 222
Tool Options bar, 223

shutter issues, exposure control, 64
side lighting, 157-158
Silicon Beach Software (Digital Darkroom), 13
single-use cameras, 48
sites. See websites
skewing image selections, 400
transformations, 237
slideshows, viewing (iPhoto), 327
SM (SmartMedia) flash memory cards, 49
Smart Blur filter, 517-519
Smart Fix button (Quick Fix icon), 222
smart quotes, 245
SmartMedia (SM) flash memory cards, 49
smiling in portraits, cheese myth, 169
smoothing images, 340
Smoothness option (Spatter filter), 578
Smudge Stick filters, 585
Smudge tool (Photoshop Elements), 229
pixels, dragging, 489-490
snap-to-feature (grids), 242
Snapfish website, 24
snapshot digital camera models, 35, 43
Casio Exilim series, 44
EX Z4U, 44
Olympus D-540, 43
soft light, 148-150
Softness option (Palette Knife filter), 582
software
Adobe Photoshop CS, 206
Adobe Photoshop Elements, 206-208
Flaming Pair Software, 670
Paint Shop Pro, 204-205
PhotoPlus 5.5, 208

Picture It!, 202-204
VCW VicMan's Photo Editor, 208
Solarize filter, 659
sorting
 browsing files, 250
 images, 233
 by date (Photoshop Elements Organizer), 308-309
 in iPhoto, 323-324
space, positive/negative, 86-87
Spatter filter, 578-579
special effects
 Render filters
 3D Transform, 533-534
 Clouds, 528
 Difference Clouds, 529
 Lens Flare, 529
 Lighting Effects, 529-532
 Texture Fill, 532
 texture filters
 Craquelure, 535-536
 Grain, 535-536
 Mosaic Tiles, 535-536
 Patchwork, 535-536
 Stained Glass, 535-536
Speckle option (Grain filter), 594
Sponge filter, 595-596
Sponge tool (Photo Elements), 229
 color saturation, levels of, 488-489
sports photography, fast moving subjects, shooting, 175
sports figures, photo release forms, 123
spot color mode, 238, 252
Spot Healing brush tool (Photo Element toolbox), 228
Spotlight light type (Lighting Effects filter), 531

spotlights
 hard lighting sources, 150
 studio lighting, 153
Spray Radius option (Spatter filter), 578
Stained Glass filter, 535-536
Step Backward button (Photoshop Element Shortcuts bar), 222
Step Forward button (Photoshop Element Shortcuts bar), 222
still life photography
 scale considerations, 97
 use of video cameras, 50
stools, portrait posing, 165
storage media, image transfers, 193-194
storytelling in photographs
 color considerations
 CMYK model, 116
 color palettes, limiting, 116
 color wheels, 115-116
 HSB parameters, 115
 monochrome, 118
 muddy colors, 115
 muted colors, 115
 neon lighting, 115
 pleasure colors, 114
 pure colors, 115
 RGB model parameters, 116
 tonality, 117-118
 communication, 107
 contrast ratio, 110
 mood considerations, 110-114
 shared experiences, 109
 symbolism, 108
 photo essays, 119
 location considerations, 119
 model release forms, 122-124
 revealing moments, 120
 shooting, 120-121

straightening images, 394-396
 portions of selections, 397-399
straightening tool (Jasc Paint Shop Pro), 205
strengthen/fade percentages for filters, 536
Stripple option (Grain filter), 594
strobe lights, studio lighting, 154
Stroke command (File menu), 234
Stroke Detail option (Palette Knife filter), 582
Stroke Length option (Rough Pastels filter), 584
Stroke Size option (Palette Knife filter), 582
stroking image selections, 341-343
studio lighting, 153
 accent lights, 155
 background light, 155
 barn door suggestions, 155
 cookies, 158-159
 fill light, 155
 flags, 158-159
 floodlights, 153
 gobos, 158-159
 hot spots, 155
 key light, 155-157
 back lighting, 157-158
 side lighting, 157-158
 low-cost solutions, 154
 photo store lights versus hardware store lights, 154
 quartz broadlights, 155
 selection considerations, 154-155
 snoots, 155
 spotlights, 153
studio portraits, mood of, 167
Stuffit utility, 192

styles
layer, 601-603
applying, 601
combining, 601
creating composites, 601-603
removing, 601
shapes
applying, 558
removing, 558
Stylize filters, 663
Emboss filter, 667
Find Edges filter, 663-664
Glowing Edges filter, 664-665
Trace Contours filter, 665
Wind filter, 666-667
styluses, Wacom tablet, brush settings, 357-358
subjects
lighting errors, compensation fixes, 423
portrait posing
animals, 170
babies, 170-171
children, 170
comfort of, 165
couples, 167-168
farm/zoo animals, 173
fast moving, 175
flattering light tricks, 168-169
groups, 168
head position, 166
older kids, 171-172
pets, 172-173
profile shots, 166
purpose of, 166
retouching, 169
stools, 165
studio mood, 167
tables, 166
toddlers, 171
wildlife, 174-175
repositioning, 491-492
Sumi-e filters, 590-591
sun
flash workarounds, 70
hard lighting sources, 150

SuperPaint program, 14
Swatches palette
foreground and background colors, 230
colors, selecting, 555-556
symbolism in photographs
horizontal lines, 108
jagged lines, 108
symmetry and perception, 100-102

T

tables, portrait posing, 166
tabletop lighting
carbinated effects, 160
crossed lights, 160
jewelry photos, 161-162
plexiglas use, 160
portrait subjects, 159
shiny object photos, 161-163
special shooting tables, 160
tent usage, 161-163
tablets (Wacom), brush settings, 357-358
Tagged Image File Format (.tif) file format, 254
tags for images
applying to (Organizer), 313-315
categories (Organizer), 313
creating (Organizer), 312-315
Tags palette (Organizer), 313
tape
cellophane, 136
crepe, 136
double-stick, 136
duct, 136
gaffer, 136
masking, 136
Targa (.tga) file format, 254

tears (crying), glycerin trick, 141
technological advances in digital photography, 13
computer program options, 17-18
graphics options, 13-14
making versus taking pictures, 18-19
telephoto lenses, 55-56
temperature, color adjustments (Quick Fix icon), 223
tents, tabletop lighting techniques, 161-163
text
Custom Shape tool, 229
layer styles
applying, 375-376
editing, 376-378
type enhancement, 142-144
warping along paths (Photoshop Elements), 378-379
web pages, font selection criteria, 295-296
Texture Coverage option (Underpainting filter), 580
Texture Fill filter, 532
Texture filters
Craquelure, 535-536
Grain, 535-536, 594-595
Mosaic Tiles, 535-536
Patchwork, 535-536
Stained Glass, 535-536
Texture Fill filter, 532
Texture option (Dry Brush filter), 577
Texture option (Watercolor filter), 575
textures
perception considerations, 104
Texture Fill filter, 532
Underpainting filter, 580
Texturizer filter, 668
.tga (Targa) file format, 254

theoretical infinity (focal length), 56
third-party filters, 511, 670
threshold, adjusting, 633-634
thumbnail images
 browsing files, 250
 contact sheets, printing, 282-283
 image transfers, 183-184
.tif (Tagged Image File Format) file format, 188-189, 254
tiling background images for web pages, 297
tints
 black-and-white photographs, applying, 475-477
 color adjustments (Quick Fix icon), 223
toddlers, portrait shooting, 171
tonality of photographs, storytelling, 117-118
toning tools (Photoshop Element toolbox), 229
Tool Options bar (Photoshop Elements Shortcuts bar), 223
tool tips (Photoshop Elements), 215-216
toolbox (Adobe Photoshop Elements)
 blending mode degree, changing, 231
 Blur tool, 229
 Brush tools, 229
 Clone Stamp tool, 228
 color tools, 230
 Cookie Cutter tool, 228
 Crop tool, 228
 Custom Shape tool, 229
 desktop, 214
 display, changing, 225
 Dodge tool, 229
 Eraser tools, 229
 Eyedropper tool, 225
 Fill tool, 229

Gradient tool, 229
Hand tool, 225
Healing Brush tool, 228
Help button, 218
How To palette, 216-217
Lasso tools, 226
Magic Wand tool, 227
Marquees tools, 226
miscellaneous tools, 228
Move tool, 225
opacity degree, changing, 231
paintbrush tools, 214
Paint Bucket tool, 229
painting tools, 228-229
palettes, 215
Pencil tool, 229
Red Eye Removal tool, 228
Selection Brush tool, 227
selection tools, 226-227
Shape tool, 228
Sharpen tool, 229
shortcuts, 230
Smudge tool, 229
Sponge tool, 229
Spot Healing brush tool, 228
swatches, 230
toning tools, 229
tool tips, 215-216
tools, displaying, 225
Type tool, 228
utility tools, 225-226
Zoom tool, 225
torn photographs, repairing, 468-470
touch-ups in natural portraits, 134
 dulling spray, 134-135
 tape, 136
traditional cameras
 creating from scratch (pinhole cameras), 28
 digital cameras versus, 33
traditional photo uses, 19

transferring images
 albums, 184
 compression, 192
 file formats and file sizes readers, 187-189, 193
 file space, saving, 189-191
 Nikon interface, 185
 Olympus Camedia software, 183-185
 scanned media, 194-198
 storage media, 193-194
 thumbnail views, 183-184
 via card readers, 186-187
transformations
 distort, 237
 free, 237
 perspective, 237
 skew, 237
Transformations command (Image menu), 236-237
transparency options
 GIF images, 292
 preferences, setting, 246
transparency papers, 273
transparent layers, 344
tricks in food photography, 140-141
tripods, use in indoor settings, 130
Turbulence tool, 635
tutorials
 Adobe Online, 453-454
 launching, 451, 453
TV/advertising photography, 23
type enhancement
 catalogs, 144-146
 natural portraits, 142-144
Type Mask tool (Photoshop Elements)
 fill and pattern options, 373
 layers, cut out effect, 374
 selection outlines, 372-373
 text, copying/pasting, 373

type tools (Photoshop Elements)
 alignment options, 369
 antialiasing, 368-369
 bold, 369
 fonts
 readability of, 372
 selecting, 371-372
 formatting options, 370
 horizontal
 letter mode, 368
 mask mode, 368
 horizontal type, adding, 370
 italic, 369
 overview, 367
 underlined, 369
 undo feature, 370
 vertical
 letter mode, 368
 mask mode, 368
 vertical type, adding, 370
 warped, 369
typography
 alignment of, 369
 antialiasing, 368-369
 bold, 369
 italic, 369
 setting circles, 643-647
 simplified, editing status, 371
 type enhancement, 142
 underline, 369
 undoing previous actions, 370
 warped, 369

U

umbrella shapes, drawing, 563-564
underlined type (Photoshop Elements), 369
Underpainting filter, 580-581

Undo command (File menu), 234
undo feature, 261
 type modifications (Photoshop Elements), 370
Undo History palette, 262
unit preferences, setting, 246
unoptimized graphics versus optimized graphics, 288-289
Unsharp Mask filter, 513-516
 launching, 441
 pixel values, 441-442
uploading photographs
 camera to computer setup, 179-183
 image transfers, 183-198
 plug and play, 179
URLs (uniform resource locators), 286
utility tools (Photoshop Elements toolbox), 225-226

V

Vanishing Point option (Photomerge), 628
variable focus camers, 54
VCW VicMan's Photo Editor, 208
vectors, drawing (Custom Shape tool), 229
velvet backdrops and props, 131
vertical location (perception), 84, 94-95
vertical type
 adding, 370
 formatting, 370
 letter mode, 368
 mask mode, 368
viewfinders, 30
viewing. See previewing

viewpoint selection, scale considerations, 99-100
vignetting
 image feathering, 339
 old photographs, 470-472
virtual space (web), 286
Visibility layer style, 602
visual angle (camera lenses), 56-57

W - Z

Warp Text dialog box, 378
Warp tool, 635
warped type (Photoshop Elements), 369
warping text along paths (Photoshop Elements), 378-379
Watercolor filters, 574-577
 Dry Brush filter, 577
 Spatter filter, 578-579
Wave filter, 658-659
web galleries
 banner category, 302
 custom color category, 303
 images, creating, 301-303
 large image category, 302
 security category, 303
 thumbnail category, 302
web interlacing (GIF images), 292
web pages
 backgrounds
 color adjustments, 299
 design guidelines, 296-299
 pattern creation, 297
 pixel sizes, 299
 cell phones, browsing via, 287

fonts
 design criteria,
 295-296
 selection criteria,
 295-296
GIF images, transparent
 creation, 299-300
graphics, optimizing,
 286-295
HTML
 publishing process,
 287
 translation/layout pro-
 grams, 287
image/information trans-
 mission process, 286
images
 potential limitations,
 286
 sharing via .Mac
 accounts, 327
 transmission process,
 286
load speeds, optimization
 tips, 300-301
URLs, 286
web publishing, digital photo
 uses, 24
websites
 AlienSkin, 670
 Arraich's Photoshop
 Elements Tips, 455
 Astronomy Picture of the
 Day, 528
 AutoFX, 670
 Flaming Pear Software,
 670
 help resources, 454
 IcingImage.com, 273
 InkjetMall.com, 273
 myJanee.com, 455
 Ofoto, 24
 Phong.com, 455
 Photoshop Cafe¢, 455
 Photoshop Elements User,
 455
 Photoshop Guru's
 Handbook, 455
 Photoshop Wire, 455

 PhotoShopUser.com, 218
 PlanetPhotoshop.com,
 218, 455
 Snapfish, 24
web-safe colors, 290, 543
weddings, digital photo uses,
 23
weight of digital cameras, 16
Welcome screen (Adobe
 Photoshop Elements)
 Mac version, 213-214
 Windows version, 213
Western perspective, vertical
 location example, 95
Whistler, J. M., 118
white balance, exposure
 control, 65
wide angle lenses, 55
wildlife, portrait shots,
 174-175
Wind filter, 666-667
Window menu (Photoshop
 Elements), 243-245
Windows version (Photoshop
 Elements), 213
wizards, Install Shield
 (Windows), 181
Working with Shapes catego-
 ry (How To palette), 449
Working with Text category
 (How To palette), 449
Wow Chrome layer style, 602
Wow Neon layer style, 602
wrist straps, digital camera
 maintenance, 73

xD (xD-Picture Card) flash
 memory cards, 49

yard sales, props, locating,
 133

zoo animals, portrait shots,
 173
zoom capabilities of profes-
 sional digital camera
 models, 47
zoom lenses versus prime
 lenses, 57-59